A MARBLE QUARRY

THE JAMES H. RICAU COLLECTION OF SCULPTURE

AT THE CHRYSLER MUSEUM OF ART

A MARBLE QUARRY

THE JAMES H. RICAU COLLECTION OF SCULPTURE

AT THE CHRYSLER MUSEUM OF ART

H. NICHOLS B. CLARK

with an essay by William H. Gerdts

HUDSON HILLS PRESS · NEW YORK

in association with The Chrysler Museum of Art

This publication is made possible by **NationsBank**

Additional support provided by

THE NATIONAL ENDOWMENT FOR THE ARTS

THE ESTATE OF CELIA STERN

MARK UMBACH

First Edition

Published in the United States by Hudson Hills Press, Inc.,
Suite 1308, 230 Fifth Avenue, New York, NY 10001-7704.

Distributed in the United States, its territories and possessions, and Canada by National Book Network.
Distributed in the United Kingdom, Eire, and Europe by Art Books International Ltd.
Distributed in Australia by Peribo PTY Limited.
Distributed in New Zealand by Nationwide Book Distributors Ltd.
Exclusive representation in China by Cassidy and Associates, Inc.

Editor and Publisher: Paul Anbinder

Assistant Editor: Faye Chiu

Copy Editor: Fronia W. Simpson

Proofreader: Lydia Edwards

Indexer: Karla J. Knight

Designer: Howard I. Gralla

Composition: Angela Taormina

Manufactured in Japan by Toppan Printing Company.

LIBRARY OF CONGRESS CATALOGUING-IN-PUBLICATION DATA

Clark, Henry Nichols Blake.
 A Marble quarry : the James H. Ricau collection of sculpture at
the Chrysler Museum of Art / H. Nichols B. Clark ; with an essay by
William H. Gerdts. — 1st ed.
 p. cm.
 Includes bibliographical references and index.
 ISBN 1-55595-131-7 (hardcover : alk. paper)
 1. Marble sculpture, American — Catalogues. 2. Neoclassicism
(Art) — United States — Catalogues. 3. Marble sculpture — 19th century —
United States — Catalogues. 4. Ricau, James H. (James Henri), 1916–1993 —
Art collections — Catalogues. 5. Marble sculpture — Private collections —
Massachusetts — Provincetown — Catalogues. 6. Marble sculpture —
Massachusetts — Provincetown — Catalogues. 7. Chrysler Art Museum —
Catalogues. I. Gerdts, William H. II. Title.
NB1210.M3C56 1997
730'.973'07474492 — dc21 97-15397
 CIP

CONTENTS

Dedicated to the Memory of James H. Ricau (1916–1993)

FOREWORD

The institution that became The Chrysler Museum of Art opened in March 1933 as the Norfolk Museum of Arts and Sciences. Housing exhibits of natural and Tidewater, Virginia, history as well as paintings and sculptures, the Museum provided programming to serve the entire community. Growing collections necessitated new gallery space, which opened with an exhibition of material on loan from Walter P. Chrysler, Jr., of New York.

Walter Chrysler was already familiar with Norfolk. His wife, Jean Outland Chrysler, was from the city and was closely involved with the Museum. In March 1971 a substantial portion of the Chryslers' extraordinary art collection — literally thousands of paintings, sculptures, and drawings, plus decorative objects — was given to the newly renamed Chrysler Museum. To accommodate these ever-expanding holdings, new spaces were added in 1976 and 1989.

The James H. Ricau Collection was the last major group of objects to come to the Museum as a result of Walter Chrysler's involvement. The circumstances of the purchase and the scope and importance of Ricau's sculptures are described in the preface to this catalogue, the second in a series of planned publications that will deal with all aspects of the holdings of this institution.

This volume is published in conjunction with the installation of the Ricau Collection in a newly created space, the NationsBank Gallery. Publications and installations of this magnitude are becoming increasingly difficult to realize without the assistance of corporate and foundation/private funding. We offer special thanks to NationsBank for its substantial additional help that enabled us to produce this volume and mount this permanent exhibition.

Additionally we are deeply indebted to the National Endowment for the Arts, the Estate of Celia Stern, and Mark Umbach for their financial support, which made the creation of this book possible.

H. Nichols B. Clark in his preface thanks the many people who have contributed to the production of this catalogue. I will not repeat their names here but do wish to add my thanks to his. Dr. Clark has dedicated his time, energy, and scholarship to making sure that this catalogue is something of which each person involved with The Chrysler Museum can be proud, and I thank him on behalf of all of us.

William J. Hennessey
Director

The James H. Ricau Collection of Sculpture consists of seventy pieces purchased by and donated to The Chrysler Museum of Art in 1986 from James H. Ricau (1916–1993). Nearly all the works are by American artists, and all but two are carved in marble. The exceptions are two bronzes — *Pax Victrix,* by Frederick MacMonnies (cat. no. 67), and a bust of Abraham Lincoln by George Edwin Bissell (cat. no. 64). James Ricau's extensive holdings constituted one of the largest gatherings of nineteenth-century American sculpture assembled by an individual, in either this century or the last.

The procurement of this remarkable group of objects stands as Walter Chrysler's last major act as a collector and, in part, reflects the tremendous respect accorded by one kindred spirit to another. That Mr. Ricau responded through his generous gift is emblematic of this mutual esteem. The transaction also reveals the insatiable thirst of a collector. When Ricau's sculptures came on the market, many major institutions such as the National Gallery of Art, the Metropolitan Museum of Art, and the National Museum of American Art vigorously pursued it. Mr. Chrysler, however, prevailed, less encumbered than they by bureaucratic constraints.

In typical fashion Walter Chrysler captured, in one fell swoop, a highly prized group of objects that instantly created for this institution one of the four major holdings of nineteenth-century American sculpture in the country. Even though the Museum was not able to obtain the entire Ricau Collection, this purchase and gift put it in league with the Metropolitan Museum of Art in New York, the Museum of Fine Arts in Boston, and the National Museum of American Art in Washington, D.C.

Equally significant is that the collecting habits of James Ricau and Walter Chrysler were so very similar. They thrived on buying against the market and relished seeking out pockets of artistic creation that were currently unfashionable and therefore inexpensive. Walter Chrysler had far greater financial means at his disposal than Mr. Ricau, and his ambitions were correspondingly greater; he was committed to assembling a comprehensive collec-

tion worthy of forming a museum. Toward this end he achieved remarkable success.

James Ricau, by contrast, was much more modest in his goals. In his introductory essay, William H. Gerdts eloquently discusses the fascinating circle of American art lovers in which Ricau moved in the 1950s and early 1960s. Where Chrysler was eclectic to the point of being omnivorous, Ricau and his circle, in their common assault on American art, were focused. Although Ricau's paintings and sculpture did not remain together, it is fortunate that the sculptures will endure virtually intact as an almost complete reflection of his activities in this sphere. That he did not live to see this volume is a deep disappointment; I was to have seen him the week he died to tell him that the catalogue was almost finished and to show him drawings for a proposed skylit gallery dedicated to the collection. It is fitting that this catalogue be dedicated to his memory.

The model for this publication was the exemplary *American Figurative Sculpture in the Museum of Fine Arts, Boston* (1986), which made this book an ambitious undertaking, to say the least. Happily, there has been a proliferation of literature, monographic and thematic, on American sculpture in recent years, which facilitated my research and amplified such pioneering efforts as Lorado Taft's *History of American Sculpture* (1924), Albert Ten Eyck Gardner's *Yankee Stonecutters* (1945), Wayne Craven's *Sculpture in America* (1968), and William H. Gerdts's *American Neo-Classic Sculpture* (1973). I am particularly indebted to William Vance's *America's Rome* (1989), Irma Jaffe's *Italian Presence in American Art, 1760–1920* (1989), Joy Kasson's *Marble Queens and Captives* (1990), and Richard Wunder's *Hiram Powers* (1991). The logistical problems of exhibiting marble sculpture are myriad, and this accounts for the medium's less visible presence in museum installations. This, too, has been rectified lately in exhibitions mounted by the Museum of Fine Arts, Boston, *The Lure of Italy* (1992), and by the Baltimore Museum of Art, *Classical Taste in America* (1993). Thus, the modern public can now better appreciate the significant role that sculpture played in nineteenth-century American culture

and taste. It is hoped that the Ricau catalogue will also contribute in some meaningful way to our understanding of this important aspect of artistic endeavor.

The research and writing of this catalogue have been my major preoccupation over the past seven years, and many people have assisted immeasurably in bringing it to fruition. First, I would like to thank David Steadman, who hired me to undertake the project, and Catherine H. Jordan, acting director, who provided unflagging support in the realization of my objectives. Most of the Museum's staff helped in innumerable ways, and I would like to express my gratitude to them. Foremost, Georgia Young, who took care of so many details and deflected so many interruptions, which permitted me to think and write. The registrar's office, with Catherine H. Jordan and Irene Roughton, facilitated my study of the pieces in storage, and the art handlers, Willis Potter, Sue Christian, Carol Cody, Richard Hovorka, and Bernie Jacobs, who had to move the entire collection to be photographed, were crucial to the realization of my task. Scott Wolff worked with me very closely to make photographs that are not only beautiful but informative; to him I am deeply grateful. The library staff—Rena Hudgins, Marissa Cachero, Peter Dubeau, Rosemary Dumais, Susan Midland, and Julia Burgess—attended to my incessant requests with cheerful efficiency. Trudy Michie and Brownie Hamilton worked diligently to prepare grant applications for the catalogue. Finally, to my colleagues, Gary Baker, Mark Clark, Trinkett Clark, Jeff Harrison, Brooks Johnson, and Jane Weber, my thanks for their various insights and for putting up with the rather inhospitable closed door behind which I hid while researching and writing.

I received considerable help beyond the walls of this institution, and several people need to be singled out. My research could not have been as thorough or efficient without the generosity of Bill Gerdts and Merl Moore, who opened their prodigious files to me. Much of my primary source material was gleaned from their folders. To Bill Gerdts I am also deeply grateful for his sensitive essay, which nicely puts James Ricau into the context of collecting at midcentury. I am very indebted to George Gurney and Jan Seidler Ramirez for reading an early draft of the manuscript and offering many helpful suggestions. They did not have the benefit of Sally Hartman's and Fronia W. Simpson's thoughtful editing, and to them I am also extremely grateful. Lucy Alfriend Thacker provided initial insights for the design of the catalogue, and Howard Gralla took over the project, creating an elegant and visually arresting volume. Finally, I must thank the late James Ricau and his curator, Mark Umbach, for their hospitality and enthusiastic commitment to my work on this project. I think Mr. Ricau would be pleased.

No acknowledgments of a publication of this magnitude would be complete without a litany of names. I have tried to be inclusive, but if I have missed someone, please accept my sincere apologies. To all, my heartfelt thanks: Harold Augenbraum, The Mercantile Library of New York; Linda Ayres, Betsy Kornhauser, and Elizabeth McClintock, Wadsworth Atheneum; Robert, David, and Jennifer Bahssin, Post Road Gallery; James Barber and Wendy Reaves, National Portrait Gallery; Barbara Batson, Valentine Museum; Sharon Bennett and Christopher T. Loeblein, Charleston (South Carolina) Museum; Annette Blaugrund and Timothy Burgard, The New-York Historical Society; Russell Burke; Barbara Butler, Mount Vernon (Ohio) Public Library; Foy Casper, in conjunction with George Wheeler and Bill Hickman of the Metropolitan Museum of Art, infused new life into much of the collection with their sensitive cleaning, and subsequently John Hirx returned several of the more problematic pieces to exhibitable condition; Nicolai Cikovsky, Jr., and Franklin Kelly, National Gallery of Art; the late Roger Clisby; Wendy Cooper and Sona Johnston, Baltimore Museum of Art; Andrew Cosentino, Library of Congress; Wayne Craven and Steve Crawford, University of Delaware; Lorna Condon and Richard Nylander, The Society for the Preservation of New England Antiquities; David Dearinger, National Academy of Design; Lauretta Dimmick, Denver Art Museum; Dottore Carlo del Bravo, University of Florence; Betsy Fahlman, University of Arizona; Jeanine Falino, Jonathan Fairbanks, Theodore E. Stebbins, Jr., and Carol Troyen, Museum of Fine Arts, Boston; Dottoressa Maria Fossi-Todorow; Robin Frank, Yale University Art Gallery; Roberta Geier and Doumia Loumato, Library, National Gallery of Art; Mr. and Mrs. Peter E. Gilbert; E. Adina Gordon; Kathryn Greenthal; Donna Hassler, Thayer Tolles and Barbara Weinberg, The Metropolitan Museum of Art; Janet Headley, Loyola University, Baltimore; Joan Hendrix and Robert Torchia, Union League of Philadelphia; Christine Hennessey, Index of American Sculpture, National Museum of American Art; Nancy Heywood and Dean Lahikainen, Essex Institute; Celia Hsu and Pat Lynagh, Library, National Museum of American Art; Susan James-Gadzinsky, Pennsylvania Academy of the Fine Arts; William R. Johnston, Walters Art Gallery; David T. Johnson, The Taft Museum; the late Dr. Bjarne Jørnæs, Thorvaldsen Museum, Copenhagen; Mr. and Mrs. Frederic R. Kellogg; Dr. Sandor Kuthy, Kunstmuseum Bern; Charles H. Lesser, South Carolina Department of Archives and History; Betty Lipsmeyer, Old Dominion University; Dina Malgeri, Malden Public Library; Silvia Martini; David B. McQuillan, Commandant, Veterans Home and Hospital, Rocky Hill, Conn.; Maureen Melton, Archives, Museum of Fine Arts, Boston; Susan Menconi, Richard York Gallery, Inc.; Niccolò Michahelles; Betty C. Monkman and Lydia S. Tederick, The White House; Eva Moseley and Abigail Yasgur, Arthur and Elizabeth Schlesinger Library, Harvard University; James W. Palmer II, Vassar Art Gallery; John C. Phillips; George Rinhart; Rachel Sandinsky, Arnot Art Museum; Elizabeth

Schaaf, Archives, Peabody Institute, Baltimore; Anne Schmoll, Vose Galleries; Darrell Sewell, Philadelphia Museum of Art; Dolly Sherwood; Marc Simpson, Fine Arts Museums of San Francisco; the late Mrs. Marjory S. Strauss; Mr. and Mrs. W. B. Dixon Stroud; Joel D. Sweimler, Olana; Dr. Peter Tigler and staff, Kunsthistorisches Institut in Florenz; Mr. and Mrs. Gilbert T. Vincent; Richard Wattenmaker and the staff of the Archives of American Art, Smithsonian Institution; Bruce Weber, Berry-Hill Galleries; Michael Wentworth, Boston Athenaeum; Nathalia Wright.

A SHARED PASSION:

New York Collectors of Nineteenth-Century American Art in the 1950s

WILLIAM H. GERDTS

I HAD PLANNED to present this historical account of the circle of people who collected American art in the 1950s, a group that included James Ricau, as factually and objectively as possible. I realize now, as I put fingers to keyboard, that this is in fact not possible, for this is an account of men and women who cared deeply not only about American art but also about one another. They were part of a social network that touched all aspects of their lives for many years, but particularly in the 1950s. There were rivalries, of course, since the passions and preferences generated by works of art necessarily affected their personal associations. The collectors formed friendships that sometimes fell apart. These collectors came from disparate backgrounds and had distinct professional identities. They were a remarkable group, united not only by the art itself but by their pursuit of that art—the ferreting out of pictures, sculptures, and furniture. They were keen to learn more about what were then considered minor figures in American art history. Although a relatively late addition, I was privileged to be associated with these people, meeting all its members early in my tenure as curator of painting and sculpture at the Newark Museum, from 1954 to 1966. The information presented here is a combination of my own recollections and interviews held with the collectors in 1990, in anticipation of such an opportunity as this. It is just as well that I conducted them then. At the time, only Susan Horsley had passed away, and now, several years later, Paul Magriel, Cy Seymour, Jimmy Ricau, and Nick Smith are gone, and one or two others are in failing health.

Most of these collectors are not well known. In the 1950s the works of even major American painters and sculptors had little command on the art market, and few dealers concerned themselves with painters such as Martin Johnson Heade and John F. Francis or sculptors such as Hiram Powers, let alone figures such as John Tilton, Paul Lacroix, or Chauncey B. Ives. It was works by these artists that our "gang" often sought and acquired. Moreover, unlike the sumptuous shows and extensive catalogues devoted to the works of art owned by the collectors

of the 1960s—Raymond and Margaret Horowitz's collection at the Metropolitan Museum of Art in 1973 and Daniel and Rita Fraad's collection at the Brooklyn Museum in 1964, for instance—the majority of the 1950s collections were never shown intact. However, the collectors were always generous in lending individual works, immeasurably strengthening the shows I mounted at the Newark Museum. And when a few were exhibited as a whole—Paul Magriel's still lifes at the Corcoran Gallery of Art in Washington, D.C., in 1957, and Lee Anderson's at the Lyman Allyn Art Museum in New London, Connecticut, in 1961—the accompanying catalogues were meager.

Though we occasionally acquired paintings from major commercial galleries such as M. Knoedler & Co., others came from more modest operations such as the Old Print Shop and from private dealers such as Victor Spark. George Guerry on Third Avenue near Sixty-fifth Street was our inveterate source. We haunted George's premises like the art "junkies" we were, and I suspect he should be considered the patron saint of that decade of American art collecting. George was volatile, irritable, and cantankerous. He was also a lovely, generous, energetic, and extremely knowledgeable figure who provided the glue that helped cement our bonds of collecting and friendship. After all, even when a couple of us might be "on the outs," it was difficult to maintain enmity with decorum when we were both pawing through stacks of paintings on George's floor. We might do this every week or even more often, for George's stock changed with amazing rapidity. And what bargains we found! Pictures for $35 and $50 were the norm in those days. I can still recall my trepidation in agreeing to pay George $250 for a superb still life by Severin Roesen—by far the costliest painting I had acquired to date. To buy it I had to borrow money from my friend and fellow collector, Henry Fuller, who was not part of this coterie. (Of course, most of us had incomes to match the low prices. My wife at the time used to point out that each $35 picture took food from the mouth of our son, and indeed, he is awfully slender even today, but seems otherwise no worse for the experience.)

How did it begin? It seems to have started with Susan Horsley, a handsome woman with sleek, jet black hair who wore heavy jewelry and extravagant hats. She had originally been interested in anthropology at the Johns Hopkins University, especially in textile collecting. She became friendly with a number of contemporary artists, especially Irene Rice Pereira and Byron Browne, as well as some of the abstract expressionist painters—Arshile Gorky, Willem de Kooning, and Mark Rothko. Susan lived on Tenth Street, near the Studio Building, and began collecting American folk art and early American furniture. In 1948 she worked in the bookstore at Columbia University as a buyer for art books and began organizing contemporary art exhibitions. Subsequently, Susan's knowledge about art books landed her a job in the bookstore at the Metropolitan Museum of Art, where she remained until her retirement.

Around 1947 she became interested in historic American painting and acquired a work by Albert Bierstadt. Books such as Samuel Isham's monumental *History of American Painting* of 1905 were an important influence on her collecting, but even more was the opening in 1951 of the M. and M. Karolik Collection of American paintings, 1815–1865, at the Museum of Fine Arts in Boston. Susan's special interest was Hudson River school landscapes, with a subspecialty in pictures of Niagara Falls. About 1951 or 1952 she added another dimension to her collection with an interest in more mystical painters, such as Ralph Albert Blakelock and Elihu Vedder. And she was always interested in the painting of the Ashcan school and its contemporaries. Susan often purchased works at auctions at the Plaza Auction Gallery, Kaliski and Gaby, Lawner's, Fischer's, and other Greenwich Village shops and auction houses. She purchased an Asher B. Durand from the Old Print Shop and acquired a work in trade from Victor Spark. Unlike the rest of the group, Susan did not patronize George Guerry.

The Durand was among her favorite pictures, as well as the Bierstadt, a Thomas Cole, and a picture by William Beard. Another of her favorites, and mine as well, was the large *Niagara Falls* by Robert Weir (fig. 1). Though she discussed exchanges and acquisitions with her fellow collectors, these kinds of transactions never took place, nor did she purchase works from artists' descendants, though she did acquire some pictures by George Luks from a friend of the artist.

Susan's collection was never published, but like her colleagues she was generous in lending to various institutions—the Newark Museum, the Hudson River Museum in Yonkers, as well as to M. Knoedler & Co. A plan, never realized, existed around 1972 for a show of her collection at the Hudson River Museum. Though some pictures have been sold, her collection remains essentially intact, and her son, Carter, is adding to his mother's acquisitions. A final disposition has not been determined, but Carter

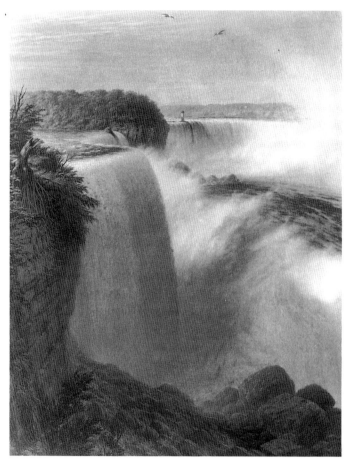

FIG. 1 Robert Walter Weir, *Niagara Falls*, 1853. Oil on canvas, 50 × 37½ in. (127 × 95.3 cm). Private collection. Photograph courtesy Berry-Hill Galleries, Inc. Helga Photo Studio

Horsley may well leave the collection to an educational institution.

I met Susan Horsley in the late 1950s when Lee Anderson took me by her apartment. Susan had a major impact on shaping Lee's collecting tendencies. They became acquainted in 1948 when Lee was getting advanced degrees at Columbia Teacher's College and Susan was working at the bookstore. She interested him in the American field and took him to his first auctions. Though there later was some rivalry between them, Susan met most of the other collectors through Lee, who was the catalyst in forming much of this group. Like Susan, Lee had been interested a bit earlier in American abstract painting and had acquired a work by Arthur Dove around 1947 or 1948. Among Lee's early acquisitions was the great *Falls of Kaaterskill* by Thomas Cole, acquired at the Astor Gallery for $110, and the delightful small *Portrait of Joseph Gales* by Samuel F. B. Morse. The former is now with the Gulf States Paper Corporation (fig. 2), and the latter is in the Corcoran Gallery of Art.

Among the formative influences on Lee's collection were the collections and exhibitions in institutions in New York City—the Whitney Museum, the New-York Historical

Society, and the Brooklyn Museum. At out-of-town museums, such as the Addison Gallery of American Art at Phillips Academy in Andover, Massachusetts, curators took Lee to basement storages to see works not normally on view. These works by the artists we were all to collect were an important part of his education. Lee was aware of the Karolik collection since he and Maxim Karolik were both collecting and ran into each other at such galleries as Kennedy's. Both were attracted to landscape painting. In fact, Lee originally acquired only landscapes, allowing himself just one work by each of the artists represented. Coming to New York from rural Indiana, he wanted to have the country in the city. Lee purchased from many sources, including auction galleries and George Guerry. From Victor Spark he acquired a Fitz Hugh Lane for $100, as well as a Washington Allston landscape. He bought from Knoedler's in New York, John Castano in Boston, and David David in Philadelphia, but he particularly patronized the Old Print Shop, also in New York. His principal acquisition from an artist's family was a landscape of the family farm at Belfield by Rubens Peale, purchased from a descendant of Charles Willson Peale. Among Lee's favorites are the Cole, the *View of the Presbyterian Church and All the Buildings as They Appear from the Meadow* by Francis Guy, now in the collection of the Maryland Historical Society, and William Rimmer's *Hagar and Ishmael,* which he still owns.

When I first met Lee, he was teaching school in Elizabeth, New Jersey. In order to give this up, he sold sixty of his more important pictures in 1965, which allowed him a comfortable early retirement. Since then, he has continued to purchase paintings and has branched out from landscapes to have a particular interest in still lifes. Today he remains the most active collector among us. Lee has become an avid collector of decorative arts, particularly furniture, and specializes in fine examples of the Gothic revival. Indeed, Lee's collection is a total ensemble in his New York home — a *Gesamtkunstwerk* of paintings, sculpture, furniture, ceramics, metalwork, and textiles. Not long ago, I asked Lee how many objects he thought he had in the house, and he replied, "Oh, I guess about a million." The casual reader may scoff in incredulity — but it may not be much of an exaggeration! Articles about Lee's collection have appeared in such magazines as *Antiques, Art in America, Casa Vogue, House and Garden,* and *Period Style.* These articles have been as much, if not more, about Lee's house and its furnishings as about his paintings. Lee will probably leave his collection to Frank Borzyma, his companion since 1968. He has no inclination to keep it together in an institution, preferring to allow other individuals to follow his lead in enjoying private acquisition and ownership.

Lee was more than just one of the collectors of the 1950s; he was the linchpin and the social arbiter of the group. We intersected with one another at his home and met others there, who joined our society even if they did not collect. These included Virginia Field, then with the American Federation of Arts; Connie Van Schaack, employed at the Old Print Shop; Hazel Guggenheim McKinley, a painter and sister of the more famous Peggy Guggenheim; Graham Williford, who concentrated on aesthetic movement pictures; Richard Brown Baker, who was creating one of the major collections of contemporary American painting so antithetical to the pursuits of our group; Bert Hemphill, the collector of twentieth-century folk art; and the English expatriate Roddy Henderson, whose collection of primarily American pictures was housed in a home in Chester Depot, Vermont, which became an occasional summer retreat for some of us. Lee found pictures for all of us and had the idea of apportioning nineteenth-century American art thematically: Jimmy Ricau to collect sculpture, Paul Magriel and Cy Seymour to collect still life, while he would have landscape painting almost all to himself. (I seem to recall that he urged me toward American animal painting, but except in a minor way, this did not take hold.) Lee figured specialization would lessen competition, though life, alas, does not fall into such neat partitions. Still, Lee led Paul to the marvelous *Blackberries* by Raphaelle Peale for $400 at Victor Spark's, a work now with the Fine Arts Museums of San Francisco, and Jimmy to his Raphaelle

FIG. 2 Thomas Cole, *The Falls of Kaaterskill,* 1826. Oil on canvas, 43 × 36 in. (109.2 × 91.4 cm). The Warner Collection of Gulf States Paper Corporation, Tuscaloosa, Alabama

FIG. 3 Raphaelle Peale,
Peaches, ca. 1817. Oil on panel,
13⅛ × 19¾ in. (33.3 × 50.2 cm).
Richard York Gallery,
New York

Peale of peaches for only $30 at L. L. Beans Antique and
Oil Painting Exchange in Trenton, New Jersey (fig. 3).

Soon after Lee began collecting American landscapes
he met Cy Seymour, in about 1949 or 1950. Cy was, in my
view, the loveliest member of our group — gentle and
sweet-natured, with a subtle wit. Cy, whose origins were
in Brooklyn, was professionally involved in textile design.
He was also a still-life painter and collector. He had
always had the collecting instinct and while in his teens
collected Americana. In addition to pictures, he later
acquired snuffboxes and plates. He was also a collector of
European still lifes but turned to American pictures when
he met Lee. He executed trompe-l'oeil still lifes in the
manner of William Michael Harnett, pictures of objects
against a flat background that we sometimes refer to as
vertical still lifes. His collection did not emphasize this
kind of picture, though one of his first acquisitions was a
work by Claude Raguet Hirst, the female member of the
Harnett "school." But Cy's preference in art was always for
tight, carefully executed pictures encompassing limited
space.

Cy acquired many of his pictures at auction, especially
at galleries around University Place, such as Gallo and
Roman's. He also frequented George Guerry's and occa-
sionally purchased works from Victor Spark. In Boston he
patronized both Vose Galleries and Childs Gallery. He did
not involve himself with artists' descendants, but he did
trade some with Lee Anderson. He met both Jimmy Ricau
and Paul Magriel at about the time he met Lee. Through
Lee he came to know Susan Horsley and John Preston.

Cy died in early 1993. But long before that, his collec-
tion was seriously decimated. In about 1960, Cy was vaca-
tioning in Europe and returned home to find that his
apartment had been burglarized. Nearly half his paint-
ings, about thirty-five in all, were stolen. For more than
thirty years, those of us who knew Cy's collection have
been on the lookout for his pictures. With the exception of
one work that Lee spotted, none has turned up. It was a
tremendous blow, and Cy never fully recovered from the
loss. In the following years he acquired almost a dozen
European still lifes but never resumed his role as a col-
lector of American painting. Cy was always convinced the
thief was knowledgeable about the field and took the bet-
ter half of his collection. I'm not so sure of his theory. It is
true that many of the better and more valuable paintings
were stolen, but many fine ones remained and are now in
the possession of Cy's friend, Ron Hoppis. These include
some beautiful examples, such as the lovely *Morning
Glories* by Paul Lacroix (fig. 4) and *Apples* by Bryant
Chapin. Nevertheless, many marvelous still lifes have dis-
appeared for good — an 1850 luncheon picture by John F.
Francis and an unusual example by William Mason Brown
of a compote of strawberries on top of a vivid green book
of Robert Burns's poetry. Also missing are Cy's favorites —
the Hirst, a violin still life by Jefferson David Chalfant, and
a pair of cake pictures by Joseph Ord.

While hardly a hermit, Cy was low-key. Though he
was generous in lending his pictures to institutions such
as the Brooklyn and Newark museums, only one or two
of his American still lifes were ever published. In that

respect, Paul Magriel was Cy's antithesis. In some ways, he was the most remarkable collector I have ever met, and one of the most perspicacious. His aesthetic instincts were not only transcendent but boundless. Alice Kaplan may be the only other collector I have known who could clearly spot the finest examples of aesthetic achievement in all periods and cultures and in every medium, from paintings and sculpture to graphics.

I understood from Jimmy Ricau that Paul first collected coins. He moved on to dance memorabilia and became the first curator of dance at New York's Museum of Modern Art as well as an editor of *Dance Index*. He replaced this interest and collection with boxing memorabilia. When I first met Paul in the mid-1950s, he was selling this collection in London, but he had already amassed what I am convinced was the finest assembly of American still lifes ever put together. It was not a large collection, but each example was a gem. At the same time, he had a mini-collection of more than a dozen small American paintings of nudes.

The still lifes were shown at the Corcoran Gallery in Washington in 1957, and in 1961 he sold them in two groups. Twenty went to Wildenstein's and then to Mrs. Norman Woolworth. The others went to Kennedy Galleries. Paul then began collecting Renaissance bronzes, and I am told by specialists in this field that his eye was as keen there as it had been in American still-life painting. After that, I believe, came a collection of American watercolors and drawings. Although I am probably overlooking some phases of Paul's collecting career, this was an area he returned to for a second collection more than a decade later. I recall that in the late 1960s he had a second American still-life collection that was very strong, but he acknowledged it did not quite measure up to the first collection because examples of outstanding quality were seldom available. When they did appear, their cost was often beyond Paul's means. Paul later collected sculptured antiquities from both occidental and oriental cultures. Shortly before he died in 1990, he started selling these and collecting small American sculptures of the late nineteenth and early twentieth centuries. Ultimately, there were fifty-six exhibitions of his various collections held during his lifetime.

Paul's interest in historic art went back to 1939–42, with his involvement at the Museum of Modern Art. During World War II, he was in the army associating with John I. H. "Jack" Baur, who became one of the nation's great American art curators. He also knew Nat Saltonstall, a major New England collector, and Willard Cummings, a leading portrait painter and founder of the Skowhegan School of Art in Maine.

Paul met Lee Anderson in 1948 through his old friend Jimmy Ricau. About the time Lee began acquiring examples of American painting, Paul also started collecting historic American art. In 1948 he acquired *Old South*

FIG. 4 Paul Lacroix, *Morning Glories*, n.d. Oil on canvas, 15 × 11½ in. (38.1 × 29.2 cm). Formerly Cyrus Seymour Collection, New York. Photograph by Gerald Kraus

Carolina for $1,200 from the centennial exhibition of still lifes by William Michael Harnett put together by Edith Halpert at her Downtown Gallery. The following year he acquired William Rickarby Miller's *Three Apples* for $75 from the Old Print Shop, Raphaelle Peale's *Blackberries* (for $400) from Victor Spark (fig. 5), to which he had been alerted by Lee, and also Margaretta Peale's *Strawberries,* for $1,000. Victor Spark also helped turn Paul on to the American artistic aesthetic. Later, George Guerry was important to Paul, who also acquired still lifes from Ginsberg & Levy. Wolfgang Born's 1947 book, *Still-Life Painting in America*, significantly influenced Paul's collecting. The first fruits of Paul's still-life collecting were on view at the Ed Hewitt Gallery in 1952 and were accompanied by a one-page catalogue.

Paul was drawn to nineteenth-century American still lifes that shared a common aesthetic. Like Cy, he preferred their factuality. He found them very organized and termed them "tidy and complete." His favorites were the Raphaelle Peale, along with Jasper Cropsey's *Green Apple* (private collection), probably the most beautifully painted apple in American art. Of the small collection of American nudes he collected at the same time, his favorite was John

FIG. 5 Raphaelle Peale, *Blackberries*, ca. 1813. Oil on panel, 7¼ × 10¼ in. (18.4 × 26 cm). Fine Arts Museums of San Francisco, Gift of Mr. and Mrs. John D. Rockefeller 3rd

O'Brien Inman's *Bathing Beauties on the Hudson* (private collection), which he acquired from Rudy Wunderlich at Kennedy Galleries. Not surprisingly, Paul was drawn to the basic theme of the nude. Though he also enjoyed these pictures for their naivete, he found the subject elusive as far as the art market was concerned. When he sold that collection, he also abandoned his plan of writing a book with Elizabeth McCausland on the history of the American nude. He generously turned over to me their files and photographs, which subsequently constituted an important component of my 1974 publication, *The Great American Nude.* Jack Baur published articles on Paul's collection in 1957 and 1961 in *Art in America.* Paul's second American still-life collection was sold to Coe Kerr Gallery in the early 1970s, though a few pictures remained, which he gave to his friend Babs Simpson.

Though Paul bought and sold works of art, he was not a dealer in terms of his own collection. His acquisitions were made out of love of the object and a thirst for knowledge about the works of art he procured. When he sold paintings, he did so to make a profit so he could continue to buy. He disbursed collections after reaching a point of diminishing returns in regard to inspiration and knowledge, not because the market was bullish. Still, because he was in the market, Paul sought to maximize his investments, and many of the collections were exhibited as a whole in institutions and commercial galleries and were published in catalogues. During Paul's last years, walking was difficult for him, and he used a wheelchair to tour small groups through the Metropolitan Museum of Art.

Characteristic of Paul, he chose not to guide viewers in a single area or department of the museum but to show them his fifty favorite objects. These small, intimate pieces ranged over cultural millennia and were memorialized in his 1987 *Connoisseur's Guide to the Metropolitan Museum of Art.*

Paul's life-style was perhaps the most varied of his fellow collectors. Drawing on his diverse credentials and experience, he remained in touch with associates from his days of involvement with the dance. Lincoln Kirstein was a close friend, as was the dancer Marie-Jeanne. Cy was a friend, as was Susan Horsley, whom Paul knew well from her position at the Metropolitan Museum. He had met Nick Smith through Lee Anderson, and Lee in 1948 through Jimmy Ricau. Paul had known Jimmy in New Orleans, having married the former Christine Fairchild of that city, and he saw him again in New York in 1946. At that time, Paul recalled, Jimmy had acquired only an Empire clock and an Audubon print.

Jimmy Ricau is central to this account of the collectors of the 1950s. Born in New Orleans, he had completed his stint with the Naval Air Force in 1946 and settled in Sheepshead Bay in Brooklyn, while he edited *The Mast,* the U.S. maritime magazine. Soon after that he became interested in historic American art. He met Lee Anderson around 1947 through their mutual friend Eloi Bordelon of New Orleans, a skilled decorative painter who specialized in painted trompe-l'oeil effects in homes. Through Lee, Jimmy met the other collectors of the group—Susan Horsley, Ross Kepler, John Preston, and myself. Jimmy

acknowledged that it was Lee who inspired him to collect. His first painting acquisition was *Boy Seated* by Joseph Wright of Derby. Perhaps due in part to his cosmopolitan New Orleans background, Jimmy never overlooked European painting and sculpture, though he concentrated on examples by American artists. In fact, in 1990 he stated that if he could relive his activity as a collector, he would have concentrated on nineteenth-century French neo-classic art. He acknowledged that his favorite among the sculptures he had owned was a Danish piece, Bertel Thorvaldsen's *Ganymede and the Eagle* (cat. no. 1). Other sources of inspiration were the collections at the city's major museums, not only the Metropolitan but also the New-York Historical Society and the Museum of the City of New York. A voracious reader, Jimmy consulted the leading survey books available at the time: Samuel Isham's *History of American Painting* of 1905; Lorado Taft's *History of American Sculpture* of 1903 (both probably in their respectively updated versions of 1927 and 1924); and Virgil Barker's 1950 *American Painting*. He also recalled a special indebtedness to the catalogue of the exhibition *Mississippi Panorama*, held at the City Art Museum of St. Louis in 1949, as well as the voluminous catalogue *The Karolik Collection of American Painting*, published by the Museum of Fine Arts, Boston, in 1951.

The collection formed by Maxim Karolik helped develop Jimmy's taste in American painting. Jimmy was an avid customer of George Guerry and also bought from Victor Spark and from Harry Shaw Newman at the Old Print Shop. Jimmy had a particular fondness for the gracious Elizabeth Clare at Knoedler's, though his greatest disappointment was his failure in 1962 to purchase the replica of Hiram Powers's *Greek Slave* from Knoedler's, which went instead to the Yale University Art Gallery (fig. 13). Jimmy also acquired a good deal from Boston auctioneers such as Louis Joseph, and dealers such as Vose Galleries, Childs Gallery, and John Castano. From Castano he purchased *Poor Cupid (Love Caught in a Trap)* by Edmonia Lewis, the African-American and Native American sculptor. The work is now in the collection of the National Museum of American Art. Jimmy also purchased objects from David David in Philadelphia, from Elmo Avet in New Orleans, and at Parke-Bernet auctions in New York City. As well, he even acquired a few works from his fellow collectors Paul and Cy.

Jimmy's great distinction as a collector, of course, was his concentration on American neoclassic marble sculpture, attested to by the remarkable catalogue that follows this essay. Only Lee and I joined him in this pursuit, and my own tentative activities were certainly stimulated by Jimmy's enthusiasm and knowledge. He was drawn to American neoclassic marbles in part because they were completely overlooked in the 1950s and often amazingly inexpensive. But, of course, there was positive motivation also. Jimmy was a frustrated sculptor who had studied in

New Orleans with Hans Mengendorf, who repaired old ironwork there during the depression. After serving as an apprentice Jimmy turned to photography and worked with Woody Whitesell, who photographed houses.

When I met Jimmy, he was the filmstrip editor for *Life* magazine, with offices in the Time-Life Building at Sixth Avenue and Fiftieth Street. His railroad flat on the fourth floor of a walk-up brownstone at Eighty-ninth Street and York Avenue was crowded with paintings, sculpture, and furniture. I recall well the arduousness of climbing those stairs, and I am grateful never to have seen the heavy marble sculptures brought up there, although these were mostly busts or full-length statues of children such as Emma Stebbins's *Samuel* (cat. no. 39). The weightier adult full-lengths were acquired only after he bought the magnificent classical temple-front home in Piermont, New York, in 1958. This building, though never restored as Jimmy would have liked, was essential to Jimmy's vision. This was, as I see it, a re-creation and an integration of two forms of cultural expression. Jimmy, I think, wanted to replicate a lifestyle drawn from Socratic Greece, for the visualization of which the marble sculptures loomed large, while duplicating also the forms of his Louisiana heritage. Therefore, the Piermont home was like a Northern version of a Louisiana plantation.

Jimmy was always generous in lending his pictures and sculpture, and I drew on him for many of the exhibitions I mounted at the Newark Museum. He also lent elsewhere, to such institutions as the New-York Historical Society. In later years, he formed a special relationship with the Brooklyn Museum, due to his fondness and respect for the curator Linda Ferber, whom he recognized as one of the best in the business. I am sure he meant to bequeath to the museum some of the many pictures he had lent on long-term loan, but he never finalized those intentions. Jimmy's sculpture was "special," but he was also quite involved with primarily American painting. The one major picture I located for him was Joseph Wright of Derby's *Dead Soldier Mourned by His Mistress*, found in a shop off Third Avenue around 1958. Shortly after Jimmy and I met, I drove him to Massachusetts to view the wonderful American pictures at my alma mater, Amherst College, a little-known collection he had never seen. Although he wanted to go, he was reluctant since there was a Parke-Bernet auction the same day. He entrusted two bids with Paul for a John F. Francis still life of cherries and Rembrandt Peale's dual portrait of his daughters, *Eleanor and Rosalba Peale*. Jimmy already had a lovely, smaller portrait by Peale of two of his other children. When we returned, Jimmy found that Paul had not bid high enough to acquire the pictures, and he never really forgave Paul, or me, for that loss. He did give me the honor of allowing me to write two articles in 1964 for *Antiques* magazine about his collection—one on the pictures, and one on the sculpture. Jimmy took the illustrations for the sculp-

ture article, which were some of the most beautiful and romantic photographs of American sculpture ever created.

Ross Kepler was probably the next collector drawn into the circle. He was an editor at McGraw-Hill who lived then, as he still does, in Maplewood, New Jersey, and was not as integrated into the group as the rest, who were New York–based. Ross had collected Japanese prints before he became interested in historic American art in 1950. He purchased a Bien lithograph after Audubon, and the Princeton, New Jersey, print dealer told him to see the Audubons at the Old Print Shop. There, Ross met Connie Van Schaack, who became a friend and introduced him to Lee. Their friendship developed after Ross purchased a supposed Asher B. Durand on Cape Cod, attracted by the Maplewood connection, since Durand had come from, and returned to, Maplewood. Ross brought the picture to Lee, who rejected the attribution, and Ross returned the picture to the artist-dealer Elliot Orr, by whom he still has some paintings. But Lee admired Ross's enthusiasm and introduced him to Paul Magriel, who encouraged Ross toward his next acquisitions—a landscape with grouse by Arthur Tait from George Guerry and a John O'Brien Inman still life at Parke-Bernet. Kennedy Galleries acquired the Inman, and Ross purchased it from them. Paul's approval and encouragement meant a great deal to Ross. In addition to Paul, Ross Kepler met Cy, Jimmy, and John Preston through Lee, as well as me, though that was later.

The historical survey book that meant the most to Ross Kepler was Henry Tuckerman's *Book of the Artists* of 1867. Also important was Robert McIntyre's 1948 volume on Martin Johnson Heade. Heade became Ross's special interest, inspired in part by the concentration of works in the Karolik collection at the Museum of Fine Arts. Ross learned about this collection through an article in *Newsweek*. Ross purchased a good deal of work from George Guerry, but none from Victor Spark, though Spark attempted to sell him a Heade flower picture of a white orchid. Through my efforts, Ross bought a Heade of apple blossoms and a nautilus shell from the Old Print Shop. I was also privileged to go with Ross on a visit to Lumberville, Pennsylvania, where he met one of Heade's collateral descendants, Elsie Heed, from whom he purchased two sketchbooks and a journal of Brazil. From another descendant, Susan Conduit in Parsippany, New Jersey, he bought three Heade paintings.

Heade was Ross's special interest but hardly his sole concern. He preferred still lifes to other forms and acquired a number by John F. Francis and John O'Brien Inman (fig. 6), encouraged by Paul and George Guerry. Ross has sold some works, most notably examples by Heade, but the collection remains pretty much intact. He has no definite plans for its disposition, except that he does not want it to go to an institution. Among his favorites are such diverse pictures as a Heade coastal scene, a beach

scene by Edward Potthast, and a painting by George Boughton of a woman with flowers.

Seeing Ralph Albert Blakelock's *Moonlight* at the Brooklyn Museum in the early 1950s kicked off the interest in American art for Nicholas Smith, who lived in Brooklyn until his death in early 1996. He was also inspired by El Greco's *View of Toledo* at the Metropolitan Museum of Art. Nevertheless, Nick's collection consisted predominantly of nineteenth-century American landscapes. As he acknowledged, there were not many books on American art then, but he recalls reading various volumes by James Flexner and, later, those by Edgar Richardson. Nick was aware of the Karolik collection and met Maxim Karolik once at Victor Spark's. Nick purchased a few works from Victor but found his prices too high. He also acquired a few from the Old Print Shop and many pieces from George Guerry. At one time, Norman Hirschl, then at Julian Levy Galleries, offered Nick a combination of landscapes by Thomas Cole, Martin Johnson Heade, Jasper Cropsey, and Frederic Church for $700, but Nick could not afford them. Nick never acquired work from families of artists, though he did know Muriel Van Rigersberg, a descendant of Eastman Johnson.

Within the group, Nick, who was a display manager for a clothing store, first met Cy Seymour at the Brooklyn Museum in the early 1950s. Cy had grown up in that neighborhood, and his mother still resided there. Through Cy, Nick became a friend of Lee Anderson, whom he found exhilarating and influential, with fine taste, but despite their mutual interest in collecting landscapes, Nick went his own way. Through Lee, Nick met the others and came to know Susan Horsley especially well. He also knew Jimmy Ricau and, to a lesser degree, Paul Magriel and Ross Kepler.

Keenly drawn by the basic aesthetic appeal of landscapes and, to a lesser degree, still lifes, Nick's collecting interests did not change over time. However, he had ceased acquiring pictures, since he found them too expensive. He bought some antiquities in recent years, while selling some twenty to twenty-five of the paintings. Among these were two of his most important acquisitions, for which he retained great fondness: *The Lost Balloon* by William Holbrook Beard, now in the collection of the National Museum of American Art (fig. 7), and a painting of icebergs by William Bradford, which he sold to the Alexander Gallery. His favorite picture among those he kept was probably a landscape by George Durrie. Even so, his preferences had broadened to an admiration of late-nineteenth-century works, including those of the impressionists, but he had no desire to own such paintings.

Nick came to know both John Preston and myself through Lee. John and I were late recruits. We also shared the inspiration toward American art gleaned from Benjamin Rowland, who taught the subject at Harvard University. Ben was a professional watercolorist of no

FIG. 7 William Holbrook Beard, *The Lost Balloon*, 1882. Oil on canvas, 47¾ × 33¾ in. (121.3 × 85.7 cm). National Museum of American Art, Smithsonian Institution, 1982.41.1

mean ability. John found further inspiration in Henry James's short story "A Landscape Painter," and he, like Lee and Nick, found landscape to be his favorite theme. It was really Lee who confirmed John's preference in that genre. Literature has always been meaningful to John. He began to collect American pictures in 1955 while working at the Argosy Book Store, and he was later the librarian at the University Club. John's first acquisition, *Wilderness* by Alfred Bricher, was purchased from Argosy, which has always maintained a fine-arts department in addition to its book services. And Bricher, in turn, remained a special interest. John also published the first significant study of Bricher in *Art Quarterly* in 1962.

Though John did purchase some works at auction — he acquired one Bricher that way for $150 — his principal source was the venerable George Guerry, to whom he was led by Lee. He also frequented the Old Print Shop, but not Victor Spark. Lee was the first American collector whom John met. He learned about him from Sam Wagstaff — another collector who was on the fringe of our circle — whom he met at a party in about 1955 or 1956.

FIG. 8 Alfred T. Bricher, *Harbor Scene*, ca. 1885. Oil on canvas, 15 × 33 in. (38.1 × 83.8 cm). Hollis Taggart Galleries, New York.
Photograph by Ali Elai, Camerarts Studio, New York

When Sam learned of John's nascent interest in the field, he told him he must meet Lee, and when that occurred, Lee commended John's interest in Bricher. Through Lee, John met most of the rest of the group.

John has not added to his collection recently, though he would like to. He has sold a few pictures, including one by William Glackens. Not surprisingly, John's favorite among his nineteenth-century pictures is a Bricher harbor scene (fig. 8). But John has also collected contemporary paintings as well. In Southampton around 1956 he came to know Paul Georges and Larry Rivers and acquired works by both artists, whom he admires greatly. He has no definite plans for the disposition of his pictures, but as with so many of our group, he seems to have no wish to keep them together or to bequeath them to an institution and believes they will probably be sold at auction.

I entered the scene in 1955, about the same time as John. My interest in American art had been cultivated in art-history courses taken during my undergraduate years at Amherst College. It was enhanced during seven months working at the Mead Art Gallery at the college after completing my course work in January 1949. This was before law school began that September. (Law school occupied my attention for exactly four days, at which time I transferred to graduate work in art history.) I met my first art dealer at this time on a visit home in New York. He was Victor Spark, and that encounter led to Amherst's acquisition from Victor of a still life by Raphaelle Peale, so that my own special interest in still-life painting had probably begun by then.

After graduate school and a year at the Norfolk Museum of Arts and Sciences (now The Chrysler Museum of Art), I joined the Newark Museum in New Jersey. I met Maurice Bloch, who was then the curator of prints and drawings at the Cooper Union Museum. When he learned of my interest in American paintings, he urged me to get in touch with Lee, which I did. Lee received me with his customary graciousness, and in turn put me in contact with all the others or took me to meet them. It was typical of both his kindness and his proselytizing for American art that, although he and Jimmy were "on the outs" at the time, he nevertheless strongly encouraged me to meet him. Soon after, Jimmy and I became very close friends, and I am sure that he was the source of my additional fascination with American marble sculpture.

But still life was, and still is, the primary concentration of my collecting. Immersed as I was in a society of focused collectors, I could not help but become one myself, despite the limitations of a curator's salary. My first acquisition, probably in 1956, was a picture of a single peach, painted by the Pennsylvania painter Martin Lawler, for $35. That did not make me a collector, but a second still life, by David Johnson, for the same price, did. These were acquired from the Rabin & Krueger Gallery in Newark, but soon after George Guerry became my principal source, though over the years there has been a fair amount acquired from other dealers throughout the country and from private owners, including my fellow collectors. I was fortunate to make contact with a number of artists' descendants, which led, for instance, to a cache

of paintings by both Jeremiah Hardy, of Bangor, Maine, and his artist-daughter, Anna Eliza Hardy. In my case, I had to clear such acquisitions with my director at the museum, but Newark came to possess a fine collection of American still lifes acquired during my tenure there, pictures by Raphaelle Peale, John F. Francis, and William Michael Harnett among others.

My present wife has joined me in admiring American still lifes and marble sculptures, and we continue to acquire examples, though no longer for $35! We lend occasionally, though the only publication of the collection is the catalogue of a show held in 1966 at the Cummer Gallery in Jacksonville, Florida, of twenty-six works each from the collections of my good friend Henry Fuller and myself. (Henry entered the fray later and was not a member of our group.) At one point I disposed of about nine of the lesser still lifes in the collection, but far more than that have since been added, in addition to some figure paintings, which include three large history paintings by Emanuel Leutze. And there is also a group of twentieth-century still lifes by Leo Dee, Bruce Kurland, Harvey Dinnerstein, and Barbara Novak, among others.

We remained as a group for about a decade, but the situation changed fairly rapidly in the 1960s. Its dissolution was undoubtedly due in part to the economic shifts in the value of American paintings and sculptures. All of us were collecting on modest means—some more modest than others. In the 1960s rising incomes could not keep pace with rising prices. But this was really only part of the story. Individual factors also had a role—Paul's abandonment of still-life paintings for Renaissance bronzes, Lee's sale of many of his finest pictures, Jimmy's move out of New York, the theft of Cy's beloved pictures, and maybe most important, George Guerry's ill health and subsequent retirement. And of course, "things change"— personal and social interaction shifted and new alliances were made outside our coterie. But as much as anything was the greater general awareness of the field among collectors, dealers, and institutions in the nation at large. Concerned as we were in the 1950s with the John F. Francises and the Alfred Brichers, not the Thomas Eakinses and the Winslow Homers, we were unearthing (practically "inventing"!) heretofore ignored artists and movements of the nineteenth century, and the excitement of discovery became part of the tie that bound. Although a decade later Francis and Bricher were still not quite household names, they were known quantities, and we were by no means the only ones searching for their works. Some of the excitement was lost as our interests moved into the mainstream, and so we all went our separate ways.

JAMES H. RICAU
AS A COLLECTOR OF SCULPTURE

H. NICHOLS B. CLARK

James Henri Ricau, Jr., "Jimmy" to all who knew him (fig. 9), was a collector of the old school who was motivated by a pure love of the object and the excitement of the chase. He had little concern for documentation, for either posterity or profit. Richard York, who knew Jimmy well as both a dealer and a friend, eloquently recalled the experience of visiting the collector's Greek revival home on the Hudson River:

Indeed, for the visitor to Jimmy's home, time seemed to stand still, and Jimmy remarked that it took him twenty years to get the dust settled just the way he liked it. Some twenty full-length marble sculptures crowded the entrance hall [fig. 10], and his drawing room was filled with French and American Empire furniture, with original albeit tattered upholstery. For the maximum time-transcending experience, Jimmy might treat his evening guests to one of his legendary candlelight tours of his collection, wherein his conversation would become increasingly lively [fig. 11]. His unending wit would combine insightful opinions about art and tales of fifty years of collecting, all peppered with his uncanny memory for jokes and even limericks.[1]

William H. Gerdts, an authority on sculpture and collectors of the period, has placed Ricau within the context of his generation of collectors who became serious about American art in the 1950s. One must keep in mind that Ricau was as passionate about paintings and furniture as he was about sculpture. He assembled his collection on a relatively limited budget, which accounts for the tangents his collecting energies took into realms of underappreciated art—namely, American portraits, still lifes, and sculpture.[2]

Ricau began collecting sculpture in the 1950s. His earliest documented acquisition was a pair of statues, *The Dancing Girl* and *The Broken Tambourine* by Thomas Crawford (cat. nos. 36, 37), which he bought for $450. Appropriately, Ricau's last recorded purchase in this medium was also a pair, Joseph Mozier's *Silence* and *Truth* (cat. nos. 30, 31), which he bought from the New York Mercantile Library in 1984 for $80,000. The magnitude of this last purchase was the exception rather than the rule, since Ricau assembled the majority of his collec-

FIG. 9 James H. Ricau, ca. 1955. Photograph courtesy of William H. Gerdts, New York

tion at a time when American sculpture was decidedly out of favor. No avenue of pursuit was too inconsequential, as the sketchy provenances of many pieces attest. No antique shop was off-limits, and Ricau delighted in prowling New York's Third Avenue junk shops, which flourished before the demolition of the elevated tracks in the 1960s. The subsequent gentrification of the area relocated many of the stores downtown to the Washington Square area. As well, Ricau faithfully frequented numerous dealers, including Robert Bahssin, Paul Gabel, Victor Carl, and Elliot Shapiro. But much of his achievement must be attributed to his own unflagging efforts and discerning eye.

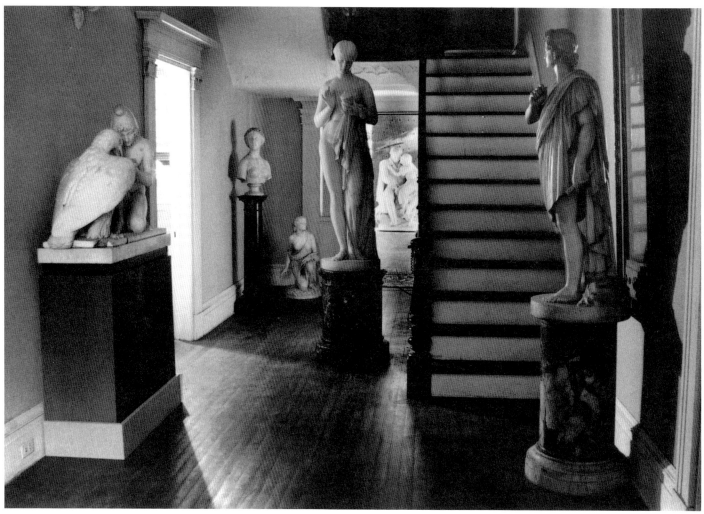

FIG. 10 Sculpture in the Central Hall at Piermont, after 1977. Photograph by James H. Ricau

Serendipity is an integral ingredient of collecting, and many of Ricau's purchases were the result of happy accident. Among such acquisitions was a bust of Andrew Jackson (cat. no. 5), which the collector spotted in the window of a junk shop outside Swansea, Massachusetts, while driving to or from Providence, Rhode Island, in 1960. Ricau did not linger but later consummated the transaction by telephone and mail. He had no idea who the sculptor was, but Jackson's association with Ricau's native New Orleans and the work's resemblance to Hiram Powers's version (The Metropolitan Museum of Art, New York) must have provided compelling motivation. It was not until after the portrait bust came to the Museum that it was attributed to Ferdinand Pettrich.

Ricau's vigilance was unflagging. He recalled seeing Randolph Rogers's *Ruth Gleaning* (cat. no. 52) in the hallway of a tenement building on 49th Street between 8th and 9th avenues, which was near his office. Since the piece had been abandoned, he negotiated with the building superintendent for its acquisition. Other purchases involved more calculating detective work, and Ricau used his own library to pursue acquisitions. He secured one of the gems of the collection, William Henry Rinehart's *Leander* (cat. no. 48), by tracking down the owner listed in a monograph on the artist. Ricau discovered the owner kept the piece in her basement and was happy to part with it. Thus, the collector purchased one of the most important nineteenth-century American statues of a male nude.

Certain acquisitions underwent extended gestation periods, and this was not always because of protracted negotiations. In the case of Chauncey B. Ives's monumental *Willing Captive* (cat. no. 22), Ricau recounted seeing it in a field while driving around the countryside near his home in Piermont, which is on the Hudson River just below Nyack and the Tappan Zee Bridge. He stopped to inspect it and another work by Ives, a life-size version of *The Hebrew Captive* (see cat. no. 24), and marveled at finding these two unfamiliar yet extraordinarily beautiful sculptures literally in the middle of nowhere. Despite repeated attempts to retrace his route, it took two years to relocate these works. Ricau was determined to own at least one of them and purchased *The Willing Captive*.

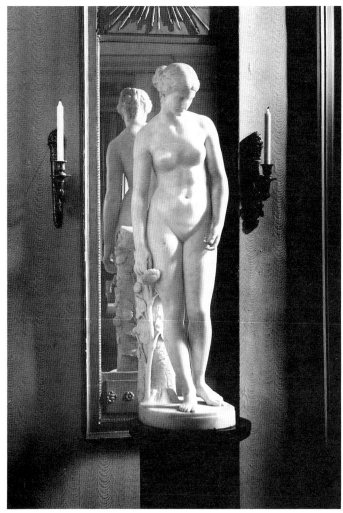

FIG. 11 Night view of William Henry Rinehart's *Clytie* (cat. no. 50) in the Salon at Piermont, after 1961. Photograph by James H. Ricau

Like all serious collections, there was an ebb and flow to Ricau's holdings. He was in the vanguard as a collector of work by Edmonia Lewis (1843/45–after 1911), the daughter of a Chippewa mother and African-American father. By the mid-1970s, Jimmy owned four sculptures by her: two portrait busts, of Anna Quincy Waterston (National Museum of American Art, Washington, D.C.) and Maria Wise Chapman (private collection), and two figural statues, *Poor Cupid* (National Museum of American Art, Washington, D.C.) and her acknowledged masterpiece— *Old Arrow Maker* (fig. 12). Toward the end of the decade he was approached by an advocate of the fledgling Frederick Douglass Museum in Washington, D.C., about selling this aspect of his collection to private individuals who would, in turn, donate them to the museum. Although Ricau was reluctant to part with these sculptures, he recognized the important role they would play in this public institution. As a result, three of the four works went to the museum while one remained in private hands. The Frederick Douglass Museum eventually became the Smithsonian Institution's Museum of African Art, and

the African-American holdings were transferred to the National Museum of American Art in 1983.

Occasionally, Ricau owned more than one version of the same statue. In the case of Emma Stebbins's *Samuel* (cat. no. 39), he gave one to the Brooklyn Museum in 1980. He also parted with solitary examples, such as Joseph Mozier's *White Lady of Avenel,* which he donated to the Newark Museum in 1978. Two years later Ricau replaced it with a smaller version bought at auction (cat. no. 34), thus reinforcing his rich holdings of this little-remembered sculptor.

In spite of the limitations and idiosyncrasies inherent in a collection formed by one individual, the Ricau Collection is impressive in both scope and depth. Comprehensiveness was not always feasible. In the early 1960s, for example, Ricau had to turn down an offer of Hiram Powers's *Greek Slave,* now in the collection of the Yale University Art Gallery (fig. 13), because he was so heavily mortgaged by both his house and his art. Nevertheless, this collection provides a remarkable survey of neoclassical sculpture, which dominated American taste from 1825 to 1875. It also offers an informative selection of examples that articulates

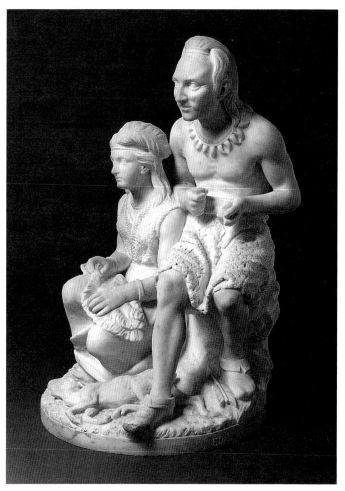

FIG. 12 Edmonia Lewis, *Old Arrow Maker,* modeled 1866. Marble, 21½ in. (54.6 cm) high. National Museum of American Art, Smithsonian Institution, Gift of Mr. and Mrs. Norman B. Robbins, 1983.95.179

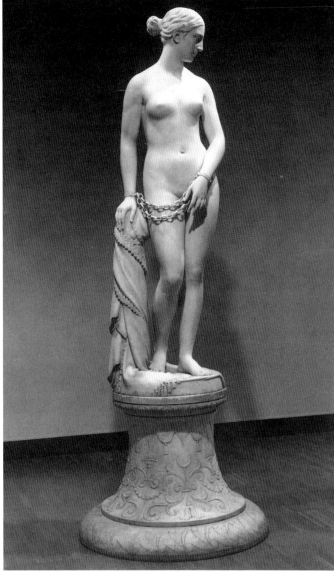

FIG. 13 Hiram Powers, *The Greek Slave*, carved 1851. Marble, 65½ in. (166.4 cm) high. Yale University Art Gallery, Olive Louise Dann Fund, 1962.43

the shift in orientation from the studios in Rome to the newer, more daring techniques emerging from Parisian ateliers.

Hiram Powers is the sculptor most extensively represented in the Ricau Collection. Although a major figure piece is lacking, there are twelve busts as well as a pirated version of *The Greek Slave*. Two of the Powers busts are portraits. One is thought to be his son Longworth (cat. no. 10). The other, of Emily Stevenson Davis Harris (cat. no. 17), has recently been identified through comparison with the collection of plaster models at the National Museum of American Art, Washington, D.C. The remaining ten busts are ideal works and offer the single largest concentration in marble of this genre in the country after the collection of the National Museum of American Art. Because of this significant holding, the individual entries, through a careful charting of the compositional nuances,

have attempted to discuss at length Powers's uncanny ability to create subtle variations on a theme.

With nine pieces in the collection, Chauncey B. Ives is the second most extensively represented sculptor. In addition to a single unidentified portrait bust (cat. no. 26) and two ideal heads (cat. nos. 20, 21), the works include his first full-length effort, *Boy Holding a Dove* (cat. no. 19); a genre piece, *The Truant* (cat. no. 25); a biblical work, *The Hebrew Captive* (cat. no. 24); and three major works, *Pandora* (cat. no. 23), *Undine Rising from the Waters* (cat. no. 27), and the monumental *Willing Captive* (cat. no. 22).

The little-studied Joseph Mozier is next most popular in Ricau's holdings, with seven sculptures. This catalogue provides the first substantial treatment of the artist, and the statues furnish particular insight into the importance of literature for sculptural expression. Mozier drew inspiration from James Fenimore Cooper (*The Wept of Wish-ton-Wish* [cat. no. 32]), Sir Walter Scott (*The White Lady of Avenel* [cat. no. 34]), and the Bible (*Rebecca at the Well* [cat. no. 28]). Mozier's *Wept of Wish-ton-Wish* and *Pocahontas* (cat. no. 29) afford a critical arena for addressing in the mid-nineteenth century the complex relationships between white women and American Indians and the perception of this association. The balance of Mozier's work, including such major pieces as *Silence* and *Truth* (cat. nos. 30, 31), helps elucidate this interesting yet underappreciated sculptor.

William Henry Rinehart is represented by five marbles, which include a reduced version of his acclaimed masterpiece, *Clytie* (cat. no. 50); a portrait of Otis Angelo Mygatt as Cupid stringing a bow (cat. no. 49); the enigmatic *Woman in Mourning* (cat. no. 51); and, unquestionably, the most important couple in the entire collection, *Hero* and *Leander* (cat. nos. 47, 48). Aside from the pair in the Newark Museum, this is the only other known grouping, and *Leander* ranks as one of the great achievements in nineteenth-century American neoclassical sculpture.

Thomas Crawford and Randolph Rogers are each represented by four works. The Crawford holdings are notable for containing his earliest ideal piece, *Paris Presenting the Golden Apple* (cat. no. 35), which is unique and reflects the impact of such contemporary European masters as Antonio Canova and Bertel Thorvaldsen. Another set of sculptures conceived as a pair is also the exclusive domain of the Ricau Collection: *The Dancing Girl* and *The Broken Tambourine* (cat. nos. 36, 37). As some of Ricau's earliest purchases, they set a high standard for quality. There is also a bust of Washington (cat. no. 38), which is one of three likenesses of the venerable statesman in the collection. The other Washington sculptures are by Antonio Canova's assistant, Raimondo Trentanove (cat. no. 3), and by an unidentified admirer of Jean-Antoine Houdon (cat. no. 68). Crawford, commissioned by the state of Virginia to create an equestrian statue for the capitol grounds in Richmond, relied heavily on Houdon's para-

digmatic bust for his likeness and created a number of busts for friends and family. Unfortunately, Crawford did not live to complete this undertaking, which was finished by his compatriot and colleague, Randolph Rogers. In addition to a pair of portrait busts, including Rogers's *Daughter Nora as the Infant Psyche* (cat. no. 54), this prolific sculptor is represented by two biblical subjects, *Ruth Gleaning* (cat. no. 52) and *Isaac* (cat. no. 53). Rogers was one of the guiding lights in moving sculpture away from classical themes to religious ones, and the Ricau Collection is fortunate to possess two of his most influential works in this category.

Other major figures are represented by one or two works. Their inclusion underscores the breadth and variety of Ricau's taste. Harriet Hosmer and Emma Stebbins exemplify two of the small group of fiercely independent women who took up the profession of sculpting and were collectively and derogatorily labeled by Henry James as "the white Marmorean flock." Hosmer is represented by her signature work, *Puck* (cat. no. 56), and its equally beguiling pendant, *Will-o-the-Wisp* (cat. no. 57), as well as a menacing and apparently unique variant on the latter conceit (cat. no. 58). Stebbins's lone offering provides insight into youthful piety with her interpretation of the biblical Samuel (cat. no. 59).

Some artists owe their reputation to a single work, and Peter Stephenson's *Wounded Indian* (cat. no. 46) is one example. Carved in Boston between 1848 and 1850, it is the first known large-scale sculpture to use marble quarried in America. It was exhibited in London at the Crystal Palace Exposition of 1851, where it was enthusiastically received but overshadowed by Powers's sensational *Greek Slave*.

Certain major figures are exemplified by seemingly atypical works, such as Augustus Saint-Gaudens's early effort in marble, *Portrait of Frederick C. Torrey (Freddie)* (cat. no. 65), which anticipates his predilection for the lively flickering surface of bronze. William Wetmore Story's early *Marguerite* (cat. no. 44), the ill-starred lover of Faust, does not epitomize the forceful, female type for which he is best remembered.

Many other sculptors in the collection, however, are well defined despite their minimal representation. The delicate naturalism of Erastus Dow Palmer's *Little Peasant* (cat. no. 41) illustrates his homegrown style, while the single examples of both George Grey Barnard (cat. no. 66) and Frederick MacMonnies (cat. no. 67) embody their Parisian orientation and attraction to Auguste Rodin and broader principles of the Beaux-Arts style.

Collectors and collecting have intrigued people for centuries, and the literature on the topic is vast.[3] Foremost, it is imperative to ask any collector what conditioned their interest in art and what inspired them to collect. Much of what I learned about Jimmy Ricau was based on a series of visits late in his life when the process of recollection

was sometimes imperfect or selective, and, sadly, I never saw the house filled with the sculptures he so cherished. Nevertheless, these conversations gave insight into the collector's activities and helped explain why he developed a passion for sculpture. The balance of this essay is based on these meetings and must, by necessity, constitute a rather personal remembrance.

Ricau was born in 1916 and reared in New Orleans, the son of a rice importer. His family was interested in art; his mother had gone to Newcomb College, where she was more attracted to two-dimensional media than to the ceramics for which the college's art program was best known. Ricau's maternal grandmother also was actively involved with the arts, primarily as a patron. Artists from Tulane University and Newcomb College would frequently visit the house. Many spent their summers in the hills of Tennessee or North Carolina and showed their latest work in the fall. Ricau's grandmother would invariably support them with purchases. A vivid aesthetic awakening for young Ricau was a trip to France in 1929, when he was thirteen. The collector recalled being struck by the resplendence of such châteaux as Malmaison. This experience kindled in him a love of beauty. Thus Ricau, from his youth, was constantly aware of creative activity, as art and the discussion of artistic matters resonated in his household.

Not surprisingly, Ricau was inspired to create. Initially, he tried his hand at sculpture, working with the German sculptor Hans Mengendorf, who supported himself repairing wrought iron in New Orleans during the Depression. Mengendorf had carved bas-reliefs for the brick buildings at the New Orleans Zoo and consequently enjoyed an artistic reputation. Ricau learned the rudiments of working in clay and casting in plaster from his mentor, but he candidly acknowledged his lack of talent. He took satisfaction in developing a sensitivity to sculpture and appreciated becoming attuned to its challenges.

Ricau was not deterred from making art, however, and he subsequently took up photography. He documented the plantation houses along the Mississippi River, which he recognized were fast disappearing. Many of his photos were published in collaboration with Harnett Kane's *Plantation Parade: Grand Manors of Louisiana* (New York, 1945) and *The Golden Coast* (Garden City, N.Y., 1959). The Brooklyn Museum recognized Ricau's talent in this arena with an exhibition of his work in 1950. Although Ricau did not pursue photography as a profession, he continued to dabble in it and particularly enjoyed photographing his sculpture collection as it began to fill his house (figs. 10, 11, 14).

Even World War II contributed to Ricau's interest in art. During his years in the Navy, he served as a pilot and flight instructor, and at one point ferried warplanes across the South Atlantic to Central Africa (fig. 15). This duty introduced him to indigenous sculpture, but he quickly

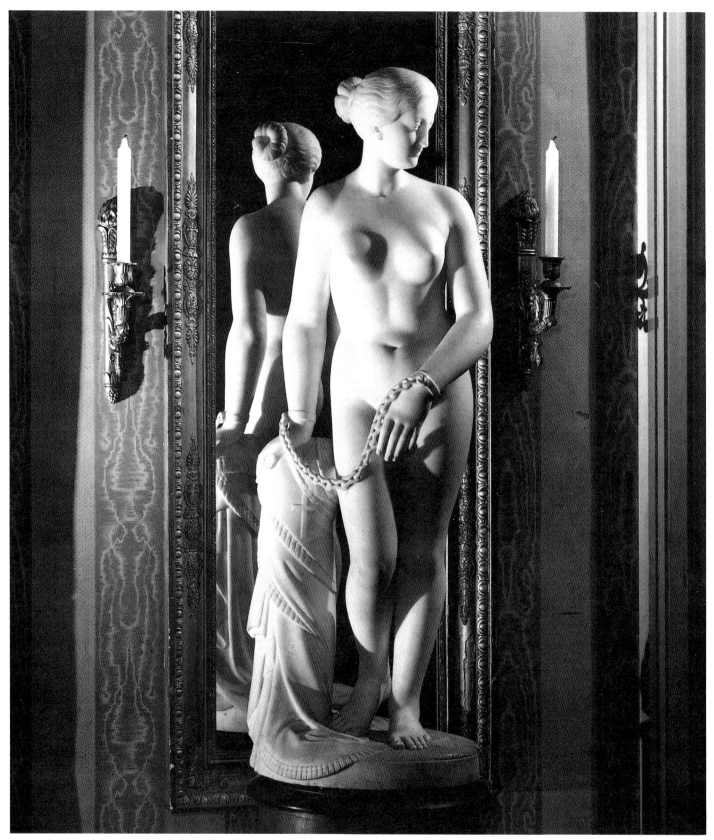

FIG. 14 Night view of *The Greek Slave,* after Hiram Powers (cat. no. 18), in the Salon at Piermont. Photograph by James H. Ricau

realized that the modern efforts he saw were inferior to older ones and that the works had been picked over. He stressed to me his belief that the form of the modern works was bad and that the color was achieved by simply darkening light woods with shoe polish. Intuitively, Ricau applied exacting principles of connoisseurship even to unfamiliar subject matter. While in the service, Ricau also pursued his creative talents, volunteering for auxiliary

duty as a photography officer. This gave him access to equipment that enabled him to refine his technique. This avocation provided some bearing on his eventual career as a film editor for *Life* magazine.

After World War II Ricau settled in Brooklyn, because he had more friends in New York than in New Orleans. He spent a brief period in the Merchant Marine. His only visit to Norfolk, Virginia, occurred when his ship wrecked off Cape Hatteras and was towed into port. During this peripatetic naval existence, Ricau visited cultural institutions in the various ports where his ship called. Even in this unlikely profession, Ricau capitalized on ways to broaden his aesthetic horizons.

Once he decided to stay on land, Ricau returned to Brooklyn and edited *The Mast*, the U.S. maritime magazine. His duties were far-ranging, and in 1949 he won an award for superior graphic presentation, thus garnering some recognition for his artistic prowess.[4] Ricau soon joined *Life* magazine to work with educational filmstrips and moved to 89th Street and York Avenue in Manhattan.

Ricau began to buy art in the late 1940s. He met another like-minded individual, Lee Anderson, whose collecting served as an inspiration and model.[5] Both were passionate about art but handicapped by modest bank accounts. Recognizing their mutual interest in a less-appreciated sphere of collecting, namely American art, Ricau and Anderson apparently agreed to carve out niches within this realm: Ricau would concentrate on still life and portraiture, while Anderson would funnel his resources into landscape and genre. Sculpture was not an issue, although there were inevitable overlap and competition in all categories. Ricau recalled that the first object he ever acquired was a painting of a boy seated in a landscape, which he found in a shop on Coney Island Avenue in Brooklyn. Ricau thought the painting was reminiscent of the work of John Singleton Copley, although it was labeled as by Joseph Wright, without distinguishing between the American or British artist. Through all his years of collecting, Ricau never parted with this initial purchase.

Although Ricau started with paintings and continued to collect them, he often thought they were too expensive. He considered sculpture a much better value. In his pursuit of paintings, he gravitated to works he thought were undervalued. Like Walter P. Chrysler, Jr., he made many astute acquisitions by buying against the market. The economic reality of modest means shaped Ricau's attraction to sculpture. Because of the logistical complexity inherent in buying statuary, there was virtually no market for it. Ricau found this combination particularly compelling. He also admitted to an abiding interest stemming from his own unsuccessful attempts at sculpting.

Even though Ricau could recall the precise identity of the first painting he bought, he was unsure which piece of sculpture he initially acquired. He thought that the bust of Andrew Jackson by Ferdinand Pettrich was among the

FIG. 15 James H. Ricau, ca. 1943. Photograph courtesy of Mark Umbach

earliest purchases he made. He clearly, though mistakenly, recollected driving to Providence in the mid-1950s and stopping at an antique shop by the side of the road where he spotted the bust. Surviving correspondence reveals that this transaction took place in the summer of 1960 and is antedated at least by the acquisition of Thomas Crawford's *Dancing Girl* and *Broken Tambourine*, which Ricau bought in 1954 from Louis Joseph, a Boston dealer.[6]

As Ricau began to purchase larger pieces of sculpture, it became readily apparent that a long, narrow apartment on the fourth floor of a walk-up brownstone was not the ideal locale to house such a collection. Consequently Ricau began looking for a house in the country. His search was intensified by imminent plans to tear down his East 89th Street neighborhood. After several attempts, he bought a wonderful, rambling Greek revival house in Piermont, New York, where he lived from 1958 until his death in March 1993. With spaciously proportioned rooms and ample grounds, Ricau's home served as an appropriate repository for his burgeoning gathering of neoclassical sculpture (fig. 10).

When asked if he ever formulated a comprehensive strategy or aesthetic goal for his collection, Ricau replied that much of what he did was predicated on expense. He bought what he could afford. When asked why certain artists, such as Shobal Vail Clevenger, Henry Kirke Brown,

John Frazee, Paul Akers, and Joel Tanner Hart were not represented, Ricau speculated that their works may have been too expensive. In hindsight, this seems to have been an answer of convenience, and one can only surmise what truly dictated Ricau's decisions. It may have been an issue of taste or simply a question of what came on the market.

Insights into Ricau's taste are elusive at best and often contradictory. In interviews, the collector said that in sculpture he disliked crouching or prone figures and was much more sensitive to vertical works. This is not completely consistent with the sculptures he bought, and one must wonder where he drew the line. Some of the most compelling works, such as Peter Stephenson's *Wounded Indian* or Randolph Rogers's *Isaac* and *Ruth Gleaning* defy this point of view. A predilection for innocence and grace seems to inform the collector's attitude. Conversely, Ricau attempted to make his point using an equally implausible example. He recalled being approached about Paul Akers's *Dead Pearl Diver,* in the Portland (Maine) Museum of Art, and declining to purchase it. The collector emphatically articulated his dislike for recumbent sculpture and expressed little disappointment at not getting this significant work. Regardless of the degree of veracity that can be attached to this anecdote, especially in light of the improbability of the museum's willingness to part with a major work by a native son, Ricau did attempt to articulate one facet of his taste. That there are glaring inconsistencies in his attitudes only underscores the futility of trying to pin down a collector's motives.

As his collection grew, Ricau admitted that his horizons broadened, and as he got richer, he wanted everything, particularly ideal pieces. Even in the unfashionable arena of marble sculpture, this was not feasible, and the collector recounted another story that identified the frustrating limits of his early activities. A *Pocahontas* by Joseph Mozier came up at auction in New Orleans, and Ricau went with his mother and father, who groaned every time he bid. Undaunted by the protestations of those who had nurtured his interest in art, Ricau pursued the sculpture aggressively, but it went past his means and sold to someone else, he recalled, for about $2,000. Eventually, he acquired a *Pocahontas* and went on to assemble the largest concentration of sculpture by Mozier in either private or public hands.

In surveying the collection as a whole, it is clear that Ricau was sensitive to sculpture in pairs. The collector observed that he liked the idea of the potential for a range of formal and emotional peaks and valleys as well as concomitant visual tensions, which could be found in pairs of works. Rinehart's *Hero* and *Leander* epitomize this in terms of emotional poignance, while Hosmer's *Puck* and *Will-o-the-Wisp* offer a tandem of comic relief, and Mozier's *Truth* and *Silence* impart an imposing moral rectitude. Ricau did not confine this ideal to sculpture but applied it to his collecting of paintings, as well.

Another divergence that provokes puzzlement is the appearance of only two bronze pieces in the collection— the bust of Abraham Lincoln by George E. Bissell (cat. no. 64) and the *Pax Victrix* by Frederick MacMonnies (cat. no. 67). Their inclusion seems particularly fortuitous in a collection predicated on serendipity. The *Lincoln* is understandable in terms of revealing one's admiration for a great individual, while the example by MacMonnies reinforces the much broader issue of the shift in aesthetic attitudes during the last quarter of the nineteenth century.

In responding to the question of their inclusion, Ricau allowed that he was very fond of bronze and expressed a particular admiration for the French *animalier* Antoine-Louis Barye. He said that he started trying to buy works in bronze but felt that they presented enormous challenges in their display. Composed primarily of dark, reflective surfaces, they are difficult to light. Ironically, Ricau was unwilling to siphon off any money from his purchase budget to make improvements to his house that would enhance the display of his collection. In aesthetic terms, he recognized in his interest in bronze an appreciation for modeling rather than carving, a predilection reflective of his own early attempts. Ricau noted that bronze sculpture, in spite of the problems of display, was nevertheless more popular with collectors than was marble. Thus, pragmatism served as the conduit to his interest in marble statuary that evolved as his abiding passion.

Whatever the medium, hero worship was not always a determining factor in the collector's decision making so far as subject matter was concerned. Ricau confirmed that he bought the *Lincoln* by Bissell because he thought it was an interesting piece of an important person. He admitted that his Southern heritage conditioned an intense dislike for Lincoln, but the quality of the bust overrode this personal antipathy. He liked the work for both its artistic merit and its reasonable price. The sculpture by MacMonnies, on the other hand, was acquired while Ricau was visiting a dealer to look at some marble statues by William Wetmore Story, and the purchase of *Pax Victrix* was entirely unpremeditated. Interestingly, this visit diminished Ricau's estimation of Story as a sculptor.

Conversely, Augustus Saint-Gaudens is represented in the collection by an early marble, *Portrait of Frederick C. Torrey,* carved in Rome in 1874 (cat. no. 65). Although marble is not the medium primarily associated with the sculptor, Ricau thought this atypical example was more suitable for what he was trying to achieve with his collection. He indicated that he had paid a significant amount for the bust, so its idiosyncratic position within Saint-Gaudens's oeuvre did not affect its market value. To underscore his commitment to this early example by Saint-Gaudens, Ricau said if he had to save one piece from the collection, it would be the portrait of Frederick C. Torrey.

At the outset, Ricau was one of this country's most serious collectors of sculpture. He issued a general mandate

to dealers to keep an eye out for appropriate examples, especially by Americans. Even his judicious demand was not sufficient to generate a reasonable supply, and the process was, by necessity, protracted. Moreover, not all works that Ricau acquired were American, and, again, affordability as well as aesthetic appeal were influential criteria. Heinrich Imhof's *Eros* (cat. no. 4) was found in England through Paul Gabel, a dealer in Nyack, who was constantly on the lookout for Ricau. Enthusiastic patronage of American sculptors in England in the nineteenth century made it a logical place to look. Imhof, a little-remembered Swiss sculptor, studied under the Danish master Bertel Thorvaldsen. This purchase, given the figure's kneeling pose, exemplifies the unpredictability of any purchase pattern.

More understandable was Ricau's purchase of Thorvaldsen's *Ganymede and the Eagle* (cat. no. 1) from Elmo Avet, a dealer in New Orleans from whom Ricau also acquired the variant version of Harriet Hosmer's *Will-o-the-Wisp* (cat. no. 58). The pairing of youth and god in the guise of an eagle may have offset any reservations about Ganymede's crouching pose. Indeed, the collector also revealed that *Ganymede and the Eagle* ranked among his favorite pieces in the collection. When asked if other Europeans such as Lorenzo Bartolini, John Gibson, Antonio Canova, or Vincenzo Vela were ever on his wish list, Ricau allowed that he greatly admired them. But, he contended, they were too expensive. He noted that the exceptional opportunity for purchase, such as he had with the Thorvaldsen, never presented itself.

Although Ricau acquired works by European sculptors, he preferred works by Americans. Yet recent research reveals that there are at least two previously unidentified sculptures in the collection that can be assigned to Europeans. The relief portrait of Charles Richard Alsop (cat. no. 40) was mistakenly assigned to Frederick Chauncey, based on the dedicatory inscription on the back. Close scrutiny of the text, however, showed that Chauncey was the recipient, not the sculptor, which explained why his name appeared in none of the standard art reference books. When the relief was removed from its frame, a signature indicated the Florentine Pio Fedi as the author. The statue of a boy kneeling in prayer (cat. no. 2) had been assigned to the Virginia sculptor Edward Virginius Valentine, based on an early photograph of his Richmond studio, which contained an identifiable version of the work in question. In this instance, it was discovered that the example in Valentine's studio was probably a second-generation plaster of an extremely popular work by another Florentine, Luigi Pampaloni. In both instances, the reattributions enhance the caliber of the collection and make an eloquent statement about the resonance between certain American and European works.

When asked the inevitable question about works that eluded him, Ricau was philosophical. He expressed great satisfaction with what he had achieved on a relatively modest budget and would acknowledge only one major regret. For him, "the one that got away" was Hiram Powers's *Greek Slave* (fig. 13). It had been offered to Ricau in the early 1960s by Knoedler & Co. for the then considerable sum of $30,000. At the time, Ricau had just negotiated several other purchases and taken out a second mortgage on his house to finance the transactions. When he could not come up with the money, he had to decline the offer. In spite of so many successes, Ricau would stand alone if he had not experienced the disappointment of an elusive quarry. That he had leveraged himself to the hilt financially is equal demonstration of the intensity and passion of his mission.

Even this abridged survey of the collection and the man who brought it together underscores the magnitude of what Jimmy Ricau was able to achieve: buying works nobody cared about by artists few had heard of at the time. As American sculpture began to be reevaluated in the late 1960s through the efforts of Wayne Craven, William H. Gerdts, and the subsequent generation of scholars they engendered, Ricau's pioneering efforts began to receive the full measure of appreciation that was their due. When the collection left Ricau's house in 1986, he was left alone without his "children." As he rattled around the now very empty and large Greek revival house, nothing gave Ricau greater pleasure than animatedly recalling a detail of a work—a curled finger by Rinehart or the translucent tambourine skin by Crawford. Let us hope he took some measure of satisfaction that this extraordinary collection will be available to an enthusiastic public for generations to come and will constitute the legacy of an individual of great vision and taste.

Notes

1. Richard York, introduction to *American Paintings from the Collection of James H. Ricau*, exh. cat., Richard York Gallery (New York, 1993), n.p.

2. Much of the information in this essay about Ricau's collecting activities and his collection was culled from a series of conversations I had with him on four occasions at his home in Piermont, N.Y. These meetings took place on June 29, 1990, Oct. 4, 1990, June 23, 1991, and Feb. 16, 1992.

3. Although it is beyond the scope of this essay to address the question in broad terms, Werner Muensterberger, *Collecting, an Unruly Passion: Psychological Perspectives* (Princeton, N.J., 1993), and Paul Staiti, "The Desire to Collect," in *Collective Pursuits: Mount Holyoke Investigates Modernism*, exh. cat., Mount Holyoke College Museum of Art (South Hadley, Mass., 1993), pp. 25–35, offer cogent and succinct reviews of some of the inherent issues.

4. "Name Winners in Industrial Marketing Editorial Competition," *Industrial Marketing* 34 (July 1949), 143.

5. See Gerdts essay in this volume.

6. Correspondence and receipts on deposit in the William H. Gerdts archive, New York.

NOTES TO THE READER

Arrangement

The catalogue is arranged chronologically according to the birthdate of the sculptor, and alphabetically for those born in the same year. Works by anonymous sculptors are listed last. There is a summary biography of each of the twenty-six known sculptors with selected bibliography. Bibliographies are not complete; emphasis has been placed on contemporary sources garnered from the rich archives of Colonel Merl M. Moore, Jr., and William H. Gerdts. Individual works are discussed in entries following the biographies. In cases where an artist is represented by more than one work, these, too, are treated chronologically by date modeled. Where the chronological sequence is uncertain, the works are arranged alphabetically. At the beginning of each entry, information is given in the following order: title, date, medium, dimensions, inscription or foundry mark, provenance, exhibition history, literature, known versions, credit line, and accession number. Where no information is known with regard to any of the categories, it is so stated. To allow the reader access to fuller discussions, literature references are not confined to the replica in the Ricau Collection. Below is a list of guidelines and abbreviations for often-used categories.

Cross-references

Works having their own entries elsewhere in the catalogue are indicated by a cross-reference to the relevant entry.

Dates for Artists Mentioned in the Text

When sculptors represented in the collection are mentioned in passing in the text, they are indicated by "(q.v.)." Dates, where known, are given only for painters, sculptors, and works of art of the eighteenth, nineteenth, and twentieth centuries.

Locations of Works of Art Mentioned in the Text

Locations of works of art are given in parentheses. When a location is not known, no location is given. Institutions that appear repeatedly have been abbreviated, and a key to these abbreviations follows.

AIHA	Albany Institute of History & Art, Albany, N.Y.
BA	Boston Athenaeum
BMFA	Museum of Fine Arts, Boston
BPL	Boston Public Library
CAM	Cincinnati Art Museum, Ohio
CGA	The Corcoran Gallery of Art, Washington, D.C.
DIA	The Detroit Institute of Arts
FAMSF	Fine Arts Museums of San Francisco
KMB	Kunstmuseum Bern, Switzerland
MMA	The Metropolitan Museum of Art, New York
NGA	National Gallery of Art, Washington, D.C.
NMAA	National Museum of American Art, Washington, D.C.
N-YHS	The New-York Historical Society
PAFA	Pennsylvania Academy of the Fine Arts, Philadelphia
PIBM	The Peabody Institute, Baltimore, Md.
PMA	Philadelphia Museum of Art
TMC	Thorvaldsen Museum, Copenhagen, Denmark
VMFA	Virginia Museum of Fine Arts, Richmond
WAG	Walters Art Gallery, Baltimore, Md.
WAHC	Wadsworth Atheneum, Hartford, Conn.
WAM	Worcester Art Museum, Mass.
WUAG	Washington University Gallery of Art, Saint Louis
YUAG	Yale University Art Gallery, New Haven, Conn.

References

Frequently cited references have been abbreviated; full citations of the shortened forms may be found at the back of the book. These provide the core of the bibliography. Other references pertinent to an individual sculptor or sculpture will be found in full in the bibliography and literature sections of the specific biography or entry. Notes use shortened forms of these citations. Unless it constituted the major source of information, dictionary references were not noted. Manuscript materials are listed by

collection and archival repository. When microfilm was consulted, frame numbers are given where possible.

Dating of Objects

The date given is the year the work was modeled. When known, the date the piece was carved is also given. When referring to other works, the date of the object in the collection cited will be used where known. In the case of public monuments, the date given is that of dedication or unveiling.

Dimensions

Overall dimensions are given in inches with centimeters in parentheses: height, width (or length), and depth.

Inscriptions and Foundry Marks

Inscriptions and foundry marks are transcribed as found on the object reading from the viewer's left to right. No indication is made of cursive signatures.

Provenance

Provenance begins with the earliest known owner. Gaps in ownership history are marked by an ellipsis. Square brackets indicate ownership by a dealer or auction house.

Exhibition History

Only exhibitions that included the specific work from the Ricau Collection have been listed. Where there is a plausible possibility, "possibly" is used.

Versions

A listed version constitutes a work that so closely resembles the Ricau piece that it appears to be virtually the same. A list of locations of versions in both public and private collections, as well as the art market, has been given to assist the interested reader. It is not, however, comprehensive. In the instance of an extremely large edition, such as Hiram Powers's *Proserpine*, no attempt has been made to enumerate all versions, and the reader is directed to appropriate sources.

Media of versions are listed in the following order: plaster, stone, and bronze. Variants in size are listed in descending order beginning with the largest. Although I have verified the existence of known versions in public and private hands, information on these works has been provided by the owners and from published sources. I have not seen all versions listed and have relied on the data supplied for dimensions and medium.

THE JAMES H. RICAU COLLECTION

Bertel Thorvaldsen

Danish, 1770–1844

The Danish-born Bertel Thorvaldsen augmented the international profile of the neoclassical movement. He also reaffirmed its Italian centrality by recounting that he had not truly been born until he arrived in Rome in 1797.[1] With this comment, Thorvaldsen acknowledged that his career meant nothing until he steeped himself in the classical world that Rome offered. From the mid-1700s until well into the next century, this was the case for any artist who embraced the tenets of neoclassicism.

Thorvaldsen championed principles inherent in the severity of antiquity by connecting his aesthetics with the purity of Polykleitos and fifth-century B.C. Greek sculpture. The young Dane rejected the more sensual attitudes of Praxiteles and his fourth-century B.C. followers, which the somewhat older Antonio Canova (1757–1822) had endorsed. Within a few years of arriving in Rome, Thorvaldsen emerged as Canova's primary rival. When Canova died in 1822, Thorvaldsen inherited his mantle as dean of neoclassicism. He was generous in guiding the younger artists of the international community in Rome, which included the first generation of American sculptors such as Horatio Greenough (1805–1852) and Thomas Crawford (q.v.).[2]

Born in Copenhagen, the son of a woodcarver in a shipbuilding yard, the young Thorvaldsen was encouraged by his parents to pursue his artistic bent. At eleven he entered the Royal Academy, where he studied under the painter Nicolai Abilgaard (1743–1809) and Johannes Wiedewelt (1731–1802), one of Denmark's earliest proponents of neo-classical sculpture.[3] During his student years, Thorvaldsen earned a number of minor medals that recognized his accomplishments in drawing and bas-relief. In 1792 he executed his first order, a decorative panel for a door, after a design by the sculptor Frederick C. Willerup (1742–1819). True affirmation of his ability came in 1793 when the academy awarded him the Grand Gold Medal for his bas-relief *The Apostles Peter and John Healing the Lame Man* (TMC). This prize entitled him to go to Rome for extended study, but he did not leave Denmark until the fall of 1796. He stopped in Malta and Naples before reaching his destination the following spring.

Thorvaldsen established his studio on the Via del Babuino, which connected the Piazza di Spagna and the Piazza del Popolo. While there he worked on some portrait commissions he had brought from Denmark. In 1798 Thorvaldsen moved to the Via Sistina near the Piazza Barberini and commenced his first ideal work, a statuette of Bacchus and Ariadne (TMC). He also devoted significant time to copying antique sculpture in both plaster and marble, thus sharpening his commitment to the classical past while generating income. He shared quarters with Joseph Anton Koch (1768–1839), a German land-scape painter who also was dedicated to infusing his art with a classical spirit. This association only redoubled Thorvaldsen's resolve.

These years were crucial to Thorvaldsen's artistic formation, but they brought few commissions, and by 1802 the young sculptor was nearly destitute. On the verge of having to return to Denmark, Thorvaldsen averted this fate when the poet Frederike Brun ordered a plaster cast of the sculptor's first major effort, the recently reworked *Jason*. Thorvaldsen's situation soon improved even more when the great English collector and arbiter of taste, Thomas Hope, commissioned a version of the same subject in marble (1803, TMC).[4] Although Hope's order was not delivered until 1828, the financial arrangement provided a measure of security. And the recognition of his talent by so influential an art lover as Hope greatly enhanced Thorvaldsen's reputation.

The young Dane's interpretation of Jason established his career, and the over-life-size work signaled a challenge to the stylistic hegemony of Canova.[5] Thorvaldsen forsook the softer early Hellenistic manner preferred by the older Italian and replaced it with his own admiration of the more severe Greek style of fifth century B.C., epitomized in Polykleitos's *Doryphoros* (National Museum, Naples). Through this evocation of Athenian antiquity, Thorvaldsen introduced into his oeuvre a sterner sense of the heroic. Even Canova admitted the *Jason* heralded a newer, grander style.[6]

Just as the illusory Peace of Amiens in 1802 had briefly opened travel on the Continent and allowed patrons such as Hope to visit Rome, its speedy dissolution at the hands of Napoleon brought such opportunities to an abrupt halt. Consequently, Thorvaldsen continued to experience financial hardship until the fall of Napoleon in 1815, when renewed mobility brought patronage to Rome from throughout Europe. The sculptor's efforts in the intervening years further confirmed his reputation and established him as one of the premier recipients of the burgeoning demand for sculpture.

Thorvaldsen's early output also proved he was not monolithic in his attitude. His

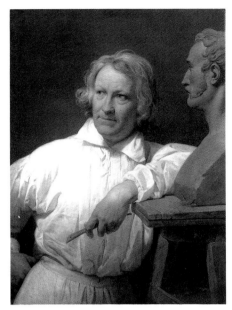

Horace Vernet, *Bertel Thorvaldsen*, 1833. Oil on canvas, 39⅜ × 29⅝ in. (100 × 75.2 cm). Thorvaldsen Museum, Copenhagen

Ganymede Offering the Cup of 1804 (TMC) demonstrates a willingness to work in the Praxitelean mode, with a more pliant physique and expressive countenance. This concession to delicacy and emotion is reiterated in other sculptures, such as *Cupid and Psyche Reunited in Heaven*, of about 1807, and *Venus*, executed between 1813 and 1816 (both TMC). These works stand in marked contrast to the bold austerity of his *Jason* yet fall short of the emphatic sensuousness of Canova. Through their poetic resonance, these efforts confirm Thorvaldsen's flirtation with romanticism, and he was certainly not alone in vacillating between the disparate poles of classicism and romanticism.

Some of this emotional input may have been conditioned by Thorvaldsen's renewed religious feeling, which was awakened in part by his association with the Nazarenes. This group of Northern artists congregated in Rome to emulate the formal and spiritual purity of late medieval painting.[7] The sculptor did not go so far as to convert to Catholicism, but his staunch Protestantism did not preclude major commissions from the Vatican, such as the *Tomb of Pius VII* in 1823. Indeed, Pope Leo XII visited Thorvaldsen's studio in 1826. Another artist recorded the event on canvas, which reveals the enormous breadth of Thorvaldsen's sculptural activity.[8]

Thorvaldsen exhibited an extraordinary versatility in his approach to sculpture, whether portrait bust, ideal figure, bas-relief, or monument. He seemed to alter

his style according to the dictates of subject or sitter, yet he always kept within the latitudes of the neoclassical canon. In portraiture Thorvaldsen endowed his bust of Adam Moltke, executed in 1803–4 (Kiel Kunsthalle), with the severity of the earlier Greek sculpture that was so pivotal to his early success. There is a tautness to Moltke's features, and his forceful personality is reinforced by the dramatically deep-set eyes. His chiseled pupils further underscore the intensity of this compellingly real visage. By contrast, the portraits of the Crown Prince Christian Frederick of Denmark and his wife, Princess Caroline Amalie, done between 1820 and 1821 (Schleswig-Holsteinisches Landesmuseum Schloss Gottorf, Schleswig), demonstrate a more delicate, refined mode reminiscent of Praxiteles and, by extension, Canova. Sensitive to the youth and elevated station of his sitters, Thorvaldsen opted for an ideal record that was flattering and timeless.

This maneuvering between broadly divergent sculptural styles informed Thorvaldsen's other efforts, as well. Bas-reliefs could be as austere and rigid as *The Abduction of Briseis*, another early work of 1803 (Woburn Abbey, England), or as imbued with lyrical grace and reticent purity as his most popular reliefs, *Night with Her Children, Sleep and Death* and *Day, Aurora with the Genius of Light*. These were modeled in 1815 (Victoria and Albert Museum, London) and betray Thorvaldsen's debt to the English sculptor John Flaxman (1755–1826).

This same duality held true for the sculptor's monumental undertakings. The equestrian statue of Prince Joseph Poniatowski (Warsaw, Poland, destroyed in World War II), who commanded Polish troops under Napoleon, echoed and perpetuated the paradigm of equestrian monuments, the *Marcus Aurelius* that graces the Campidoglio in Rome. Thorvaldsen's design for the *Lion of Lucerne*, commissioned in 1818–19 as a memorial to the Swiss Guards killed in the uprising of 1792 against Louis XVI of France, offers a synthesis of the polarity of his approach. The cavelike setting is powerfully emotive while the formidable yet restrained presence of the lion reverberates with dignity and reserve. This noble record of the Swiss Guards' untimely end ensures them immortality in an appropriately neoclassical context of heroic pathos.

At the other end of the spectrum is the commission for the memorial to Lord Byron awarded in 1829, which some consider his most romantic work (Trinity College, Cambridge). Byron, who sat for the sculptor in 1817 for a portrait bust,

complained that the likeness did not make him sad enough.[9] In the seated monument, originally intended for Westminster Abbey, Thorvaldsen placed Byron within an appropriately classical context. However, this tribute to the past is compromised by the contemporary costume, pensive expression, and mediating gesture of Byron's holding a pencil or pen to his chin. These elements convey a sense of the moment and imply the imminent arrival of elusive and unpredictable divine inspiration.

Thorvaldsen's greatest labor of love was the project to restore the pedimental sculptures of the Temple of Aphaia at Aegina, which Prince Ludwig of Bavaria brought to Munich in 1812.[10] These late archaic works amplified Thorvaldsen's penchant for severity and reaffirmed his commitment to the enduring nobility of this style. The experience influenced the design of the sculptor's personal favorite, *Hope*, which he created in 1817 to honor the completion of the restoration project (TMC). This allegorical figure, removed from the here and now, conveys a solemn austerity tempered by grace and elegance. Thus, within a single figure, Thorvaldsen fused his sculptural ideals.

Demand for Thorvaldsen's work was enormous, and, consequently, his output was prodigious. The sculptor accommodated his popularity through a remarkably efficient studio, where he placed primary emphasis on quality control. He was able to produce a number of different works simultaneously because of the system he perfected.[11] Like his rival Canova, Thorvaldsen eschewed the common practice of simply working from small sketch models, or *bozzetti*. Instead, he created accurate, full-size plaster models. These final models resulted from numerous steps initiated by a drawn sketch, which was translated into a small clay model and amplified into the final conception. As a result, the craftsmen who translated the model into marble had clear guidelines and could work to the penultimate stage with a minimum of supervision. Thorvaldsen put the finishing touches on the marble himself to achieve the desired effect, particularly with regard to surface. The master oversaw, in addition to the purely creative side of the process, all the operations with the utmost scrutiny. With the frenzy of activity, the throngs of visitors to Thorvaldsen's studio were hardpressed to comprehend his working method fully.

Thorvaldsen's prominence brought him numerous honors from all quarters, including election to the presidency of Rome's Academy of St. Luke in 1827.

In 1838 he moved back to his native Copenhagen while continuing to operate his studio in Rome. The following year discussions commenced for a museum bearing his name to be built in his native city to house the contents of his studio as well as his collection of antiquities.

In spite of the extraordinary success and accolades that Thorvaldsen enjoyed, he remained eminently approachable and never lost the enthusiasm or respect for his art, or for the art of others. As one American who made his acquaintance was to recount: "There is no monotony in his day's work, for if he is but a student, every day makes him stronger in the art he loves, and reveals some beauty which he had never seen before."[12] The lack of complacency reflected in Thorvaldsen's viewpoint enabled him to keep his work in perspective. His humility and awareness of his humble beginnings permitted him to provide an inspirational model for a broad circle of students and admirers.

Notes

1. [Tuckerman], "Reminiscences of Thorwaldsen" (1855), p. 96.

2. For a recent and readable account of Thorvaldsen's impact in America, see Dimmick, "Mythic Proportion: Bertel Thorvaldsen's Influence in America" (1991).

3. Janson 1985, p. 57.

4. See H. W. Janson, "Thorvaldsen and England," in Jørnæs et al., *Thorvaldsen* (1977), 2:107–115.

5. Janson 1985, p. 57.

6. Janson, "Thorvaldsen and England," p. 108. Janson bases his citation on the recollection of Frederike Brun in 1812, published in Thiele, *Thorvaldsen's Leben* (1852–56), 1:76.

7. Edith Luther, "Gesellschaftliche Spielräume. Die Nazarener—Zusammenleben als Einheit von Glauben und Kunst," in Peters et al., *Künstlerleben in Rom. Bertel Thorvaldsen* (1991), pp. 427–434.

8. The painting, *Pope Leo XII Visiting Thorvaldsen's Studio on St. Luke's Day, 1826*, by H. D. C. Martens (1795–1864), was completed in 1830. It is on loan to the Thorvaldsen Museum from the Statens Museum for Kunst in Copenhagen and is reproduced in Janson 1985, p. 70.

9. Helsted, "Thorvaldsen's Technique" (1972), p. 229.

10. Janson 1985, p. 71.

11. Helsted, "Thorvaldsen's Technique," pp. 228–234.

12. [Tuckerman], "Reminiscences of Thorwaldsen," p. 96.

Bibliography

Tuckerman 1855, pp. 54–55; Calvert 1846, pp. 120, 140, 147–149, 153–154; David d'Angers, "A Letter upon the Genius of Thorwaldsen," *Bulletin of the American Art-Union*, May 1850, pp. 22–23; Jus Mathias Thiele, *Thorvaldsen's Leben*, 3 vols. (Leipzig, 1852–56); [Henry T. Tuckerman], "Personal Reminiscences of

Thorwalden," *Putnam's Monthly Magazine* 1 (Jan. 1853), 93–97; Lee 1854, 1:233–239; Eugène Plon, *Thorvaldsen: His Life and Works*, trans. I. M. Luyster (Boston, 1873); Clara E. Clement, *Handbook of the Artists* (New York, 1874), pp. 566–569; Sandhurst 1876, p. 226; *A Guide to Thorvaldsen's Museum* (Copenhagen, 1880); Freeman 1883, pp. 78–81; Gay Wilson Allen, *Walt Whitman*, rev. ed. (Detroit, 1969), p. 40; *The Age of Neo-Classicism*, exh. cat., Arts Council of Great Britain, Royal Academy and Victoria and Albert Museum (London, 1972), pp. 284–289; "Il Cavaliere Alberto," *Apollo*, n.s., 97 (Sept. 1972), 176–193; Dyveke Helsted, "Thorvaldsen's Technique," *Apollo*, n.s., 96 (Sept. 1972), 228–234; John Kenworthy-Browne, "Drawings and Models by Thorvaldsen," *Connoisseur* 184 (Dec. 1973), 256–260; Bjarne Jørnæs et al., *Bertel Thorvaldsen*, exh. cat., Kunsthalle Köln, 2 vols. (Cologne, 1977); Elena di Majo et al., *Bertel Thorvaldsen (1770–1844), scultore danese a Roma*, exh. cat., National Gallery of Modern Art (Rome, 1990); Dyveke Helsted, Eva Henschen, and Bjarne Jørnæs, *Thorvaldsen* (Copenhagen, 1990); Ursula Peters et al., *Künstlerleben in Rom. Bertel Thorvaldsen (1770–1844), Der dänische Bildhauer und seine deutschen Freunde*, exh. cat., Germanisches Nationalmuseum, Nuremberg, and Schleswig-Holsteinisches Landesmuseum Schloss Gottorf, Schleswig (Nuremberg, 1991); Lauretta Dimmick, "Mythic Proportion: Bertel Thorvaldsen's Influence in America," in Patrick Kragelund and Mogens Nykjær, eds., *Thorvaldsen. L'ambiente, l'influsso, il mito* (Rome, 1991), pp. 169–192

1
Ganymede and the Eagle

Modeled ca. 1815–17
Marble
$32^3/8 \times 41^3/4 \times 16^1/8$ in. (82.2 × 106 × 40 cm)
No inscription

Provenance [Elmo Avet, New Orleans]; James H. Ricau, Piermont, N.Y., by 1961

Exhibition History *The Ricau Collection*, The Chrysler Museum, Feb. 26–Apr. 23, 1989

Literature "Models from Thorvaldsen's Works," *Bulletin of the American Art-Union*, June 1850, p. 47; Benjamin Silliman and C. R. Goodrich, eds., *The World of Science, Art, and Industry, Illustrated from Examples in the New-York Exhibition, 1853–1854* (New York, 1854), p. 16; Rembrandt Peale, "Reminiscences. Painters and Sculptors," *Crayon* 1 (Mar. 14, 1855), 162; Fuller 1856, pp. 40–43; Eugène Plon, *Thorvaldsen: His Life and Works*, trans. I. M. Luyster (Boston, 1873), pp. 103, 199, 273; Sandhurst 1876, p. 226; Whiting 1910, p. 42; Agard 1951, pp. 111–113; Anthony M. Clark, "Thorvaldsen and His *Ganymede and the Eagle*," *Minneapolis*

Institute of Arts Bulletin 55 (1966), 25–35; Joseph Masheck, "Beauty Incarnate: Considerations on a Drawing by George Santayana," *Arts* 50 (Oct. 1975), 75–76; Bjarne Jørnæs, "Thorvaldsens 'klassische' Periode, 1803–1819," in Bjarne Jørnæs et al., *Bertel Thorvaldsen*, exh. cat., Kunsthalle Köln, 2 vols. (Cologne, 1977), 1:182–183; 2:57–59, 87–88, 90, 97; M. Mondini and C. Zani, *Paolo Tosio. Un collezionista bresciano dell'ottocento* (Brescia, 1981), pp. 86–87; Michael Conforti, "French and Italian Sculpture, 1600–1900," *Apollo*, n.s., 118 (Mar. 1983), 229–230, 232; Vance 1989, 1:324–325; Elena di Majo et al., *Bertel Thorvaldsen (1770–1884), scultore danese a Roma*, exh. cat., National Gallery of Modern Art (Rome, 1990), pp. 102–103, 113

Versions PLASTER National Academy of St. Luke, Rome; MARBLE The Minneapolis Institute of Arts; Thorvaldsen Museum, Copenhagen; REDUCED [Heim Gallery, London, as of 1972]; Pinacoteca Tosio-Martinengo, Brescia, Italy; Boston Athenaeum (studio of?)

Gift of James H. Ricau and Museum Purchase, 86.525

Adherents of the neoclassical aesthetic gravitated toward subject matter taken from ancient Greek and Roman history and mythology. In the latter category, the story of Ganymede was especially popular. Characterized in both Homer's *Iliad* and Ovid's *Metamorphoses*, Ganymede was the son of Tros, a legendary king of Troy. A beautiful shepherd, he attracted the attention of Zeus, who fell in love with him. In the guise of an eagle, Zeus carried Ganymede off to Olympus, where the youth became the cupbearer to the gods.

The legend of Ganymede had special resonance through the ages. To the ancient Greeks, it sanctioned homosexual love. Early Christian and Renaissance writers applied the story to considerations of human and divine love.[1] Such was the liberality of interpretation that in the *Moralized Ovid*, which appeared in the early fourteenth century, Ganymede became a prefiguration of St. John the Evangelist with his symbol, the eagle, standing for Christ.[2] As Masheck points out, the sexual implications were never fully subsumed, since Shakespeare's Rosalind in *As You Like It* (act 1, scene 3, lines 121–124) refers to herself as "Ganymede" when she dresses as a man. The myth enjoyed great popularity as a subject for artistic expression, and most interpretations centered on the guileless Ganymede offering the eagle a drink or his subsequent aerial abduction.

In spite of his rudimentary education, Bertel Thorvaldsen owned at least two books of Greek mythology, which undoubtedly served as sources for the plethora of myths he interpreted.[3] Moreover, the sculptor was particularly enamored of the Ganymede story and undertook no fewer than five separate versions throughout his career. The earliest rendition dates from about 1804 and depicts a standing Ganymede holding out a filled goblet (fig. 66). The second interpretation, executed around 1816, is a minor variant on the initial work. In it Ganymede pours liquid into the cup. Both pieces derive from antique works that Thorvaldsen could have seen in Roman collections.[4]

The third adaptation, of which the Ricau replica is an example, constitutes a radical departure with its depiction of a kneeling Ganymede holding a bowl from which the eagle drinks. Here, too, the sculptor relied on antiquity for his composition, namely a design taken from a third-century A.D. Roman gem that was part of his collection of antiquities.[5] The initial copy of this version was ordered in 1815, but it was overshadowed by the variant commissioned in 1817 by the earl of Gower, which is now in the Minneapolis Institute of Arts (fig. 16).[6] Thorvaldsen returned to the theme in the early 1830s, creating two bas-reliefs, *Ganymede and Eros Dicing* of 1831 and *Hebe Presenting Ganymede the Pitcher and Bowl*, done two years later (both TMC). Thus, within his prolific output, the story of Ganymede ranked among his favorite and most popular efforts.

The provenance of the Ricau version of *Ganymede and the Eagle* is obscure. The collector recalled purchasing it from a dealer in New Orleans around 1960, which would make it one of his earliest acquisitions.[7] This *Ganymede* is identical in pose to the initial version ordered by Fürstin Grassalkovitch in 1815, in which Ganymede's genitals are covered by his chlamys. The sculpture's "cache-sexe" motif relates it to the smaller version Count Pietro Tosio ordered in 1815,[8] and a drawing of the group in the Royal Museum of Fine Arts in Copenhagen (fig. 17) confirms this use of the drapery for purposes of modesty. This covering was removed in the Gower rendition. Why purchasers of the first version required such constraint is unknown, but Thorvaldsen also saw fit to adorn the plaster example of this *Ganymede and the Eagle* that he presented to the Academy of St. Luke in 1831 with a fig leaf.

As with his standing versions of *Ganymede*, this interpretation places primary emphasis on frontality to establish a profile tableau. Thorvaldsen constructs

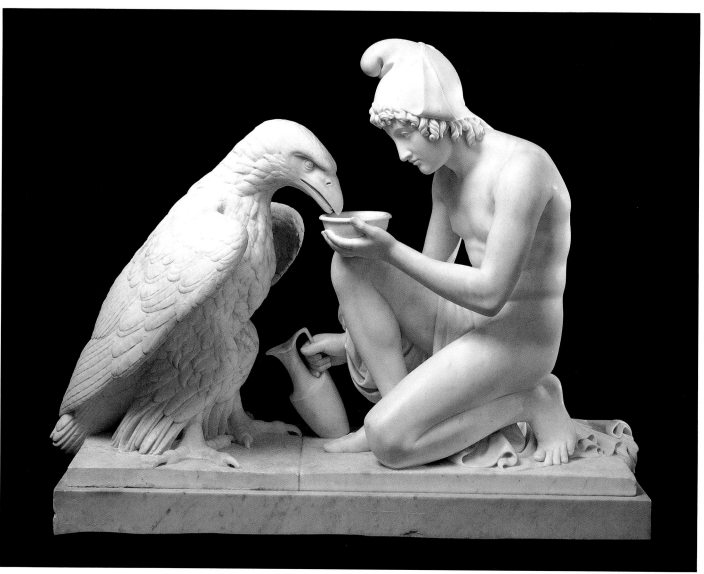

Cat. no. 1 Thorvaldsen, *Ganymede and the Eagle*

a system of interlocking triangles that are confined within an overall triangular configuration. This geometric network provides a crystalline subordination of parts to the whole, which was integral to neoclassical precepts. The sculptor did permit himself minor variations from an absolute adherence to this attitude, by letting a bit of drapery and the lower section of the eagle's feathers spill over the plinth. While Ganymede's countenance conveys a restrained severity and timelessness consistent with Thorvaldsen's admiration for more archaic sculpture, the boy's physique possesses a youthful, almost effeminate, suppleness that connects it to Praxiteles more than to Polykleitos. Nevertheless, the sculptor establishes admirable visual counterpoints between the smooth surfaces of the body and the rich textures of the eagle's feathers and the serpentine folds of drapery.

Thorvaldsen explores this contrast in microcosm when he sets the simplicity of the Phrygian cap against the complexity of the tightly curled hair that it covers. Inherent in this work are the dissonances of simple and complex, smooth and textured, austere and emotive. These contrasts continually inform the dialectic of the Dane's mature sculptural style.

Thorvaldsen's preeminent reputation was not lost on Americans, and the young Republic witnessed his presence in myriad ways. As early as 1832, he began to enjoy widespread exposure through exhibitions in such populous eastern centers as Boston and Philadelphia and extending to more remote communities like Detroit and Chicago and later to San Francisco.[9] His role as artistic mentor was equally significant. His *Mercury* was used as the subject for the drawing competition at the National Academy of Design in 1832, and

his guidance of first-generation American sculptors such as Horatio Greenough (1805–1852), Hiram Powers (q.v.), and Thomas Crawford (q.v.) was of major consequence.[10] The Danish sculptor also was assimilated into the American consciousness through the printed word. In 1835 he was the subject of a brief biography by an American.[11] By the 1850s, the bibliography had expanded to encompass periodical literature, published travel diaries, and inclusion in a survey of sculpture and sculptors.[12]

Within this framework, Thorvaldsen's *Ganymede and the Eagle* attained its own elevated plateau of prominence. A variant of the sculptor's 1804 version was lent by William Appleton to the Boston Athenaeum for an exhibit in 1839–40.[13] In this version Thorvaldsen replaced the supporting tree stump with an eagle. This work had a profound and lingering

impact on Margaret Fuller Ossoli (1810–1850). Her visit in 1843 to the Eagle's Nest, a promontory overlooking the Rock River in Oregon, Illinois, called the subject to mind and inspired the American journalist and transcendentalist to compose a lengthy poem.[14] A replica of the Gower version was lent to the Crystal Palace Exhibition of 1853 in New York by the Danish consul and was illustrated in one of the commemorative catalogues.[15] This major display also included Thorvaldsen's *Apostles,* which captured the attention of Walt Whitman, who singled them out for their colossal size.[16] By the time of the 1876 Centennial Exposition in Philadelphia, the taste for neoclassicism was in eclipse. However, Thorvaldsen's *Ganymede and the Eagle* was featured as a high-quality porcelain reproduction that catered to the Victorian taste for bric-a-brac to be placed around the parlor.[17]

From this broad platform of popular culture, appreciation of *Ganymede and the Eagle* had receded by the end of the century to more rarefied spheres of admiration, such as its contribution to George Santayana's formative thinking for his philosophy of beauty.[18] Thus, Thorvaldsen's *Ganymede and the Eagle* enjoyed diverse yet sustained appreciation throughout the nineteenth century. After a brief interlude in the ebb tide of taste, it has returned to its rightful place, along with its creator, as one of the major examples of neoclassical taste and temperament.

Notes

1. For an extended discussion of the various applications of the Ganymede myth, see Masheck, "Beauty Incarnate" (1973), pp. 73–79.

2. L. P. Wilkinson, *Ovid Recalled* (Cambridge, 1955), p. 384. He cites another example, Giles Fletcher's *Christ's Victorie and Triumph,* which appeared in 1610, as equating the ascending Christ with Ganymede; see Wilkinson, *Ovid Recalled,* p. 437.

3. Elena di Majo and S. S., "Ganimede e l'aquila," in di Majo et al., *Thorvaldsen* (1990), p. 162.

4. Jørnæs, "Thorvaldsens 'klassische' Periode, 1803–1819," in Jørnæs et al., *Thorvaldsen* (1977), 2:57–59, and Jørgen Birkedal Hartmann, "Motivi antichi nell'arte di Thorvaldsen," in di Majo et al., *Thorvaldsen* (1990), p. 67.

5. Clark, "Thorvaldsen and His *Ganymede and the Eagle*" (1966), p. 52.

6. Jørnæs, "Thorvaldsens 'klassische' Periode, 1803–1819," 2:87–88.

7. Interview with James Ricau, Piermont, N.Y., Oct. 4, 1990.

8. Mondini and Zani, *Paolo Tosio* (1981).

9. Rutledge 1955, p. 229; Perkins and Gavin 1980, p. 141; and Yarnall and Gerdts 1986, 5:3511–3512 and 6: passim.

10. Thomas S. Cummings, *Historic Annals of the National Academy of Design . . . from 1825 to the Present Time* (Philadelphia, 1865), p. 125. For Thorvaldsen's impact in America, see Dimmick, "Mythic Proportion: Bertel Thorvaldsen's Influence in America" (1991).

11. Tuckerman 1853, pp. 54–55.

12. Lee 1854, 1:233–239.

13. Perkins and Gavin 1980, p. 141. William L. Vance suggests this identity; see Vance 1989, 1:325.

14. For Fuller's reaction, see J. F. Clarke, R. W. Emerson, and W. H. Channing, *Memoirs of Margaret Fuller Ossoli,* 2 vols. (Boston, 1852), 1:271, and for the poem, see Fuller 1856, pp. 40–43.

15. Silliman and Goodrich, *The World of Science, Art, and Industry* (1854), p. 16. I am grateful to Dr. Bjarne Jørnæs for this reference.

16. Gay Wilson Allen, *Walt Whitman,* rev. ed. (Detroit, 1969), p. 56.

17. Once again, the image was reproduced in one of the souvenir catalogues; see Sandhurst 1876, p. 226.

18. Masheck, "Beauty Incarnate," pp. 75–76.

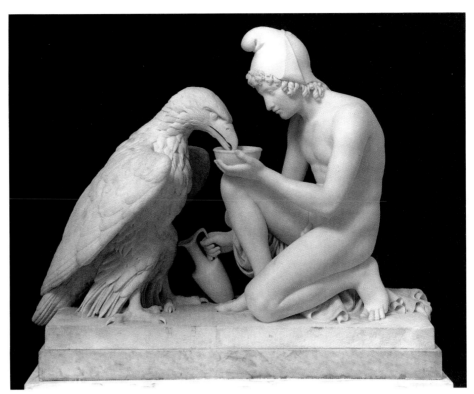

FIG. 16 Bertel Thorvaldsen, *Ganymede and the Eagle,* 1817–29. Marble, 34¾ in. (88.3 cm) high. The Minneapolis Institute of Arts, Gift of the Morse Foundation, 66.9

FIG. 17 Bertel Thorvaldsen, *Ganymede and the Eagle,* ca. 1817. Graphite on paper, 6¾ × 12 in. (17.1 × 30.5 cm). Department of Prints and Drawings, Royal Museum of Fine Arts, Copenhagen

Luigi Pampaloni

Italian, 1791–1847

In his day, Luigi Pampaloni was an enormously popular and highly regarded contemporary sculptor both in Tuscany and well beyond its borders. He shared this status with his mentor, Lorenzo Bartolini (1777–1850), and Pio Fedi (q.v.), another distinguished Bartolini disciple.[1] Time has not been kind to this generation of sculptors, and only recently has Pampaloni garnered renewed critical attention.[2] Indeed, Mr. Ricau originally attributed Pampaloni's *Kneeling Boy* to Edward Virginius Valentine (1838–1930), based on a plaster replica depicted in a photograph of the sculptor's studio in Richmond, Virginia.[3] Recent research has returned credit to the sculpture's rightful creator, Pampaloni.

Luigi Pampaloni was born in Florence into a family of modest means that was sympathetic to his desire to pursue the arts as a profession. Pampaloni's early studies included apprenticing with his brother Francesco in an alabaster shop, where they made souvenir carvings for the tourist trade. Young Luigi exhibited greater ambition and talent than this mechanical approach involved. He later took formal art classes at the academies in both Carrara and Florence; in Florence his master was Lorenzo Bartolini. Among his contemporaries in Carrara was Pietro Tenerani (1798–1870), who also established a major reputation. During his youthful years, Pampaloni earned several prizes for his student efforts, most notably the bas-relief *Achilles Receiving Divine Weapons*. Much of his early career was taken up making small works, often in alabaster. He also executed copies of such famous statues as Antonio Canova's (1757–1822) *Venus* and *Narcissus*.

It was not until 1826 that Pampaloni received his first major commission, the *Fountain of Three Naiads* for the Piazza Farinata degli Uberti in Empoli. Located in the town's central square that was dominated by its venerable church, Pampaloni's design marked the culmination of a project that began in 1817.[4] The fountain's harmonious balance of architecture and sculpture is punctuated by three formidable, yet graceful, female figures who hold up a wide, flat basin.

This important debut was followed the next year by an order from Polish nobility, the Potocki family, who, on the basis of two independent compositions by Pampaloni, requested a funeral monument in remembrance of their youngest daughter. He had already designed a figure of a sleeping little girl and a young boy kneeling beside her in prayer. Anna Potocki asked that the sleeping girl be adapted to the memorial for the family chapel in Cracow. Both figures struck a resonant chord with a broader audience, and the young boy especially captivated the public's attention. He was repeated individually no fewer than ten times in marble and countless times in plaster (cat. no. 2).

In these sentimental interpretations of children, Pampaloni moved away from the severity of the prevailing neoclassical aesthetic and gravitated toward the naturalism of Bartolini. The popularity of these pieces engendered widespread demand for variations on the theme, and Pampaloni created a plethora of youthful subjects in a variety of secular and sacred contexts. Although these efforts provided financial security, they cast a trivializing shadow on his career.

Pampaloni was capable of impressive work, however, and the statues of Arnolfo di Lapo and Filippo Brunelleschi established his credibility as a serious sculptor. Commissioned in 1827 to grace the piazza of the cathedral in Florence designed four centuries earlier, these works possessed a monumentality and gravity that elicited an enthusiastic response from the acknowledged master of neoclassical sculpture, Bertel Thorvaldsen (q.v.).[5] Especially noteworthy was Pampaloni's sensitive handling of the drapery, which amplified his naturalistic treatment of the human form. In this regard he rivaled Bartolini, who did not lavish comparable attention on his draperies. The enthusiastic response to these statues when they were unveiled in 1830 brought Pampaloni a wealth of prestigious commissions, which helped offset his reputation as a modeler of ingenuous children.

Foremost among these orders was the monumental statue of Emperor Leopold I, who was also the grand duke of Tuscany, which was placed in the Piazza Santa Caterina in Pisa in 1833. This colossal image not only underscored Pampaloni's ability to work in an academically classical mode, but it also redoubled interest from aristocratic patrons. Leopold I immediately commissioned a portrait bust of his second wife, Marie-Antoinette de Bourbon. Numerous other dignitaries followed suit, including Marie-Ferdinand of Saxony, the emperor and empress of Russia, Pope Pius IX, Matilda Bonaparte Demidoff, and the duke of Reichstadt. These contacts led to more substantial commissions, and through the 1830s Pampaloni undertook a series of significant projects. These ranged from a monument to the esteemed poet Lazzaro Papi (1835, Lucca) and a Pietà

(1836, Genoa) to a portrait of Leonardo da Vinci for the portico of the Uffizi (1837–39) and a cenotaph for Marianna Frescobaldi in the church of Santo Spirito in Florence (1839).

The success of Pampaloni's early commission from the Potocki family resulted in other orders destined for eastern Europe. In addition to a funerary monument for a child of the Tyszkiewicz family in Czerwony Dwór, which strongly resembled the sculptor's initial effort, Pampaloni created a memorial to the matriarch of the Tyszkiewicz family, Wanda Wankowicz, who died in 1842.[6] If the monuments to the children reflect Pampaloni's admiration for such Renaissance masters as Desiderio da Settignano or Bernardo Rossellino, the Wankowicz tomb illustrates his debt to Bartolini's monument to Sofia Zamoyska, executed between 1837 and 1844 and placed in Santa Croce in Florence. The combination of the naturalism of the recumbent figure and the innocence and idealism of the relief figures adorning the sarcophagus elucidates the guiding principles of his artistic vision.

As befits an artist of serious purpose, Pampaloni's sources of inspiration were far from monolithic. Among his last works, such as the monument to Julie Clary Bonaparte, countess of Survilliers, commissioned in 1846 and completed the following year, the sculptor admirably demonstrated his range of inspiration. The architectural composition emulates those of Rossellino, while some of the individual figures in the relief carving, especially the elderly man led by the child at the left, recall similar groupings in such plaster reliefs as *Teaching the Ignorant* or *Giving Food to the Hungry* modeled by Antonio Canova in 1795 (Canova Museum, Possagno).[7]

Luigi Pampaloni assimilated a broad spectrum of sculptural attitudes into his own repertoire and was able to shed his early fame as a sentimental interpreter of children. His stature was further confirmed by his appointment as professor of sculpture at the Academy of Fine Arts in Florence, but fate was not kind to him. His untimely death in 1847, after a brief illness, brought his career to an abrupt halt. Such was his esteem, however, that his studio remained open to the public after his death, and the surviving plasters were eventually housed with those of Bartolini in Florence to stand as one of the significant legacies of nineteenth-century artistic achievement in that city.

Notes

1. Guidici, "Correspondance particulière" (1859), p. 40.

2. For the most recent treatment of Pampaloni, see Calloud, "Note su Luigi Pampaloni" (1981).

3. Holt, "The History of the Valentine Museum" (1973), p. 153. Personal examination of the plaster model reveals it to be one of the commercial reductions that flooded the market during Pampaloni's lifetime. I am grateful to Barbara Batson of the Valentine Museum for her assistance in clarifying this matter.

4. Mancini, "La Fontana di Empoli e Luigi Pampaloni" (1920), p. 45.

5. Guidici, "Correspondance particulière," p. 46.

6. Calloud, "Note su Luigi Pampaloni," pp. 59–60.

7. Ibid., p. 65.

Bibliography

M[elchior] M[issirini], *Della statue de Arnolfo di Lapo e di Filippo di ser Brunelleschi eseguite da Luigi Pampaloni e pubblicate da Luigi Bardi dichiarazione di M. M.* (Pisa, 1830); *Prospetto storico ed economico delle spese per la statua del Gran-Duca Leopoldo I* (Pisa, 1854); Melchior Missirini, *"La Chloe." Statua di Luigi Pampaloni esposizione di M. M.* (Florence, 1857); Carlo Pontani, *Delle opere del Sig. Professore Luigi Pampaloni, scultore fiorentino* (Rome, 1859); Paolo Emiliano Guidici, "Correspondance particulière de la Gazette des Beaux-Arts," *Gazette des Beaux-Arts* 2 (1859), 40–46; Emilio Poggi, *Della scultura e della pittura in Italia dall'epoca di Canova ai tempi nostri* (Florence, 1865), pp. 19–21; M[elchior] M[issirini], *Memorie sulla vita e sui lavori dell'insigne scultore fiorentino Luigi Pampaloni* (Florence, 1882); Luigi Callari, *Storia dell'arte contemporanea italiana* (Rome, 1909), pp. 26–27; Emilio Mancini, "La Fontana di Empoli e Luigi Pampaloni scultore fiorentino," *Arte e historia*, 6th ser., 39 (Jan.–Feb. 1920), 44–51, (May–June 1920), 77–85, (July–Sept. 1920), 106–112, and (Oct.–Dec. 1920), 150–154; W. Pennestri, "Luigi Pampaloni," in *Cultura neoclassica e romantica nella toscana granducale*, exh. cat., Gallery of Modern Art of Florence (Florence, 1972), pp. 40–42, 87, 127, 214–215; Molly Holt, "The History of the Valentine Museum," *Antiques* 103 (Jan. 1973), 145–155; Annarita Caputo Calloud, "Note su Luigi Pampaloni," *Ricerche di storia dell'arte*, nos. 13–14 (1981), 57–70

2
Kneeling Boy

Modeled 1826
Marble
27 3/8 × 15 7/8 × 12 1/4 in. (70.2 × 40.3 × 31.1 cm)
No inscription

Provenance [Victor Carl, New York]; James H. Ricau, Piermont, N.Y.

Exhibition History *The Ricau Collection,* The Chrysler Museum, Feb. 26–Apr. 23, 1989

Literature Carlo Pontani, *Delle opere del Sig. Professore Luigi Pampaloni, scultore fiorentino* (Rome, 1859), p. 5; Paolo Emiliano Guidici, "Correspondance particulière de la Gazette des Beaux-Arts," *Gazette des Beaux-Arts* 2 (1859), 42–45; Emilio Poggi, *Della scultura e della pittura in Italia dall'epoca di Canova ai tempi nostri* (Florence, 1865), p. 20; M[elchior] M[issirini], *Memorie sulla vita e sui lavori dell'insigne scultore fiorentino Luigi Pampaloni* (Florence, 1882), pp. 12–14; W. Pennestri, "Luigi Pampaloni," in *Cultura neoclassica e romantica nella toscana granducale*, exh. cat., Gallery of Modern Art of Florence (Florence, 1972), pp. 40–42, 87, 127, 214–215; Molly Holt, "The History of the Valentine Museum," *Antiques* 103 (Jan. 1973), 153; Annarita Caputo Calloud, "Note su Luigi Pampaloni," *Ricerche di storia dell'arte*, nos. 13–14 (1981), 57–59

Versions PLASTER Gallery of Modern Art, Florence; MARBLE Pinacoteca Tosio-Martinengo, Brescia; Galleria del Palazzo Bianco, Genoa

Gift of James H. Ricau and Museum Purchase, 86.527

LUIGI PAMPALONI's *Kneeling Boy* was instrumental in launching the sculptor's career. Its sentimental appeal brought him commissions and recognition, but the subject matter was not sufficiently elevated to accord him the stature he sought. Pampaloni initially exhibited the plaster in the fall of 1826 at the annual competitive exhibition of the Academy of Fine Arts in Florence. During this time Anna Tyszkiewicz, then married to her first husband, Alexander Potocki, was visiting her uncle Stanislaw Poniatowski following the death of her young daughter Julia. Upon seeing Pampaloni's *Recumbent Child* and *Kneeling Boy*, her determination for a funerary monument crystallized. She recounted in her memoirs the impact these sculptures had on her, recalling that "it produced in my heart a poignant effect; it suggested such a strong resemblance to the child I mourned. I determined to have a copy of it made for the memorial chapel on which my thoughts were entirely focused."[1]

The monument ultimately consisted of the girl sleeping with a boy praying at her side; it has since been dismantled, and the components are housed in the Baworowski Library in Lvov, Ukraine.[2] Subsequently, each component enjoyed an independent popularity. By 1859 the sleeping child, which was already a prevalent metaphor for death, had been ordered at least four times, while her kneeling companion was repeated more than nine times.[3] *Kneeling Boy* attracted such widespread popularity that commercially made plaster replicas were sold in "immense numbers."[4] Second- or third-generation stone reductions turned up on tombs in Italy and America.[5]

Kneeling Boy, with its aura of innocence and piety, struck a sympathetic chord among its nineteenth-century audience. Its universality generated a variety of titles, ranging from *Praying Samuel* in England to *L'Orfano* in Italy. Such was its adaptability that in some quarters it was suggested that the sculptor had in mind the son of Napoleon praying for the welfare of his father. Preventing Pampaloni from working on more serious themes, the popularity of *Kneeling Boy* led to his series of lighthearted variants, including *A Little Girl Playing with a Dog* (1827), *Little Girl with a Tortoise* (1831), and *Putto with a Swan* (1834, plasters, Gallery of Modern Art, Florence).

Pampaloni applied his successful formula to other religious subjects, and he executed several commissions of St. John the Baptist as a child.[6] One of these images, ordered by Princess Esterhazy of Liechtenstein, is known through an engraving. The standing pose, with clasped hands and eyes cast heavenward, recalls Emma Stebbins's *Samuel* (cat. no. 39) and the unidentified statuette of a youth praying (cat. no. 70) in the Ricau Collection. The sentimental piety that connects *Kneeling Boy* with these works is indicative of attitudes in the mid-nineteenth century.

Technically, Pampaloni reveals himself as extremely accomplished. The carving of the cushion on which the young boy kneels is a marvel of material illusion. The sculptor has captured the softness of the pillow and how it is displaced by weight. Other details, such as the pudginess of the youth and the chiseled irises and pupils, reinforce the statue's compelling naturalism. The eyes gazing heavenward and the lips slightly parted in prayer underscore the piety of the moment.

In spite of these naturalistic elements, Pampaloni retains a concern for neoclassical components such as smooth, planar surfaces of the body and tightly coiled, stylized curls of hair. Ultimately, a balance is struck, as these visually pure elements are offset by the soft folds of material draped across the midsection and left thigh of the boy.

Pampaloni does not appear to have been overly rigid in replicating this composition, since both of the known marble versions are variants on the plaster model (fig. 18). The tassels at the four corners of the cushion in the original plaster are absent in the finished replicas, and the

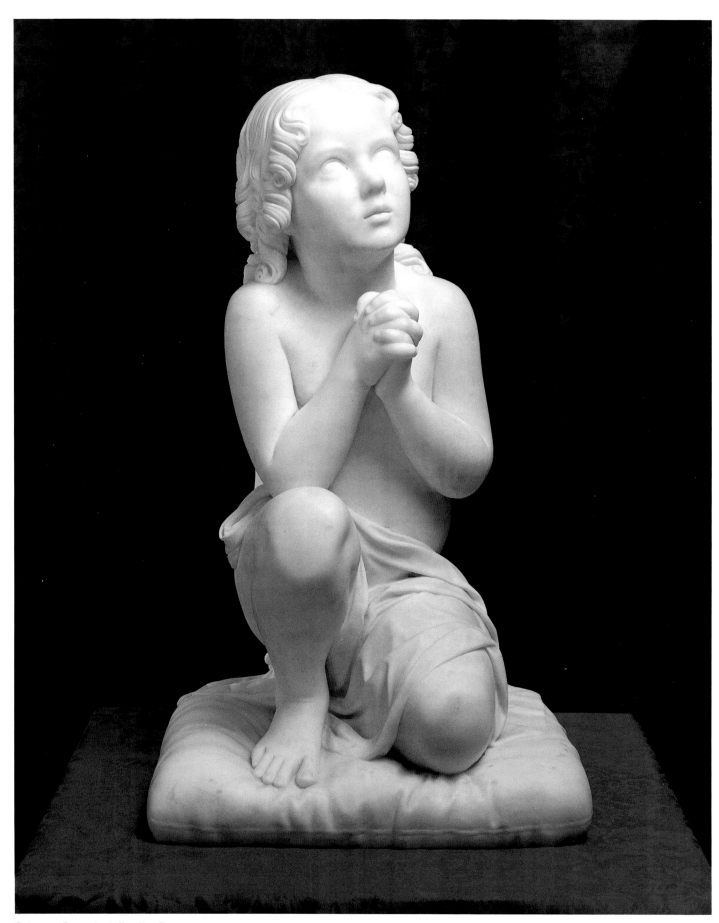

Cat. no. 2 Pampaloni, *Kneeling Boy*

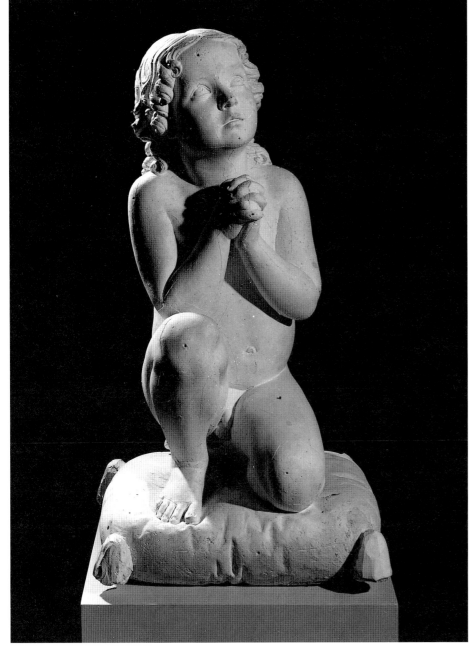

FIG. 18 Luigi Pampaloni, *Praying Child (L'Orfano)*. Plaster, 28¼ in. (71.8 cm) high. Gallery of Modern Art, Florence. Photograph courtesy of Ministero per i Beni Culturali e Ambientali

Raimondo Trentanove
Italian, 1792–1852

Raimondo Trentanove's premature death from consumption impedes meaningful assessment of his place within the ranks of nineteenth-century sculptors. His future was bright; he was considered Antonio Canova's (1757–1822) favorite pupil and, as a result, enjoyed patronage from leading figures of the European aristocracy. Trentanove also had influential access to the American market through Thomas Appleton, United States consul in Livorno and common-law husband of Trentanove's sister. Yet for all these promising beginnings, he is little remembered today.

Raimondo Trentanove was born in Faenza, situated in the Po valley between Bologna and Rimini. He was the son of Antonio Raimondo (d. 1812), a sculptor and stucco worker who undoubtedly shaped his son's future. Around 1804 the elder Trentanove was appointed by the chairman of the architecture department at the Academy of Fine Arts in Carrara to become the practicing modeler and carver of the school.[1] At this time, the academy in Carrara was deemed the most vibrant teaching arena in northern Italy and considered best suited to the needs of the period. It was in this fertile milieu that the young Raimondo received his earliest training.

He learned drawing from Jean-Baptiste Desmarais (1756–1813) and modeling from Lorenzo Bartolini (1777–1850); the latter had a profound impact on many first-generation American sculptors.[2] While Desmarais adhered to the rigid regimen of neoclassicism, Bartolini modified his ideal canon with an infusion of naturalism and an admiration for quattrocento Florentine sculpture.[3] Presumably, the young pupil was introduced to this broad range of ideas through the curriculum.

Around 1809 Trentanove left the academy and returned to his native Faenza to apply his new skills.[4] His talents did not go unnoticed. In 1814 the committee overseeing the local Congregation of Charity stipend awarded Trentanove this coveted prize, which entitled him to spend three years in Rome.[5] Under these prestigious auspices, Raimondo entered the studio of Antonio Canova, who held the position of eminence in the field of neoclassical sculpture.

There are few recorded details of Trentanove's tutelage under Canova. However, the master thought sufficiently well of his pupil by 1816 to delegate to him the execution of the bas-relief panels of the pedestal of a seated statue of George

wrinkles and folds created by the weight of the body on the cushion are nowhere near as convincing as they are in the prototype. The Ricau version differs from its marble counterpart (Pinacoteca Tosio-Martinengo, Brescia) and the original plaster in that a certain modesty is affected by the inclusion of the drapery over the midsection. Again, this was not unusual, and Bertel Thorvaldsen's *Ganymede and the Eagle* was subjected to similar editorial discretion (cat. no. 1). However, the elements not compromised in all three interpretations are the innocence and sentimentality of the subject, compelling motifs that assured the statue's popularity.

Notes

1. Cited in Calloud, "Note su Luigi Pampaloni" (1981), p. 59.

2. Ibid., p. 60.

3. Pontani, *Opere del Luigi Pampaloni* (1839), p. 5.

4. Waters and Hutton 1894, 2:163.

5. With no pretense to being systematic, examples have been found in the Protestant Cemetery in Florence; the Spring Grove Cemetery in Cincinnati, Ohio; the Greenwood Cemetery in New York; and Mount Auburn Cemetery in Cambridge, Mass. Also, a miniature pair serves as bookends in one of the Victorian dollhouses at the Lyman Allyn Art Museum in New London, Connecticut.

6. Calloud, "Note su Luigi Pampaloni," p. 60.

Washington. The statue was commissioned by the state of North Carolina for its capitol.[6] Trentanove's creative involvement must have been considerable, since he received more than one-third of the fee.[7] Unfortunately, full appreciation of this early and important undertaking is stymied by the statue's destruction by fire in 1831. Contemporary documents do reveal information about the identity of the four panels, and a few surviving fragments offer modest insight into their execution (North Carolina Museum of History, Raleigh). According to correspondence between Thomas Appleton, who was acting as agent for Canova and Trentanove, and the General Assembly of North Carolina, the panels represented four subjects: the surrender of Cornwallis, Washington resigning his commission, Washington taking the oath of office, and the great leader portrayed as Cincinnatus (the farmer who was called from his fields to lead the Roman army).[8] Trentanove probably had access to the engravings made after the paintings of these scenes by John Trumbull (1756–1843). In addition to a quest for authenticity, certain elements suggest the sculptor's classical orientation. Surviving fragments indicate figures dressed in appropriate military costume, while at least one object, perhaps a tripod with a jar on it, implies antiquity. The contemporary aspect of these panels compensated for the classical garb of the principal figure of Washington. Despite the modest insight into Trentanove's development that these works reveal, the connection with Canova was of paramount importance. Of comparable significance was Appleton's support, which served the young sculptor in good stead with the American patronage that was gathering momentum in the second decade of the nineteenth century.

The early history of sculpture in America was confined to artisans creating gravestones, monuments for churches, figureheads for ships, and trade signs. In the eighteenth century the few monumental works ordered were entrusted to foreigners such as Jean-Antoine Houdon (1741–1828), who created the statue of George Washington for the state capitol in Virginia. As the young nation became more established, there was an increased demand for statuary. Its execution, however, remained dependent on foreigners until the second quarter of the nineteenth century, when native talent such as Horatio Greenough (1805–1852), Hiram Powers (q.v.), and Thomas Crawford (q.v.) began to emerge. Given the dearth of talent in America, it was not uncommon for foreign sculptors to immigrate in search

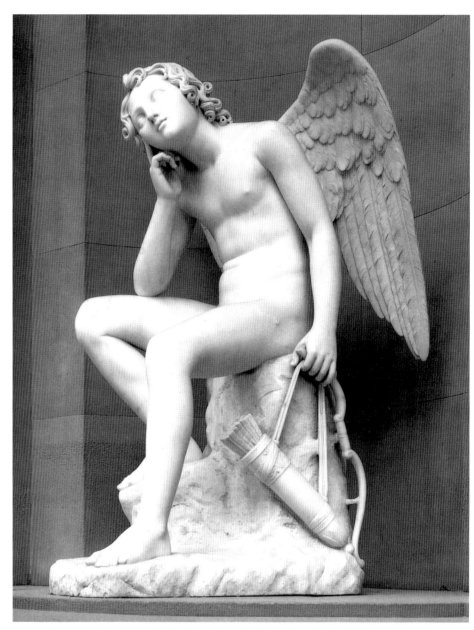

FIG. 19 Raimondo Trentanove, *Resting Cupid*, n.d. Marble, 42 in. (106.7 cm) high. Devonshire Collection, Chatsworth, inv. no. A72. Reproduced by permission of the Chatsworth Settlement Trustees. Photograph courtesy of the Courtauld Institute of Art

of their fortunes. Although Trentanove did not follow the example of his countrymen Giuseppe Ceracchi (1751–1802), Carlo Franzoni (1786–1819), or Luigi Persico (1791–1860), all of whom came to America, the young artist was able to tap the American market from his native land.

Trentanove achieved his success through his professional and familial connection with Appleton and secured portrait commissions from such distinguished citizens as General Robert Goodloe Harper of Baltimore, whose bust of 1819 was displayed in the Peale Museum in that city as early as 1822 or 1823 (Maryland Historical Society, Baltimore).[9] The sculptor also contributed

to Appleton's enterprise of exporting artwork to America by supplying historical busts of such figures as Christopher Columbus and Amerigo Vespucci.[10] This venture generated income as well as exposure, and it was in this manner that numerous busts of George Washington by Trentanove made their way to the young nation (cat. no. 3).

Other busts of famous personages, while based in great part on imagination, reveal the sculptor's concern for creating a compelling likeness. One work that appears frequently in Appleton's account book is Trentanove's likeness of Christopher Columbus, originally commissioned by his mentor, Antonio Canova,

for the Pantheon in Rome when it was dedicated as a temple to men of genius.[11] Trentanove completed the original in 1817, and it joined his earlier interpretation of the illustrious Renaissance painter and teacher of Raphael, Perugino, carved in 1815 (Capitoline Museum, Rome). Although Columbus had yet to enjoy the heroic status in America that would come at midcentury, demand for his image was considerable. While emphasizing the epic nature of the explorer's accomplishments, the sculptor also managed to make his subject very real. The facial structure reflects an understanding of anatomy, and the treatment of details such as the long, flowing hair and the fur collar and cap underscores Trentanove's commitment to enliven this great adventurer.

With few exceptions, this type of bust defines the balance of Trentanove's career. Those that have come to light reveal a range from ordinary citizen and aristocrat such as General Harper of Baltimore and Count Potocki of Poland (1830, Castle Lancut, Poland) to allegories, such as *Alma Mater* (1827, Galerie d'Arenberg, Brussels), and the heroic, embodied in *Napoleon* (1827). All these works share an equilibrium between an effort to dignify character and the delight in rendering meticulous detail, which echoed the concerns of both of Trentanove's mentors, Canova and Bartolini.

Trentanove attracted a few monumental commissions, including a bas-relief of Venus and Cupid for a grave monument to Camilla Sagredo Raspi, executed in 1816 (Cemetery, Ferrara), and what some consider his most important work, a cinerary urn for the ashes of Cardinal Celio Caliagni.[12] The vase is mounted on a pedestal embellished with a bas-relief portrait of the cardinal raised up by two lions, the allegories of History and Genius.

In addition to America, Trentanove enjoyed considerable success in England, which offers further testimony to the promise of his career.[13] The influential duke of Devonshire ordered for his country seat at Chatsworth, a *Resting Cupid*, which attracted the attention of Canova (fig. 19). *Resting Cupid*, with its serpentine elegance and soft, fleshy quality, evokes the work of Praxiteles and his early Hellenistic followers. The smooth, planar surfaces are given a lively counterpoint in the meticulous rendering of such details as Cupid's hair, wings, and quiver. The delicate handling of this work anticipates another sculpture in the Ricau Collection, Heinrich Imhof's somewhat later *Eros* (cat. no. 4). Imhof, who went to Rome in 1824 to study with Bertel Thorvaldsen (q.v.), was part of a circle that perpetuated

the neoclassical aesthetic well into the nineteenth century and would have been receptive to Trentanove's work.

Raimondo Trentanove's personal legacy was modest. In sustaining Canova's neoclassicism, however, he assured the hegemony of this attitude for another quarter century. While he never enjoyed the reputation or renown of many of his contemporaries, through his busts of such eminent figures as Christopher Columbus and George Washington, Trentanove accommodated an avid demand in America for those heroes who could be linked to the young Republic's illustrious past and, in so doing, created inspirational examples for its future.

Notes

1. Hubert, *La Sculpture dans l'Italie napoléonienne* (1964), p. 330.
2. See Hyland 1985 for a recent discussion of this topic.
3. Fehl, "The Account Book of Thomas Appleton" (1974), p. 128.
4. Raggi, *Della r[eggia]. Accademia di Belli Arti di Carrara* (1873), p. 61.
5. Hubert, *La Sculpture dans l'Italie napoléonienne*, p. 373.
6. Philipp Fehl, "Thomas Appleton of Livorno and Canova's Statue of George Washington," in *Festschrift Ulrich Middeldorf*, ed. Antje Kosegarten and Peter Tigler, 2 vols. (Berlin, 1968), 2:532–535.
7. Ibid., p. 543. Of the $11,151 paid out, Trentanove received $4,044.
8. Thomas Appleton to Gov. William Miller of North Carolina, Nov. 16, 1818; reprinted in R. D. W. Connor, *Canova's Statue of Washington* (Raleigh, N.C., 1910), p. 40.
9. *Catalogue of the Second Annual Exhibition in Peale's Baltimore Museum, of the Works of American Artists, including Sculpture, Painting, Architecture, Drawing, Engraving &c. likewise, a Selection from the Various Cabinets of OLD MASTERS, in this City and Vicinity* (Baltimore, 1823), p. 10, no. 250.
10. See Fehl, "The Account Book of Thomas Appleton," pp. 128ff.
11. Ibid., pp. 130–131.
12. Azario, "Raimond Trentanove" (n.d.).
13. Gunnis, *Dictionary of British Sculptors, 1660–1851* (n.d.).

Bibliography

F. de Boni, *Biografia degli artisti* (Venice, 1840), p. 1023; Carlo S. Azario, "Raimond [sic] Trentanove," in *Biographie universelle, ancienne et moderne*, ed. Joseph Michaud (Paris, 1843–1865), 42:127; G[iuseppe] Campori, *Memorie biografiche degli scultori, architetti, pittori, etc. (Nativi di Carrara e di altri luoghi della provincia di Massa)* (Modena, 1873), p. 366; Oreste Raggi, *Della r[eggia]. Accademia di Belli Arti di Carrara* (Rome, 1873), p. 61; Antonio Messeri and Achille Calzi, *Faenza nella storia e nell'arte* (Faenza, 1909), pp. 434, 457–458; Thieme-Becker, s.v., "Raimondo Trentanove"; Ulysse Desportes, "Giuseppe Ceracchi in America and His Busts of George Washington," *Art Quarterly* 26

(Summer 1963), 140–179; Gérard Hubert, *La Sculpture dans l'Italie napoléonienne* (Paris, 1964), pp. 175, 373, 417; Philipp Fehl, "The Account Book of Thomas Appleton of Livorno: A Document in the History of American Art, 1802–1825," *Winterthur Portfolio* 9 (1974), 123–151; Rupert Gunnis, *Dictionary of British Sculptors, 1660–1851* (London, n.d.), p. 400; Craven 1984, pp. 63–64; Denis Coekelberghs, *Sculpture de maîtres anciens, des frères Duquesnoy à Dalou*, exh. cat., Galerie d'Arenberg (Brussels, 1991), pp. 52–53

3
George Washington

Modeled ca. 1815, carved in 1820
Marble
24⅞ × 13⅝ × 11 in. (63.2 × 34.0 × 27.9 cm)
Inscribed on rear edge of bust: *R: Trentanove Fece Roma 1820*; on front of pedestal: WASHINGTON

Provenance James H. Ricau, Piermont, N.Y., by 1978

Exhibition History *The Ricau Collection*, The Chrysler Museum, Feb. 26–Apr. 23, 1989

Literature Gustav Eisen, *Portraits of Washington*, 3 vols. (New York, 1932), 3:852, 945; Swan 1940, pp. 155–156; Philip Fehl, "Thomas Appleton of Livorno and Canova's Statue of George Washington," in *Festschrift Ulrich Middeldorf*, ed. Antje Kosegarten and Peter Tigler, 2 vols. (Berlin, 1968), 2:535, 550–552; Craven 1968, pp. 63–64; Philipp Fehl, "The Account Book of Thomas Appleton of Livorno: A Document in the History of American Art, 1802–1825," *Winterthur Portfolio* 9 (1974), 128–132, 138–149; Jonathan P. Harding, "The Making of an Art Museum," in *A Climate for Art*, exh. cat., Boston Athenaeum (Boston, 1980), p. 4; Hyland 1985, p. 129

Versions MARBLE New York Public Library; Musée de la Légion d'Honneur, Paris

Gift of James H. Ricau and Museum Purchase, 86.526

In the late eighteenth century, George Washington assumed iconic stature as he became a highly sought-after subject for the artist's brush and the engraver's burin.[1] By contrast, demand in the three-dimensional arena was modest, and Washington sat for only three sculptors: Joseph Wright (1756–1793) in 1783, Jean-Antoine Houdon (1741–1828) in 1785, and Giuseppe Ceracchi (1751–1802) in either 1791 or 1792. Of the results, only the busts by Houdon and Ceracchi were influential. The three busts of Washington in the

Ricau Collection confirm the desire to own images of the country's founding father. It is fortuitous that Ricau bought variants of both major sources of inspiration. Houdon's legacy is manifest in the examples by Thomas Crawford (cat. no. 58) and an unidentified sculptor (cat. no. 68), while the likeness by Raimondo Trentanove (cat. no. 3) conveys the influence of Ceracchi.

Many of Trentanove's Ceracchi-derived busts came to America as part of a commercial venture to augment the meager salary as United States consul of his protector and promoter, Thomas Appleton. Appleton ensured the sculptor's successful involvement in exporting busts of great heroes such as Christopher Columbus and Amerigo Vespucci to America. George Washington became a logical addition in 1809 when Appleton acquired a plaster likeness of the first president by Ceracchi from his fellow diplomat William Lee.[2] Initially, Appleton made this plaster available to Antonio Canova (1757–1822) for his statue of Washington to be placed in the North Carolina state capitol. Trentanove, in his capacity as assistant and collaborator on this project, would have enjoyed immediate and sustained access to the plaster model. Cognizant of its commercial potential, Trentanove needed little persuasion to undertake a bust of Washington.

Since Appleton rarely assigned a sculptor to the entries in his account book, and Trentanove is mentioned only in reference to payment for the North Carolina project, it is impossible to ascertain when his busts of Washington first appeared in America. Robert Goodloe Harper of Baltimore, whose portrait Trentanove sculpted in 1819, also ordered a bust of Washington, which he lent to the Peale Museum for an exhibition in 1822 or 1823.[3] Whereas Harper's likeness is in the Maryland Historical Society, the bust of Washington has disappeared.

Appleton's connection with Boston was central to the acquisition by the Boston Athenaeum through subscription of a bust of Washington by Trentanove in 1824.[4] Horatio Greenough was immediately attracted to it and made an early sketch after it.[5] The bust became an institutional fixture and was exhibited almost annually between 1839 and 1856.[6] It subsequently adorned the long room of the library but left the Athenaeum's possession in 1924.[7]

The Ricau version, dated 1820, is the earliest known example by Trentanove to come to light. Unfortunately, its early history is unknown. Efforts to connect it with any of these early examples are frustrated by the large number of *Washingtons* by Trentanove in the country by this time.

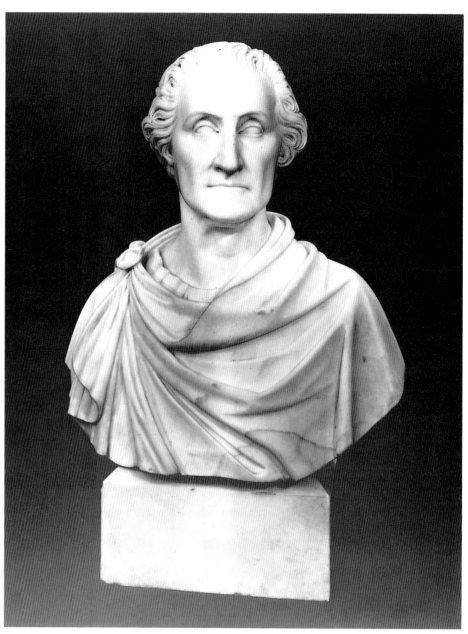

FIG. 20 Raimondo Trentanove, *George Washington*, 1824. Marble, 28½ in. (72.4 cm) high. Collection of the New York Public Library, Astor, Lenox and Tilden Foundations

Appleton confirmed this presence in a letter of 1831 to Governor Montford Stokes of North Carolina:

[H]e [Trentanove] now stands unrivalled in his profession. Many of his works are in the U.S.—at Baltimore, Phila[delphia]., New York and Boston. I presume that not less than a dozen of the busts of Washington are in those cities, for he has greatly improved the likeness of Washington from that formed by Canova, in several journies to London and Paris, and which are universally acknowledged to approach so near the original features of the hero, as to remain unrivalled by any European artist.[8]

While it is difficult to verify the accuracy of Appleton's euphoric comments, one cannot deny the substantial numbers of this bust in America.

Despite the criticism that Canova endured for clothing Washington in classical garb, Trentanove opted for the toga motif in his more elaborate busts of the statesman. Inevitably, minor variations existed in the disposition of the folds of the drapery or the design of the clasp and may be related to the type of bust. The version executed for James Lenox in 1824 (fig. 20) contains full shoulders and upper arms, and the drapery and clasp are more elaborate than in the replica under discussion. In comparison, the Ricau rendering is truncated at the juncture of the shoulder and the upper arm. The drapery,

with the exception of the emphatic loop at the center, is less pronounced, and the clasp is less ornate. Trentanove may have had an individual model for each bust, since the Ricau version is virtually identical to the bust of Washington in Paris (Musée de la Légion d'Honneur). For practical purposes, he may have used a particular model to satisfy a client's aesthetic tastes and financial means.

These three known versions evince a uniform facial type. They share an oblong face articulated by arching eyebrows and eyes left blank, long aquiline nose, sunken cheeks, and double chin (fig. 21). The wattle provides the sole point of contact to the Houdon-inspired bust of Washington, by Thomas Crawford, while the remaining features differ distinctly from those by Houdon and connect them to the work of Ceracchi.

While Appleton's plaster by Ceracchi is not known, a marble by the Italian, which the White House acquired in 1817, points to his role as source (fig. 22).[9] Although Washington is depicted as a young man, the formation of the eyes, nose, and general facial structure provide compelling points of comparison. The major point of departure, aside from age, is the treatment of the hair. In the White House version, Ceracchi adhered to a system of comma-like curls, reminiscent of antique prototypes, while Trentanove has approximated the swept-back coiffure of the unidentified bust of Washington after Houdon. The young Italian, however, endowed his subject with a much thicker head of hair than the Frenchman or his imitator and has enlivened it by means of wavy undulations of stylized curls.

Finally, the severe, almost dour, expression that Washington communicates imparts a seriousness and dignity that epitomized this great American personage. Yet, in suggesting Washington's advanced years, Trentanove has acknowledged that his subject was indeed human and vulnerable to the vicissitudes of time. Consequently, this work reflects the synthesis of Raimondo Trentanove's formative influences: the naturalism of Lorenzo Bartolini (1777–1850) and the tempered classicism of Antonio Canova.

Notes

1. For a discussion of the graphics aspect of this phenomenon, see Wendy Wick, *George Washington, an American Icon: The Eighteenth-Century Graphic Portraits*, exh. cat., National Portrait Gallery (Washington, D.C., 1982).

2. Fehl, "The Account Book of Thomas Appleton" (1974), p. 159. Lee was posted in Bordeaux and had been engaged in the same kind of export business.

3. Yarnall and Gerdts 1986, 5:3553. Appleton recorded in his account book on July 8, 1822, a cash payment of $98.60 from General Harper with no other information. Presumably, this was for one or both of the busts.

4. Swan 1940, pp. 155–156.

5. Nathalia Wright, *Horatio Greenough, the First American Sculptor* (Philadelphia, 1963), p. 48.

6. Perkins and Gavin 1980, p. 144.

7. Trentanove folder, archives, Boston Athenaeum. The bust was removed in Dec. 1924 to be sold.

8. The letter is dated Aug. 10, 1831, and is cited in Fehl, "Appleton and Canova's Washington" (1968), p. 551.

9. Ulysse Desportes, "Giuseppe Ceracchi in America and His Busts of George Washington," *Art Quarterly* 26 (1963), p. 170.

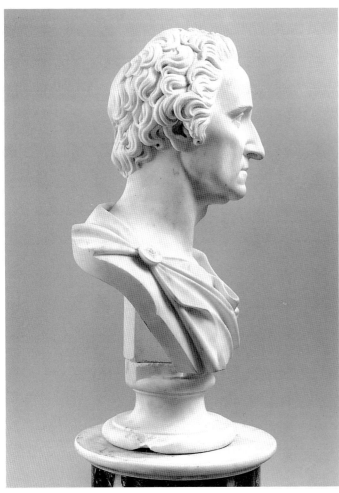

FIG. 21 Trentanove, *George Washington*, side view

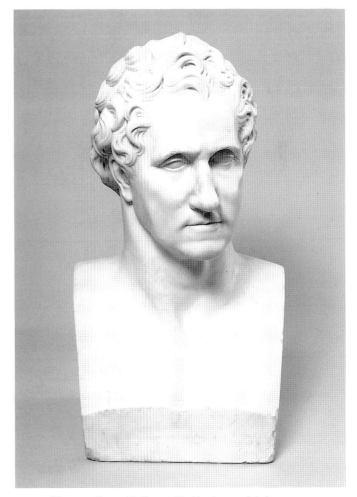

FIG. 22 Giuseppe Ceracchi, *George Washington*, modeled ca. 1790–94, carved ca. 1815. Marble, 22 in. (55.9 cm) high. The White House

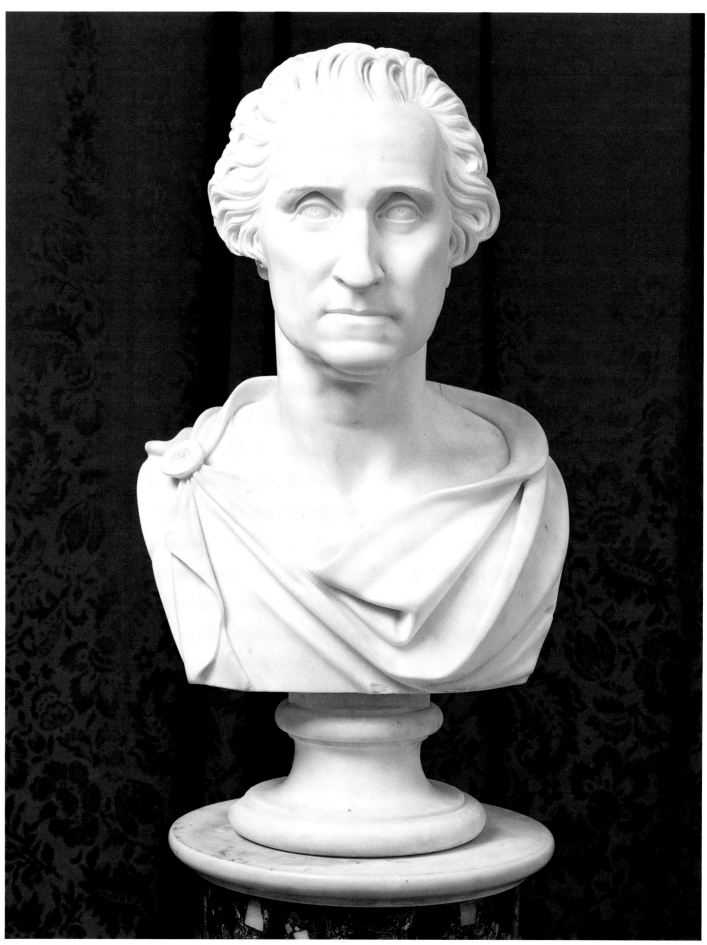

Cat. no. 3 Trentanove, *George Washington*

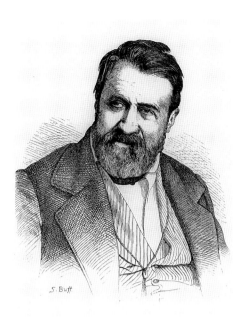

S. Buff, *Heinrich Imhof*, n.d. Engraving.
Photograph courtesy of Kunstmuseum Bern

Heinrich Maximilian Imhof

Swiss, 1795–1869

Heinrich Imhof is a little-remembered figure in the history of nineteenth-century sculpture. However, contemporary accounts portray him as an artist of enviable accomplishment.[1] He enjoyed royal patronage and enthusiastic support from numerous influential individuals; his work entered several public collections, as well. But like so many sculptors of his generation, his adherence to a neoclassical style resulted in a reputation in eclipse, as artistic taste shifted dramatically in the last quarter of the century.

Imhof was born in Switzerland in the village of Bürglen, best known as the traditional birthplace of the legendary hero William Tell. Imhof's family enjoyed comfortable circumstances and chose to live a rustic life in the mountains, and young Imhof's early education instilled in him principles of diligence and decorum as well as a love of art. Under elementary conditions, Imhof learned the rudiments of carving and modeling. He could craft a variety of utilitarian objects with a minimum of guidance and a paucity of tools. His first recorded effort was a dove, symbolizing the Holy Spirit, which he formed after a drawing by his teacher, Xavier Triner (1767–1824).

Imhof's uncle recognized his nephew's talents as a sculptor and placed him with Franz Abart (1769–1865), who had won a gold medal for his sculpture in the 1810 annual exhibition at Bern. This was a formidable step, since Abart lived a considerable distance away, and Imhof had to leave home. He responded to the opportunity by zealously setting out to improve his drawing, modeling, casting, and working of various types of stone.

After a short time with Abart, Imhof attracted the attention of the noted geographer Dr. Johann Gottfried Ebel, who admired Imhof's youthful carving *Dove of the Holy Spirit*. Ebel, though Prussian by birth, actively promoted his adopted country and invited the young sculptor to accompany him to Zurich to further his training. Imhof accepted and moved there in November 1818. In addition to instruction, Imhof began to establish an independent career. He executed carvings in wood and made alabaster portraits, none of which is known today. Dr. Ebel's support had profound consequences. In 1819 he arranged for Imhof to take the likeness of the crown prince, later King Frederick William IV of Prussia, who stopped briefly in Zurich while traveling through Switzerland. The crown prince was so pleased with Imhof's effort that he ordered several replicas.[2]

The following year brought the young sculptor another major opportunity—the chance to work in the studio of the highly regarded German sculptor Johann Heinrich Dannecker (1758–1841). In June 1820 Imhof moved to Stuttgart to embark on the next phase of his career. The beginnings were traumatic, however. He quickly recognized the inadequacy of his training and was filled with self-doubt and homesickness. His work was adversely affected, but sympathetic friends helped to dispel his anxiety. He was soon drawing and modeling after nature and the antique as well as concentrating on making casts of hands and feet. Dannecker expressed great pleasure with his student, and Imhof commenced some independent work on life-size portrait busts and smaller likenesses in alabaster. In addition to gaining self-confidence, Imhof learned much from studying plaster casts after the antique. These casts and Dannecker's encouragement awakened in Imhof the desire to go to Rome and study with the dean of neoclassicism, Bertel Thorvaldsen (q.v.).

Once again, Dr. Ebel was instrumental in helping his protégé achieve his goal, and in the fall of 1824 Imhof embarked for Rome. Once there, he quickly established contact with Thorvaldsen, who accepted him into his studio. To provide financial assistance, one of Imhof's Stuttgart supporters commissioned him to make a replica of Thorvaldsen's famous bas-relief *Night*, which the Dane supervised. Upon completing this task, Imhof began studying mythology and ancient history in earnest, and in the spring of 1825 he sketched his first original composition, a modestly scaled interpretation of Cupid and Psyche. Thorvaldsen praised it highly, and Imhof presented it to Dr. Ebel.

Imhof amplified his commitment to the classical world with a trip to Herculaneum and Pompeii in the summer of 1826, but illness clouded his return to Rome and prevented him from working until the fall. The next summer he modeled his *David with the Head of Goliath* (plaster, KMB), his first large-scale piece. David carries Goliath's head in his left hand and rests his sword on his right shoulder. The youth's pose pays homage to the *Apollo Belvedere* (fig. 113), but the handling of the anatomy and drapery emulates classical rather than Hellenistic masters. Thorvaldsen again responded enthusiastically, and the Prussian minister to Rome included Imhof's *David* in an exhibition of German and Swiss artists. Crown Prince Frederick William, who remembered Imhof from his travels through Switzerland in 1819, saw the sculpture and was sufficiently impressed to have it translated into marble. Thus, *David with the Head of Goliath* secured Imhof's reputation, and he was inundated with orders for portrait busts.

Although Imhof's career was well established by 1830, the new decade commenced on an unhappy note, with the death of his friend and patron, Dr. Ebel. Even without this enthusiastic promoter, Imhof continued to attract influential patrons. King Ludwig of Bavaria ordered busts of Maximilian I and Johann Reuchlin, the esteemed Renaissance humanist, for the Central Hall at Valhalla, the German Pantheon designed by Leo von Klenze (1784–1864). Among Imhof's other projects in the early part of the decade were a companion piece to *Cupid and Psyche*, *Atalanta* (plaster, KMB), and a bust of Dr. Ebel that Imhof presented in 1834 to the family with whom Ebel had resided in Zurich.

In 1855 King Otto of Greece, having lost the services of another Thorvaldsen disciple, Ferdinand Pettrich (q.v.), as professor of sculpture in his newly formed academy, approached Imhof about the position. Principal duties included overseeing the restoration of recently excavated antiquities. Imhof assumed this new position in the summer of 1856, but it proved to be an unfortunate experience. Funds were limited and commissions were few. Upon conclusion of the restoration obligation, Imhof managed to create several works, including *Sappho, Cupid Playing the Lyre*, and several religious subjects. Once again, illness intervened and compounded his

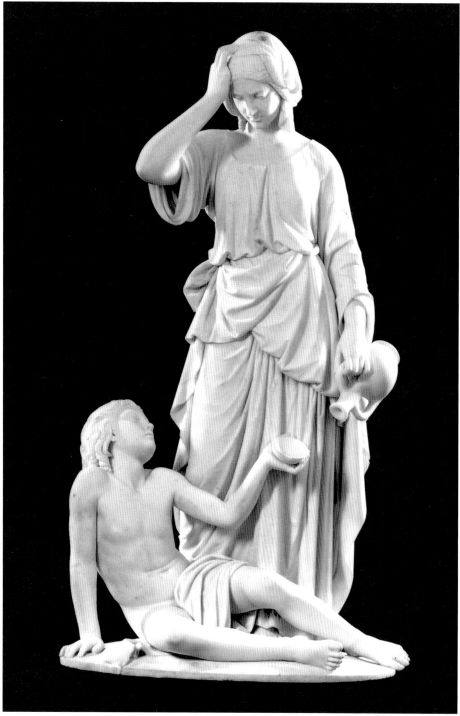

and resumed work on a mixture of religious themes, mythological subjects, and portrait busts. Among the religious subjects were an ambitious *Eve before the Fall* (KMB) as well as a *Madonna and Child* executed for the Queen Mother of Russia. He also received a commission to create a bust of the educational reformer Johann Heinrich Pestalozzi, while mythological and allegorical works such as *Cupid and Mercury, Cupid and Hebe,* and *The Maiden from Afar* after Schiller's poem of 1796 also demanded his attention. These projects and numerous other biblical subjects took up the balance of the decade.

The years from about 1850 to 1865 are glossed over by Imhof's early biographers, and recent attempts to unravel the cause of this lacuna have failed. Not until 1866 does Imhof's career appear to resume with a design for *Eurydice* and a statue of the education of Jesus in the Temple. One last composition remained, and, fittingly, it was a monument to William Tell ordered by the town of Altdorf near where both the hero and the sculptor had their beginnings. The ultimate disposition of this commission is not clear, since a travel guide published in 1889 mentioned a colossal plaster statue of William Tell, erected in 1861 to mark the spot where Tell's son stood with the apple on his head.[3]

Imhof died May 4, 1869, just ten days short of his seventy-fourth birthday, and was buried in his beloved Rome. Although Heinrich Imhof is virtually forgotten today, he was highly respected in his own time for his sensitive rendering of the human form while infusing it with the lofty ideals of classical art that reflected the lessons of his mentors Dannecker and Thorvaldsen. Moreover, his art sought the highest spiritual plane, which was conditioned by his attraction to religious subject matter. Whether sacred or profane, the quality of his work mirrored a concern for the standards that had been instilled in him from childhood.

Notes

1. The basis for this biography is Küchler, "Imhof" (1967), and Prosch, "Imhof" (1870). As this book went to press, the author was apprised of a recent publication; see Iten, *Imhof* (1995).
2. Küchler, "Imhof," p. 126.
3. Karl Baedeker, *Switzerland and the Adjacent Portions of Italy, Savoy, and the Tyrol: Handbook for Travellers* (Leipzig, 1889), pp. 101–102. The guidebook's information is not without problems, since it indicates that the statue was in plaster and that it was installed in 1861.

Bibliography

"Nekrologe," *Kunst-Chronik* 6 (Aug. 6, 1869), 189; E. Prosch, "Heinrich Max Imhof," *Neujahrsblatt der Künstlergesellschaft in Zürich für 1870* 30

disillusionment. In the summer of 1858 Imhof returned to Rome, where his health was restored and his spirits refreshed.

Imhof then embarked on some major productions taken from the Old Testament. Among these were *David as a Youthful Shepherd, Rebecca* (KMB), and *Hagar and Ishmael* (fig. 23). His work continued to impress aristocracy, and in 1843 the duke of Leuchtenburg and his wife, the Grand Duchess Maria of Russia, ordered *Hagar and Ishmael* to be translated into marble.

This commission inspired Imhof to design a pendant, *Tobias with the Angel Raphael.* Other works that occupied him at this time were *Ruth* (KMB) and *The Abandonment of the Child Moses,* which he eventually translated into marble for Emperor Nicholas I of Russia.

In addition to Imhof's growing professional triumphs, 1846 was a year of great personal happiness. He returned briefly to Switzerland to marry Henrietta Ott of Zurich. He took her with him to Rome

(1870), 1–11; A. Küchler, "Heinrich Max Imhof," in Carl Brun, *Schweizerisches Künstler-Lexikon*, 3 vols. (Frauenfeld, 1908; reprint, 1967), 2:126–129; *Thieme-Becker*, s.v., "Heinrich Maximilian Imhof"; Karl Iten, *Heinrich Max Imhof, 1795–1869, Ein urner Bildhauer in Rom*, exh. cat., Historisches Museum (Altdorf, 1995)

4
Eros or *Cupid*

Attributed to Heinrich Imhof
n.d.
Marble
38¾ × 27⅞ × 39¾ in. (98.4 × 70.8 × 101 cm)
No inscription

Provenance England [or Florentine Craftsmen, New York]; James H. Ricau, Piermont, N.Y.

Exhibition History *The Ricau Collection*, The Chrysler Museum, Feb. 26–Apr. 23, 1989

Literature None known

Versions None known

Gift of James H. Ricau and Museum Purchase, 86.475

DESPITE the dearth of information about Heinrich Imhof and his work, Ricau acquired this statue of Eros, or Cupid, with this attribution. If correct, it reveals the sculptor's considerable ability. Themes dealing with Eros and his exploits had been popular since antiquity, and they continued to sustain favor among the neoclassicists. The subject was particularly attractive to Imhof—his first known original composition was a rendition of Cupid and Psyche—and throughout the rest of his career, the sculptor returned to the subject no fewer than three times. He modeled *Cupid Playing the Lyre* at the end of his tenure in Greece around 1837, and in the following decade he executed such standard subjects as *Cupid and Mercury* and *Cupid and Hebe*.

The *Eros* in the Ricau Collection does not agree with the references to any of these productions. None of the paired figures are appropriate, nor does the Ricau statue suggest the making of music. Although Eros's left hand appears to have held something, it is likely to have been a slender staff or light bow, since the diameter created by the curled fingers of the left hand is so small, and the object appears to have been anchored adjacent to the youth's left foot. His gaze and outstretched right hand draw the viewer to the clump of flowers in the foreground, but no narrative is readily discernible.

Stylistically, Imhof's *Eros* reflects the prevailing neoclassical taste of the period.

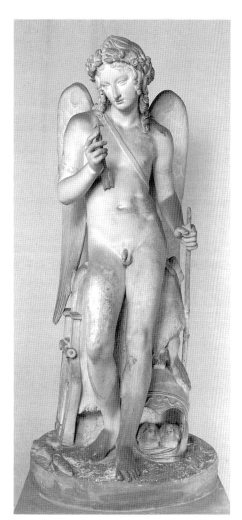

FIG. 24 Bertel Thorvaldsen, *Cupid Triumphant*, 1814. Plaster (original model), 57½ in. (146.1 cm) high. Thorvaldsen Museum, Copenhagen

The smooth, planar surfaces of the body retain aspects of the taut musculature that echoes Bertel Thorvaldsen's (q.v.) preference for early classical Greek sculpture. Imhof's tutelage in Thorvaldsen's atelier exposed him to such works by the master as *Cupid Triumphant* of 1814 (fig. 24). The prominent wings are also treated in the stylized manner of Thorvaldsen. But the soft flesh and a lack of specific activity in Imhof's work recall Raimondo Trentanove's *Resting Cupid* (fig. 19). By extension, it acknowledges the more sensual vein of Antonio Canova (1757–1822). Imhof most likely was aware of the work of one of Thorvaldsen's German disciples, Emil Wolff (1802–1879), whose *Cupid with the Attributes of Hercules* of 1856 (Staatliche Museen zu Berlin, Nationalgalerie) was created while Imhof was working with the Danish master. Contrary to Thorvaldsen's approach, the physique of Wolff's *Cupid* is much softer and effeminate, speaking more to Hellenistic sculpture than to the severe classical tradition and evoking

Donatello's *David* of the 1450s (Bargello Museum, Florence).

Imhof added complexity to his rendition. Tight, wavy curls of hair offset the smooth contours of the body and timeless blank eyes. Ancillary objects, such as the wicker basket of flowers, arrows for the missing bow, and foliage on the ground, enliven the visual experience through meticulously rendered details. This exquisite balance of the closely observed and the earthbound with the elevated and theoretical found favor with Imhof's patrons and admirers.

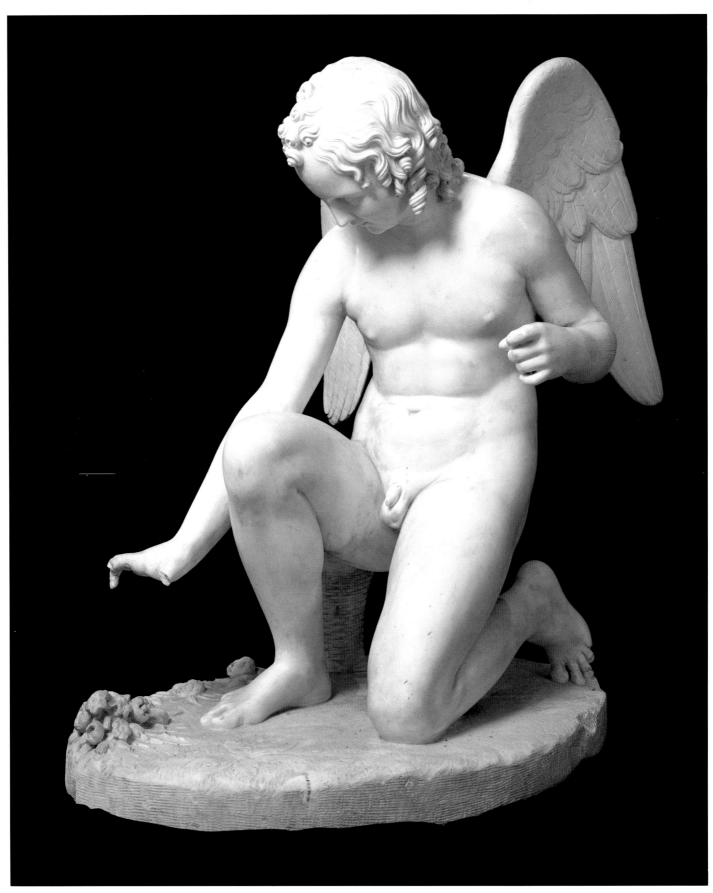

Cat. no. 4 Attributed to Imhof, *Eros* or *Cupid*

Frederick Augustus Ferdinand Pettrich

German, 1798–1872

Ferdinand Pettrich and Thomas Crawford (q.v.) virtually passed each other on the Atlantic Ocean in 1835. Pettrich, a German sculptor, sailed to the United States to pursue greater fame, while the American embarked on a pilgrimage to Italy to further his education as a sculptor. Both men shared the common bond of tutelage under the eminent Danish neoclassical sculptor Bertel Thorvaldsen (q.v.). However, their experiences abroad differed enormously. Crawford would inherit the mantle of neoclassicism from his mentor and, in his abbreviated career, ascend to the pinnacle of sculptural achievement in America. Pettrich, in contrast, would see his hopes and ambitions dashed by politically motivated xenophobia, and his American sojourn would constitute the nadir of his professional experience.

Born in Dresden, Saxony, Ferdinand Pettrich was the son of Franz Pettrich (1770–1844), sculptor to the Saxon court and professor of sculpture at the Dresden academy. Ferdinand's early training was at the School of Fine Arts and the academy, where his father started instructing him in 1817. Family ties proved advantageous, since Ferdinand Pettrich's earliest recorded work is a bust of King Friedrich Augustus I. With the encouragement and connections of his father, who had studied in Rome under Antonio Canova (1757–1822), Pettrich embarked for Italy via Vienna at the outset of 1819 in the entourage of Prince Anton of Saxony.

When the aspiring sculptor arrived in Rome, he gravitated toward the revered Thorvaldsen. Among Pettrich's initial efforts was a *Christ Child Sleeping on the Cross*, executed in 1820 (Pffarkirche, Schönlinde, Czechoslovakia). The motif, symbolizing death and innocence, was popular in the nineteenth century and launched the career of Pettrich's Florentine contemporary, Luigi Pampaloni (q.v.). The recumbent child reflects the neoclassical concern for ideal form in the smooth, planar surfaces of the body, which are complemented by the elegantly sinuous folds of drapery and curls of hair. Pettrich thought enough of this work to exhibit the model (or a variant with the same title) at the Pennsylvania Academy of the Fine Arts in 1843.[1]

With the exception of a brief interlude in Florence in 1823 and Athens in 1833, Pettrich maintained his studio in Rome until he decided to go to America in 1835.

Ferdinand Pettrich, *Self-Portrait*, 1840. Plaster, 29 in. (73.7 cm) high. National Museum of American Art, Smithsonian Institution, XX24

The majority of his work comprised religious subjects, although there were some secular allegories and history subjects as well as portrait busts. In 1825 he sent a piece entitled *The Fishermaiden* to an exhibition in his native Dresden, where it received extensive notice in a contemporary periodical.[2] The critic described the fishermaiden as lying in wait for her catch and complimented the artist for his composition and rendering of form. Pettrich also thought highly of this work, since he had the plaster model shipped to America and cut a life-size replica in marble. This

was exhibited at the Pennsylvania Academy in 1843 and again in 1847.[3]

In 1826 Pettrich received his first commission of consequence, a funerary monument commemorating the young son of Count von Hohenthal (Hohenpriessnitz near Eilenburg, Germany). While such an order was encouraging professionally, a major personal milestone was reached the following year—Pettrich's marriage to Anna Michelina Baldassari, whose beauty is confirmed in the likeness he took of her not long after their arrival in America (NMAA).

While details of Pettrich's career remain sketchy for the ensuing years, it is known that in 1833 he was in Athens, where he modeled and carved a bust of King Otto I of Greece (University of Athens). This was as much a tour de force in the rendering of the king's tunic as it was the creation of his likeness. Pettrich found great favor with the royal family, who tried to persuade him to remain in Greece rather than settle in Bavaria at the behest of King Ludwig. Pettrich may have resolved his predicament by returning to Rome and subsequently electing to go to America.

Back in Rome, positive response to Pettrich's abilities continued with his appointment in 1835 to create a likeness of Pope Gregory XVI. With attention from such exalted circles of patronage, Pettrich must have been optimistic about his prospects in America, where he assumed there was considerable demand for sculpture to adorn the buildings of the young Republic. Unfortunately, he was to be bitterly disappointed.

Pettrich and his wife initially settled in Philadelphia.[4] His activities there are not known, but he must have encountered the artistic community. When Pettrich moved to Washington in 1836, Thomas Sully (1783–1872) wrote a letter of introduction on his behalf to Ralph E. W. Earl (ca. 1785–1838), who had close ties to President Andrew Jackson.[5] In announcing Pettrich's imminent arrival, Sully mentioned that Pettrich was a student of Thorvaldsen, that he excelled in "works of magnitude," and that he was quickly becoming attuned to the general apathy toward sculpture in America.

Although Pettrich secured a few private commissions and was aggressive in pursuing government contracts, most of his efforts were in vain. He was victimized by the growing sentiment that work for government buildings should be given to American artists.[6] Even Luigi Persico (1791–1860), who had already completed projects for the Capitol and enjoyed the benefit of familiarity, encountered this chauvinistic resistance. Nevertheless, Pettrich's entrée to the White House not only resulted in the opportunity to take the president's likeness (cat. no. 5) but also provided him with access to many prominent Washington citizens. Since Pettrich had to maintain himself on portrait commissions, this base of support was critical. Pettrich's list of sitters included such renowned figures as Henry Clay, Martin van Buren, John Tyler, and Joel Poinsett (Secretary of War under Jackson). Yet these sympathetic parties were powerless to reward him in the public arena, which must have been doubly frustrating since Pettrich received favorable notice in the press.[7]

Pettrich's residence in Washington was enhanced by one other series of events—visits of delegations from American Indian tribes. They came in the latter half of 1837 to negotiate treaties. Pettrich was keenly interested in the Indians and persuaded many of the chiefs to visit his studio, where he executed studies; some of these were published in lithographic form in 1842. Pettrich modeled the Indian heads later in Brazil, working from drawings, and most of these works are now in the Vatican Museums in Rome.[8] The most enduring effort from this endeavor is *The Dying Tecumseh* (fig. 25), which was modeled between 1837 and 1840 and cut in marble in Brazil in 1856 to the order of DeWitt Clinton Van Tuyl, an American dentist practicing in Rio de Janeiro.[9]

In creating *The Dying Tecumseh*, which bears many associations to Peter Stephenson's *Wounded Indian* (cat. no. 46), Pettrich created a monumental sculpture with a poignant message.[10] He chose to represent the Shawnee chief who had forged a powerful confederacy in the regions of the Great Lakes as well as between the Ohio and Mississippi rivers to resist the white man's purchase of Indian lands. Tecumseh's leadership and death in battle during the War of 1812 assured his enduring fame. Pettrich makes an iconic statement about the inevitability of westward expansion and its cost to the civilization being displaced. The sculpture recognized the dignity of the oppressed, and Tecumseh's powerful physique is reinforced by the crisp carving, which demonstrates a preference for more archaic forms of ancient Greek sculpture while incorporating the pathos of *The Dying Gaul* of the Hellenistic era (Capitoline Museum, Rome). Tecumseh's semirecumbent pose is almost indicative of an architectural setting such as a pedimental program. In fact, it bears a certain similarity to figures from the pediment of the Temple of Aphaia at Aegina. The figure's austerity and dignity are also consistent with Pettrich's severe approach to his portrait busts.

In addition to his unrelenting lobbying efforts for government commissions, Pettrich established an association with Georgetown University. He taught there and situated his studio in a nearby abandoned church. In an attempt to ingratiate himself with the local citizenry, Pettrich advertised that he would open a free school of sculpture to introduce pupils to the theoretical and practical knowledge of art.[11] It is not known whether the school was successful, but its existence was short-lived, since Pettrich and his family returned to Philadelphia in the spring of 1838.

Upon arriving in Philadelphia, Pettrich gained steady employment by joining the firm of John Struthers, a marble mason. In this capacity, Pettrich executed architectural sculpture as well as sepulchral works. These less distinguished pursuits did not deter his ambition, however, and Pettrich lobbied for the commission to erect a statue of Washington in Philadelphia, which had been under discussion since 1835. Newspaper accounts of 1840 indicate he was successful, and that William Strickland (1788–1854) was chosen to design the pedestal.[12] The original concept for an equestrian statue was modified to a standing figure, which Pettrich designed to represent the warrior-statesman resigning his commission (plaster, NMAA). Pettrich's interpretation of Washington's head was aided immeasurably by Houdon's life mask, which Struthers had given him.[13] Once again, Pettrich was to be disappointed, since the plan to erect the statue never came to fruition. It was eventually cast in bronze after he left the United States and placed in front of the Customs House in New York, but the sculptor had no connection with this undertaking.

While in Philadelphia, Pettrich received an overture from the federal government in the summer of 1841 to create the pedestal for Horatio Greenough's statue of Washington, which was en route from Italy. Pettrich seized this opportunity to add his stamp to the pedestal with a series of relief panels. His impulse engendered a heated controversy, pitting Pettrich and his allies against the Greenough constituency. Greenough was understandably incensed, and his side was to prevail. Not surprisingly, Pettrich, whose move to Washington had been a failure, causing him to live in poverty, became thoroughly disillusioned at this juncture and contemplated the overture of the king of Greece to return to Athens as sculptor to the court.

The destitute sculptor's professional disappointment was to pale in comparison with the calamity that befell him on the evening of May 29, 1842, when he was brutally stabbed by two attackers while working in his Washington studio.[14] Critically wounded, Pettrich received financial help from several of his friends. But this unwarranted, and possibly politically motivated, assault must have been the final signal for him to move. Consequently, in February 1843 Pettrich and his son Adolph sailed from Boston for Rio de Janeiro, while the rest of the family went to South America by way of Hamburg.

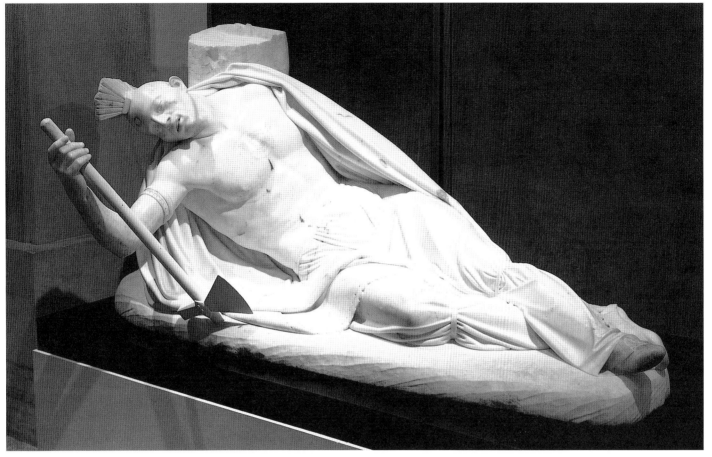

FIG. 25 Ferdinand Pettrich, *The Dying Tecumseh*, carved 1856. Marble on metal base, 36⅜ in. (92.4 cm) high. National Museum of American Art, Smithsonian Institution, transfer from the U.S. Capitol, 1916.8.1

It is a mystery why Pettrich rejected King Otto's offer to return to Greece. However, Pettrich could rejoice that the upcoming phase of his career in Brazil would be in the responsive confines of the court of Pedro II. The opportunity to work on a grand scale and the court's positive reception must have been refreshing for Pettrich after the bitter disappointment of his North American experience. His vindication was further enhanced when a French correspondent, writing on the surprisingly accomplished state of the arts in Brazil, considered Pettrich one of the country's two leading sculptors.[15] Ironically, the artist enjoyed some of his most enthusiastic private patronage from an American dentist, DeWitt Clinton Van Tuyl, and this may have inspired him to persevere with his American Indian subjects. *The Dying Tecumseh* is one of the rare examples of his legacy that we can admire in this country.

Early in 1858, when Pettrich was almost sixty, he felt the lure of Rome calling him back. When he arrived in Leghorn, Italy, in May, he applied for his passport through the American consulate and listed his last residence as the United States; nothing is known of the nature or duration of this brief interlude.[16] In Rome, Pettrich established his studio near the Piazza Barberini and was soon rewarded with the commission for the monumental tomb of Cardinal Bartholomew Pacca, who had died in 1844 (Santa Maria in Campitelli, Rome). In addition to this major project, Pettrich created several allegorical statues and bas-reliefs, and the lyrical grace of the latter evoked his debt to Thorvaldsen. The balance of his output was made up of portrait busts. It is fitting that one of the last works he created was a bust of the father of neoclassicism, Johann Joachim Winckelmann (1717–1768).

By the 1860s most of the sculptors Pettrich knew from his early stay in Rome had died, and as they died, so did the commitment to neoclassical style. Thus, Pettrich's death in 1872, at the age of seventy-four, marked a further stage in the demise of a sculptural tradition that embodied a Rome steeped in the past. A new style was being forged in Paris, where fresh energy and excitement were unfolding. Rome was to fade from the limelight, and with its eclipse dissolved the commitment to an ideal canon of beauty that had held sway for more than four centuries. But for Ferdinand Pettrich the passing of a sculptural tradition at the end of his career must have seemed far less disappointing than the rejection he experienced in America, when, in the prime of his career, he was so confident of success.

Notes

1. Rutledge 1955, p. 172. For the most recent account of Pettrich, see Stehle, "Ferdinand Pettrich in America" (1966).

2. The notice, "Betrachtungen über die Aussstellung in Dresden im August und September 1825," in the September issue of *Artistischen Notizenblatt*, is quoted at length in Geller, *Pettrich* (1955), p. 114.

3. Rutledge 1955, p. 172. In 1847 *The Fishermaiden* was purchased by a General Keim, who lent it to Pennsylvania Academy exhibitions for the next three years. Whether his patronage was a bond of nationality or motivated by genuine admiration for Petttrich's work, General Keim also acquired a cast of the *Infant Jesus*.

4. A painstaking account of this American sojourn is to be found in Stehle, "Ferdinand Pettrich in America."

5. James G. Barber discusses this in conjunction with how Pettrich might have met Andrew Jackson in his *Andrew Jackson: A Portrait Study* (1991), p. 126. See cat. no. 5 for a full discussion.

6. Vivien Green Fryd, *Art and Empire: The Politics of Ethnicity in the United States Capitol, 1815–1860* (New Haven and London, 1992), pp. 44–47.

7. A Looker on in Venice, "Inauguration at Washington," *Spirit of the Times*, Mar. 25, 1837, p. 47. The correspondent refers to two "beautiful classic groups" in Pettrich's studio.

8. See Paolo dalla Torre, *Le Plastiche a soggetto indigeno nordamericano del Pettrichi nel Pontifico Museo Missionario Etnologico*, Annali lateransi, 4 (Rome, 1940), pp. 9–96.

9. Stehle, "Ferdinand Pettrich in America," p. 410.

10. See Julie Schimmel, "Inventing 'The Indian,'" in William Truettner et al., *The West as America: Reinterpreting Images of the Frontier*, exh. cat., National Museum of American Art (Washington, D.C., 1991), pp. 169–170.

11. "Free School of Sculpture," *New-York Mirror*, June 10, 1837, p. 400. The school was advertised to open the following October.

12. Stehle, "Ferdinand Pettrich in America," pp. 399–400.

13. This life mask, now in the collection of the Pierpont Morgan Library in New York, had an interesting life of its own, as Pettrich later gave it to William Wetmore Story; see William Wetmore Story, "The Mask of Washington," *Harper's Weekly* 31 (Feb. 26, 1887), 144–146.

14. "Assassination," *Boston Transcript*, June 1, 1842, p. 2.

15. "Art in Brazil," *Bulletin of the American Art-Union*, Sept. 1851, p. 95.

16. I am grateful to Col. Merl M. Moore, Jr., for the information on Pettrich's passport. In his exhaustive researches of the comings and goings of artists to and from America, he has uncovered no information about Pettrich's second stay in the United States.

Bibliography

A Looker on in Venice, "Inauguration at Washington," *Spirit of the Times*, Mar. 25, 1837, p. 47; F. Pettrich, "Free School of Sculpture," *New-York Mirror*, June 10, 1837, p. 400; "Equestrian Statue of Washington," *Saturday Courier* (Philadelphia), June 20, 1840, p. 2; "Equestrian Statue to Washington," *National Gazette* (Philadelphia), July 6, 1840, p. 2; "Equestrian Statue of Washington," *Saturday Courier* (Philadelphia), July 25, 1840, p. 2; "Statue of Washington," *National Gazette* (Philadelphia), Aug. 17, 1840, p. 2; "Assassination," *Boston Transcript*, June 1, 1842, p. 2; "Art in Brazil," *Bulletin of the American Art-Union*, Sept. 1851, p. 95; "Work of Art," *Home Journal*, Nov. 12, 1859, p. 2; Hans Geller, *Franz und Ferdinand Pettrich: Zwei sächsische Bildhauer aus der Zeit des Klassizismus* (Dresden, 1955); Georgia S. Chamberlain, "Pettrich, the Sculptor of Washington, Clay, and Poinsett," *Antiques Journal* 10 (Feb. 1955), 18–19, 39; Georgia S. Chamberlain, "Ferdinand Pettrich, Sculptor of President Tyler Indian Peace Medal," *Numismatist* 70 (Apr. 1957), 387–390; Georgia S. Chamberlain, "The Face of Washington," *This Day* 10 (Feb. 1959), 21–24; R. L. Stehle, "Ferdinand Pettrich in America," *Pennsylvania History* 33 (Oct. 1966), 388–411; James G. Barber, *Andrew Jackson: A Portrait Study* (Washington, D.C., and Nashville, Tenn., 1991)

5
Andrew Jackson

Modeled in 1836, carved between 1836 and early 1843
Marble
24⅜ × 14⅝ × 11½ in. (61.9 × 37.1 × 29.2 cm)
No inscription

Provenance [Mrs. G. B. Baker, Swansea, Mass.]; James H. Ricau, Piermont, N.Y., Aug. 1960

Exhibition History *The Ricau Collection*, The Chrysler Museum, Feb. 26–Apr. 23, 1989; *The Portrait in America*, The Chrysler Museum, Jan. 26–Apr. 8, 1990

Literature *The Official Catalogue of the Tennessee Centennial Exposition* (Nashville, 1897), p. 106; *Antiques* 86 (Sept. 1964), cover ill.; James G. Barber, *Andrew Jackson: A Portrait Study* (Washington, D.C., and Nashville, Tenn., 1991), pp. 125–127

Versions MARBLE Ursuline Convent Archives and Museum, New Orleans; Historical Society of Pennsylvania, Philadelphia; Maine Historical Society, Portland; George Washington National Masonic Temple, Alexandria, Va.; National Portrait Gallery, Washington, D.C.; Pink Palace Museum, Memphis, Tenn.

Gift of James H. Ricau and Museum Purchase, 86.458

ANDREW JACKSON (1767–1845) served as seventh president of the United States from 1829 to 1837 and continued the tradition of military hero turned statesman. He was the first president to come from modest origins, and his humble background shaped his egalitarian principles. This homespun character, coupled with his military accomplishments, contributed significantly to Jackson's enormous popularity, despite the political turbulence of his presidency. Neither handsome nor sophisticated in appearance, Jackson nevertheless projected an imposing bearing that generated enormous artistic appeal. Like George Washington, he was bedeviled by requests to sit for portraits, and consequently, Jackson ranks among the most depicted of American presidents.

The bust of Andrew Jackson in the Ricau Collection defied attribution until recent research unveiled Ferdinand Pettrich as the logical candidate for authorship.[1] Pettrich gained access to the president courtesy of Thomas Sully's (1783–1872) letter to Ralph E. W. Earl (ca. 1785–1858), who was Jackson's nephew by marriage and the president's artist-in-residence. Pettrich confirmed his acquaintance with Jackson in a letter to Bertel

Thorvaldsen (q.v.) written in July 1836.[2] The president felt some obligation to the German sculptor, since he had approved Pettrich's request to submit models for sculpture to adorn the east front of the Capitol.[3] When Pettrich's ideas were rejected, the then ex-president signed the sculptor's petition requesting compensation. Curiously, there is no known published reference to Pettrich's bust of President Jackson. This is especially puzzling given the publicity accorded his other busts of prominent citizens, and that at least seven replicas of Jackson were cut.

Jackson was seventy years old and in the final year of his presidency when Pettrich met him. Jackson's two terms had been marked by major external and internal struggles, including a near total breakdown of diplomatic relations with France, the removal of eastern Indian nations from their lands, and the heated controversy over the charter of the Bank of the United States. The resolution of these issues revealed Jackson as a man of shrewdness masked in simplicity. They pointed out his forthrightness, loyalty, and strength of conviction that precluded compromise. It was this combination of strength and obstinacy that elicited such fervent reactions to Jackson.

Pettrich encountered an individual who showed and felt his age and had no illusions about masking the truth, as befitted his direct nature. The young Hiram Powers (q.v.) had taken a likeness of Jackson the previous year (fig. 26), and in reply to the concern of one witness that the sculptor had been too faithful in his recording of the face, the president reassured the aspiring sculptor:

Make me as I am, Mr. Powers, and be true to nature always, and in everything.... I have no desire to *look* young as long as I *feel* old.... [T]he only object in making a bust is to get a representation of the man who sits, that it be nearly as possible a perfect likeness. If he has no teeth why then make him *with* teeth?[4]

It was this same frank vision that Pettrich brought to his interpretation.

Whether Pettrich saw Powers's effort is neither documented nor likely. Although Pettrich's portrayal shares the same attention to age through the emphasis on wrinkles and drawn features, the head in the Pettrich version is more oblong, the forehead more prominent, and the mouth more structured. In form and physiognomy, Pettrich's bust bears a stronger affinity to Luigi Persico's (1791–1860) likeness taken in 1829 (The Hermitage, Hermitage, Tenn.). The Italian presented his bust in 1834 to President Jackson, who put it on view in the White House, where

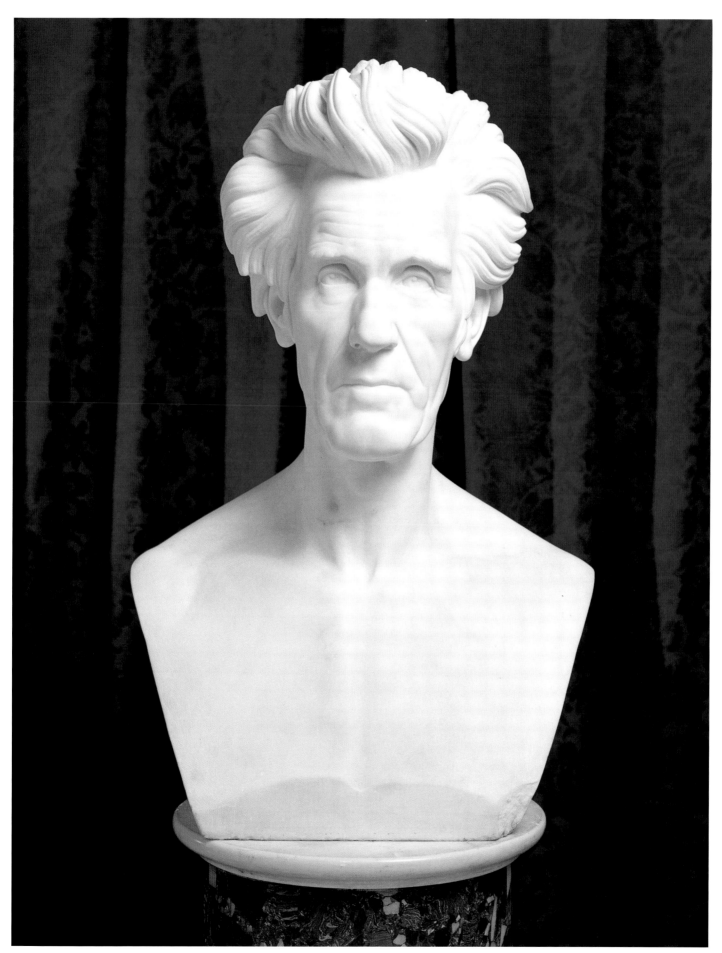

Cat. no. 5 Pettrich, *Andrew Jackson*

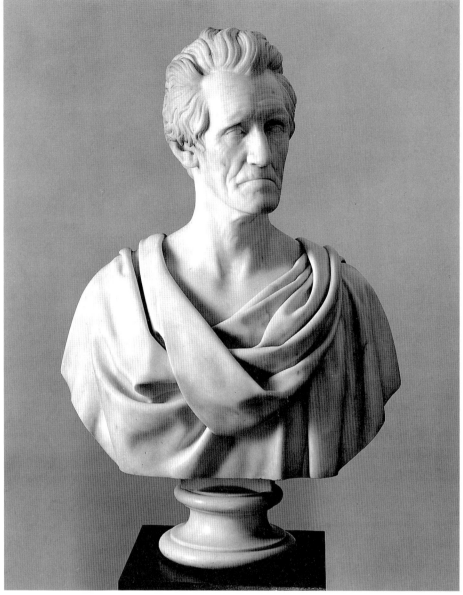

FIG. 26 Hiram Powers, *Andrew Jackson*, 1856. Marble, 34½ in. (87.6 cm) high. The Metropolitan Museum of Art, Gift of Mrs. Frances V. Nash, 1894 (94.14)

thought to be Aristotle, described the "leonine type" as having "deep-set eyes, a large eyebrow, square, square forehead, rather hollow from the center, overhanging towards the brow and nostril below the forehead like a cloud."[7] Jackson's deeds substantiated the power imparted by his visage, but Pettrich and his contemporaries enhanced this aura by subtly manipulating reality to convey an appropriate measure of heroism. Other compositional elements, such as the slight turn of the head and distant gaze, reinforce the intense yet quiet dignity befitting a legendary figure in the twilight of his career. Regardless of whether Jackson's stature as a great president has diminished in the revision of history, his place as an American hero seems secure. It is this heroic image that Ferdinand Pettrich, with his grounding in the ideals and achievements of antiquity, brought to his sculpted interpretation with such emphatic vigor.

Notes

1. Barber, *Andrew Jackson: A Portrait Study* (1991), pp. 125–127.

2. Pettrich, Washington, D.C., to Bertel Thorvaldsen, July 20, 1856, Thorvaldsen Museum Archive, Copenhagen, Denmark.

3. R. L. Stehle, "Ferdinand Pettrich in America," *Pennsylvania History* 33 (Oct. 1966), p. 397.

4. Albert Ten Eyck Gardner, "Hiram Powers and 'The Hero,'" *Metropolitan Museum of Art Bulletin* 2 (Oct. 1943), p. 106.

5. Barber, *Andrew Jackson: A Portrait Study*, p. 106.

6. See John S. Crawford, "Physiognomy in Classical and American Portrait Busts," *American Art Journal* 9 (May 1977), 49–60.

7. Ibid., p. 59, quotes from "Aristotle," *Physiognomics*, 5.809b. 14–21.

Pettrich could have seen it.[5] In emulation of Persico, Pettrich chiseled the pupils into the eyes to convey a greater sense of immediacy. While this detail differs from that of the American sculptor, the hair and hairstyle employed by Pettrich are closer to Powers's. Pettrich opted for a billowing look in the way the hair is combed back with strands deeply chiseled to make the hair seem stiff and wiry. The hair in the Persico and Pettrich's original version (Ursuline Convent Archives and Museum, New Orleans) is carved to appear more slicked back with a softer and finer texture. The deep chiseling of the hair creates bolder contrasts of light and shadow and enhances the dramatic presence of the bust.

All three sculptors shared a similar objectivity in rendering the elder statesman's features and emphasized his wrinkles, sunken cheeks, pursed lips, and deep-set eyes. These concerns reflected the current interest in the science of physiognomy that captivated many Americans.[6] In the case of Powers, it augmented his deep commitment to phrenological studies. The study of physiognomy emanated from classical Greek thought and espoused the idea that character was revealed through physical aspects of the body. Artistically, the close scrutiny of facial characteristics permitted sculptors to associate their work with Greek and Roman portraiture, and Jackson's features bore a marked resemblance to portraiture of the Roman republic. Persico's and Pettrich's examples reflect a close connection to an ancient treatise on physiognomy in which the author, for a long time

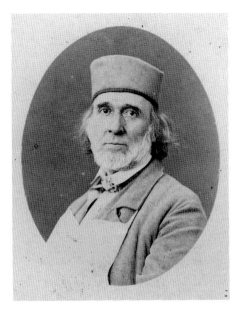

Hiram Powers. Photograph courtesy of the Archives of American Art, Smithsonian Institution

Hiram Powers
American, 1805–1873

Hiram Powers was instrumental in extending America's sculptural art beyond the confines of portraiture and in promoting a serious commitment to works of ideal and literary inspiration. He enjoyed enormous commercial success and artistic admiration, which contributed to the great respect accorded the sculptural profession. Powers's success also fostered jealous detractors, and his manner with regard to divergent artistic opinion was less than conciliatory. Nathaniel Hawthorne offered the following insight into the sculptor's contentiousness: "Powers has had many difficulties on professional grounds . . . and with his brother artists. No wonder! He has said enough in my hearing to put him at swords' points with sculptors of every epoch and every degree between the two inclusive extremes of Phidias and Clark Mills."[1] Yet Powers, ever mindful of the help he received at the outset of his career, was always glad to assist and counsel new arrivals in Florence, where he spent most of his life. Despite Powers's fractious nature, few could deny the significant impact he had on the course of American sculpture in the mid-nineteenth century.

Powers's early life was filled with hardship and isolation, which did not augur his eventual profession. He was born in Woodstock, Vermont, to a struggling farm family. By the time Hiram was thirteen, financial reverses prompted the family to move to Ohio. Misfortune struck the fol-

lowing year when Powers's father succumbed to malaria. In addition to a sense of responsibility, Hiram's legacy from his father was practicality and mechanical aptitude, for he had instilled in his son appreciation of craftsmanship and the highest standards of excellence. Young Hiram manifested an innate talent as he transformed discarded tools into a variety of mechanical apparatuses.

His father's death forced Powers to leave home and look for a job in Cincinnati, which was fast becoming a major economic and cultural center. He worked at a variety of menial jobs, including a stint in a produce store, where he secretly molded butter into animal forms. Subsequent employment in a clock and organ factory unveiled Powers's creative talents. He impressed his employer, Luman Watson, with his ability for technical concerns and mechanical invention. Watson encouraged him to develop these skills, which led to Powers's informal instruction in drawing and modeling from the recently arrived Prussian sculptor Frederick Eckstein (1775–1852).

Powers soon modeled his first portrait bust in relief of Aaron H. Corwine (BMFA), a painter who died prematurely of tuberculosis.[2] Carved in beeswax, this delicate relief caught the attention of Cincinnati citizens, particularly Joseph Dorfeuille who operated the Western Museum, a center of diverse amusements. Dorfeuille hired Powers around 1826 to repair wax effigies of fictional and historical characters as well as create new displays. During his tenure Powers and the Englishwoman Frances Trollope, the future author of American manners who resided for a time in Cincinnati, devised a mechanical tableau vivant, the *Infernal Regions* based on Dante. Complete with sound and smoke, this exhibit achieved great renown for its lurid ambience and convincing depiction of flesh. The favorable reception resulted in orders for some portraits, including Powers's first bust modeled in the round, a likeness of fellow student and painter Miner K. Kellogg (1814–1889, CAM). Powers's work attracted the attention of Nicholas Longworth, a leading Cincinnati businessman and devoted art patron.

Longworth immediately recognized Powers's potential and offered to finance a trip to Italy. Powers declined, not wishing to assume such an obligation at that point in his life; but five years later, in 1834, he prevailed on Longworth to facilitate a trip to the East Coast in search of commissions. Longworth provided Powers with money and letters of introduction to many influential politicians. Consequently,

Powers gained audiences with several of the country's leading figures, including President Andrew Jackson, whose head he modeled in 1835 (fig. 26). This penetrating image of the aged warrior did not spare wrinkles or other manifestations of age and ran contrary to the prevailing taste for more idealized likenesses. Other luminaries, such as John Quincy Adams and Daniel Webster, were impressed with the sculptor's faithful reportage and willingly consented to sit for him. Powers was sought after for his ability to avoid the stereotypic, mechanical recording of features that was the standard of contemporary portraiture. Instead, he probed the character and fused this with a painstaking attention to detail. Powers was a devoted student of phrenology, the study of the cranium to evaluate character. He also was committed to Swedenborgianism, with its belief in the existence of an otherworldly realm corresponding to this earthly one. These two beliefs heightened Powers's interest in the conflation of the material and the spiritual.[3] Thus, Powers brought an elevated interpretation to his portraits.

The ensuing two years took Powers to Philadelphia, Boston, and New York, where positive response to his work convinced him that a foreign journey would solidify his abilities. With the support of Longworth and a new admirer, Colonel John S. Preston of South Carolina, Powers sailed for Italy in the fall of 1837 with his wife and two young sons, never to return to his homeland. Possibly his acquaintance with Horatio Greenough (1805–1872) in Washington the previous year persuaded Powers to settle in Florence, where the cosmopolitan Bostonian facilitated his arrival. From the outset, Powers sought to transcend a reliance on portraiture as his means of support, and he began fashioning ideal busts such as *Ginevra*, modeled in 1837–58 (CAM), and the initial version of *Proserpine*, commenced in 1841 (PMA), which became his most popular work (cat. no. 6). Inspired by the works he saw around him, Powers quickly embarked in 1839 on a full-length interpretation of Eve Tempted (NMAA). He later presented the sculpture to Colonel Preston.[4] The eminent Danish sculptor Bertel Thorvaldsen (q.v.) enthusiastically praised the work. Powers's subsequent appointment to a teaching professorship at the Academy of Fine Arts further confirmed his growing international stature. This recognition was a major accomplishment for someone so new to the profession.

Powers, ever the pragmatist, soon learned the strategies for running a studio and engaged local talent to help cut mar-

ble. He had cut enough on his own to realize how uneconomical it was, but the experience helped him determine exactly what he desired in terms of surface finish and detail. Powers devoted significant time and patience to training his assistants, who numbered as many as nine when the studio was in full production. To improve efficiency Powers developed tools for modeling directly in plaster. This invention obviated the initial step in the clay method that traditionally moved from model to plaster cast to marble replica. It also eliminated inevitable modifications of the preliminary casting process. Although Powers patented his ideas and some colleagues used them, his technique never gained the popularity he envisioned. Nevertheless, improved technology and capable management enabled Powers's operation to become a virtual factory, accommodating the unrelenting demand for portraits and idealized female busts. The Ricau Collection possesses ten separate but closely related examples of Powers's ideal sculpture.

The work that vaulted Powers into international prominence was his *Greek Slave,* conceived in 1841 and first cut into marble in 1844 (Raby Castle, England). In addition to the replicas that came out of Powers's studio, the statue achieved widespread recognition through reproduction in various media, as well as pirated replicas by unauthorized workshops (cat. no. 18). Its popularity was a result of clever marketing of a potentially controversial work with a morally appropriate message. The fame that *The Greek Slave* brought Powers ensured that he would never lack commissions.

In both the full-length statue and the more affordable ideal bust, Powers established a consistently graceful sense of form and refined delicacy of surface that distinguished his work from that of his contemporaries. These characteristics sustained an unabated appeal that kept Powers's studio operating well after his death. Such major works as *The Fisher Boy,* modeled 1841–44 and carved 1859–60 (fig. 30), *America* of 1855 (marble destroyed by fire in 1865; plaster model, NMAA), *California* of 1858 (MMA), and *Eve Disconsolate* of 1859–71 (The Hudson River Museum, Yonkers, N.Y.) spanned the sculptor's prolific career and garnered him a constant outpouring of critical admiration. For logistical and financial reasons, Powers created relatively few full-length works, and he invariably extrapolated busts from these more ambitious projects.

In addition to his emphasis on profit, Powers articulated a profound theoretical

program. At the midpoint of his career in Italy, Powers wrote Elizabeth Barrett Browning, a member of the Anglo-Florentine literary circle, that "the legitimate aim of art should be spiritual and not animal," and that "the nude statue should be an unveiled soul."[5] This comment encapsulated the complex relationship between the real and the ideal in the sculptor's artistic and personal ideology. Matter was perceived with unflinching objectivity but was commingled with a zealous belief in mystical Swedenborgian principles and other speculative phenomena. Powers embraced the Swedenborgian idea that nature, in all its manifestations, was but a conduit to a higher order of meaning. While he believed that portraiture was a biography to which the artist could not graft invented episodes, he probed character to elucidate the spiritual facet. Powers's grasp of phrenology served this dual purpose by considering scientific and spiritual elements. This discipline flourished in an era of social reform in America, and cranial analysis was thought to contribute to physical and moral improvement, which could ultimately lead to salvation.

Technical considerations played a central role in Powers's work. He popularized Seravezza marble, which he considered superior in quality to the more prevalent Carrara marble quarried nearby. The sculptor believed the less-flawed Seravezza stone conveyed a purer image, which resulted in a more righteous spirituality.

Commensurate with his ambition, Powers was unabashedly immodest and opinionated. His only professional disappointment was the lack of a major government commission. Powers brought this on himself, however, since he believed his high status relieved him of the indignity of submitting to an open competition. Powers did create statues of Benjamin Franklin and Thomas Jefferson for the Statuary Hall in the United States Capitol, but these were just two of many of the major figures in America's relatively brief political history to be remembered in this way.

In addition to an insufferably high opinion of his talent, Powers made some controversial artistic pronouncements. His ambivalence about one of the acclaimed paragons of artistic expression in the Uffizi Gallery in Florence, the *Venus de Medici,* astounded many, yet his thoughts were not devoid of merit. Powers objected principally to the treatment of the head and face, which he considered diminutive and insipid. In phrenological terms he complained that Venus possessed a cranium that would render her incapable of

even basic intelligence.[6] Not only did he question the antique canon of proportion, but he voiced his objection to the demeaning of women's intelligence.

Despite his expatriation, Powers remained staunchly American. He kept abreast of current events in his native land and maintained a prodigious correspondence on a broad range of topics. He and his family learned only enough Italian to obtain the necessities of life and to communicate with craftsmen. Although Powers often contemplated a voyage home, he never made one. He did not think he could leave the studio for such a long time, and he was convinced that if he went home, his wife, who was never entirely happy in Italy, would refuse to return. The compelling reason Powers went to Italy was for his profession, for there he had access to live models, anatomical study, and affordable workmen.[7] Powers undoubtedly realized he could never achieve the material success in the United States that he had in Florence. Although he settled in a country that could be so spiritually seductive, his reasons for staying were practical and pecuniary.

Hiram Powers could reflect on the success of his career as he lived out his final four years in the impressive villa and studio he had built on the outskirts of Florence. With the exception of *The Last of the Tribes* (NMAA), his final major undertaking, and the steady influx of portrait commissions, Powers let his sons administer the studio in executing orders for existing works. His failing health prevented him from pursuing his craft with the vigor of the previous three decades. When Powers died in June 1873, the press in America and Europe extolled his long and successful career. Even then the winds of change were blowing. Powers's sculpture—what it stood for and how it was created—was rapidly being supplanted by new ideas and artistic attitudes emerging in Paris.

Notes

1. Hawthorne 1858, p. 306. The best starting point for information on Powers is Wunder 1991.

2. See Jan Seidler Ramirez, "Aaron Houghton Corwine," in BMFA 1986, pp. 30–31.

3. See Colbert, "Phrenology and Powers" (1986), and Reynolds 1977, passim, for discussions of Powers's connection to these two popular nineteenth-century phenomena.

4. Wunder 1991, 2:139–144. The original version is presently unlocated, but a replica is in the National Museum of American Art, Washington, D.C.

5. Powers to Elizabeth Barrett Browning, Aug. 7, 1853, Powers papers, AAA, roll 1136, frames 850–851. Originally cited in Reynolds, "Powers's Embodiment of the Ideal" (1977), p. 394.

6. Colbert, "Powers and Phrenology," pp. 288–289.

7. Bellows, "Seven Sittings with Powers" (1869), pp. 470–471.

Bibliography

R. H. W., "Powers, the Sculptor," *Knickerbocker* 18 (Dec. 1841), 525–528; Lester 1845, 1:1–154; Charles E. Lester, "The Genius and Sculptures of Hiram Powers," *American Whig Review* 2 (Aug. 1845), 199–204; Calvert 1846, pp. 88–96; Edward Everett, "Hiram Powers, the Sculptor," *Littell's Living Age* 15 (1847), 97–100; "Hiram Powers," *United States Magazine and Democratic Review* 14 (Feb. 1844), 202–206; Henry T. Tuckerman, *Italian Sketch Book* (New York, 1848), pp. 262–264; Taylor 1848, pp. 331–335, 360; "Powers and Clevenger," *Bulletin of the American Art-Union*, July 1850, p. 65; Horace Greeley, *Glances at Europe* (New York, 1851), pp. 216–217; Andrew MacFarland, *The Escape* (Boston, 1851), pp. 182–183; "Letter from Florence," *Bulletin of the American Art-Union*, Apr. 1851, pp. 12–13; "The *Eve* by Hiram Powers," *Bulletin of the American Art-Union*, Nov. 1851, pp. 152–153; W. S., "Old Habits. Extract of a Letter from an American Residing Temporarily in Florence," *Daily National Intelligencer* (Washington, D.C.), Feb. 20, 1852, p. 1; Benjamin Silliman, *A Visit to Europe in 1851*, 2 vols. (New York, 1853), 1:91; Hillard 1853, 1:178–181; Hiram Powers, "Letter from Hiram Powers—The New Method of Modeling in Plaster for Sculpture," *Putnam's Monthly Magazine* 2 (Aug. 1853), 154–155; Lee 1854, 2:146–153; Greenwood 1854, pp. 358–359; Samuel Y. Atlee, "Hiram Powers, the Sculptor," *Littell's Living Age*, 2d ser., 42 (1854), 566–571; "Hiram Powers," *Littell's Living Age* 44 (Jan.–Mar. 1855), 703–704; Athenaeum, "Powers on Color," *Crayon* 1 (Mar. 1855), 149; Hiram Powers, "The Perception of Likeness," *Crayon* 1 (Apr. 11, 1855), 229–230; Anna Lewis, "Art and Artists of America: Hiram Powers," *Graham's Magazine* 46 (Nov. 1855), 397–401; Fuller 1856, pp. 231–232; Fuller 1859, pp. 260–262; Hawthorne 1858, pp. 271–275, 285–288, 302–317, 332–335, 362–365, 426–432, 482–483; "Sketchings. Domestic Art Gossip," *Crayon* 6 (July 1859), 220–221; Benjamin Paul Akers, "Our Artists in Italy: Hiram Powers," *Atlantic Monthly* 5 (Jan. 1860), 1–6; Jarves 1864, pp. 275–277; Katherine C. Walker, "American Studios in Rome and Florence," *Harper's New Monthly Magazine* 33 (June 1866), 104–105; Tuckerman 1867, pp. 276–294; C. S. Robinson, "A Morning with Hiram Powers," *Hours at Home* 6 (Nov. 1867), 52–57; Katherine Walker, "American Sculptors in Florence," *New-York Daily Tribune*, Apr. 23, 1868, p. 4; "A Sculptor's 'Finishing' Process," *New-York Evening Post*, May 7, 1868, p. 1; "Hiram Powers," *Eclectic Magazine* 71 (Aug. 1868), 1028–1029; Henry W. Bellows, "Seven Sittings with Powers, the Sculptor," *Appleton's Journal of Literature, Science, and Art* 1 (1869), 342–343, 359–361, 402–404, 470–471, 595–597, and 2 (1870), 54–55, 106–108; Samuel Osgood, "American Artists in Italy," *Harper's New Monthly Magazine* 41 (Aug. 1870), 420–425; "Hiram Powers, Obituary," *Art Journal* (London), n.s., 12, 35 (Aug. 1873), 231; "ART. Hiram Powers," *Aldine* 6 (Sept. 1873), 187; "The Studio of Hiram Powers since His Death," *San Francisco Daily Evening Bulletin*, Nov. 6, 1873, p. 4; James J. Jarves, "Pen-Likenesses of Art-Critics and Artists: Hiram Powers, and His Works," *Art Journal* (London), n.s., 13, 36 (1874), 37–39; Thomas A. Trollope, "Some Recollections of Hiram Powers," *Lippincott's Magazine* 15 (Feb. 1875), 205–215; Clark 1878, pp. 45–50; Samuel G. W. Benjamin, "Sculpture in America," *Harper's New Monthly Magazine* 57 (Apr. 1879), 659–662; Benjamin 1880, p. 158; Ball 1891, pp. 172–173, 200–202; Waters and Hutton 1894, 2:189–190; Henry Boynton, "Hiram Powers," *New England Magazine*, n.s., 20 (July 1899), 519–533; Taft 1924, pp. 57–71; Samuel Bassett, "Hiram Powers," in *Vermonters: A Book of Biographies*, ed. Walter H. Crockett (Brattleboro, Vt., 1931), pp. 173–176; Paul B. Metzler, "The Sculpture of Hiram Powers" (M.A. thesis, Ohio State University, 1939); Albert Ten Eyck Gardner, "Hiram Powers and William Rimmer, Two Nineteenth-Century American Sculptors," *Magazine of Art* 36 (Feb. 1943), 42–47; id., "Hiram Powers and 'The Hero,'" *Metropolitan Museum of Art Bulletin* 2 (Oct. 1943), 102–108; Gardner 1945, pp. 27–32; Edward H. Dwight, "Art in Early Cincinnati," *Cincinnati Art Museum Bulletin*, n.s., 3 (Aug. 1953), 3–11; Thomas B. Brumbaugh, "A New Letter of Hiram Powers," *Ohio Historical Quarterly* 65 (Oct. 1956), 399–402; Everard M. Upjohn, "A Minor Poet Meets Hiram Powers," *Art Bulletin* 42 (Mar. 1960), 65–66; Margaret F. Thorp, "Rediscovery. A Lost Chapter in the History of Nineteenth-Century Taste: The Nude and the *Greek Slave*," *Art in America* 40, no. 2 (1961), 46–47; Thorp 1965, pp. 70–78; Craven 1984, pp. 111–123; Crane 1972, pp. 169–272; Richard P. Wunder, "The Irascible Hiram Powers," *American Art Journal* 4 (Nov. 1972), 10–15; id., *Hiram Powers, Vermont Sculptor* (Woodstock, Vt., 1974); Linda Hyman, "*The Greek Slave* by Hiram Powers: High Art as Popular Culture," *Art Journal* 25 (Spring 1976), 216–223; Reynolds 1977; Donald Reynolds, "*The Unveiled Soul:* Hiram Powers and the Embodiment of the Ideal," *Art Bulletin* 59 (Sept. 1977), 394–414; Soria 1982, pp. 253–254; Vivien M. Greene, "Hiram Powers's *Greek Slave*, Emblem of Freedom," *American Art Journal* 14 (Autumn 1982), 31–39; Hyland 1985, pp. 185–247; Jan Seidler Ramirez, "Powers," in BMFA 1986, pp. 27–40; Charles Colbert, "*Each Little Hillock Hath a Tongue:* Phrenology and the Art of Hiram Powers," *Art Bulletin* 68 (June 1986), 281–300; Headley 1988, pp. 142–253; Janet A. Headley, "The (Non) Literary Sculpture of Hiram Powers," *Nineteenth-Century Studies* 4 (1990), 23–39; Wunder 1991; Fryd 1992, pp. 204–208; Giuliana A. Treves, *The Golden Ring: The Anglo-Florentines, 1847–1862* (London, n.d.), pp. 152–155

6
Proserpine

Second version
Modeled ca. 1844–49
Marble
21 × 14⅞ × 9 in. (53.3 × 37.8 × 22.9 cm)
Inscribed at rear: *H. Powers / Sculp.*

Provenance James H. Ricau, Piermont, N.Y.

Exhibition History *The Ricau Collection,* The Chrysler Museum, Feb. 26–Apr. 23, 1989

Literature Lester 1845, 1:16–17; "The Fine Arts," *Home Journal*, July 28, 1849, p. 2; "Exhibition of Powers's Works," *Literary World* 5 (Oct. 13, 1849), 318; Horace Greeley, *Glances at Europe* (New York, 1851), pp. 216–217; "Letter from Florence," *Bulletin of the American Art-Union*, Apr. 1851, pp. 12–13; "Personal," *Home Journal*, May 12, 1855, p. 2; "Philadelphia Art Notes," *Round Table* 1 (June 4, 1864), 392; Tuckerman 1867, pp. 282, 286; "Sculptors and Sculpture," *New-York Evening Post*, Feb. 23, 1872, p. 1; "Closing Sale of Mr. Morgan's Paintings and Statuary," *New-York Evening Post*, Jan. 28, 1876, p. 4; Clark 1878, p. 50; Gardner 1945, pp. 12, 15; Crane 1972, pp. 188, 192, 199; Gerdts 1973, pp. 51, 52, 92–93; Reynolds 1977, pp. 1070–1076; Wilmerding et al. 1981, pp. 46, 158–159; Susan Menconi, *From the Studio: Selections of American Sculpture, 1811–1941*, exh. cat., Hirschl & Adler (New York, 1986), pp. 10–11; Headley 1988, pp. 164–165, 173–174, 186–197, 246–247; Wunder 1991, 2:187–204, as no. 106 of 2d version

Versions The subject was to become Powers's most popular ideal bust and was offered in life-size and two-thirds life-size versions. The final number probably exceeds 150 replicas; see Wunder 1991, 2:189–202

Gift of James H. Ricau and Museum purchase, 86.505

ALTHOUGH full-length works generated the most prestige for any sculptor, they appealed to a relatively narrow market because of size and expense. Ever the businessman, Hiram Powers quickly realized that many potential patrons lacked the money or space for large ideal pieces such as *The Greek Slave* (fig. 13). For them, he offered compositions in a more convenient bust-length size. The Ricau Collection contains several examples of these truncated versions of full-length sculptures: *The Fisher Boy, America, California,* and *Eve Disconsolate* (cat. nos. 7, 8, 11, 12).

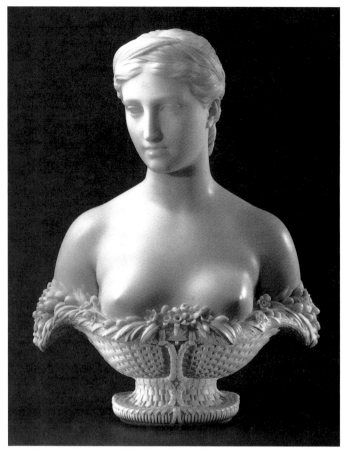

FIG. 27 Hiram Powers, *Proserpine*, 1843 (first version). Marble, 24½ in. (62.2 cm) high. Philadelphia Museum of Art, Gift of Mr. and Mrs. F. Woodson Hancock in memory of Edward Carey Gardner, 1978-18-1a. Photograph by Graydon Wood, 1994

FIG. 28 Powers, *Proserpine,* detail of hair

Powers also envisioned the ideal bust to stand as an independent work, and one of the sculptor's earliest efforts in this genre was *Proserpine.* He conceived it to complement *Ginevra* (CAM), completed in 1838 and presented to his patron, Nicholas Longworth.[1] The sculptor commenced *Proserpine* soon after completing the model of *Ginevra* and wrote Longworth on November 5, 1838, about the new work, describing it as "a female head with a wreath of wheat in bloom crowning her hair, with acanthus leaves, emblem of immortality, around her waist."[2] Powers dropped the idea until 1840, when the Philadelphia publisher and art collector Edward L. Carey approached him about creating an original work. Powers's preoccupation with *The Greek Slave* and *The Fisher Boy* further deflected attention from this proposal until April 1843. Finally devoting himself to the task, Powers had nearly finished the model by mid-May when he decided to name the piece *Proserpine.* Presumably, his original conceit of 1838 did not reassert itself until the model was sufficiently well advanced.

The initial replica (fig. 27) revealed Proserpine emerging from a woven wicker basket filled with spring flowers, but Powers quickly recognized how labor-intensive this would be for his assistants and revised the design so the bust rose out of a bed of acanthus leaves. By 1849 orders for the work stretched his studio capacity to its limits, and the sculptor modified the termination to an uncomplicated fringe. Displaying his shrewd knack for marketing, Powers claimed to prefer this third version, since it revealed more of the figure and simplified the visual effect.[3]

Proserpine, in all its permutations, became his most popular work. Over the course of his career, Powers and his studio assistants executed more than 150 replicas.[4] These ideal busts were available in two sizes: life-size and two-thirds life-size. The Ricau replica is one of the reduced versions of the acanthus-leaf type. Given Powers's enormous output, it is impossible to connect the Museum's bust to an original order. Ricau recalled acquiring it at auction in 1957, making it one of his earliest purchases.[5]

Proserpine set a standard for Powers's ideal busts. The cool, detached expression emanates from graceful and exquisitely refined facial features. There is a sense of an underlying anatomical structure, which helps anchor the piece in the world of the living. The surface treatment of the marble denies its properties as stone and emits a convincing illusion of flesh. Sheaves of wheat encircle the head, creating a vegetal tiara. Delicate, wispy hair is pulled back into a loop fastened by a ribbon, and several ringlets fall onto the nape of the neck (fig. 28). Here, too, the sculptor has infused the classically derived hairstyle with verisimilitude, and the viewer continues to vacillate between perceptions of the ideal and the real. In addition to fulfilling a symbolic function, the acanthus-leaf border mitigates the abrupt terminus of the bust form. In his oeuvre of ideal busts Powers evolved a generic core that he could alter through subtle shifts in pose, expression, and attribute.

Despite his rudimentary education, Powers was familiar with classical literature. His correspondence contains a detailed explanation of the story of Proserpine taken from ancient Roman mythology.[6] According to the legend, the goddess Proserpine was the daughter of Jupiter and Ceres. She was carried off to the underworld by Pluto, who wed her

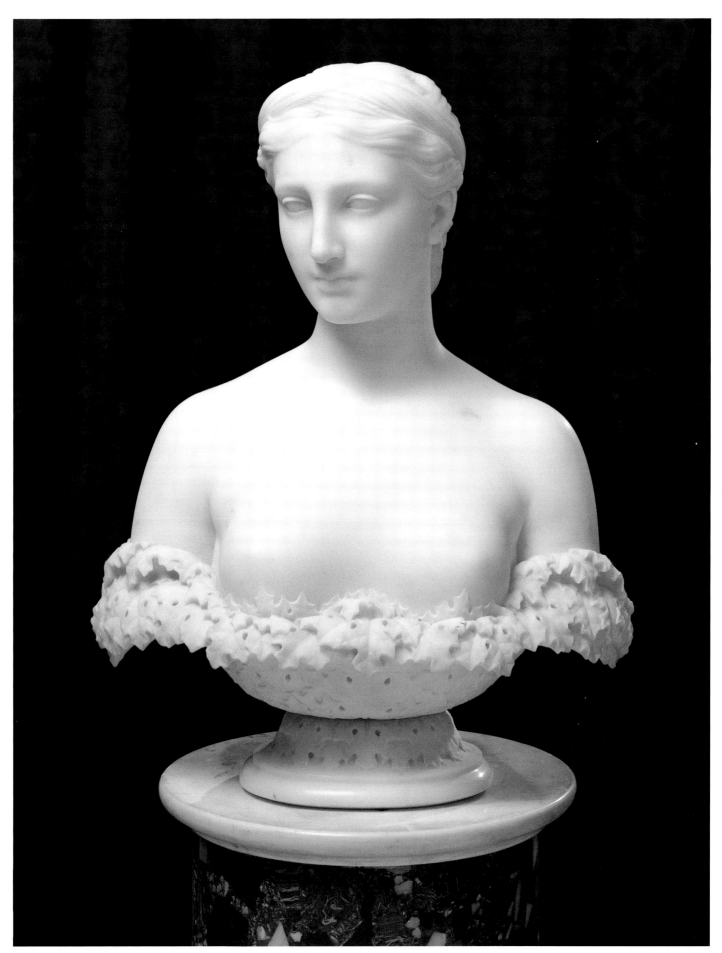

Cat. no. 6 Powers, *Proserpine*

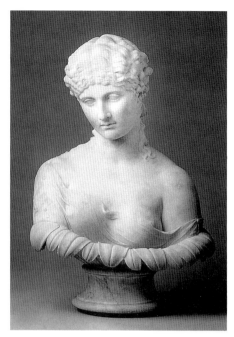

and made her rule alongside him in Hades. Proserpine could return to the upper earth for only a part of each year, and her visit marked the advent of spring. The crown of wheat in Proserpine's hair alludes to her mother, Ceres, the goddess of agriculture. The acanthus leaves that ring her torso—a decorative innovation devised by Powers to soften the truncation of the figure's arms and chest—symbolize her immortality through her ability to escape the kingdom of death each year and return to the world of the living.

To modify *Proserpine*'s base of ornate basket filled with flowers, Powers found his solution in a drawing of the famous Greco-Roman bust of the so-called *Clytie* in the British Museum (fig. 29).[7] This bust, which also influenced William Henry Rinehart's masterful *Clytie* (cat. no. 50), possessed an acanthus-leaf border that Powers immediately appropriated. Although the choice of border was fueled by economic considerations, the question arises whether there was an iconographic deviation. Did the initial profusion of flowers allude to an optimistic yet ephemeral connection with spring and rebirth? And did the subsequent acanthus-leaf motif suggest regenerative immortality shrouded in the specter of death? Although Powers was mute on this matter, his use of symbolism anticipated a shift in his attitude toward the use of literature.[8]

Powers's initial attempt at an ideal bust, *Ginevra*, revealed his dependence on a specific literary source, Samuel Rogers's

poem "Italy" (1822), yet for *Proserpine*, the sculptor adopted a myth with broader appeal. The story of Proserpine had wide currency in contemporary romantic literature, which included treatment by both the Shelleys, Benjamin Disraeli, and Walter Savage Landor, among others. This compelling story of magical regeneration held enormous fascination for Victorian audiences, which undoubtedly accounted for the bust's phenomenal popularity. Because of a fortuitous literary association, Powers's *Proserpine* enjoyed unparalleled success.

Notes

1. Though finished in 1838, the replica was not cut until 1841 and delivered to Longworth the following year. See Wunder 1991, 2:154.

2. Powers to Nicholas Longworth, Nov. 5, 1858, Powers papers, Cincinnati Historical Society. Originally cited in Crane 1972, p. 192.

3. Powers to Horace Greeley, July 28, 1852, Powers papers, AAA, roll 1136, frame 97.

4. Wunder 1991, 2:187–204, provides the most exhaustive accounting of this output.

5. This information was supplied in an interview with James H. Ricau on Oct. 4, 1990, at Piermont, N.Y. Wunder indicates that this replica, which includes the acanthus-leaf border, may be the one sold at the sale of Edward Hurburt Litchfield's collection at Parke-Bernet, New York, June 8, 1951, lot 125: Wunder 1991, 2:199. Thus, Ricau may have bought it even earlier than he recalled.

6. Unidentified correspondence cited in Wunder 1991, 2:189.

7. Headley 1988, pp. 188–191, first explored this idea.

8. Ibid., pp. 192–196.

7
Bust of the Fisher Boy
Modeled ca. 1849
Marble
21⅞ × 14¾ × 9⅜ in. (55.6 × 37.5 × 23.8 cm)
Inscribed at rear: *H. Powers / Sculpt.*

Provenance James H. Ricau, Piermont, N.Y.

Exhibition History *The Ricau Collection,* The Chrysler Museum, Feb. 26–Apr. 23, 1989

Literature Gardner 1965, pp. 4–5; Gerdts 1973, pp. 56–57; Reynolds 1977, p. 1080; Headley 1988, pp. 210–215, 227; Wunder 1991, 2:148–149

Versions MARBLE (life-size) Cincinnati Art Museum; MARBLE (two-thirds life-size) Nicholas Smith, Brooklyn, N.Y.; Mr. and Mrs. Donald Webster, Washington, D.C.; MARBLE (19-in. version) [Hirschl & Adler Galleries, New York]

Gift of James H. Ricau and Museum Purchase, 86.506

IN American sculpture, the depiction of the male nude is much rarer than that of the female nude. The full-length version of *The Fisher Boy* was unique in Hiram Powers's oeuvre (fig. 30). He commenced modeling the statue by January 1841, but work was interrupted when the sculptor directed his full attention to *The Greek Slave* (fig. 13). Consequently, the model was not finished until 1844 and the first replica not delivered until 1846. Powers discussed the work as early as 1845 and dwelled on it in the context of appropriate subject matter:

It is a difficult thing to find a subject of modern times whose history and peculiarities will justify entire nudity—but where the subject and its

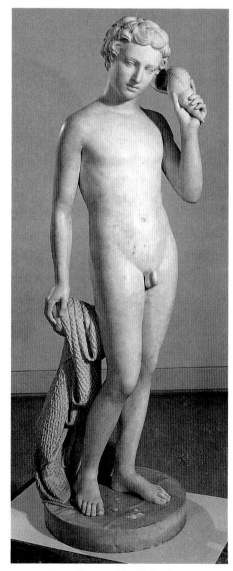

FIG. 30 Hiram Powers, *The Fisher Boy,* carved 1859–60. Marble, 58 in. (147.3 cm) high. Virginia Museum of Fine Arts, Richmond. Lent by Miss Jane Carey Thompson and Miss Sarah Alston Thompson

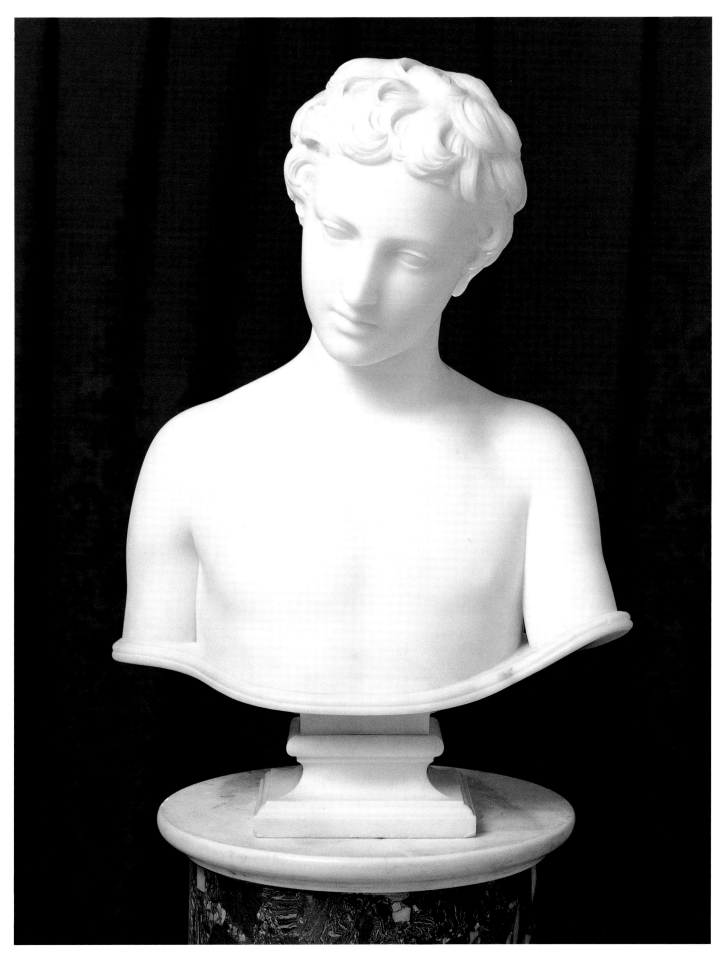

Cat. no. 7 Powers, *Bust of the Fisher Boy*

history make this necessary, it may be looked upon with less reserve than it could be if exposure were intentional on the part of the artist.... It was not my object for interest's sake to set before my countrymen demoralizing subjects, and thus get even my bread at the expense of public chastity.... I have endeavoured in these two statues to avoid anything that could either by form or import offend the purest mind.... This figure [*The Fisher Boy*] is a kind of Apollino, but the character is modern; for I hold that artists should do honor to their own religion, instead of going back to mythology to illustrate, for the thousandth time, the incongruous absurdities and inconsistencies of idolatrous times, especially as our times and our religion are full of subjects equal in beauty, and have all qualities necessary to a full development of art.[1]

In the wake of the unprecedented success of *The Greek Slave*, *The Fisher Boy*, with its allegorical content based on the innocence of youth, resonated with a less charged emotional message. Yet it, too, touched a sympathetic nerve and enjoyed some commercial popularity, with six replicas ordered by such influential patrons as Sidney Brooks, Hamilton Fish, and Prince Anatole Demidoff of Russia.

Inspiration for *The Fisher Boy* may have been literary, and Powers himself alluded to works of John Dryden and William Wordsworth.[2] Powers's statue stands at the midpoint between the two best-known interpretations of the subject, those of François Rude (1784–1855), exhibited in 1831, and Jean-Baptiste Carpeaux (1827–1875), first shown in 1858. Rude's depiction of a naked boy sitting by the shore playing with a small tortoise was pivotal in challenging the neoclassical idea of acceptable subject matter.[3] The French sculptor was castigated not only for the imagery but also for basing his figure too directly on nature and suppressing any ideal canon of beauty. The modernity of the subject matter had great importance for Powers.

The pose of Powers's *Fisher Boy* recalls several prototypes, ranging from the antique *Germanicus* to the mannerist *Ganymede* by Benvenuto Cellini.[4] The *Hermes* of Praxiteles, known through copies, should not be ignored; similar are the stance and the soft, effeminate rendering of the flesh. This sexual ambivalence was consistent with the sculptor's objectives regarding a model, since in 1842 he noted finding a good hermaphrodite boy, though it is not clear whether the model was specifically intended for *The Fisher Boy*.[5] Nevertheless, Powers infused an element of androgyny into the finished work. The delicately chiseled facial features and the tousled locks create an aura of vulnerability that is reinforced by the tentative turn and tilt of the head. No doubt by

design, this work possessed none of the vigor or assertiveness of most of Powers's ideal female heads.

To adapt the bust of *The Fisher Boy* from the full-length sculpture, Powers eliminated the upraised left hand, which held a conch shell to the left ear. As a result, this head, devoid of attribute, became the most generic of his extrapolations. The sculpture was modestly successful by Powers's standards, with at least seventeen replicas ordered.[6] Available in life-size and two-thirds life-size replicas and in a nineteen-inch version, *The Fisher Boy* offered the choice of full shoulders and upper arms or a more truncated, inexpensive variant. Decorative banding across the base was also an option. The Ricau replica is of the two-thirds-size variety with full shoulders and banding. Unfortunately, nothing is known of its early ownership.

Notes

1. Lester 1845, 1:85–90.
2. Ibid., p. 89.
3. Janson 1985, pp. 111–112.
4. Headley 1988, p. 212, suggests the *Germanicus*, which would have been well known through prints, and Reynolds 1977, p. 1080, offers Cellini's hermaphroditic *Ganymede* in the Bargello in Florence as a plausible source.
5. Reynolds 1977, p. 143, refers to the sculptor's studio memorandum of Feb. 26, 1842.
6. Wunder 1991, 2:148–149.

8
Bust of America

Modeled ca. 1850–54
Marble
27¾ × 17⅞ × 12⅝ in. (70.5 × 45.4 × 32.1 cm)
Inscribed at rear: *H. Powers / Sculpt.*

Provenance Margaret McConville, Brooklyn, N.Y. (who acquired it directly from the artist); by descent through the McConville family; [M. Knoedler & Co., New York]; James H. Ricau, Piermont, N.Y., July 1970

Exhibition History *The Ricau Collection*, The Chrysler Museum, Feb. 26–Apr. 23, 1989

Literature "Our Artists in Florence," *Literary World* 6 (Feb. 16, 1850), 157; Katherine C. Walker, "American Studios in Rome and Florence," *Harper's New Monthly Magazine* 33 (June 1866), pp. 104–105; Reynolds 1977, pp. 1082–1083; Thomas B. Brumbaugh, "Hiram Powers on Politics, Art, and Other Important Matters: An Unpublished Letter," *Southeastern College Art Conference Review* 10 (Spring 1982), pp. 70–74; Vivien Green Fryd, "Hiram Powers's *America*: 'Triumphant as Liberty and Unity,'"

American Art Journal 18 (Spring 1986), 54–75; Headley 1988, pp. 198–199, 252–253; Wunder 1991, 2:121–124

Versions PLASTER National Museum of American Art, Washington, D.C.; MARBLE Dallas Museum of Art, Dallas, Texas; Wadsworth Atheneum, Hartford, Conn.; The Art Institute of Chicago; Woodmere Art Gallery, Germantown, Pa.; Falmouth Public Library, Falmouth, Mass.; Fogg Art Museum, Harvard University, Cambridge, Mass.; Ottauquechee Chapter of the Daughters of the American Revolution, Woodstock, Vt.; The Metropolitan Museum of Art, New York; Corcoran Gallery of Art, Washington, D.C.; Citibank, New York; [James Graham & Sons, New York]; [M. Knoedler & Co., New York]; and at least sixteen listed by Wunder as unlocated

Gift of James H. Ricau and Museum Purchase, 86.509

As with several ideal busts in the Ricau Collection, *America* was excerpted from a full-length over-life-size statue Hiram Powers hoped would enhance his reputation and fortune. The story of *America* is especially complex and offers considerable insight into the sculptor's working methods.[1] The allegorical figure of America (fig. 51) testified to Powers's egalitarian principles and his concerns for marketing. Powers started work on *America* in early 1848 and spent the next two decades trying to adapt it to the changing political climate. Soon after work began, the sculptor altered the figure to identify it as Liberty in support of the ill-fated revolutions of 1848 that flared up across Europe. Recognizing their failure, Powers quickly returned to his original concept that dealt with the theme of America and her successful break from the tyrannical rule of England. When he realized that Britain was a fertile market for his sculpture, he modified the image of the figure trampling a crown and substituted a more general symbol of oppression in the form of chains. Powers's hopes for favorable response from his own government were dashed as the unfolding rift over the slavery issue rendered the piece politically inflammatory. The terms of the Kansas-Nebraska Act of 1854 solidified Powers's opposition to slavery, but he refused to assign *America* such a condemnatory function.[2] With the Civil War approaching, the sculptor attempted to make the statue all things to all people. He encouraged viewers to read two meanings of freedom into the work—a universal liberty and a specific black emancipation. He emphasized an allegorical content of unity for all nations. Ultimately, he envisioned

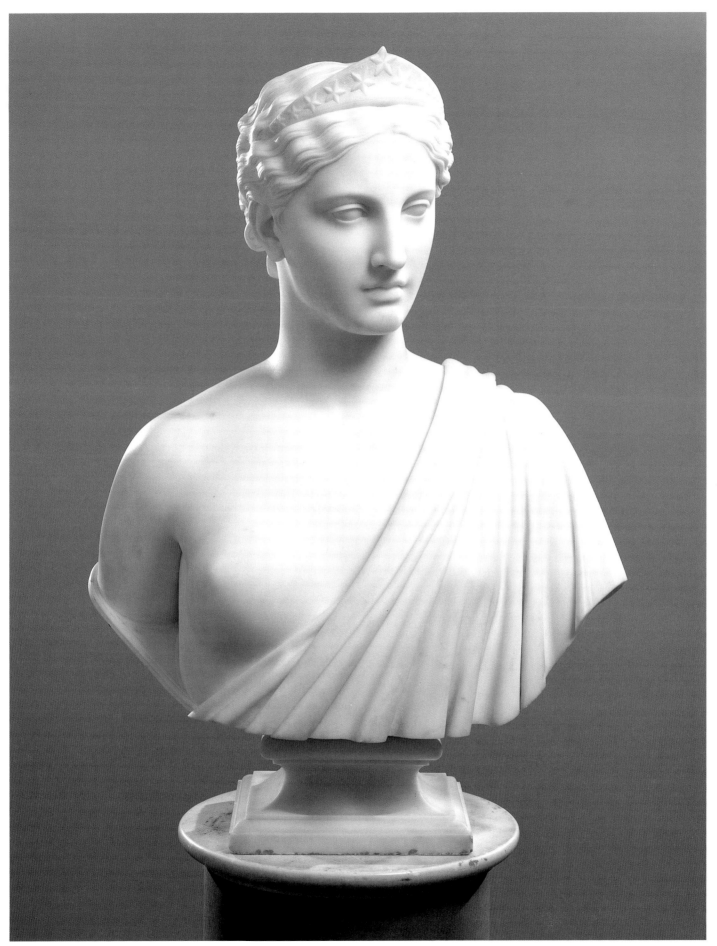

Cat. no. 8 Powers, *Bust of America*

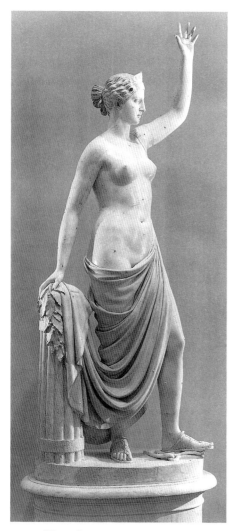

FIG. 31 Hiram Powers, *America* or *Liberty*, 1848–50. Plaster, 89½ in. (227.5 cm) high. National Museum of American Art, Smithsonian Institution, Museum purchase in memory of Ralph Cross Johnson, 1968.155.4

FIG. 32 Hiram Powers, *Bust of America*, detail of diadem

the work as transcending the borders of the United States and communicating a general message that would attract wide commercial appeal. Much to the sculptor's disappointment, *America*, in its full-length manifestation, never brought him the recognition or financial reward he felt he was due, and the one version translated into marble was destroyed by fire in 1865.

As with *Eve Disconsolate* (cat. no. 12), to create the bust of *America* from the full-length version, the left arm had to be modified to a downward position and the drapery had to be adjusted. The ideal head reflects Powers's patriotic rethinking of the overall composition in 1850 with the inclusion of a diadem with thirteen jeweled stars (fig. 32). By this obvious allusion to the original thirteen states formed after the American Revolution, the sculptor fervently wished to defuse the current incendiary political climate. Even from his distant perch, Powers was acutely aware

of the inevitable divisiveness of the slavery question and hoped his sculpture could bring the country to its senses.[3] The bust, with its greater marketability, offered a succinct visual message.

America possesses a stoic presence, and the sculptor considered it far more serious than his extremely popular *Proserpine* (cat. no. 6). He articulated this point to his close friend and champion, Edward Everett of Boston, and observed, "If one might be called a queen, then the other is an empress."[4] This hierarchy reflected the great potential Powers placed on *America* as an instrument of good. The sculptor sent the bust to Everett in appreciation for efforts on his behalf, and the recipient waxed enthusiastic in his letter of gratitude, writing, "There is a serene and dignified beauty in the features and expression, that cannot be surpassed; and the purity of the marble and exquisite finish of the work are in admirable harmony with the conception and sentiment."[5] Powers's high opinion of this bust resulted in his modification of it into *Diana* in 1852 (cat. no. 9).

The first order for a bust of *America* came in June 1850 and was intended as a companion to the sculptor's bust of Washington.[6] When the client, Osmond C. Tiffany, died, the order was canceled, and Powers did not receive another request until 1854. This initial reluctance was illusory. Powers eventually enjoyed considerable success with the bust and received as many as twenty-eight orders.

Notes

1. Fryd, "Hiram Powers's *America*" (1986), pp. 54–75. Her exemplary work provides the basis for much synoptic discussion of the full-length piece.

2. Ibid., pp. 68–69.

3. Ibid., p. 66.

4. Powers to Edward Everett, Nov. 14, 1859, Powers papers, AAA, roll 1140, frame 427.

5. Edward Everett, in Boston, to Powers, Apr. 1, 1860, Powers papers, AAA, roll 1140, frame 639.

6. Wunder 1991, 2:121.

9
Bust of Diana

Modeled 1852
Marble
25⅝ × 17¼ × 10⅜ in. (65.1 × 43.8 × 26.4 cm)
Inscribed at rear: *H. Powers. / Sculpt.*

Provenance James H. Ricau, Piermont, N.Y.

Exhibition History *The Ricau Collection*, The Chrysler Museum, Feb. 26–Apr. 23, 1989

Literature Strahan 1879–82, 3:74; Gerdts 1973, pp. 78–79; Wunder 1991, 2:131–134

Versions PLASTER (head only, two versions) National Museum of American Art, Washington, D.C.; MARBLE High Museum of Art, Atlanta, Ga.; Corcoran Gallery of Art, Washington, D.C.; Wadsworth Atheneum, Hartford, Conn.; J. Paul Getty Museum, Malibu, Calif.; National

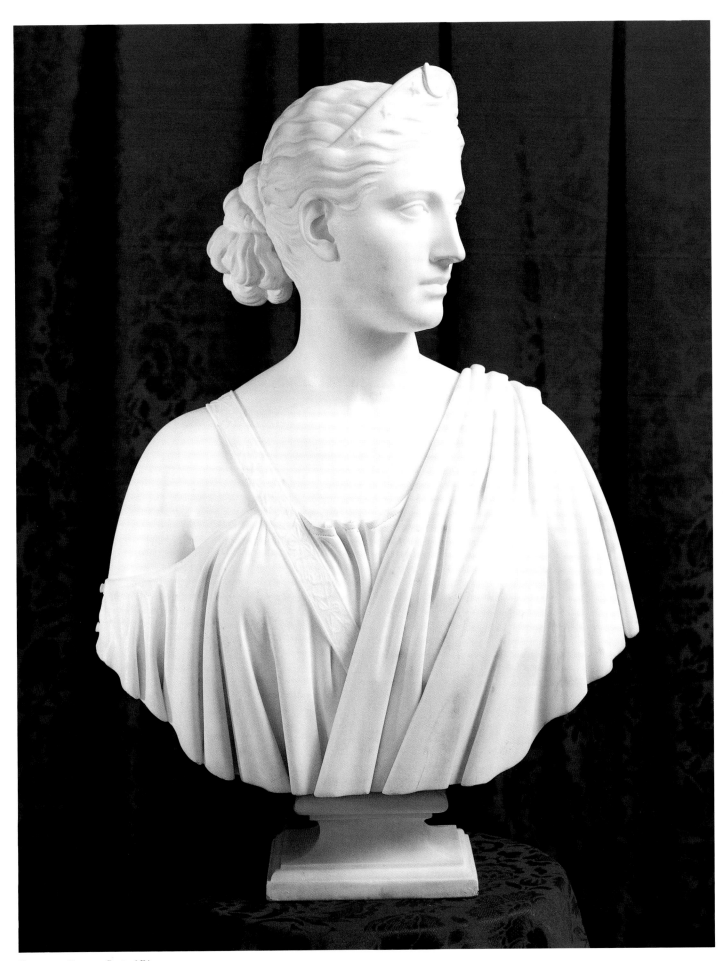

Cat. no. 9 Powers, *Bust of Diana*

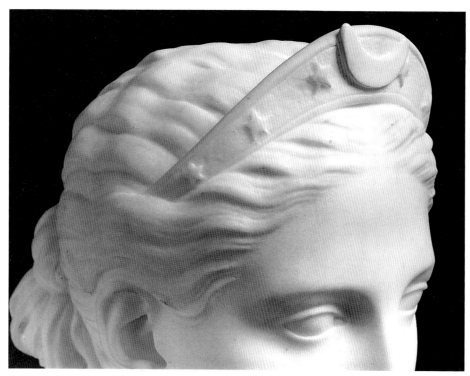

FIG. 33 Powers, *Bust of Diana*, detail of tiara

Museum of American Art, Washington, D.C.; Glasgow Art Gallery and Museum, Glasgow, Scotland; Stephen Edlich, New York; private collection

Gift of James H. Ricau and Museum Purchase, 86.503

DEPICTIONS of mythological figures constituted an important category for sculptors of nearly all epochs, and American sculptors of the nineteenth century were no exception. Of the four busts that Hiram Powers devoted to mythological subjects—*Clytie*, *Diana*, *Proserpine*, and *Psyche*—only the last one eluded Ricau. Certain figures, such as Psyche or Pandora, were utilized for their association with such Christian themes as the immortal soul or original sin.[1] *Diana*, too, carried moral overtones and appealed to a Victorian sense of propriety through her connection with chastity.

In 1846 Lucius Manlius Sargent of Boston visited Powers's studio and commissioned him to create an ideal bust of a subject that the sculptor had not modeled before. Sargent reinforced his earnest intent by advancing Powers full payment the following year.[2] This gesture of goodwill had little effect on the sculptor, since it took the admonition of his friend and financial agent, Sidney Brooks, in December 1851 finally to motivate Powers to commence the long overdue commission. Powers obliged and within two months reported that he would soon

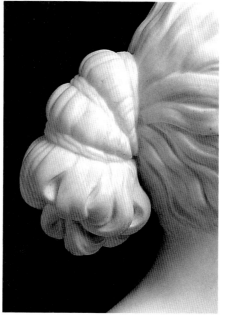

FIG. 34 Powers, *Bust of Diana*, detail of hair

complete the model. There were problems, however. Two blocks of marble had to be discarded because of flaws, and the finished work was not shipped until April 1853. Nevertheless, Powers demonstrated his golden touch, as *Diana* attracted at least twenty-six subsequent orders. It is impossible to connect the Ricau version with any of the original requests.

Powers expedited this obligation by slightly altering his bust of *America*,

which was also in progress (cat. no. 8). The most obvious change is the drapery, a Greco-Roman himation, which is gathered into a more complex system of folds at the left shoulder and which falls across the left breast with a straight edge of material rather than in the curving arc described in *America*. The underlying fichu with hemmed edge reinforces this modesty as it extends across the chest to cover the right breast. Powers signified the bust's identity with an intricately tooled leather strap, ornamented with symbols of the chase, that comes over the right shoulder and suggests the existence of a quiver of arrows. Powers also modified the tiara (fig. 33), which is more rounded than that of *America* and anticipates the ones worn by *Faith* and *Hope* some fifteen years later (cat. nos. 14, 15). He also reduced the number of stars from thirteen to six, while adding Diana's crescent moon to its front.

In yet another subtle modification of *America*, the sculptor slightly altered the head position so Diana is turned more to her left. The facial features are virtually identical, however. Also common to both busts is the hair, which is parted in the middle, pulled back tightly, and tied into a bun with a ribbon. The gather of hair in the *Diana* is somewhat larger, and its greater mass causes it to droop (fig. 34). As had come to be his forte, Powers made just enough adjustments to create a work that honored the demand for originality.

Like any serious artist, Powers had definite ideas about the display of his work and let his clients know them. When Junius Spencer Morgan, father of the legendary financier J. P. Morgan, ordered his *Diana* (WAHC), Powers, in notifying Morgan of the piece's shipment, offered a wealth of advice about installation, lighting, care, and maintenance of the work.[3] These instructions constituted standard operating procedure, and the correspondence is worth quoting at length, since it provides such explicit insight into the sculptor's intent:

Some careful person should be present on the delivery of these works [it seems that Powers sent more than one sculpture] from shipboard, and should not leave them until in a place of safety, otherwise there is always great danger. These things will not bear rough handling.

There is a spindle on the top of the shaft of the column, with a hole through it, and there is an iron loop in the case to put on it for the purpose of fastening a crossbar to raise it by—use a strong cord to do this. Care should be taken in putting the bust on the pedestal not to chip the corners. It should be lowered down upon it slowly.

The best light is an elevated one in order to produce the necessary shadows on the face—the shade of the nose should descend below the

middle of the upper lip. If the light is too low the expression is lost.

It spoils the surface of marble to handle it, for there is oil in the skin which cannot be got out of marble. It turns yellow after a time. Therefore do not allow people to see the bust with their fingers, as some do. It should be covered during the summer with gauze to keep off the flies. There is some dust in a small buckskin on the case to rub off soils on the marble. This should be used with a bit of flannel—put on flannel and rub.[4]

Undoubtedly, Powers wanted to ensure the best possible circumstances for the appreciation of his work.

The sculptor immediately assigned greater value to this bust than others. When he provided his price list to a prospective client in December 1852, available busts such as *Proserpine, The Greek Slave,* or *Psyche* were priced at seventy-five pounds, while he asked one hundred pounds for *Diana.*[5] Powers offered no explanation for the cost differential; presumably, his most recent effort warranted more money.

Notes

1. Gerdts 1973, pp. 78–79.
2. Wunder 1991, 2:152.
3. Ibid., 2:153. The bust of *Diana* passed through the family until 1914, when it was given to the Wadsworth Atheneum in Hartford, Conn.
4. Powers to Junius S. Morgan, June 4, 1857, Powers papers, AAA, roll 1159, frames 96–97.
5. Powers to Shaw, Dec. 16, 1852, Powers papers, AAA, roll 1156, frames 569–570. English pounds were the universal currency; one English pound was the equivalent of approximately five U.S. dollars.

10
Portrait of Nicholas Longworth Powers (?)

Modeled ca. 1852
Marble
29½ × 21¼ × 12⅛ in. (74.9 × 54 × 30.8 cm)
Inscribed at rear: *H. Powers / Sculp.*

Provenance [Butterfield and Butterfield, San Francisco, Sept. 22, 1983, lot 2151]; [Post Road Antiques, Larchmont, N.Y., 1983]; James Ricau, Piermont, N.Y.

Exhibition History *The Ricau Collection,* The Chrysler Museum, Feb. 26–Apr. 23, 1989

Literature *Antiques* 124 (Sept. 1983), 575, ill.; Glen P. Opitz, ed., *Dictionary of American Sculptors* (Poughkeepsie, N.Y., 1984), p. 607, ill.; Wunder 1991, 2:85, ill.

Versions None known

Gift of James H. Ricau and Museum Purchase, 86.499

Aʟᴛʜᴏᴜɢʜ not questioned as a portrait of Hiram Powers's eldest surviving son Nicholas Longworth Powers (1835–1924), there is no mention of this bust in the studio archives.[1] Offsetting this lacuna, however, is the recognition that the sculptor's correspondence contains reference to his having taken likenesses of all members of his family. Since no sculptures of daughter Ellen or sons Preston and Edward Everett have come to light, the studio archive is by no means definitive. Therefore, the identification of this bust as Longworth, on the basis of existing evidence, is circumstantial.

Powers was disappointed by the lack of direction and initiative his three sons exhibited in establishing careers. He could take solace that Longworth, after numerous false starts, settled on a productive career as a photographer in Florence. Born in 1835, Nicholas Longworth Powers was named in honor of his father's first patron, Nicholas Longworth of Cincinnati. Powers had high hopes for this son, and these expectations were unrealized for several years.

Through the efforts of another patron, the influential politician Edward Everett (for whom Powers's last son was to be named), Longworth secured an appointment to West Point in 1852 at the age of seventeen.[2] However, the weaknesses of his schooling in Florence and eye troubles necessitated his dismissal after only a semester. Remedial education in a preparatory school was equally discouraging, and it became obvious that Longworth had little inclination for academics. A final attempt was made in 1853, when he enrolled in Rensselaer Polytechnic Institute in Troy, New York, to pursue a degree in civil engineering. Although he stayed for a year and had passing grades, Longworth did not graduate. By 1855 the elder Powers was sufficiently frustrated to bring his son back to Florence. A variety of jobs ensued, including managing his father's studio, all to no avail. Once again a solution was sought in America, this time in Leavenworth, Kansas, to look after his father's real-estate ventures. But here, too, Longworth showed himself incapable of such independence, and in 1859 he returned to Florence for good. While resisting his father's efforts to engage him in the railroad business, Longworth showed an interest in photography, and Powers, recognizing the possible advantage of having a resident photographer to shoot sculpture, sitters, and friends, supported his son's endeavor.

At the age of twenty-five, Longworth Powers had found his vocation. He manifested talent and became the leading portrait photographer in Florence. In 1862 his father finally expressed parental pride, declaring in a letter to Everett: "He has to work hard to keep up with his orders, and is rapidly making money.... A steadier and better young man than he cannot be found."[3] Longworth marketed himself adroitly, advertising in Murray's *Handbooks,* the indispensable guidebooks of the period. He was a principal provider of cartes de visites for American and English visitors to the city. His father's connections did not hurt either, enabling him to photograph such luminaries as William Cullen Bryant. With his father's declining health, Longworth assumed financial responsibilities for the family. His brothers' profligate ways made life difficult for him in this regard, but Longworth could take satisfaction that he had fulfilled some measure of his father's expectations in terms of establishing a career and setting a positive example.

In the youthful portrait, Longworth is depicted wearing a smock enlivened by horizontal bands of piping and embroidery, a turned-down collar, and four buttons that are fastened. Below the band of rosette-designed embroidery at the chest, the smock falls in a series of vertical pleats and folds. Underneath he wears a shirt buttoned to the throat. Once again, the sculptor exhibited mastery in rendering the garments with a convincing sense of verisimilitude. The sitter looks to his left with a serious demeanor that belies his age. His thick, curly hair and prominent beaklike nose reinforce the quiet strength the portrait exudes. Possibly, Powers took this likeness in 1852, when Longworth was seventeen and basking in the honor of his appointment to the United States military academy. Recognizing that his son would be away for an extended period of time, the sculptor would have wanted to create a likeness as a remembrance. Flush with pride, Powers imbued his son with the dignity and determination that would elude the sitter over the next eight years.

Notes

1. Wunder 1991, 2:85.
2. The details of Nicholas Longworth Powers's biography have been culled from Wunder 1991, 1:20–21 and passim.
3. Powers to Edward Everett, May 20, 1862, Powers papers, AAA, roll 1141, frames 981–982. Cited in Wunder 1991, 1:315.

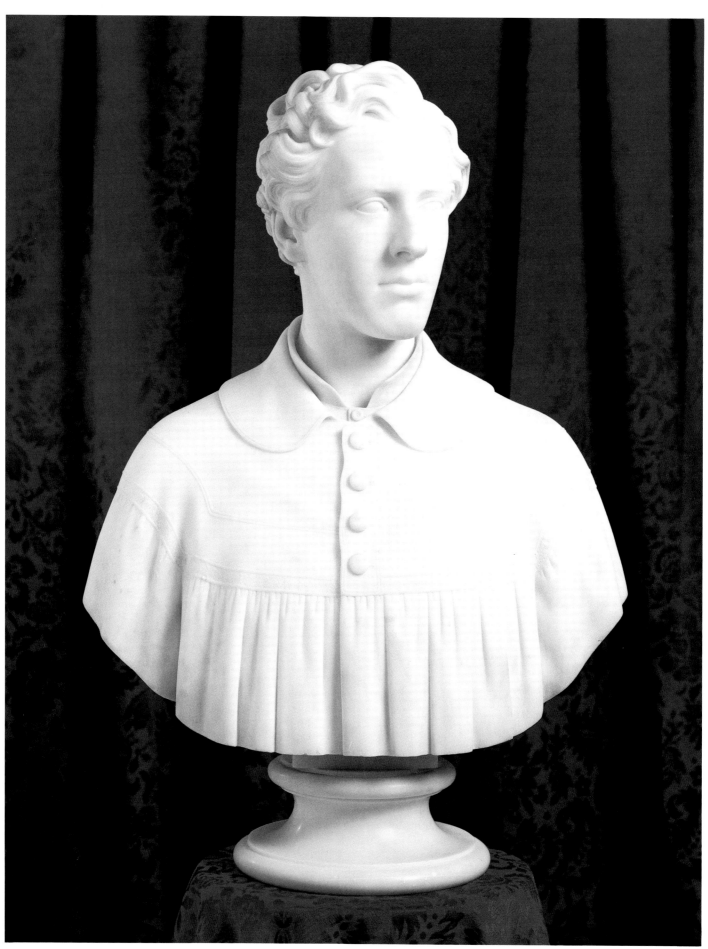

Cat. no. 10 Powers, *Portrait of Nicholas Longworth Powers* (?)

11

Bust of California

Modeled ca. 1860, carved ca. 1865–66
Marble
27 × 17¾ × 13 in. (68.6 × 45.1 × 33 cm)
Inscribed at rear: *H. Powers / Sculpt.*

Provenance William L. Chamberlain, New York, by April 1866;...; private collection, New York; [Hirschl and Adler, New York, Jan. 1979]; private collection, 1984; James H. Ricau, Piermont, N.Y., 1984

Exhibition History *The Ricau Collection,* The Chrysler Museum, Feb. 26–Apr. 23, 1989

Literature "Powers's Statue of *California,*" *Bulletin of the American Art-Union,* May 1851, p. 33; Weed 1866, p. 509; Tuckerman 1867, pp. 288–290; Albert Ten Eyck Gardner, "A Relic of the California Gold Rush," *Metropolitan Museum Bulletin* 8 (Dec. 1949), 117–121; Gerdts 1973, pp. 124–125; Reynolds 1977, p. 1083; Sotheby Parke-Bernet, New York, Oct. 27, 1978, lot 96, ill.; Wunder 1991, 2:126–127

Versions PLASTER not located; MARBLE Fine Arts Museums of San Francisco; National Museum of American Art, Washington, D.C.

Gift of James H. Ricau and Museum Purchase, 86.504

SOMETIME around 1860 Hiram Powers adapted the original bust of *California* (FAMSF) from the life-size full-length statue (fig. 35) at the request of Robert B. Woodward of San Francisco.[1] Woodward was the proprietor of Woodward Gardens, an amusement park that also presented exhibitions of paintings and statuary.[2] The Ricau version is most likely the one ordered by William L. Chamberlain of New York in the spring of 1865. The client confirmed the verbal agreement of cost, seventy-five pounds, and anticipated an execution time of six months.[3] Powers could not meet the second stipulation, however, and the finished work was not shipped until April of the following year. He informed Chamberlain of his good fortune, since the price had just been raised to one hundred pounds. With no more than four known replicas, *California* did not rank among the sculptor's commercial successes.

The full-length statue was inspired by the Gold Rush of 1849. That year Powers began an allegorical figure personifying the discovery of gold, with implied commentary on the perils of greed.[4] While the work was in its early stages, Powers considered calling the figure *El Dorado,* but he settled on *California,* since, as he later

explained, the Spanish name was masculine, and his sculpture was feminine.[5] He wrote to his brother Stephen in the summer of 1850 outlining his original concept, which called for an Indian woman crowned with a diadem of pearls and precious stones and dressed in a buckskin kirtle ornamented with a feather fringe and embroidery.[6] Powers envisioned supporting the sculpture with a cornucopia spewing gold that he would enhance with gilding.[7]

The sculptor radically modified these preliminary ideas in the ultimate realization. He opted for a nude figure and transformed the cornucopia into a shaft of quartz, thereby defusing his trenchant commentary on greed. Powers retained such definitive attributes as the divining rod and thorns, which still carried a powerful message, described in his own words:

It represents an Indian woman in the early prime of life...holding the divining rod in her left hand and pointing with it down to the earth, under a large quartz crystal, which supports the figure on the right. Quartz is the matrix of gold and the divining rod is the miner's wand, or the scepter of *California.* These emblems have never before been introduced in any work of art that I know of. In the right hand, which is held behind, there is a branch of thorns, to finish the allegory, for she is the miner's goddess, or *Fortune* with good in one hand and evil in the other, by suitable emblems I have done so with *California,* and the moral is that all is not gold that glitters—one must not trust to appearances but look well and all 'round before taking steps which may prove fatal to us as they did indeed prove to many who did not know how to woo *California,* a great and most beautiful country, but she must be approached understandingly.[8]

At least one visitor to Powers's studio admired the full-length of *California,* which he saw in its early stages.[9] The model was completed by 1855, and the first replica was ordered by William Backhouse Astor in 1858.[10] The work was subjected to more critical scrutiny in 1860, when a tourist praised the execution and beauty of expression of much of what he saw in Powers's studio, although he described many of the works as "lacking in antique boldness and forcefulness of expression."[11] Implicit in this commentary is a recognition of an evenhanded, formulaic approach. Because of his commercial success, Powers was inadvertently perceived as lapsing into a perfunctory reworking of existing pieces to sustain his career, which was undergoing petrification.[12]

From the outset, Powers entertained high hopes of placing this piece in California. Stephen Powers, a San Francisco resident, passed his brother's

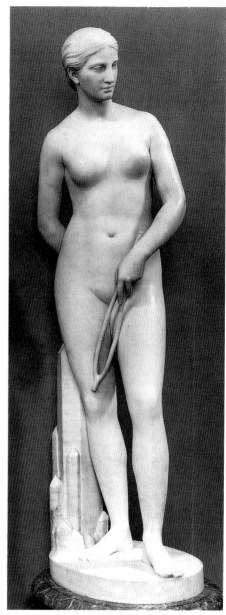

FIG. 35 Hiram Powers, *California,* 1858. Marble, 71 in. (180.3 cm) high. The Metropolitan Museum of Art, gift of William B. Astor, 1872 (72.3)

explanatory letter along to the *San Francisco Courier* to publicize this desire. This ambition was not realized until 1867, when the second replica was acquired by Milton S. Latham, a successful San Francisco lawyer who had recently served as the governor of the young state.[13]

Powers modified the full-length piece into a bust by truncating the figure just below the breasts and adorning the lower edge with a curved, reeded molding. Devoid of any identifiable attributes, this head relies on knowledge of the full-length statue for full appreciation. In keeping with its role as a modern allegory, the bust's features are less dependent on elements culled from the antique.

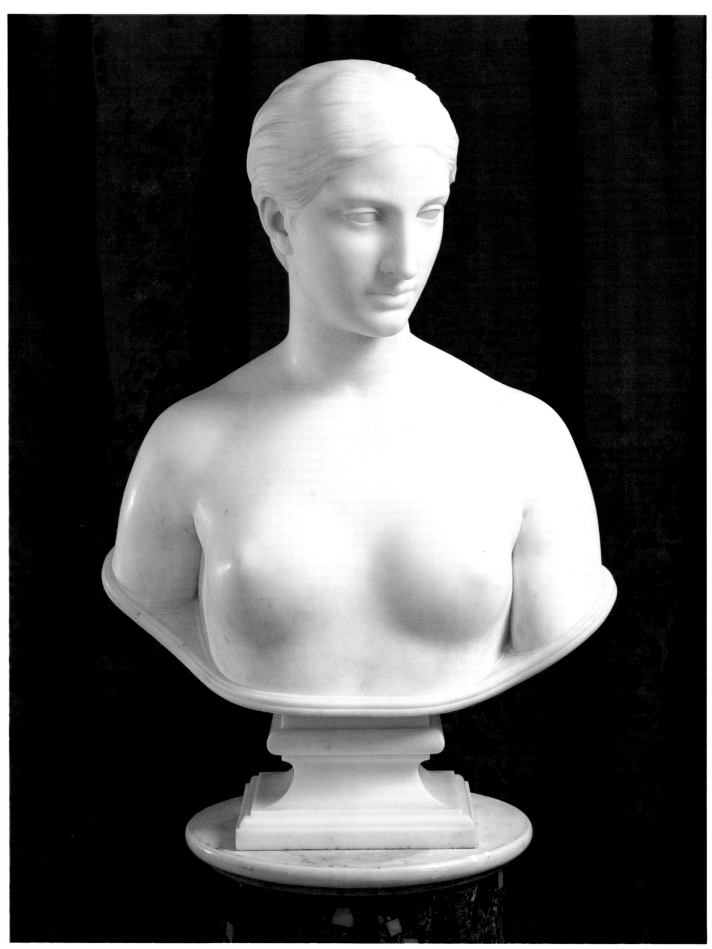

Cat. no. 11 Powers, *Bust of California*

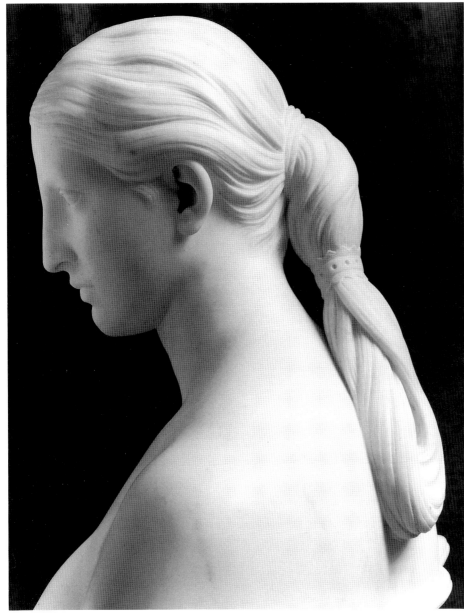

FIG. 36 Hiram Powers, *Bust of California*, detail of hair

Most notable is the hair, which is parted in the middle and pulled back in a manner one would expect of Powers, but the strands are much finer and do not possess the bold waviness of many of his other more classically derived works (fig. 36). In addition, the hair is gathered at the back and bound again in a way that anticipates the treatment of the hair in *The Last of the Tribes* (NMAA). This suggests Powers was attempting to establish an ethnographic identity.

The facial expression is a variation on the type he used for *Proserpine* (cat. no. 6), and the major alteration involved the eyes. The sculptor made them more oblong and almond-shaped, and a resultant narrowing of countenance instilled a more men-

acing mien. The cold, severe expression may account for the modest popularity of this work, and the sculptor's reliance on technical virtuosity could not compensate for the lack of compassion or sympathy the work conveyed. The implied message unsettled many Americans who chose to avert their eyes from its mordant commentary on the destructive potential of wealth.

Notes

1. Wunder 1991, 2:127.
2. Ellen Schwartz, *Nineteenth-Century San Francisco Exhibition Catalogues* (Davis, Calif., 1981), p. 162.
3. Ibid. The letter from Chamberlain to Powers is dated Apr. 6, 1865, and must have been written pursuant to the studio visit, since Powers

replied the following day. English pounds were the universal currency; one pound was the equivalent of approximately five U.S. dollars.

4. See Headley 1988, pp. 233–236, for an insightful discussion of this work.
5. Powers to William A. Buffum (U.S. consul at Trieste), Oct. 18, 1858, Powers papers, AAA, roll 1139, frame 1186.
6. "Powers's Statue of *California*" (1851), p. 33. This description was contained in a letter from Powers to his brother Stephen in San Francisco written Aug. 18, 1850, and was originally published in the *San Francisco Courier*.
7. Powers to Edward Everett, May 23, 1850, Powers papers, AAA, roll 1134, frames 1164–1165.
8. Powers to George Gordon, Mar. 5, 1867, Powers papers, AAA, roll 1143, frame 792. Originally cited in Wunder 1991, 2:125.
9. Weed 1866, p. 509. The letter commenting on Powers's work was initially penned on Feb. 4, 1852.
10. Wunder 1991, 2:124–125.
11. E. K. Washington, *Echoes of Europe; or, Word Pictures of Travel* (Philadelphia, 1860), p. 365.
12. Wunder 1991, 1:166, provides a telling letter written in 1850, which reveals the narrow and inflexible range of Powers's aesthetic thinking.
13. Wunder 1991, 2:126.

12
Bust of Eve Disconsolate

Modeled ca. 1862
Marble
28⅜ × 19⅜ × 12⅜ in. (72.1 × 49.2 × 31.4 cm)
Inscribed at rear: *H. Powers / Sculpt.*

Provenance James H. Ricau, Piermont, N.Y.

Exhibition History *Hiram Powers's "Paradise Lost,"* The Hudson River Museum, Yonkers, N.Y., Nov. 19, 1985–Jan. 24, 1986; *The Ricau Collection*, The Chrysler Museum, Feb. 26–Apr. 23, 1989

Literature "The Webb Collection," *New-York Evening Post*, Mar. 27, 1876, p. 3; Gerdts 1973, pp. 70–71; Cornelius Vermeule, "Neoclassic Sculpture in America: Greco-Roman Sources and Their Results," *Antiques* 108 (Nov. 1975), 972–981; Reynolds 1977, p. 1086; April Kingsley, *Hiram Powers's "Paradise Lost,"* exh. cat., The Hudson River Museum (Yonkers, N.Y., 1985), p. 19, fig. 8; Jan Seidler Ramirez, "Hiram Powers," in BMFA 1986, pp. 56–58; Headley 1988, pp. 198–199, 202–203, 222–224; Wunder 1991, 2:136–139

Versions PLASTER (head only) National Museum of American Art, Washington, D.C.; MARBLE Rhode Island School of Design, Providence; Victoria and Albert Museum, London; Toledo Museum of Art; Dayton Art Institute, Dayton, Ohio; National Museum of American Art,

Washington, D.C.; Museum of Fine Arts, Boston; The Brooklyn Museum, Brooklyn, N.Y.; Utah Museum of Fine Arts, Salt Lake City; Huntington Art Gallery, University of Texas, Austin; Charles Hosmer Morse Foundation, Inc., Winter Park, Fla.; Gallery of Modern Art, Florence, Italy; William H. Gerdts, New York; Micahelles family, Florence, Italy; Mrs. Waylande Gregory, Warren, N.J.; Haussner's Restaurant, Baltimore, Md.; [Hirschl & Adler Galleries, New York]

Gift of James H. Ricau and Museum Purchase, 86.508

DEPICTIONS of Adam and Eve have been a staple of Western art all through the Christian era. Their narrative provided opportunity to address central conflicts of good and evil, innocence and worldliness, sin and redemption. In nineteenth-century America, these themes were especially apt since the young Republic was considered an Edenic wilderness being explored and settled by the new Adam.[1] In contrast to the simplicity and naïveté of Adam, Eve signified more complex and ambiguous concepts. She particularly appealed to American neoclassic sculptors, since she furnished an opportunity to render the female nude within a Christian context. Indeed, the poles of Hiram Powers's career are marked by interpretations of Eve, with his earliest ideal piece addressing her temptation, while one of his last efforts considered her fall and subsequent remorse.[2]

Powers devoted considerable time and thought to his early renderings of Eve. In May 1839 he rejected an attraction to Eve's rumination on her transgression, which he contemplated calling *Eve Reflecting on Death*, inspired by Salomon Gessner's well-known idyll, "Der Tod Abels" (1758).[3] Instead, Powers opted for an earlier moment of guilelessness in which Eve scrutinizes the apple, oblivious to the ramifications of her imminent action.

The sculptor's initial version of *Eve Tempted* (fig. 37) had formal associations with *Aphrodite with the Apple* (The Museum of Fine Arts, Houston) by the acknowledged master of neoclassical sculpture Bertel Thorvaldsen (q.v.). The open, frontal pose with its unabashed nudity underscored Eve's innocence and the poignance of her dilemma. In September 1842 the purchaser of the first replica withdrew his order, fearing that the nudity would shock the citizenry of his native Albany, New York.[4] Whether the client capitulated is unclear, but Powers slightly revised the work so the pose was

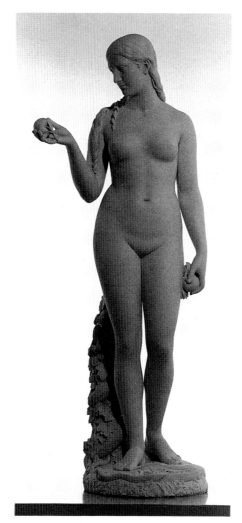

FIG. 37 Hiram Powers, *Eve Tempted* or *Eve before the Fall*, modeled 1842. Marble, 68⅞ in. (174.9 cm) high. National Museum of American Art, Smithsonian Institution, Museum purchase in memory of Ralph Cross Johnson, 1968.155.126. Photograph by James Duggins

more modest, the figure more attenuated, and the mood more meditative. The sculptor liked his improvements and was especially pleased with the implied hesitation that nonetheless could not stave off Eve's inevitable surrender to temptation. Although Powers derived great satisfaction from *Eve Tempted* and its favorable reception, this achievement was overshadowed by publicity accorded the concurrent unveiling of *The Greek Slave* (fig. 13). Consequently, *Eve Tempted* was a commercial disappointment. Powers gave the replica based on the second design to his patron from South Carolina, Colonel Preston. Other marbles, based on the designs, were not completed until after Powers's death.[5]

Powers returned to the theme of Eve in 1859 and addressed the moment after the fall, which had haunted him in this intervening period. He referred to his subject

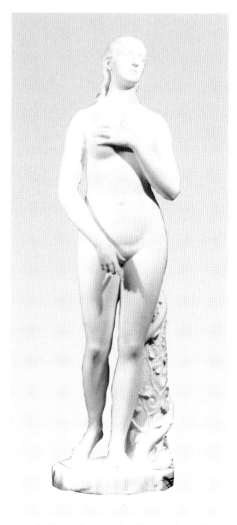

FIG. 38 Hiram Powers, *Eve Disconsolate*, 1871. Marble, 77 in. (195.6 cm) high. Collection of The Hudson River Museum, Gift of the Berol Family in memory of Mrs. Gella Berolholzheimer, 51.81. Photograph by Scott Bowron

alternately as *Eve Disconsolate* and *Paradise Lost*, and the allusion to Milton was not unwarranted. Powers had recently commenced another sculpture, *La Penserosa* (High Museum of Art, Atlanta, Ga.), based on the great English poet's poem *Il Penseroso*. Themes of melancholy and solemn dignity extrapolated from Milton's poem rekindled the sculptor's interest in the biblical subject.

Although the model of *Eve Disconsolate* was completed in 1861, orders were not forthcoming. No marble version was delivered until 1871, when Nathan Denison Morgan of New York requested a replica (fig. 38). This statue was acquired from Morgan the following year by the department-store magnate Alexander T. Stewart and joined the *Eve Tempted*, which Stewart had purchased from Colonel Preston. Stewart's uniting of these two works fulfilled Powers's long-standing

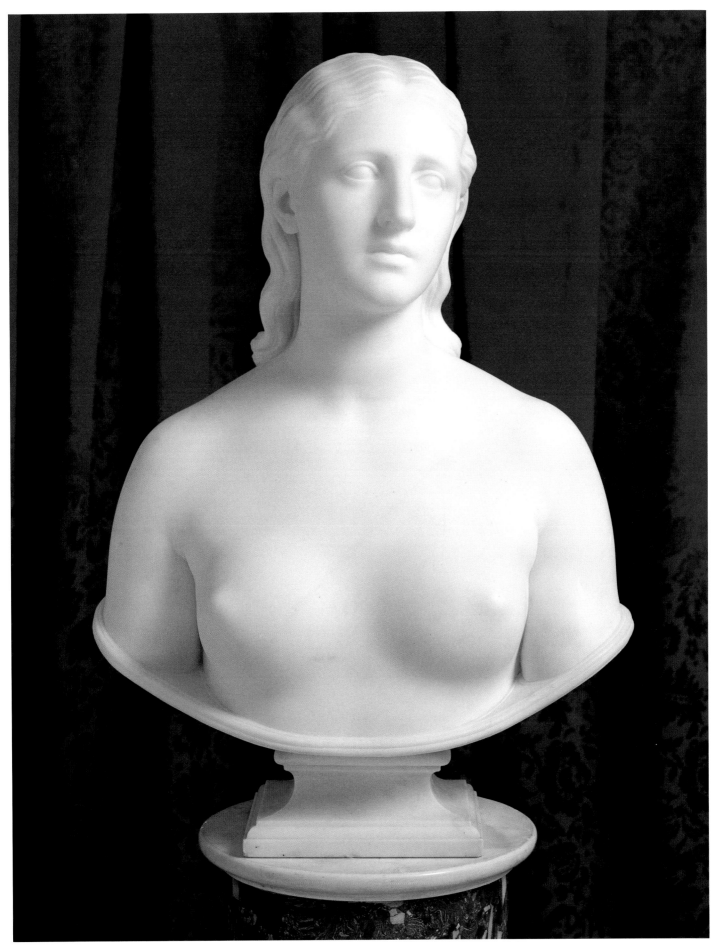

Cat. no. 12 Powers, *Bust of Eve Disconsolate*

wish to see the full range of the story brought together, but the dispersal of Stewart's collection in 1887 separated them.[6]

Formally, *Eve Disconsolate* possesses less stasis and sinuous contrapposto than the earlier interpretations. Early Renaissance art may have been influential, and Masaccio's fresco *The Expulsion from Paradise* (Brancacci Chapel, Santa Maria del Carmine, Florence) has been suggested as a source.[7] The placement of the hands, though in reverse, as well as the upturned head bear a plausible resemblance. Although the hands shield the breasts and genitals, the fingers are extended so the screen is deceptively transparent. While the sculptor avoided complete concession to modesty, he contended that the arrangement was suitable for mixed company.[8]

On an emotional level, Powers sought a tempered pathos in his interpretation, and this sense of restraint in Eve's expression recalls Titian's painting of the repentant Magdalene, which Powers would have seen in the Pitti Palace.[9] The sculptor was attuned to a wide range of emotions, explaining to the purchaser of this revised version that "the temptation of Eve did not afford an opportunity for the expression of bewilderment, distress, and remorse, which must have appeared on the face and in the attitude of Eve, when she replied, 'The serpent beguiled me, and I did eat.'"[10] Powers made her emphatic supplication for forgiveness in the wake of her fateful act the central focus of the bust.

Powers, ever sensitive to recouping his investment, began accepting orders as early as 1862 for a bust based on *Eve Disconsolate*. His only modification was the position of the upper left arm, which in the truncated design terminates below the breasts in an ovoid saucerlike form adorned with a molded edging. No longer shielding her breasts, Eve appears more exposed and possibly vulnerable. Her hair falls in a more naturalistic fashion, which distances her from a classical ideal.

The bust was available in two sizes: slightly larger than life, which replicated the statue, and two-thirds life-size. The larger bust enjoyed satisfying popularity, with twenty-six orders for replicas listed by Wunder, including the Ricau version.[11] A large number of untraceable examples renders it impossible to identify the early ownership of the Ricau replica or when it was carved.

Powers, sensing his mortality during the creation of *Eve Disconsolate*, strove to make it his best effort. In his letter to Nathan Morgan, he revealed the high standards he placed on himself and explained his message:

I continually found something to be improved and am far from presuming it to be perfect. I aimed at nobleness of form and womanly dignity of expression. She is forlorn, but does not quite despair, for she looks up imploringly. She accuses the serpent with one hand, and herself most with the other. The serpent retires for Eve repents. She now resists evil.

She is not a goddess, but a woman—a primitive woman, the mother of mankind. She has never been in society nor is she educated.[12]

Powers, through his spiritual concerns, especially Swedenborgian tenets and their belief in the existence of an otherworldly realm corresponding to this earthly one, set up a dichotomy between primal and civilized states. In the physiognomy of Eve, the sculptor eloquently revealed an interior world and consummately effected a fusion of the real and the ideal. In both full-length and bust formats, *Eve Disconsolate* conveyed a universal drama that spoke to a collective loss of innocence. This theme of remorse was especially timely as the nation experienced the unfolding conflict of the Civil War.

Notes

1. Jan Seidler Ramirez, "Some Remarks on Adam, Eve, and the 'New Adam's' *Eve*," in *Hiram Powers' Paradise Lost* (1985), p. 4.

2. Kingsley, *Hiram Powers's "Paradise Lost*," discusses Powers's infatuation with these themes in an exemplary fashion.

3. Kasson 1990, pp. 173–181, provides a thoughtful discussion of the shifting interpretations of Eve with special reference to Powers.

4. Wunder 1991, 2:142.

5. Ibid., pp. 142–144.

6. American Art Association, New York, *Catalogue of the A. T. Stewart Collection of Paintings, Sculpture, and Other Objects of Art*, Mar. 23–30, 1887, p. 173.

7. Gerdts 1973, p. 71.

8. Powers to George P. Gardner, Oct. 24, 1861, Powers papers, AAA, roll 1141, frames 589–590.

9. Ramirez, "*Eve Disconsolate*," in BMFA 1986, p. 58, contained this observation.

10. Powers to Nathan Denison Morgan, Dec. 7, 1871, Powers papers, AAA, roll 1145, frame 202.

11. Wunder 1991, 2:136–139. Eight of the two-thirds-size versions are listed as well as two replicas of an intermediate size.

12. Powers to Morgan, Dec. 7, 1871, Powers papers, AAA, roll 1145, frame 203.

13
Bust of Clytie

Modeled ca. 1865–67, carved after 1868
Marble
26¼ × 17⅝ × 10⅛ in. (66.7 × 44.8 × 25.7 cm)
Inscribed at rear: *H. Powers / Sculpt.*

Provenance James H. Ricau, Piermont, N.Y.

Exhibition History *The Ricau Collection*, The Chrysler Museum, Feb. 26–Apr. 23, 1989

Literature Reynolds 1977, p. 1084; Wunder 1991, 2:129–130

Versions PLASTER (head only) National Museum of American Art, Washington, D.C.; MARBLE Minneapolis Institute of Arts; Michahelles family, Florence, Italy; National Museum of American Art, Washington, D.C. (two replicas); government of the Philippines, Manila; [Spanierman Gallery, New York]

Gift of James H. Ricau and Museum Purchase, 86.507

POWERS maintained an interest in ancient Greek and Roman mythology into the mid-1860s. The story of Clytie had long been popular with artists. Clytie, the daughter of Oceanus, was a sea nymph who became so enamored of the sun god, Apollo, that every day she tracked his course across the sky. The gods took pity on her and changed her into a heliotrope, or sunflower, and she came to signify constancy of devotion.[1]

Powers began to model *Clytie* in late 1865. In January 1866 he wrote the purchaser of the first replica, Gardner Brewer of Boston, that it was shaping up as his best ideal bust and that reaction to the piece seemed to substantiate his opinion.[2] Despite his enthusiasm, Powers did not complete the model until 1867, and Brewer did not receive his replica until the middle of 1868. A period photograph shows *Clytie*, complete with pedestal, in the parlor of the Gardner Brewer House at 29 Beacon Street (fig. 39). This document provides insight into how such a work was placed in the home with respect to the sculptor's specifications about optimum lighting.

Formally, this bust is a subtle mixture of appropriation and invention. In terms of sources, Powers was familiar with one of the most famous images of Clytie in the British Museum (fig. 29).[3] The sculptor knew this ancient work from a drawing he had used to modify the base of his *Proserpine* in 1844 (cat. no. 6). Presumably, the popularity of Clytie inspired him to address the subject of the lovelorn nymph. Unlike William Henry Rinehart's appro-

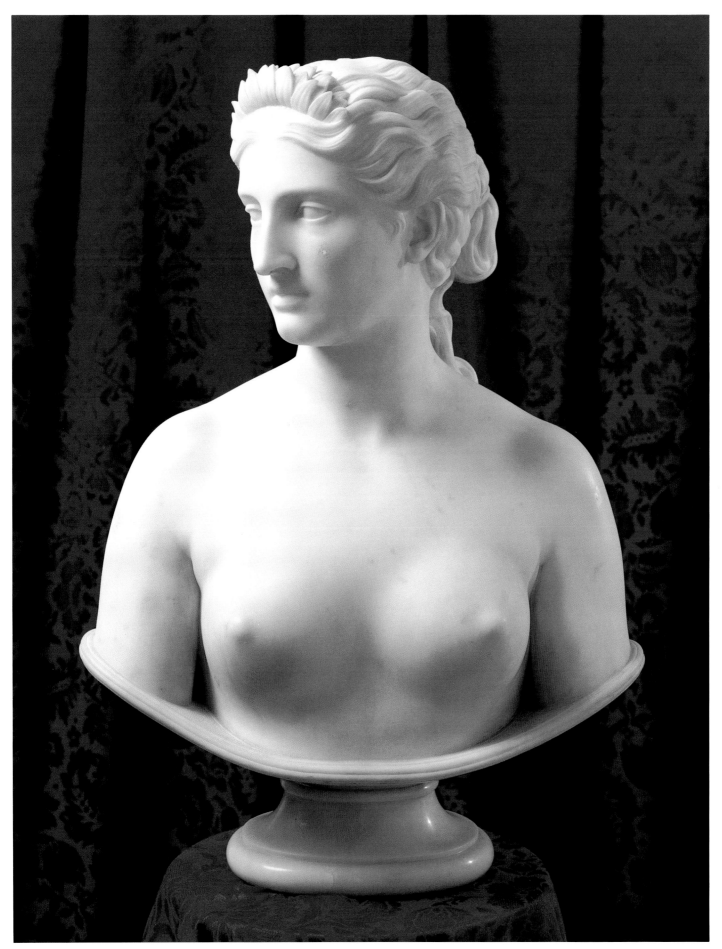

Cat. no. 13 Powers, *Bust of Clytie*

FIG. 39 The parlor of the Gardner Brewer House, Boston (with Powers's *Clytie*). Photograph, Gift of Mrs. George Lyman, 1916, courtesy of the Society for the Preservation of New England Antiquities

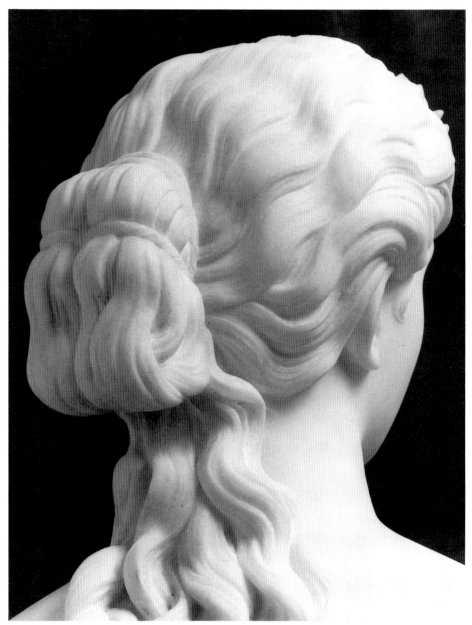

FIG. 40 Powers, *Bust of Clytie*, detail of hair

priation, in which the head is turned down in much the same manner as the classical work (cat. no. 50), Powers posed his *Clytie* in a manner similar to his *Hope*, which was also in progress (cat. no. 16). Honoring the spirit of the prototype in the British Museum, the general appearance of the hair is comparable, although Powers made just enough alterations, especially in the loose knot and ringlets at the back, to differentiate his concept from the original (fig. 40). In affirming his creativity, the sculptor replaced the countenance of his primary source, substituting the bathetic expression with his preferred neutral gaze. He also subtly modulated the facial type to distinguish it from his existing works. He adorned the hair with a tiara of sunflower petals, endowing the work with its iconographic identity. The distinctive flamelike appearance of the petals and hair at the temples visually connects the motif to the flame attribute of Powers's concurrent *Charity* (cat. no. 15).

What standard Powers set for himself is difficult to fathom, given his boast that *Clytie* was his best ideal bust to date. He employed the subtlest of nuances to generate an original piece and amplified its importance with his enthusiasm. Patrons did not suspect the creative enervation and failed to distinguish among the plethora of closely aligned busts, since *Clytie* enjoyed modest popularity, with at least ten replicas ordered.[4]

Notes

1. For a more complete treatment of the story of Clytie and its relation to American sculptors, see cat. no. 50 on William Henry Rinehart's full-length *Clytie*.

2. Powers to Gardner Brewer, Jan. 28, 1866, Powers papers, AAA, roll 1143, frame 138.

3. See cat. no. 50 on Rinehart's *Clytie*, for a more detailed discussion of this antique sculpture.

4. Wunder 1991, 2:129–130.

14
Bust of Faith
Modeled ca. 1866–67
Marble
$28\frac{1}{2} \times 19\frac{5}{8} \times 12\frac{1}{8}$ in. (72.4 × 49.9 × 30.8 cm)
Inscribed at rear: *H. Powers / Sculpt.*

Provenance [Flemming]; James H. Ricau, Piermont, N.Y., by 1967

Exhibition History *The Ricau Collection*, The Chrysler Museum, Feb. 26–Apr. 23, 1989

Literature Strahan 1879–82, 2:97, 3:91; Reynolds 1977, p. 1084; Jan Seidler Ramirez, *Faith*, in BMFA 1986, pp. 38–40; Wunder 1991, 2:144–146

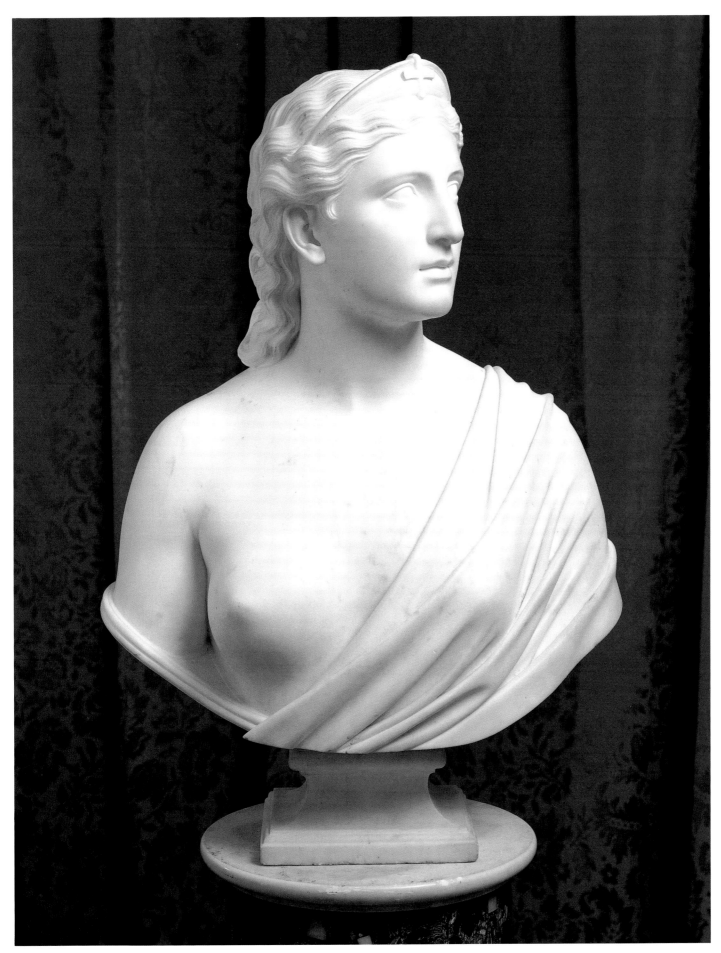

Cat. no. 14 Powers, *Bust of Faith*

Versions PLASTER National Museum of American Art, Washington, D.C.; MARBLE American Red Cross National Headquarters, Washington, D.C.; Mount Holyoke College Art Museum, South Hadley, Mass.; New York Society Library, New York; The Saint Louis Art Museum; The Valentine Museum, Richmond, Va.; Estate of James H. Ricau, Piermont, N.Y.; [Ramon Osuna, New York]; [Christie's, New York, Mar. 16, 1994, lot 55]

Gift of James H. Ricau and Museum Purchase, 86.500

The completion period for this bust and its two companions (*Charity* and *Hope*, cat. nos. 15, 16) was inordinately protracted. As early as 1852, Marshall Woods of Providence, Rhode Island, asked Powers to create a pair of busts of new subjects. Woods, in Paris at the time, also commissioned casts of his daughter's and wife's hands and, through Powers, ordered a statue of his young son to be executed by one of Powers's Italian assistants, Odoardo Fantacchiotti (1809–1877).[1]

Since his wife's frail condition concerned him, Woods expressed his desire to have at least one of the busts when he returned to America in 1854.[2] The order languished, however, and it was not until 1866 when the commission was enlarged to encompass the three Heavenly Graces, Faith, Hope, and Charity, at a cost of one thousand dollars each, that Powers finally became motivated.[3] Although Woods commissioned a full set, Powers, true to his business sense, sold replicas individually. Consequently, full sets are extremely rare, and Ricau possessed two, including the original group commissioned by Woods.

Once the agreement between sculptor and patron was formalized, Powers immediately set to work on *Faith*. By August 1866 he reported that the model was nearly completed, with the exception of the hair ornament. Progress bogged down, however, and the tiara with Greek cross was not finished for another year. The bust was not shipped to Leghorn, Italy, for export to Rhode Island until July 3, 1868. *Faith* attracted an enthusiastic response, and at least twenty replicas were ordered, making it the most desired of the trio.

Although *Faith* constituted a Christian variant on his ideal secular themes, Powers adhered to a standard type of ancient imperial portrait bust.[4] The garment partially covering the upper torso, the hair pulled back and parted in the middle, the slight profile of the head, and the dignified expression convey an appropriately divine image. She also looks upward, perhaps to the divine light, as if radiating heavenly thoughts. Given the profusion of ideal busts that originated in Powers's studio, the basic vocabulary varied little; only the attribute provided the specific identity.

The sculptural embodiment of virtues was in vogue by the early 1850s and may have received some impetus from contemporary literature. Sylvester Judd's novel of 1845, *Margaret* (rev. ed., 1851), contains the story of a young sculptor and his patronage. It has often been cited with regard to the preference for statues of the virtues rather than personages in the commissioning of sculpture.[5] Among the first to respond to this new attitude was Erastus Dow Palmer (q.v.), who created a bas-relief of Faith in 1851–52 (St. Peter's Church, Albany, N.Y.). Depicting a young woman with clasped hands, looking up at a cross, the composition reverberated with a sentiment that reflected the taste of the day. The relief's popularity was magnified through photographs, which adorned many middle-class parlors.[6] Palmer earned similar accolades for his representations of Mercy and Supplication (AIHA).

The association of virtues with women was customary in the Victorian era, and their translation into sculptural form constituted a recognition of esteem. This point of view was reinforced in contemporary literature, where sculpture was assigned an elevated and respected role. In the wake of the Civil War, however, there was a shift from the consideration of beauty and symbolism in sculpture to its utilization as a vehicle for social commentary. William Dean Howells, who was keenly attuned to sculpture through his brother-in-law, Larkin Mead (q.v.), embraced this attitude in *The Rise and Fall of Silas Lapham* (1885), in which the protagonist adorned his ostentatious drawing room with statues of Faith and Prayer. Although their initial inclusion served an ironic purpose, they assumed major significance later in the novel, when they were the sole remnants of Silas's possessions after his disastrous financial reverses. Even in satire, Howells declined to challenge the boundaries of propriety.

Powers created his ensemble with the earlier, more uplifting context in mind, and he confirmed this intention in an interview of 1869: "*Hope* was the bud, *Faith*, the flower, *Charity*, the fruit; and so he tried to make his heads—*Hope*, cheerfully expectant, but not in possession; *Faith*, calmly assured, more rapt and exalted, having attained; *Charity* should be the diffusion of what *Faith* has acquired, and her figure would still be different."[7] Even in the final phase of his career, when his creative energies had been sapped, Powers persisted in generating a poetic context for his work.

Notes

1. Wunder 1991, 1:329.
2. Marshall Woods, Paris, to Powers, Feb. 12, 1853, Powers papers, AAA, roll 1156, frames 507–508.
3. Wunder 1991, 2:144.
4. Ramirez's entry in BMFA 1986, pp. 38–40, offers a concise discussion of sources.
5. Thorp 1965, p. 4; Curtis Dahl, "Sculpture in Victorian Fiction," *Nineteenth Century* 7 (Summer 1981), 47; and Ramirez, *Faith*, in BMFA 1986, p. 40.
6. Thorp 1965, p. 147.
7. Henry W. Bellows, "Seven Sittings with Powers, the Sculptor," *Appleton's Journal of Literature, Science, and Art* 1 (1869), p. 597.

15
Bust of Charity

Modeled 1867, carved ca. 1871
Marble
29 × 19⅞ × 13⅜ in. (73.7 × 50.5 × 34 cm)
Inscribed at rear: *H. Powers / Sculp.*

Provenance [Flemming]; James H. Ricau, Piermont, N.Y., by 1967

Exhibition History None known

Literature Strahan 1879–82, 2:97; Reynolds 1977, p. 1085; Wunder 1991, 2:127–129

Versions PLASTER (head only and full bust) National Museum of American Art, Washington, D.C.; MARBLE Estate of James H. Ricau, Piermont, N.Y.; J. B. Speed Museum, Louisville, Ky.; The Newark Museum, Newark, N.J.; American Red Cross National Headquarters, Washington, D.C.; The Valentine Museum, Richmond, Va.; [Raydon Gallery, New York]

Gift of James H. Ricau and Museum Purchase, 86.502

In 1852 Hiram Powers did not respond immediately to Marshall Woods's request for a pair of ideal busts whose subjects he had not previously treated. It was not until 1866 when Woods, a gentleman from Providence, Rhode Island, returned to Florence and expanded the order to three busts interpreting the three Heavenly Graces that Powers gave serious attention to the commission. *Charity* was the last of the trio that Powers undertook. He commenced the model in the summer of 1867, but work on it languished and the marble version was not shipped with the other two in the summer of 1868.[1] In a letter to Woods, the sculptor explained that the bust of *Charity* needed more

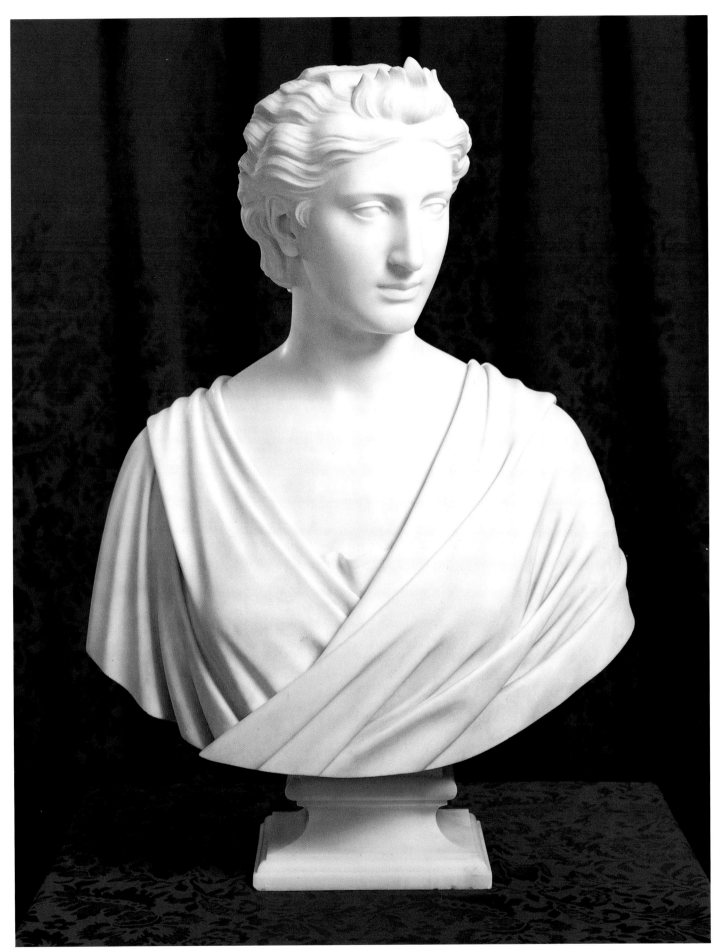

Cat. no. 15 Powers, *Bust of Charity*

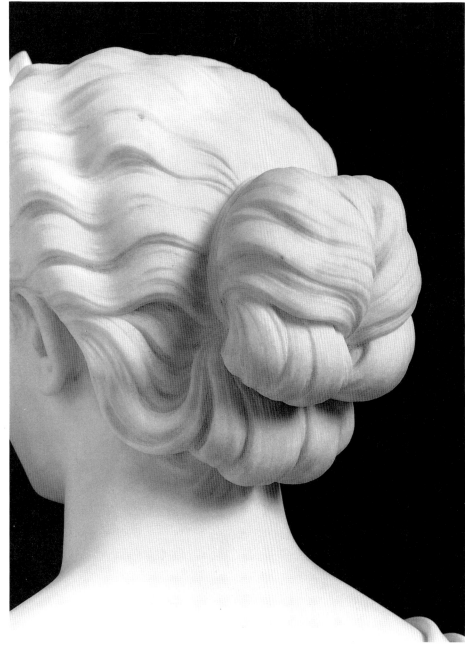

FIG. 41 Powers, *Bust of Charity*, detail of hair

Middle Ages.[2] The attribute was prevalent in the history of art, and Powers needed only to go to the church of Santa Maria Novella in his adopted city to see *Charity* wearing a flaming crown in a fresco by the Renaissance master Filippino Lippi. For Powers, *Charity* "should be the diffusion of what *Faith* has acquired."[3] In this piece the flame embodied this convective element.

Given the stage in his career when Powers conceived this work and its protracted gestation period, *Charity* attests to the sculptor's popularity. Demand for this work contributed to the bustle of his workshop, since he had orders for as many as nine replicas. The Ricau version might be the one ordered by James R. Nichols of Boston in 1871.[4] There are only two other replicas unaccounted for, and since they were allocated to family members, they may still be in the possession of descendants.

Notes

1. Wunder 1991, 2:128.
2. Guy de Tervarent, *Attributs et symboles dans l'art profane, 1450–1600* (Geneva, 1958), p. 184.
3. Henry W. Bellows, "Seven Sittings with Powers, the Sculptor," *Appleton's Journal of Literature, Science, and Art* 1 (1869), p. 597.
4. Wunder 1991, 2:128.

16
Bust of Hope

Modeled 1866
Marble
28 × 19⅜ × 12 in. (71.1 × 49.2 × 30.5 cm)
Inscribed at rear: *H. Powers / Sculpt.*

Provenance [Flemming]; James Ricau, Piermont, N.Y., by 1967

Exhibition History *The Ricau Collection,* The Chrysler Museum, Feb. 26–Apr. 23, 1989

Literature Strahan 1879–82, 2:97; Reynolds 1977, p. 1085; Wunder 1991, 2:177–179

Versions PLASTER (head only and full bust) National Museum of American Art, Washington, D.C.; MARBLE American Red Cross National Headquarters, Washington, D.C.; National Museum of American Art, Washington, D.C.; The Brooklyn Museum, Brooklyn, N.Y.; Estate of James H. Ricau, Piermont, N.Y.; The J. Paul Getty Museum, Malibu, Calif.

Gift of James H. Ricau and Museum Purchase, 86.501

refinement. He finally shipped the replica in June 1871.

Given the position of the head and the symmetrical arrangement of the costume, Powers intended *Charity* to be flanked by *Faith* and *Hope* (cat. nos. 14, 16). She is the most demurely garbed, with both shoulders draped in a Greco-Roman himation that crosses at the sternum. Further modesty is provided by the hemmed undergarment that masks the décolletage. The folds of the drapery are blockier and more massive than in the other two busts, which reinforces its centrality. A concern for unity is also apparent in the treatment of the hair, which conforms to that of its

companions, although the knot in the back is tighter and less pendulous (fig. 41).

The sculptor's legerdemain comes to the fore in the conception of this bust. *Charity* bears a strong resemblance to the recently completed *Clytie* (cat. no. 13), particularly with regard to the pose, facial type, and crown of flamelike sunflower petals. To satisfy his patron, Powers reversed the pose, clothed the figure, and modified the hair to secure his new invention.

In dealing with the iconography (which may have been the bane of his "refinement"), Powers adopted the venerable flame motif associated with divine love and connected to Charity since the

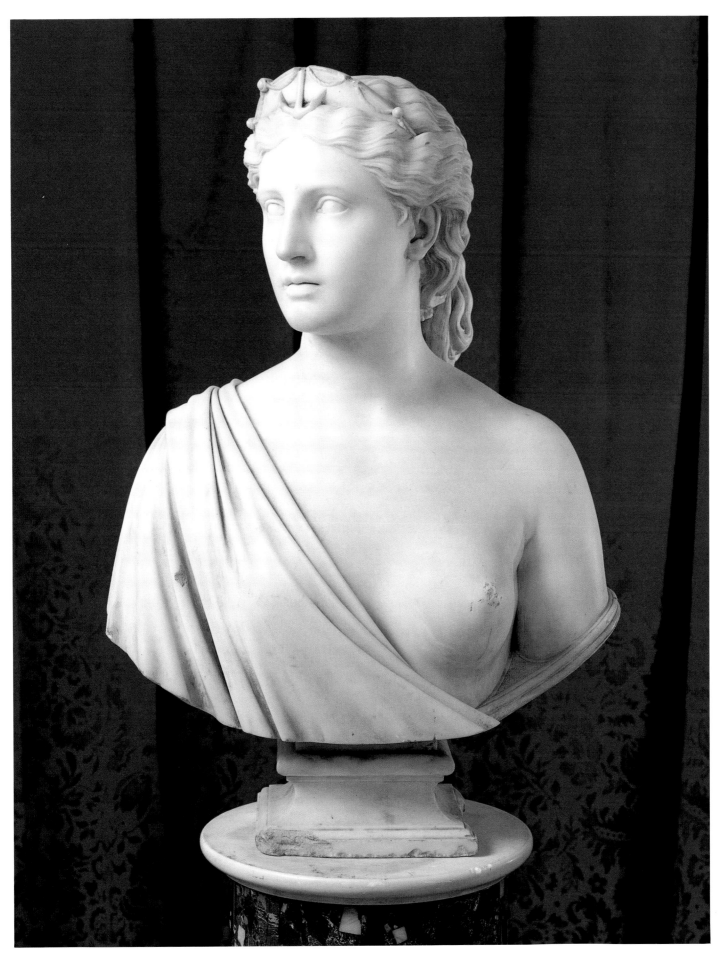

Cat. no. 16 Powers, *Bust of Hope*

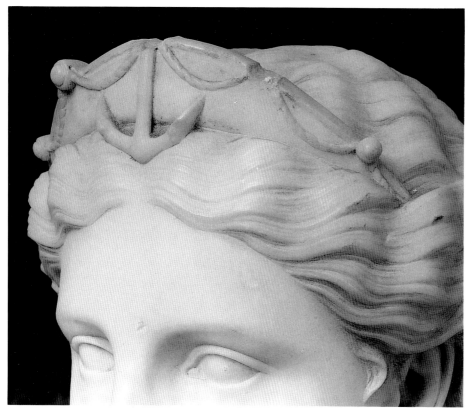

proved significantly less compelling with the buying public, since no more than eleven replicas (or half the number of *Faith*s) were ordered.

Ricau retained the original set of *Faith, Hope,* and *Charity,* while the Museum acquired the second set. It is possible the Museum's version of *Hope* was ordered by either E. H. R. Lyman of New York, H. P. Kidder of Boston, or Jacob Richards Dodge of Nashua, New Hampshire.[4] The first two gentlemen took delivery of busts completed in the sculptor's lifetime, whereas Mr. Dodge's order was finished posthumously. Given the disciplined nature of Powers's studio operation, this would have had little bearing on the quality of the final product.

Notes

1. Powers to Marshall Woods, Mar. 8, 1866, Powers papers, AAA, roll 1145, frame 1225.
2. Wunder 1991, 2:177.
3. Henry W. Bellows, "Seven Sittings with Powers, the Sculptor," *Appleton's Journal of Literature, Science, and Art* 1 (1869), p. 597.
4. Wunder 1991, 2:178–179.

17
Portrait of Emily Stevenson Davis Harris

Modeled 1867, carved 1867–68
Marble
26¾ × 18¼ × 10½ in. (68 × 46.4 × 26.7 cm)
Inscribed at rear: *H. Powers / Sculp.*

Provenance Mr. and Mrs. Caleb Fiske Harris, Providence, R.I., until 1881; . . . ; James H. Ricau, Piermont, N.Y.

Exhibition History *The Ricau Collection,* The Chrysler Museum, Feb. 26–Apr. 23, 1989

Literature Wunder 1991, 2:51

Version PLASTER National Museum of American Art, Washington, D.C.

Gift of James H. Ricau and Museum Purchase, 86.498

As mentioned in the entry on *Faith* (cat. no. 14), Marshall Woods's request for two ideal pieces went unanswered for fourteen years. When he returned to Florence in March 1866, he rekindled his enthusiasm and reached an agreement with Hiram Powers for three busts of the Heavenly Graces. *Hope* was the first of the trio to be completed, and it was shipped to America on July 15, 1866.[1] Powers's speed in executing this order demonstrates how efficient he could be when the situation warranted.

Faith and *Hope* were apparently conceived as the flanking works of the trio, since they virtually mirror each other. The poses and treatment of the drapery are, with certain exceptions, reversed. *Hope*'s head is turned and her gaze is leveled at *Faith* and *Charity* rather than heavenward. Her drapery falls in a more acute angle across her chest, while the folds are less complex and deeply channeled. Her eyes are not as wide open, and her expression is more subdued. The hairstyles—parted in the middle, pulled back tightly, and gathered into a loose fall—are nearly identical in both, as is the basic tiara. The sculptor superimposed a more elaborate motif to identify *Hope,* as he suspended the traditional anchor from a rope attached to the tiara by five evenly spaced bosses (fig. 42). Why he found

it so difficult to replace this with the Greek cross to identify *Faith* remains a puzzle.

Recent scholarship connects *Hope* with the *Bust of America,* which Powers created between 1850 and 1854 (cat. no. 8). *Hope* has similar drapery but totally original facial features.[2] Although the drapery is comparable, there are discernible differences. The garment, a Greco-Roman himation common to Powers's ideal busts, falls across the chest in more of a curving arc, and there are more folds at the base than are found in *America.* While *Hope*'s hair is parted and pulled back in a corresponding manner, it is gathered into a knot that does not fall onto the neck. *Hope*'s tiara has a gentle arc rather than the peaked apex of the earlier crown. The subtle shades of difference among Powers's ideal busts confirm his mastery of the infinite variations on a theme.

In discussing the three pieces, Powers adopted a floral metaphor and envisioned *Hope* as the bud, with *Faith* the flower and *Charity* the fruit.[3] He deemed *Hope* "cheerfully expectant," but this is not a sentiment conveyed by the sculpture's severe and subdued expression. In accommodating the tenor of the times with its preference for moral virtue, Powers opted for an understated approach in his *Hope.* Whether this restraint, compared to the more emotive *Faith,* was the cause, *Hope*

HIRAM POWERS quickly established a reputation for portraiture. From the outset he was admired for his faithful depiction of an individual's features. The sculptor also received special praise for an uncanny aptitude to interpret character. In explaining his approach, Powers subscribed to the age-old dictum that the face was the true index of the soul, with the eyes as windows and the mouth as door. He asserted it was the artist's mission to decipher the text written on the face.[1] In addition to a keen sense of observation, Powers maintained that intuition constituted a crucial component of this process.

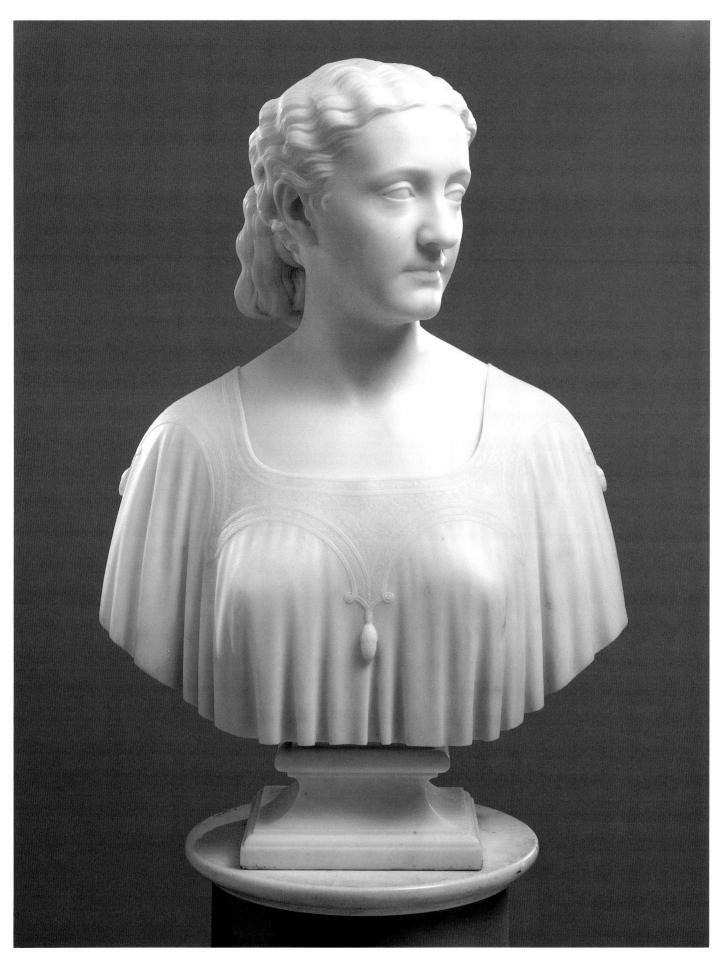

Cat. no. 17 Powers, *Portrait of Emily Stevenson Davis Harris*

The determining factor, however, was talent to translate these elements into sculptural form.

Powers's technical skills contributed enormously to his success, especially his ability to manipulate the marble's surface to achieve an elastic musculature and the convincing look of flesh.[2] His visual acuity retained a down-to-earth aspect that impressed one viewer: "He is a shrewd observer of men and manners, with a keen perception of the ludicrous; and relates, with admirable humor, the odd traits of character and manner, which are exposed to the glance of an artist."[3] Even in the twilight of Powers's career, American travelers were eager for him to create their portraits.

When Ricau bought this bust, he thought it was a portrait of Powers's daughter Louisa, or "Loulie." This identification appeared highly plausible in connection with the known portraits of Louisa Greenough Powers Ibbotson (fig. 43) and her younger sister Anna Barker Gibson Powers done around 1862 (NMAA).[4] Recent comparison of the Ricau bust with the Powers plasters at the National Museum of American Art (fig. 44) identifies it as the previously unlocated portrait of Emily Stevenson Davis (Mrs. Caleb Fiske) Harris, and details such as the dress and the wavy hair provide conclusive evidence.[5]

In 1867, when Mr. and Mrs. Caleb Fiske Harris commissioned Powers to execute their likenesses, the venerable sculptor was beginning to feel the toll of advancing years. He lamented his growing disinclination to correspond or converse and realized that he would not make the often contemplated return to his beloved America. The year was relatively quiet in terms of original production. Those of the Harrises seem to be the only portraits Powers initiated. In addition to his final major effort, *The Last of the Tribes* (NMAA), his other novel work centered on the ideal busts *Clytie, Faith,* and *Charity* (cat. nos. 13, 14, 15). This comparative dearth of output may have been due to Powers's preoccupation with the construction of his villa and studio outside the Porta Romana.

Mr. and Mrs. Harris sat for Powers in the spring of 1867, and the modeling was completed by the middle of June. Although Powers hoped to deliver the finished busts by Christmas, he did not keep this promise. He was under no pressure from Caleb Harris, who, in remitting partial payment, indicated that he was in no hurry to receive the busts.[6] Powers took him at his word, and the completed busts were not delivered for some time: *Emily Harris* in October 1868 and *Caleb Harris* the following April.[7]

The Harris commissions were among Powers's most challenging. In an article entitled "The Perception of Likeness," published in 1855, Powers articulated some of his reasons why women were poor judges of their husbands' portraits, noting that contrary to widespread opinion, wives often were so sensitive to their husbands' expressions that it was difficult to achieve full satisfaction since women would take issue with the slightest deviation they perceived.[8] Moreover, this concern for expression was compounded when both likenesses were taken, and

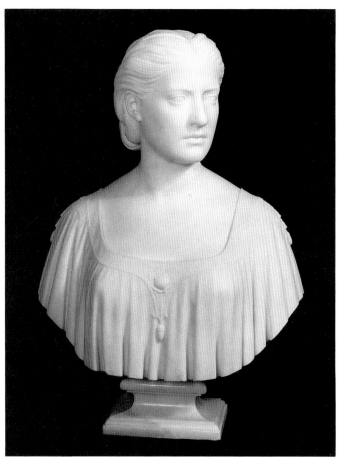

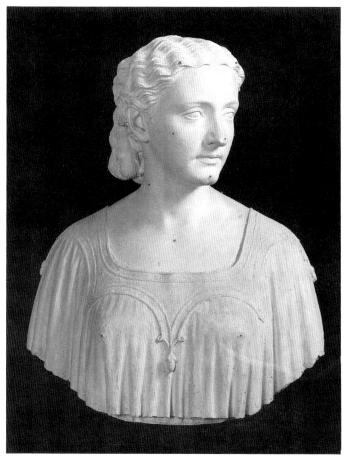

FIG. 43 Hiram Powers, *Portrait of Louisa Greenough Powers Ibbotson,* 1862. Marble, 28¼ in. (71.8 cm) high. National Museum of American Art, Smithsonian Institution, Museum purchase in memory of Ralph Cross Johnson, 1968.155.64

FIG. 44 Hiram Powers, *Portrait of Emily Stevenson Davis Harris,* 1867. Plaster, 23 in. (58.4 cm) high. National Museum of American Art, Smithsonian Institution, Museum purchase in memory of Ralph Cross Johnson, 1968.155.70

the sculptor had to contend with criticism of both parties, which persisted until the final sitting.

Little is known about Emily Stevenson Davis Harris. A Philadelphian by birth, she married Caleb Fiske Harris in 1866. Presumably their European sojourn was a wedding trip. She perished with her husband in a boating accident in 1881, leaving no children.[9] Caleb Harris, a native of Warwick, Rhode Island, was a successful New York merchant who developed a taste for art and early printed books.[10] The small amount of information about the couple shows them to be typical of the wealthy merchant class that generated such a great demand for portraiture in the mid-nineteenth century.

Emily Harris is depicted wearing a type of tunic frequently used by Powers. Edged at the collar and banded at the shoulders and chest in wide scallops with tassels providing further decoration, it evokes a Renaissance costume. She looks to her left, and since her husband looks to his right, there was, undoubtedly, specific consideration given to their eventual placement. Concerning this issue, Powers often gave advice about placing a bust with regard to lighting, advising one patron, "The light in which the bust should stand should be single, and a little above it, so as to cast the necessary shadows upon the features—otherwise the expression will be lost—a little experimenting will prove what light is best."[11]

Emily Harris's wavy hair is pulled back to reveal her forehead and ears, and, in the manner of the antique, the locks are gathered, looped under and tied with a ribbon (fig. 45). It has been suggested that Powers focused special attention on particular features of his female sitters to accommodate his interest in phrenology.[12] In his commitment to address sexual identity, the sculptor considered the conventional feminine faculties associated with "domestic affections," but in emphasizing the forehead, he indicated the existence of such capacities as intellectual prowess. Revealing the ears was also a signal of mental capacity and reinforced Powers's intention to accord greater profundity to his female subjects.

The choice of loose-fitting garments also had phrenological implications, since advocates such as Powers considered the modern-day corset to be the bane of healthy vital organs. Consequently, the sculptor's choice of garment served a twofold purpose: it provided an association with earlier styles of dress, whether antique or Renaissance, and it enabled Powers to apply his scientific beliefs to sculpture. Whether the Harrises were

FIG. 45 Powers, *Portrait of Emily Stevenson Davis Harris,* detail of hair

aware of the full extent of Powers's ideas is unknown, but when the bust of Emily Harris arrived in Providence in the fall of 1868, Caleb Harris, in acknowledging its receipt, said his wife was especially pleased with the drapery design.[13]

Powers's rendering of the facial features testifies to his acclaim as a master of the portrait genre. There is convincing accuracy of physiognomy. Certain components, such as the seemingly large nose, underscore an unflinching objectivity. The sculpture provides a remarkably convincing illusion of flesh and musculature. He also imparts some of the intangible elements of character that he read in his sitter's face. Strength coupled with compassion, a gentle assertiveness, and an alertness that indicates a keen mind are

brought to the fore. In his consummate handling of marble and understanding of anatomy and personality, Powers has created a work that both probes and engages.

Notes

1. These ideas were articulated as early as 1845 in Lester 1845, 1:65–66.

2. Hillard 1853, 1:179.

3. Ibid.

4. Wunder 1991, 2:55, 83.

5. Ibid., 2:51.

6. Caleb Fiske Harris, Paris, to Powers, June 18, 1867, Powers papers, AAA, roll 1143, frames 994–995.

7. Wunder 1991, 2:51.

8. Hiram Powers, "Perception of Likeness," *Crayon* 1 (Apr. 1855), 229–230. In the form of a letter, dated Jan. 13, 1851, this correspondence was originally intended for publication in the

Bulletin of the American Art-Union, which ceased publication with the demise of that organization in 1851.

9. "Accident at Moosehead Lake," *New York Times*, Oct. 6, 1881, p. 3.

10. "Caleb Fiske Harris," *The National Cyclopaedia of American Biography*, 56 vols. (New York, 1898–1984), (1932) 22:457.

11. Powers to James S. Wadsworth, July 22, 1858, Powers papers, AAA, roll 1159, frame 926.

12. Charles Colbert, "*Each Little Hillock hath a Tongue:* Phrenology and the Art of Hiram Powers," *Art Bulletin* 68 (June 1986), pp. 289–294.

13. Caleb Fiske Harris to Powers, Oct. 9, 1868, Powers papers, AAA, roll 1144, frames 354–355.

18
The Greek Slave

After Hiram Powers
Marble
44¾ × 15⅝ × 15⅞ in. (113.7 × 39.7 × 35.2 cm)
No inscription

Provenance James H. Ricau, Piermont, N.Y.

Exhibition History *The Ricau Collection,* The Chrysler Museum, Feb. 26–Apr. 23, 1989

Literature Samuel A. Roberson and William H. Gerdts, "'… so undressed, and yet so refined …': *The Greek Slave,*" *The Museum* (Newark), n.s., 17 (Winter–Spring 1965), p. 25; Reynolds 1977, p. 1076; Wunder 1991, 2:252

Version MARBLE private collection

Gift of James H. Ricau and Museum Purchase, 86.510

HIRAM POWERS's *Greek Slave* stood as one of the major achievements of American sculpture in the nineteenth century and enjoyed unprecedented public exposure and press. The sculptor's fame rested largely on his *Greek Slave*, which he completed in 1843 (fig. 46).[1] The cost of large statues was daunting, and during the next twenty-five years Powers executed only five more life-size replicas. Soon after Powers's death, his son Longworth directed the sculptor's two principal Italian carvers, Remigio Peschi and Antonio Ambruchi, to produce three additional authorized replicas two-thirds life-size. The fame and popularity of the sculpture created widespread demand for it in an affordable form. Therefore, *The Greek Slave* was soon marketed extensively on both sides of the Atlantic in Parian ware (a variety of porcelain), bronze, and plaster. In the twentieth century, *The Greek Slave* has been reproduced, presumably without authorization, in Carrara marble and alabaster by firms in Florence and Pisa, offering the customer a choice of nine reduced sizes.[2] Numerous other pirated versions infiltrated the market, and it is necessary to summarize the history of *The Greek Slave* to appreciate its enormous appeal.

In Powers's original sculpture, a virtuous Greek Christian woman—stripped of her clothes by her heathen Turkish captors and manacled at the wrists—turns her head in shame and resignation as she is sold into slavery in a Constantinople market. Among her discarded clothes are a cross and a locket, symbolic of her faith and the family she was forced to leave. In a letter of 1868, Powers confirmed that the sculpture's subject was taken from the war of Greek independence waged against the Turks from 1821 to 1830, and expressed his outrage at the debased treatment of the victims:

> It was several years after being in this city [Florence], and while thinking about some new work to be commenced that I remembered reading of an account of the atrocities committed by the Turks on the Greeks during the Greek revolution.… During the struggle the Turks took many prisoners, male and female, and among the latter were beautiful girls, who were sold in the slave markets of Turkey and Egypt. These were Christian women and it is not difficult to imagine the distress and even despair of the sufferers while exposed to be sold to the highest bidders. But as there should be a moral in every work of art, I have given to the expression of the Greek Slave what trust there could still be in a Divine Providence for a future state of existence, with utter despair for the present, mingled with somewhat of scorn for all around her. She is too deeply concerned to be aware of her nakedness.[3]

In the final replica that he sold to Edward Stoughton (1869, The Brooklyn Museum, Brooklyn, N.Y.), Powers substituted elaborate, ornamental chains for the original simpler, more symbolic manacles to reflect his antislavery stance.[4]

Although the design of *The Greek Slave* was influenced by two classical prototypes, the *Venus de Medici* (Uffizi Gallery, Florence) and *Venus of Cyrene* (Terme Museum, Rome), Powers also drew inspiration from a young girl who served as his model, the seventeen-year-old daughter of his wife's seamstress. Thus, the classical ideal was tempered with direct observation. Prudish Victorian audiences traditionally took a dim view of nudity in sculpture, but most viewers of *The Greek Slave* accepted and even applauded its nudity, which they felt was justified by the sculpture's lofty moral tone and the figure's plight. Several American clergymen praised the sculpture, noting that though the woman was naked, she was nonetheless "clothed in Christian virtue."

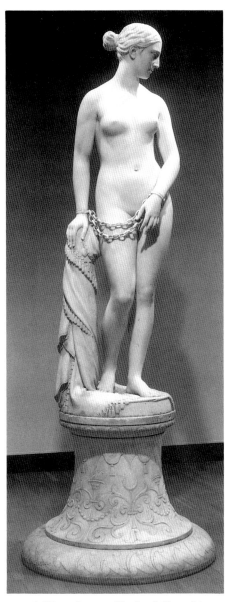

FIG. 46 Hiram Powers, *The Greek Slave*, this version carved 1851. Marble, 65½ in. (166.4 cm) high. Yale University Art Gallery, Olive Louise Dann Fund, 1962.43

In his letter to Stoughton, Powers wrote of the figure, "It is not her person but her spirit that stands exposed, and she bears it all as only Christians can." Abolitionists also praised the moral message of *The Greek Slave*, recognizing its veiled indictment of slavery in America. The universally positive response to *The Greek Slave* helped curb the prejudice against nudity in sculpture in mid-nineteenth-century America.

When one of Powers's replicas of the statue toured the United States beginning in 1847, it was enthusiastically applauded and brought the artist more than $25,000 in revenues. Another replica, shown with equal fanfare at the Crystal Palace Exhibition in London in 1851, solidified Powers's fame in Europe. In addition to

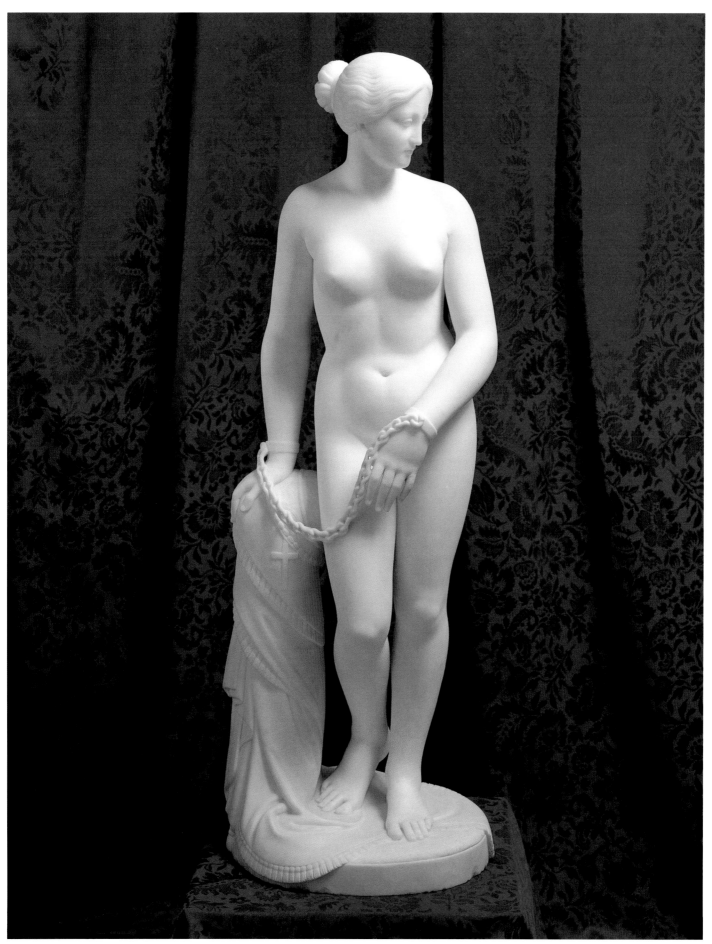

Cat. no. 18 After Powers, *The Greek Slave*

evoking rhapsodic responses in the press, *The Greek Slave* inspired a plethora of poetry, most notably Elizabeth Barrett Browning's sonnet.[5]

Thus, it is little wonder that replicas of this famous statue in any size and medium, in good, bad, and indifferent versions, flooded the market through the years. The authenticity of the Ricau *Greek Slave* was questioned as early as 1965, and it is excluded from the recent definitive study of productions that came out of Powers's studio either before or after his death.[6]

Comparison of the Ricau version with authorized replicas quickly reveals its shortcomings. Physically, there is little resemblance. The face of the Ricau version is broader, the nose less aquiline, and the chin less delicately defined. The torso is thicker, and the rib cage and abdomen are given a more muscular articulation. The transitions are much more abrupt, resulting in a clunkier, chunkier anatomy. The hands are almost grotesquely large in relation to the rest of the body and demonstrate none of the refinement of Powers or his studio. This is also true of the pedestrian treatment of details such as the chain, fringed drapery, and the cross. They all lack the crisp definition associated with the work of the master. The quality of the carving is not comparable, and this is readily apparent in the less accomplished treatment of the surface as well as the unconvincing sense of flesh. Given the remarkable fame of the statue and the demand for reproductions, it is not surprising that *The Greek Slave* would have been pirated by freelance artisans who were obviously indiscriminate.

Notes

1. The reader can derive a comprehensive overview of *The Greek Slave* from the following sources: Roberson and Gerdts, "*The Greek Slave*" (1965), pp. 1–32; Linda Hyman, "*The Greek Slave* by Hiram Powers: High Art as Popular Culture," *Art Journal* 35 (Spring 1976), 216–223; Vivien M. Green, "Hiram Powers's *Greek Slave:* Emblem of Freedom," *American Art Journal* 14 (Autumn 1982), 31–39; Michele Bogart, *The Attitude toward Sculpture Reproductions in America, 1850–1880* (Chicago, 1979); and Wunder 1991, 1:207–275.

2. Wunder 1991, 2:168.

3. Powers to Edward Stoughton, Nov. 26, 1869, Powers papers, AAA, roll 1144, frame 854.

4. Green, "*Greek Slave:* Emblem of Freedom," pp. 32ff.

5. Roberson and Gerdts, "*The Greek Slave*," pp. 15, 18ff.

6. Ibid., p. 25, and Wunder 1991, 2:232.

Photograph of Chauncey B. Ives. Photograph courtesy of the Archives of American Art, Smithsonian Institution

Chauncey Bradley Ives
American, 1810–1894

Chauncey Bradley Ives's vaunted reputation as a sculptor suffered from the vanishing market for his work, a situation that characterized the shifting attitude toward neoclassical sculpture in the second half of the nineteenth century. At midcareer the sculptor enjoyed such great prestige that a December 1860 article surmised that Ives, "in the full tide of success," would be among the American sculptors whose genius in modeling and marble working "will eventually place our [America's] genius near to that of the Hellenes, the remnants of whose works prove how matchless must have been their creations in marble."[1]

How markedly this prediction differs from Lorado Taft's dismissal of Ives's works at the turn of the century. He found them "trifling and weak in their conception" and the equivalent of "pre-eminently Italian commercial sculpture."[2] Although the sculptor did not live to endure this harsh assessment, he experienced evaporating demand for his work. During the peak of his career, there was a rich litany of transactions in Ives's account book. In contrast, Ives had to endure the postponement of an auction in 1891 due to lack of interest.[3] Despite this disappointing conclusion, Ives played a significant role in popularizing sculpture in America, and much of his success stemmed from his versatility. Ives imbued naturalism and flattery into his portrait busts, endowed his ideal pieces with an appropriate dig-

nity, and infused his genre pieces with an appealing sentimentality. Although he was acutely aware of the demands of his clientele, Ives simply outlived the taste for work steeped in neoclassical ideals.

Ives was born into a farm family in Hamden, Connecticut, north of New Haven. As with many families in the nineteenth century, including Harriet Hosmer's (q.v.), tuberculosis ravaged the Ives household, and young Chauncey lost four siblings to the pernicious disease. The combination of Chauncey's frail health and a preference for art over farming prompted Ives's father to apprentice his son to a woodcarver in New Haven, Rodolphus Northrup. Young Ives may have sought additional instruction from that city's leading practitioner in wood and marble, Hezekiah Augur (1791–1858), who was fast emerging as America's first professional sculptor.[4] Nearly ten years of tutelage provided Ives with a solid foundation in the art of carving, and by 1837 he was determined to establish an independent studio.

Ives moved to Boston and quickly achieved modest success. His initial effort was a copy of *Sir Walter Scott*, after Sir Francis Chantrey's (1781–1841) bust that Thomas H. Perkins had presented to the Boston Athenaeum in 1827.[5] The New York Apollo Association (later the American Art-Union) acquired this piece and distributed it as one of its annual lottery prizes in 1839. In the ensuing years, Ives sought broader exposure by exhibiting at the National Academy of Design in New York, the Pennsylvania Academy of the Fine Arts in Philadelphia, and the Boston Athenaeum.[6] The exhibition records, as well as Ives's account book, reveal the emerging sculptor's ability to attract such prestigious patrons as Governor Edward Everett of Massachusetts, Noah Webster, the architect Ithiel Town, Daniel Wadsworth, Lydia H. Sigourney, and Thomas Sully (1783–1872). The bust of Ithiel Town, carved in 1840 (YUAG), with its deep-set eyes, furrowed brow, wrinkles, and other naturalistic details, reflects the sculptor's objective approach in his portrait style.

Amid the promise of this unfolding accomplishment loomed the uncertainty of Ives's health. In 1841, while working in Meriden, Connecticut, the sculptor's vulnerable constitution alarmed a local doctor, who recommended that Ives relocate to a more temperate climate. Uncertain finances prevented him from acting on this prescription until 1844, when he received monetary assistance from several dedicated patrons to go to Italy for both his health and his art.

Initially, Ives settled in Florence. The presence of Horatio Greenough (1805–1852) as well as Lorenzo Bartolini (1777–1850) and the latter's doctrine of naturalism may have attracted Ives to this Tuscan city rather than to Rome.[7] Ives took classes at the Academy of Fine Arts, under the direction of Bartolini, and supported himself executing commissions for portrait busts. He also created some ideal busts. The first was *Beatrice*, carved in 1844, followed by *Jephtha's Daughter* and *Flora*. A milestone came in 1847 when Ives completed his first full-length ideal piece, *Boy Holding a Dove*, which heralded his appealing images of children (cat. no. 19).

It was a bust of a bacchante, modeled and carved in 1848 (private collection, New York), however, that garnered Ives his first popularity and financial success, since it was replicated eight times. This was followed by the even more popular *Ruth*, which elicited ten orders over the course of Ives's career (cat. no. 20). These achievements, coupled with steady demand for portraits, enabled Ives to commence another ambitious full-length piece in 1850, the first version of his *Pandora* (VMFA), which he modeled in Florence but did not translate into marble until after moving to Rome late in 1851.[8]

Ives's reasons for moving to Rome are not clear, but his growing commitment to ideal pieces provided ample incentive to seek a more sympathetic working environment. Whatever the cause, it proved to be an agreeable transfer, and Rome became his permanent home. Initially working in the courtyard of the American painter William Page's (1811–1885) house, Ives soon gravitated to the area populated by many of his compatriots.

Although there was a brief hiatus in requests for portraits, Ives embarked on several ideal works, including the allegorical statue *Flora* and the well-liked bust of *Ariadne* (cat. no. 21). His major triumph was the highly esteemed *Rebecca at the Well*, created in 1854 (MMA). Rebecca leans against a section of masonry wall and looks expectantly to her left. The serene idealization of her expression is marred by an ungainly handling of her arms and legs. This ineptitude is obscured by the detailed drapery, turban, and water vessel. Despite the shortcomings, the well-known biblical narrative and rich, ornamental detail appealed to Ives's audience, and the statue elicited twenty-four orders.

The sculptor's growing esteem attracted a fresh infusion of portrait commissions, including one for the wife of the sculptor Joseph Mozier (q.v.), who settled in Rome around the same time as Ives. Some of these commissions resulted from the first of Ives's numerous return visits to America. The sculptor also occupied himself with additional full-length works, such as the first version of *Undine Receiving Her Soul* (fig. 55), created in 1859 and ordered by the influential patron Marshall O. Roberts.

A wave of popularity and prosperity carried Ives into the next decade, and his output assumed a well-established pattern. In 1862 he began work on an ambitious, multifigure composition, *The Willing Captive* (cat. no. 22), and the following year he created two more popular works, *Sans Souci* (CGA) and the remodeled *Pandora* (cat. no. 23). Each work attracted at least fifteen orders and clearly articulated the two veins of Ives's creative lode. With its anecdotal quality and emphasis on a naive innocence, *Sans Souci*, in which a young schoolgirl is caught in a moment of fanciful reverie, appealed to the lighter side of Victorian taste. Its success may have inspired a mischievous sequel, *The Truant*, executed in 1871 (cat. no. 25). *Pandora*, on the other hand, reflected the sculptor's commitment to the purity of the neoclassical canon.

Ives's self-effacing temperament disposed him against seeking government commissions for public monuments; rather, the government sought him. With the death of Edward Sheffield Bartholomew in 1858 (q.v.), Ives emerged as Connecticut's most prominent sculptor. As a result, he was approached from several quarters to execute public sculptures. In 1867 Washington College (now Trinity College) in Hartford commissioned a bronze statue of its first president, Bishop Thomas Church Brownell, which was Ives's first major effort in the medium. The following year, the state ordered a marble statue of Jonathan Trumbull for the Statuary Hall in the United States Capitol. This was followed by one of Roger Sherman for the same hall. Eventually, the sculptor was asked to create larger-than-life replicas of these two Connecticut heroes for the capitol in Hartford. They were installed on each side of the central tympanum over the east entrance of the building.

In the 1870s the taste for neoclassical sculpture was on the wane, but Ives continued to produce work instilled with a prescribed formula. With the exception of *The Beggar Boy* of 1875, *Egeria* done in 1876 (VMFA), and *Undine Rising from the Waters* of 1880, which reinterpreted his initial version (cat. no. 27), Ives no longer enjoyed a predictably positive response to his every effort. In 1875 the first material harbinger of things to come presented itself when an auction of Ives's works in New York attracted less than brisk bidding, and a number of the most valuable pieces were withdrawn from sale.[9] He participated in the Centennial Exposition in Philadelphia by sending one of his latest mythological pieces, *Ino and Bacchus* of 1873 as well as busts of William Henry Seward (plaster, Senate House, State Historical Site, Kingston, N.Y.) and General Winfield Scott.[10] The neoclassical examples of Ives and his contemporaries were challenged by the visually vibrant efforts of a younger generation of sculptors. At this juncture, the effects of Ives's frail constitution began to take their toll, and, aside from the new *Undine*, original work virtually ceased. The studio continued to execute orders for replicas, but the creative spark had been extinguished. Undoubtedly, Ives's advancing years dictated a reluctance, if not inability, to adopt a fresh aesthetic viewpoint. During the balance of his life, Ives witnessed the sad and relentless decline of his reputation, which at one time had placed him at the pinnacle of Victorian-era artists. He died in Rome in 1894 and was buried in the Protestant cemetery there.

Notes

1. "Ives" (1860), p. 165. For the most recent account of Ives, see Gerdts, "Ives" (1968).

2. Taft 1924, p. 112.

3. A typescript of Ives's manuscript register is in the Ives file in the department of American painting and sculpture at the Metropolitan Museum of Art; for an account of the 1891 auction, see "Art Gossip. Sales Announced and Pictures Now on Exhibition," *New York Evening Telegram*, Mar. 19, 1891, p. 5.

4. Gerdts, "Ives," p. 714.

5. Harding 1984, p. 78.

6. Cowdrey 1943, 1:263; Rutledge 1955, p. 108; Perkins and Gavin 1980, p. 85.

7. Hyland 1985, pp. 262–265.

8. "American Artists Abroad," *Bulletin of the American Art-Union*, Apr. 1851, pp. 12–13, in a letter from S., dated "Florence, Jan. 20, 1851," reports on Ives's progress. His imminent departure for Rome is recorded in "Fine Arts," *Home Journal*, Sept. 27, 1851, p. 5.

9. "Sale of Statuary," *New-York Daily Tribune*, Jan. 15, 1875, p. 12.

10. Gerdts, "Ives," p. 718.

Bibliography

Taylor 1848, pp. 330–331; Greenwood 1854, pp. 222–225; Hawkes LeGrice, *The Artistical Directory; or Guide to the Studios of the Italian and Foreign Painters and Sculptors Resident in Rome* (Rome, 1856), p. 61; J. Beavington Atkinson, "International Exhibition 1862, No. VII: English and American Sculpture," *Art Journal* (London), n.s., 1, 24 (Dec. 1860), 250; "Chauncey B. Ives," *Cosmopolitan Art Journal* 4 (Dec. 1860), 163–164; Tuckerman 1867, pp. 582–585; Osgood 1870; French 1879, pp. 82–83; Benjamin 1880, p. 156; American Art Galleries, New York, *Catalogue of Important Sculptures by*

the Late C. B. Ives, Apr. 26, 1899; Taft 1924, pp. 112–113; William Todd, "Chauncey B. Ives, Sculptor," *Publications of the Hamden Historical Society* (Hamden, Conn., 1958), pp. 52–57; Gardner 1945, p. 67; William H. Gerdts, "Chauncey Bradley Ives, American Sculptor," *Antiques* 94 (Nov. 1968), 714–718; Craven 1984, pp. 284–288; Hyland 1985, pp. 262–265; Vance 1989, 1:260–261, 320

19
Boy Holding a Dove

Modeled 1847, carved after late 1851
Marble
39⅜ × 13¼ × 13¼ in. (100 × 33.7 × 33.7 cm)
Inscribed at right rear of base: C. B. IVES / FECIT ROMÆ

Provenance Mr. Sanford, Brooklyn, N.Y., by 1860; . . . ; [auction, New York]; James H. Ricau, Piermont, N.Y.

Exhibition History *The Ricau Collection,* The Chrysler Museum, Feb. 26–Apr. 23, 1989

Literature Taylor 1848, p. 330; "Chauncey B. Ives," *Cosmopolitan Art Journal* 4 (Dec. 1860), 164; Hyland 1985, p. 263

Versions None known

Gift of James H. Ricau and Museum Purchase, 1986.483

In a letter from October 1847 one of Chauncey Ives's Hartford patrons, Horace Bushnell, encouraged the sculptor by writing, "You are just beginning now to get out as a name before our American public. Go on and we will give you an equestrian statue of Washington or a Jupiter or something else one of these days. When the tide begins to flow, you will get on faster."[1] In reference to Jupiter, Bushnell may have been alluding to Horatio Greenough's (1805–1852) controversial monument to Washington in the guise of Jupiter, which put Ives into august company. While sensitive to the infancy of art patronage in America, Bushnell expressed confidence in Ives's future. These enthusiastic expectations exceeded even Ives's own goals, and the sculptor's first substantive effort was a harbinger of the more modest subject matter he preferred.

An entry in Ives's account book for 1847 lists "Group—Boy and Dove—Marble—Florence 1847." This establishes his earliest known life-size figurative piece.[2] The entry also indicates that the statue was sold to a Mr. Sanford of Brooklyn, New York, and that the model was destroyed.[3]

This information raises a number of vexing issues about the precise identification of this maiden effort and its connection to the piece in the Ricau Collection.

Part of the confusion arises from Ives's submission in 1847 of three works to the Pennsylvania Academy of the Fine Arts: a bust of Beatrice, a bust of Jephtha's daughter, and a sculpture entitled *A Child Receiving the First Impression of Death.*[4] All three pieces were listed as being for sale, and each was exhibited again at the Pennsylvania Academy in both 1848 and 1849. The conjecture arises: Was someone in Philadelphia acting on Ives's behalf? If so, was it Charles Chauncey, one of the financial backers of the sculptor's trip to Europe? Was the plaster being exhibited? Or had Ives gambled by translating it into marble? Can the piece in Philadelphia be connected with the one in Ives's account book? Of these several questions, the last one can be answered with some confidence.

The statue entitled *A Child Receiving the First Impression of Death* can be connected with the *Boy and Dove* that Ives referred to in his account book. Bayard Taylor, the poet and author, confirmed this association in *Views A-Foot,* the record of his trip through Europe published in 1848. In recounting his visit to Ives's studio in Florence, Taylor commented favorably on two recently completed models:

> One of these represents a child of four or five years of age holding in his hand a dead bird on which he is gazing with childish grief and wonder that it is so still and drooping. It is a beautiful thought. The boy is leaning forward as he sits holding the lifeless playmate close in his hands, his sadness touched with a vague expression, as if he could not yet comprehend the idea of death.[5]

Taylor surmised that this statue and another model he saw, the bust of Jephtha's daughter, would greatly enhance Ives's reputation in America, thus echoing Bushnell's private utterance. The sentence addressing the young lad's inability to understand the notion of death provides the most compelling point of contact, especially since titles of artworks have continually undergone marked transformations. Moreover, what Ives entered in his account book may have been for personal reference and would not have necessarily carried the poetry or polish of a more calculated title intended for a public audience.

Although Taylor's account clarifies the identity of this early work, one has to stretch his description of the boy sitting and leaning forward to conform to the somewhat innocuous way that the youth

rests on the tree trunk and tilts his head forward. Accepting this premise, the question still remains as to what Ives exhibited in 1847 in Philadelphia and its relation to the Ricau piece. Connecting these two works is complicated since Ives supposedly modeled the statue in Florence, sold the statue, and destroyed the model. The Ricau work is inscribed as having been made in Rome, where the sculptor moved in 1851. Once again, any plausible theory carries substantial speculative baggage.

At least two possibilities present themselves. First, Ives did not destroy the model until after he moved to Rome, where he produced a second, unrecorded replica. Second, Ives sent the plaster to America and did not translate it into marble until after 1851, having received an order through its exposure in America. If Ives modified the composition when he got to Rome, a visit to the Vatican collections may have proved influential, since he could have seen several antique sculptures depicting young children holding birds. Whether these issues can be resolved remains to be seen, but scrutiny of the Ricau statue will confirm its place early in Ives's oeuvre.

One theory is that Ives may have been inspired by Lorenzo Bartolini's (1777–1850) contemporaneous ideal bust, *Child with a Dead Bird* (San Salvi, Florence), and that a shared symbolism centered on the loss of innocence.[6] In the Bartolini sculpture, which depicts a young girl holding a bird to her breast while she looks away, the subject articulates the loss of virtue. The Italian sculptor may have been responding to the conceit popularized by the eighteenth-century French artist Jean-Baptiste Greuze (1725–1805). Bartolini's approach is more abstract and rarefied than that of his American pupil. Ives's effort conveys a young boy's curiosity about the limp, inanimate object he holds, and the overall effect, while suffused with sentiment, is immediate and direct.

Befitting an early work, the composition is relatively simple. A young boy rests on an ivy-entwined tree stump that supports the sculpture from the back (fig. 47). He holds the dead bird in both hands, and with his right index finger supports its limp head while he gazes at the bird in bewilderment. The pose is natural and relaxed; the right leg bears the weight of the body, while the left is bent in repose. The boy is attired in a tunic of vertically ribbed material belted at the waist. A system of undulating folds conveys the material's pliancy. This attention to detail is also evident in the meticulous rendering of the bird's feathers and beak.

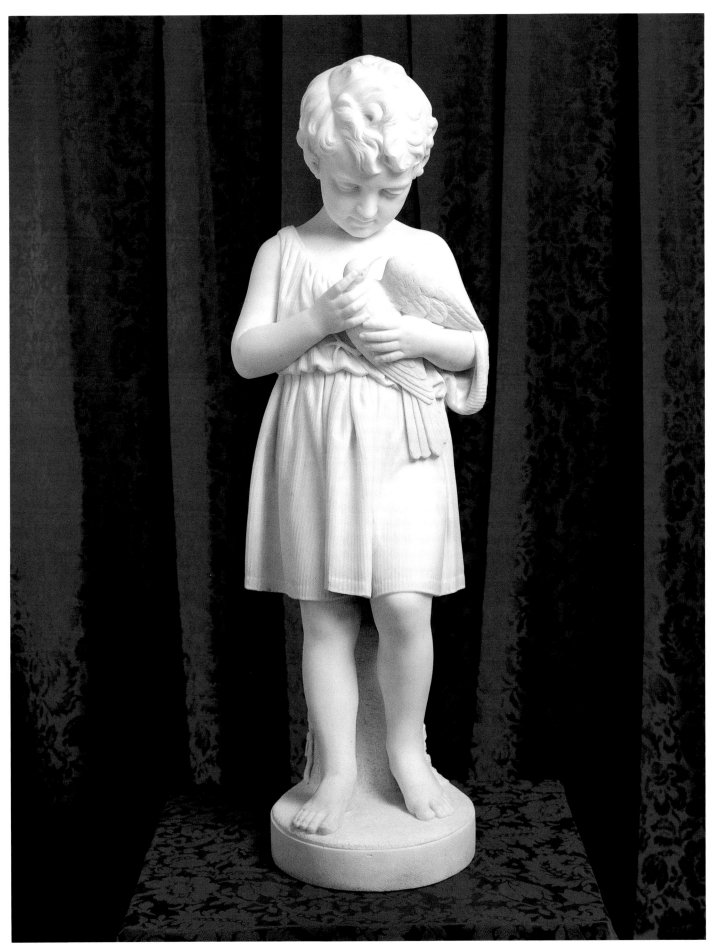

Cat. no. 19 Ives, *Boy Holding a Dove*

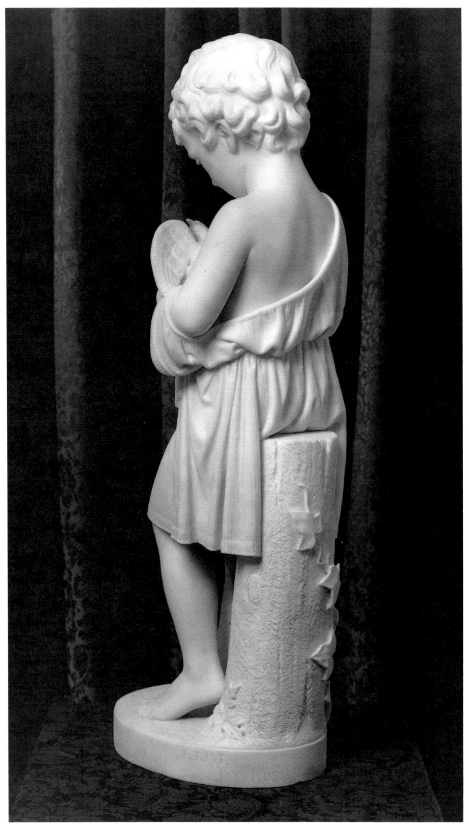

FIG. 47 Ives, *Boy Holding a Dove*, back view

The handling of the boy's body suggests an incipient departure from Bartolini's tenets of naturalism. The overall effect is graceful and elegant, conveying an ideal canon. The facial features are more refined than the typical pudgy countenance of a child of five or six. The delicate nose and crisply articulated eye sockets confirm this idealizing tendency, as do the hands that lack the customary chubbiness.

While much of the success of surface effect can be attributed to the abilities of Ives's assistants, there are one or two aspects in the design that reflect an awkwardness inherent in an early work. Most telling is the oversized head. It almost makes the sculpture top-heavy, and one can only assume that the fledgling sculptor had overstated the natural and not attuned his eye to an ideal canon of proportion. The other significant shortcoming concerns the youth's hair. Ives endowed the lad with a thick mass of curls detailed by fine striations within the locks that lack a convincing organic flow and assume the appearance of an awkwardly placed cap. This deficiency may relate to Ives's modeling, and these inept elements suggest that this work should be placed early in his career.

Notes

1. Horace Bushnell to Ives, Oct. 20, 1847, Ives autograph album, AAA, roll 3134, frame 614.
2. Ives, "Account Book," typescript, p. 3. The manuscript of this account book was said to be in the possession of Ives's great-granddaughter, the late Elizabeth Bartholet. At present it cannot be located, but there is a typed copy in the Ives file in the department of American painting and sculpture at the Metropolitan Museum of Art, New York.
3. Mr. Sanford's ownership is confirmed in the press as of 1860; see "Ives" (1860), p. 164.
4. Rutledge 1955, p. 108.
5. Taylor 1848, p. 330.
6. Hyland 1985, p. 263.

20
Ruth

Modeled ca. 1849
Marble
25¼ × 12½ × 9½ in. (59.1 × 31.8 × 24.1 cm)
Inscribed on back of pedestal: C. B. IVES. / FECIT. ROMÆ

Provenance [auction, New York]; James H. Ricau, Piermont, N.Y., by 1967

Exhibition History *The Ricau Collection,* The Chrysler Museum, Feb. 26–Apr. 23, 1989

Literature "The Fine Arts," *Literary World* 5 (Nov. 10, 1849), 407; "Chauncey B. Ives," *Cosmopolitan Art Journal* 4 (Dec. 1860), 164; "Fine Arts. The Ives Marbles," *New York Tribune,* Jan. 23, 1872, p. 5; "Mr. Ives's Statuary," *New-York Evening Post,* Jan. 13, 1875, p. 4; "Sale of Statuary," *New-York Daily Tribune,* Jan. 15, 1875, p. 12; "Art Notes," *Boston Daily Evening Transcript,* Mar. 19, 1887, p. 10

Versions [William Doyle Galleries, New York, Apr. 23, 1986, lot 3]; a total of eleven are listed in Ives's account book

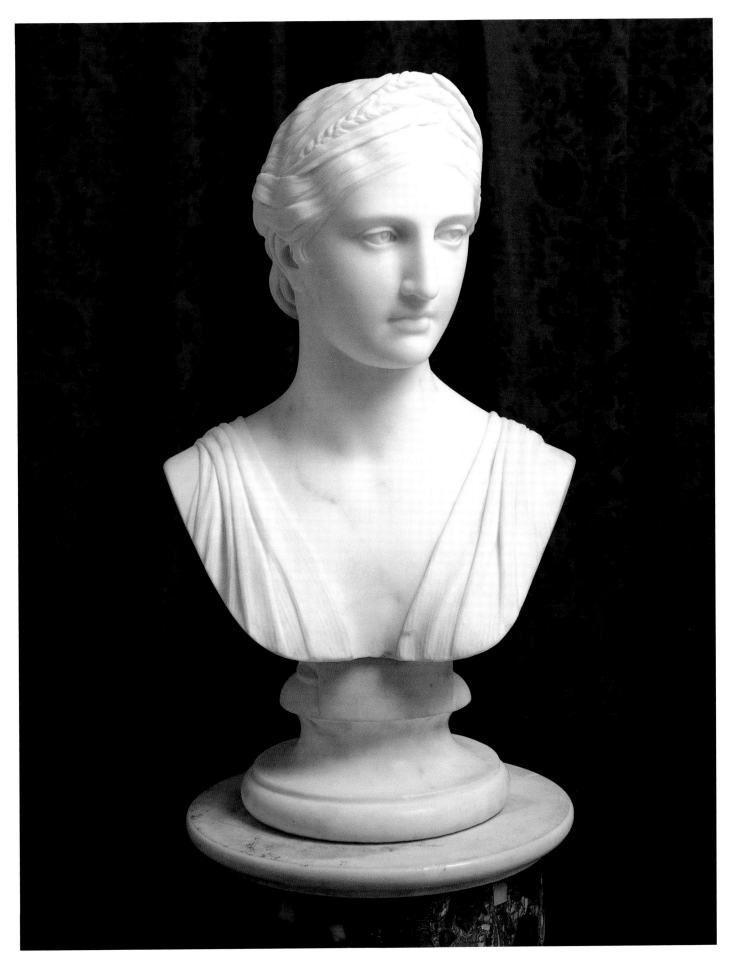

Cat. no. 20 Ives, *Ruth*

Gift of James H. Ricau and Museum Purchase, 1986.479

THE LITERARY WORLD reported in November 1849 that Chauncey Ives had recently arrived in New York to escape the political turmoil in Italy and had brought with him three ideal female busts.[1] The author identified these works as *Bacchante* (private collection), *Jephthah's Daughter*, and *Ruth* and commended the sculptor for "remarkable versatility of skill, as exhibited in the totally different yet characteristic expression of each."

Inspired by the Old Testament's book of Ruth, Ives, like many of his contemporaries, was afflicted with "Ruth fever."[2] The story of Ruth and Boaz centers on the moment when Ruth, working as a gleaner in the fields of the rich farmer Boaz, looks up and sees him for the first time. On the advice of her former mother-in-law, Naomi, who is related to Boaz, Ruth maintains a modest demeanor. She shows her devotion to Boaz only by lying at his feet as he sleeps in the field one night. Impressed by the qualities of her character, Boaz eventually takes Ruth as his bride.

Unlike the more specific *Ruth Gleaning* by Randolph Rogers, begun around the same time (cat. no. 52), Ives addressed a more generalized concept of modesty. So abstract was the meaning of the sculpture that for a long time the figure was identified as Ceres, based on the wheat motif in the hair.[3] Association with the mythological figure was erroneous, since the sculptor's account book contains no reference to a Ceres, while *Ruth* appears to be one of the last works Ives created before moving to Rome. Most persuasively, a newspaper article published in 1872 confirmed the identity of Ives's *Ruth* with its reference to the stalks of wheat entwined in her hair.[4]

Sensitive to Ruth's meekness, Ives designed the figure so she looks slightly to her left; thus, the pose is more restrained than that of *Ariadne* (cat. no. 21), who requires a more dramatic format. Wearing a headbandlike arrangement of wheat sheaves in her hair, *Ruth* is dressed in a garment of thin, slightly ribbed material. Although the dress's design delineates a pronounced décolletage, there is no immodesty. Once again, a subdued approach to the drapery's handling complies with the sculpture's visual message and contrasts with the baroque complexity of folds in *Ariadne*'s antique garment, which augments that figure's emotional agitation.

Other details enumerate the varied approach that Ives accorded individual works. The pupils and irises of *Ruth*'s eyes are chiseled, unlike those of *Ariadne*; yet the effect, rather than conveying the usual notion of alertness and immediacy, is one of timelessness. Ruth's hair is parted in the middle and pulled over the temples and ears into a gather of strands, secured in back by a piece of plain, thin ribbon. The contrast with *Ariadne*'s hairdo is marked. The gently undulating waves of *Ruth*'s hair reinforce the equanimity of the work, whereas the bold handling of *Ariadne*'s curls reiterates her emotional fervor. Common to both works is an elegantly idealized facial structure, dominated by attenuated, straight noses, small mouths, and restrained eye sockets. In this regard, the core of each work is infused with a classic serenity.

Certain aspects of *Ruth*'s features betray the sculpture's place at the outset of Ives's career. The cheeks and chin have an ungainly, almost bloated quality, while the articulation of the neck and chin is overly crisp. The prominent vertical elongation of the frontal view obscures these flaws. The work assumes greater elegance and refinement when viewed in profile, where contour takes precedence.

Despite these minor shortcomings, Ives achieved a desired impression of modesty and innocence in his interpretation of Ruth. He accomplished this effect through a restrained handling of form and detail. The resulting visual understatement endowed the subject matter with an appropriate feminine identity.

Ruth was one of Ives's personal favorites. He repeated it eleven times, and not all to order. He recognized its appeal, and it, like *Ariadne*, became one of the staples at the intermittent auctions the sculptor organized to dispose of his works. Among the busts, *Ruth* provided strong remunerative competition for *Ariadne*, its larger, more dramatic counterpart.[5] One critic acknowledged *Ruth*'s merit in 1875, nearly thirty years after its creation: "The bust of *Ruth* expresses feminine youth, beauty, loveliness and integrity, and is an excellent commentary on the character of the loving daughter-in-law of Naomi."[6] Although certain critics accused Ives of possessing little imagination or creative profundity, in *Ruth* he demonstrated an admirable sensitivity to his choice of literary figure.

Notes

1. "The Fine Arts," *Literary World* 5 (Nov. 10, 1849), 407.

2. This disease was coined by a critic visiting the Roman studios in 1854; see Florentia, "A Walk through the Studios in Rome," *Art Journal* (London), n.s., 6 (June 1, 1854), 186.

3. Interview with James H. Ricau, Oct. 4, 1990, Piermont, N.Y. This was the case as recently as 1986, when a bust of *Ruth* was auctioned as *Ceres*; see William Doyle Galleries, New York, Apr. 23, 1986, lot 3.

4. "Fine Arts. The Ives Marbles," *New York Tribune*, Jan. 23, 1872, p. 5.

5. In 1875 it realized $175 to the $200 bid brought by *The Sailor Boy* and the $275 *Ariadne* attracted; "Sale of Statuary," *New-York Daily Tribune*, Jan. 15, 1875, p. 12. In 1883 *Ruth* was auctioned for $280, only $20 less than the bid for *Ariadne*.

6. "Mr. Ives's Statuary," *New-York Evening Post*, Jan. 13, 1875, p. 4.

21

Ariadne

Modeled 1852, carved 1853
Marble
26⅝ × 19 × 12⅜ in. (65.1 × 42.3 × 31.4 cm)
Inscribed on back of pedestal: C. B. IVES. / SCULP: / ROMÆ / 1853

Provenance James H. Ricau, Piermont, N.Y.

Exhibition History *The Ricau Collection*, The Chrysler Museum, Feb. 26–Apr. 23, 1989

Literature Greenwood 1854, p. 223; "Chauncey B. Ives," *Cosmopolitan Art Journal* 4 (Dec. 1860), 164; "Sculptors and Sculpture," *Cosmopolitan Art Journal* 4 (Dec. 1860), 182; Henry H. Leeds & Co., New York, *Catalogue of the Celebrated Collection of Pictures, Known as the "Düsseldorf Gallery"...*, Dec. 19, 1862, lot 109; "Fine Arts. The Ives Marbles," *New-York Daily Tribune*, Jan. 23, 1872, p. 5; "Mr. Ives's Statuary," *New-York Evening Post*, Jan. 13, 1875, p. 4

Versions MARBLE The Newark Museum, Newark, N.J.; [Spanierman Gallery, New York]

Gift of James H. Ricau and Museum Purchase, 1986.477

ACCORDING to legend, Ariadne was the daughter of Minos, king of Crete, who exacted from Athens an annual tribute of youths and maidens to be sacrificed to the Minotaur. When Theseus, son of Aegeus, king of Athens, was dispatched to rescue the young Athenians, Ariadne helped him penetrate the labyrinth and the monster's lair, where Theseus slayed it. Ariadne fell in love with Theseus, and he carried her away to the island of Naxos, where he subsequently abandoned her. At this juncture, legends differ. One story has Ariadne hanging herself in despair, while another tells of her discovery by Dionysos, who takes her as his wife.

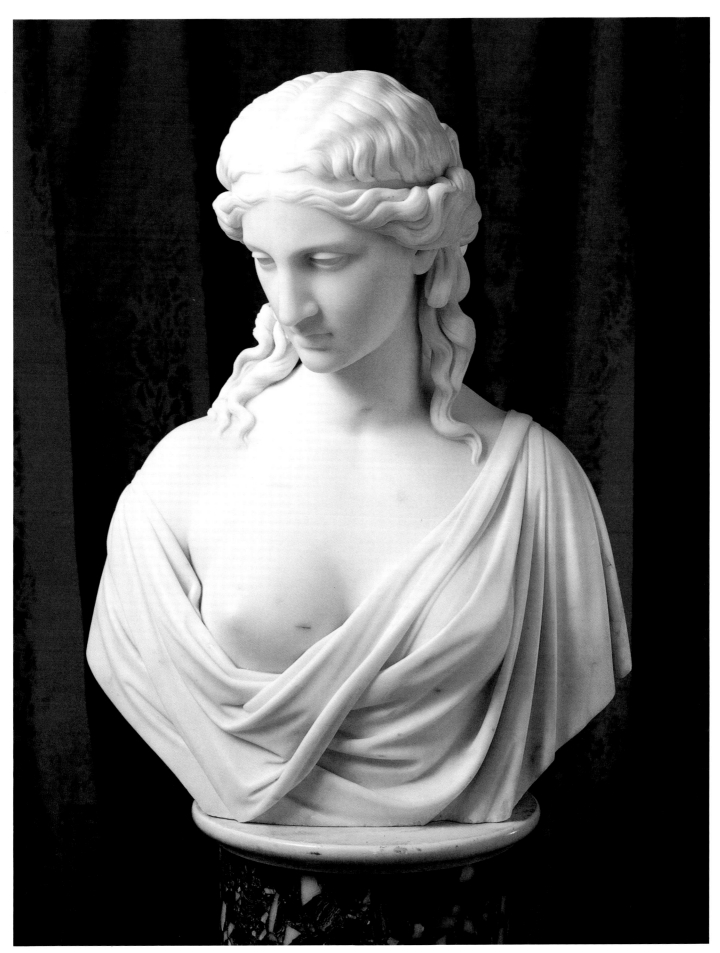

Cat. no. 21 Ives, *Ariadne*

The story of Ariadne enjoyed substantial artistic attention through the ages, and most representations centered on Ariadne's grief. In America, John Vanderlyn's (1775–1852) bold portrayal of the nude heroine asleep on the island of Naxos brought fame to the subject in the early nineteenth century (PAFA). Such attention had its benefits, and the painting was engraved by Asher B. Durand (1796–1886) with successful commercial results. Almost single-handedly, this image broadcast in America the story of the ill-fated heroine.

In the realm of sculpture, Ariadne was not of major appeal, and the bust by Ives may be the rare interpretation. This was one of the first pieces he created after moving to Rome in 1851, when he expanded his repertoire to include ideal pieces taken from the Bible or classical mythology. His account book indicates that *Ariadne* was modeled in 1852, after the initial *Pandora* (VMFA) and *Flora* were completed. The Ricau version of *Ariadne* is dated 1853, making it one of the earliest of the thirteen replicas ordered. Unfortunately, nothing else of its history is known.

Initial assessment of the work was favorable. Grace Greenwood, whose real name was Sarah Lippincott, provided one of the early travel accounts of Europe with her *Haps and Mishaps of a Tour in Europe*, published in 1854. During her trip she visited artists' studios while in Rome, including that of Ives, where she recalled:

With some of the works of Mr. Ives I have been much pleased. If not an enthusiast, he seems a conscientious student in his art. If he does not produce works startlingly powerful and original, whatever he does he does well. He models with taste, feeling, and careful finish. His portrait busts seem to me remarkably good, and some of his ideal busts are exceedingly fine. Of the latter, I like, especially, a head of Ariadne—full of beauty of a noble character.[1]

Greenwood's intuition that Ives's technical ability outshone his imagination was astute, and her opinion of *Ariadne* was equally sensitive.

The sculptor himself may have recognized *Ariadne*'s potential appeal. He sent a marble replica to America for exhibition at the Pennsylvania Academy in 1860.[2] It is possible the same copy was displayed in New York at both the Düsseldorf Gallery and the Cosmopolitan Art Association.[3] In the latter exhibition, Ives included the statue *Flora*, and the catalogue referred to him as "one of the most talented sculptors of his time."[4] The entry indicated that these specimens signified Ives's earlier and later productions, and that *Ariadne*, one of the sculptor's latest works, possessed a "clas-

FIG. 48 Ives, *Ariadne*, detail of hair

sic beauty in her sober grace—an exquisitely modelled and highly finished bust."[5] *Ariadne* did not find a buyer and was shown again in 1861 at the Düsseldorf Gallery with the description taken from the Cosmopolitan Art Association pamphlet of the previous year. This replica was auctioned by the gallery in 1862, but nothing is known of its disposition.[6]

In subsequent auctions, however, versions of *Ariadne* commanded impressive prices and brought the highest bids among the ideal busts. In 1875 it realized $275, while the next most expensive bust only realized $200. Another lot, a full-length statue of Innocence, only fetched $285.[7] This pattern was repeated at an auction in 1885, where an *Ariadne* brought $500 and the nearest competitor was a *Ruth* (cat. no. 20), which fetched $280.[8] Although

Ives's full-figure pieces brought respectable prices, the trend confirmed an earlier assessment that his minor works were preferable, since they were less ambitious.[9]

In general, ideal busts were usually life-size or reduced to three-quarters or two-thirds life-size. The Ricau *Ariadne*, with its full-size dimensions, makes a formidable visual statement, and its monumentality is reinforced by the pensive yet dignified countenance. For years this bust remained unidentified, until an 1872 newspaper article was discovered that described Ariadne as looking down in grief.[10] Ariadne's disconsolate state is tempered by a restraint in the handling of the features. This idealization elevates any emotional content to a more cerebral plateau. The facial structure assumes a verticality accented by the

long aquiline nose, while the close-set eyes and small mouth do little to provide equivalent horizontal axes. The smooth planes of the face are offset by the complex configuration of the thick hair that falls on the shoulders in ringlets of rope-like curls. This rich visual statement carries to the back of the head, where a complex knot and gathering of locks cascade down the nape of the neck. A thin band of plain ribbon appears to hold the hair in place, but in back the ribbon and the knot intersect in an implausible fashion (fig. 48). The ribbon's purpose appears to be primarily visual, providing a smooth strip within the field of undulating curls.

The sculptor sought a similar contrast by playing the rich system of drapery folds off parts of the smooth upper torso. The garment falling off the right breast creates a V-shape that subtly reiterates the downturned pose of Ariadne's head. *Ariadne's* dishevelment may allude iconographically to her fallen state, but it does so in the service of formal emphasis, wherein a rich network of details enlivens an otherwise reticent composition. This balance between austerity and intricacy constituted Ives's true strength as a sculptor.

Notes

1. Greenwood 1854, p. 223.
2. Rutledge 1955, p. 108.
3. Its appearance at the Düsseldorf Gallery is noted in "Ives" (1860), p. 164, and its exhibition at the Cosmopolitan Art Association is listed in Yarnall and Gerdts 1986, 3:1904.
4. Cosmopolitan Art Association, exh. cat. (New York, 1860), p. 16; cited in Yarnall and Gerdts 1986, 3:1904.
5. Ibid. The author of the entry must have been mistaken regarding chronology, since, according to the account book, both works in question were among Ives's earlier productions.
6. Henry H. Leeds & Co., New York, *Catalogue of the Celebrated Collection of Pictures, Known as the "Düsseldorf Gallery"...*, Dec. 19, 1862, lot 109.
7. "Sale of Statuary," *New-York Daily Tribune,* Jan. 15, 1873, p. 12.
8. Madison Square Art Rooms, New York, *Catalogue of Statuary, by Mr. C. B. Ives, of Rome,* Nov. 15, 1883, n.p. *Ariadne* was lot 15, and *Ruth* was lot 1.
9. "Fine Arts. The Ives Marbles," *New-York Daily Tribune,* Jan. 23, 1872, p. 5.
10. Ibid.

22
The Willing Captive

Modeled ca. 1862–68, carved 1871
Marble
73 × 64⅜ × 27⅝ in. (185.4 × 163.5 × 70.2 cm)
Inscribed on right side of plinth: C. B. IVES / FECIT / ROMÆ 1871

Provenance Peter C. Cornell, Brooklyn, N.Y.; . . . ; West African missionaries, Pearl River, N.J.; James H. Ricau, Piermont, N.Y., by ca. 1983

Exhibition History *The Ricau Collection,* The Chrysler Museum, Feb. 26–Apr. 23, 1989

Literature Tuckerman 1867, p. 583; "New Statue for Newark: Dr. J. Ackerman Coles's Generous Gift to the City," *Sentinel of Freedom,* Sept. 10, 1895, p. 8; William Todd, "Chauncey Bradley Ives, Sculptor," *Publications of the Hamden Historical Society* (1958), p. 55; William H. Gerdts, "The Marble Savage," *Art in America* 62 (July 1974), 68; Kasson 1990, pp. 98–100

Version BRONZE Lincoln Park, Newark, N.J.

Gift of James H. Ricau and Museum Purchase, 1986.480

The WILLING CAPTIVE is one of four sculptures in the Ricau Collection devoted to American Indian themes. Two others are by Joseph Mozier, *Pocahontas* and *The Wept of Wish-ton-Wish* (cat. nos. 29, 32). The fourth is Peter Stephenson's *Wounded Indian* (cat. no. 46). Ives's work is the most ambitious of the four pieces and ranks as his most challenging undertaking. *The Willing Captive* is also of major importance since it is one of the rare multifigure compositions in American neoclassical sculpture.

The group depicts the story of a Caucasian girl captured by Indians and raised as part of the tribe. When contact with white men brought the possibility of rejoining her native civilization, she rejected the entreaties of her mother and chose to stay with the Indians as wife of the tribal chief. The story is related to actual instances of whites being captured and assimilated into Indian tribes along the American frontier, which George Bancroft chronicled in his pioneering book, *History of the Colonization of the United States.*[1]

Ives's sculpture possibly alludes to the history of Eunice Williams, daughter of the Reverend John Williams of Deerfield, Massachusetts.[2] She was captured at a young age, separated from her parents, and taken to Canada in 1704, where she later married an Indian from the Mohawk tribe. When she returned years later to Deerfield with her husband, she refused to readapt to white society.

Henry Tuckerman, who knew Ives's work only through photographs the sculptor exhibited in 1864, dwelt at length on *The Willing Captive* in his *Book of the Artists* and offered a very sympathetic reading:

The romantic remainder of the story is well told in marble, warmed and toned beneath the hands of an artist. A fine specimen of the Aborigines supports a young girl, dressed in Indian garb, but having strongly-marked European features. The mother, reversing the order of nature, kneels to her child with an agonized expression of entreaty; but the daughter's love for her Indian husband is a stronger motive than the long-forgotten affection of her mother, and she clings to the savage with a rudely simple tenderness that is very effective.[3]

Like Mozier's slightly earlier *Wept of Wish-ton-Wish,* taken from James Fenimore Cooper's popular novel of the same name, *The Willing Captive* considered the decision of a white woman to reject the opportunity to return to white "civilization" after being exposed to Indian tribal culture.

In a broader context, *The Willing Captive* represents the conflict between the love of unspoiled nature and the need to control and Christianize a race perceived as the New World's aboriginal inhabitants. The American Indian had been viewed as both a physical threat and a moral challenge to the white, Christian community, and missionaries were dispatched to tame their savagery and convert them. Ives makes this point by contrasting the discreet clothes of the Christian mother to the wild animal skins worn by her daughter and Indian husband. Thus, the dichotomy between "primitive" and "civilized" cultures was unequivocally represented.

Ives created a visually evocative composition. The Indian stands at center flanked by his "captive" wife and her mother, who kneels in supplication at his feet. The sculpture embodies all of the mid-nineteenth-century love of drama and moral tension. It deals poignantly with the ambivalence toward the Indian felt by white Christian culture. During the first quarter of the century, Indians were depicted as a threat, but as time passed and they lost their land, whites viewed them more sympathetically. Ironically, Indians were perceived increasingly as innocent savages perishing along with the primeval forest and plains that were their homes.[4]

Consistent with its monumental conception, *The Willing Captive* possesses an imposing frontal presence created by the triangular composition. The stoic Indian

FIG. 49 *Poseidon*, Greek, late second century B.C. Marble, 85½ in. (217.2 cm) high. National Archaeological Museum, Athens

cradles his wife in his left arm while holding a spear in his right hand, and an impressive buffalo skin is draped over his arm. The brave's pose recalls the late Hellenistic statue of Poseidon from the late second century B.C. (fig. 49), and, in this manner, Ives alludes to the Indian's capacities for strength. While conveying an aura of dignity and nobility, his anatomically convincing physique conveys his human nature. The neoclassical canon is further tempered by a wealth of meticulously rendered details such as the animal skins, spear, and feathered topknot.

In contrast to the authoritative presence of the male figure, both women are portrayed as helpless and dependent. They collapse in a profusion of gentle curves offset by the rectilinearity of the Indian. Consequently, they provide an emotive ingredient to the otherwise austere moment. In establishing such formal and emotional disparities, Ives subscribed to a familiar formula of presenting a distinct male-female polarity, epitomized in such pioneering neoclassical works as Jacques-Louis David's (1748–1825) *Oath of the Horatii* of 1784 (Musée du Louvre, Paris).

Despite the magnitude of this undertaking, references to *The Willing Captive* were scant in Ives's lifetime. His account book records his commencing the work in 1862 and finishing it in marble in 1868. This first copy was sold to Henry Farnham. Peter C.

Cornell of Brooklyn, who had acquired a replica of *The Hebrew Captive* (cat. no. 24), purchased the second. Since the Ricau version is dated 1871, it must be the one Cornell owned. Aside from the entry in the account book and Tuckerman's commentary, the only other known notice was an article in the *New York Tribune* in 1872 that called *The Willing Captive* Ives's "most considerable work."[5]

Ives envisioned *The Willing Captive* as appropriate for a public space, and, for technical reasons, he remodeled parts and had it cast in bronze in 1886.[6] He offered the finished bronze at an auction he organized in 1887, but it did not find a buyer since the sculptor refused to accept less than five thousand dollars.[7] The auction catalogue carried a brief explanation of the type of episode that inspired the sculptor:

In the early Colonial history of our country, it sometimes happened that white captives who had grown up from infancy among the Indians, refused to leave them and return to their forgotten parents. Such an incident is related in Bancroft's *History of the United States*, where in a treaty of peace with the Indians, they agreed to deliver a certain number of captives to their friends at Sandy Creek, Ohio, and some of them chose to remain with the Indians, and this record has suggested to the artist the present group.[8]

The bronze languished until 1895, when Jonathan Ackerman Coles, a native of Newark, New Jersey, purchased it and presented it to the city in honor of his father, Dr. Abraham Coles.[9] It was unveiled in Lincoln Park, where it still stands. In his letter of presentation, Coles alluded to New Jersey's benevolent treatment of local tribes from earliest times and reprinted part of a speech made before the New Jersey legislature in 1832 that bragged: "It is a proud fact in the history of New Jersey that every foot of her soil has been obtained from the Indians by voluntary purchase and transfer—a fact no other State of the Union, not even the land which bears the name of Penn, can boast of."[10] In his conclusion, Coles determined that the monument was especially fitting in the honor it paid to the American Indian.

The story of Ricau's acquisition of *The Willing Captive* is extraordinary.[11] He recalled driving around the New York and New Jersey countryside near his home in late 1979 and coming upon two sculptures in the middle of a field. He examined and admired the pieces but neglected to make note of where he found them. Consequently, it was several years before he relocated them on property in New Jersey owned by West African missionaries and could negotiate a sale by auction. The works were *The Willing*

Captive and a life-size version of *The Hebrew Captive*. Ricau purchased only *The Willing Captive* and contented himself with a reduced version of the other from a different source (cat. no. 24). Circumstantially, these may have been the statues originally purchased by Peter Cornell of Brooklyn. How they found their way to a field in northern New Jersey remains unknown.

Notes

1. George Bancroft, *History of the Colonization of the United States*, 10 vols. (Boston, 1846–75), 3:212–214. For the most recent discussion of this textual source, see Kasson 1990, pp. 98–100.

2. For a recent account of this episode, see John Demos, *The Unredeemed Captive* (New York, 1994).

3. Tuckerman 1867, p. 583. In a brief note on Ives's return to America with a group of sculptures, Tuckerman alluded to the portfolio of photographs; see [Henry Tuckerman], "The Fine Arts. A New Studio of Sculpture," *New-York Evening Post*, Nov. 16, 1864, p. 2.

4. For a thorough discussion of the depiction of Indian as savage threat, see Vivien Green Fryd, "Two Sculptures for the Capitol: Horatio Greenough's *Rescue* and Luigi Persico's *Discovery of America*," *American Art Journal* 19, no. 2 (1987), 16–39.

5. "Fine Arts. The Ives Marbles," *New York Tribune*, Jan. 23, 1872, p. 5.

6. Ives, "Account Book," typescript, p. 8. The manuscript of this account book is said to be in the possession of Ives's great-granddaughter, Elizabeth Bartholet. At present it cannot be located, but there is a typed copy in the Ives file in the department of American painting and sculpture at the Metropolitan Museum of Art, New York.

7. 432 Fifth Avenue, New York, *Catalogue–Private Sale*, until Mar. 10, 1887, lot 19. A newspaper article reporting the sale did not report it among the works sold; see "Art Notes," *Boston Daily Evening Transcript*, Mar. 19, 1887, p. 10.

8. *Catalogue–Private Sale* (1887), n.p.

9. "New Statue for Newark: Dr. J. Ackerman Coles's Generous Gift to the City," *Sentinel of Freedom*, Sept. 10, 1895, p. 8.

10. Ibid.

11. Interview with James H. Ricau, Oct. 4, 1990, Piermont, N.Y.

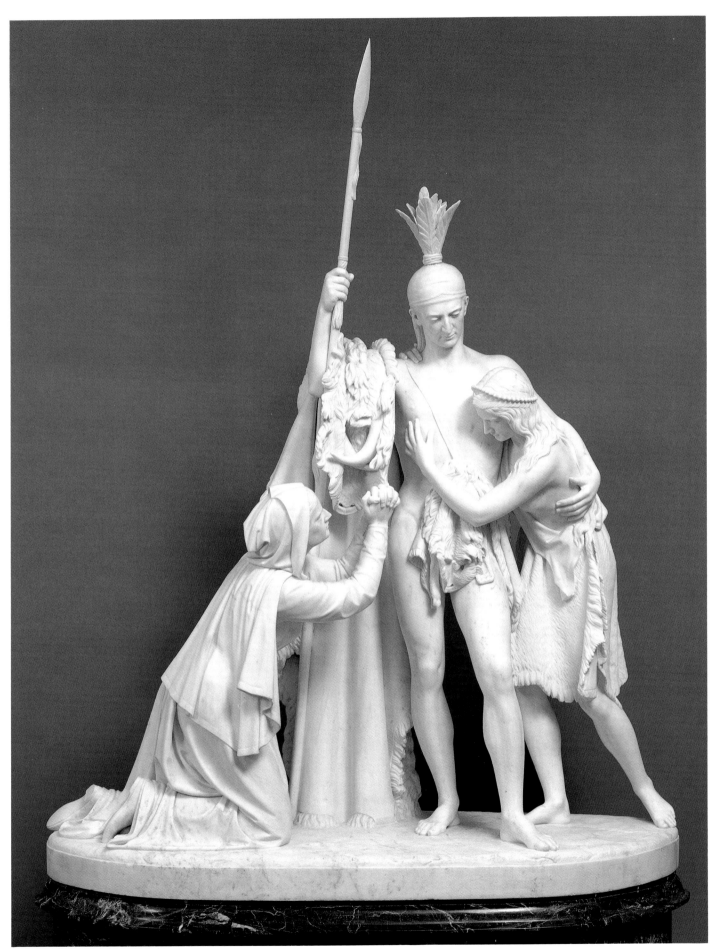

Cat. no. 22 Ives, *The Willing Captive*

23
Pandora

(First version)
Modeled 1851, remodeled 1863
Marble
66½ × 23 × 23 in. (168.9 × 58.4 × 58.4 cm)
Inscribed at left rear of base: C. B. IVES /
FECIT, ROMAE

Provenance Private collection, Yonkers,
N.Y.; James H. Ricau, Piermont, N.Y.,
ca. 1960

Exhibition History *The Ricau Collection,*
The Chrysler Museum, Feb. 26–Apr. 23,
1989

Literature Osgood 1870, p. 422; "Mr. Ives's
Statuary," *New-York Evening Post,* Jan. 13,
1875, p. 4; "Summer in Rome. The Artists,"
Boston Daily Evening Transcript, Aug.
25, 1876, p. 4; "Art Notes," *Boston Daily
Evening Transcript,* Mar. 19, 1887, p. 10;
William H. Gerdts, "Nudity in Marble," *Art
in America* 59 (May–June 1971), 63; Gerdts
1973, p. 55; Jonathan Fairbanks, "A Decade
of Collecting American Decorative Arts
and Sculpture at the Museum of Fine Arts,
Boston," *Antiques* 120 (Sept. 1981), 633; Jan
Seidler Ramirez, *Pandora,* in BMFA 1986,
pp. 45–47; Susan Menconi, *Uncommon
Spirit: Sculpture in America, 1800–1940,*
exh. cat., Hirschl & Adler Galleries (New
York, 1989), p. 14; Kasson 1990, pp. 190–202

Versions MARBLE (remodeled version)
The Detroit Institute of Arts; City of
Bridgeport, Conn.; The Brooklyn
Museum, Brooklyn, N.Y.; Museum of
Fine Arts, Boston; The St. Johnsbury
Athenaeum, St. Johnsbury, Vt.; Passaic
County Historical Association, Paterson,
N.J.; High Museum of Art, Atlanta, Ga.

Gift of James H. Ricau and Museum
Purchase, 1986.476

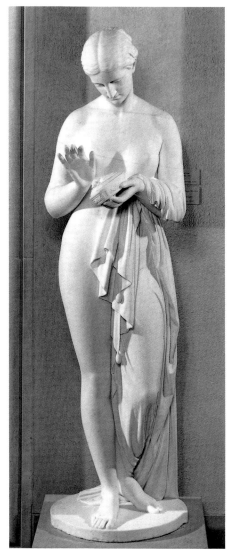

FIG. 50 Chauncey B. Ives, *Pandora* (first
version), 1854. Marble, 64¼ in. (163.2 cm) high.
Virginia Museum of Fine Arts, Richmond, Gift
of Mrs. William A. Willingham, 50.4.2

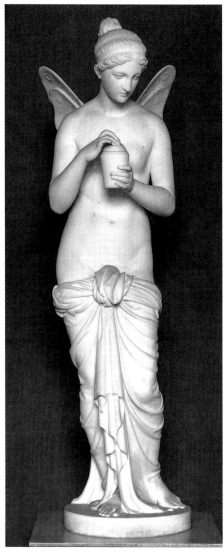

FIG. 51 Bertel Thorvaldsen, *Psyche with the Jar
of Beauty,* modeled 1806. Marble, 52 in. (132.1 cm)
high. Thorvaldsen Museum, Copenhagen.
Photograph by Jonals

THE story of Pandora derives from Greek
mythology and is best known through the
account in Hesiod's *Works and Days.*[1]
Upon defeating the other Titans and be-
coming ruler of the gods, Zeus gave the
lesser gods Prometheus and Epimetheus
the task of creating all the living creatures
on Earth. After making the other animals,
they made a man in the image of the gods
out of clay and gave him the gift of fire,
which Prometheus stole from Heaven.
Angered that man had been given such
special favors, Zeus ordered Hephaestus
to make a clay woman, Pandora, and had
the Four Winds breathe life into her. Each
of the goddesses of Olympus gave Pandora
an attribute of grace or beauty. Thus,
the name *Pandora* means "the gift of all."
She was also given a box containing all
the world's evils and told never to open

it. Zeus sent her to Epimetheus, who
accepted her as his wife despite
Prometheus's warning. Pandora let her
curiosity get the best of her and opened
the box, releasing the evils into the world
to plague mankind. In this Greek account
of the Creation, Pandora held a position
comparable to Eve, and tradition has long
associated the two ill-fated heroines.[2]

Pandora's popularity as a theme was
widespread in the nineteenth century
in Europe and the United States, and
Ives enjoyed a commercial success with
this version that confirmed America's
reaction. As was the case with *Undine
Rising from the Waters* (cat. no. 27), the
sculptor modified the original statue, and
Ricau owned a copy of this subsequent
effort. In both instances, the second ver-
sion overshadowed the original.

In *Pandora,* the differences between the
first conception and the altered work are
less obvious than those of *Undine.* In the
original version, modeled in 1851 and
replicated three times (fig. 50), Pandora
holds a box, or *pyxis,* which stems from
a Renaissance interpretation of the story.
Significantly, the lid is decorated with a
coiled snake.[3] In the reworked version,
Ives eliminated the obvious Christian ref-
erence to temptation and made the vessel
more of a jar, in the spirit of a *pithos,*
which the Greeks used for both storage
and burial. Consequently, he made the
imagery more consistent with the myth's
Greek origins.

Changes in the positioning of the head
and hands also contribute to an important
shift in meaning. In both versions, Pandora
holds the container in her left hand. In the

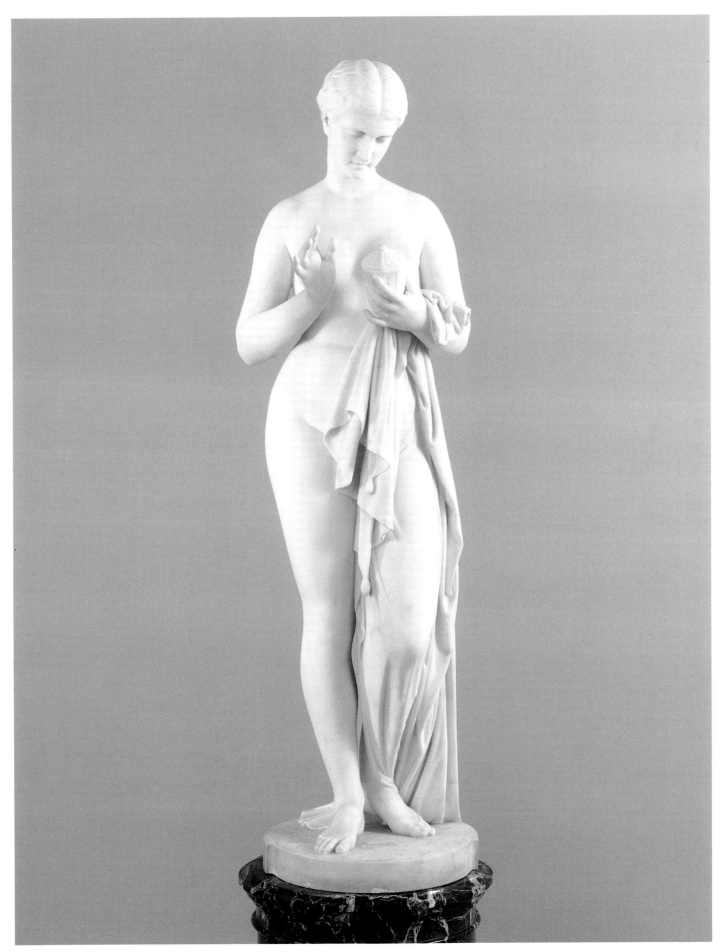

Cat. no. 23 Ives, *Pandora*

earlier depiction, she tilts the box toward her outstretched right hand and looks intently at both her hands and the box. Removal of the lid is imminent, and Pandora has made her fateful decision. In the revised composition, Ives widened the space between the hand holding the vessel and the active right hand. Moreover, he reinforced this implied hesitation by turning the top of the jar away from the right hand and altering the position of Pandora's head accordingly. As a result, she focuses on the jar and not on what her free hand will do. This changes the entire meaning of the piece from resolve to indecision, which defused what has recently been termed "direct acknowledgement of woman's demonic potential."[4]

In repositioning the left hand and arm, Ives made the work more modest, since elevating these elements concealed the initially exposed left breast. He was apparently under no pressure to effect this; Hiram Powers's *Greek Slave* (fig. 13) established an important precedent regarding the propriety of nudity in sculpture. Nevertheless, Ives discreetly arranged the drapery to cover *Pandora*'s genitals. Critical reaction to the early *Pandora* was enthusiastic about the work, and impropriety was not an issue.[5] In fact *Pandora* was compared favorably to Powers's masterpiece and preferred for its "grace and disposition, and . . . ideality and power of rendering emotion."[6] Despite these encomiums, Ives felt compelled to refine the statue and reinforce the idea of contemplative innocence.

Pandora strikes a graceful pose that associates her with Venus types from antiquity. There were immediate sources, as well. Antonio Canova's (1757–1822) *Psyche* (private collection, England), as well as interpretations by John Gibson (1790–1866) and the recently deceased Sir Richard Westmacott (1775–1856) have been suggested.[7] Bertel Thorvaldsen's presence remained influential in Rome, even after his death, and his *Psyche with the Jar of Beauty* (fig. 51) bears a strong affinity to Ives's *Pandora*.

Ives purified the features and anatomy of *Pandora*, as the naturalism he had learned in Florence gave way to the neoclassicism of Rome. Although the body conveys an earthbound fullness, the classical influence becomes especially noticeable in the face and hair. The smoothness of surface in the physiognomy and the rhythmic repetition of the curls impart a reticent abstraction that is cerebral rather than sensual. To offset this, Ives provided detailed treatment of the jar and sensitive handling of the drapery to accommodate his lingering concern for the tangible.

The second *Pandora* became one of Ives's most famous works. He reproduced it nineteen times, and as late as 1891. To enhance its marketability, Ives offered a half-size statuette in addition to the life-size figure. The statue was a staple of the intermittent sales the sculptor held to dispose of his work, and it, too, was vulnerable to the decline in prices that Ives's sculpture suffered as neoclassical taste waned.[8]

Given the large number of replicas and the various ways they came on the market, it is impossible to trace the provenance of Ricau's life-size *Pandora*. He owned one of the half-size replicas at one time and recalled acquiring his first *Pandora* sometime around 1960.[9]

Notes

1. *Hesiod and Theognis*, trans. with introduction by Dorothea Wender (Harmondsworth and Baltimore, 1973), pp. 61–62, ll. 60–104.
2. Kasson 1990, pp. 191ff.
3. Ramirez, *Pandora*, in BMFA 1986, p. 47, and Kasson 1990, pp. 195–196.
4. Kasson 1990, p. 200.
5. Ramirez, *Pandora*, p. 45.
6. "Chauncey B. Ives," *Cosmopolitan Art Journal* 4 (Dec. 1860), 164.
7. Ramirez, *Pandora*, p. 47.
8. "Sale of Statuary," *New-York Daily Tribune*, Jan. 15, 1875, p. 12, reported that *Pandora* brought $1,275; Madison Square Art Rooms, New York, *Catalogue of Statuary, by Mr. C. B. Ives, of Rome, Italy*, Nov. 15, 1885, n.p. The statuette (lot 8) realized $715, while the full-size statue (lot 14) commanded $1,225. In 1887 the small version had slipped to $560 and the large version to $950; "Art Notes," *Boston Daily Evening Transcript*, Mar. 19, 1887, p. 10.
9. Interview with James H. Ricau, Piermont, N.Y., Oct. 4, 1990.

24
The Hebrew Captive
Modeled 1864
Marble
35⅛ × 19¾ × 28⅜ in. (89.2 × 50.2 × 72.1 cm)
Inscribed on right side of plinth: C. B. IVES. / FECIT. ROMÆ.

Provenance Mr. Sterling, New York; . . . ; private collection, New Jersey; [Eliot Shapiro, The Den of Antiquity, Mamaroneck, N.Y.]; [Robert Bahssin, Post Road Antiques, Larchmont, N.Y.]; James H. Ricau, Piermont, N.Y., by 1985

Exhibition History *The Ricau Collection*, The Chrysler Museum, Feb. 26–Apr. 23, 1989

Literature "Fine Arts. The Ives Marbles," *New York Tribune*, Jan. 23, 1872, p. 5; William H. Gerdts, "Chauncey B. Ives, American Sculptor," *Antiques* 94 (Nov.

1968), 717; Jan Seidler Ramirez, "The Lovelorn Lady: A New Look at William Wetmore Story's *Sappho*," *American Art Journal* 14 (Summer 1985), 80–90

Version MARBLE (large version, 56 in. high) [Robert Bahssin, Post Road Antiques, Larchmont, N.Y.]

Gift of James H. Ricau and Museum Purchase, 1986.478

THE paucity of references to *The Hebrew Captive* in Chauncey Ives's day was such that recent scholarship identified it as *Sappho*.[1] Although Ives's account book makes no mention of this tragic Greek poetess, it indicates that the sculptor modeled a work entitled *The Hebrew Captive* in 1864 and translated it into marble in 1868. This copy was sold to Peter E. Cornell of Brooklyn, N.Y., who also acquired the second replica of *The Willing Captive* (cat. no. 22).

The statue enjoyed limited appeal, since only two orders were recorded. One is life-size (Post Road Antiques, Larchmont, N.Y.), while the Ricau version is half-life-size. Since the life-size version of *The Hebrew Captive* was discovered in a field in New Jersey along with the replica of *The Willing Captive* ordered by Cornell, presumably Cornell owned the large version of *The Hebrew Captive*, as well. A person named Sterling bought the second replica.[2]

The question arises as to how many replicas were cut since a life-size version was offered at the posthumous sale of Ives's work held in New York in 1899.[3] It was entitled *The Hebrew Maiden*, which conformed to the only known published reference to the piece in Ives's lifetime.[4] A large version passed into the possession of Catholina Lambert of Paterson, New Jersey, who was reported to have collected on the scale of John G. Johnson, Peter A. B. Widener, and Benjamin Altman.[5] Amassed in the late nineteenth and early twentieth century, Lambert's collection was auctioned in 1916, and the sculpture in question was illustrated with the title *The Jewish Maiden*.[6] Although the title had migrated, the photograph identifies it with Ives's original conception.

According to Ives's account book, *The Hebrew Captive* was his first major religious piece since *Rebecca at the Well*, which had been modeled ten years earlier, in 1854. This subsequent effort, unlike *Rebecca* and the slightly later *Jephthah's Daughter*, does not allude to a readily identifiable character in the Bible. The only pertinent reference to Hebrew captivity and harps is found in the first half of Psalm 137 (vv. 1–3, 8):

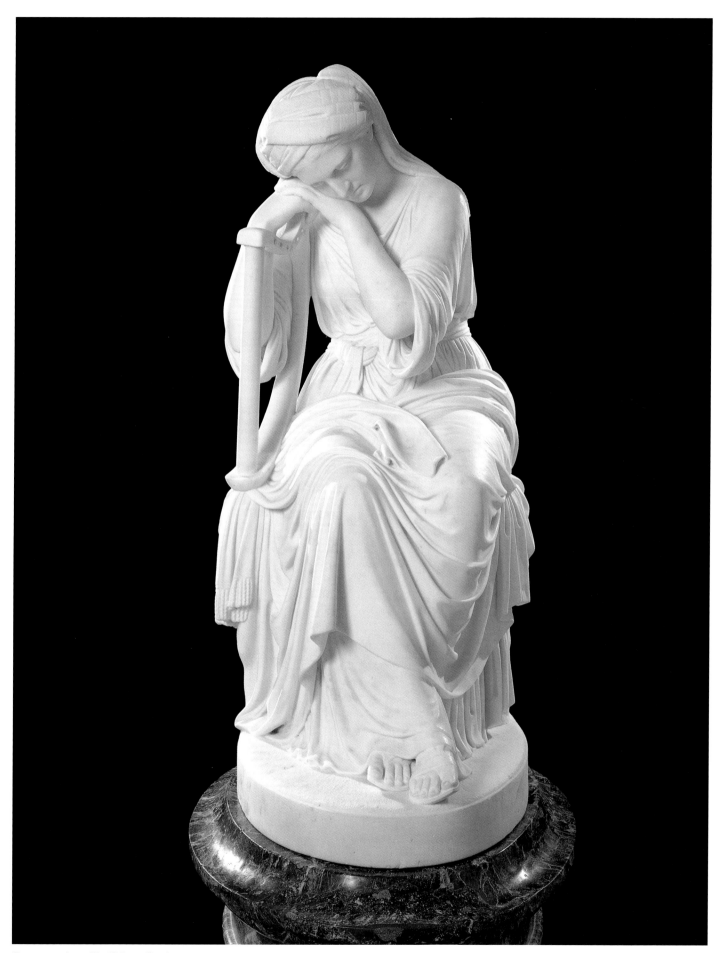

Cat. no. 24 Ives, *The Hebrew Captive*

By the waters of Babylon we sat down and wept,
when we remembered thee, O Sion.
As for our harps, we hanged them up upon the
trees that are therein.
For they that led us away captive, required of us
then a song, and melody in our heaviness: Sing
us one of the songs of Sion. . . .
O daughter of Babylon, wasted with misery;
yea, happy shall he be that rewardeth thee as
thou hast served us.[7]

Ives's interpretation resonates with the melancholy air of this hauntingly beautiful psalm.

Formally, *The Hebrew Captive* reflects the sculptor's continued allegiance to the neoclassical ideal. The maiden is seated on a rough masonry bench and rests her head on her clasped hands, which in turn balance a portable harp in an upright position. She wears an ornately arranged turban of striped and ribbed material adorned by fringe. Her dress and sash generate an ample gathering of folds that cascade off the right knee and thigh. The plethora of material obscures the stone bench from the front. The visual complexity of the costume is augmented by the intricate configuration of the long, tight braid secured around a cleatlike hair comb at the back of the head.

In obvious contrast to the richly detailed garments, the face and arms are idealized and provide a visual respite of restrained and smooth surfaces that reiterate the gentle curve and austere planarity of the harp. The aquiline nose and volumetric eyelids, reminiscent of the sculptor's earlier *Ariadne* (cat. no. 21), provide a purifying abstraction that counteracts the particularity of the drapery. Thus, Ives sets up an effective visual tension between the central elements of costume and anatomy.

In handling certain accessories, Ives demonstrated a sophistication that betrayed his rudimentary education. The harp is given just enough detail, the six keys and holes for ten strings, to connect it with the *kinnor,* a small eight- or ten-stringed instrument on a portable wooden frame.[8] The sandals are another example of Ives's concern for authenticity. Designed with a prominent strap of leather extending over the toes, the sandals possess a Middle-Eastern look rather than one of antiquity, which further secures the biblical identity of the maiden. Finally, the sprig of foliage, possibly ivy or philodendron, grows from the base of the bench's left side and may carry a symbolic connotation. Does this suggestion of a plant's ability to grow in the most improbable context allude to the resilience of the Tribes of Israel? Is it the Tree of Jesse? Whatever the literary or symbolic impetus, *The Hebrew Captive* conveys a muted

poignance that signifies a dimension not generally ascribed to Ives's work.

Notes

1. Ramirez, "The Lovelorn Lady" (1985), 87.
2. Ives, "Account Book," typescript, p. 7, Metropolitan Museum of Art, New York, and interview with James H. Ricau, Piermont, N.Y., Oct. 4, 1990. See cat. no. 22 for a full account of how these works surfaced.
3. American Art Galleries, New York, *Absolute Sale, Sculptures by the Late Chauncey B. Ives,* Apr. 26, 1899, lot 23.
4. "Fine Arts. The Ives Marbles," *New York Tribune,* Jan. 23, 1872, p. 5.
5. William Roberts, introduction to American Art Association, New York, *Illustrated Catalogue of the Valuable Paintings and Sculptures by Old and Modern Masters Forming the Famous Catholina Lambert Collection Removed from Belle Vista Castle, Paterson, New Jersey,* Feb. 21–24, 1916, n.p.
6. Ibid., lot 377. This version was listed as measuring 51 in. high, while the one known today at Post Road Antiques measures 56 in.
7. I am grateful to the Reverend Irwin M. Lewis, Jr., for suggesting this source to me.
8. Willi Apel, *Harvard Dictionary of Music* (Cambridge, Mass., 1950), p. 326.

25
The Truant
Modeled in 1871
Marble
36⅝ × 17 × 29⅜ in. (93 × 43.2 × 74.6 cm)
Inscribed at right rear of base: C. B. IVES. / FECIT. ROMÆ.

Provenance [auction, New York]; James H. Ricau, Piermont, N.Y.

Exhibition History *The Ricau Collection,* The Chrysler Museum, Feb. 26–Apr. 23, 1989

Literature "Mr. Ives's Statuary," *New-York Evening Post,* Jan. 13, 1875, p. 4; "Art and Artists," *Boston Daily Evening Transcript,* Apr. 9, 1875, p. 6; Gerdts 1973, pp. 134–135

Version MARBLE The New-York Historical Society

Gift of James H. Ricau and Museum Purchase, 1986.482

CHAUNCEY IVES's *Truant,* along with his *Boy Holding a Dove* (cat. no. 19), joins Thomas Crawford's *Dancing Girl* and *The Broken Tambourine* (cat. nos. 36, 37), Joseph Mozier's *Young America* (cat. no. 33), and Larkin Mead's *Battle Story* (cat. no. 62) in offering an enviable sampling of nineteenth-century genre sculpture. Recognizing the growing popularity in painting for subject matter dealing with everyday life, numerous sculptors sought to capitalize on this trend.[1] Sensitive to the

growing fondness for sentimental subjects, artists chose themes centered on aspects of childhood. *The Truant* depicts a nine- or ten-year-old barefoot girl who avoids school by stopping to listen to the roar of the ocean in the shell she holds to her ear. A straw hat and books, emblems of responsibility, lie discarded at her side (fig. 52), while the miscreant's carefree attitude is emphasized by her disheveled state of dress. Ives was not the first to interpret truancy; Randolph Rogers (q.v.) addressed the theme in the form of a skater in 1854 (NMAA).

Ives modeled *The Truant* in 1871, hoping to repeat the phenomenal success of his *Sans Souci,* created the previous decade in 1863 (CGA). This initial work, repeated at least twenty times, represented a girl with an open book held carelessly in one hand, while, in the words of Henry Tuckerman, "she casts back her lithe frame in the very attitude of childish *abandon,* the smile and posture alike expressive of innocence and *naïve* enjoyment."[2] This mixture of mischief and guilelessness connected the two works, and they were considered companion pieces soon after *The Truant*'s appearance.[3]

The sequel did not captivate the public imagination in the way that *Sans Souci* had, and only three replicas are recorded in Ives's account book. An early report, which discussed the works as a pair, confirmed this partiality. It acknowledged that both were commendable, but that most people would prefer *Sans Souci.*[4] Contemporary auction results support this contention. Among the works Ives sold in the winter of 1875, *Sans Souci* fetched $910, while *The Truant* commanded only $600.[5] In a similar sale, held in the fall of 1883, *Sans Souci* realized $525, while *The Truant* failed to sell.[6] Four years later, no version of *Sans Souci* was available for auction, and *The Truant* was bought for $450.[7] Versions of each were sold consecutively in the posthumous sale held in 1899, but no record of their prices has come to light.[8] In addition to chronicling the specific predilection for *Sans Souci* over *The Truant,* these dwindling auction prices pinpoint the declining favor accorded Ives's *retardataire* work.

Stylistically, Ives adopted a predictable formula. The lounging pose of the little girl is, indeed, the "free, graceful attitude, idly holding a shell to the ear," that described the piece not long after its completion.[9] This relaxed posture challenged the inelastic properties of the marble and drew attention to the sculptor's virtuosity. In seating his subject on a rocky outcropping, complete with shell lying in the foreground, Ives created a virtual mise-

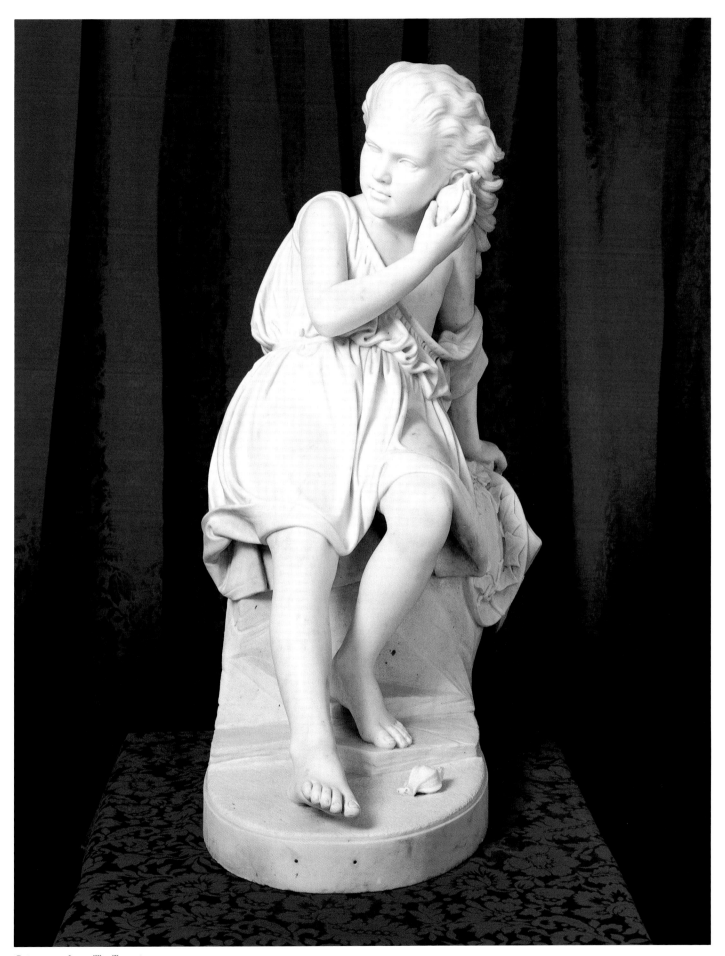

Cat. no. 25 Ives, *The Truant*

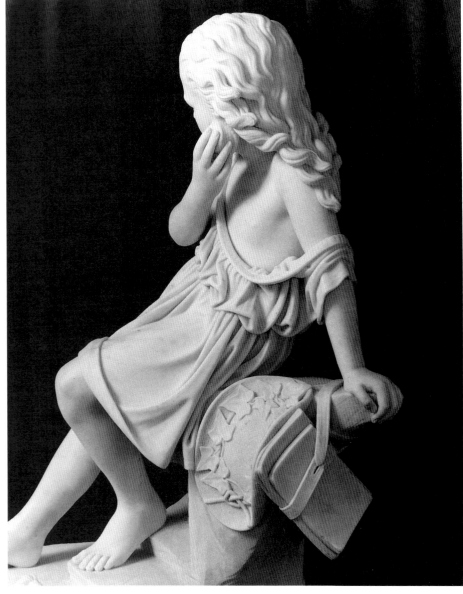

FIG. 52 Ives, *The Truant,* back view

the commercial Boston gallery Williams &
Everett; see "Art and Artists," *Boston Daily
Evening Transcript,* Apr. 9, 1875, p. 6.

6. Madison Square Art Rooms, New York,
*Catalogue of Statuary, by Mr. C. B. Ives of Rome,
Italy,* Nov. 15, 1885, n.p. *Sans Souci* was lot 2 and
The Truant was lot 17.

7. "Art Notes," *Boston Daily Evening
Transcript,* Mar. 19, 1887, p. 10.

8. American Art Galleries, New York, *Absolute
Sale. Sculptures by the Late Chauncey B. Ives,*
Apr. 26, 1899, n.p.; lots 5 and 6 were *The Truant*
and its pedestal, while lots 7 and 8 comprised
Sans Souci.

9. "Art and Artists," *Boston Daily Evening
Transcript,* Apr. 9, 1875, p. 6.

26
The Sailor Boy

Modeled by 1875
Marble
17¾ × 13 × 7¾ in. (45.1 × 33 × 19.7 cm)
Inscribed at rear of pedestal: C. B. IVES.
FECIT. / ROMAE.

Provenance Private collection, Malibu,
Calif.; James H. Ricau, Piermont, N.Y., by
1975

Exhibition History *The Ricau Collection,*
The Chrysler Museum, Feb. 26–Apr. 23,
1989

Literature "Mr. Ives's Statuary," *New-York
Evening Post,* Jan. 13, 1875, p. 4; "Art
Notes," *Boston Daily Evening Transcript,*
Mar. 17, 1887, p. 10

Versions MARBLE The Newark Museum,
Newark, N.J.; [Christie's, New York, Mar.
14, 1991, lot 140]

Gift of James H. Ricau and Museum
Purchase, 1986.484

THE place of *The Sailor Boy* within
Chauncey Ives's oeuvre is puzzling. There
is no reference to a work by this title in
his account book, and yet at least three
versions are known to exist. Furthermore,
Ives placed this work at auction on at
least three separate occasions. In 1875
The Sailor Boy commanded a respectable
$200.[1] The review of the auction's prelimi-
nary exhibition commented that it was
"remarkable for its free and open expres-
sion, the index of a soul that makes the
ocean its playmate."[2] In 1885 a Mrs.
Barlow of New York City also paid $200
for *The Sailor Boy.*[3] Four years later the
sculptor put another group of works up
for sale in New York, where *The Sailor
Boy* realized only $155.[4] Despite its omis-
sion from Ives's records, this piece was a

en-scène for his composition. By reinforc-
ing the anecdotal content with details
such as the straw hat entwined with ivy
and the schoolbooks secured with a strap,
the sculptor hoped to captivate the pub-
lic's imagination.

Technical considerations were of major
importance to Ives. The meticulous ren-
dering of details creates a visual counter-
point to the more generalized elements.
Thus, the wavy, windswept hair as well
as the rich folds and gathers of the dress
offset the smooth surfaces of the young,
supple body and further animated the
composition.

The girl's face possesses a naturalism
that echoes *The Sailor Boy*'s verisimilitude
(cat. no. 26). The facial structure is con-
vincingly handled except for the eyes,
which the sculptor inexplicably left blank.

This undermined the immediacy of the
rest of the work and diminished the illu-
sion of having transformed the brittle,
unforgiving marble into something
infused with life. Although it was not one
of Ives's commercially successful sculp-
tures, *The Truant* nicely mirrors the
Victorian predilection for sentimental
themes.

Notes

1. Gerdts 1973, pp. 134–135.
2. Tuckerman 1867, pp. 582–583.
3. "Fine Arts. The Ives Marbles," *New York
Tribune,* Jan. 23, 1872, p. 5.
4. "Mr. Ives's Statuary," *New-York Evening
Post,* Jan. 13, 1875, p. 4.
5. "Sale of Statuary," *New-York Daily Tribune,*
Jan. 15, 1875, p. 12. Curiously, Ives must have had
a second replica at the ready, since he sent
another copy of *The Truant* to an exhibition at

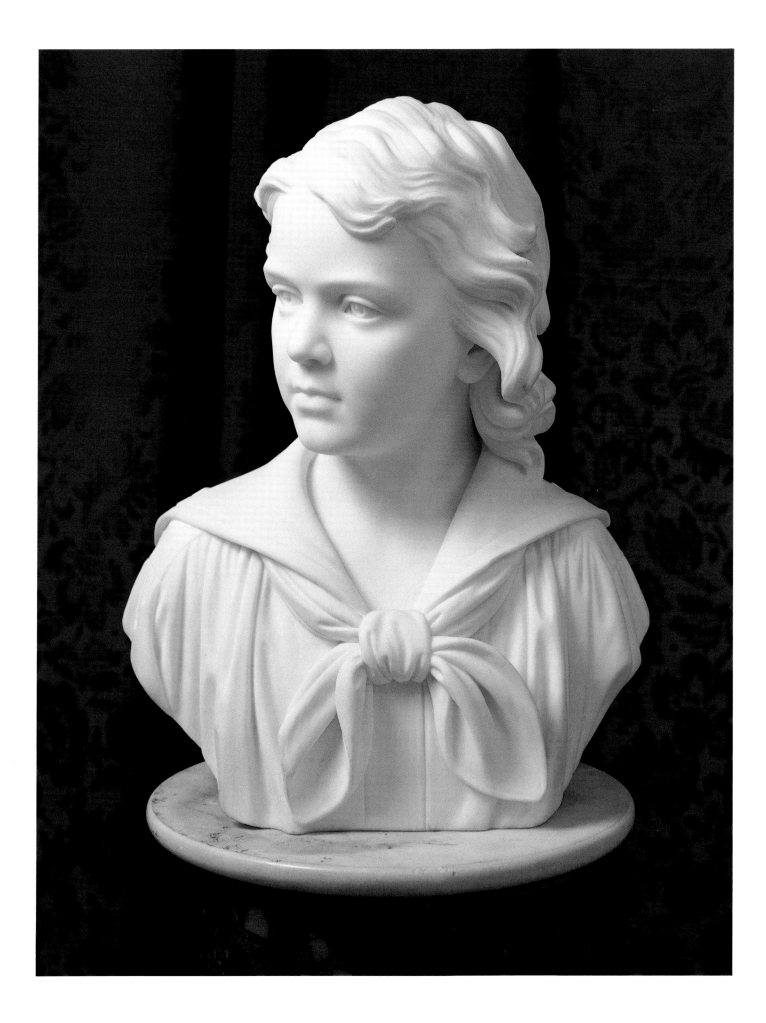

trusted staple in the sculptor's ongoing series of dispersal sales.

The existence of these generic sailor boys casts doubt on an early suggestion that the Newark Museum version was a portrait of one of the children of New Jersey Governor Marcus L. Ward, an esteemed patron of the arts.[5] Although the idea was circumstantially compelling since the sculpture was left to the museum by one of Ward's children, it was impossible to connect the bust to any of the Ward children through comparison with existing portraits. Ives's account book further discourages this hypothesis, since neither Ward nor his children ordered anything from Ives. Consequently, the origins of *The Sailor Boy* remain a mystery within the sculptor's oeuvre.

The Sailor Boy reveals a different side of Ives's artistic temperament. The work embodies a convincing naturalism that sets it apart from the ideal pieces and allies it with his portraits. He endowed his subject with a credible pug nose as well as fleshy cheeks and chin. These latter attributes, in conjunction with the ridged eyebrows, exhibit Ives's ability to replicate underlying bone structure. In persuading the viewer that marble has been transformed into flesh, Ives chiseled the pupils and irises of the eyes. A slight turn of the head helps make the boy seem alive and alert. The handling of the hair also contributes to this vivid image. It is thick and unruly, which would be typical for a boy of eight or nine. The wavy hair generates a pulsating rhythm; it augments the piece's visual energy and may even constitute a visual pun in its reference to an undulating sea.

Ives used details of costume to reinforce his quest for a convincing realism. The piped edge of the collar, the stars, and the applied shoulder band give the shirt a military appearance consistent with the title. The pliant folds of the shirt and the masterfully rendered knot of the kerchief demonstrate Ives's concerted effort to impart a satisfying tactile sensation. While the particularity of the boy's features and the meticulous rendering of the details of the costume suggest that *The Sailor Boy* was a portrait, its three nearly identical repetitions contradict this.[6] Why Ives neglected to refer to the sculpture in his account book cannot be explained, since he deliberately marketed it under its given title. Despite its problematic position within Ives's output, *The Sailor Boy* reflects the *Cosmopolitan Art Journal*'s admiration of the sculptor's portrait busts for their truthfulness and the "artist's own individuality impressed in the marble."[7]

Notes

1. "Sale of Statuary," *New-York Daily Tribune*, Jan. 15, 1875, p. 12.

2. "Mr. Ives's Statuary," *New-York Evening Post*, Jan. 15, 1875, p. 4.

3. Madison Square Art Rooms, New York, *Catalogue of Statuary of Mr. C. B. Ives, of Rome, Italy*, Nov. 15, 1885, lot 3.

4. 452 Fifth Avenue, New York, *Catalogue–Private Sale*, until Mar. 10, 1887, n.p., lot 1; "Art Notes," *Boston Daily Evening Transcript*, Mar. 19, 1887, p. 10.

5. William H. Gerdts, "Sculpture by Nineteenth-Century American Artists," *The Museum* (Newark), n.s., 14 (Fall 1962), 8.

6. Of the three busts that have come to light, only the Newark version differs in having blank eyes.

7. "Chauncey B. Ives," *Cosmopolitan Art Journal* 4 (Dec. 1860), 164.

27
Undine Rising from the Waters

Modeled ca. 1880–82

Marble

50⅝ × 12¾ × 15¾ in. (128.6 × 32.4 × 40 cm)

Inscribed at back left of base: C. B. IVES. / FECIT. ROMÆ

Provenance James H. Ricau, Piermont, N.Y., ca. 1985

Exhibition History *The Ricau Collection*, The Chrysler Museum, Feb. 26–Apr. 23, 1989

Literature "Art Treasures of N.Y.," *Fine Arts* 1 (Mar. 1872), 6; "The Note Book," *Art Amateur* 7 (Oct. 1882), 91; William H. Gerdts, "Marble and Nudity," *Art in America* 54 (May–June 1971), p. 65; Gerdts 1973, pp. 88–89; Kasson 1990, pp. 168–173

Versions MARBLE (life-size) National Museum of American Art, Washington, D.C.; (three-quarter life-size) Yale University Art Gallery, New Haven, Conn.; private collection, New York; [Spanierman Gallery, New York]

Gift of James H. Ricau and Museum Purchase, 1986.481

THE story of Undine can be traced to medieval legends. According to these tales, undines were Mediterranean sea spirits who were mortal but without souls. To gain a soul and immortality, an undine had to assume human form and trick a mortal into marrying her. She could then leave the sea, but only so long as her mate remained faithful. If he discovered her real identity and rejected her, she was obliged to destroy him.

In the nineteenth century, the story gained prominence through Baron Frederick Heinrich Karl de la Motte-Fouqué's novel *Undine*, which initially appeared in 1811. With its Northern European setting, the novel quickly achieved widespread popularity. Translated into English in 1814, it appeared in America in 1823 as *Undine, or the Spirit of the Waters, a Melodramatic Romance*. In this tragic story, Undine marries a mortal, Sir Huldebrand of Ringstetten, who eventually betrays her. To avenge her husband's infidelity, she is forced to take his life.

The tale's melodramatic content rendered it suitable for adaptation to opera. A production by the little-remembered Albert Lortzing (1801–1851) premiered in 1845 and enjoyed critical acclaim in America as early as 1856.[1] Since opera was an accessible form of entertainment in the nineteenth century, the story would have been familiar to a broad, cultured audience.

Artists were also attracted to the theme of Undine, and interpretations were before the public eye in America as early as 1850.[2] Although painters first addressed the subject, sculptors recognized the appeal of the story, as well. Ives was one of five Americans known to base works on Undine.[3] The others were Joseph Mozier (q.v.), Thomas Ridgeway Gould (1818–1881), Benjamin Paul Akers (1825–1861), and Louisa Lander (1826–1923). Only the efforts of Ives and Mozier have come to light.

With the possible exception of Akers's and Lander's unlocated sculptures, which are dated to about 1855 and 1858 respectively, Ives was the first to attempt the subject.[4] He created two separate versions, and at one time, Ricau owned examples of each, selling his initial version in the late 1980s (fig. 53).[5]

According to his account book, Ives finished his original *Undine* in 1859 for the eminent collector Marshall O. Roberts of New York. Roberts and his wife had commissioned Ives to create a full-length statue of their daughter Kitty in 1857, and satisfaction with its outcome prompted this subsequent order. After receiving *Kitty* in late 1858, Mrs. Roberts wrote an enthusiastic letter of gratitude and referred to the progress of *Undine:*

I trust that my Undine—tho' so widely different in every aspect from my pet Kitty—will be an *equal* success. I imagine the contrast will be a beautiful as well as a striking one. Do not forget my charges about the drapery, which must of necessity be light and flowing. I wish a happy medium maintained—that my fastidious friends may not have occasion to criticise severely.[6]

The figure's nudity was not an issue, since Mrs. Roberts embraced the current predilection for diaphanous drapery that had attracted such attention at the London

Crystal Palace Exhibition of 1851 in the work of the Italian Raffaele Monti (1818–1881).[7] The drapery of the initial version is much more classical in appearance than the later interpretation, and this may have established the appropriate decorous tone for the statue.

Undine arrived in New York in early 1860, and public reaction was favorable, as the press reported the piece was "etherial in contour, delicate in proportions, with lilies and other aquatic flowers at her feet, and that purity of air and expression we associate with a fair spirit of the waters."[8] Initial commercial response was enthusiastic. By 1865 a fourth replica, ordered by D. N. Crouse of Utica, New York, was on view at the Utica Mechanics' Association.[9]

This first version of Ives's *Undine* enjoyed a crescendo of exposure, and in 1872 it was exhibited with Mozier's tour de force in New York (fig. 54). Each work benefited from the installation, as one critic observed:

Both are strikingly lovely. The Undine of Moshier [*sic*] is veiled, as though by a mist rising from the fountain; the face and form are exquisite, distinctly visible through the misty veil which envelops them. The Undine of Ives represents the water-spirit, after love for Sir Hildebrand had inspired her soul, and she leaves her native element, standing proudly erect, while she casts aside the misty veil which had partially concealed the full radiance of her beauty. An expression of joy and triumph rests upon the half-parted lips, and the upraised arm and hand are of perfect symmetry.[10]

Despite the ongoing praise for this statue, only one more order for this initial version ensued. It was not until about 1880 that Ives commenced his second, far more remunerative interpretation.

In his account book Ives gives a date of 1880 in referring to the second version of *Undine*, but completing the new composition entailed an extended incubation period. In late 1882 a visitor to Ives's studio reported seeing the sculptor at work on the clay model of *Undine*, which was covered in wet muslin.[11] Ives was striving for the effect of wet drapery and remained mindful of the praise accorded Mozier's statue for its misty veiled effect.

Unlike *Pandora* (cat. no. 23), which underwent only minor modifications, Ives completely revamped *Undine* and even interpreted a different episode of the story. Rather than choosing the moment early in the story when Undine reveals herself to the noble Huldebrand from her island sanctuary and transforms from sprite to mortal, Ives selected the equally dramatic climax of the tale. He captured the tragic moment when Undine rises like a beautiful fountain from the well to seek revenge

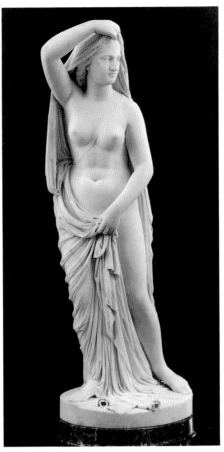

FIG. 53 Chauncey B. Ives, *Undine Receiving Her Soul* (1st version), 1859. Marble, 47¾ in. (121.5 cm) high. Private collection. Photograph courtesy of Russell E. Burke III, Inc.

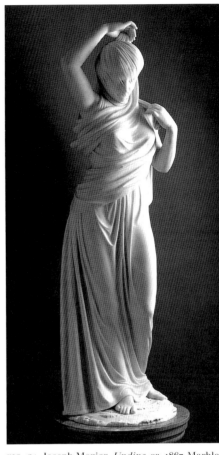

FIG. 54 Joseph Mozier, *Undine*, ca. 1867. Marble, 55 in. (139.7 cm) high. Collection of Jo Ann and Julian Ganz, Jr., Los Angeles

on her unfaithful husband. Water spirits were frequently pictured as dangerous creatures who inhabited streams, springs, rivers, lakes, and fountains, waiting to lure men with their songs and physical charms, but Ives avoided the theme of retribution or the menacing side of his heroine, and Undine wears an expression of sad resignation instead of anger.

The moralizing story of Undine combines the threat of a watery grave with the timeless story of the abandoned woman wreaking revenge on her wayward spouse. Unlike sirens and other water spirits who lure men to their deaths without cause, the vengeful death of Undine's husband was a moral lesson of infidelity punished. Ives, however, did not portray his Undine as vengeful but as victimized, tragically caught up in the web of her own fate.[12] This emotional restraint was consistent with a certain aspect of the classical canon, while the muted sentimentality appealed to the Victorian sensibility.

The beauty of *Undine*'s body is accentuated by her dress. The wet cloth of her garments clings to her body (fig. 55), reminiscent of the *Nike of Samothrace* (Musée

du Louvre, Paris). The delicate carving of the drapery folds and thinness of the marble cloak held high above her head recall the relief of *The Birth of Venus* (Terme Museum, Rome). Also known as the *Ludovisi Throne*, this work is one Ives would have encountered during his visits to Roman museums. The emulation of this diaphanous effect imparted far more sensuosity than the nudity of the earlier, more severe version.

Undine seems to float on air as she dances on the wavelets. Her pose and rapturous look connect the work to the Christian tradition of blessed souls rising to heaven on Judgment Day. The observing Christians among Ives's audience must have linked the figure's rapture to this Christian experience. Others, with more earthly interests, marveled at *Undine*'s physical charms cloaked in see-through fabric. Nevertheless, the thematic classical or Christian associations countered any prurient response.

Ives made at least ten replicas of *Undine*. Despite its popularity, *Undine* was not exempt from the effects of diminishing esteem for Ives's work. Its rejection was

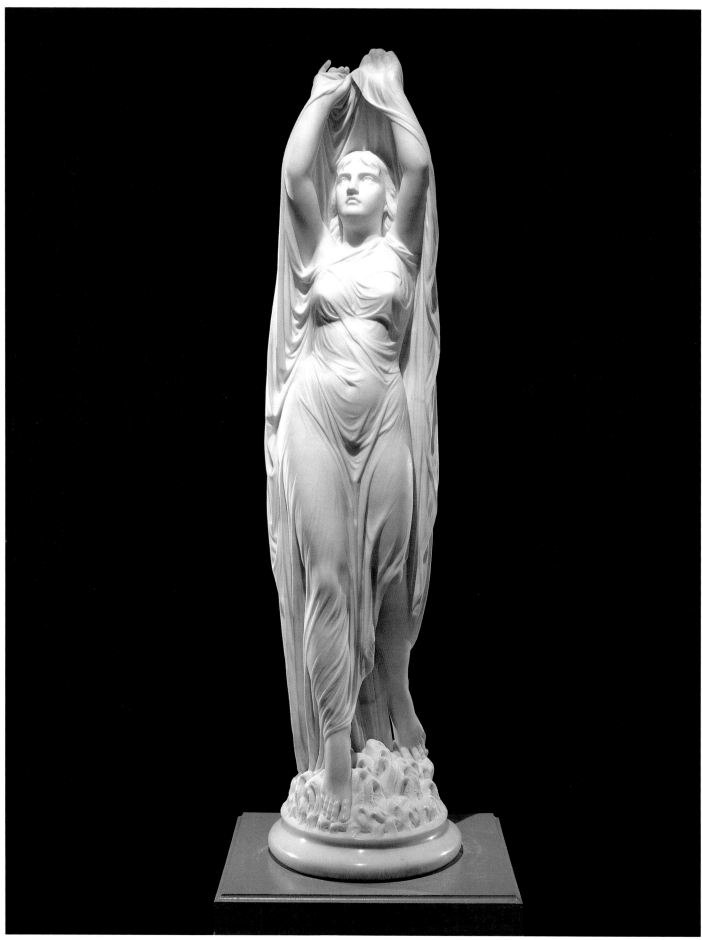

Cat. no. 27 Ives, *Undine Rising from the Waters*

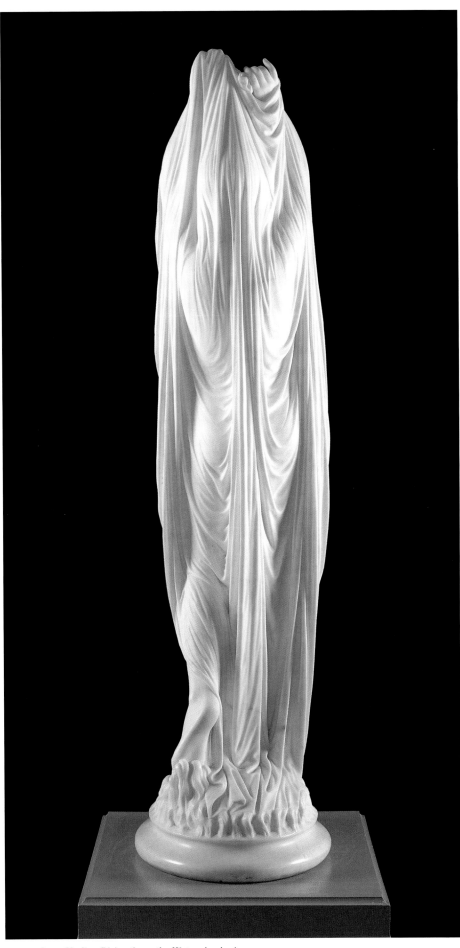

FIG. 55 Ives, *Undine Rising from the Waters*, back view

the most poignant, since the sculptor endured its failure in person. In 1891 he withdrew the statue from a sale in New York because the only bid did not even cover half the cost of the block of marble.[13] Nevertheless, the exceptional quality of the carving makes *Undine Rising from the Waters* one of the most beautiful pieces in the Ricau Collection.

Notes

1. Gerdts 1973, pp. 82–83, and "Sketchings. Domestic Art Gossip," *Crayon* 3 (Nov. 1856), 345.

2. A *Scene from Undine*, by Moritz Retzsch, was exhibited at the Albany Gallery of the Fine Arts in 1850; see Yarnall and Gerdts 1986, 4:2928.

3. Gerdts 1973, p. 89.

4. Jan Seidler Ramirez, "Benjamin Paul Akers," in BMFA 1986, p. 143, and Charlotte S. Rubinstein, *American Women Sculptors* (Boston, 1990), p. 60.

5. It is unclear why this version of *Undine* was not included in the transaction with The Chrysler Museum. I am grateful to Russell Burke for providing this information.

6. C. D. [Mrs. Marshall O.] Roberts, New York, to Ives, Nov. 29, 1858, Ives letters, 1858–83, AAA, roll 3154, frames 608–609.

7. Tallis, *The Crystal Palace* (New York and London, 1851), vol. 1, pt. 1, p. 41.

8. Z., "Letter from New York," *Boston Transcript*, Feb. 14, 1860, p. 1.

9. Yarnall and Gerdts 1986, 3:1904.

10. "Art Treasures of N.Y.," *Fine Arts* 1 (Mar. 1872), 6.

11. "The Notebook," *Art Amateur* 7 (Oct. 1882), 91.

12. Kasson 1990, p. 170.

13. "Art Gossip," *New York Evening Telegram*, Mar. 19, 1891, p. 5.

Joseph Mozier
American, 1812–1870

Joseph Mozier, a merchant-turned-sculptor, inspired divergent opinions. Lorado Taft, author of *History of American Sculpture*, pegged Mozier by including him in his chapter entitled "Some Minor Sculptors of the Early Days."[1] This crystallized the prevailing judgment, and little attention has been paid to Mozier since. In the same book, Taft commended the sculptor for his ability to render drapery and other details while finding him lamentably deficient in handling anatomy. This analysis echoed the reaction of Nathaniel Hawthorne, who was "indifferently impressed" by Mozier's work with the exception of "a smiling girl playing with a cat and dog, and a school-boy mending a pen" (cat. no. 33).[2]

Mozier's success as a businessman provided a financial security that obviated his dependence on portrait commissions and allowed him to concentrate on more ambitious ideal pieces. It was in this realm, however, that his work elicited the most serious reservations, yet he still attracted a coterie of enthusiastic admirers. Despite his stylized, almost formulaic approach, Mozier garnered considerable commercial and critical success because so many of his pieces interpreted popular literature.

Joseph Mozier was born in Burlington, Vermont, but grew up in rural Mount Vernon, Ohio, between Columbus and Akron. Details of his youth are sketchy, but he appeared destined for a career in commerce, and by 1834 he had moved to New York with his young wife, where he established himself as a partner and merchant in the wholesale dry-goods store of Tweedy, Mozier & Co.[3] While pursuing his business interests, Mozier became infatuated with art. In the fall of 1842 he visited Europe for the first time, ending the journey with visits to Florence and Rome.[4] Whether this was a reconnaissance mission for his forthcoming career change is not clear.

While Mozier was in Florence he met the sculptor Shobal Vail Clevenger (1812–1843). After Clevenger's untimely demise the following year, Mozier offered to coordinate an exhibition in New York to benefit the sculptor's widow. This included displaying the small-scale model of Clevenger's *Indian* to raise sufficient funds to have it translated into a life-size marble statue under the supervision of Hiram Powers (q.v.).[5] While this second part of the venture came to naught, the experience immersed Mozier in the world of art. He quickly amassed a substantial fortune, which permitted him to retire

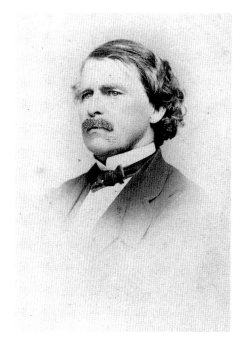

Photograph of Joseph Mozier. Photograph courtesy of the Archives of American Art, Smithsonian Institution

from the dry-goods business and realize his desire to become a sculptor.

In the late spring of 1845 Mozier and his family embarked for Europe, and by early July they were on the Continent. They gravitated toward Florence. Mozier's earlier association with Powers regarding the Clevenger sculpture influenced this decision, and the former merchant came armed with a bundle of Cincinnati newspapers to help renew the acquaintance. What commenced as a cordial friendship evolved into a complex relationship that ultimately disintegrated due to shared acerbic antipathy. Powers added Mozier to the lengthy list of sculptors whom he considered malefactors.[6] As the preeminent American sculptor of the day, Powers was the target of jealous rivals, but his own capacity for abrasiveness complicated matters, as well.

When Mozier first approached him, Powers was most accommodating and offered the fledgling sculptor instruction and advice. He even assisted with the modeling of Mozier's first attempt, a bust of his young daughter Isabelle. Whether it was ambition or aptitude, Mozier made rapid progress, and in the fall of 1846 he secured orders for busts of Mr. and Mrs. Asaph G. Stone of New York as well as an ideal bust of Pocahontas from the same patrons (PIBM).[7] All three works were exhibited at the National Academy of Design in 1848, where the portraits were

pronounced "excellent," while *Pocahontas* was deemed "a pretty, ideal head."[8]

By the winter of 1847, Mozier reported he was busy with portrait commissions at fifty pounds a bust and that he had just received a fifth order for his *Pocahontas* at the same price.[9] Relapsing to his former mercantile ways, he admitted the price of the latter was "more than the merit of the thing deserves."[10] Mozier also indicated he had been asked to create a companion bust for *Pocahontas*, but, if completed, it has eluded identification. Mozier spent the balance of the decade creating portrait and ideal busts, which served more as an apprenticeship than a source of income. Several portrait commissions stemmed from a visit to America in 1849, when he was appointed U.S. consul at Ancona, Italy. These sculptural efforts were well received. Mozier was commended for the fidelity of his portrait busts and for introducing more complex draperies into his female busts, which enlivened the severity of the antique form.[11]

In 1850 Mozier received a highly complimentary review of his ideal bust *The Star Gem'd Aurora*, which Ogden Haggerty lent to the National Academy of Design that spring. The writer for the *Literary World* proclaimed it the sculptor's best effort and likened Mozier's style and manner of work to those of Hiram Powers, especially the latter's *Proserpine*.[12] This proved a bittersweet analogy for Mozier, given the hostile campaign of denigration he was mounting against his former mentor.

Perhaps prompted by the growing animosity toward Powers, Mozier moved to Rome in late 1850. By this time, he had begun his first full-length figure, *Rebecca at the Well* (cat. no. 28), and reported in June 1851 that he had received two orders for it, as well as several other commissions.[13] Within three years, several of the sculptor's full-length ideal works and busts, including *Pocahontas* (cat. no. 29), *Silence* (cat. no. 30), and *Daphne*, were being discussed in the press.[14] *Silence* and its companion piece, *Truth* (cat. no. 31), were presented to the New York Mercantile Library by Henry A. Stone. These imposing statues constituted Mozier's first representation in a public institution. Mozier had belonged to the library during his merchant days, and he thought the sale sufficiently important to warrant his presence at the unveiling.[15]

By the second half of the decade, Mozier's relentless productivity became apparent. In February 1857 the *Home Journal* carried a notice about photographs of four works in progress: *Boy Mending a Pen* (*Young America*, cat. no. 33); *Girl with a Melodeon*; *The Indian*

Girl's Lament, from Bryant's poem (Hearst Castle, San Simeon, Calif.); and *The Prodigal Son* (fig. 56).[16] In addition to partially clarifying questions of chronology, this selection encapsulates the divergent paths of Mozier's subject matter.

Mozier's group of the *Prodigal Son* earned the begrudging admiration of Nathaniel Hawthorne, who generally disliked the sculptor's more imposing subjects.[17] The piece received considerable notice in the contemporary press; one early critique commended it as a fine work of art but took exception to the sculptor casting the son as an adolescent rather than a young man.[18]

In 1859 the *Art Journal* published a substantial discussion of the author and the figural pair, which provided Mozier much coveted international coverage.[19] The article referred to Mozier as a man of independent means, "who follows Art more from love of it than as a profession." Despite the implication of an amateur status, the critic connected him with the group of artists in Rome that was contributing to the growing appreciation of the arts in America. Formally, the author assigned *The Prodigal Son* to the naturalistic school, observing that nature rather than antiquity served as Mozier's guide. This reaction was generated by the profusion of detail and the deeply felt pathos of reconciliation. Indeed, the sentiment imparted by the group contributed significantly to the widespread opinion that *The Prodigal Son* was Mozier's most important work. This attitude persisted when Mozier exhibited the group in New York in 1866.[20] This assessment also endured in posthumous analyses.[21] Curiously, *The Prodigal Son* did not galvanize demand for Mozier's works, and it was not purchased until 1869, when J. Gillingham Fell acquired it for the Pennsylvania Academy of the Fine Arts.

While Mozier was working on *The Prodigal Son*, he completed a companion piece to his popular *Pocahontas*, entitled *The Wept of Wish-ton-Wish*, based on the novel by James Fenimore Cooper (cat. no. 32). The sculptor continued his commitment to biblical subjects with a rendition of Queen Esther, which a visitor to his studio noticed in 1859.[22] Created for a patron in New York, it received advance notice, and the critic for the *Home Journal*, responding to the photograph of the sculpture Mozier sent him, informed his readers that the piece

represents her [Esther] as she comes, uncalled, into the presence of Ahasuerus, robed in the dress most becoming to her beauty, to plead against the fatal order of Haman, which she holds in her hand. Her life and that of the whole

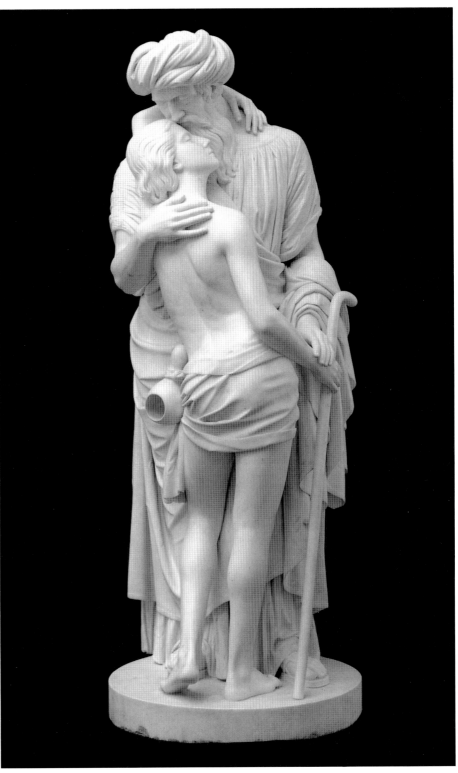

FIG. 56 Joseph Mozier, *The Prodigal Son*, ca. 1845–57. Marble, 76 in. (193 cm) high. Courtesy of the Pennsylvania Academy of the Fine Arts, Philadelphia, Gift of J. Gillingham Fell, 1869.2

of her despised race depends on her pleasing the king's eye; and that dress, of course, is to be a turning point in history.[23]

The author believed the design and arrangement of the drapery relegated the figure to secondary importance. Mozier continued to be haunted by the observation that inconsequential details overshad-

owed the more compelling sculptural aspects of the figure and its conception.

The final decade of Mozier's abbreviated career witnessed the sculptor's ongoing alternation between literary and biblical subjects. In the wake of *Queen Esther*, he commenced *The Peri* (Mount Olivet Cemetery, Nashville, Tenn.), an exotic variation on the angelic theme.[24] Inspired

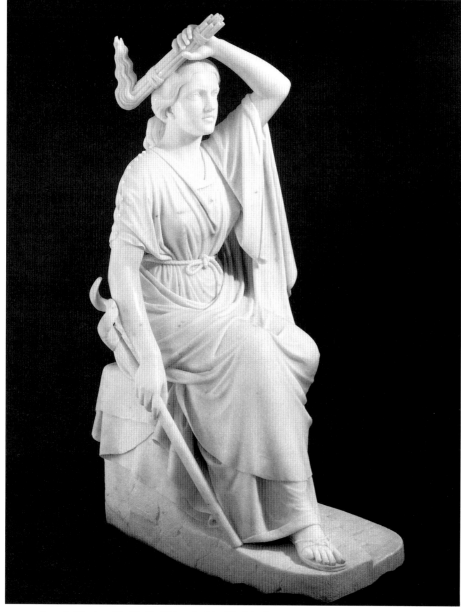

FIG. 57 Joseph Mozier, *The Vigil of Rizpah*, 1869. Marble, 60 in. (152.4 cm) high. Courtesy of Spanierman Gallery, New York

sculptor may not have realized it, this exhibition of seven works displayed at the Tenth Street Studio Building was to be the last concentrated display of his sculpture in his lifetime. Five of the seven pieces were already known to the public. In addition to *The Prodigal Son, Pocahontas, The Wept of Wish-ton-Wish, The Peri,* and *Jephthah's Daughter,* the sculptor introduced his *Penseroso* (NMAA), inspired by John Milton's poem of 1652, and *Undine Rising from the Castle Well* (Collection of JoAnn and Julian Ganz, Jr.), taken from Baron de la Motte-Fouqué's romance (fig. 54).

The collection received mixed reviews. The critic for the *Round Table* considered *Jephthah's Daughter* the most attractive piece in the group, calling it a creation of "exquisite beauty and grace."[26] This author also singled out *Undine,* marveling at the skill, albeit mechanical, of rendering the transparent veil, yet arguing that Mozier had not captured the essence of the subject. While recognizing technical merit, the writer thought Mozier's work was devoid of originality. Mozier had no intention of taking these works back to Italy and arranged to have them auctioned after the exhibition closed. Nothing is known of the sale's results.[27]

Mozier never penetrated the first rank of sculptors but did merit brief acknowledgment in Tuckerman's *Book of the Artists,* which first appeared in 1867.[28] The author mentioned two recent designs, *The White Lady of Avenel* (cat. no. 34), taken from Sir Walter Scott, and *The Vigil of Rizpah* (fig. 57), which interpreted a passage from the second book of Samuel. Tuckerman described *Rizpah* as a seated figure, holding a torch in her upraised right hand as if to peer into the gloom. A visitor to Mozier's studio in 1868 noted that *Rizpah* was much admired in England.[29] However, the work rapidly lost its luster. A notice of the posthumous auction of the sculptor's work held in New York in 1873 deemed it "more ambitious in purpose than prosperous in result."[30] Taft considered it the nadir of Mozier's career, marred by the ineptitude of the figure. Mozier's creative shortcoming, a pursuit of the literal, continued to undermine the nobility of concept.

In his quest for a convincing naturalism, Mozier, under the influence of the esteemed British sculptor John Gibson (1790–1866), experimented with tinting some of his sculptures. One of Mozier's patrons lent a tinted work, entitled *Spring* (The Hudson River Museum, Yonkers, N.Y.), to the 1866 exhibition at the Pennsylvania Academy of the Fine Arts with little apparent reaction.[31] Mozier also had colored versions of *The Wept*

by "Paradise and the Peri" in Thomas Moore's poem *Lalla Rookh* (1817), the subject refers to this fallen angel's attempt to reenter Paradise, which she does by bringing God the tears of a repentant old man. The subject may have been inspired by Thomas Crawford's effort of 1855 (CGA), but stylistically *The Peri* departed from a commitment to classical grace and restraint and assumed a more baroque spirit. The ample proportions of the female form, the illusion of the tears on the angel's hand, and the segment of a visually arresting corkscrew column, serving as support, confirm this shift in attitude.

Although his success was personally fulfilling, Mozier aspired to place his reputation in a more universal context and sent four works to the International Exhibition

in London in 1862. He included *The Wept of Wish-ton-Wish, The Indian Girl's Lament, Queen Esther,* and *Jephthah's Daughter.* All but *Queen Esther* were reproduced in an article reviewing the modern sculpture in the exhibition. The critic thought highly of *Queen Esther* and *Jephthah's Daughter* while observing that the form of *The Wept of Wish-ton-Wish* went counter to the dictum of "equanimity," which Winckelmann had determined was inherent in the noble art of sculpture.[25] Once again, Mozier was guilty of undue concern with the inconsequential at the expense of more profound aspects of sculptural expression.

Mozier kept his work before the American public and organized a solo show in the fall of 1866. Although the

of *Wish-ton-Wish*, which were generally unfavorably received. One observer hedged, contending that tinting enhanced the costume and legs but compromised the anxiety of the facial expression.[32] A posthumous assessment was less equivocal. The author considered the attempts of Gibson, whom he admired, a lamentable failure, and asserted that the lesser talents of Mozier created an effect commensurate with a tobacconist's sign.[33]

Mozier's activities were seriously curtailed in the late 1860s owing to his declining health. He made one final visit to America in 1870, but on his way back to Rome, illness forced him to interrupt his journey while in London. Although realizing his prospects for recovery were hopeless, Mozier determined to set out for Rome in his weakened condition, believing he could sleep well only under the Roman cypresses.[34] He died en route in Faido, Switzerland, and was buried in the Testaccio Cemetery in Rome.

Although Joseph Mozier was not a sculptor of genius, he earned genuine respect as a gifted and skillful artist with a serious sense of purpose. His work was appreciated by a wide circle of discriminating patrons, and he could take pride in his commercial success. His pragmatic nature, reinforced by positive financial results, enabled him to endure limited critical endorsement. On a personal level, Mozier was multifaceted. He was guilty of professional jealousy, primarily directed at Hiram Powers. But those individuals who knew him in a different light considered Mozier a genial, generous friend always willing to help those in need. Even Nathaniel Hawthorne, who counted Powers among his loyal friends, could not deny Mozier's appealing character.

Notes

1. Taft 1924, pp. 109–112. For the most recent accounts of Mozier, see A. A., "Mozier" (1954), and Wilmerding et al. 1981.

2. Hawthorne 1858, pp. 148–149.

3. One early account indicated that Mozier moved to New York around 1831, but he does not appear in a city directory until 1834; see *Longworth's American Almanac, New-York Register, and City Directory* (New York, 1834), p. 685.

4. Passport for Joseph Mozier issued Sept. 24, 1842, no. 948, Passport Applications, 1795–1905, *National Archives Microfilm Publication M 1372*, roll 12, General Records of the Department of State, Records Group 59, National Archives, Washington, D.C. I am grateful to Col. Merl Moore, Jr., for this information.

5. Wunder 1991, 1:135.

6. Ibid., pp. 153–155.

7. This commission is referred to in a letter from Mozier to James Cameron, Oct. 5, 1846,

Cameron papers, Mills College, Oakland, Calif., AAA, roll 2294, frames 1233–1234.

8. Cowdrey 1943, 2:45. Notice of the busts appeared in "National Academy of Design. Twenty-third Annual Exhibition. Eighth Visit," *New-York Evening Post*, June 21, 1848, p. 2. This was not his maiden showing at the academy, since he had exhibited two marble busts the previous year, one of which was lent by another patron, Mr. J. L. Locke.

9. In the nineteenth century the English pound served as international currency, and one pound sterling was equivalent to about five U.S. dollars.

10. Mozier to Cameron, Apr. 9, 1847, Cameron papers, Mills College, Oakland, Calif., AAA, roll 2294, frames 1236–1239.

11. "The Fine Arts," *Literary World*, Mar. 17, 1849, p. 254.

12. "The Fine Arts. The National Academy of Design," *Literary World* 6 (May 1850), 497.

13. Reported in a letter from Mozier to his patron Asaph G. Stone, initially published in the *Christian Inquirer* (n.d.) and reprinted in the column "American Artists Abroad," *Bulletin of the American Art-Union*, June 1851, pp. 49–50.

14. Florentia 1854, p. 185, and Greenwood 1854, p. 222.

15. "Sketchings. Domestic Art Gossip," *Crayon* 2 (Oct. 1855), 233.

16. "Mere Mention. Four Photographs of Moziers," *Home Journal*, Feb. 14, 1857, p. 3.

17. Hawthorne 1858, pp. 148–150.

18. "Foreign Correspondence," *Cosmopolitan Art Journal* 1 (June 1857), 121.

19. "*The Prodigal Son*. From the Group by J. Mozier," *Art Journal* (London), n.s., 5 (1859), p. 124.

20. "Art Matters," *American Art Journal* 5 (Oct. 18, 1866), 408.

21. Clark 1878, p. 120, and Taft 1924, p. 110.

22. Fuller 1859, p. 270.

23. "Miss Stebbins's Nationality of Genius," *Home Journal*, July 23, 1859, p. 2.

24. Gerdts 1973, pp. 76–77.

25. Atkinson 1863, p. 322.

26. "Art. The Picture Galleries," *Round Table*, Nov. 3, 1866, p. 227.

27. "Fine Art Items. Mozier's Statuary," *New-York Evening Post*, Nov. 7, 1866, p. 1.

28. Tuckerman 1867, pp. 590–591.

29. Brewster 1869, p. 197.

30. "Art. The Mozier Marbles," *New-York Daily Tribune*, Mar. 17, 1873, p. 5.

31. Rutledge 1955, p. 147. The original catalogue apparently distinguished between the tinted and untinted work.

32. Brewster 1869, p. 197.

33. "The Mozier Marbles," *Daily Tribune*, Mar. 17, 1873, p. 5.

34. "Obituary. Joseph Mozier," *Art Journal* (London), n.s., 10, 33 (Jan. 1, 1871), 6.

Bibliography

"Our Artists in Florence," *Literary World* 6 (Feb. 16, 1850), 157; "American Artists Abroad," *Bulletin of the American Art-Union*, June 1851, pp. 49–50; Florentia 1854, p. 185; Greenwood 1854, p. 222; Hawthorne 1858, pp. 148–150; Fuller 1859, pp. 270–271; Atkinson 1863, pp. 313–324; "Art Matters," *American Art Journal* 5

(Oct. 1866), 408; Tuckerman 1867, pp. 590–591; James H. Hopkins, *European Letters to the Pittsburgh Post, 1869–70* (Pittsburgh, Pa., 1870), pp. 82–85; "Obituary. Joseph Mozier," *Art Journal* (London), n.s., 10, 33 (Jan. 1, 1871), 6; Rodman J. Sheirr, "Joseph Mozier and His Handiwork," *Potter's American Monthly* 6 (Jan. 1876), 24–28; Clark 1878, pp. 120–121; Huidekooper 1882, pp. 182–183; Taft 1924, pp. 109–112; A. A., "Joseph Mozier," *Dictionary of American Biography* (New York, 1954), 7:503–504; Dentler 1976, p. 39; Wilmerding et al. 1981, pp. 153–154; Hyland 1985, pp. 266–269

28

Rebecca at the Well

Modeled ca. 1849, carved 1855
Marble
59 × 19⅜ × 16½ in. (149.9 × 49.2 × 41.9 cm)
Inscribed on right edge of wall: *J. Mozier Sc. / Rome. 1855.*

Provenance [auction, New York, after 1958]; James H. Ricau, Piermont, N.Y., before Dec. 1967

Exhibition History *The Ricau Collection*, The Chrysler Museum, Feb. 26–Apr. 23, 1989

Literature "American Artists in Italy," *Literary World* 5 (May 26, 1849), 458; Fuller 1856, p. 371; "Our Artists in Florence," *Literary World* 6 (Feb. 16, 1850), 157; "American Artists in Florence," *Home Journal*, Aug. 31, 1850, p. 3; "Bits Too Good to Be Lost," *Home Journal*, Nov. 23, 1850, p. 2; "Sketchings. Domestic Art Gossip," *Crayon* 4 (Apr. 1857), 123; "The Fine Arts. Mr. R. L. Stuart's House and Art Collection," *Home Journal*, Apr. 2, 1859, p. 2; Fuller 1859, pp. 270–271; Tuckerman 1867, p. 591; "What Americans Are Doing in Rome," *Boston Daily Evening Transcript*, Jan. 22, 1869, p. 1; *Art Journal* (London), n.s., 9 (1870), 78; "Art," *New-York Evening Post*, Mar. 14, 1873, p. 2; "Art. The Mozier Marbles," *New-York Daily Tribune*, Mar. 17, 1873, p. 5; Clark 1878, p. 120; Huidekooper 1882, p. 182; Waters and Hutton 1894, 2:155; Taft 1924, p. 109; A. A., "Joseph Mozier," *Dictionary of National Biography* (New York, 1954), 7:504

Versions MARBLE The New-York Historical Society; Crocker Art Museum, Sacramento, Calif.

Gift of James H. Ricau and Museum Purchase, 86.492

BIBLICAL themes began to challenge subject matter from antiquity as preferred sources for sculpture in the mid-nineteenth century. The Old Testament

heroine Rebecca, wife of Isaac and mother of Jacob and Esau, was a perennial favorite among American neoclassical sculptors.[1] She appears in Genesis 24:1–28, when Abraham's servant Eliezer, seeking a wife for his master's son, Isaac, travels to the city of Nahor. There, kneeling beside a well, Eliezer prays that the first woman who gives him a drink from her pitcher will be the bride God has chosen for Isaac. He then meets Rebecca, who gives him a drink and, in so doing, reveals herself as Isaac's divinely chosen wife. The inherent appeal of the story gained added resonance through its association with the search for and discovery of an ideal mate.

Rebecca at the Well was Joseph Mozier's first attempt at a full-length figure, begun while he was still in Florence. Margaret Fuller, writing to the *New-York Tribune* in early 1849, included a complimentary discussion of Mozier's portrait and ideal busts and mentioned that he had modeled a *Rebecca*, which she had not seen.[2] Work on *Rebecca* was interrupted by Mozier's return to New York in the spring of 1849, where he secured some portrait commissions. It was not until February 1850 that he gave a personal report on his progress:

I am at last busy on my statue of "Rebecca." It is my first attempt at a life-size figure, but I have had this subject so long in my mind, and have made so many small studies of it, that I anticipate no great difficulty in working it up to my conception of the character. I am trying to represent her at the moment she is first accosted at a distance by the messenger of Abraham, who finds her at the well with her pitcher on her shoulder, filled with water. Her step is stayed and her eye arrested by the servant's salutation as he ran to meet her, saying, "Let down thy pitcher, I pray thee, that I may drink."[3]

Of particular interest is the revelation that Mozier made numerous small preparatory studies to help shape his final interpretation; unfortunately, none of these is known to have survived. Work on *Rebecca* proceeded briskly, and by late summer the sculptor reported he was ready to turn the model over to the *formatore* to have it cast in plaster.[4] Consistent with his business acumen, Mozier intended to send drawings or daguerreotypes of *Rebecca* to New York to advertise the work.

The sculptor's move to Rome in 1850 further hindered his progress. The decision to relocate was a good one, and by his own account, Mozier waxed enthusiastic about the merits of the Eternal City.[5] He admitted that because of his move he had done little work during the winter except for producing a few busts and beginning one or two ideal pieces. Mozier noted he had received two orders for

Rebecca. These orders and several other commissions would keep him and his assistants occupied for at least a year.

No records have come to light to reveal who commissioned these first two replicas, but references to two owners are known. A notice in the April 1857 issue of the *Crayon* mentioned that a J. Cameron Stone had recently purchased a copy of Mozier's *Rebecca*.[6] Two years later, the *Home Journal*, in an article on architectural taste, discussed the house and collection of the renowned art patron Robert L. Stuart and mentioned he possessed "a figure of Rebecca, by Mozier—a work of great merit" (N-YHS).[7]

Rebecca's imposing quality exemplifies Mozier's heavy, stalwart figure style and his initial taste for broadly massed drapery patterns. He offset the planar aspect of the outer garment with a detailed floral and foliage design in the hem, a device reiterated by the Greek-key pattern in his subsequent statue *Silence* (cat. no. 30). The increasingly intricate handling of the dress beneath the outer robe anticipates the direction Mozier's abilities with drapery would take. The garment falls to her ankles in what one commentator was later to call a system of "corrugated folds."[8] In her left hand, Rebecca holds a sash that secures the inner garment and convincingly intertwines with the fringe of her tassel.

While signaling his penchant for detail, Mozier also displayed sensitivity to the human form, which he neglected after his move to Rome in 1850. Rebecca's facial features are refined and natural with evidence of bone structure as well as individuality and dignity of expression. Mozier established an ideal of beauty blended with anatomical accuracy, which extended to other parts of the body. The arms possess a convincing articulation and skeletal structure. He was not entirely successful, however. The middle toes of the right foot are awkwardly executed, and Rebecca's hair rests on her head like a helmet, bearing out later criticism that this feature in his works was generally too heavy and solid.[9] The handling of the coiffure at the back is more successful. Mozier resolved the fall of hair with a twisted loop terminating in a coil secured by a delicate ribbon.

As a full-length sculpture, this was an ambitious first effort. Mozier understood the engineering requirements and nicely integrated the masonry edge of the well as the structural support for the sculpture, which also provided a sense of place. Conversely, the placement of the pitcher on Rebecca's left shoulder eluded a fully satisfactory solution. Rebecca's right hand

fails to grasp the handle of the pitcher convincingly, and the vessel rests weightlessly on her left shoulder, generating no pressure on the skin.

Formally, *Rebecca at the Well* stands apart from the rest of Mozier's oeuvre. Although the drapery is blocky, the figure imparts an elegance and human quality that reflect his Florentine sojourn steeped in the emphasis placed on naturalism by sculptors such as Lorenzo Bartolini (1777–1850), Horatio Greenough (1805–1852), and Hiram Powers (q.v.).

While early response to *Rebecca at the Well* was positive, reaction evolved into oblique assessments. A commentary on artistic activity in Rome in 1870, published in the *Art Journal*, admired Rebecca's lovely countenance, which the critic observed could be interpreted as saying, "My face is my fortune."[10] This intriguing insight places great emphasis on superficial criteria and, depending on the reading of "fortune," casts Rebecca as a calculating opportunist, which is alien to any traditional reading. A later observation in the notice of the posthumous exhibition and sale of the contents of Mozier's studio was less flattering, since the author deemed Rebecca "haughty and imperious."[11] Whatever the reaction, Mozier undeniably imbued *Rebecca* with a sense of remoteness possibly intended to denote shyness. Subsequent mentions in literature on American sculpture simply listed *Rebecca at the Well* as part of Mozier's output without commentary. As Mozier's reputation was eclipsed in America, so was his earliest full-length figure.

Notes

1. Gerdts 1973, pp. 68–69.
2. "American Artists in Italy," *Literary World*, May 26, 1849, p. 458. This article was a reprint of a letter by Margaret Fuller originally published in the *Tribune*, datelined Rome, Mar. 20, 1849.
3. "Our Artists in Florence," *Literary World* 6 (Feb. 16, 1850), 157. This letter from Mozier originally appeared in the *Home Journal*. It was reprinted in "Notes and Opinions. American Artists Abroad," *Bulletin of the American Art-Union*, Apr. 1, 1850, p. 15.
4. "American Artists in Florence," *Home Journal*, Aug. 31, 1850, p. 3.
5. "The Chronicler," *Bulletin of the American Art-Union*, June 1851, pp. 49–50. The lengthy account was a reprint of a letter from Mozier that initially appeared in the *Christian Inquirer*.
6. "Sketchings. Domestic Art Gossip," *Crayon* 4 (Apr. 1857), 123.
7. "The Fine Arts," *Home Journal*, Apr. 2, 1859, p. 2. The article mentioned that Robert L. Stuart also owned an *Isaac* by Randolph Rogers (q.v.), which would be the first version.
8. "Art Matters," *American Art Journal* 5 (Oct. 18, 1866), 408.
9. Ibid.

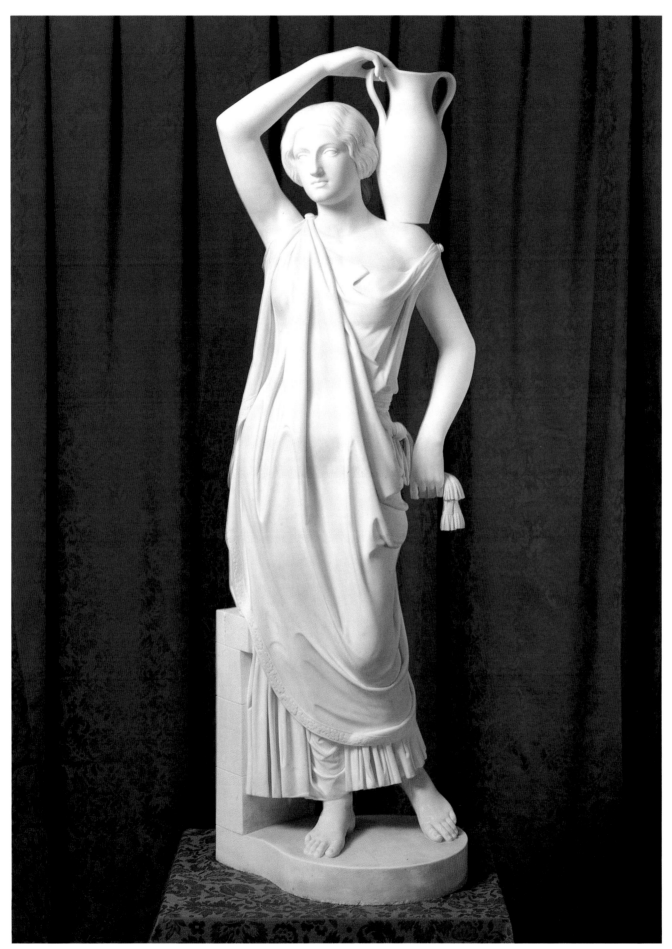

Cat. no. 28 Mozier, *Rebecca at the Well*

10. *Art Journal* (London), n.s., 9 (1870), 78. The author observed incorrectly that *Rebecca* was one of Mozier's more recent statues.

11. "Art. The Mozier Marbles," *New-York Daily Tribune*, Mar. 17, 1873, p. 5.

29
Pocahontas

Modeled ca. 1850, carved 187_ (date not completed)
Marble
48½ × 19 × 16⅞ in. (123.2 × 48.3 × 42.9 cm)
Inscribed at left of base: J. MOZIER. SC: / ROME 187_ ; on front of shield-shaped base: POCAHONTAS

Provenance [unidentified art gallery, University Square, New York); James H. Ricau, Piermont, N.Y., by Dec. 1967

Exhibition History *The Ricau Collection,* The Chrysler Museum, Feb. 26–Apr. 23, 1989; *Pocahontas: Her Life and Legend,* Virginia Historical Society, Richmond, Oct. 15, 1994–Apr. 30, 1995

Literature Florentia 1854, p. 185; Fuller 1856, p. 371; Hawthorne 1858, p. 148; C., "Fine Arts Exposition," *Boston Daily Evening Transcript,* May 28, 1859, p. 1; "The Prodigal Son. From the Group by J. Mozier," *Art Journal* (London), n.s., 5 (1859), 124; Fuller 1859, pp. 270–271; L., "Philadelphia Art Notes," *Round Table,* July 9, 1864, p. 59; "Mozier's Sculptures," *New-York Evening Post,* Oct. 16, 1866, p. 2; "Art Matters," *American Art Journal* 5 (Oct. 1866), 408; "Art. The Picture Galleries," *Round Table,* Nov. 3, 1866, p. 227; Tuckerman 1867, p. 591; "The Death of Joseph Mozier," *New-York Evening Post,* Oct. 22, 1870, p. 2; "Obituary. Joseph Mozier," *Art Journal* (London), n.s., 10, 33 (Jan. 1, 1871), 6; *Coldwater (Michigan) Republican,* Aug. 10, 1872, n.p.; Rodman J. Sheirr, "Joseph Mozier and His Handiwork," *Potter's American Monthly* 6 (Jan. 1876), 26–27; Clark 1878, p. 120; Huidekooper 1882, pp. 182–183; Waters and Hutton 1894, 2:135; Taft 1924, p. 109; A. A., "Joseph Mozier," *Dictionary of National Biography* (New York, 1934), 7:504; Gerdts 1973, pp. 130–131, ill. p. 131, 142–143, ill. p. 143; Carole Simon Drachler, "The Gallery and Art Collection of Henry Clay Lewis" (Ph.D. diss., University of Michigan, 1980), p. 162; Soria 1982, p. 206; Menconi 1982, pp. 26–27; Kasson 1990, pp. 93–94; William H. Truettner, "Prelude to Expansion: Painting the Past," in *The West as America: Reinterpreting Images of the Frontier,* exh. cat., National Museum of American Art (Washington, D.C., 1991), p. 83; William M. S. Rasmussen and Robert S. Tilton, *Pocahontas: Her Life and Legend,* exh. cat., Virginia Historical Society (Richmond, Va., 1994), pp. 26–27, ill.; Robert S. Tilton, *Pocahontas: The Evolution of an American Narrative* (Cambridge, Mass., 1994), pp. 127, 129, ill.

Versions MARBLE Museum of Fine Arts, Boston; J. V. Fletcher Library, Westford, Mass.; Mr. Joseph M. Napoli, Brooklyn, N.Y.; private collection, Louisiana; [Hirschl & Adler Galleries, New York]

Gift of James H. Ricau and Museum Purchase, 86.493

Pocahontas, along with its companion piece, *The Wept of Wish-ton-Wish* (cat. no. 32), are two of the four sculptures in the Ricau Collection devoted to American Indian themes. The virtuous Indian woman was a popular topic for America's neoclassical sculptors. Male Indians were occasionally depicted as murdering savages, epitomized in Horatio Greenough's (1805–1852) *Rescue* for the United States Capitol. Sometimes sculptors viewed the males as heroic victims of the encroaching white civilization, exemplified in Peter Stephenson's *Wounded Indian* (cat. no. 46). They tended to view the female Indians more sentimentally, portraying them as pious innocents receptive to white culture and amenable to conversion to Christianity.

Pocahontas (1595–1617) was the Indian princess who allegedly saved the life of Captain John Smith at the moment of his intended execution by her father, Powhatan. She later embraced the Christian faith, took the name Rebecca, and married the colonist John Rolfe. Moving to England in 1616, she initially attracted great attention, but within a year, neglected and impoverished, she died. The events surrounding the lives of Pocahontas and her father received considerable artistic attention in the mid-nineteenth century, most notably in John Gadsby Chapman's (1808–1889) large painting *The Baptism of Pocahontas at Jamestown, Virginia, 1613,* which he completed in 1840 for the rotunda of the United States Capitol.[1] Chapman was one of the artists Joseph Mozier befriended when he moved to Rome in 1850.

Pocahontas interested Mozier from the outset of his career, and she constituted one of his earliest attempts at an ideal bust (PIBM). The sculpture enjoyed immediate commercial success as well as favorable notice at the National Academy of Design in 1848. Margaret Fuller was impressed by the work when she visited the sculptor's studio in March 1849. She was less taken with it as an ethnographic likeness but admired it for "the union of

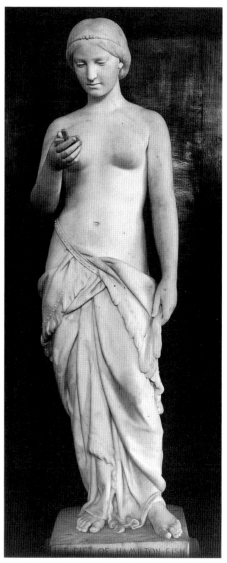

FIG. 58 Erastus Dow Palmer, *The Indian Girl* or *The Dawn of Christianity,* modeled 1853–56, carved 1856. 59½ in. (151.1 cm) high. The Metropolitan Museum of Art, Gift of the Hon. Hamilton Fish, 1894. (94.9.2)

sweetness and strength with a princelike, childlike dignity, very happily expressive of his idea of her character."[2] The sculptor took Fuller's praise seriously, and in his more ambitious full-length version he strove to incorporate the characteristics she articulated.

Mozier began work on the full-length *Pocahontas* soon after moving to Rome. It was translated into marble by 1854 when a correspondent for the *Art Journal* reported on her visit to his studio.[3] The author provided her readers with a full account of Pocahontas's deeds and commended the new work as "full of deep sentiment and unaffected purity, with a striking originality as to costume and treatment." The article interpreted the sculpture as depicting the moment of Pocahontas's spiritual conversion, when

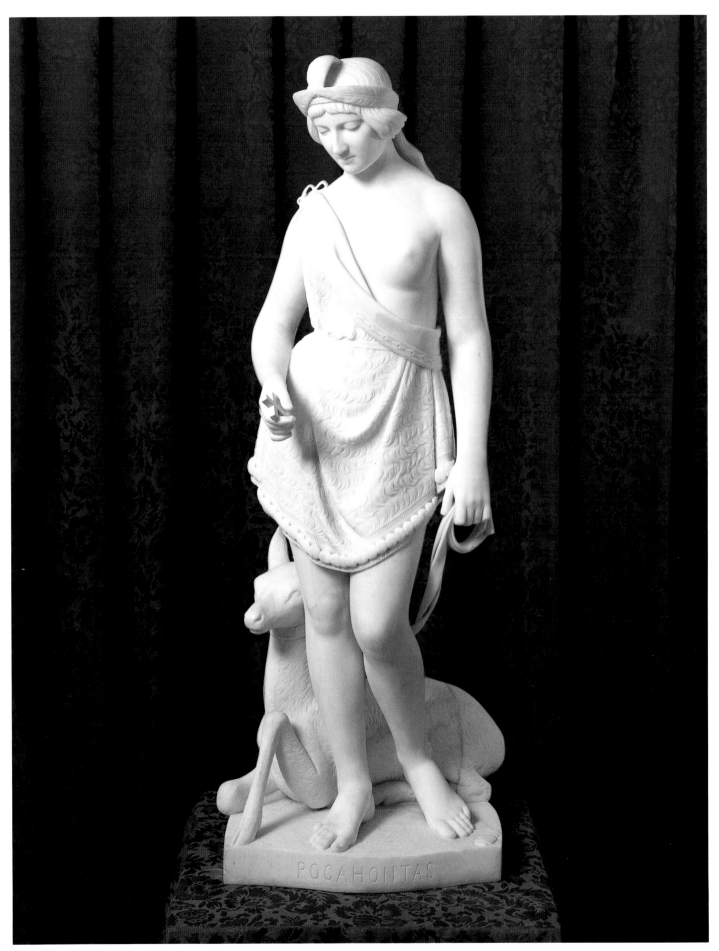

Cat. no. 29 Mozier, *Pocahontas*

she walked through the forest with a pet deer and stopped to contemplate the significance of the cross she has found. The critic pointedly mentioned the deer as symbolizing the chase and Pocahontas's untamed condition. Recent interpretations connect this spiritual epiphany of her finding the cross in the woods with viewing Pocahontas as a child of nature and an embodiment of innocence, whose Christianity unfolded in an indigenous setting rather than through European contact.[4] This consideration of a pure, native-derived Christianity found simultaneous expression in Erastus Dow Palmer's (q.v.) *Indian Girl*, which was alternately titled *The Dawn of Christianity* (fig. 58). This piece was conceived as early as 1852 and exhibited to great acclaim in New York in 1856.[5] Both sculptures suggest an equilibrium between the values of indigenous culture and the supposedly ameliorating impact of European-derived Christianity.

From the outset, *Pocahontas* was popular with Mozier's clientele, and in 1858 Hawthorne noted that it had been repeated several times.[6] The sculpture was known as far west as Chicago, where, according to a correspondent for the *Boston Transcript*, it was a choice addition to the McCagg Collection.[7] Not all reaction was favorable, however. When Joseph Harrison of Philadelphia opened his collection to the public to benefit the Sanitary Fair fund in 1864, the critic for the *Round Table* was not so generous about Harrison's replica and criticized the costume as "strange" and the expression as "lugubrious."[8]

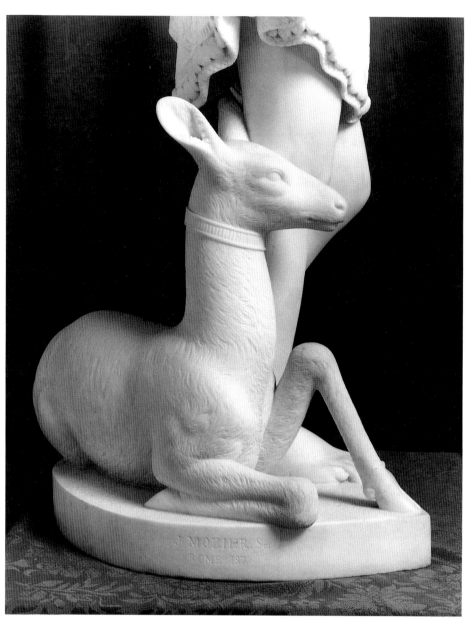

FIG. 60 Mozier, *Pocahontas*, detail of fawn

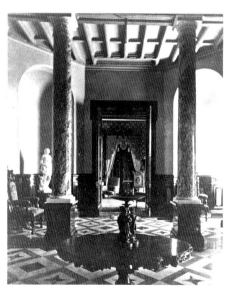

FIG. 59 Photograph of the entrance hall of the LeGrand Lockwood House, ca. 1870. Photograph courtesy of the Lockwood-Mathews Mansion House, Norwalk, Conn.

Published reaction to *Pocahontas* did not improve when Mozier displayed seven of his sculptures at the Tenth Street Studio Building in the fall of 1866. Although the critic for the *Round Table* considered the work poetical and graceful in pose, he persisted in questioning its ethnographic accuracy.[9] The reviewer for the *American Art Journal* was less kind and considered *Pocahontas* and *The Wept of Wish-ton-Wish* the poorest statues in the collection and called them "trivial in conception and bad in drawing, utterly unworthy of Mr. Mozier's talent."[10] This stinging assessment did not deter the ill-fated financier LeGrand Lockwood from acquiring replicas of both statues for what he intended to be the most magnificent country house in America (fig. 59).[11] *Pocahontas* achieved international admiration when it entered a private collection in Great Britain.[12] In spite of the negative reaction, *Pocahontas* endured as one of Mozier's most significant works. Various obituaries, as well as the first extensive treatment accorded him after his death, ranked it among his best efforts.[13]

Compositionally, Mozier deftly recrafted the arrangement he had employed in *Rebecca at the Well* (cat. no. 28). The hip-shot pose and positioning of the legs are comparable, although *Pocahontas* generates a greater feeling of stasis. As he did with the masonry well in *Rebecca*, Mozier utilized a symbol, the fawn, for a narrative as well as structural purpose (fig. 60). Mozier endowed Pocahontas with more ample proportions. While they convey a flawless quality, he moved away from the slender elegance of Rebecca, where the

FIG. 61 Gallery of Henry C. Lewis collection, Coldwater, Mich. Photograph courtesy of the University of Michigan Museum of Art

body approached anatomical credibility. The almost pneumatic element of Pocahontas's body, by contrast, would pervade the sculptor's approach to the human form and immediately manifested itself in both *Silence* and *Truth* (cat. nos. 30, 31).

The more canonical Mozier became concerning the human form, the more attention he devoted to meticulous rendering of accessories. He lavished great care on Pocahontas's feathered headgear and deerskin garment. The feather is anchored by a leather braid that also secures her hair at the back and permits it to fall in a controlled cascade down the back. The dress, with its complex pattern of comma-like tufts of fur, is enriched by the tooled leather and punched diamond pattern along its upper edge as well as the braided leather and feather hem. The folds of the dress have a greater fluidity and verisimilitude than in previous attempts. The fawn is also carved with utmost attention and constitutes an exercise in elegance and grace.[14] Consistent with his penchant for minutiae, Mozier rendered the fur of the garment and animal more convincingly than the carapace-like hair of the maiden herself.

Mozier's emphasis on details helped reinforce the symbolic content, however. The fawn—and animals were rarely carved—served as more than a decorative accessory and symbolized an innocence and purity to which both Pocahontas and

the wilderness were connected. The projectile point embedded in the ground by her left foot alludes to her origins, and its burial is as meaningful as the cross she holds. The maiden's exposed left breast signifies both her purity and her primitive state, but Mozier designated Pocahontas's innocence by means of greater modesty than the contrived chastity of Hiram Powers's (q.v.) *Greek Slave* (fig. 13). With *Pocahontas* Mozier emerged as a master of detail, and this prowess in conjunction with the literary appeal of his subjects put his career on a successful track.

The popularity of *Pocahontas* and absence of its record in any account book makes tracing the Ricau version to its original owner impossible. The date of the Ricau replica is incomplete, which suggests it was finished near the end of the sculptor's career, if not posthumously. Nevertheless, one possibility does exist. As mentioned before, LeGrand Lockwood owned replicas of *Pocahontas* and *The Wept of Wish-ton-Wish*, which were dispersed when his collection was sold in April 1872.[15] The pair was broken up, and *Pocahontas*, along with Emma Stebbins's *Samuel* (cat. no. 39), passed into the collection of Henry C. Lewis of Coldwater, Michigan, who installed them in his residential gallery (fig. 61).[16] He bequeathed the bulk of his collection, including *Pocahontas*, to the University of Michigan in 1884.[17] The university, in turn, sold

much of the collection, including the sculpture, to Tobias and Fischer, Inc., of New York in 1950.[18]

Ricau owned his replica of *Pocahontas* by 1967 and recalled acquiring it from a gallery in Washington Square in New York. Given the market for American neoclassical sculpture at the time, it is possible Ricau may have purchased the version that once belonged to Lockwood, who had amassed one of the most prominent, if short-lived, collections formed after the Civil War.

Notes

1. Truettner, "Prelude to Expansion" (1991), pp. 71ff.

2. Fuller 1856, p. 371. The notice originally appeared as a letter to the *New York Tribune*, dated Rome, Mar. 20, 1849, and was also published as "American Artists in Italy," *Literary World* 5 (May 26, 1849), 458.

3. Florentia 1854, p. 185.

4. Gerdts 1973, p. 151, and Truettner, "Prelude to Expansion," p. 83.

5. Webster 1983, pp. 149–151.

6. Hawthorne 1858, p. 148.

7. C., "Fine Arts Exposition," *Boston Transcript*, May 28, 1859, p. 1.

8. L., "Philadelphia Art Notes," *Round Table*, July 9, 1864, p. 59.

9. "Art. The Picture Galleries," *Round Table*, Nov. 3, 1866, p. 227.

10. "Art Matters," *American Art Journal* 5 (Oct. 18, 1866), 408.

11. Margaret Donald Schaack, "History in Houses: The Lockwood-Mathews Mansion," *Antiques* 97 (Mar. 1970), 378.

12. Dentler 1976, fig. 21.

13. "The Death of Joseph Mozier," *New-York Evening Post*, Oct. 22, 1870, p. 2; "Obituary. Joseph Mozier," *Art Journal* (London), n.s., 10, 33 (Jan. 1, 1871), 6; and Rodman J. Sheirr, "Joseph Mozier and His Handiwork," *Potter's American Monthly* 6 (Jan. 1876), 26–27.

14. Gerdts 1973, p. 142. Gerdts suggests that Mozier may have been influenced by some of the sculptures of animals in the Vatican's collection.

15. "The Lockwood Gallery," *New-York Evening Post*, Apr. 9, 1872, p. 4.

16. *The Lewis Art Gallery. Catalogue of Paintings and Statuary* (Coldwater, Mich., 1875), p. 22, cat. no. 471. Henry Lewis paid $680 for *Pocahontas*; see Drachler, "The Gallery and Art Collection of Henry Clay Lewis" (1980), p. 162. That *Pocahontas* and *The Wept of Wish-ton-Wish* were sold separately in the Lockwood sale refutes Susan Menconi's suggestion that the pair signed and dated 1859, which are owned by Hirschl & Adler and were recently on loan to the Lockwood-Mathews Mansion in Norwalk, Conn., were the ones owned by Lockwood; see Menconi 1982, pp. 26–27.

17. Drachler, "The Gallery and Art Collection of Henry Clay Lewis," p. 247. Ownership was not transferred until Mrs. Lewis's death in 1895.

18. University of Michigan Art Museum Archives, deaccession records, card 1895.183.

30
Silence

Modeled ca. 1853, carved 1855
Marble
67⅞ × 25⅜ × 25⅜ in. (172.4 × 64.5 × 64.5 cm)
Inscribed at right of base: J. MOZIER SC: / ROME, 1855; on front of base: SILENCE; on pedestal: *Presented by / Henry A. Stone, Esq. / September 1855*

Provenance Henry A. Stone; The Mercantile Library of New York, 1855–1984; James H. Ricau, Piermont, N.Y., 1984

Exhibition History *The Ricau Collection,* The Chrysler Museum, Feb. 26–Apr. 23, 1989

Literature William Cullen Bryant, "Letter from Mr. Bryant, No. XL. Rome, 17 May 1853," *New-York Evening Post,* June 9, 1853, p. 2; Greenwood 1854, p. 222; "Domestic Art Gossip. Art Notes," *Crayon* 2 (Oct. 1855), 216–217; "The Exhibition of the Horticultural Society," *Crayon* 2 (Oct. 1855), 232; Fuller 1856, p. 371; "Studios of American Artists," *Home Journal,* Feb. 16, 1856, p. 1; "Studios of American Artists," *Home Journal,* Mar. 22, 1856, p. 1; *Thirty-fifth Annual Report of the Board of Directors of the Mercantile Library Association of the City of New York* (New York, 1856), pp. 29–30; "Art Intelligence," *Boston Daily Evening Transcript,* Dec. 9, 1856, p. 2; Atelier, "Foreign Correspondence. Rome, November 1856," *Cosmopolitan Art Journal* 2 (Mar. 1857), 89; "Sketchings. Domestic Art Gossip," *Crayon* 8 (Feb. 1861), p. 44; Tuckerman 1867, p. 591; "Art," *New-York Evening Post,* Mar. 14, 1873, p. 2; "Fine Arts. The Mozier Statues," *Arcadian* 1 (Mar. 20, 1873), 10; Clark 1878, p. 120; Huidekooper 1882, p. 182; Waters and Hutton 1894, 2:135; Taft 1924, p. 109; A. A., "Joseph Mozier," *Dictionary of National Biography* (New York, 1934), 7:304; Hyland 1985, p. 268

Version MARBLE (half-life-size) Mount Vernon Public Library, Mount Vernon, Ohio

Gift of James H. Ricau and Museum Purchase, 86.489

Although *Silence* and *Truth* (cat. no. 31) were presented to the Mercantile Library Association of New York as companion pieces, they were not discussed as such in the earliest references that have come to light. William Cullen Bryant offered the first known mention of *Silence* in the spring of 1853 when he was reporting back to New York on his travels through Europe. After an account of the activities of Thomas Crawford (q.v.), Bryant remarked that

Richard S. Greenough (q.v.), Randolph Rogers (q.v.), Chauncey B. Ives (q.v.), and Joseph Mozier were all busy on works that would surpass their previous efforts. Bryant singled out Mozier's *Silence,* judging it would do him much credit and described it as "a female figure, standing in an attitude of command, with a calm severity of aspect, the forefinger of the left hand pointing to the lips."[1] This positive assessment was reiterated a year later in the account of one of the myriad travelers through Europe who made an obligatory visit to artists' studios. The author, writing under the pseudonym Grace Greenwood, was assiduous in her task and provided a thorough account of artistic activity in Rome.[2] She noted that Mozier had several ideal works in progress and identified *Silence* as the furthest advanced. She was particularly taken with the treatment of the garment and expounded:

Silence... is chiefly remarkable for the lightness and gracefulness of its drapery. And here is a point where Mr. Mozier usually excels—he manages drapery with rare skill and taste, and however much he may give to his statues, it never looks heavy, or too massive. When finished, I think the *Silence* will be a figure of much dignity and beauty.[3]

Greenwood also alluded to Mozier's ideal busts, specifically *Daphne,* but made no reference to *Truth.* Possibly, Mozier had not started work on this statue, but if he were considering the works as a pair, presumably he would have said so.

Although the statues entered the Mercantile Library as a pair, Mozier thought especially highly of *Silence,* since he made one or two subsequent replicas. About a year after the originals had been presented to the library, a journalist writing from Rome reported that "Mr. Mozier has just completed a statue called *Silence,* which is thought by some to be his finest work."[4] Several months later, in March 1857, a correspondent for the *Cosmopolitan Art Journal* concurred in this judgment, indicating that *Silence* was "one of the best pieces of original work executed in Rome for several years." According to the author, this achievement was considerable, given the presence of such esteemed sculptors as the Englishman John Gibson (1790–1866). In his enthusiasm for Mozier's work, the critic informed his readers: "To our taste, Mr. Mozier executes with more grace in form and feature than his brother artists. He aims not at grandeur, but accomplishes his end by the sweetness and beauty of his conceptions, and the exquisite finish of his work."[5] While the appraisal complied with the prevailing attitude toward Mozier's work—that detail was superior to concept—

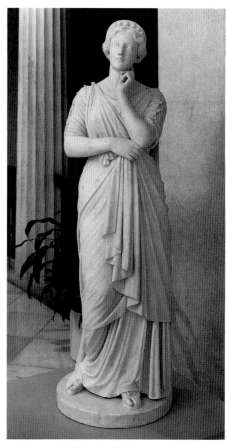

FIG. 62 Joseph Mozier, *Il Penseroso,* ca. 1860–69. Marble, 68⅜ in. (173.7 cm) high. National Museum of American Art, Smithsonian Institution, transfer from the U.S. Capitol, XX75

the sculptor must have been gratified with the encomiums *Silence* brought him.

This statue extended the horizon of Mozier's reputation beyond his wildest expectations when an Australian by the name of Josephson acquired a copy in 1861 for the gallery he was forming. An article in the *Crayon* reported this transaction and touted *Silence* as the artist's favorite conception, noting that it would accompany John Gibson's *Venus* as well as works by Randolph Rogers and the Englishman Benjamin Spence (1822–1866).[6] Although not mentioned in this article, Mr. Josephson also bought two works by Harriet Hosmer, a replica of the enormously popular *Puck* (cat. no. 56) and *Beatrice Cenci* (Mercantile Library, Saint Louis). Mozier must have been honored to be included in a purchase involving some of the most eminent sculptors working in Rome.

Mozier completed a somewhat smaller replica of *Silence,* which was auctioned after his death (Mount Vernon Public Library, Mount Vernon, Ohio).[7] One correspondent deemed the work very graceful but thought that, despite her gesture, *Silence* was capable of garrulity.[8] This

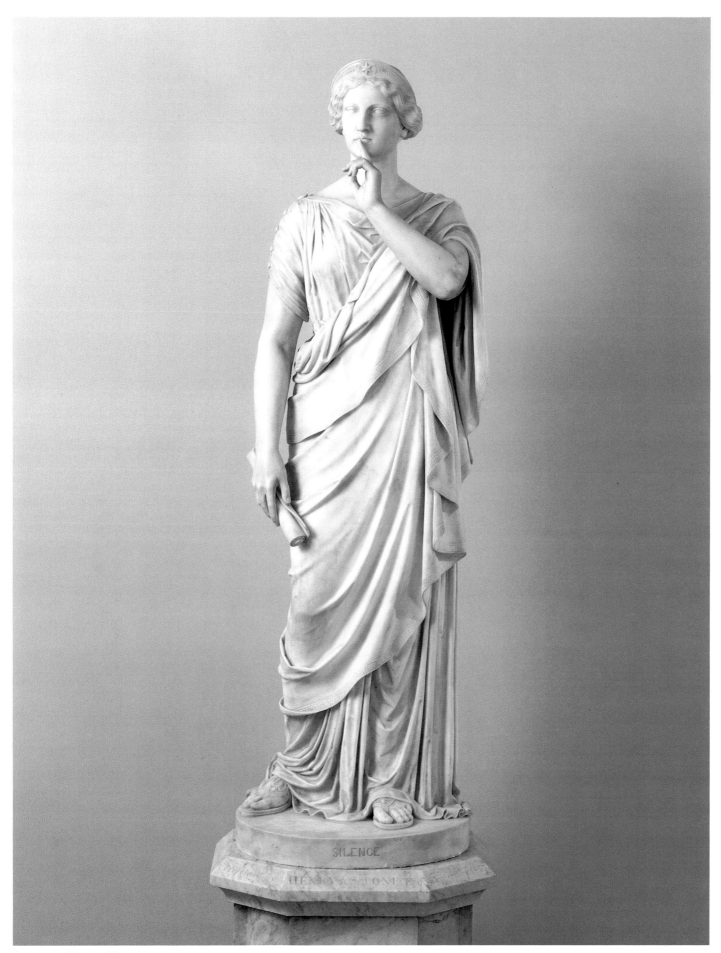

Cat. no. 30 Mozier, *Silence*

observation suggests that Mozier, or one of his carvers, may have infused more humanity into this subsequent work, since the original is so uncompromisingly austere.

Like her companion, *Silence* conveys an imposing presence articulated by her static, columnar posture. The bold massing of drapery underscores this appearance, and the widely spaced, opaque folds obscure the body. The disposition of these folds creates the graceful rhythm that became a pleasing hallmark of Mozier's style. Conversely, his handling of the human form anticipates his growing indifference to anatomy. As in *Truth*, the face is generalized and conveys an inanimate quality. The undefined treatment of the arms also reflects the sculptor's difficulty with anatomy, and *Silence* does not convincingly grip the scroll placed in her right hand.

Mozier, despite his animosity toward Hiram Powers (q.v.), adopted some of his mentor's working methods, such as creating a new work by means of a subtle variation on a theme. *Silence*'s general pose anticipates *Il Penseroso* (fig. 62), which Mozier commenced early in the next decade. Ironically, it corresponds to Powers's composition of the same subject, which he was working on at about the same time Mozier began *Silence* and *Truth*.[9] Although the attitude of *Silence* resembles that of *Il Penseroso*, the positioning of the later work's legs and feet derives from *Truth*'s. The placement of *Il Penseroso*'s left forearm has been altered so the index finger touches the left cheek rather than the lips, and the right arm extends across the abdomen so the right hand can grasp the gathered train of the robe. The costume of *Il Penseroso* is more intricately rendered than that of her predecessor, and the scheme of folds conveys a complex yet delicate visual effect. The treatment of the hair, a system of closely furrowed channels, also imitates the earlier statues, but the face, though still highly generalized, has a more sympathetic expression, responding, perhaps, to Milton's text. *Silence* and *Il Penseroso* are crowned with similar tiaras, but for the later work the sculptor reduced the number of stars from seven to just one. Thus, through the subtle manipulation of accessories, Mozier created a new work that had a strong basis in previous efforts and emulated Powers's formula for originality.

Mozier's ideal pieces lacked individuality and spontaneity, and they were devoid of spirituality. Such characteristics reflected the approach of sculptors based in Florence who responded to the naturalism and emotional resonance of Lorenzo

Bartolini's (1777–1850) work.[10] Mozier initially embraced these precepts, but when he moved to Rome, he adopted the more dogmatic and formulaic approach to sculpture he found there, which was steeped in classical antiquity. Works such as *Truth* and *Silence* resulted from this shift in attitude.

Notes

1. William Cullen Bryant, "Letter from Mr. Bryant, No. XL. Rome, 17 May 1853," *New-York Evening Post*, June 9, 1853, p. 2.
2. Greenwood 1854, pp. 219–223.
3. Ibid., p. 222.
4. "Art Intelligence," *Boston Transcript*, Dec. 9, 1856, p. 2. This article was excerpted from an earlier one that had appeared in the *Newark Advertiser*.
5. Atelier, "Foreign Correspondence. Rome, November 1856," *Cosmopolitan Art Journal*, Mar. 1857, p. 89.
6. "Sketchings. Domestic Art Gossip," *Crayon* 8 (Feb. 1861), 44.
7. See "Art," *New-York Evening Post*, Mar. 14, 1873, p. 2, for a complete listing of the statues to be auctioned.
8. "Fine Arts. The Mozier Statues," *Arcadian* 1 (Mar. 20, 1873), 10.
9. Wunder 1991, 2:182–183.
10. See Hyland 1985, pp. 266–269, for Mozier's response to Bartolini.

31
Truth

Modeled ca. 1854, carved 1855
Marble
69⅝ × 25¼ × 25¼ in. (176.9 × 64.1 × 64.1 cm)
Inscribed at right of base: J. MOZIER SC: / ROME, 1855; on front of base: TRUTH; on pedestal: *Presented by / Henry A. Stone, Esq. / September 1855*

Provenance Henry A. Stone; The Mercantile Library of New York, 1855–1984; James H. Ricau, Piermont, N.Y., 1984

Exhibition History *The Ricau Collection*, The Chrysler Museum, Feb. 26–Apr. 23, 1989

Literature "Mere Mention," *Home Journal*, Oct. 7, 1854, p. 3; "Sketchings," *Crayon* 2 (Oct. 1855), 216–217; "The Exhibition of the Horticultural Society," *Crayon* 2 (Oct. 1855), 232; "Studios of American Artists," *Home Journal*, Feb. 16, 1856, p. 1; "Studios of American Artists," *Home Journal*, Mar. 22, 1856, p. 1; *Thirty-fifth Annual Report of the Board of Directors of the Mercantile Library Association of the City of New York* (New York, 1856), pp. 29–30; Tuckerman 1867, p. 591; Clark 1878, p. 120; Huidekooper 1882, p. 182; Waters and Hutton 1894, 2:135; Taft 1924, p. 109; A. A., "Joseph Mozier,"

Dictionary of National Biography (New York, 1934), 7:504; Soria 1982, p. 206

Versions None known

Gift of James H. Ricau and Museum Purchase, 86.488

ALTHOUGH nothing is known about the inspiration for *Truth* and its companion piece, *Silence* (cat. no. 30), the subject matter indicates they were envisioned for a setting appropriate to an atmosphere of quietude and center of honesty. The Mercantile Library Association of New York, founded in 1821, was an institution associated with the commercial life of the city that provided just such an environment. Its object was "the encouragement of moral and intellectual improvement, by the dissemination of knowledge."[1] Why the donor, Henry A. Stone, chose to give these two works to the Mercantile Library remains a mystery, since he was not a member. Stone was a New York merchant who settled in Rome for an extended period in the 1850s and met Joseph Mozier there. The sculptor's former capacity as a merchant in New York as well as his membership in the Mercantile Association may help explain the disposition of the works.

For his beneficence, Stone was elected an honorary member of the association.[2] The resolution passed by the members commended the donor for his generosity in providing such enriching works that would be enjoyed by the library's many visitors. The press covered the ceremony celebrating the presentation of the sculptures, and the *Crayon* stressed the appropriateness of the subject matter for the Mercantile Library.[3] The article expressed puzzlement that this type of benefaction was not more prevalent in America, since it ensured an individual's posterity.

At midcentury, the patronage of art and of sculpture in particular was still in its infancy in America, and Mozier articulated the special challenge confronting an expatriate artist in a letter published in 1851.[4] Referring to Americans passing through Rome, Mozier lamented that these visitors of means were concerned with obtaining quantity rather than quality. He contended that this quest for a mediocre bargain biased them against American artists in Rome, and that their attitude demonstrated a lack of national feeling and pride. There was sufficient commitment to the arts in America to render Mozier's position extreme, and his remarks may have reflected the anxiety of embarking on a new career. His experience ran counter to his lament, and his business connections helped him achieve enviable artistic success.

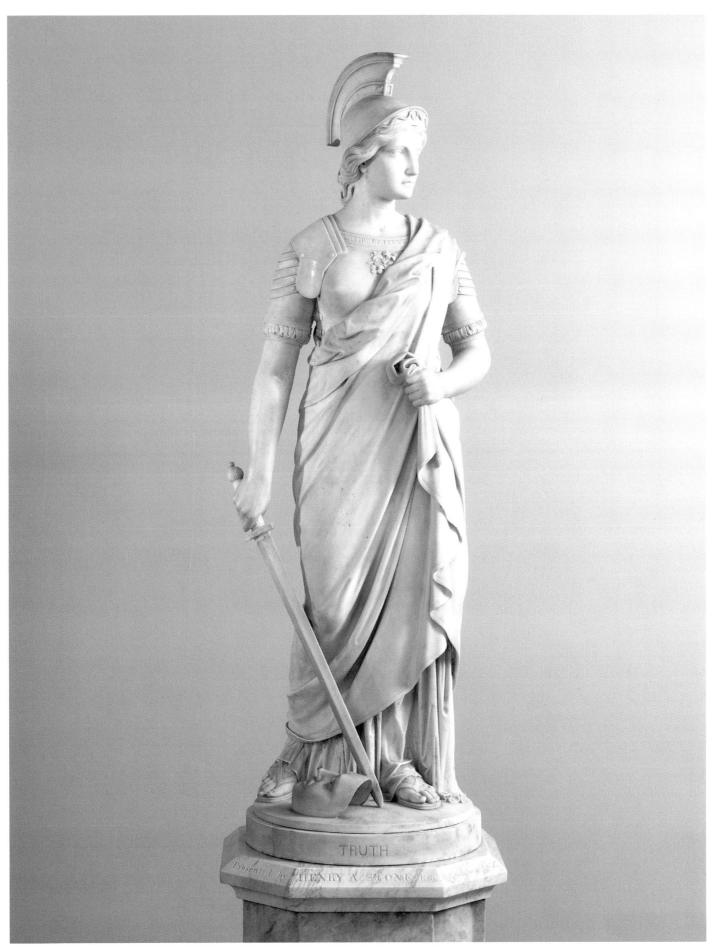

Cat. no. 31 Mozier, *Truth*

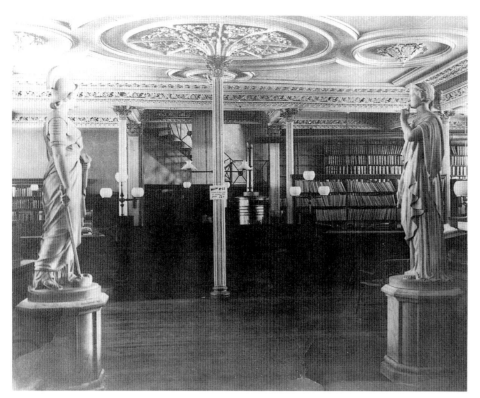

FIG. 65 Reading Room of The Mercantile Library of New York, at its Astor Place location, last quarter nineteenth century. Courtesy of The Mercantile Library of New York. Photograph by Ali Elai, Camera Arts

Unquestionably, the sale of *Truth* and *Silence* provided an important springboard for Mozier's career, and he returned to America to oversee their placement and installation in the library's reading room in September 1855 (fig. 65). The sculptor recognized that these statues were central to introducing his abilities to the citizenry of New York, and he wanted to capitalize on this visibility. The press did not disappoint him, since there were numerous references to the works in the ensuing months. By March 1856 the statues were considered well enough known to New Yorkers to require little more than mere mention.[5]

According to a report in the *Home Journal*, Mozier had completed *Truth* by the fall of 1854. The author provided his readers with a detailed preview of the work based on a photograph supplied by the sculptor:

The artist has entirely discarded the Egyptian personification of Truth, which made her a naked, crouching figure, with a mirror; and has sought to represent her attributes in a more majestic and imposing manner. Truth, in his statue, is an armed female, wearing a helmet, and carrying a two-edged sword in her right hand, adumbrating her perpetual combat with error. At her feet, near the point of the sword she bears, lies a mask, apparently just struck from the face which wore it, while with her left hand, she is in the act of gathering her garments quickly about her, as if to avoid contact

with falsehood. On the front of the helmet are serpents supporting a ring, emblematic of wisdom, and on her breastplate is the lily, as a symbol of purity.[6]

In alluding to the Egyptian personification, the author employed an exotic frame of reference to underscore the statue's actual imagery. Traditionally, Truth appeared in a wide variety of guises, and Mozier incorporated several of the most recognizable components into his composition.[7] Rather than a nude personification of the "naked" truth, with the emphasis placed on a straightforward lack of artifice, the sculptor deflected the potential controversy centering on an unclothed figure. Instead, he selected a more complex and militant treatment in which the figure draws her protective garb around her, having defeated falsehood and fraud, symbolized by the mask at her feet. The motif of the serpents in the helmet may refer to the entwined snakes of Mercury's caduceus, while the ring they hold could connote a solar association. These details further enrich the iconographic program, since both Mercury and the sun were among the attributes of Truth. Through this conflation of symbols, Mozier confronted the viewer with a visually demanding statue.

Truth heads the litany of Mozier's works in which the sculptor gives priority to details rather than the human form. He

handled accessories such as the armor, helmet, sword, drapery, and sandals in an admirable fashion, but faltered in articulating the details of anatomy, and this shortcoming compromised the statue's presence. The face wears a stern expression, but the features are so generalized that the effect is one of detached impassiveness. *Truth* strikes a dignified yet static pose, and the massive folds of the drapery, while imposing, reveal little of the figure beneath. The statue assumes a columnar monumentality that intimidates the viewer into respecting its message, but the sculptor's inability to transform the marble into flesh renders the image devoid of any human quality. Thus, *Truth*'s austere aura of strength and fortitude negates response on a human level and denies the figure emotional appeal.

Notes

1. Edwin Williams, ed., *New-York as It Is, in 1833; and Citizens' Advertizing Directory* (New York, 1833), p. 57.
2. *Report of the Mercantile Library* (1856), p. 30.
3. "Sketchings," *Crayon* 2 (Oct. 1855), 216.
4. Mozier's letter to Asaph Stone of New York was published in the *Bulletin of the American Art-Union*, June 1851.
5. "Studios of American Artists," *Home Journal*, Mar. 22, 1856, p. 1.
6. "Mere Mention," *Home Journal*, Oct. 7, 1854, p. 3. This dispatch was excerpted from a previous article in the *New-York Evening Post*.
7. See Guy de Tervarent, *Attributs et symboles de l'art profane* (Geneva, 1958), pp. 110, 165, 171, 226, 227, 233, 251, 262, 269, 273, 301, 332, 356, and 402, for references to some of the most salient attributes.

32
The Wept of Wish-ton-Wish

Modeled ca. 1857–58, remodeled 1864, carved 1866
Marble
$51\frac{5}{8} \times 20\frac{1}{8} \times 16\frac{7}{8}$ in. (131.1 × 51.1 × 42.9 cm)
Inscribed on front of base: THE WEPT OF WISH-TON-WISH; at right of base: *J. Mozier. Sc. / Rome. 1866*

Provenance [Paul Gabel, Nyack, N.Y.]; James H. Ricau, Piermont, N.Y.

Exhibition History *The Ricau Collection*, The Chrysler Museum, Feb. 26–Apr. 23, 1989; I*mage and Object: Alfred Jacob Miller, George Catlin, and the American Indian*, The Chrysler Museum, Aug. 4– Sept. 29, 1991

Literature Hawthorne 1858, p. 148; Atkinson 1863, pp. 314, 322; "Art in Continental States. Rome," *Art Journal*

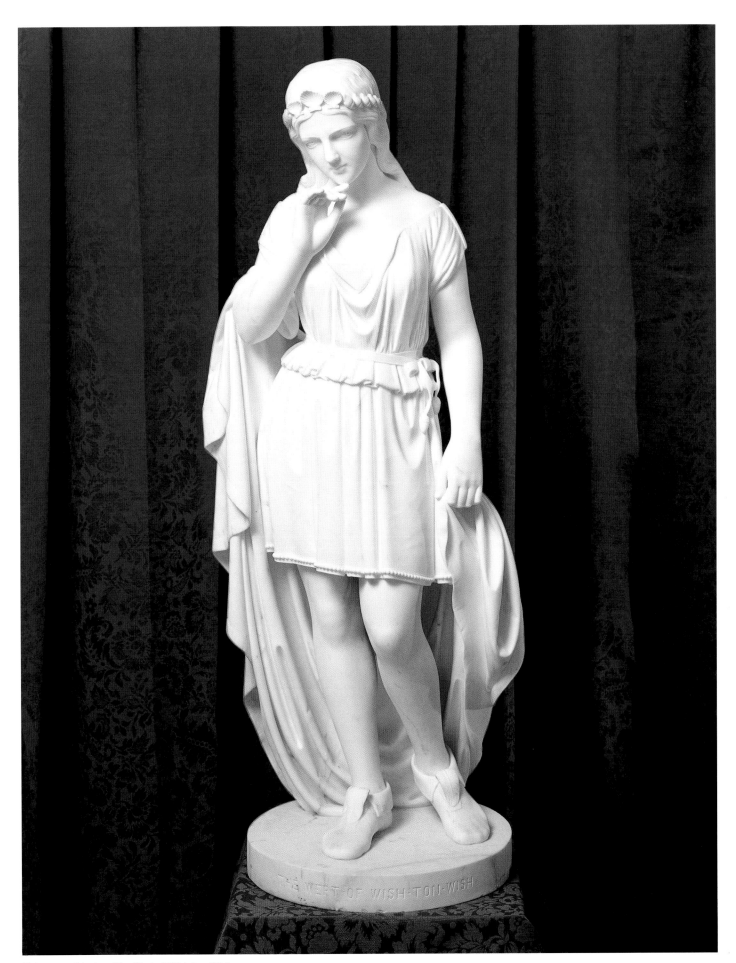

Cat. no. 32 Mozier, *The Wept of Wish-ton-Wish*

(London), n.s., 3 (1864), 185; "Affairs in Rome: Art and Artists—New Sculptures," *New-York Evening Post*, Jan. 5, 1865, p. 1; Walker 1866, p. 102; "Art Matters," *American Art Journal* 5 (Oct. 1866), 408; "Mozier's Sculptures," *New-York Evening Post*, Oct. 16, 1866, p. 2; "Art. The Picture Galleries," *Round Table*, Nov. 3, 1866, p. 227; Tuckerman 1867, p. 591; "What Americans Are Doing in Rome," *Boston Daily Evening Transcript*, Jan. 22, 1869, p. 1; Brewster 1869, p. 197; Osgood 1870, p. 422; "The Death of Joseph Mozier," *New-York Evening Post*, Oct. 22, 1870, p. 2; "Obituary. Joseph Mozier," *Art Journal* (London), n.s., 10, 33 (Jan. 1, 1871), 6; "Art," *New-York Evening Post*, Mar. 14, 1873, p. 2; "Art. The Mozier Marbles," *New-York Daily Tribune*, Mar. 17, 1873, p. 5; "Fine Arts. The Mozier Statues," *Arcadian* 1 (Mar. 20, 1873), 10; Rodman J. Sheirr, "Joseph Mozier and His Handiwork," *Potter's American Monthly* 6 (Jan. 1876), 26–27; Clark 1878, p. 120; Strahan 1879–82, 2:142; Waters and Hutton 1894, 2:135; Taft 1924, pp. 109–110; A. A., "Joseph Mozier," *Dictionary of National Biography* (New York, 1934), 7:505; C. B. Lang, "Thomas Buchanan Read in Rome," p. 52, in *Thomas Buchanan Read, Artist, Poet, Sculptor*, ed. George N. Highly (Chester County, Pa., 1972); Gerdts 1973, pp. 120–121; William H. Gerdts, "The Marble Savage," *Art in America* 62 (July 1974), 68–69; Soria 1982, p. 206; Menconi 1982, pp. 27–28; Hyland 1985, p. 268; Kasson 1990, pp. 93–98

Versions MARBLE (first version) Yale University Art Gallery, New Haven, Conn.; (remodeled versions) Arnot Art Gallery, Elmira, N.Y.; [Hirschl & Adler Galleries, New York]

Gift of James H. Ricau and Museum Purchase, 86.494

THE WEPT OF WISH-TON-WISH was the most renowned of Joseph Mozier's creations and the one Lorado Taft thought redeemed Mozier's reputation.[1] The sculptor took the subject from James Fenimore Cooper's novel of the same name, *The Wept of Wish-ton-Wish*, which was written in Florence and published in 1829. Although Mozier depicted the fictional white heroine of Cooper's book, Ruth Heathcoat, her character had ample precedent in actual history.

The story is set in a seventeenth-century frontier village in western Connecticut called Wish-ton-Wish, which Cooper believed referred to the nocturnal whip-poorwill, and tells how Ruth was abducted from the village by Narragansett Indians while still a child. Raised by the tribe as one of its own, she embraced the Indian culture completely. By the time her relatives found her many years later, she had married a Narragansett brave, Conanchet, borne him a son, and taken a tribal name, Narra-mattah. She has been likened to the biblical Ruth who forsook her own tribe for her husband's people.[2]

Although Narra-mattah's parents try to make peace with the Narragansett tribe and reestablish ties with their long-lost daughter, their plans go tragically awry when an informant from a rival tribe betrays them. In saving the Heathcoat family, Conanchet is captured and executed. Narra-mattah, devastated by the loss, dies of a broken heart, but not before she reconnects with her European heritage. Buried next to her noble husband, Narra-Mattah's headstone was simply inscribed, "The Wept of Wish-ton-Wish," a mournful sobriquet that alluded to the tears her mother shed for her after she had been taken by the Indians.

For Narra-Mattah's appearance, Mozier drew from the text where the heroine is reintroduced to her parents:

The age of the stranger was under twenty. In form she rose above the usual stature of an Indian maid, though the proportions of her person were as light and buoyant as at all comported with the fullness that properly belonged to her years. The limbs, seen below the folds of a short kirtle of bright scarlet cloth, were just and tapering, even to the nicest proportions of classic beauty; and never did foot of higher instep, and softer roundness, grace a feathered moccason [*sic*]. Though the person, from the neck to the knees, was hid by a tightly-fitting vest of calico and the short kirtle named, enough of the shape was visible to betray outlines that had never been injured, either by the mistaken devices of art or by the baneful effects of toil. The skin was only visible at the hands, face, and neck. Its lustre having been a little dimmed by exposure, a rich, rosy tint had usurped the natural brightness of a complexion that had once been fair even to brilliancy. The eye was full, sweet, and of a blue that emulated the sky of evening; the brows, soft and arched; the nose, straight, delicate, and slightly Grecian; the forehead, fuller than that which properly belonged to a girl of the Narragansetts, but regular, delicate, and polished; and the hair, instead of dropping in long straight tresses of jet black, broke out of the restraints of a band of beaded wampum, in ringlets of golden yellow.[3]

The sculptor made modifications to the figure's dress: the tight-fitting calico vest was replaced by a looser, classically derived tunic that was less revealing than the outfit Cooper described. While color was not an issue for the sculpture, Mozier, in emulation of John Gibson (1790–1866), executed several tinted versions of *The Wept of Wish-ton-Wish*, which met with mixed reactions.[4]

Compositionally, the sculptor selected a moment later in the narrative, when Narra-Mattah's mother tries to reestablish contact with her daughter by singing the lullabies of her infancy.[5] Mrs. Heathcoat, in a maneuver of desperation, draws her daughter to her knee and begins to sing a melodic tune. The effect is galvanic, and Narra-mattah's reaction suggests that Cooper himself envisioned the moment as it would be depicted later in marble:

At the first low breathing notes of this nursery song, Narra-mattah became as motionless as if her rounded and unfettered form had been wrought in marble. Pleasure lighted her eyes, as strain succeeded strain; and ere the second verse was ended, her look, her attitude, and every muscle of her ingenuous features, were eloquent in the expression of delight.[6]

This triumph was short-lived, however, since moments after the lullaby concludes, Narra-mattah's brother Mark bursts into the room with his sister's son. The infant's arrival reaffirms Narra-mattah's commitment to her new life, while establishing the conflict that results from mixing cultures and the inviolate barrier that exists between them. Her reconciliation and almost immediate death underscore this conflict that Cooper and, subsequently, Mozier were unwilling to address.[7]

The pose of Wish-ton-Wish constitutes the familiar adaptation and conflation of the Medici and Cyrene Venuses, and the subject both recalls and contrasts with not only Hiram Powers's (q.v.) *Greek Slave* (fig. 13) but also Erastus Dow Palmer's (q.v.) recently completed *White Captive* (MMA). Whereas these earlier works alluded to the treachery of captivity, Mozier's effort addresses the conflicting emotions of conversion. Narra-mattah's expression and gesture of bringing her finger to her chin emphasize the mental struggle she experiences. While not suggesting unabashed delight in response to the nursery song, her demeanor echoes her struggle to recall her family after the first encounter, where the author described her as standing "in the attitude which a sibyl might be supposed to assume, while listening to the occult mandates of the mysterious oracle, every faculty entranced and attentive."[8] This remote sense of reverie prevents her sensibility from becoming overly saccharine.

The facial structure emulates Cooper's description of delicacy and refinement, although the broad forehead, wide-set eyes, and cheekbones that narrow to the pointed chin give the face a pronounced triangular shape. In chiseling the irises and pupils of the eyes, Mozier intended to capture the immediacy of the moment

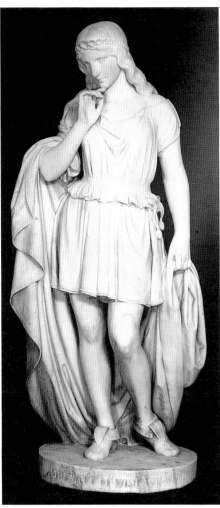

FIG. 64 Joseph Mozier, *The Wept of Wish-ton-Wish* (first version), carved 1859. Marble, 66 in. (167.6 cm) high. Yale University Art Gallery, Gift of the heirs of Mrs. Joseph E. Sheffield, 1889.5

and establish a counterpoint to the idealism of the overall facial configuration. He created a "wall-eye" effect in the left eye, which one reviewer noted as a "peculiarly eccentric cast of the eye" constituting "a direct violation of that equanimity which Winckelmann . . . laid down as inherent to the noble art of sculpture."[9] Whether this aberration was deliberate or accidental, Mozier infused an appropriate romantic sensibility into his work. In so doing, the sculptor transgressed the cardinal tenet of "noble simplicity and calm grandeur," which the eminent eighteenth-century classical scholar and archaeologist Johann Winckelmann considered central to the greatest works of Greek antiquity. Although seriously diminished by the mid-nineteenth century, the influence of Winckelmann and his ideas was of utmost importance to neoclassical taste.[10]

Despite such minor idiosyncrasies, Mozier's Roman experience generated a greater emphasis on the ideal or general in his rendering of anatomy. While the treatment of Narra-mattah's limbs is not as indifferent as that of *Silence* or *Truth* (cat. nos. 30, 31), they still do not convey an anatomically convincing quality. The sausagelike right thumb is a case in point. The hair, too, has a stylized, inert look to it and is further constrained by the headband of shells. The carving of the hair on the scalp is shallow but gives way to deeper, rhythmically curving channels, in which the hair falls to the small of the back.

Mozier demonstrated his ability for executing drapery. He framed the figure with a mass of material—presumably a cloak or blanket—that falls off her right elbow, cascades down her right side, and terminates on the far side in her left hand, creating a built-in architectural niche. The folds in the drapery and costume are not as massive as in previous efforts, but the starched quality makes them less pliable than what was customary in sculpture of this period.

The sculptor continued his attention to the meticulous rendering of details. He reworked the piece in late 1864, and it was in the minutiae that all the changes occurred—to the satisfaction of the critics.[11] Comparing the altered Ricau version with the earlier version, modeled in 1857–58 (fig. 64), the scallop-shell headband has been modified to include periwinkle shells, which provide a greater diagonal emphasis. The hair, initially carved to simulate the ringlets described by Cooper, has been straightened slightly and pulled off the shoulder, becoming less obtrusive from the front. The folds of the large piece of drapery have been toned down, according greater prominence to the figure, while the folds of the tunic and skirt have been flattened to reduce their visual impact. Finally, the feathered moccasins, which are made of such thin material that the toes can be seen through it, have undergone an equally subtle modification. In the initial version, the flap around the top was decorated with three prominent horizontal bands of beads. Mozier altered this arrangement to a more discreet system of vertical strips of quill that are effective as decoration, but less obtrusive. In modifying the statue, the sculptor intended to reduce the visual energy of the work and, through this understatement, reinforce the meditative aspect.

Begun in late 1857 or early 1858, *The Wept of Wish-ton-Wish* was sufficiently advanced in 1858 to warrant Nathaniel Hawthorne's notice.[12] Critical reaction to *The Wept of Wish-ton-Wish* was mixed. Isaac Edwards Clarke, an American attorney with offices in London, provided the earliest known opinion.

Reporting on activities in Rome in the winter of 1858, Clarke mentioned that a Mr. Sheffield of New Haven, Connecticut, had been so taken with Mozier's *Wept of Wish-ton-Wish* that he immediately ordered a copy.[13] Clarke, a close friend of Hiram Powers, was keenly aware of the professional jealousy between the two sculptors and was less than charitable about Sheffield's acquisition, observing that "he has what I should not care to possess!" Mention has already been made about one critic's reservation with the sculpture's eyes, and this critique found reaffirmation in a later reaction: a visitor to Mozier's studio noted, upon seeing the work, that the eyes were like those of a fish.[14]

After the piece was reworked in late 1864, the statue was thought to be improved, but this did not assure complete approbation. When the work was exhibited in New York in the fall of 1866, it was considered "celebrated."[15] But the sculpture, along with *Pocahontas*, was summarily dismissed as the poorest in the collection.[16] One other aspect of public opinion regarding *The Wept of Wish-ton-Wish* centered on the versions that Mozier tinted. With the exception of the way the face was handled, people tended to admire them.[17] In the obituary notices, it was referred to as a widely known piece, so for better or worse, *The Wept of Wish-ton-Wish* ultimately garnered Mozier a substantial measure of recognition.

Little is known about the history of the Ricau version. Ricau recalled that the dealer from whom he acquired it had found it in a junkyard in upstate New York. Ironically, the sculpture may have originally been in the LeGrand Lockwood collection. An undated advertisement promoted a version of *The Wept of Wish-ton-Wish* dated 1866, as is the Ricau version, and indicated that it came from the collection of a distinguished New York lawyer who had originally acquired it in the Lockwood sale.[18] Although Mozier executed two replicas in 1859, a second version dated 1866 has yet to appear, and for the moment the Ricau version can plausibly be connected to the one originally owned by LeGrand Lockwood.

Mozier's *Wept of Wish-ton-Wish* is a prime example of the "willing captive" in American neoclassical sculpture. It poignantly but subtly alludes to the dilemma of a white woman who must choose between the culture of her captors and returning to white "civilization." The subject was popular in nineteenth-century American frontier lore and is also exemplified in the Ricau Collection in Chauncey B. Ives's slightly later *Willing Captive* (cat. no. 22).

Notes

1. Taft 1924, p. 109.

2. Kasson 1990, p. 96.

3. James Fenimore Cooper, *The Wept of Wish-ton-Wish*, 2 vols. (Philadelphia, 1829), 2:127–128.

4. Brewster 1869, p. 197, admired the tinting of the costume and legs, but thought that the facial expression was more effective in the unpainted version.

5. This episode was initially identified by Katherine C. Walker (see Walker 1866, p. 102), and given irrefutable confirmation in Clinton Hall Sale Rooms, New York, *Catalogue of Marble Statuary, Comprising Eleven Pieces by the Late Joseph Mozier, Esq.*, Mar. 22, 1873, n.p., which was the exhibition and auction catalogue for the dispersal of the sculptures in Mozier's studio after his death.

6. Cooper, *The Wept of Wish-ton-Wish*, 2:166.

7. Kasson 1990, pp. 96–98.

8. Cooper, *The Wept of Wish-ton-Wish*, 2:132.

9. Atkinson 1863, p. 322.

10. L. D. Ettlinger, "Winckelmann," in *The Age of Neo-Classicism*, exh. cat., Royal Academy and Victoria and Albert Museum (London, 1972), pp. xxx–xxxiv.

11. "Art in Continental States. Rome," *Art Journal* (London), n.s., 3 (1864), 185, and "Affairs in Rome. Art and Artists—New Sculptures," *New-York Evening Post*, Jan. 5, 1865 (the article in the *Evening Post* from Rome was dated Dec. 10, 1864).

12. Hawthorne 1858, p. 148.

13. Isaac Edwards Clarke, Rome, to Powers, Feb. 7, 1858, Powers papers, AAA, roll 1139, frame 626.

14. Lang, "Read in Rome" (1972), p. 32.

15. Walker 1866, p. 102.

16. "Art Matters," *American Art Journal* 5 (Oct. 1866), 408.

17. Lang, "Read in Rome," p. 32.

18. "Details of the Life Size Statue on Revolving Pedestal: *The Wept of Wish-ton-Wish*," undated notice placed by Guffanti's Original, 274 7th Avenue, New York, curatorial files, Yale University Art Gallery.

33
Young America

Modeled ca. 1857, carved 1868
Marble
39⅜ × 14⅜ × 20¼ in. (100 × 56.5 × 51.4 cm)
Inscribed at left of base: J. MOZIER. SC. / ROME. 1868; on front of base: *Young America*

Provenance [Corci Bros. or Victor Carl, New York]; James H. Ricau, Piermont, N.Y.

Exhibition History *The Ricau Collection*, The Chrysler Museum, Feb. 26–Apr. 23, 1989

Literature "Mere Mention. Four Photographs of Mozier," *Home Journal*, Feb. 14, 1857, p. 3; Hawthorne 1858, p. 148; Fuller 1859, pp. 270–271; Huidekooper 1882, p. 182; Taft 1924, p. 110; A. A., "Joseph Mozier," *Dictionary of National Biography* (New York, 1934), 7:304; Gerdts 1973, pp. 134–135

Version MARBLE Arnot Art Gallery, Elmira, N.Y.

Gift of James H. Ricau and Museum Purchase, 86.491

During the mid-nineteenth century American paintings of genre subjects (scenes of everyday life) enjoyed great popularity. Recognizing this, certain sculptors diversified their commitment to the powerful influences of neoclassical style and subject matter. By the mid-1840s Thomas Crawford was creating such sweetly sentimental works as *The Dancing Girl* and *The Broken Tambourine* (cat. nos. 36, 37), which were more approachable than his classically redolent *Boy Playing Marbles* (WAM).[1] Other sculptors, such as Randolph Rogers (q.v.) and Joseph Mozier, followed suit in the ensuing decade. In addition to chronicling recreational activities, they paid significant attention to young Americans' major pastime, going to school—or not.

From the outset of the nineteenth century, education was recognized as a crucial vehicle for personal advancement, and its availability to all as early as 1811 astounded one foreign visitor:

You should not look for profound philosophers and celebrated professors in America; but you will be astonished at the correct notions of the humblest citizens respecting the most abstract matters. The son of the first banker in the land goes to the same school with the son of the most destitute day laborer. Everyone studies the geography of his country, knows the rudiments of arithmetic and has a general idea about other sciences.... Education at home is unknown here: all the children go to public schools, and this develops their ideas the sooner and teaches them, in a sense, to think concertedly and see things in the same light.[2]

Thus, education was identified quite early as a central component of democracy in the young Republic.

School and schooling became a favorite topic for artistic expression in the nineteenth century. Depictions ranged from themes of stern discipline, exemplified in Francis W. Edmonds's (1806–1863) *Young Scholar* of 1845 (private collection), to the delights of dismissal, evidenced in Henry Inman's (1801–1846) *Dismissal of School on an October Afternoon* of the same year (BMFA). While interest in school-oriented subject matter persisted after the Civil War, it took on a deeper sensibility as demonstrated by Eastman Johnson's *Early Morning Scholar* of about 1865 (NGA) and, most forcefully, in Winslow Homer's (1836–1910) series of school and school-

room subjects, where the artist emphasized the shift to a more female-dominated and humane profession.[3] It was not surprising for sculptors to address the subject of book learning with equal enthusiasm.

Thomas Crawford included schoolboys and a schoolmaster in his pedimental program, *The Progress of Civilization*, completed in 1853 for the Senate wing of the United States Capitol in Washington and, in so doing, alluded to the benefits of education in a public arena. One of his last works, however, addressed the inevitable yielding to temptation: *The Truants* (Nebraska Art Association, Lincoln) depicts two children, a boy with his books and a girl with a bunch of wildflowers, who pause to inspect a bird's nest. The sculpture's title identifies the children's errant ways.[4] Randolph Rogers also selected the fallible side of the educational process in *The Truant* of 1854 (NMAA), which depicts a young boy opting for ice skates over schoolbooks. Truancy sustained a special appeal, and Chauncey B. Ives addressed the theme in the early 1870s (cat. no. 25). These themes of school days were evident in the Roman studios when Mozier decided to undertake his subject.

Whether the recent acquisition of two major works, *Silence* and *Truth* (cat. nos. 30, 31), by the New York Mercantile Library in 1855 inspired Mozier to create a statue dealing with learning is uncertain, but his image of a boy trimming a pen was sufficiently complete to be included among the four photographs of recent works that the sculptor sent to a New York periodical in early 1857.[5] The critic for the *Home Journal* liked "boy mending a pen" the best and called it "expressive of exactly the quiet thoughtfulness with which a schoolboy does this, with his 'line of copy' in his memory while he thus prepares to write it." The work sustained this high level of praise from Nathaniel Hawthorne, who visited Mozier's studio in April 1858.[6] While the author openly criticized Mozier's sculpture, especially his ideal pieces, he approved of the genre subjects and contended they alone exemplified the sculptor's cleverness and ingenuity. Hawthorne astutely anticipated the consensus opinion of Mozier as a sculptor.

A number of replicas of the subject existed and bore a variety of titles, but only two can be located today. In addition to *Young America*, which was not carved until 1868, there is a version inscribed *Thomas Moore as a Boy*, translated into marble in 1870 (Arnot Art Museum, Elmira, N.Y.).[7] At least one other replica, known as *Young Ben Franklin*, exists, but

Cat. no. 33 Mozier, *Young America*

remains unlocated.[8] Since the two known versions were carved late in Mozier's career and the work was modeled considerably earlier, several replicas, presumably, remain undiscovered.

The subject portrays a young boy seated on a barrel, concentrating intently on sharpening his writing quill with a pocketknife. An inkwell sits on the floor beside his left foot, and a book, perhaps his writing journal, is balanced between his feet. Mozier depicted an affluent scholar neatly dressed in jacket, trousers, bow tie, socks, and shoes. The plethora of objects enabled Mozier to lavish great attention on details. He devoted painstaking care to such elements as shoelaces, buttons, shirt pleats, herringbone piping on the trousers, and the spreading pages of the book.

In choosing the particular activity of sharpening a quill, Mozier fused several important activities into one composition. The boy's action signals preparation for one of the educational disciplines crucial at the time, penmanship. The pocketknife signifies the centrality of this instrument to a boy's formative years. One American gentleman observed in his memoirs: "No portrait of an American is deemed complete, whether in the saloon or the senate-chamber, at home or on the highway, unless with penknife and shingle in hand."[9] The author placed greatest weight on whittling, which he contended contributed to nurturing mechanical and manual dexterity. Whittling was a common motif in genre painting in the nineteenth century and ranged from a youthful pastime, as depicted in Charles Bird King's (1785–1862) *Itinerant Artist* of about 1815–25 (New York State Historical Association, Cooperstown) to a stalling ploy by adults in William Sidney Mount's (1807–1868) *Bargaining for a Horse* of 1855 (N-YHS), also known as *Coming to the Point*. In Mount's piece two men used their whittling to mask the intentions of their negotiations.

In addition to whittling, the pocketknife was an important tool for a young boy's leisure activity. In mumble-the-peg, a game of knife-throwing skills, the loser had to pull a wooden peg from the ground with his teeth. This game was captured on canvas by Henry Inman in 1842 (PAFA). The scene shows two young scholars, one more well-to-do than the other, competing with a friendly intensity. The painting exudes an aura of well-being and optimism for the future that was echoed in an article entitled "Young America," which expounded on the relevance of America's youth for a strong future and the critical role education would play.[10] Mozier's humble beginnings attuned him to this

belief in potential, and in this sculpture of youth, responsibility, and promise, he focused on the utilitarian function of sharpening and thereby cast the pocketknife in a positive light.

Notes

1. Dimmick 1986, pp. 298–505.
2. Pavel Svinin, "A Glance at the Republic of the United States," in *Picturesque United States of America, 1811, 1812, 1813, Being a "Memoir on Paul Svinin,"* ed. Avrahm Yarmolinsky (New York, 1930), p. 15.
3. See Nicolai Cikovsky, Jr., "Winslow Homer's *School Time:* 'A Picture Thoroughly National,'" in *In Honor of Paul Mellon: Collector and Benefactor,* ed. John Wilmerding (Washington, D.C., 1986), pp. 47–70.
4. Dimmick 1986, pp. 700–702.
5. "Mere Mention. Four Photographs of Mozier," *Home Journal,* Feb. 14, 1857, p. 3. The other three works were *The Indian Maiden,* taken from the poem by William Cullen Bryant; *The Return of the Prodigal Son;* and *Vocal and Instrumental,* depicting a young girl playing a melodeon with a greyhound howling his disapproval at her side.
6. Hawthorne 1858, p. 148.
7. Moore was a poet whom Mozier evidently admired, since he was inspired by the poet's *Lalla Rookh* to create his *Peri.*
8. Gerdts 1973, p. 135.
9. S. G. Goodrich, *Recollections of a Lifetime, or Men and Things I Have Seen: in a Series of Familiar Letters to a Friend, Historical, Biographical, Anecdotal, and Descriptive,* 2 vols. (New York and Auburn, N.Y., 1856), 1:92–93.
10. O. A. Brownson, "Young America," *New-York Mirror: A Weekly Gazette of Literature and the Fine Arts* 20 (Oct. 22, 1842), 358.

34
The White Lady of Avenel
Modeled ca. 1864, carved 1869
Marble
51⅜ × 21⅛ × 16⅝ in. (150.5 × 53.7 × 42.2 cm)
Inscribed at left of base: J. MOZIER. SC: / ROME. 1869; on front of base: *Here lies the volume thou hast boldly sought; Touch it, and take it,–'twill dearly be bought!*

Provenance [Clinton Hall Sale Rooms, New York, Mar. 22, 1873]; . . . ; [Sotheby's, New York, Oct. 17, 1980, lot 90]; James H. Ricau, Piermont, N.Y.

Exhibition History *The Ricau Collection,* The Chrysler Museum, Feb. 26–Apr. 23, 1989

Literature Tuckerman 1867, p. 591; "What Americans Are Doing in Rome," *Boston Daily Evening Transcript,* Jan. 22, 1869, p. 1; Brewster 1869, p. 197; "Obituary. Joseph Mozier," *Art Journal* (London), n.s., 10, 33 (Jan. 1, 1871), 6; "Art," *New-York Evening Post,* Mar. 14, 1873, p. 2; "Important Art Exhibition and Sale," *Boston Daily Evening*

Transcript, Mar. 22, 1876, p. 5; Waters and Hutton 1894, 2:155; Taft 1924, p. 109; A. A., "Joseph Mozier," *Dictionary of National Biography* (New York, 1934), 7:505; Sotheby's, New York, *American Eighteenth-Century, Nineteenth-Century, and Western Paintings, Drawings, Watercolors, and Sculpture,* Oct. 17, 1980, lot 90, ill.

Versions MARBLE (life-size) The Newark Museum, Newark, N.J.; [Christie's, New York, Sept. 22, 1993, lot 102]

Gift of James H. Ricau and Museum Purchase, 86.490

JOSEPH MOZIER created *The White Lady of Avenel* in the latter part of his career. Tuckerman referred to it in his *Book of the Artists* (1867) as a "new design."[1] However, the earliest known version is dated 1864 (The Newark Museum, Newark, N.J.).[2] Despite this minor discrepancy, the piece exerted an immediate and decisive impact. In 1869 a report from Rome ranked it among Mozier's most successful and well-known efforts.[3] This assessment was reiterated in the *Art Journal*'s obituary of the sculptor, which considered *Undine* (Collection of JoAnn and Julian Ganz, Jr.) and *The White Lady of Avenel* to be his best works.[4] The death notice further canonized Mozier's reputation for the delicacy and grace of his female figures. This evaluation contradicted Mozier's own assessment that his strength lay in rendering accessories.

Historically, poetry provided greater inspiration than prose for sculptural expression, but in the nineteenth century, novels began to figure as sources for many important sculptures. While Continental literature attained a certain popularity among American practitioners, English writings were more influential because the language provided no barrier. Thus, American neoclassical sculptors often derived their subjects from contemporary British literature, particularly romantic poems and Victorian novels that found favor with their American patrons.

In *The White Lady of Avenel*, Mozier depicted a character from Sir Walter Scott's novel of 1820, *The Monastery,* which gained broad exposure through adaptation into operatic form. *La Dame blanche,* by François-Adrien Boiledieu, was first performed in 1825 to international acclaim. It is possible the public knew the subject mostly through such popular entertainment.[5] The novel is set during the reign of Elizabeth I, when reformed religious doctrines were being introduced into Scotland and creating trouble within the monastic communities. The plot focuses on two sons of a monastery tenant who

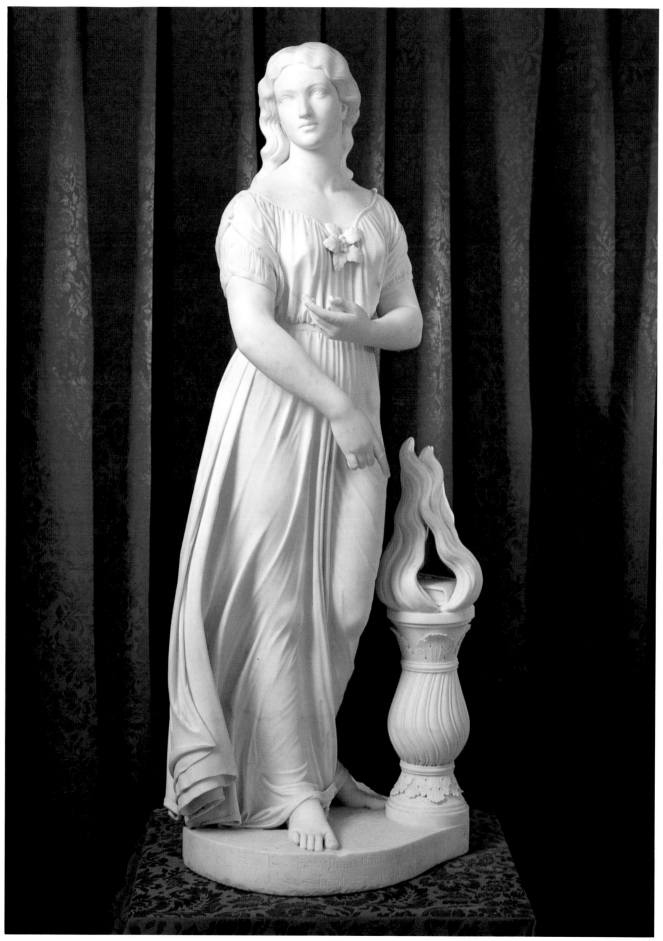

Cat. no. 34 Mozier, *The White Lady of Avenel*

vie for the hand of Mary Avenel, an orphan from a distinguished family who has been raised with them. One son represents the active life; the other, the contemplative life. It is the former who eventually succeeds in winning Mary's hand. He does so by fighting a duel with an arrogant and vain English knight, who has taken refuge in Scotland because of his intrigues in the Catholic interests. This genre of historical romance, at which Scott was so adept, appealed enormously to contemporary audiences. The religious issues were particularly pertinent in America since the anti-Catholic nativist movement stirred up passionate sentiment in the mid-1830s, to peak by 1850.[6]

Scott used this novel to employ supernatural machinery. The "White Lady" was a spirit or sylph, who served as the patron spirit of the Avenel family, overseeing and protecting its members through the ages. For a time she acted as guardian of the family's Bible. She hid it in a subterranean grotto, placing it in a fire that miraculously preserved and protected it. In time she relinquished the Bible to the novel's hero, Halbert Glendenning, admonishing, "Here lies the volume thou hast boldly sought; Touch it, and take it,—'twill dearly be bought!"[7]

Mozier was predisposed toward such supernatural figures, having already created ethereal spirits in the guise of *Undine* and *Peri*. This fascination with the occult was widespread during the mid-nineteenth century, and Mozier would have been aware of Hiram Powers's (q.v.) interest in spiritual phenomena.[8] His own ideas on this topic remain unclear, but he certainly gravitated toward the evocative properties of its subject matter.

The sculptor established a formal lineage for his *White Lady of Avenel* by electing to have her pose recall, in reverse, the *Venus de' Medici* (Uffizi Gallery, Florence), which Mozier is likely to have admired during his stay in Florence. Although the pose conveys a sense of grace, scrutiny of anatomical details confirms the assessment that bedeviled Mozier. The face echoes the broad physiognomy seen in *The Wept of Wish-ton-Wish* (cat. no. 52), and the smooth planar transition yields a vacuous ideal type. The expression is inanimate, and the chiseling of the pupils and irises does little to infuse life into the figure. The arms and gestures of the hands provide some visual interest, but here again, attention to anatomical accuracy is perfunctory. This weakness is exacerbated by the awkward rendering of the toes. The sculptor lavished great attention on the spirit's hair and obviously relished the opportunity to create long, flowing locks.

Mozier is predictably attentive to other details. The sylph's dress is evocative of the Renaissance, but the sculptor augments his concern for historical accuracy by creating a visual device for long flowing curves. Building on his tour-de-force treatment of the drapery in *Undine*, Mozier let the garment cling to the legs, resulting in a masterfully transparent quality.

He did not ignore iconographical issues completely and, following his text, prominently placed a sprig of holly with berries on the bodice of the spirit's dress. Rich in meaning, holly was significant in both sacred and profane contexts. Its properties as an evergreen linked it with immortality in Christian thought, while in pagan circles holly branches were distributed as a sign of good wishes during New Year festivals.

Mozier also labored over the accessory that housed the family Bible and protective flame. The brazier departs from the more traditional neoclassical tripod form and becomes a bulbous balustrade reminiscent of garden architecture of the period. In this instance, Mozier may have recalled the brazier in a statue of a young priestess from the Antonine period (A.D. 138–192), which was in the Uffizi Gallery.[9] Here, too, the sculptor excelled in rendering the twisting folds of the column, the acanthus-leaf decoration, and the Bible (complete with clasp) within the confines of the substantial flames. Consequently, the sinuous visual effects of the drapery and the brazier carry the sculpture, at the expense of the emotional state of the figure, which should have defined the intensely charged moment.

Despite the work's critical acclaim, only three replicas are known. Mozier's failing health undoubtedly contributed to his declining productivity. Ricau owned two versions of the sculpture, although not at the same time. He acquired the original life-size version in the mid-1960s and donated it to the Newark Museum in 1978.[10] Earlier, it had been in the collection of William H. Webb of New York and was auctioned with the contents of his estate in March 1876.[11] The second, smaller version was sold in New York in 1873 at the estate sale of Mozier's sculpture.[12] It did not resurface until 1980 when it was auctioned at Sotheby's, where Ricau acquired it to replace his recent gift.[13]

Notes

1. Tuckerman 1867, p. 591.
2. *American Art in the Newark Museum: Paintings, Drawings, and Sculpture* (Newark, N.J., 1981), p. 414.
3. Brewster 1869, p. 197.
4. "Obituary. Joseph Mozier," *Art Journal* (London), n.s., 10, 33 (Jan. 1, 1871), 6.
5. Gerdts 1973, p. 83.
6. Leonard L. Richards, *"Gentlemen of Property and Standing: Anti-Abolition Mobs in Jacksonian America* (New York, 1970), p. 18.
7. Sir Walter Scott, *Monastery*, intro. by Arthur Melville Clark (London and New York, 1969), p. 145.
8. Wunder 1991, 1:19.
9. Margarete Bieber, *Ancient Copies: Contributions to the History of Greek and Roman Art* (New York, 1977), p. 225 and fig. 866.
10. *American Art in the Newark Museum* (1981), p. 414.
11. "Important Art Exhibition & Sale in New York at Miner's Art Galleries, No. 845 Broadway, of the Superb Collection of Modern Oil Paintings, Statuary, Bronzes and Art Library of Mr. Wm. H. Webb of New York," *Boston Daily Evening Transcript*, Mar. 22, 1876, p. 5.
12. "Art," *New-York Evening Post*, Mar. 14, 1873, p. 2. The article distinguishes between the large and small pieces and thus identifies the version coming from this sale as the one now in the Chrysler. The sale was held on March 22, 1873.
13. Sotheby's, New York, Oct. 17, 1980, lot 90.

Thomas Crawford
American, 1813/14?–1857

Thomas Crawford's mentor, the Danish sculptor Bertel Thorvaldsen (q.v.), asserted that he was not born until he arrived in Rome at the age of twenty-six, and the same may be said of the twenty-two-year-old American. Although Crawford's early training in America was beneficial, it was the Roman years during the balance of his career that brought to fruition his ambitions to become a professional sculptor. This gifted artist, whose life was cut short by brain cancer while he was in his mid-forties, joined Hiram Powers (q.v.) and Horatio Greenough (1805–1852) in the vanguard of Americans who established sculpture as a profession in the young Republic.

Unlike his slightly older contemporaries who settled in Florence, Crawford opted for Rome and was the first American to move there to study sculpture. Under the guidance of Thorvaldsen, the acknowledged dean of neoclassicism, Crawford absorbed the canon of a severe classical style and subject matter, which he gradually tempered by expanding his range of theme and treatment. Despite his abbreviated career, Crawford had a profound impact on the course of sculpture in America, in both the public arena and the private parlor.

Thomas Crawford's birthplace, presumed to be New York City, and date of birth remain in question, and even the sculptor himself was inconsistent with regard to the latter, alternating between 1813 and 1814.[1] The son of Protestant Irish immigrants, Crawford came from a family of modest means and attended school with the purpose of entering a commercial profession. This was not the course that the young Crawford set for himself, however, and in his early teens, he took drawing lessons in New York at both the American Academy of Fine Arts and its successor, the National Academy of Design. Indicative of the marginal status of sculpture in America, neither of these institutions offered instruction in this medium, and Crawford had to pursue on his own whatever meager resources were available.

What conditioned his determination to become a sculptor remains unclear, but around 1827, at age fourteen, he apprenticed himself to a woodcarver. After concluding this apprenticeship in 1832, he entered the leading marble firm in New York, Frazee and Launitz, whose owners were instrumental in establishing sculpture as a profession in America. John Frazee (1790–1852) is credited with creating the first marble bust in America, while Robert Launitz (1806–1870), who immigrated to America in 1828, brought a European foundation, especially from his instruction by Thorvaldsen. Although the majority of the firm's work was confined to gravestones and architectural ornaments, Crawford assisted Frazee on several portrait commissions and gained experience in the more substantive aspects of carving. During these years, Crawford attempted some original work, including a bust of Ceres and a portrait of fellow-artist William Page (1811–1885). The latter was his maiden entry to the National Academy of Design in 1835 and received brief mention in the press.[2]

While Frazee imparted the importance of naturalism in portraiture to his aspiring student, Launitz provided a more classical orientation through the allure of Rome. Recognizing the young man's ambition, he encouraged Crawford to pursue his training abroad, and after nearly two and one-half years in the benevolent employ of Frazee and Launitz, Crawford embarked for Rome in 1835 with a modest sum of money and a crucial letter of introduction to Launitz's mentor, Bertel Thorvaldsen.

Arriving in Rome in September 1835, Crawford was overwhelmed by the city and its resources. Any insecurity was allayed by Thorvaldsen's willingness to take him on as a pupil and provide him with studio space. Since Crawford was the only American sculptor in Rome at this time, the Dane's generosity assumed added significance. In addition to the convenience of working in an established studio with all of its amenities, Crawford benefited from the master's daily visits. Thorvaldsen imparted his criticism in a frank yet positive manner and let his sculpture teach by example. Crawford was to relay the profound impact of this experience to Launitz:

I was astonished to find that he exceeded even my utmost ideas; he is just such a man as we may fancy Phidias to have been, both as regards character and genius; in his bas-reliefs it is established beyond doubt that he has no equal; and for the composition of his single figures, who is like him? Rome cannot produce a rival, and certainly if Rome cannot, I doubt if any other portion of the world can.[3]

With Thorvaldsen's guidance, Crawford took advantage of other opportunities that Rome offered. He visited churches and collections of antique statuary, took drawing classes at the French Academy, studied anatomy in the mortuary of a local hospital, and participated enthusiastically in the artistic discussions at the legendary Caffè Greco.

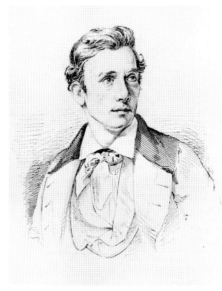

Thomas Crawford. Engraving after a pencil sketch by Kuchler, ca. 1845, in Charles Edwards Lester, *The Artists of America* (New York, 1846)

Crawford sought to establish his independence quickly, and within a year of arriving in Rome, he took the first of a series of studios in the area around the Piazza di Spagna. Financial realities quickly motivated him to solicit commissions, and, inevitably, portraits were the most practical source of much-needed income. Among his early efforts was the portrait of Mrs. John Jones Schermerhorn, executed in 1837 (N-YHS), which reflected the sculptor's appreciation of Roman republican portraiture both in the objective likeness and in the antique costume. In the same year, Crawford carved a full-scale copy of Demosthenes from the original in the Vatican collection for a patron in New Orleans (New York Bar Association, New York) and executed his first full-length ideal piece, *Paris Presenting the Golden Apple to Venus* (cat. no. 35).

Crawford's personable nature worked to his advantage. He befriended the American consul, George Washington Greene, and through him, secured enough commissions to survive. Of greatest importance, Greene introduced the struggling artist to the influential Charles Sumner of Boston, who was much taken with Crawford's *Orpheus* (BMFA), begun in 1839. Sumner arranged for a subscription to acquire a marble translation of the work from members of the Boston Athenaeum.[4] Although completion of the piece was protracted and payment for it was even more prolonged, this commission established Crawford's reputation in America. Artistically, it crystallized his youthful goals of creating a pure and ideal beauty in the spirit of the ancient Greek masters,

which he articulated in a letter of May 1839 to his sister Jennie.[5]

As the next decade unfolded, Crawford adhered to a rigidly classical vein, evident in his *Hebe and Ganymede,* modeled in 1842 (BMFA), and copies of Thorvaldsen's famous reliefs, *Night* and *Day,* executed to fulfill a commission. As his work garnered attention and he gained self-confidence, Crawford expanded his repertoire of subject matter to include literary and allegorical themes. By 1843 he had conceived of several biblical subjects, culminating in his ambitious full-length pair, *Adam and Eve* (BA). He also recognized the appeal of genre themes, and indications of this less serious trend appear in the sculptor's *Genius of Mirth* of 1843 (MMA) and his *Boy Playing Marbles,* commenced the following year (WAM).

The middle of the decade was punctuated by a return to America and Crawford's marriage to Louisa Ward, who came from a prominent New York family, an alliance that augmented Crawford's steadily growing circle of influential contacts. In 1846 Crawford carved an exquisite bust of his young bride, which reflected the tenderness of his devotion (Museum of the City of New York). He did not succumb to temptations of a comfortable marriage, however, and used his visit to America to lobby in Washington for government commissions. The balance of the 1840s saw Crawford's unflagging output alternate between portrait and ideal busts as well as the more accomplished ideal figures, which culminated in *The Dancing Girl* of 1850 (cat. no. 36).

In 1850 Crawford little realized he had only six more productive years left to him. Nonetheless, he worked like a man possessed. His reputation had prospered so that he no longer needed to pursue portrait commissions, and his aspirations focused on making his mark with public monuments. In 1849 the growing political unrest in Italy prompted Crawford to seek refuge in the United States. He soon entered the competition for a bronze equestrian statue of George Washington to be erected in Richmond, Virginia. He won and relished the prestige of receiving the second major equestrian commission to be undertaken in America.[6] This massive project involved coordinating an equestrian statue with statues of six of Virginia's famous sons as well as integrating the sculptural program with the architectural component. This became just one of several major commissions that occupied Crawford in the final years of his career. In addition to the lofty considerations that he brought to this undertaking, the sculptor also created an ideal bust of

Washington based on his study of Houdon (cat. no. 38). Although Crawford completed most of the monument before his illness set in, the casting and finishing of several of the figures around the base were executed by Randolph Rogers (q.v.) at the request of Crawford's widow.

By 1853 the sculptor demonstrated the breadth of his sculptural expression with the enchanting figure *Flora,* whose diaphanous drapery and sprays of dainty flowers were a tour de force of delicacy and charm (The Newark Museum, Newark, N.J.). He also embarked on his heroic bronze portrait of Beethoven, which was unveiled in Boston in 1855 (New England Conservatory of Music, Boston). Crawford simultaneously attracted the attention of Captain Montgomery Meigs, chief engineer of the Capitol and arbiter of government commissions. Meigs asked both Crawford and Hiram Powers to submit designs for the Senate pediment and portico, and the field was left clear for Crawford when Powers refused to lower himself to the indignity of having to compete for a commission. Crawford had revealed an interest in broader American themes with his *Mexican Girl Dying,* completed as a private commission in 1848 (MMA). The pediment's program dealt with the conquest of a great civilization over uncivilized life, with America personified as the central figure. Crawford also designed figures of History and Justice, which were placed within the portico over the Senate doorway.

Captain Meigs was sufficiently impressed by Crawford's work to have him design the doors for both the Senate and the House of Representatives as well as a large allegorical figure to surmount the dome of the Capitol. The doors, in emulation of Lorenzo Ghiberti's famous *Gates of Paradise* on the Baptistery in Florence, were conceived to deal with the theme of War and Peace, and the majestic nineteen-foot-high figure atop the Capitol was a personification of Armed Freedom. Crawford, obsessed with the idea of being the sculptor of the Capitol, also suggested creating a nine-foot-high, three-hundred-foot-long bas-relief for the interior base of the dome, but Meigs balked at this for reasons of expense.

The sculptor was not satisfied with this impressive array of notable commissions and was concurrently working on a majestic, ten-foot-high statue of James Otis for the Mount Auburn Cemetery (Harvard University, Cambridge, Mass.); a major literary theme, *Peri* (PAFA); and informal pieces such as *The Broken Tambourine* (cat. no. 37). Crawford's appetite for work was insatiable, but after returning to Rome

from a brief American sojourn in the fall of 1856, an eye affliction impeded his ability to work. In early 1857 he went to Paris in search of medical treatment and never returned to his beloved studio and residence in Rome. His condition was hopeless, and despite valiant efforts to save his life, Crawford died of brain cancer on October 10, 1857, in the prime of an extraordinarily successful career.

Crawford's widow ensured that his projects would be realized and his obligations fulfilled. His studio operated under her supervision for more than a year after his death to complete all the unfinished work. Louisa Crawford made arrangements with Randolph Rogers, William Henry Rinehart (q.v.), and Clark Mills (1815–1883) to bring to fruition the public sculptures that Crawford had started.

Given the outpouring of eulogies and testimonials in both Europe and America, Thomas Crawford, in the brief time allowed him, made a profound impact on the world of sculpture in the nineteenth century. He demonstrated a sensitivity to changing taste as his style evolved from a severe neoclassicism to one informed by a greater naturalism and expressive power. On a more far-reaching level, Crawford elevated the status of the sculptural profession in America and, through his example, educated the public that talent and creative genius were central to the sculptor's career.

Notes

1. Crawford varied his date of birth between Mar. 22, 1813, and Mar. 22, 1814, on various passport applications. I am indebted to Col. Merl M. Moore, Jr., for this information. The best starting point for information on Crawford is Dimmick, "Veiled Memories" (1989).

2. Dimmick 1986, p. 9.

3. Robert L. Launitz, "Reminiscences of Crawford," *Crayon* 6 (Jan. 1859), 28. The letter, dated June 27, 1857, was published after Crawford's death.

4. For a thorough discussion of this work, see Jan Seidler Ramirez, *Orpheus,* in BMFA 1986, pp. 59–64, and Dimmick, "Thomas Crawford's *Orpheus*" (1987).

5. Craven 1984, pp. 125–126, reprints much of the text of this letter of May 1839 from Crawford to his sister Jennie, which originally appeared in George S. Hillard's eulogy (1869), pp. 45–46.

6. For an extensive discussion of this commission see Dimmick, "Crawford and His *Virginia Washington Monument*" (1991).

Bibliography

Jane Crawford, "The Sculptor in His Studio," *United States Magazine and Democratic Review* 12 (June 1843), 567–568; George Washington Greene, "Crawford, the Sculptor," *Knickerbocker* 17 (Feb. 1846), 174; Lester 1846, pp. 255–257; "Fine Arts Gossip," *Bulletin of the American Art-Union,* May 1849, pp. 25–26; "Art in America,"

Art Journal (London), 12 (Sept. 1850), 295; "American Sculptors in Rome," *Bulletin of the American Art-Union*, Oct. 1851, pp. 13–14; Hillard 1853, pp. 260–265; Lee 1854, 2:173–177; Greenwood 1854, pp. 219–221; Florentia, "Crawford and His Last Work," *Art Journal* (London), n.s., 1, 17 (1855), 41; "Crawford and His Washington," *Cosmopolitan Art Journal* 1 (Nov. 1856), 46; "Thomas Crawford," *Art Journal* (London), n.s., 3, 20 (Nov. 1857), 348; "Thomas Crawford," *Crayon* 4 (Dec. 1857), 380; "Thomas Crawford," *Cosmopolitan Art Journal* 2 (Dec. 1857), 27–28; Thomas Hicks, *Thomas Crawford; His Career, Character, and Works. A Eulogy..., Read before the Century Club in New York, on Tuesday Evening, January 26, 1858* (New York, 1858; reprint, 1865); "Thomas Crawford," *Littel's Living Age* 56 (Jan. 1858), 274–280; Henry T. Tuckerman, "Crawford and Sculpture," *Atlantic Monthly* 2 (June 1858), 64–78; Hawthorne 1858, pp. 124–126; Robert L. Launitz, "Reminiscences of Crawford," *Crayon* 6 (Jan. 1859), 28; Samuel Osgood, "Crawford the Sculptor," *Cosmopolitan Art Journal* 3 (Mar. 1859), 59; "The Artists of America. Thomas Crawford," *Crayon* 7 (Feb. 1860), 46–48; "Sketchings: Domestic Art Gossip," *Crayon* 7 (Nov. 1860), 525; "Crawford and Ives," *Cosmopolitan Art Journal* 4 (Dec. 1860), 524–526; George Washington Greene, *Biographical Studies* (New York, 1860), pp. 121–154; William Stillman, "American Sculpture," *Cosmopolitan Art Journal* 4 (March 1860), 1–4; Tuckerman 1867, pp. 306–320; George S. Hillard, "Eulogy on Thomas Crawford," *Atlantic Monthly* 24 (July 1869), 40–54; W. H. Ingersoll, "Crawford the Sculptor as Represented in Central Park," *Aldine* 2 (Aug. 1869), 87–88; Samuel Osgood, *Thomas Crawford and Art in America: An Address before the New-York Historical Society* (New York, 1875); Clark 1878, pp. 61–73; Benjamin 1880, pp. 138, 145, 149; "Notable Examples of American Art in the Collection of Mrs. H[icks] L[ord]," *Curio* 1 (Nov. 1887), 97–104; Gale 1964; Thorp 1965, pp. 30–41; Crane 1972, pp. 273–408; Jan Seidler Ramirez, "Thomas Crawford," in BMFA 1986, pp. 52–66; Dimmick 1986; Lauretta Dimmick, "Thomas Crawford's *Orpheus:* The American *Apollo Belvedere*," *American Art Journal* 19 (Fall 1987), 47–84; id., "Veiled Memories, or, Thomas Crawford in Rome," in *The Italian Presence in American Art, 1760–1860,* ed. Irma B. Jaffe (New York and Rome, 1989), pp. 176–194; id., "'An Altar Erected to Heroic Virtue Itself': Thomas Crawford and His *Virginia Washington Monument*," *American Art Journal* 23, no. 2 (1991), 2–73; Fryd 1992, pp. 111–124 and passim

35
Paris Presenting the Golden Apple to Venus
Modeled and carved 1837
Marble
57½ × 22⅛ × 18 in. (146.1 × 56.2 × 45.7 cm)
Inscribed on tree trunk at back:
T. Crawford Fect. / Rome, / 1837

Provenance Meredith Calhoun, New Orleans, by 1839; ...; private collection, Pasadena, Calif., by late 1950s; [Pennington Museum Treasures, Los Angeles, by 1976]; James H. Ricau, Piermont, N.Y., by 1977

Exhibition History *A Collection without Walls: Problems in Connoisseurship,* Fine Arts Gallery, California State University, Northridge, Oct. 7–Nov. 3, 1976, no. 13; Los Angeles County Museum of Art, 1977–78; *The Ricau Collection,* The Chrysler Museum, Feb. 26–Apr. 23, 1989

Literature George Washington Greene, "Letters from Modern Rome. No. One, To Henry Wadsworth Longfellow, Oct. 1, 1839," *Knickerbocker* 15 (June 1840), 489–490; Thomas Crawford, "Mr. Crawford's Works," *Literary World,* Mar. 2, 1850, p. 207, and *Boston Evening Transcript,* Feb. 13, 1850, p. 4; Thomas Hicks, *Thomas Crawford; His Career, Character, and Works. A Eulogy..., Read before the Century Club in New York, on Tuesday Evening, January 26, 1858* (New York, 1858; reprint, 1865), p. 31; "Sketchings. The Eulogy of Thomas Crawford," *Crayon* 5 (Mar. 1858), 87; "The Artists of America. Thomas Crawford," *Crayon* 7 (Feb. 1860), 47; "Notable Examples of American Art in the Collection of Mrs. H[icks] L[ord]," *Curio* 1 (Nov. 1887), 100; Gale 1964, p. 198, no. 62; Crane 1972, pp. 284, 454; *A Collection without Walls: Problems in Connoisseurship,* exh. cat., Fine Arts Gallery, California State University, Northridge (Northridge, Calif., 1976), pp. 11–12, ill.; "Pennington Museum Treasures," *Apollo* 104 (Sept. 1976), 46, ill.; Dimmick 1986, pp. 23, 628–651; id., "Thomas Crawford's *Orpheus:* The American *Apollo Belvedere*," *American Art Journal* 19 (Fall 1987), 47ff.; id., "Veiled Memories, or, Thomas Crawford in Rome," in *The Italian Presence in American Art, 1760–1860,* ed. Irma B. Jaffe (New York and Rome, 1989), pp. 178–179, ill. p. 182

Versions None known

Gift of James H. Ricau and Museum Purchase, 86.463

Pʀᴏᴅᴜᴄᴇᴅ in 1837, *Paris Presenting the Golden Apple to Venus* constitutes Thomas Crawford's earliest original full-length, though slightly less than life-size, ideal piece. It holds the place of honor as one of the first male nudes in the history of American sculpture.[1] Created when the young sculptor was establishing his reputation, the statue was conceived and executed during a period of extraordinary activity, which was to define Crawford's modus operandi. George S. Hillard, an attorney with a strong interest in art, commented on this enthusiasm and energy in his eulogy of the artist, noting that during a period of ten weeks in 1837, Crawford modeled seventeen busts to be translated into marble and made a full-length copy of the statue of Demosthenes in the Vatican (New York Bar Association, New York).[2] It was probably in the wake of this valuable training exercise that Crawford felt empowered to embark on a project of his own devising.

The model of *Paris* attracted an immediate response, since it was acquired by Meredith Calhoun of New Orleans as early as 1839.[3] Despite the work's apparent success, Crawford was dissatisfied with it, as he had been with his other early original full-length effort, *Bacchante;* he destroyed both plasters. The sculptor must have blocked this early work, since he erroneously recalled in 1850 that it had been modeled in 1838.[4] Although Crawford himself belittled it, *Paris* was listed in the *Crayon* among his major mythological efforts.[5] It stands as his most significant accomplishment prior to the work that established his reputation—*Orpheus,* which was begun in 1839 (BMFA).

Conditioned by the immersion into classical Rome, Crawford derived his earliest subjects from ancient mythology. Paris, with his connection to the Trojan War, had long been a popular subject for artists, and John Flaxman's (1755–1826) drawings for the *Iliad* (1795) were especially influential. The son of Priam, king of Troy, Paris was prophesied to bring ruin to the city, so he was abandoned as an infant to die on the slopes of Mount Ida. However, shepherds discovered him and raised him as their own. Maturing into a handsome young man, Paris engaged in a dalliance with the nymph Oenone, who loved him dearly. All was well until Paris was singled out by Jupiter, who wished him to judge a question: Of the goddesses Juno, Minerva, and Venus, who was most beautiful? The question stemmed from the outrage of Eris, the goddess of discord, who had been excluded from the wedding of Peleus and Thetis. Angrily, she threw among the guests a golden apple that was inscribed, "for the fairest." Unable to decide who should be the recipient of the apple, Jupiter sent the three main con-

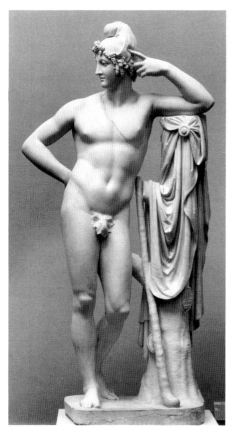

FIG. 65 Antonio Canova, *Paris*, 1807–12. Marble, 80¾ in. (205.1 cm) high. Bayerische Staatsgemäldesammlungen, Munich

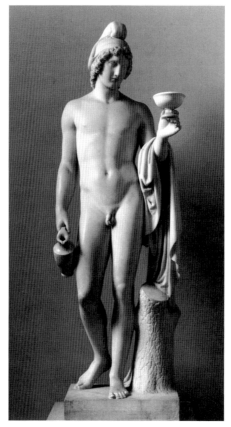

FIG. 66 Bertel Thorvaldsen, *Ganymede Offering a Full Goblet*, modeled 1804. Marble, 53⅜ in. (135.6 cm) high. Thorvaldsen Museum, Copenhagen

tenders to Paris for a decision. The beautiful shepherd was wooed by each goddess with offers of power and riches (Juno), glory and renown in war (Minerva), and the fairest of women for his wife (Venus). Paris decided in favor of Venus and gave her the apple, thereby earning the enmity of Juno and Minerva and setting the stage for the Trojan War.

In Crawford's sculpture, Paris, his left hand raised pensively to his chin, is in the throes of making the decision. The pose and gesture impart a sense of hesitation as well as languor. Given the youthful date of the work, its derivative nature is not surprising, and Antonio Canova's (1757–1822) *Paris*, executed between 1807 and 1812 (fig. 65), along with a Roman prototype best known through the *Paris* in the Marbury Hall collection, have been suggested as central influences.[6] While the positioning of the legs argues persuasively for this connection, there are numerous elements that separate the two works. The hip-shot pose in the Canova is more pronounced and the musculature more developed with an expression that exudes greater confidence than the uncertain mien of Crawford's *Paris*.

While Canova's work provided a compelling source, Crawford, in his youthful exuberance, would not have confined himself to such a monolithic approach. Although Bertel Thorvaldsen (q.v.) forbade the copying of his own works, the young American could not have remained immune to them, given the formative period he spent in the Danish master's studio. Consequently, Thorvaldsen's *Ganymede Offering a Full Goblet* (fig. 66) also suggests a persuasive model. The positioning of the legs is reversed but shares a common debt to the influential *Apollo Belvedere* in the Vatican collection (fig. 113). The more restrained pose and the elegant modeling of the anatomy result in a softer, more lithe, and effeminate body. In addition, the shared use of drapery over the arm, connecting the figure to the supporting tree stump, provides formal affinities between the statues by Crawford and his mentor.

A third, lesser-known work, a *Paris* in bronze (Count von Schönborn Collection) by the German sculptor Rudolph Schadow (1786–1822), can be related to Crawford's on a speculative level. Schadow, the son of Gottfried Schadow (1764–1850), himself

a sculptor who worked in Berlin, was one of the few noted sculptors in the circle of Thorvaldsen. Schadow modeled *Paris* in Rome, but it was cast in Berlin, where Count Schönborn subsequently acquired it. Although it is difficult to determine whether Crawford might have known this work, the common approach of both is intriguing. Schadow's rendition shows Paris in a pose almost identical to Crawford's. His figure holds the apple in his right hand while placing the left finger on his chin in a gesture of quizzical contemplation. Each work imparts the hesitation implicit in making this momentous decision, and the lack of confidence is reiterated by the still adolescent physique. Because Schadow's work was cast in bronze, there was no need for the supporting tree stump and drapery. Other slight modifications are readily apparent in the Crawford: the hand holding the apple is not as elevated as in the Schadow; the head is not tilted as sharply to look at the apple; and the positioning of the fingers of the left hand on the chin is different. But the moment captured and the spirit of the sculpture are the same.

All the works under discussion depict their subjects wearing the Phrygian cap, although Crawford elected to let the straps fall on Paris's shoulders, adding to the visual complexity of the work. He also sought a richer display by adorning Paris with a leather belt secured across his chest as well as intricately rendered sandals decorated with anthemion leaves. Such elaborate details were natural for someone trying to make an impression.

The apparent dependence on earlier examples reflected his respect for tradition, but may also have contributed to *Paris*'s demise. Crawford believed he was extracting elements from admired works and recombining them into an original composition. But he destroyed the model, perhaps feeling there was too much of his mentors' presence in it and not enough of himself. If this were the case, it is another indication of the high standards Crawford set for himself. Nevertheless, he retained a certain admiration for this youthful attempt, since he infused much of the *Paris* into the Ganymede of his *Hebe and Ganymede*, which he started in 1842 (BMFA).

Notes

1. Gerdts 1973, p. 57, considered Crawford's *Orpheus* of 1839 to be the first life-size mature male nude by an American sculptor, but subsequent discovery of *Paris* would shift this honor.

2. George S. Hillard, "Eulogy on Thomas Crawford," *Atlantic Monthly* 24 (July 1869), p. 44.

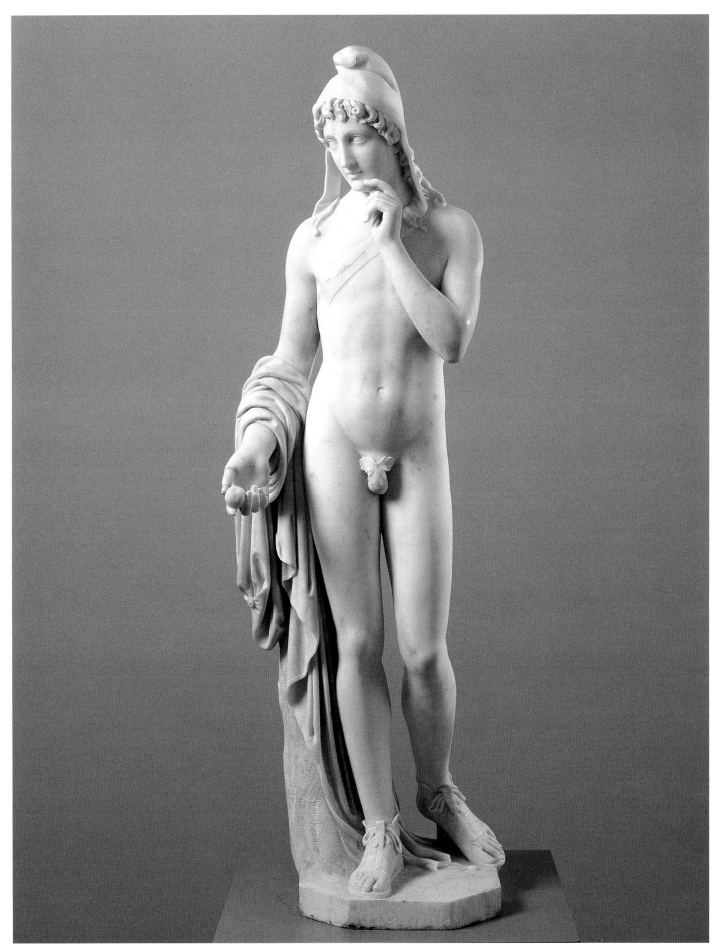

Cat. no. 55 Crawford, *Paris Presenting the Golden Apple to Venus*

3. Greene, "Letters from Modern Rome" (1840).

4. Crawford, "Mr. Crawford's Works," *Literary World*, Mar. 2, 1850, p. 207, and *Boston Evening Transcript*, Feb. 13, 1850, p. 4.

5. "Sketchings. The Eulogy of Thomas Crawford," *Crayon* 5 (Mar. 1858), 87.

6. Dimmick, "Veiled Memories" (1989), pp. 178 and 186 n. 11.

36
The Dancing Girl

Modeled by 1849, carved 1855
Marble
42⅝ × 14 × 16¼ in. (108.5 × 35.6 × 41.3 cm)
Inscribed at left of base: T. CRAWFORD. FECIT. / ROMÆ. 1855.

Provenance [Louis Joseph, Boston]; James H. Ricau, Piermont, N.Y., Sept. 1954

Exhibition History Fountain Elms, Utica, N.Y., Oct. 1960–July 1962; *Classical America, 1815–1845*, The Newark Museum, Newark, N.J., Apr. 26–Sept. 2, 1963, no. 237, as *Daughter of the Artist*; *The Ricau Collection*, The Chrysler Museum, Feb. 26–Apr. 23, 1989

Literature Thomas Crawford, "Mr. Crawford's Works," *Literary World*, Mar. 2, 1850, p. 207, and *Boston Evening Transcript*, Feb. 13, 1850, p. 4; Florentia 1854, p. 185; "To the Editors of the Crayon," *Crayon* 2 (July 18, 1855), 41; "Art Items," *New York Tribune*, Feb. 1, 1860, p. 6; "The Artists of America. Thomas Crawford," *Crayon* 7 (Feb. 1860), 48; Z., "Letter from New York," *Boston Transcript*, Feb. 7, 1860, p. 1; "Amusements: The Düsseldorf Gallery," *New-York Evening Post*, Apr. 26, 1860, p. 1; "Art Gossip," *Cosmopolitan Art Journal* 4 (Dec. 1860), 128; "Notices," *New York Tribune*, Jan. 4, 1862, p. 1; "Works of Art: Exhibition in Central Park of Plaster Casts Presented to the City Oct. 18, 1860 by Mrs. Crawford," *New-York Evening Post*, Aug. 14, 1866, p. 1; Tuckerman 1867, p. 313; Clark 1878, p. 72; Waters and Hutton 1894, 1:170; "Notable Examples of American Art in the Collection of Mrs. H[icks] L[ord]," *Curio* 1 (Nov. 1887), 102; Richard B. K. McLanathan, "History in Houses, Fountain Elms in Utica, N.Y.," *Antiques* 79 (Apr. 1961), 358, ill.; William H. Gerdts, *Classical America, 1815–1845*, exh. cat., The Newark Museum, Newark, N.J. (Newark, N.J., 1963), p. 203; Gale 1964, p. 196, no. 18; William H. Gerdts, "American Sculpture: The Collection of James H. Ricau," *Antiques* 86 (Sept. 1964), 292, 294, 298, ill.; Gerdts 1973, pp. 82, 83, fig. 60; Dimmick 1986, pp. 41, 302, 376–587

Version MARBLE Tulane University Art Collection, New Orleans

Gift of James H. Ricau and Museum Purchase, 86.464

Themes of childhood in sculpture go back to classical antiquity, and such subject matter held great appeal for the Victorian audience, which placed great emphasis on the innocence of youth. This taste is well represented in the Ricau Collection, which contains at least six examples, two of them by Thomas Crawford.

Crawford is heralded by some as the most prolific interpreter of children among American sculptors.[1] It is likely he recognized them as a more marketable antidote to his serious works. It has been suggested that Crawford's personal happiness played a role, since his family was rapidly expanding, eventually to include three daughters and a son.[2] But *Genius of Mirth*, executed in 1843 (MMA), and *Boy Playing Marbles*, the following year (WAM), were both initiated prior to Crawford's marriage. This helps confirm Crawford's early commitment to youthful subject matter.

Building on the incipient naturalism employed in *Genius of Mirth*, Crawford continued to treat music and the idea of imparting sound through a silent medium in *The Dancing Girl* and its companion, *The Broken Tambourine* (cat. no. 37). *The Dancing Girl* was modeled and translated by 1850, and the original marble belonged to Crawford's sister, Jane Crawford Campbell.[3] Affirming the predilection for such subjects, the piece was repeated four times. The title of the work took on a life of its own. It was known variously as *Joy, The Happy Child, Daughter of the Artist*, and, most popularly, *Dancing Jennie*.[4] The last appellation referred to the sculptor's middle daughter, who was known among the family for her proclivity to dance. Crawford began alluding to the work as *Dancing Jennie* around 1853, when his daughter, at age five, had grown to be the size of the girl in the sculpture. At the time he commenced the statue, Jennie Crawford would have been less than two years old.

A visitor to Crawford's studio in 1854 saw the work with its companion and referred to the pair as "the *Happy* and the *Unhappy Child*."[5] She considered these childhood subjects particularly successful and admired *The Dancing Girl* for conveying innocent fun and for the natural treatment of the girl's hair, which was slightly raised to suggest the wind's passing through it. Not all reactions were favorable, however. Crawford exhibited the sculptures at the 1854 version of the Crystal Palace Exhibition in London, where he was the only American invited

to participate. The pair did not impress the eminent British art critic Anna Jameson, who considered them unworthy of his genius and reputation. Crawford seemingly agreed, since he did not attempt to have them moved from an inferior location in the show.[6]

Nevertheless, the statues enjoyed broad exposure, and *The Dancing Girl* kept Crawford's name before the public after his death since it was on extended view at the Düsseldorf Gallery in New York beginning in 1860.[7] Here, too, it elicited mixed reactions. Although one critic admired the statue for its simplicity and sweetness, he or she did not think the subject matter suitable for "the severe dignity of marble."[8] A more positive assessment reflected a personal bias on the part of the author:

Several years ago, in the heyday of his prosperous activity, Crawford executed a statue of his little daughter in the act of "taking her steps"—the attitude natural and simple—the body bent forward and the fingers holding up the robe; it is easy to trace in the infantile features the likeness to the now mature child; there is a sweet *naiveté* about this unpretending and graceful work, and, associated, as it is, with the artist's domestic life and days of health and happiness, it forms a most appropriate gift for his last and devoted medical friend, Dr. Fell, to whom the sculptor's widow presented it. The little statue which is called *Dancing Jenny* is now on exhibition at the Dusseldorf.[9]

Despite the writer's sentimental judgment, he or she perpetuated the mythical association between the statue and Crawford's daughter as its model.

Dancing joyfully, the girl is caught in the instant before misfortune befalls her tambourine-playing companion. Besides celebrating the innocence of childhood, Jennie evokes thoughts about the power of music, which is almost audible as we gaze on the determined dancer. Sculptors used musical themes to infuse a vitality into their works that transcended the inherent immobility of the medium. Well within Crawford's frame of reference, Bertel Thorvaldsen (q.v.) treated the subject of the dancer on several occasions, and, while these efforts retained their neoclassical trappings, he did not deny them a sense of movement. In *The Dancer*, executed between 1817 and 1822 (TMC), the front foot extends beyond the edge of the plinth, reinforcing the sense of motion. Crawford did not break the plane of the plinth in his own attempt, but the lifted big toe of the forward foot suggests movement.

In contrast to the work of his mentor, however, *The Dancing Girl* signals the moment when Crawford's work became more naturalistic. This statue and its com-

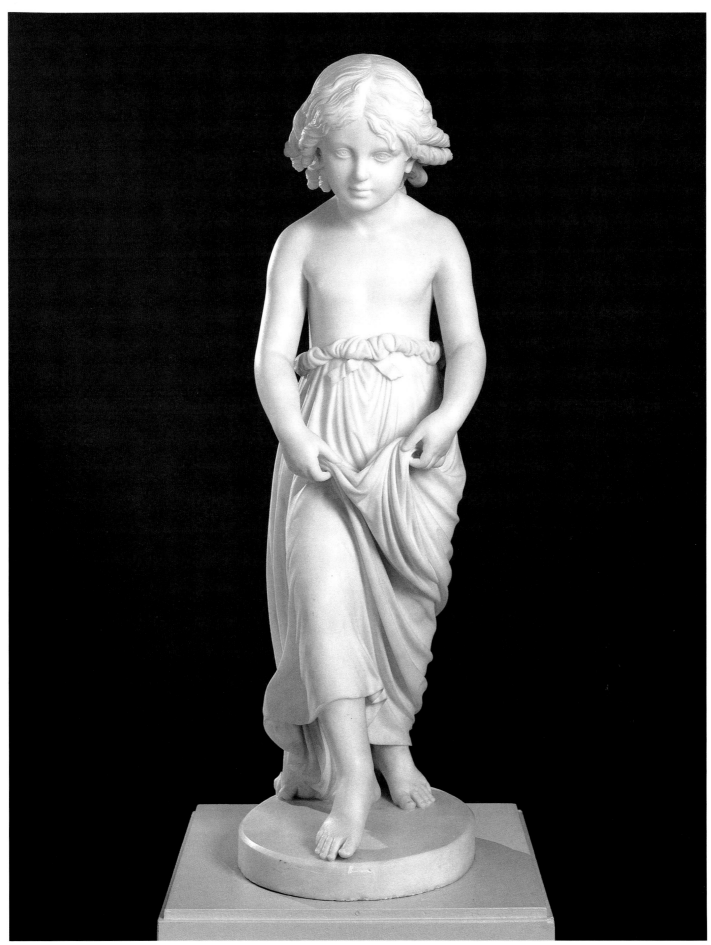

Cat. no. 36 Crawford, *The Dancing Girl*

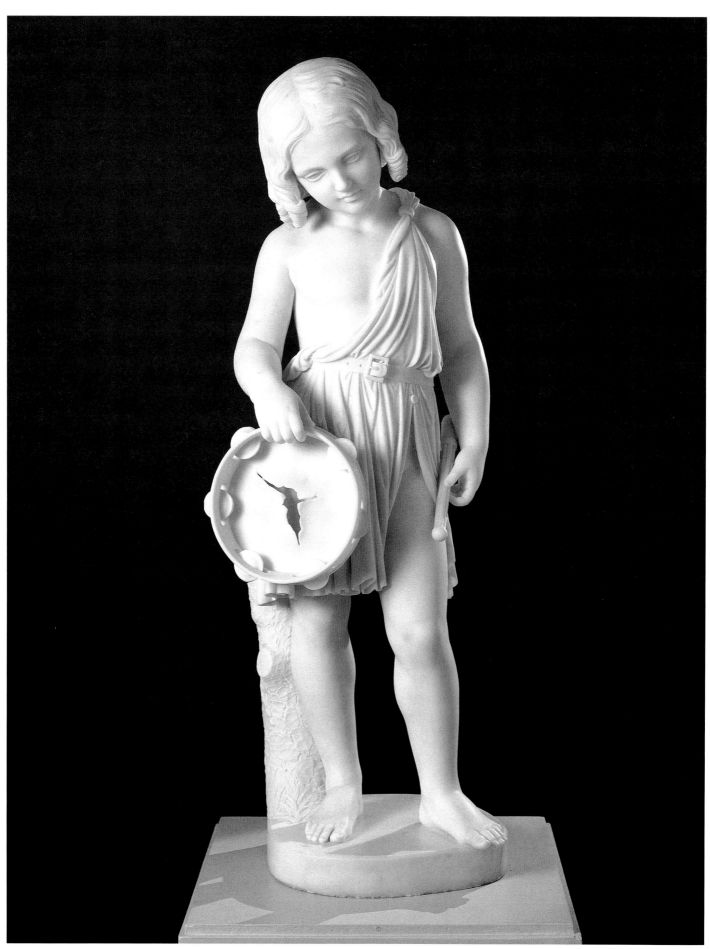

Cat. no. 37 Crawford, *The Broken Tambourine*

panion piece, the sculptor's portraits of two contemporary children in dress evocative of antiquity, show his ability to meld elements from the past and the present. This was an aim of American neoclassic sculptors, and Crawford's achievement of this goal was confirmed by George S. Hillard, lawyer and art enthusiast, who observed that the sculptor's statues "remind us, by their life and animation, of the best productions of Grecian art.... [T]he marble or bronze is not merely a correct transcript of the human form and face, but it is penetrated and informed with the soul of humanity."[10]

Notes

1. Gerdts 1973, p. 39.
2. Dimmick 1986, p. 41.
3. Crawford, "Mr. Crawford's Works," *Literary World*, Mar. 2, 1850, p. 207, and *Boston Evening Transcript*, Feb. 13, 1850, p. 4.
4. Dimmick 1986, pp. 376–387.
5. Florentia 1854, p. 185.
6. Dimmick 1986, pp. 379–380.
7. Newspaper notices advertising its display range from at least Apr. 1860 to Jan. 1862. See "Amusements," *New-York Evening Post*, Apr. 26, 1860, p. 1, and "Notices," *New York Tribune*, Jan. 4, 1862, p. 1.
8. "Art Items," *New York Tribune*, Feb. 1, 1860, p. 6.
9. Z., "Letter from New York," *Boston Transcript*, Feb. 7, 1860, p. 1.
10. George S. Hillard, "Eulogy on Thomas Crawford," *Atlantic Monthly* 24 (July 1869), p. 53.

37
The Broken Tambourine
Modeled ca. 1853, carved 1855
Marble
45⅛ × 16½ × 13 in. (109.5 × 41.9 × 33 cm)
Inscribed at right rear on top of base:
T. CRAWFORD. FECIT / ROMÆ. 1855.

Provenance [Louis Joseph, Boston]; James H. Ricau, Piermont, N.Y., Sept. 1954

Exhibition History Fountain Elms, Utica, N.Y., Oct. 1960–July 1962; *The Ricau Collection*, The Chrysler Museum, Feb. 26–Apr. 23, 1989

Literature Florentia 1854, p. 185; "To the Editors of the Crayon," *Crayon* 2 (July 18, 1855), 41; "Art Items," *New York Tribune*, Feb. 1, 1860, p. 6; "The Artists of America. Thomas Crawford," *Crayon* 7 (Feb. 1860), 48; "Works of Art: Exhibition in Central Park of Plaster Casts Presented to the City Oct. 18, 1860 by Mrs. Crawford," *New-York Evening Post*, Aug. 14, 1866, p. 1; "Notable Examples of American Art in the Collection of Mrs. H[icks] L[ord]," *Curio* 1 (Nov. 1887), 102; Gale 1964, p. 195, no. 7; William H. Gerdts, "American

Sculpture: The Collection of James H. Ricau," *Antiques* 86 (Sept. 1964), 292, 294, 298, ill.; Gerdts 1973, pp. 82, 83, fig. 61; Dimmick 1986, pp. 41, 302, 311–317

Versions MARBLE National Museum of American Art, Smithsonian Institution, Washington, D.C.; Georgetown University Art Collection, Washington, D.C.; Villa Crawford, Sant' Agnello di Napoli, Sorrento

Gift of James H. Ricau and Museum Purchase, 86.465

MUSIC and musical instruments were popular themes for American neoclassical sculptors, and the type is well represented in the Ricau Collection. Historically, *The Broken Tambourine* has been linked to *The Dancing Girl* as a pendant (cat. no. 36).[1] In a vignette showing the sadness of one who is deprived of making music, the statue depicts a poignant mishap of childhood that suited Victorian taste. Childhood was revered during the nineteenth century as a period of innocence and joy, and children were idealized, partially as a result of the era's high infant mortality rate.

The earliest known reference to *The Broken Tambourine* appears in an August 1853 letter from Crawford to his wife.[2] Thereafter, he always considered it in connection with *The Dancing Girl*. Crawford never associated the young boy with a family member the way he connected the little girl to his middle daughter, Jennie. Although usually exhibited with *The Dancing Girl*, *The Broken Tambourine* tended to be overshadowed by its counterpart and received minimal attention in the press. In contrast to the extended discussion accorded *The Dancing Girl*, a visitor to Crawford's studio in 1854 dismissed the sculpture in question by saying, "The other child, sad and melancholy in aspect, holds a broken tambourine."[3] Only *The Dancing Girl* was advertised as being on view in the Düsseldorf Gallery after Crawford's death, and no evidence has come to light to confirm *The Broken Tambourine* was ever exhibited there. Henry Tuckerman, in his account of Crawford in *Book of the Artists* (1867), chose not to include this statue in the substantial list of the sculptor's works.[4] This is surprising since *The Broken Tambourine* contained all the necessary ingredients to satisfy the Victorian penchant for sentimentality and carried the added attraction of Crawford's tour-de-force carving of the broken tambourine skin.

As in *The Dancing Girl*, Crawford fused the spirit of the antique with a modern aesthetic into *The Broken Tambourine*. The young boy possesses a softly modeled

torso and delicately chiseled facial features appropriate to his youth. The smooth surfaces of the body are offset by the rippling folds of the garment and the crisply delineated curls of hair. The sculptor further enhanced the effect of visual immediacy by chiseling the pupils of the eyes, meticulously rendering the belt, carefully detailing the tree stump, and extending the left foot beyond the plinth of the sculpture. Consequently, Crawford established a sense of equilibrium between the ideal and the natural as well as between stasis and movement. The focal point of the sculpture, however, is the tambourine, which is a flawless demonstration of virtuoso stone carving. Its delicate, broken membrane is magically portrayed in hard, unyielding marble. And herein lies the moral. The unbridled striking of the tambourine reflects the ingenuous exuberance of youth; its destruction signifies the fragility of all things and constitutes a learning experience as part of growing up.

Thus, *The Broken Tambourine* and its pendant, while situated modestly within the overall scheme of Thomas Crawford's oeuvre, demonstrate the sculptor's sensitivity to current taste and adherence to the highest standards of craftsmanship regardless of the subject's seemingly minor importance.

Notes

1. Florentia 1854, p. 185.
2. Dimmick 1986, p. 311.
3. Florentia 1854, p. 185. See cat. no. 36 for a discussion of the exhibition history.
4. Tuckerman 1867, p. 313.

38
George Washington
Modeled ca. 1850
Marble
31½ × 22⅝ × 12½ in. (80 × 57.5 × 31.8 cm)
Inscribed on front of base: WASHINGTON

Provenance [Sotheby Parke-Bernet, New York, Jan. 24, 1974, lot 382]; James H. Ricau, Piermont, N.Y., 1974

Exhibition History *The Ricau Collection*, The Chrysler Museum, Feb. 26–Apr. 23, 1989

Literature "American Art Abroad," *Home Journal*, June 2, 1849, p. 1; "Italian Matters—American Artists," *Boston Evening Transcript*, June 23, 1858, p. 2; Henry T. Tuckerman, *The Character and Portraits of Washington* (New York, 1859), p. 81; Tuckerman 1867, p. 313; Ernest Harms, "A Rediscovered Washington Portrait," *Antiques* 63 (Feb. 1953), 135; id., "The Real Features of George

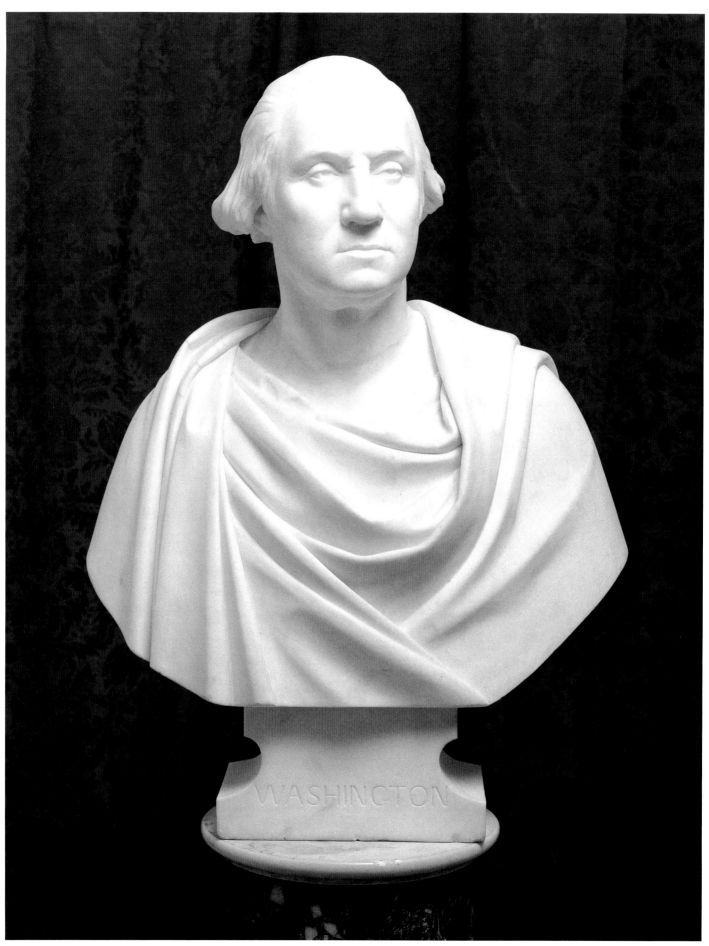

Cat. no. 38 Crawford, *George Washington*

Washington," *Art in America* 43 (Dec. 1955), 45–47, 56; Thomas B. Brumbaugh, "The Evolution of Crawford's *Washington*," *Virginia Magazine of History and Biography* 70 (1962), 13; Gale 1964, p. 197, no. 215; Sotheby Parke-Bernet, New York, Jan. 24, 1974, lot 582, as *Marble Bust of George Washington*; Lauretta Dimmick, "'An Altar Erected to Heroic Virtue Itself': Thomas Crawford and His *Virginia Washington Monument*," *American Art Journal* 23, no. 2 (1991), 66

Versions MARBLE New York Public Library; The New-York Historical Society; Museum of Our National Heritage, Lexington, Mass.; Burlington Trust, Lynn, Mass. (now unlocated)

Gift of James H. Ricau and Museum Purchase, 86.466

THOMAS CRAWFORD's bust of George Washington is one of three likenesses of the esteemed military figure and states-man in the Ricau Collection.[1] It was extrapolated from the sculptor's monu-mental bronze equestrian statue commis-sioned by the state of Virginia to be erected in Richmond. Although the head was a subordinate presence in the overall scheme, the sculptor relished the chal-lenge of putting his own mark on such a legendary image. He was successful, and one observer commented that Crawford brought to his interpretation a zeal and insight that resulted in an "expressive, original and finished character."[2]

Efforts to honor Washington with an equestrian statue were initiated shortly after the conclusion of the Revolutionary War. Given the precarious financial con-dition of the young Republic, these attempts floundered. It ultimately took Washington's native state of Virginia to realize such a monument. When the call for entries for the memorial was pub-lished in the American press in the fall of 1849, Crawford happened to be in America. Like many other American and European sculptors, Crawford had pri-vately contemplated such a project. Charles Lester, an early chronicler of American art, noted three statues of Washington, two designs for monuments, and a design for an equestrian monument in the partial list of Crawford's accom-plishments, which he included in his chapter on the sculptor published in 1846.[3] Although Crawford could not refer to any of the existing ideas he had made, because they were in Rome, he produced some clay models in just over a month. These were sufficient to win him the commission.

Crawford's research for the statue of George Washington was thorough. Henry Tuckerman in his pioneering book on *The Character and Portraits of Washington*, published in 1859, noted that the sculptor particularly admired Joseph Wright's (1756–1793) *Portrait of Washington* (Historical Society of Pennsylvania, Philadelphia) for the accuracy of the military costume.[4] The sculptor recog-nized the prudence of this contemporary approach given the criticism leveled at Antonio Canova (1757–1822) and Horatio Greenough (1805–1852) for their interpre-tations à l'antique. He was undoubtedly aware that Jean-Antoine Houdon (1741–1828) had been forced to compromise regarding costume. Obliged to dress Washington in military uniform for his statue, Houdon was able to exercise autonomy in the busts, which were classi-cal in appearance. Crawford emulated this strategy with successful results, and Tuckerman indicated a steady stream of orders.[5] A newspaper account listed the bust of Washington among the more pop-ular works available after the sculptor's death, noting that a patron could secure it in a plaster cast by Caproni or "with the advantage of Crawford's own well-trained workmen and original models."[6]

Houdon's bust of Washington, originally taken from life, served as the model for the head (fig. 67).[7] Crawford's specific focus on this aspect of the work was such that a visitor to his studio in 1854 recounted that the head was being modeled in a chamber completely separate from the space where the bulk of the monument was being con-ceived.[8] Crawford was meticulously true to his French source. He re-created the pose of the head, slightly turned to the left, emulated the facial structure, and faithfully captured the sense of the sag-ging flesh, especially evident in the wattle under the chin as well as the creases where the chin and neck meet below the left ear. Such convincing accuracy derived from the life mask that Houdon took. The hair in Crawford's version corresponds to the swept-back coiffure of the Houdon. To reinforce the sense of immediacy, Crawford also chiseled the pupils and irises. All these elements, as well as the generalized, planar forehead and boldly rendered folds of the togalike garment, relate closely to the Frenchman's para-digm. With the exception of minor dis-parities in dimensions, the known replicas by Crawford are almost identical. This reflects the discipline and loyalty of Crawford's workshop and the adminis-trative skills of Crawford's widow, who fulfilled her husband's major obligations with no apparent sacrifice in quality.

Notes

1. See Trentanove's version (cat. no. 3) and the unidentified bust of Washington after Houdon (cat. no. 68).

2. Henry T. Tuckerman, "Crawford and Sculpture," *Atlantic Monthly* 2 (June 1858), 75.

3. Lester 1846, p. 257.

4. Tuckerman, *Character and Portraits of Washington* (1859), p. 41.

5. Ibid., p. 81.

6. "Italian Matters—American Artists," *Boston Evening Transcript*, June 23, 1858, p. 2.

7. "American Sculptors in Rome," *Bulletin of the American Art-Union*, Oct. 1851, p. 113. This report was reprinted from the *Home Journal*.

8. Florentia 1854, p. 184.

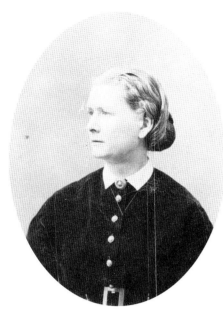

Photograph of Emma Stebbins. Photograph courtesy of the Archives of American Art, Smithsonian Institution

Emma Stebbins

American, 1815–1882

Emma Stebbins's career as a sculptor was a constant struggle to combat the stigma of amateur status. Her background disposed her to the realm of the dilettante. She came from a venerable family of comfortable means. Her father, John L. Stebbins, was president of North River Bank in New York and descended from an old New England family. Growing up in the city, Emma Stebbins was exposed to the arts at an early age. When she displayed a more active interest, she received enthusiastic support from her family. Her brother Henry, later the head of the New York Stock Exchange, especially encouraged her artistic pursuits.

At the outset Stebbins studied painting and drawing and worked to please her friends and charitable causes. Her talent attracted professional attention when Henry Inman (1801–1846), during a commission to paint portraits of Stebbins's parents, saw examples of her work and offered to teach her oil painting.[1] Around the same time, she was introduced to the basic principles of sculpture by Edward Augustus Brackett (1818–1908), who resided in New York between 1839 and 1841. Stebbins responded enthusiastically to sculpture and sensed her true medium. Despite her social status, Stebbins's resolve was such that Henry Tuckerman accorded her serious consideration, writing, "She long worked with crayon and palette as an amateur—making likenesses of her friends, copying fine pictures in oil,

improving every opportunity to cultivate her taste, and discipline her ability."[2] From the outset, Stebbins did not shun the public arena; she exhibited occasionally, showing copies of oil paintings at the Pennsylvania Academy of the Fine Arts as well as portraits in oil and crayon at the National Academy of Design, where she was elected an associate academician in 1842.[3] Yet Stebbins was content to work on her own terms until 1856, when she decided to make art more than an avocation and embarked for Rome at age forty-one with the financial and moral support of her brother.

Living in Rome and meeting Harriet Hosmer (q.v.) opened Stebbins's eyes to the vast possibilities of sculpture. She sought the counsel of Hosmer's mentor, John Gibson (1790–1866), who directed her to the studio of Paul Akers (1825–1861), an American sculptor from Maine. Akers provided sympathetic instruction, and Gibson, too, encouraged her by commissioning an ideal work, *The Lotus Eater*, in the spring of 1857. This statue was Stebbins's first undertaking in Rome. She based her figure on the *Satyr* of Praxiteles in the Capitoline Museum, the Hellenistic sculpture that later inspired Nathaniel Hawthorne's *Marble Faun*.

In addition to establishing influential artistic connections, Stebbins found an appropriate social milieu. Soon after settling in Rome she met the accomplished American actress Charlotte Cushman, who had recently moved to the Eternal City. Cushman organized weekly soirées that attracted the upper echelons of the Anglo-American community. The women's friendship blossomed, and in 1859 Cushman commissioned Stebbins to model her portrait as a gift for R. D. Shepherd, a gentleman who had encouraged Cushman on her recent tour of America. The work was well received, and at least three copies were ordered.[4] Cushman was a persuasive agent for Stebbins, whose studio soon became part of the obligatory tour for visitors to Rome.[5] The actress introduced Stebbins to many reigning luminaries in the arts, such as George Sand, Rosa Bonheur (1822–1899), and Robert and Elizabeth Browning.

The sculptor's New York connections stood her in good stead, as well. In 1858, during a visit to New York, Stebbins secured a commission from the wealthy industrialist August Heckscher. He ordered personifications of Industry in the guise of a miner and Commerce represented as a sailor (Heckscher Museum, Huntington, N.Y.). Like *The Lotus Eater*, these works echoed Hellenistic sculptures that Stebbins

had seen in Italy. *Industry* recalled the *Doryphorus* of Polykleitos (National Museum, Naples), while *Commerce* also drew its inspiration from Praxiteles' *Satyr*.[6]

Stebbins used her trip to America in the spring of 1860 to introduce New Yorkers to her work. She exhibited *The Lotus Eater, Charlotte Cushman,* and the two sculptures for Heckscher at Goupil's in New York in the summer of 1860. All were received with great enthusiasm, although one critic considered the two allegories for Heckscher too refined for the ideas they symbolized.[7] Nevertheless, based on this initial display, the author predicted the future augured well for Stebbins. Around this time, the sculptor also attracted the attention of Marshall O. Roberts, an important New York collector who expressed great pleasure with a bas-relief showing the treaty of Henry Hudson with the Indians, which Stebbins modeled in 1860. Its appealing qualities prompted him to commission a life-size statue of Columbus in 1865 (Brooklyn Supreme Court, Brooklyn, N.Y.).[8] The sculptor could take great satisfaction in the positive response her work was eliciting.

Cushman's strong ties to Boston were not ignored, and Stebbins exhibited *The Lotus Eater* there in the spring of 1861 and remained on hand to witness its reception. A reviewer for the *Boston Transcript* contended that Stebbins was so well known to the Boston public that she needed no introduction.[9] The author accorded the work extravagant praise and urged viewers to read Tennyson's inspirational poem of the same title to further their enjoyment. The favorable reception was especially welcome, since Stebbins had to overcome major technical problems in finishing *The Lotus Eater*. The fledgling sculptor encountered difficulty in achieving the desired degree of delicacy and finish in the leaves and flowers of *The Lotus Eater* and wrote Hiram Powers (q.v.) requesting some tools he had invented for working directly on plaster.[10] Her concern for technical matters emanated from a commitment to doing her own carving. This practice was time-consuming and financially unremunerative, and it set Stebbins apart from most of her contemporaries. This unconventional approach was, no doubt, conditioned by her not having to operate her studio as a business.

The extended sojourn in America during 1860 and 1861 was important to Stebbins in many ways. The exhibitions in New York and Boston introduced her sculpture to a broader audience, which led to three major commissions. Such confidence in her work defused any self-doubts Stebbins had had about her profes-

sional status. While one of the projects, a monument to Commodore Matthew C. Perry (Newport, R.I.), eventually went to the sculptor John Quincy Adams Ward (1830–1910), the other two brought enduring visibility to Stebbins in both Boston and New York.

Shortly after Horace Mann's death in 1859, the Massachusetts legislature approved funding for a statue of the great educator and politician to balance Hiram Powers's *Daniel Webster* in front of the Boston State House. Given Mann's progressive advocacy of female education, the committee considered it fitting that he be immortalized by a woman. Aware of this opinion, Cushman played a central role in securing the commission for Stebbins, since she had the confidence of Mann's widow, who was an influential voice.[11] The contract was far less favorable to Stebbins than had she been a man. It neglected to mention any terms of payment, and Cushman ultimately undertook the obligation of raising the necessary funds. Modeled in Rome and cast into bronze in Munich, the work was unveiled only in the summer of 1865 after many delays. Stebbins attempted to infuse her subject with great sensitivity. However, its immediacy and contemporary style were compromised by the overlay of classical garb and pose that accurately records a Roman oratorical gesture.[12] To Stebbins's disappointment, reaction to the Mann statue was lukewarm at best.

The second project to evolve from Stebbins's 1860–61 visit to America became her most ambitious undertaking, *Angel of the Waters*, for the Bethesda Fountain in Central Park. The presence of her brother Henry on the Central Park Commission complicated matters at the outset, but once he resigned from the commission in 1862 to enter the House of Representatives, he lobbied on his sister's behalf with impunity. Emma Stebbins submitted sketches for the figures of the fountain in 1861, but because of the potential conflict of interest, the commission was not officially awarded her until 1863. Her program illustrated the story from the Gospel of John about the angel stirring the waters that gave healing powers at the pool of Bethesda. The fountain is composed of three basins, designed by Jacob Wrey Mould (1825–1884). The uppermost basin contains the *Angel of the Waters*, an impressive winged female figure balancing on a rock. The second tier is supported by four childlike figures representing Temperance, Purity, Health, and Peace. These somewhat generic, youthful cherubs relate closely to other biblical characters such as *Samuel* (cat. no. 39)

that Stebbins subsequently made. The sculptor worked on these figures from 1864 until 1867, sending the plaster models to Munich for casting. The Franco-Prussian War delayed delivery of the finished bronzes until 1871, and the completed fountain was not unveiled until May 1873. The result did not meet with universal acclaim, and one critic who disapproved pointed to the sculpture's lack of expression, grace, dignity, psychology, and scale.[13] Negative reaction notwithstanding, Stebbins felt this was her most important project, and it stands as the most impressive undertaking by an American woman sculptor in the nineteenth century.

Given her personal involvement in a work from start to finish, Stebbins's output was small. Few portrait busts are known. In addition to the one of Charlotte Cushman, only one of her brother John Wilson Stebbins (The Mercantile Library of New York), a nephew, John Neal Tilton (private collection), and the Roman beauty Nanna Risi (private collection) have come to light. Most of Stebbins's oeuvre was devoted to ideal pieces, and among the most notable is *Angel of Prayer*, modeled in 1862, which illustrated Longfellow's poem "Sandalphon."[14] Other notable works are an interpretation of Satan, statuettes of such biblical figures as Joseph as a young boy and, what may have been her last effort, *Samuel*. *Satan* drew praise from the influential critic James Jackson Jarves.[15] Aside from *Satan*, these works share a gentle purity and innocence, which, according to Cushman, rendered them particularly apt for placement in the parlor. This assessment identifies Stebbins's temperament as a sculptor. She championed a refinement and delicacy that did not challenge the norm of sculptural expression.

By the time the figures for the Bethesda Fountain were installed in 1873, Stebbins had returned to America. She put her career aside to minister to her devoted companion, Charlotte Cushman, who was dying of breast cancer. They engaged Richard Morris Hunt (1827–1895) to design a villa in Newport, Rhode Island, where they settled after Cushman made one final triumphant theatrical tour of the country. Cushman died in 1876, and Stebbins devoted herself to publishing a memoir of her friend, which appeared in 1878.[16] Emotionally drained and in frail health, Stebbins created nothing of consequence after this. She died in her native New York City on October 25, 1882, just two months after her sixty-seventh birthday.

Emma Stebbins's career was fraught with conflict. Her recognition as a serious

artist may have suffered from her unwillingness to establish a competitive studio. Her financial circumstances provided her with an enviable independence, yet the absence of necessity and her allegiance to Charlotte Cushman further dictated against any full-blown commitment as a true professional. One need only compare her attitude to that of Harriet Hosmer, who had to support herself and shunned any personal commitment lest it jeopardize her career. Despite her ambivalence, Stebbins was adamant about her abilities as a sculptor. She recognized her role in a pioneering group of women who had to contend with enormous difficulties in terms of gaining respect in a male-dominated profession. In light of these circumstances, there can be little diminution of her contribution and accomplishments.

Notes

1. Milroy, "Stebbins" (1980), p. 3. Milroy's M.A. thesis offers the most recent account of Stebbins.
2. Tuckerman 1867, p. 602.
3. Milroy, "Stebbins," p. 3. Her election along with five other candidates was nullified on procedural grounds, and Stebbins chose not to resubmit her name.
4. Ibid., Catalogue, p. 8.
5. Fuller 1859, p. 271.
6. Milroy, "Stebbins," Catalogue, p. 4.
7. "Sketchings. Domestic Art Gossip," *Crayon* 7 (Nov. 1860), 323.
8. "Personal," *Boston Daily Evening Transcript*, July 24, 1868, p. 2.
9. H., "The Lotus Eater," *Boston Transcript*, Mar. 22, 1861, p. 2.
10. Stebbins, Rome, to Powers, Mar. 15, 1860, Powers papers, AAA, roll 1114, frame 597.
11. Milroy, "Stebbins," pp. 26–27.
12. See John Stephens Crawford, "The Classical Orator in Nineteenth-Century American Sculpture," *American Art Journal* 6 (Nov. 1974), 65–66. Mann is represented making a gesture in the colloquial radius, or informal zone, that would have been commonly employed during the *narratio*, or statement of facts in an oration.
13. "Art. Central Park Bronzes," *Aldine* 6 (Oct. 1873), 207.
14. "Art Items," *New-York Evening Post*, Dec. 13, 1866, p. 1, mentions a *Bacchus*, and an undated circular from Schaus's Art Gallery in New York advertises the *Angel of Prayer*. The circular is in the New-York Historical Society papers, AAA, roll NY-1, frame 80.
15. James Jackson Jarves, "Progress of American Sculpture in Europe," *Art Journal* (London), n.s., 10, 33 (Jan. 1, 1871), 7.
16. Emma Stebbins, *Charlotte Cushman: Her Letters and Memoirs of Her Life* (Boston, 1878).

Bibliography

"Studios of American Artists," *Home Journal*, Feb. 16, 1856, p. 1; "Personal," *Home Journal*, Sept. 18, 1858, p. 3; Mrs. Ellet, *Women Artists in All Ages and Countries* (New York, 1859), pp. 346–349; Fuller 1859, pp. 271, 288–289; "Miss

Stebbins's Nationality of Genius," *Home Journal,* July 23, 1859, p. 2; "Sketchings. Domestic Art Gossip," *Crayon* 7 (Nov. 1860), 523; H., "The Lotus Eater," *Boston Daily Evening Transcript,* Mar. 22, 1861, p. 2; H. W., "Lady Artists in Rome," *Art Journal* (London), n.s., 5 (June 1866), 177; "Art Items. Sculpture," *New-York Evening Post,* Dec. 15, 1866, p. 1; Tuckerman 1867, pp. 602–603; "American Artists in Paris," *Boston Daily Evening Transcript,* Aug. 1, 1867, p. 2; "Personal," *Boston Daily Evening Transcript,* July 24, 1868, p. 2; "Art. Central Park Bronzes," *Aldine* 6 (Oct. 1873), 207; "Sale of Bric-a-Brac," *New-York Evening Post,* June 7, 1876, p. 4; "Necrology of the Year. Art," *Boston Daily Evening Transcript,* Dec. 30, 1882, p. 8; Waters and Hutton 1894, 2:269; Taft 1924, p. 211; Margaret F. Thorp, "The White, Marmorean Flock," *New England Quarterly* 32 (June 1959), 160; Soria 1982, pp. 275–276; Craven 1984, pp. 228, 284, 330, 333, 345, 360; Elizabeth Milroy, "The Public Career of Emma Stebbins, 1857–1882" (M.A. thesis, University of Pennsylvania, 1980); Charlotte S. Rubenstein, *American Women Sculptors* (Boston, 1990), pp. 65–66

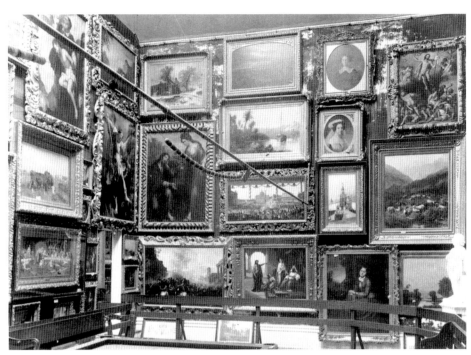

FIG. 68 Gallery of Henry C. Lewis collection, Coldwater, Mich. Photograph courtesy of the University of Michigan Museum of Art

39
Samuel

Modeled ca. 1865–66, carved 1870
Marble
39¾ × 15⅝ × 9⅞ in. (101 × 39.7 × 25.1 cm)
Inscribed on lower left side of stele:
Emma. Stebbins / Rome. 1870

Provenance Church, South Nyack, N.Y.; James H. Ricau, Piermont, N.Y.

Exhibition History *The Ricau Collection,* The Chrysler Museum, Feb. 26–Apr. 23, 1989

Literature "The Lockwood Gallery," *New-York Evening Post,* Apr. 9, 1872, p. 4; William H. Gerdts, *A Survey of American Sculpture: Late Eighteenth Century to 1962* (Newark, N.J., 1962), p. 39; id., "I Dreamt I Dwelt in Marble Halls: A Century of American Sculpture," *Antiques* 82 (Aug. 1962), 149, ill.; Margaret D. Schaack, "History in Houses: The Lockwood-Mathews Mansion," *Antiques* 97 (Mar. 1970), 379, ill.; Cikovsky et al. 1972, cat. no. 11; Soria 1982, p. 276; Charlotte S. Rubenstein, *American Women Sculptors* (Boston, 1990), p. 64

Version MARBLE The Brooklyn Museum, Brooklyn, N.Y.

Gift of James H. Ricau and Museum Purchase, 86.521

EMMA STEBBINS produced this statuette of Samuel, the beloved Old Testament prophet, using her young nephew John Neal Tilton for a model.[1] Tilton, born in 1860, was the second son of the American painter John Rollin Tilton (1828–1888) and

Stebbins's younger sister, Caroline. Young Tilton's features were incorporated into the subsidiary figures of cherubs who support the uppermost basin in the Bethesda Fountain, which Stebbins worked on in the mid-1860s. The Tiltons left Rome on an extended trip to America in 1866, so the modeling must have been completed before this date. Presumably, Stebbins adapted Tilton's head to the figure of Samuel, which she started in 1866. The earliest known marble was not cut until 1868 (The Brooklyn Museum, Brooklyn, N.Y.), and a second copy was executed in 1870. No doubt, Stebbins was motivated by the success of her earlier *Joseph, the Dreamer,* executed between 1862 and 1865.

Given the figure's idealization, it is difficult to ascribe a specific age. Nevertheless, the child appears to be about five or six, which would be consistent with young John's age. A bust of the young Samuel remains in the possession of the sitter's descendants, and from this we may infer that it must have been intended as a portrait of the model.

For her interpretation, Stebbins selected the moment of Samuel's early childhood when he was ministering to the Lord in the temple. Asleep near the ark of God, Samuel has been summoned by the Lord, and to this entreaty replies, "Speak, for thy servant heareth."[2] Opinion differed at one time as to what was being depicted. One scholar suggested the sculptor may have chosen a less dramatic and more neutral moment centering on the boy

being girded in the *ephod,* or priest's garb.[3] An engraving after *Samuel* in a Tilton family scrapbook, however, includes the text of I *Samuel* 3:10: "Speak Lord! For Thy Servant Heareth!"[4] This points to the more dramatic moment.

This choice of biblical subject matter reflected the broad interest in religious themes in the second half of the nineteenth century, and Stebbins revealed her interest in Old Testament characters through her earlier depiction of Joseph. The Old Testament, with its narrative riches, was preferred over the more dogmatic attitudes associated with the New Testament.[5] Moreover, *Samuel* is as much about childhood and innocence as it is an adaptation of a biblical theme, and this sentimental subject matter held great appeal for the Victorian audience in the second half of the nineteenth century.

In addition to the bust of Samuel, there are two known copies of the full-length statuette. Both were owned at one time by Mr. Ricau, who gave the earlier version, signed and dated 1868, to the Brooklyn Museum in 1980.[6] This copy had a rather interesting history. Its earliest known owner was the ill-fated financier LeGrand Lockwood, who placed the sculpture in the entrance hall of his mansion in Norwalk, Connecticut, where it stayed until his collection was sold in April 1872.[7] The piece passed into the possession of Henry C. Lewis of Coldwater, Michigan, who installed it in the gallery in his residence (fig. 68).[8] Lewis bequeathed the

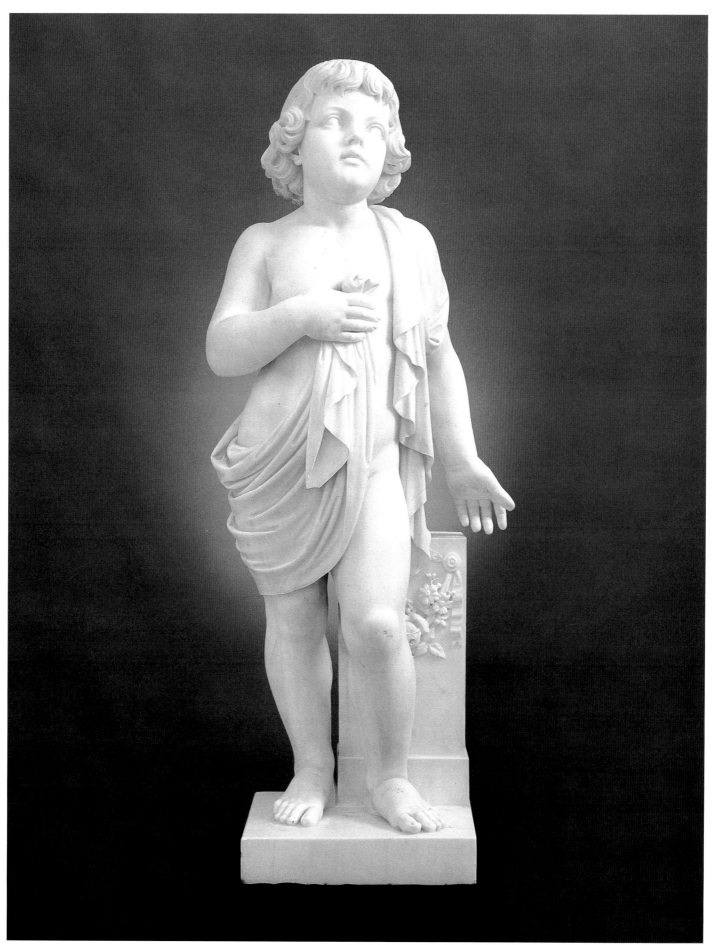

Cat. no. 39 Stebbins, *Samuel*

bulk of his collection, including *Samuel,* to the University of Michigan in 1884, but ownership was not transferred until his wife's death in 1895.[9] The university, in turn, sold the piece to Tobias and Fischer, Inc., of New York in 1950.[10] Ricau acquired this copy of *Samuel* by 1962, but details of where he bought it are sketchy.[11] Unfortunately, there is no information about the history of the Chrysler version. That at least two copies of the sculpture were ordered attests to its modest success, especially since one was bought by such a prominent collector as Lockwood.

Notes

1. Elizabeth Milroy, "The Public Career of Emma Stebbins, 1857–1882" (M.A. thesis, University of Pennsylvania, 1980), Catalogue, p. 52.

2. See I Sam. 5:2–10, for appropriate text.

3. Cikovsky et al. 1972, cat. no. 11, suggested the text may have been I Sam. 2:18: "But Samuel ministered before the Lord, *being* a child, girded with a linen ephod."

4. Stebbins scrapbook, AAA, roll 2082, frame 973.

5. Gerdts 1973, pp. 68–69.

6. Interview with James H. Ricau, Piermont, N.Y., Feb. 16, 1992.

7. See Schaack, "The Lockwood-Mathews Mansion" (1970), p. 579, for its location in the central rotunda. The sculpture was identified as dating to 1868 in the notice advertising the sale of the Lockwood Gallery; see "The Lockwood Gallery," *New-York Evening Post,* Apr. 9, 1872, p. 4. Lockwood suffered great losses on the stock market and was forced to sell his collection.

8. *The Lewis Art Gallery. Catalogue of Paintings and Statuary* (Coldwater, Mich., 1875), p. 22, cat. no. 472. Lewis paid $480 for *Samuel;* see Carole Simon Drachler, "The Gallery and Art Collection of Henry Clay Lewis" (Ph.D. diss., University of Michigan, 1980), p. 162.

9. Drachler, "The Gallery and Collection of Henry Clay Lewis," p. 247.

10. University of Michigan Art Museum Archives, deaccession records, card 1895.185.

11. Gerdts, *A Survey of American Sculpture* (1962), p. 59. Ricau recalled that one version came out of a church in South Nyack, N.Y., and that he bought the other version from Café Nicholson when it moved from 57th Street to 58th Street. Apparently the new location was where Jo Davidson had his studio, and this is where the piece had been. It appears most likely that the 1868 version was the one found in the city; interview with James H. Ricau, Piermont, N.Y., June 25, 1991.

Pio Fedi
Italian, 1816–1892

With one minor exception, there has been no recent, substantive treatment of the life and career of Pio Fedi.[1] In his day, Fedi was a capable sculptor who enjoyed sustained patronage from Tuscan aristocracy. He was best known for his monumental sculpture, *The Rape of Polyxena,* which he executed for the Loggia dei Lanzi in Florence (fig. 69). This work and the attention it garnered attracted the notice of American clientele. This may explain the unusual circumstance of how a posthumous relief portrait of an American gentleman, Charles Richard Alsop, was executed by an Italian at a time when many American sculptors were available.

Pio Fedi was born in 1816 in Viterbo, in the Lazio region between Orvieto and Rome. By 1852 he was in Florence, learning the goldsmithing trade in one of the shops on the Ponte Vecchio. Fedi soon went to Vienna to study engraving under Raphael Morghen (1758–1853), who died not long after his arrival. The young artist subsequently sought instruction from one of Morghen's disciples, Giovanni Garaviglia (1790–1855), who died two years later. Subsequently, Fedi enrolled in the Imperial Academy of Vienna to study engraving. The academy must have broadened Fedi's horizons, since he returned to Italy around 1840 to study sculpture.

Initially, Fedi entered the academy in Florence, where he worked under the tutelage of the aging Lorenzo Bartolini (1777–1850). He must have demonstrated promise since he subsequently went to Rome and studied with Pietro Tenerani (1798–1870) from about 1842 to 1846 on a scholarship provided by the Tuscan Grand Duke Leopold II. This Roman sojourn produced his earliest works, including *Christ Healing the Paralytic* (plaster relief, Academy of St. Luke, Rome); *Religion and Charity,* a grave relief for a Roman cemetery; *St. Sebastian,* which was modeled in 1844; *Cleopatra on Her Deathbed,* executed in marble for a Mr. Benoit of New York; and *The Good Hunter,* a realistic costume piece. These early efforts were well received when exhibited in Florence, and they demonstrated Fedi's ability to render general effects and details convincingly.

Fedi returned to Florence in 1846 and immediately enjoyed the patronage of Leopold II, who asked him to model and carve statues of the thirteenth-century sculptor Niccola Pisano (fig. 70) and the sixteenth-century physiologist Andrea Cesalpino for niches in the Uffizi court-

Pio Fedi, *Self-Portrait,* ca. 1860–65. Marble, 23 in. (58.4 cm) in diameter. Gallery of Modern Art, Florence

yard. In 1849 Leopold, satisfied with these efforts, commissioned Fedi to create a marble group for the park of the imperial palace in Florence. Fedi selected a subject from Dante's *Purgatory* (5.133ff.), Pia de' Tolomei e Nello della Pietra, which told the sad story of a calumniated yet innocent wife who was abandoned by her jealous husband to die of malaria. The group generated an enthusiastic response and was reproduced for several private English collections.

These commissions provided a visibility that launched the sculptor's career, and he began to receive numerous local and foreign orders. Some were from royalty, and in 1852 Fedi was engaged by Prince Lwoff of St. Petersburg to create a life-size figure of a guardian angel for his daughter's tomb. Other major accomplishments of the decade included a colossal group of the Marchese Pietro Torrigiani with his son, dressed in classical Roman garb, commissioned by the marchese for the park at his Florentine villa, and an imposing civic monument entitled *Tuscan Civilization,* ordered by Prince Carignano of Turin. In addition to these necessarily classicizing works, Fedi created more sensitive, ideal works such as *Poetry* (Civic Museum of Modern and Contemporary Art, Verona).

Fedi achieved singular fame as the last Italian naturalist. For this honor he was indebted to the tutelage of Bartolini, who was best remembered for espousing the cause of naturalism. The impact of his mentor's group *Pyrrhus and Astayanax* (Poldi Pezzoli Museum, Milan) on *The Rape of Polyxena* was considerable. Fedi completed a terra-cotta model as early as 1855, and the composition elicited such enthusiastic response that a group of citizens banded together to raise the funds

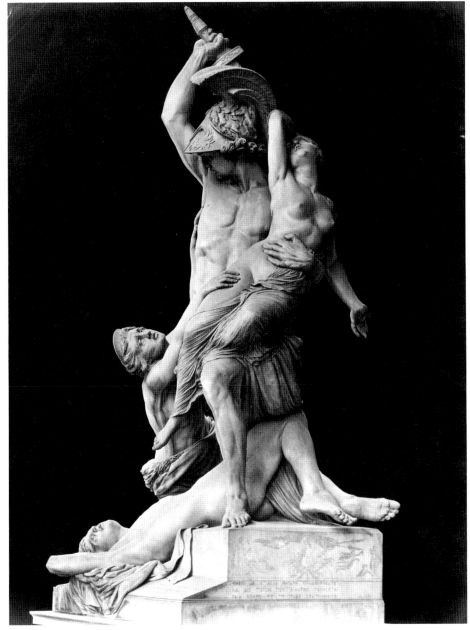

FIG. 69 Pio Fedi, *The Rape of Polyxena*, 1865. Marble. Loggia dei Lanzi, Florence. Photograph courtesy of Kunsthistorisches Institut in Florenz

FIG. 70 Pio Fedi, *Niccola Pisano*. Marble. Piazzale degli Uffizi, Florence. Photograph courtesy of Kunsthistorisches Institut in Florenz

to install it in one of Florence's public squares.[2] A flurry of publicity helped raise enough money by 1858 to enable Fedi to complete the project.

The colossal group depicted the rape of Hecuba's daughter Polyxena by Achilles' son Pyrrhus in revenge for her treachery against his father. Fedi combined the versions of the story set down by Euripides and Virgil and concentrated on the moment of greatest drama when Pyrrhus abducts Polyxena, having slain her brother Polites and fended off Hecuba. The work evokes Hellenistic sculpture in its complex composition and forceful emotional content. The sculpture's placement in the Loggia dei Lanzi, where it joined Benvenuto Cellini's *Perseus* and

Giambologna's *Rape of the Sabines*, confirmed the respect it was accorded. It was unveiled December 14, 1865, amid great celebration. While working on *The Rape of Polyxena*, Fedi received generous offers for replicas from two Americans, one a Bostonian, and the other a New Yorker who wanted to place it in Central Park.[3] Despite these transatlantic overtures, Fedi decided the work should remain unique, given the genesis of the commission.

Thought by some to be a virtuoso performance of late Italian classicism, *The Rape of Polyxena* constituted a triumph of convention and quality. The often harsh critic James Jackson Jarves considered it a favorable example of modern academics, who "treat whatever motives may be pre-

sented to them in a skillful manner, devoid of other ambition than to make an effective tableau."[4] Because of the publicity engendered by *The Rape of Polyxena*, Fedi's fame attracted the attention of Italians and foreigners for both mythological works and portraits, and consequently he received the commission for the relief of Charles Richard Alsop (cat. no. 40) and created a bust of Abraham Lincoln.[5]

The balance of Fedi's productive career involved filling a wide variety of orders, ranging from ideal pieces such as *La Florentina* of 1872 (Walker Art Gallery, Liverpool, England) to tomb monuments. He produced a monument in 1870 for the agronomist P. Cuppari (Camposanto, Pisa) as well as an academic marble tomb of the poet Giovanni Battista Niccolini, unveiled in Santa Croce in 1883 (fig. 71). Fedi also created civic statues such as the bronze likeness of General Manfredo Fanti, erected in the Piazza San Marco in 1872. One of his last efforts was the imposing colossal group, *Le Furie di Atamante*.

In addition to the rich visual legacy of work spread around Florence and other Italian cities, Fedi left many of his original models to the city of Florence. This meaningful bequest joined the benefactions of

FIG. 71 Pio Fedi, *Niccolini Monument*. Marble. Photograph courtesy of Kunsthistorisches Institut in Florenz. Photograph by Luigi Artini

Bartolini and Luigi Pampolini (q.v.). Like them, Fedi's reputation was such during his lifetime that de Gubernatis, in his *Dictionary of Italian Art*, published in 1889, exclaimed, "The name of Pio Fedi should be carried to the summit of famous artists."[6]

Notes

1. Conforti, "French and Italian Sculpture, 1600–1900" (1985), pp. 251–252, gives a brief discussion of the sculptor, although the birthdate he provides, 1825, is incorrect.
2. Ibid., p. 252.
3. Waters and Hutton 1894, 1:250.
4. Jarves 1869, p. 168.
5. The bust of Abraham Lincoln passed through Sotheby's, New York, on Mar. 15, 1995, lot 69. The nature of its commission is not known.
6. De Gubernatis, *Dizionario* (1889).

Bibliography

"Florentin," *Zeitschrift für bildenden Kunst* (1867), 110–118; Theodosia Trollope, "Notes on the Most Recent Productions of Florentine Sculptors," *Art Journal* (London), n.s., 7 (1861), 210–211; A. R. Willard, *History of Modern Italian Art* (New York, 1898), pp. 117f.; Angelo de Gubernatis, *Dizionario degli artisti vivendi* (Florence, 1889), pp. 196–197; Waters and Hutton 1894, 1:249–250; Thieme-Becker, 11:556–557; Michael Conforti, "French and Italian Sculpture, 1600–1900 [in the Minneapolis Institute of Arts]," *Apollo*, n.s., 117 (Mar. 1985), 231–233

40
Relief Portrait of Charles Richard Alsop

Modeled 1865, carved 1866
Marble
19 × 19 × 2⅝ in. (48.3 × 48.3 × 6.7 cm)
Inscribed on back of relief: *Charles Richard Alsop, / died March 5th, 1865. / Frederick Chauncey to / his Uncle Joseph / December 25th, 1865;* on edge of relief: *Pio Fedi Faceva 1866*

Provenance Joseph W. Alsop Jr., 1866; . . . ; [Larry Weisner, Nyack, N.Y.]; James H. Ricau, Piermont, N.Y.

Exhibition History None known

Literature None known

Versions None known

Gift of James H. Ricau and Museum Purchase, 86.462

As a member of an old, distinguished family from Middletown, Connecticut, Charles Richard Alsop (1802–1865) followed in the tradition of patrician achievement.[1] The son of the prosperous merchant Joseph W. Alsop, Charles was graduated from Yale in 1821. After brief study with a local lawyer, Jonathan Barnes, Alsop moved to New York to pursue the legal profession. In 1832 he returned to Middletown to establish his own practice, and from 1843 to 1846 he served as mayor of Middletown. While in office, Alsop enhanced his own business interests by lobbying for construction of the New York and Boston Railroad, of which he later became president. Although he obtained a charter to establish a railway branch into Middletown, this did little to augment the local economy. Speculation in railroad development, however, provided more financial security than the Alsop family's traditional commercial enterprises.

Alsop's death in 1865 at age sixty-three inspired his brother, Joseph W. Alsop, Jr., to commission a relief of Charles. Joseph was in partnership with Henry Chauncey in their firm, Alsop & Chauncey, which was in New York. Less obvious is why Frederick Chauncey, Charles Alsop's nephew, elected to order the work from Pio Fedi. By 1865 there were numerous accomplished American sculptors working in America who could execute such a commission. Joseph Alsop supported American artists when he ordered a copy of *The Sleeping Children* (private collection) from William Henry Rinehart (q.v.) in 1868.[2] Erastus Dow Palmer (q.v.) and Launt Thompson (q.v.) were conveniently situated in Albany and New York City.

Many American sculptors also had established careers in Italy, including Thomas Ball (1819–1911) in Florence and Margaret Foley (1827–1877) in Rome. Perhaps the publicity and excitement that Fedi's *Rape of Polyxena* (fig. 69) generated in 1865, coupled with the fact that a New Yorker had attempted to secure a replica of it for Central Park, induced young Chauncey to select a foreigner currently in the limelight.

Although the inscription indicates the relief was intended as a Christmas gift in 1865, Fedi's recorded date reveals that it was not completed until the following year. Such delays were common, and given Fedi's involvement with the final stages of *The Rape of Polyxena*, scheduled for unveiling in December 1865, this postponement is understandable.

This posthumous medallion portrait, presumably derived from a photograph, depicts the sitter facing right, wearing a smocklike garment that seems alien to Alsop's stature as a successful businessman. The sensitive handling of the physiognomy and details of dress reflects Lorenzo Bartolini's (1777–1850) legacy of naturalism. Fedi convincingly rendered the facial structure, most notably the sunken temples and the wrinkles and crow's feet at the eyes. Equally veristic is the tousled quality of the thinning hair. The balding pate contrasts with a full walrus mustache and beard, which possess a fine, silky quality that Fedi achieved by making delicate striations in the marble. The smock's illusion of soft, velvety material was achieved with a delicate series of folds bunched at the collar seam. Fedi produced an animated interpretation that belies the fact that the portrait was not made from life.

Chauncey cannot be faulted for choosing Fedi, and the relief compares favorably

FIG. 72 Margaret Foley, *Relief Portrait of William Cullen Bryant*, 1867. Marble, 16⅞ in. (42.9 cm) in diameter. Mead Art Museum, Amherst College, S Ca. 1871.3

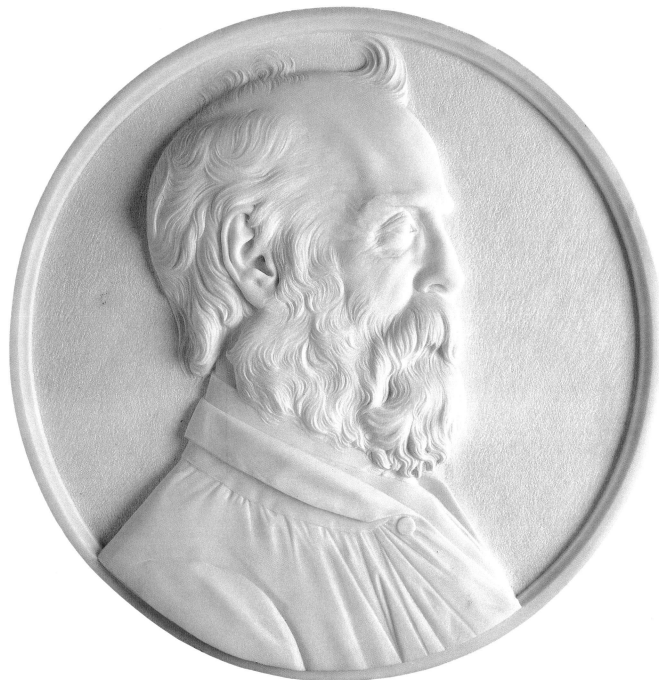

Cat. no. 40 Fedi, *Relief Portrait of Charles Richard Alsop*

with the efforts of his American contemporaries. When related to a medallion by Erastus Dow Palmer, *Edward C. Herrick,* also done in 1865 (YUAG), the Italian portrait satisfies with its degree of naturalism and departs from the Palmer only in the inclusion of garment and a more particular rendering of the hair. The handling of hair in the Herrick portrait is pure Palmer, with the dissolved quality of the locks imparting an inviting silkiness. Fedi and Palmer shared an emphasis on objectivity in their sculptural approach.

A more telling contrast to Fedi's work presents itself with Margaret Foley's portrait of William Cullen Bryant, executed in 1867 (fig. 72).[3] Foley went to Rome in 1860 and excelled in the medallion portrait, an outgrowth of her early training in carving cameos. There are noteworthy elements of her powers of observation in the Bryant profile, especially the vein bulging from the left temple, but most details seem overly refined. The hair and beard are handled in a conflicting configuration of curls, but each is treated in a repetitive, systematic fashion. The facial features and flesh, while detailed, have a crispness and tautness that defy Bryant's true age of seventy-four. Foley was responding to the ideal canons still prevalent in neoclassical Rome. Fedi, with his Florentine orientation, was molded by a concern for naturalism.

Notes

1. For a thorough discussion of the Alsop family, see John Eduard Barry, "The Starrs, Huntingtons, and Alsops of Middletown, Connecticut: A Study in Family and Community, 1650 to 1850" (honors paper, Wesleyan University, Middletown, Conn., 1981).

2. William Henry Rinehart, "Libra Maestro," Mar. 16, 1868, p. 122, Rinehart papers, Peabody Institute, Baltimore, Md., AAA, roll 3116, frame 845.

3. The seminal work on Foley is Eleanor Tufts, "Margaret Foley's Metamorphosis: A Merrimac 'Female Operative' in Neo-Classical Rome," *Arts* 56 (Jan. 1982), 88–95.

Erastus Dow Palmer
American, 1817–1904

Erastus Dow Palmer's conversion to sculpture as a profession had the same element of serendipity as did that of his near contemporary William Wetmore Story (q.v.). Palmer's transformation was far more plausible, however, since he came from a background of carpentry rather than law. Further comparison of these two artists provides revealing insight into their highly divergent paths and heralds Palmer's exceptional achievement as a sculptor. His rural roots and limited formal education constituted a striking, though by no means unusual, contrast to the cosmopolitan and literate upbringing of his urbane counterpart.

Palmer chose to base himself in the comfortable but provincial confines of Albany, New York, rather than gravitate to a major cultural center in America or Europe. Consequently, he brought a homespun aesthetic to his work, which reinforced his disinclination to study abroad. When Hiram Powers (q.v.) was shown daguerreotypes of Palmer's work and told he had never been to Europe, the venerable sculptor replied, "He has no need to come."[1] Palmer's work was predicated on a strong affirmation of nature rather than antiquity, and even his ideal works are more factual than abstract. Despite these seeming limitations, Palmer enjoyed an enormously successful career and earned recognition as one of the most prominent sculptors in the second half of the nineteenth century.

Born in Pompey, New York, Palmer displayed a predisposition to his father's vocation as a carpenter. His formative years were peripatetic, anchored by seven years in Utica, and he experienced more than his share of misfortune. His father died when Erastus was seventeen, and by the age of twenty-three he had lost his first wife and infant son after less than two years of marriage. Bearing this burden of sorrow, in 1840 Palmer returned to Utica from where he had been living near Buffalo. He established himself as a carpenter and pattern maker, a trade that entailed fabricating wooden patterns for industrial molds.

Palmer remarried in 1843 but still had no inclination of his eventual calling. In 1846 he chanced on a cameo portrait and attempted to make one of his wife. Receiving enthusiastic local recognition for his initial effort, Palmer pursued cameo cutting as a profession. He divided the balance of the decade between Utica and Albany with a brief foray to New York City, where he earned favorable notice as

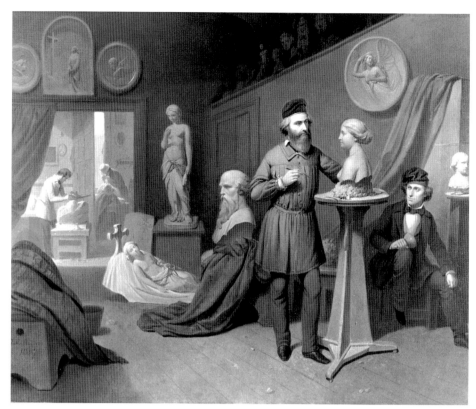

Tompkins H. Matteson, *A Sculptor's Studio* (Erastus Dow Palmer), 1857. Oil on canvas, 29¼ × 36½ in. (74.3 × 92.7 cm). Collection of the Albany Institute of History & Art, Gift of Walter Launt Palmer, 1907.51

a *conchiglia* (shell) artist. This intricate work demanded manual dexterity as well as intense concentration, which caused severe eyestrain that quickly took its toll. As a result, Palmer decided to work on a larger scale. In his new capacity as sculptor, he settled in Albany in 1849.

Within a year he had produced several pieces, culminating in *The Infant Ceres* of 1850 (private collection). Although somewhat tentative in execution, the bust signals Palmer's sensitive handling of the medium of marble and his inclination to use family members as models for narrative subjects, as was the case with the *Bust of the Little Peasant* (cat. no. 41). From the outset, the sculptor concerned himself with the confluence of the general and the specific to make his work immediately graspable.

Palmer resisted the temptation to move to New York and accommodated the enthusiastic demand for commissions in Albany. But he entertained more than parochial aspirations and sent *The Infant Ceres* to the National Academy of Design's exhibition in 1851, where it received favorable notice. Palmer was further encouraged when one of his reliefs, *Morning*, finished in 1850 (AIHA), was acquired by the American Art-Union and distributed as one of its prizes. The public sector also responded to his work, and Palmer

received a commission to create a seal, the *New York State Arms of 1850*. This opportunity may have derailed his intentions of going to Europe.[2] In the wake of this growing reputation, Palmer's career was filled with intense activity, running the gamut from portrait busts and reliefs to full-length ideal pieces.

By the mid-1850s Palmer enjoyed extended press coverage. In March 1855 William James Stillman, a founder of the influential magazine *The Crayon*, reported on his visit to the sculptor's studio and recognized a "new phase of artistic feeling."[3] Consistent with his advocacy of English Pre-Raphaelitism and its close scrutiny of nature, Stillman praised Palmer for emphasizing this approach and eschewing reliance on the antique. Stillman paid considerable attention to the nearly completed *Indian Girl* (or *The Dawn of Christianity;* MMA), which he praised more for the accomplished rendering of detail than for the story. Curiously, Stillman reversed this adulation eight years later in the dogmatic Pre-Raphaelite organ, *The New Path.*[4]

The Indian Girl catapulted Palmer into national prominence. It was the centerpiece of his solo exhibition in 1856 at the Church of the Divine Unity in New York City. The exhibition was so favorably received that a group of prominent

Bostonians negotiated a showing in their city. Taking his cue from the critical acclaim and commercial success of Hiram Powers's *Greek Slave*, Palmer created a life-size work that combined nudity and spiritual fulfillment. The story of the young Indian maiden finding a cross dropped in the woods by a traveling missionary addressed a popular theme—the conversion of the savage yet noble American Indian to the civilizing influences of Christianity. This idea enjoyed widespread contemporary expression, notably in the writings of James Fenimore Cooper and the paintings of Thomas Cole (1801–1848). Moreover, Palmer began his statue soon after Joseph Mozier created his *Pocahontas,* who, although clad, also contemplates a crucifix, suggesting a similar epiphany (cat. no. 29).[5]

Prior to exhibiting in New York, Palmer espoused his aesthetic ideas in an article published in the highly sympathetic *Crayon.* Central to Palmer's thinking was the belief that

[t]he mission of the sculptor's art, is not to imitate forms alone, but through them to reveal the purest and best of our nature. And no work in sculpture, however well wrought out physically, results in excellence, unless it rests upon, and is sustained by the dignity of a moral or intellectual intention.[6]

Palmer harped on the crucial distinction between imitation and representation. Although art had to be based in nature, it must transcend mere copying to achieve a resonant statement. Nature was the springboard, the storehouse, the teacher, but it was the artist's mission to use this nature as a point of departure in the pursuit of beauty, whose force has been "designed as a great moral agent, inexhaustible, and ever present with man, wherever he may have been placed." For a man of limited formal education, Palmer possessed an enviable eloquence and a sensitivity to the transcendentalist thought of Ralph Waldo Emerson and Henry David Thoreau.[7]

The exhibition in New York and Boston confirmed Palmer's growing stature and intensified his productivity. His studio was a beehive of activity, and Henry Tuckerman described its businesslike efficiency in an article of 1856.[8] The author marveled at Palmer's method, order, and activity, commenting that the scene was worthy of the most productive studio in Italy. He described Palmer as wearing a blouse and cap reminiscent of Greenough and Powers, and orchestrating the duties of his assistants while working on original compositions. Tuckerman noted the different stages on which specific assistants were engaged, singling out one

who was finishing a statue of a child. The sculptor's domain was delineated in pictorial form the following year by Tompkins H. Matteson (1813–1884), which provides a partial inventory of completed or nearly completed works.

In spite of the mushrooming demands for private orders, Palmer made an overture to the federal government for a public commission in 1857. The negotiation entailed the design of a pediment group for the House of Representatives wing of the United States Capitol, which Palmer suggested should depict the landing of the Pilgrims at Plymouth in 1620. In one of the few rebuffs of his career, the idea was rejected as too parochial for a national building. This terminated any further dealings between Palmer and the government. Despite this disappointment, 1857 signaled the commencement of Palmer's greatest triumph.

If *The Indian Girl* launched Palmer's national reputation, *The White Captive* (MMA) guaranteed its duration. The sculptor conceived the work to complement his earlier effort. Where *The Indian Girl* demonstrated the effect of Christianity on the so-called savage, the new work addressed the effect of the savage on Christianity. *The White Captive* reveals Palmer's growth as a sculptor. The rendering of the nude figure is more convincing, the details are handled with greater sophistication, and the elements of drama and personal feelings are enhanced. The statue held special appeal since the subject matter was deemed truly American. Along with Frederic Church's (1826–1900) *Heart of the Andes, The White Captive* was heralded as the sensation of the 1859–60 art season.[9] Its purchase by one of New York's leading citizens, Hamilton Fish, affirmed the work's importance.

Riding a crest of popularity and recognition, Palmer settled into producing a steady stream of sculpture. This output included many portraits—both reliefs and busts—of distinguished citizenry, including a posthumous likeness of Washington Irving executed in 1865 (N-YHS). Ideal works reflected a sensitivity to the times, especially the vicissitudes of the Civil War. Palmer completed *Peace in Bondage* with its allegorical message in 1863 (AIHA). *Angel of the Sepulchre,* commissioned for the grave of General Robert Lenox, was unveiled in 1868 in an Albany cemetery.

Palmer demonstrated remarkable shrewdness in using photography as an ally. Those who could not see the sculptor's work firsthand could enjoy it in this new medium. By 1864 it was reported that photographs of the "Palmer Marbles" were in shop windows in Paris, London,

and Berlin as well as in the private galleries and parlors of America.[10] Through photography, Palmer generated an inordinate amount of exposure from his perch in Albany.

Although Palmer is touted as the sculptor who stayed at home, it was not for want of trying to go abroad. An important commission and illness foiled previous attempts, but in 1873 he was not to be denied. The compelling reason for this foreign sojourn was to facilitate work on the statue of Chancellor Robert Livingston, which had been commissioned by the state of New York for the Statuary Hall in the United States Capitol. Although Palmer's travels took him to Italy for four months, he went primarily to see the sights. His goal regarding *Livingston* was Paris, and this destination signaled the shifting balance of power in the world of sculpture. Arriving in Paris in early 1874, Palmer commenced modeling the *Livingston* and completed it in an astonishing fifty-seven days. He oversaw its casting into bronze and left France by late June. The *Livingston* stands as Palmer's crowning achievement; none of his subsequent sculpture equals the vitality and dignity of this work.

Palmer devoted increasing amounts of time to his family in the late 1870s, and by the mid-1880s he had ceased working. Nevertheless, testament to the importance of Palmer's contribution to the field persisted. Invited in 1892 to submit work to the World's Columbian Exposition in Chicago, he declined, declaring himself a holdover from an earlier era who was "quite obsolete."[11] Despite this candid self-assessment, Palmer received many honors, including election as a fellow of the National Sculpture Society in 1896. He was recognized as an important mentor of many younger sculptors, including Launt Thompson (q.v.). Palmer's death in 1904 was as peaceful as his life and, by extension, his sculpture. His obituary nicely intertwined these elements: "'So his life has flowed from its mysterious urn, a sacred stream in whose calm depth the beautiful and the pure are alone mirrored.' His end was peaceful, his passing away being as the sighing of a summer breeze."[12]

Notes

1. Tuckerman 1867, p. 566. For the most recent treatment of Palmer, see Webster 1983.
2. Webster 1983, p. 22.
3. S[tillman], "Sketchings. Editorial Correspondence," *Crayon* 1 (Mar. 1855), 202.
4. A., "Palmer the Sculptor," *New Path* 1 (July 1863), 25–30.
5. Reference to Mozier's full-length appears as early as June 1854; see Florentia 1854, p. 185.

6. Palmer, "Philosophy of the Ideal," *Crayon* 3 (Jan. 1856), 18.

7. Richardson, "Palmer: Craftsman and Sculptor" (1946), 340.

8. [Tuckerman], "The Sculptor of Albany" (1856), 395. Although this article had no byline, it was incorporated into Tuckerman's *Book of the Artists*, published in 1867.

9. Webster 1983, p. 29.

10. Bigelow, "Palmer, the American Sculptor" (1864), 264.

11. Webster 1983, p. 37.

12. Ibid., p. 58.

Bibliography

W[illiam] J[ames] S[tillman], "Sketchings. Editorial Correspondence," *Crayon* 1 (Mar. 1855), 202; Erastus D. Palmer, "The Philosophy of the Ideal," *Crayon* 3 (Jan. 1856), 18–20; "Masters in Art and Literature II: Erastus D. Palmer," *Cosmopolitan Art Journal* 1 (1856), 48–49; *Catalogue of the Collection of Marbles at the Hall Belonging to the Church of Divine Unity, 548 Broadway, New York* (New York, 1856); [Henry T. Tuckerman], "The Sculptor of Albany," *Putnam's Monthly Magazine* 7 (Apr. 1856), 394–400; "Art Items," *Home Journal*, Jan. 24, 1857, p. 3; William J. Stillman, "The Palmer Marbles," *Crayon* 4 (Jan. 1857), 18–19; "The Sculptor Palmer," *Cosmopolitan Art Journal* 2 (Mar.–June 1858), 141–142; Z., "Letter from Albany," *Boston Evening Transcript*, July 9, 1860, p. 1; A., "Palmer the Sculptor," *New Path* 1 (July 1863), 25–30; Jarves 1864, pp. 278–281; L. J. Bigelow, "Palmer, the American Sculptor," *Continental Monthly* 5 (Mar. 1864), 258–264; Tuckerman 1867, pp. 355–369; Clark 1878, pp. 111–112, 117–119; Samuel G. W. Benjamin, "Sculpture in America," *Harper's New Monthly Magazine* 57 (1878–79), 666, 669; Benjamin 1880, pp. 140, 156, 161; Clement and Hutton 1894, 2:161–162; Post 1921, 2:230, 236; Adeline Adams, *The Spirit of American Sculpture* (New York, 1929), pp. 31–32; Taft 1924, pp. 132–141; Charles A. Ingraham, "Erastus Dow Palmer, a Great American Sculptor," *Americana* 24 (1930), 7–21; Gardner 1945, pp. 32–33; Helen Ely Richardson, "Erastus D. Palmer: Craftsman and Sculptor," *New York History* 27 (July 1946), 324–340; Gardner 1965, pp. 16–18; Thorp 1965, pp. 132–133, 144–148; J. Carson Webster, "A Checklist of the Works of Erastus D. Palmer," *Art Bulletin* 49 (June 1967), 143–151; Craven 1984, pp. 158–166; J. Carson Webster, "Erastus D. Palmer: Problems and Possibilities," *American Art Journal* 4 (Nov. 1972), 34–43; Gerdts 1973, pp. 44–45; Webster 1983

41

Bust of *The Little Peasant* or *First Grief*

Modeled ca. 1860, carved 1869
Marble
20 × 12¼ × 7½ in. (50.8 × 31.1 × 19.1 cm)
Inscribed at bottom of right shoulder:
Palmer '69

Provenance [Florentine Craftsmen, New York]; James H. Ricau, Piermont, N.Y., by 1977

Exhibition History *The Ricau Collection*, The Chrysler Museum, Feb. 26–Apr. 23, 1989

Literature "Art Items," *New-York Evening Post*, Oct. 9, 1858, p. 2; "Sketchings. Domestic Art Gossip," *Crayon* 6 (Apr. 1859), 126; "Photographs of Palmer's Marbles," *Home Journal*, Oct. 15, 1859, p. 2; "Sketchings. Domestic Art Gossip," *Crayon* 7 (Jan. 1860), 24; Z., "Letter from Albany," *Boston Evening Transcript*, July 9, 1860, p. 1; Webster 1983, p. 158

Versions MARBLE Pioneer Museum, Colorado Springs, Colo.; Julius Tauss, Glenmont, N.Y.

Gift of James H. Ricau and Museum Purchase, 86.495

THE bust of *The Little Peasant* in the Ricau Collection exemplifies the common sculptural practice of deriving a bust from a full-length work, which rendered it more accessible both physically and financially. Erastus Dow Palmer conceived the full-length subject in 1856 and completed it three years later. From the outset, it was highly praised for its expression and finish.[1] The sculpture was also successful commercially, since it was repeated at least four times, and the Baltimore art patron William T. Walters acquired one (fig. 73). Popular press and influential ownership enhanced the desirability of the bust as well, and at least five of these were ordered.

Palmer gleaned the idea for the sculpture from a family incident—the disappointment of his young daughter at discovering the newborn birds she had been tending had flown their nest. By translating this episode into a sentimental genre piece, the sculptor was in step with the taste of the times. The work's popularity endured, since the sculpture was used to illustrate verses in a children's magazine as late as 1880.[2] Palmer's creative process also exhibited what the poet James Russell Lowell deemed the "gift of second sight . . . transfiguring matter of fact into matter of meaning."[3] The sculptor expressed this idea in his own words when he reminisced:

While it [the sculpture] represents an actual event in the life of one of our children, it was not executed merely to illustrate the event, but rather as an expression of sympathy with that universal sentiment which prompts veneration for anything which once belonged to a beloved but departed object.[4]

Thus, Palmer summarized his remarkable facility to use the readily graspable daily event and make an overarching statement infused with elevating ideas.

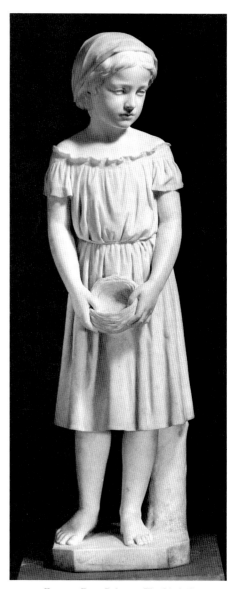

FIG. 73 Erastus Dow Palmer, *The Little Peasant*, carved 1861. Marble, 46¾ in. (118.7 cm) high. Walters Art Gallery, Baltimore

The full-length sculpture depicts a young girl clad in a simple dress with a slight ruffle at the neckline and a kerchief over her hair. She stands, looking off slightly to her left, and holds the empty nest in both hands. Her stance is natural and does not echo a pose borrowed from the antique. Her emotive expression embodies the Victorian era and conveys, through the downturned face, lament which, contrary to recent opinion, is not sufficiently overwrought to deem the work an example of "kitsch."[5] Furthermore, the little girl's mien imparts none of the cloying sentiment or sexual innuendo of the paintings by the eighteenth-century French artist Jean-Baptiste Greuze (1725–1805), whose work enjoyed a renewed interest at this time. The emotion and sense of loss are tempered by the fresh-

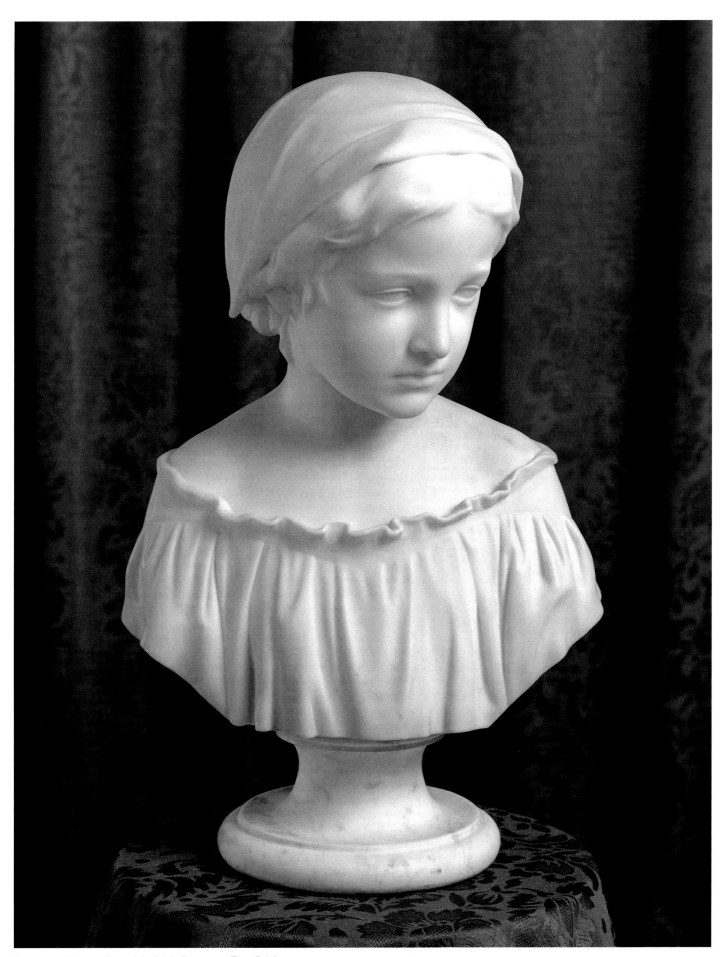

Cat. no. 41 Palmer, *Bust of the Little Peasant* or *First Grief*

ness and directness of Palmer's approach, in which he joined the concrete with the fanciful.

Although the bust does not carry the narrative impact of the full-length work, it admirably conveys the pathos by means of the tilt of the head and sad expression. Palmer's ability to render textures persuasively complements the emotional quality. The strands of the girl's hair are somewhat coarse and generalized, yet the overall effect is convincing. This summary handling reifies Palmer's theoretical ideas, espoused in his article "The Philosophy of the Ideal," where the sculptor devoted considerable attention to the treatment of hair. He denounced the attempt to render individual strands, which he believed produced a wiry effect; rather, he advocated greater reliance on effects of light and dark playing across the surface, which resulted in a more satisfactory softness and harmony.[6] Palmer contended that emphasizing a material's mass made it more palpable and, therefore, more credible. A sense of softness is seen in other elements of the bust: the dress, the kerchief, and the handling of the flesh. The folds and ruffle of the garment are specific without being fussy, and the flesh conveys a softness that defies the nature of the medium. Here, too, Palmer avoided entrapment by the trivial, and his ability to create delicate finishes in his surfaces contributed immeasurably to his reputation as a sensitive interpreter of individuals.

Notes

1. "Sketchings. Domestic Art Gossip," *Crayon* 6 (Apr. 1859), 126.

2. *St. Nicholas: Scribner's Magazine for Boys and Girls* 7 (Mar. 1880), ill. opp. p. 361. For the verses, see R. S. Chilton, "The Little Peasant," *St. Nicholas* 7 (Mar. 1880), 420.

3. Taft 1924, p. 137.

4. From an entry in Palmer's diaries, dated at Leamington, England, June 1, 1873; cited in Webster 1983, p. 158.

5. Maurice Rheims, *Nineteenth-Century Sculpture* (New York, 1977), p. 379.

6. Erastus D. Palmer, "The Philosophy of the Ideal," *Crayon* 3 (Jan. 1856), 19.

Richard Saltonstall Greenough
American, 1819–1904

Even Richard Saltonstall Greenough's most devoted biographer could not permit his subject a place among the major nineteenth-century American sculptors.[1] Nevertheless, the younger brother of Horatio Greenough (1805–1852) occupies an important place in the evolution and nurturing of sculptural taste in America. He embodies the tenacious hold neoclassical aesthetics maintained on numerous sculptors of the period. The strong factual element in Greenough's portraits suggests that naturalism was a significant ingredient. In fact, Greenough's portraits often suffered from his overbearing attention to detail. While he never subscribed to the vital naturalism emerging in the French Beaux-Arts tradition, Greenough's struggle with the opposing forces of ideal and fact reflects the broader reconciling of conflicting tendencies in sculptural expression in play during the second half of the nineteenth century.

Devastating financial reverses to the Greenough family business prevented young Richard from following his four older brothers to Harvard University. After completing his studies at Boston Latin School, he entered the counting-house of his brothers' business as commission merchants and loyally fulfilled his obligations. The appeal of the arts beckoned with increasing intensity, however, and Richard devoted greater parts of his leisure time to modeling and sketching. His brothers, sensing his fervent desire to follow the path of brother Horatio, enabled him to join the latter in Florence in 1837.

Under the guidance of Horatio, Richard immersed himself in the artistic life, visiting museums, drawing from the antique, and spending time in sculptors' studios refining his talents. As had been the case with Horatio, illness forced Richard to cut short his foreign tutelage and return home. After recovering, the determined Greenough, although barely twenty years old, set up a studio in Boston. Commissions were so sparse he rejoined his brothers' firm and supported himself there for five years. Then he received a commission that changed the course of his professional aspirations.

In 1844 the eminent historian William Hickling Prescott, at the request of the Greenough family, asked the struggling sculptor to model his likeness. Richard obliged, and the result was deemed by the sitter to be "a most faithful likeness . . . it augurs well for his success in a profession where mediocrity is not tolerated by

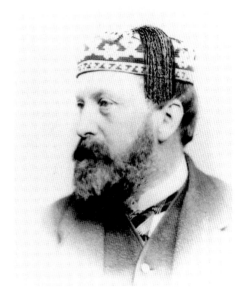

Photograph of Richard Saltonstall Greenough. George Rinhart Collection

gods or men."[2] Only plaster casts were produced, but Prescott's father presented one to the Boston Athenaeum. Its enthusiastic reception paved the way for numerous other commissions, which put Greenough's career on a sound footing. His earliest known work in marble is the posthumous portrait bust of the youthful Augustus Edward May, dated 1846 (BMFA). The serenity of expression as well as the softly modeled features and toga recall the classically inspired examples of Greenough's older brother.[3] But Richard soon revealed his preference for a more contemporary approach, evidenced in *Cornelia Van Rensselaer* (N-YHS). Modeled and cast in plaster in Boston in 1848, it was carved in Rome the following year.[4] The sculpture's animated facial expression and Greenough's obvious delight in simulating delicate materials such as lace reflect the sculptor's shifting approach.

With his confidence and bank book buoyed by the enthusiastic response of Bostonians, Greenough returned to Italy in 1848 and settled in Rome with his bride, rather than join his brother in Florence. Contrary to expectation, he did not succumb to the more stringently classical attitudes of Rome but continued to manifest the growing predilection for the naturalism he had absorbed in Florence. A flourishing portrait trade accommodating increasing numbers of itinerant Americans enabled Greenough to attempt ideal pieces. Some were conventional, such as *Psyche*, which eventually adorned his wife's tomb after her death in 1885 (Protestant Cemetery, Rome). Others bordered on the ludicrous, such as *Cupid Warming an Icicle with His Torch*.

Greenough's first major accomplishment in the ideal genre was his *Shepherd Boy with Eagle,* modeled in Rome in 1853 and exhibited at the Williams' Gallery in Boston in 1855.[5] Enough members of the Boston Athenaeum admired it to raise a subscription to have it cast in bronze at the Ames Foundry in Chicopee, Massachusetts. The subject, reminiscent of Bertel Thorvaldsen's *Ganymede and the Eagle* (cat. no. 1), departs from the austere prototype and chronicles the repercussions suffered by a youth who is attacked while caught robbing an eagle's nest. This readily graspable narrative appealed enormously to Greenough's audience.

During the 1850s Greenough had his greatest professional triumph—the coveted commission in 1855 for a bronze statue of Benjamin Franklin for the front of Boston City Hall. It was unveiled in 1856 to an enthusiastic reception and thoroughly documented in a commemorative book of more than four hundred pages.[6] Determined to avoid the toga-clad fiasco of brother Horatio's *George Washington,* the overseeing committee placed strict emphasis on accuracy. Richard relied on Jean-Antoine Houdon's (1741–1828) bust of Franklin (ca. 1778), on exhibit at the Athenaeum during the 1850s.[7] He also utilized the suit Franklin wore to the signing of the treaty of alliance with France in 1778, which the committee provided. In addition to the statue, Greenough designed two of the four bas-reliefs for the pedestal. The other two were created by Thomas Ball (1819–1911), while the pedestal was designed by Richard's architect-brother Henry (1807–1883). The unqualified success of the *Franklin* commission provided a formidable impetus to Richard Greenough's career.

While *Franklin* was in progress, Greenough received another major commission: a statue of John Winthrop, the first Massachusetts governor, for Mount Auburn Cemetery in Cambridge. Greenough modeled the statue in Paris, where he had moved in 1855. One of the first American sculptors to work in Paris, Greenough adapted little to the sculptural ferment unfolding there in reaction to entrenched neoclassical attitudes. In fact, *John Winthrop* embodies the aesthetic dilemma that Greenough never resolved. In placing utmost emphasis on meticulous details, such as the ruff collar and fur trim, as well as pristine surface, Greenough sacrificed any psychological penetration of character that would have expressed profundity or nobility. This insistent element of superficial artifice informed Greenough's mature style and prevented him from meaningful achievement.

During the next two decades, Greenough worked primarily in Paris. He also established a studio in Newport, Rhode Island, which was fast becoming the fashionable summer resort of America's wealthy elite. These years were marked by a steady output of portrait busts, ranging from society doyennes such as Mrs. R. C. Winthrop, Jr., of 1860 (Society for the Preservation of New England Antiquities, Boston), to eminent figures of intellectual and diplomatic stature, such as John Lothrop Motley, who sat for Greenough in 1861 while on his way to the Austrian court in Vienna (BPL). Whereas Greenough portrayed Mrs. Winthrop in a garment in the spirit of the antique, he opted to portray Motley in a business suit rather than a toga. This rejection of the classical motif prevailed in most of his subsequent portraiture.

Greenough's historical and ideal pieces of this period are not terribly distinguished. *Washington Sheathing His Sword,* modeled and cast in plaster in 1858, is unresolved. The figure is derived from Houdon's, and the horse constitutes an awkward intrusion. The prestige of Greenough's reputation, however, helped the plaster model find its way into the collections of the Louvre. A bronze copy was cast in America for the United States Military Academy Museum in West Point, New York. *The Carthaginian Girl* of 1863 (BA), deriving from the *Venus de Milo* and the increased vitality of Hellenistic sculpture, is more evocative, but any perpetuation of the neoclassical ideal of purity is overshadowed by virtuoso rendering of detail. Greenough continued to vacillate with his dramatically different *Mary Magdalen at the Tomb* of 1866 (Cooper-Hewitt Museum, New York). Not only was the subject matter a radical departure, but stylistically he ventured into a mode of expression associated with the highly charged baroque sculpture of Gianlorenzo Bernini. Dissimilar in spirit was the Civil War memorial, *Alma Mater Crowning Her Heroes,* unveiled in 1870 for his high school, Boston Latin. In this work, dominated by one of his last classically draped figures, Greenough achieved a sense of solemnity and dignity appropriate to the commission.

By 1874 Greenough had returned to Italy, and he divided his time for the balance of his career between Rome and his residence in Newport. He completed his last American commission, a standing version of *John Winthrop* in marble, for the Statuary Hall in the United States Capitol in 1876 and had it cast in bronze four years later for placement in Scollay Square, Boston (now in the yard of the First Church, Boston). Once again,

Greenough emphasized the details of costume and failed to endow his subject with any meaningful interpretation of character. The sculptor's last major work was his *Circe* of 1882 (MMA). Its anecdotal element elicited enthusiastic response, but here, too, the insignificant was permitted to overshadow any formidable presence, and *Circe* pales in comparison with any of William Wetmore Story's (q.v.) comparable heroines.

In the twilight of his career, Greenough continued to attract portrait commissions, but they reflected a perfunctory approach. The death of his wife in 1885 took the edge off his creative inspiration, but ultimately, Richard Greenough was a product of his time. He could never shed the conventional academic approach of his training, and consequently his work had nothing in common with the innovations of Auguste Rodin (1840–1917), Augustus Saint-Gaudens (q.v.), or George Grey Barnard (q.v.).

Notes

1. Brumbaugh, "The Art of Richard Greenough" (1965), p. 77. For the most recent accounts of Greenough, see Brumbaugh, "The Art of Richard Greenough" (1965), and Jan Seidler Ramirez, "Richard Saltonstall Greenough," in BMFA 1986, pp. 102–106.

2. Prescott, Boston, to Horatio Greenough, Mar. 31, 1844, in William H. Prescott, *The Correspondence of William Hickling Prescott* (Cambridge, Mass., 1925), p. 455. Originally cited in Brumbaugh, "The Art of Richard Greenough," p. 62.

3. Jan Seidler Ramirez, *Augustus Edward May,* in BMFA 1986, p. 104.

4. Wayne Craven, *Catalogue of American Portraits in the New-York Historical Society,* 2 vols. (New Haven, Conn., 1974), 2:794–795.

5. Harding 1984, p. 37.

6. Shurtleff, *Memorial of the Inauguration of the Statue of Franklin* (1857).

7. Perkins and Gavin 1980, p. 81.

Bibliography

Lee 1854, 2:227; Greenwood 1854, p. 222; W. J. Stillman, "R. S. Greenough's *Franklin,*" *Crayon* 1 (Mar. 21, 1855), 186–187; "Portrait Sculpture," *Crayon* 2 (Sept. 1855), 165; Nathaniel Shurtleff, *Memorial of the Inauguration of the Statue of Franklin* (Boston, 1857); Stella, "American Artists in Paris," *Home Journal,* May 21, 1859, p. 2; Tuckerman 1867, p. 595; "Art and Artists," *Boston Daily Evening Transcript,* Mar. 3, 1876, p. 6; Truman H. Bartlett, "Civic Monuments in New England," *American Architect and Building News* 9 (June 1881), 201; id., "Sitting Statues, III," *American Architect and Building News* 14 (June 1886), 200; "Richard S. Greenough, a Visit to His Roman Studio," *New York Herald* (Paris ed., Sunday supplement), Dec. 27, 1891, p. 2; Taft 1924, pp. 190–194; Post 1921, 2:254; Thomas B. Brumbaugh, "Horatio and Richard Greenough: A Critical Study with a Catalogue of Their Sculpture" (Ph.D. diss., Ohio State University,

1955); id., "The Art of Richard Greenough," *Old-Time New England* 53 (Jan.–Mar. 1963), 61–78; Craven 1984, pp. 269–274; Gerdts 1973, pp. 72–73, 105, 114–115; Walter Muir Whitehill, "Portrait Busts in the Library of the Boston Athenaeum," *Antiques* 103 (June 1973), 1141–1156; Harding 1984, pp. 36–38; Jan Seidler Ramirez, "Richard Saltonstall Greenough," in BMFA 1986, pp. 102–106

42
Head of a Young Lady

Modeled by 1883, carved 1883
Marble
17¾ × 7⅞ × 7¼ in. (45.1 × 20 × 18.4 cm)
Inscribed on rear edge of bust: *R. S. Greenough Sct.;* on shaft of pedestal: ROMA / 1883

Provenance James H. Ricau, Piermont, N.Y., by 1964

Exhibition History *The Ricau Collection,* The Chrysler Museum, Feb. 26–Apr. 23, 1989

Literature William H. Gerdts, "American Sculpture: The Collection of James H. Ricau," *Antiques* 86 (Sept. 1964), 296, ill., 297

Versions None known

Gift of James H. Ricau and Museum Purchase, 86.469

Portrait and ideal busts formed a significant aspect of a sculptor's market in the nineteenth century, since they were less costly and more manageable than life-size or near-life-size ideal pieces. Many American sculptors working in Italy earned the bulk of their living modeling likenesses of rich Americans passing through Florence and Rome.[1] Before the popularity of photography, sculpted busts and painted and drawn portraits were common additions to the homes of wealthy citizens, and by midcentury the sculpted bust took on added resonance. A glowing white Carrara marble bust denoted travel abroad. Occasionally, the sitter would be portrayed with the attributes of a god or goddess, although this often went counter to a patron's desire for straightforward representation. Typically, the sitter's likeness was modeled in clay and then carved in stone. Richard Greenough's output in this mode is often problematic, however, since it is difficult to ascertain whether he was being specific or ideal in his interpretation.

This bust of a young girl could be real or ideal and shares aspects of his two approaches. On the one hand, it reflects a realistic mode of expression that characterized much of American sculpture being

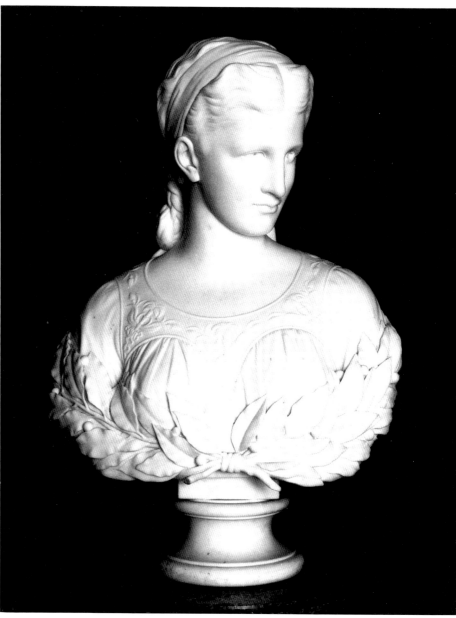

FIG. 74 Richard Saltonstall Greenough, *Idealized Portrait of a Woman*, 1868. Marble, 21⅝ in. (54.9 cm) high. Library of the Boston Athenaeum, U.H. 125.1956

produced by 1875. The incised pupils of the eyes and convincing rendering of the hair typify this more veristic approach. Yet these very elements bear a strong affinity to an ideal head of 1868 in the Boston Athenaeum (fig. 74). The busts share similar facial structures, especially the formation of the nose, the set of the eyes, and the shape of the lips. The more complete Athenaeum bust is clothed in a Renaissance-style garment and emerges from a wreath of laurel leaves. This latter element recalls Hiram Powers's *Proserpine* (cat. no. 6) and Harriet Hosmer's (q.v.) *Daphne* (Washington University, Saint Louis). Greenough would have been aware of Powers's success with this particular bust, and he appreciated Hosmer's output, having, perhaps, emulated her

artistic triumph with his own *Puck.*[2] He had utilized foliage to mitigate the abrupt truncation of a bust as early as 1872.[3]

The Ricau bust, in its severely abbreviated form, is less ambitious than many of Greenough's other known works, but it still carries the hallmarks of his style. In addition to achieving vitality in the deeply chiseled irises and pupils, the sculptor bestowed his subject with a pensive expression that inexplicably borders on the vapid. Flawless features convey the sitter's youth while implying an ideal. Their similarity to those in the Athenaeum head confirms the sculptor's preference for a type. In contrast, Greenough achieved a masterful illusion of soft flesh. He complemented this technical virtuosity with his handling of the ribbon tied on top of the

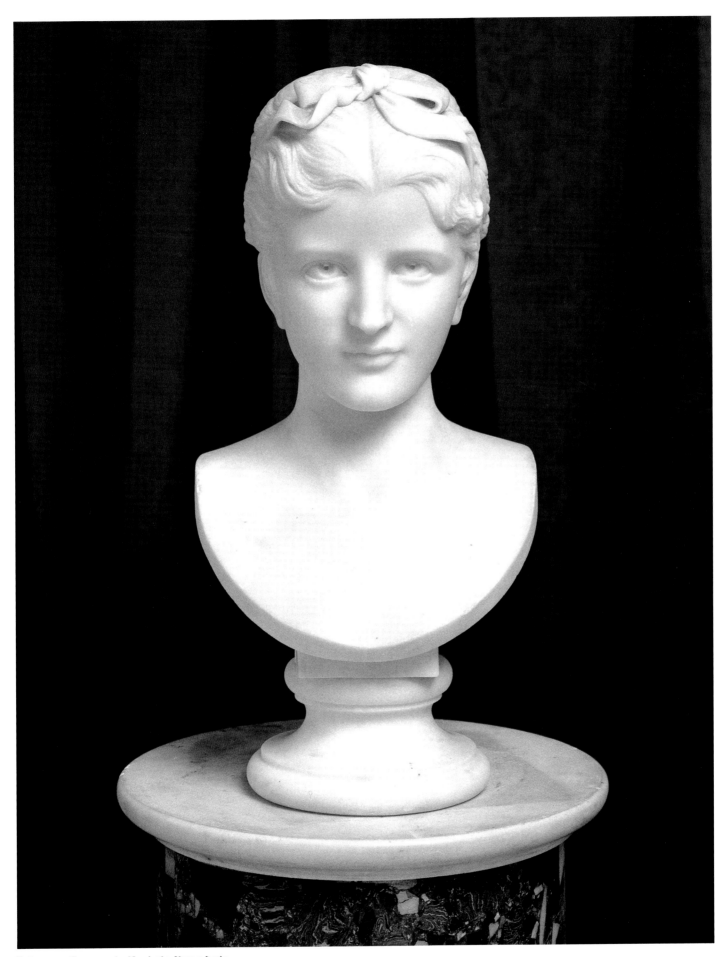

Cat. no. 42 Greenough, *Head of a Young Lady*

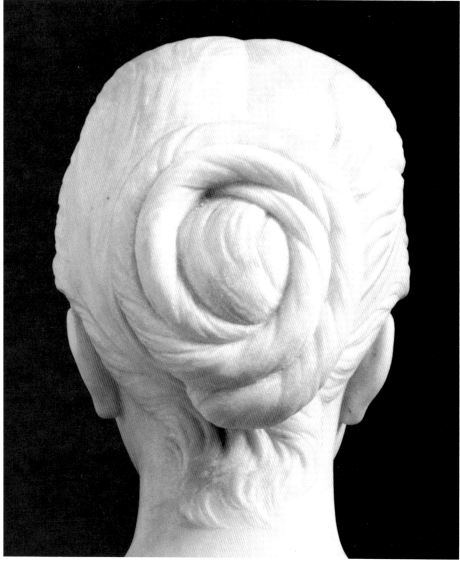

FIG. 75 Greenough, *Head of a Young Lady*, back view

head and the wonderfully complex twist of hair arranged in a concentric coil at the back of the head (fig. 75). The knot of ribbon convinces the viewer of the pliancy of the material, while the hair, including delicate strands that defy control and lie on the nape of the neck, reiterate the sculptor's commitment to detail. Here again, emphasis on minutiae overshadows profound sculptural statement. Greenough was not rigidly monolithic, however. The bust, in its frontal pose, departs from his preferred three-quarters pose, which he contended provided the best view of the human face.[4] With the three-quarters pose, Greenough often tilted the head forward to convey a downward gaze. Thus, there was a literal and figurative infusion of the oblique as well as an element of superiority. This, too, is absent in the Ricau bust. Perhaps the youthfulness and innocence of the subject dictated a more direct approach.

As with much of Greenough's output in this genre, nothing is known about its patronage or the history of its ownership. Even Mr. Ricau could not recall where he found this particular bust, although he was immediately attracted to its sensitive and sensuous handling.[5]

Notes

1. William H. Gerdts, "Celebrities of the Grand Tour: The American Sculptors in Florence and Rome," in Stebbins et al. 1992, pp. 66–93.
2. "Art and Artists," *Boston Daily Evening Transcript*, Mar. 3, 1876, p. 6.
3. A *Portrait Bust of an Unidentified Woman* recently came on the market; see Sotheby's, New York, Sept. 26, 1990, lot 122.
4. "Richard S. Greenough, a Visit to His Roman Studio," *New York Herald* (Paris ed., Sunday supplement), Dec. 27, 1891, p. 2.
5. Interview with James H. Ricau, Piermont, N.Y., June 23, 1991.

43
Relief Portrait of a Young Lady

Modeled by 1883, carved ca. 1883
Marble
19⅝ × 12½ × 7¼ in. (49.9 × 31.8 × 18.4 cm)
No inscription

Provenance James H. Ricau, Piermont, N.Y.

Exhibition History *The Ricau Collection*, The Chrysler Museum, Feb. 26–Apr. 23, 1989

Literature None known

Versions None known

Gift of James H. Ricau and Museum Purchase, 86.470

RELIEF PORTRAIT OF A YOUNG LADY is one of only three reliefs in the Ricau Collection.[1] Relief sculpture had been popular since antiquity for both ideal subject matter and portraits. It also served as a subsidiary decoration on monumental sculpture. The impetus for relief sculpture in the nineteenth century stemmed from Bertel Thorvaldsen (q.v.), whose popular pair, *Night* and *Day* (TMC), recalled such influences as the Parthenon friezes.[2]

Richard Greenough's brother Horatio (1805–1852) could have provided inspiration for *Relief Portrait of a Young Lady* since his *Castor and Pollux* of about 1847 (BMFA) was exemplary in this genre. The Americans William Henry Rinehart (q.v.), Erastus Dow Palmer (q.v.), Launt Thompson (q.v.), and Margaret Foley (1827–1877) were among the most dedicated practitioners of bas-relief. Their allegiance may have grown out of their early training in cameo cutting. Palmer was the best known and most adept at relief sculpture and preferred it for religious or spiritual subject matter. Although bas-relief was not of utmost importance to him, Greenough considered it appropriate for certain ideal themes.[3] He also created two of the bas-relief panels for the pedestal of his statue of Benjamin Franklin.

The unidentified relief depicts the same sitter as in *Head of a Young Lady* by Greenough in the Ricau Collection (cat. no. 42) and was derived from the same plaster model. Greenough reworked the bust by slicing it in half and applying the right side to a plain marble background. It sits crisply on the surface rather than emerging from the marble as was the case with similar works by Greenough's contemporaries and consequently appears in higher relief than others. In remodeling the bust, Greenough made some subtle yet interesting alterations. The hair, which is coiled at the back, is braided rather than

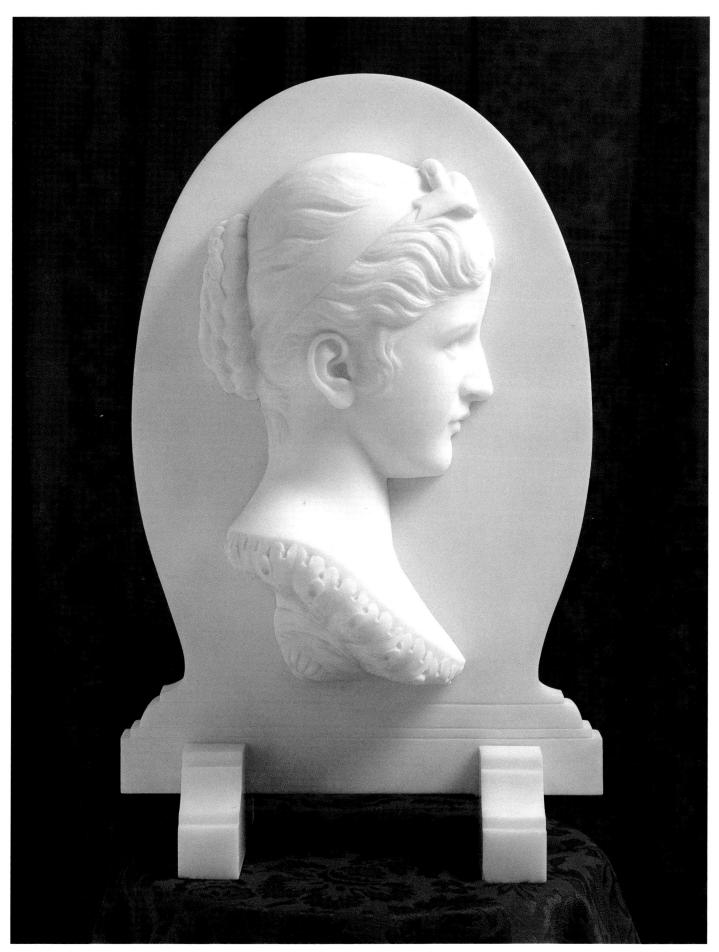

Cat. no. 43 Greenough, *Relief Portrait of a Young Lady*

twisted, which provides a cleaner, more coherent visual statement. Additionally, the unadorned socle and edge of the bust take on a formal prominence in the relief. The sculptor modified the visual austerity by adding an organic decoration that grows from a rosette into a twist of material that in turn produces a profusion of stylized leaves. Consequently, those elements that were secondary in the bust have been accorded greater attention in the relief to enhance the visual impact.

It is difficult to assign identities to most of Greenough's busts. That this particular subject survives in both a full bust and a bas-relief suggests it is most likely an ideal subject. Several possibilities present themselves. In notes from an undated studio visit there are references to *Portia*, *Beatrice*, and *Elaine*.[4] And a visitor to Greenough's studio in 1891 mentioned a bust of Juliet.[5] Any of these personifications of youthful beauty and innocence could apply, but more precise identification remains elusive. As with the bust, little is known about the origins or ownership of this relief and whether it was intended to be paired with the bust.

Notes

1. See Pio Fedi, *Relief Portrait of Charles Richard Alsop* (cat. no. 40) and George Grey Barnard, *Solitude* (cat. no. 66).

2. Gerdts 1973, pp. 60–61.

3. "Richard S. Greenough, a Visit to His Roman Studio," *New York Herald* (Paris ed., Sunday supplement), Dec. 27, 1891, p. 2.

4. Thomas B. Brumbaugh, "Horatio and Richard Greenough: A Critical Study with a Catalogue of Their Sculpture" (Ph.D. diss., Ohio State University, 1955), pp. 257–258.

5. "Richard S. Greenough," *New York Herald* (Paris ed.), Dec. 27, 1891, p. 2.

Photograph of William Wetmore Story. Photograph courtesy of the Archives of American Art, Smithsonian Institution

William Wetmore Story
American, 1819–1895

William Wetmore Story, a rising lawyer of prominence, embarked on his career as a sculptor by chance. Approached in 1845 by the committee convened to erect a memorial to his recently deceased father, Justice Joseph Story, the eminent law professor and associate justice of the Supreme Court, William so impressed the group with his ideas that they awarded him the commission. This affirmation of his ability persuaded Story, an amateur artist, to eschew the law for sculpture. This capacity to change professional gears with such apparent ease is matched only by the difficulty of assessing Story's accomplishments.

Born in Salem, Massachusetts, Story grew up in Cambridge, where his parents were beacons of intellectual and social life.[1] His formal education culminated in undergraduate and law degrees from Harvard University. Story and his fellow Bostonian Horatio Greenough (1805–1852) stand in marked contrast to their sculptural contemporaries. They were the most educated and sophisticated of all the neoclassicists, sharing backgrounds of affluence, impressive family lineage, and college education with a strong foundation in the classics.

After receiving his law degree in 1840, Story entered the prestigious law office of Charles Sumner and George S. Hillard, where he quickly made a name in the realm of contracts and personal-property transfers. This successful path changed course dramatically when Story's father died in 1845. A group of citizens wished to erect a memorial to Justice Story in Mount

Auburn Cemetery and approached his son for recommendations. The committee's decision to seek his counsel was not unwarranted, since Story had garnered admiration as a talented amateur sculptor. While at Harvard, he had often visited Washington Allston's (1779–1843) studio and participated in discussions encompassing a wide range of artistic topics. Allston proved to be a major influence in the importance Story placed on the literary approach to the visual arts. After graduating, Story wrote poetry and literary criticism and amused himself by sketching and modeling in clay. Thus, his creative impulses were as actively engaged as his professional pursuits, and a threshold was crossed when he assumed the responsibility to memorialize his father.

Story moved to Rome in 1847 to educate himself for the task at hand. Ensconced in appropriate lodgings, he began his training in earnest, and by 1853 he presented the committee with a model worthy of approval. His independent means afforded him the luxury of pursuing his objective unencumbered by the necessity of seeking portrait commissions. Story did not shun portraiture completely but undertook a bust only if the subject held interest or meaning for him. Among the select few likenesses he captured were those of his literary friends, Robert (Keats-Shelley Memorial Association, Rome) and Elizabeth Barrett Browning (BA) and James Russell Lowell (Harvard University, Cambridge, Mass.).

Although Story intended the memorial project to be a temporary detour from his legal career, life in Rome changed that. His return to Boston in 1855 to resume his law career was short-lived, since he perceived Boston to be parochial and the law, tedious. Within a year he was back in Rome, and sculpture was his stated profession. For someone to whom everything came so easily, assuming an artistic career brought a rude awakening. Despite his business and social connections, commissions and serious critical appraisal were scarce.

Story sculpted for himself, taking his ideas for ideal subjects from a range of literature including Goethe, the ancient Greeks, Milton, and Shakespeare. Among his early works were *The Arcadian Shepherd Boy* of 1852 (BPL), *Marguerite* (cat. no. 44), *Cleopatra* of 1858 (Los Angeles County Museum of Art), and *The Libyan Sibyl* (MMA). His career received a major boost from Pope Pius IX, who underwrote the costs of sending *Cleopatra* and *The Libyan Sibyl* to the 1862 International Exhibition in London. Shown in the section devoted to contem-

porary Roman artists because his work had been rejected by the American committee, Story's sculptures received their first critical praise. The statues' brooding personalities and passionate, theatrical histories appealed to the public's penchant for the melodramatic. Story also benefited from reflected glory when it was discovered that he and his *Cleopatra* formed the basis for much of Nathaniel Hawthorne's *Marble Faun,* published in 1860.

Story's initial efforts, such as *The Arcadian Shepherd Boy* and *Marguerite,* were tentative and restrained compared to the emboldened and romantically forceful treatments of *Cleopatra* and *The Libyan Sibyl.* As he gained confidence, the sculptor relied less on a stringently classical idiom and let his expressive inclinations take wing. His literary interests established a leitmotif, and his work contains a wealth of detail that amplifies the narrative content. Not until Story addressed heroic subjects taken from exotic literary sources did his sculpture transcend mere narrative and assume an imposing formal presence.

Story attained the height of his creative powers in the 1860s. His output included such potent pieces as *Saul,* begun 1862 and reworked in 1881 (FAMSF), which reflects a logical debt to Michelangelo. He finished *Judith* in 1863 (National Botanic Gardens, Glasnevin, Dublin), *Medea* in 1866 (BMFA), *Delilah* in 1868 (MMA), and *Polyxena* in 1869–70 (The Brooklyn Museum, Brooklyn, N.Y.). As counterpoints to the emotional turbulence of these works, Story created more contemplative subjects such as *Sappho* and *Bacchus* in 1863, and *Venus Anadyomene* in 1864 (all BMFA). Within his commitment to probe the demonic power of women, most forcefully exemplified in *Judith* and *Medea,* Story established a balance between retribution and redemption.[2] These two works explore the profound psychological drama involved in the contemplation of the action rather than the brutal deed itself.

Medea finally brought Story recognition in America. It was exhibited at the new Metropolitan Museum in 1874, won a medal at the Centennial Exposition in Philadelphia two years later, and garnered two orders from American patrons.[3] This encouragement did not allay Story's disenchantment with his native land, however, since it came at the time taste was shifting from the neoclassical restraint of Rome to the more expressive concerns unfolding in Paris.

Although Story resented America's lack of appreciation for his ideal work, he maintained an association with his homeland through portrait commissions on a monumental scale. Since he did not depend on them financially and professed that portraiture did not interest him, Story tolerated them to secure a presence in America. Many of these monuments received mixed reviews. His statue of Edward Everett in 1866 (Public Gardens, Dorchester, Mass.) struck a rhetorical pose and was criticized because it imitated rather than evoked the classical past. Originally intended to adorn the grounds of the State House in Boston, it was relocated, which irritated the artist. Other major and successful monuments included *Josiah Quincy* in 1860 for Harvard University, *Joseph Henry* in 1881 for the Smithsonian Institution, *Chief Justice John Marshall* in 1884 for the United States Supreme Court, and *Francis Scott Key* in the mid-1880s for Golden Gate Park in San Francisco. Story's final and most touching work, *Angel of Grief Weeping over the Dismantled Altar of His Life,* was a memorial to his wife, Emelyn, who died in 1895 and was buried in the Protestant Cemetery in Rome. With her death, the bereaved Story lost his initiative and moved to Florence to live with his daughter Edith. He died at their country villa in Vallambrosa in 1895 at age seventy-six.

Nathaniel Hawthorne, at the outset of Story's career, touched on the vexing problem of evaluating this gifted individual when he referred to his "perplexing variety of talents and accomplishments— he being a poet, a prose writer, a lawyer, a painter, a musician, and a sculptor."[4] Although sculpture was Story's professed vocation, it is impossible to ignore his literary contributions. *Roba di Roma* (1862), *Graffiti d'Italia* (1868), and the two-volume *Conversations in a Studio* (1890) run the gamut from fiction and poetry to discourses on aesthetics and taste. Story's biographer, Henry James, himself an eminent author and perceptive critic, found the task of evaluating Story's activities equally difficult. Was he simply an accomplished and cultivated gentleman who was loath to channel his creative energies and did not realize the full potential of his abilities? The critical acclaim and honors that came to Story both in America and abroad toward the end of his career argue against this. Although twentieth-century assessments have been unkind to him, Story's place as one of the major figures of second-generation neoclassical American sculpture is beyond question.

Notes

1. Jan Seidler (Ramirez) provides the most recent and comprehensive treatment of Story in her Ph.D. dissertation of 1985.
2. Kasson 1990, pp. 205–240, offers the most recent consideration of Story's approach.
3. Jan Seidler Ramirez, *Medea,* in BMFA 1986, pp. 126–127.
4. Hawthorne 1858, p. 71.

Bibliography

Lee 1854, 2:227–228; Greenwood 1854, pp. 221–222; "Portrait Sculpture," *Crayon* 2 (Sept. 1855), 165; Atelier, "Letter from Abroad," *Cosmopolitan Art Journal* 1 (June 1857), 122; Hawthorne 1858, pp. 71–72, 133–134, 171, 198–199, 217, 385, 434–435, 442–443; "Editor's Easy Chair," *Harper's New Monthly Magazine* 27 (June 1863), 133, and (Sept. 1863), 566–567; Jarves 1864, pp. 281–285; Tuckerman 1867, pp. 576–578; Jarves 1869, p. 295; Brewster 1869, p. 196; Osgood 1870, p. 423; "Art Notes and Minor Topics," *Art Journal* (London), n.s., 13, 36 (1874), 225; "Editor's Easy Chair," *Harper's New Monthly Magazine* 49 (Sept. 1874), 587–588; Forney 1876, pp. 115–116; Clark 1878, pp. 81–95; "American Artists and American Art, Pt. V: William Wetmore Story," *Magazine of Art* 2 (1879), 272–276; S. G. W. Benjamin, "Sculpture in America," *Harper's New Monthly Magazine* 58 (Apr. 1879), 688; Benjamin 1880, pp. 152–154; Eugene L. Didier, "American Authors and Artists in Rome," *Lippincott's Magazine of Popular Literature and Science,* n.s., 8 (1884), 491; William Wetmore Story, *Conversations in a Studio,* 2 vols. (Boston, 1890); id., *Excursions in Arts and Letters* (Boston, 1891); Waters and Hutton 1894, 2:277; "Obituary," *New York Times,* Oct. 8, 1895, p. 5; "Obituary," *L'Illustrazione italiana* 61 (Oct. 1895), 230; Mrs. Lew Wallace, "William Wetmore Story: A Memory," *Cosmopolitan Magazine* 21 (Sept. 1896), 464–472; Mary E. Phillips, *Reminiscences of William Wetmore Story, the American Sculptor and Author* (Chicago, 1897); "American Studio Talk," *International Studio* 8 (Aug. 1899), supplement, pp. vi–viii, and (Sept. 1899), supplement, p. ix; James 1903; Carr 1912, p. 336; Stanley W. Braithwaite, "William Wetmore Story, Sculptor-Poet of Salem," *Boston Evening Transcript,* Feb. 12, 1919, n.p.; Edward W. Emerson, "William W. Story," in *Later Years of the Saturday Club,* ed. M. A. de Wolfe Howe (Boston, 1927); Taft 1924, pp. 150–159; Albert Ten Eyck Gardner, "William Story and 'Cleopatra,'" *Metropolitan Museum Bulletin,* n.s., 2 (Dec. 1943), 147–152; Gardner 1945, pp. 33–37; Van Wyck Brooks, *The Dream of Arcadia* (New York, 1958), pp. 101–108, 158–159; Gertrude Reese Hudson, *Browning to His American Friends* (New York, 1965); Thorp 1965, pp. 41–50; Craven 1984, pp. 274–281; Herbert M. Schneller, "An American in Rome: The Experiments of W. W. Story," in *Frontiers of American Culture* (West Lafayette, Ind., 1968), pp. 41–68; William H. Gerdts, "William Wetmore Story," *American Art Journal* 4 (Nov. 1972), 16–33; Gerdts 1973, pp. 76, 82–85, 94, 110, 112, 114; Frank DiFederico and Julia Markus, "The Influence of Robert Browning on the Art of William Wetmore Story," *Browning Institute Studies* 1 (1973), 65–85; Soria 1982, pp. 281–282; Jan Seidler Ramirez,

"William Wetmore Story's *Venus Anadyomene* and *Bacchus:* A Context for Reevaluation," *American Art Journal* 14 (Winter 1982), 32–41; id., "The 'Lovelorn Lady': A New Look at William Wetmore Story's *Sappho,*" *American Art Journal* 15 (Summer 1983), 81–90; Seidler 1985; Vance 1989, 1:145–151 and passim; Kasson 1990, pp. 204–240; Stebbins et al. 1992, pp. 185–184 and passim

44
Marguerite

Modeled ca. 1851–58, carved 1858
Marble
46⅞ × 14½ × 16½ in. (119.1 × 36.8 × 41.9 cm)
Inscribed at rear of base: *W. W. Story. Rome. 1858*

Provenance [Kohn & Kohn Antiques, Philadelphia]; [Schweitzer Gallery, New York]; James H. Ricau, Piermont, N.Y.

Exhibition History *The Ricau Collection,* The Chrysler Museum, Feb. 26–Apr. 23, 1989

Literature Hawthorne 1858, p. 71; Fuller 1859, p. 271; Mary E. Phillips, *Reminiscences of William Wetmore Story, the American Sculptor and Author* (Chicago, 1897), pp. 111, 295; James 1903, 2:258–260; Taft 1924, p. 151; Craven 1984, p. 276; Soria 1982, p. 281; Frank DiFederico and Julia Markus, "The Influence of Robert Browning on the Art of William Wetmore Story," *Browning Institute Studies* 1 (1973), 66–67; Jan Seidler Ramirez, "William Wetmore Story's *Venus Anadyomene* and *Bacchus:* A Context For Reevaluation," *American Art Journal* 14 (Winter 1982), 32; Seidler 1985, 1:518–532, 396–399, 2:411, 448, 451, 558, 719; Kasson 1990, p. 210; William H. Gerdts, "Celebrities of the Grand Tour: The American Sculptors in Florence and Rome," in Stebbins et al. 1992, p. 87

Version MARBLE Essex Institute, Salem, Mass.

Gift of James H. Ricau and Museum Purchase, 86.523

WHEN Nathaniel Hawthorne visited William Wetmore Story's studio in 1858, he immediately recognized a shift in the sculptor's outlook. Upon viewing the finished *Marguerite* and the recently commenced clay of *Cleopatra,* he observed:

He has a beautiful statue, already finished, of Goethe's Margaret, pulling a flower to pieces to discover whether Faust loves her; a very type of virginity and simplicity. The statue of Cleopatra, now only fourteen days advanced in the clay, is as wide a step from the little maidenly Margaret as any artist could take; it is a grand subject, and he is conceiving it with depth and power, and working it out with adequate skill.[1]

This commentary revealed Story's conviction that his smaller, more understated works were not bringing him attention or commissions and that he needed greater scale and boldness of approach.[2]

Goethe's writings remained popular well into the mid-nineteenth century. Story, a literary aficionado, developed an increasing dislike of this author over the years. *Faust,* the source for this sculpture, held his admiration, although he considered the stakes too paltry to tempt the likes of Faust.[3] The narrative deals with a mortal, Faust, who sells his soul to the devil in return for gratification on demand, and Marguerite becomes an unfortunate victim of this by-play. Yet Story was not immune from the great popularity of the play and its potential artistic appeal.

Visitors to exhibitions in America could have seen numerous interpretations of Marguerite. Story, during his brief return to Boston in 1855, would have seen Emanuel Leutze's (1816–1868) painting and possibly that of William Morris Hunt (1824–1879) hanging in the Boston Athenaeum.[4] Hunt's composition, depicting Marguerite in profile plucking a daisy, was legibly reproduced in a view of the "Gallery of Paintings at the Athenaeum," in *Ballou's Pictorial* for March 31, 1855.[5] Hunt's painting constituted a reaffirmation of intent rather than an inspiration, since *Marguerite* ranked among Story's earliest artistic ideas. A drawing of the ill-fated heroine dates from the early 1850s (fig. 76) and offers a foundation for the finished version.

The sculptor chose the moment when Marguerite is in the garden, plucking the petals of a daisy to determine Faust's allegiance. Her association with innocence and purity is reinforced by the crucifix she wears around her neck, signifying a celestial and eternal love rather than the carnal and fleeting variety that will soon entrap her. This paragon of virtue nevertheless succumbs to Faust's charms and bears him an illegitimate child whom she proceeds to drown. She is subsequently imprisoned for this heinous act. True to the spirit of redemption, Marguerite assumes the persona of a penitent spirit that ultimately assures Faust's salvation.

For Goethe and his audience, Marguerite represented a positive force of faith and hope that offset the destructive, negative forces of the evil Mephistopheles. Story, for his part, subscribed to this attitude, which was consistent with the accepted Victorian view of victimized women suffering in silence. This perception was being challenged at midcentury, however. Sir Edward Bulwer-Lytton, in

FIG. 76 William Wetmore Story, *Marguerite,* ca. 1851. Graphite on paper, ca. 8 × 6 in. (20.3 × 15.2 cm). Art Collection, Harry Ransom Center for the Humanities, University of Texas at Austin

his sensational novel *Lucretia,* characterized his heroine as capable of such cruel depravity that he was forced by hostile critical reaction to revise his ending.[6] Story embraced the prevailing view of decorum in describing the contemplative side of Marguerite, while deflecting the visceral forces she possessed. But he quickly realized that the sensational would capture the public's attention, and he charted his future accordingly.

Although a number of years passed between the initial idea recorded in the drawing and the realization in marble, the formal idea remained constant. From the outset, Story depicted Marguerite plucking petals from the daisy. He made his intentions absolutely clear in the drawing by including the German inscription for "He loves me; he loves me not" on the front of the plinth. He eliminated this in the sculpture, however. Story retained the intent, almost reverential gaze Marguerite brings to her task, suggesting that the spiritual aspect of the bond will overcome any physical considerations. It was this pious devotion that struck a resonant chord

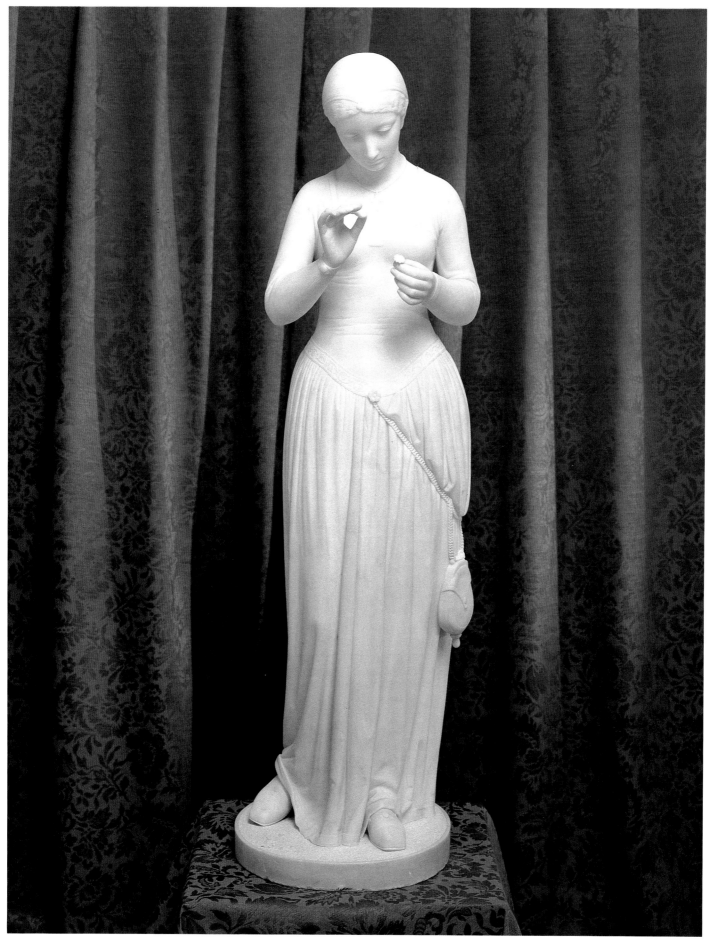

Cat. no. 44 Story, *Marguerite*

with contemporary audiences. Minor alterations included reversing the positioning of the feet. At the same time, Story drastically changed the costume. Instead of the simple peasant dress suggested in the drawing, the sculptor settled on an elaborate robe with lavish accessories. He showed his technical skill in the exquisite handling of the purse and its chain-link strap; the minutely detailed trim of the hem, waist, collar, and cuffs; the excruciatingly tight lacing of the bodice in the back; and the widow's-peak cap and buttoned shoes. A recent assessment of Story suggests he was responding to growing enthusiasm for the historical costume piece and worked diligently to replicate an appropriately medieval German costume.[7] In his quest for historical accuracy, Story allowed a preponderance of fussy detail to overshadow emotional content.

Visually, the sculpture possesses a controlled, almost columnar presence. The only departures from complete stasis are the projecting right foot, which suggests motion, and the visual tension achieved between the smoothly rendered surfaces and the complex details. Marguerite's neutral features and expression, reinforced by her blank eyes, border on the nondescript. The focal point of the work is the delicately rendered gesture of the hands as they ply the petals. By using the hands rather than the face to convey the narrative, Story defused the emotive potential of the work and reduced it to an intellectual exercise. This commitment to restraint is further underscored by the diminutive dimensions of the sculpture, which is only three-quarters life-size. Thus, its physical presence is as modest as its emotional impact. Story, intent on addressing the issue of a timeless, eternal devotion, operated within a purer strain of romantic reticence to achieve the appropriate visual effect.

Notes

1. Hawthorne 1858, p. 71.
2. Seidler 1985, 2:448. Seidler provides an extremely thorough and cogent discussion of *Marguerite*, pp. 318–331, and I am indebted to her for many of the points in this essay.
3. James 1903, 2:260.
4. Seidler 1985, 1:321. The Hunt was in the Athenaeum's 1854 exhibition, lent by a friend and future patron, Martin Brimmer; Perkins and Gavin 1980, p. 83.
5. "The Boston Athenaeum," *Ballou's Pictorial Drawing-Room Companion* 8 (Mar. 31, 1855), 201.
6. Kasson 1990, p. 203.
7. Seidler 1985, 1:324–329.

William Page, *Edward Sheffield Bartholomew.* Graphite on paper, 9¾ × 7½ in. (24.8 × 19.1 cm). Courtesy Wadsworth Atheneum, Hartford, Conn., 1858.6

Edward Sheffield Bartholomew
American, 1822–1858

The life of Edward Sheffield Bartholomew was plagued by misfortune, leaving unknown the full extent of his artistic potential. Bartholomew was just beginning to enjoy widespread recognition and demand for his sculpture when an ulcerated, infected throat overwhelmed his already frail constitution at age thirty-six. His sculpture conformed to the neoclassic tradition, but the extent of Bartholomew's talent, according to a friend, embraced "an intuitive perception of the strongest and most statuesque aspect of a theme."[1]

Bartholomew was born in Colchester, Connecticut, the eldest child of Abial and Sarah Bartholomew. Although his family was not rich, young Edward attended the Bacon Academy in his native town. During this schooling, his interest in fine arts was recognized and encouraged. When he was fifteen, Edward and his family moved to Hartford. The relocation was difficult for the young Bartholomew, who was painfully shy. Moreover, Edward's father disapproved of his son's artistic leanings and had him apprenticed to a bookbinder, an arrangement that was short-lived. Subsequently, Bartholomew was indentured to a dentist, Dr. William S. Crane, an apprenticeship he endured out of filial duty. During this employment, he read Benvenuto Cellini's *Autobiography*, which galvanized his desire to become an artist.[2]

Acting on these intentions, Bartholomew moved to New York about 1844 and enrolled in painting classes at the National Academy of Design while supporting himself with his dental skills. After a year, he returned to Hartford to accept a post at the new Wadsworth Atheneum. Duties ranged from curatorial to janitorial, and the pay was minimal. But any disadvantages were offset by what Bartholomew considered a congenial workplace. With the encouragement and aid of his former instructor, Dr. Crane, Bartholomew set out to educate himself utilizing the modest collection at hand. However, he soon learned he was color-blind. Refusing to abandon his avowed profession, Bartholomew turned to modeling and carving. Lack of proper tools hampered his progress, but James G. Batterson, who was in the marble business, encouraged Bartholomew and supplied him with proper materials for sculpting. Bartholomew's determination soon resulted in a bas-relief of the poet Lydia H. Sigourney (WAHC), whom he greatly admired, and a creditable marble bust of Flora.[3] From the outset, the sculptor sought to balance the real and the ideal.

By December 1847 Bartholomew had returned to New York and settled in the University Building with his friend and fellow townsman, Frederic E. Church (1826–1900) as a neighbor.[4] The purpose of this interlude was to take Dr. Robert Watts's anatomy course at the National Academy of Design. While capitalizing on the resources of the metropolis to improve his abilities as an artist, Bartholomew also fell victim to the hazards of an urban environment. Through neglect, Bartholomew's laundry was exposed to the smallpox virus, and the sculptor contracted the deadly disease. Although he recovered, he was a shell of his former athletic, handsome self and was left lame. Unsuccessful water cures in Vermont and Boston strengthened Bartholomew's determination to go abroad to further his career and improve his health.

Leaving America late in 1850, Bartholomew arrived in Rome in January. By all accounts, he endured a miserable passage that strained his severely weakened constitution. With indomitable resolve, he launched into as full activity as his limited funds permitted. Lack of commissions enabled him to familiarize himself with collections of the antique and improve his technique in bas-relief under the guidance of Giorgio Ferrero. Adequate funds allowed him to spend several months in Greece and the Near East, where he immersed himself in the lure of the classical past. By the spring of 1852 Bartholomew's fortunes began to improve, and, according to various American papers, he did not want for orders.[5] These

accounts also observed that his work was appealing because of its touching subject matter and noble sentiment. Reflecting this assessment is the bas-relief portrait of William George Read in the character of Belisarius, completed in 1853 (Maryland Historical Society, Baltimore). Read, whose bust Bartholomew had sculpted the previous year, and fellow Baltimorean, James McHenry, initiated the extensive patronage that Bartholomew enjoyed from that city. Other supporters included the influential and magnanimous Enoch Pratt as well as the Carroll family, who commissioned him to create a monument to Charles Carroll for the chapel of Doughoregan Manor, near Baltimore. The latter work was shipped from Leghorn in September 1853.[6] Bartholomew subsequently made one of only two return visits to America to oversee its installation.

By the middle of the decade, Bartholomew's Roman studio was alive with activity, and a letter to his friend Church reveals just how busy he was:

I am full of orders and works of all kinds. I am making a number of portrait busts, I counted them a week ago, and there were *ten*, since then I have given up counting them. Ex-president Fillmore is among them and is so much liked that I have got to make seven copies of it for different persons and places. My "Eve" is not yet quite finished, my studio is crowded from morning till night with visitors to see it.[7]

Bartholomew, like all his compatriots, could not avoid the staple of the sculptor's livelihood, the portrait, since it provided the income that permitted him to create more ambitious pieces such as *Eve Repentant* (fig. 77).

Completed by 1855, *Eve Repentant* was universally considered to be Bartholmew's most important work. A visitor to his studio contended it "won for him golden opinions."[8] Nathaniel Hawthorne was less generous and addressed the issue of nudity. He wrote of seeing *Eve*

with her wreath of fig-leaves lying across her poor nudity; comely in some points, but with a frightful volume of thighs and calves. I do not altogether see the necessity of ever sculpturing another nakedness. Man is no longer a naked animal; his clothes are as natural to him as his skin, and sculptors have no more right to undress him than to flay him.[9]

Hawthorne's objections did not jeopardize the fate of the piece, since it had been purchased by a prominent collector from Philadelphia, Joseph Harrison, Jr. Unfortunately, the Harrison version, which is the original, has disappeared, and the statue is known only through the posthumous replica, carved to the order of loyal citizens of Hartford. Nevertheless,

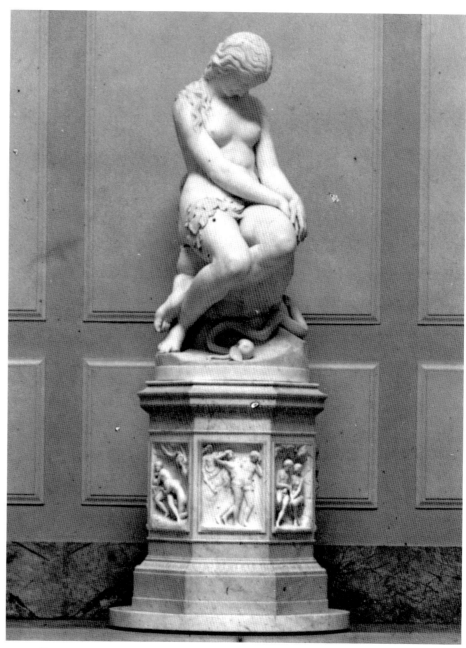

FIG. 77 Edward Sheffield Bartholomew, *Eve Repentant*, ca. 1855. Marble, 53 in. (134.6 cm) high. Courtesy Wadsworth Atheneum, Hartford, Conn., Watkinson Fund

the subject matter of *Eve Repentant* and the sculptor's concern for lofty ideals tempered with meticulous detail reflected the prevailing taste of the day.

In April 1856 Bartholomew gained even greater prominence and exposure when his relief *Hagar and Ishmael* (fig. 78) was reproduced and discussed at length in the influential *Art Journal*. The author admired the pleasing composition, especially the convincing attitudes of mother and child. Conflicting comments focused on overwrought folds of drapery and dismay that no one had bought the piece.[10] Such encomiums and lively demand for his work made Bartholomew's final visit to America in 1857 seem almost like a

triumphal tour. He spent September in Baltimore with his most devoted patron, Enoch Pratt, who had ordered several busts as well as replicas of *The Shepherd Boy* (cat. no. 45) and *Campaspe* (PIBM) as well as his tombstone, which did not require installation until 1896. The pinnacle of satisfaction for Bartholomew was the joint testimonial dinner given in his and Frederic Church's honor in Hartford in November.

When Bartholomew returned to Rome in December 1857, he carried a sheaf of orders and the gratification that he had succeeded against overwhelming odds. Within six months, however, he was dead, unable to withstand the ravages of an

infected throat, and America lost one of its truly promising artists. With a sense of premonition, Bartholomew said not long before he died that he wanted to be buried in the shadow of Virgil in the Protestant Cemetery in Naples. Consistent with his determination, he made the excruciatingly painful journey south from Rome to fulfill this final wish. Bartholmew's demise was keenly felt, and thirty-one of the major figures of the artistic community in Rome signed the resolution lamenting his death.[11] Lydia Sigourney, one of his earliest supporters, honored him with a eulogy in the *Cosmopolitan Art Journal* in March 1860.

Bartholomew left his financial affairs in turmoil, and his early mentor, James G. Batterson, was delegated to straighten them out. He went to Rome in September 1858 and successfully resolved the chaos, providing Bartholomew's widowed mother with a modest settlement of the estate. The citizens of Hartford were forthcoming in honoring their adopted native son. As well as the replica of *Eve Repentant*, they acquired on behalf of the Atheneum the contents of Bartholomew's studio, which included marbles such as *Sappho* and *Diana* and virtually all the plasters.[12]

In addition to the portrait busts, Bartholomew's output centered on ideal subjects based on themes derived from Greek and Roman mythology, the Bible, and various works of history and literature. Next to *Eve Repentant*, his best-

known work was the oversize statue of Washington, ordered by the successful dry-goods merchant Noah Walker, to adorn the niche on the third floor of his Baltimore store. When the building was demolished in the 1890s, the statue was relocated to the entrance of Druid Hill Park.

Bartholomew's conceptions tended to derive from intimate and introspective episodes and disposed him to imbue his work with delicacy and simplicity. Yet the sculpture endures through its probing of immutable sensibilities. Contemporaries recognized the special qualities that empowered this ill-starred sculptor to bring such confidence and sensitivity to his calling. When she visited his studio in 1853, Grace Greenwood observed, "Mr. Bartholomew has poetic sentiment, with taste, strength, and patience—he has a genuine reverence for his art, and a modest estimate of himself."[13] Fourteen years later, Henry Tuckerman, in the earliest biographical treatment of the sculptor, offered an equally perceptive and poignant analysis:

Bartholomew was a manly enthusiast. His early life was struggle with narrow means and uncongenial associations; when he found his vocation, all the earnestness of his nature concentrated thereon. With patient self-devotion, a generous interest in and appreciation of others, and a versatile and constantly enlarging scope and impulse, he possessed all the elements of success and enjoyment as an artist.[14]

Notes

1. Tuckerman, "Two of Our Sculptors, Benjamin Paul Akers and Edward Sheffield Bartholomew" (1866), p. 552. For the most recent account of Bartholomew, see Wendell, "Bartholomew, Sculptor" (1962).
2. Crane, "Bartholomew" (1896), p. 204.
3. Ibid., p. 206.
4. Bartholomew's arrival is referred to in a letter from Church to Aaron C. Goodman, dated Dec. 6, 1847, Archives of Olana State Historic Site, OL.1982.1515.
5. "Americans in Rome," *Boston Transcript*, Apr. 21, 1852, p. 2.
6. "Monument to Charles Carroll," *Boston Daily Evening Transcript*, Sept. 7, 1853, p. 2. The notice indicated that several works by Bartholomew were being shipped at the same time.
7. Bartholomew, Rome, to Frederic E. Church, Mar. 11, 1856, Archives of the Wadsworth Atheneum, Hartford, Conn.
8. Florentia, "Studios, Pt. V," *Art Journal* (London), 1 (1855), 228.
9. Hawthorne 1858, p. 171.
10. "*Hagar and Ishmael*," *Art Journal* (London), Apr. 1856, p. 116 and opp.
11. "Obituary," *Crayon* 5 (July 1858).
12. Wendell, "Bartholomew, Sculptor," pp. 9–10.

13. Greenwood 1854, p. 223.
14. Tuckerman, "Two of Our Sculptors," p. 552.

Bibliography

"Americans in Rome," *Boston Transcript*, Apr. 21, 1852, p. 2; Greenwood 1854, p. 223; "*Hagar and Ishmael*," *Art Journal* (London), Apr. 1856, p. 116; Hawthorne 1858, pp. 170–171; "Obituary," *Crayon* 5 (July 1858), 211; "Edward S. Bartholomew," *Cosmopolitan Art Journal* 2 (Sept. 1858), 184–186; Washington 1860, pp. 515–516; Henry T. Tuckerman, "Two of Our Sculptors, Benjamin Paul Akers and Edward Sheffield Bartholomew," *Hours at Home* 2 (Apr. 1866), 525–552; Tuckerman 1867, pp. 609–612; Clark 1878, pp. 151–152; French 1879, pp. 112–118; Susan Underwood Crane, "Edward Sheffield Bartholomew," *Connecticut Quarterly* (July–Sept. 1896), 202–214; Taft 1924, pp. 194–196; Alexandra Lee Levin, "Enoch Pratt as Patron of Edward S. Bartholomew, Sculptor," *Maryland Historical Magazine* 51 (Dec. 1956), 267–272; William G. Wendell, "Edward Sheffield Bartholomew, Sculptor," *Wadsworth Atheneum Bulletin*, Winter 1962, pp. 1–18; Craven 1984, pp. 319–321; Betsy Fahlman, "Art Displays in New Haven: Edward Sheffield Bartholomew and Yale's Exhibition of 1858," *Journal of the New Haven Colony Historical Society* 58 (Fall 1991), 27–45

45
The Shepherd Boy or *The Campagna Shepherd Boy*

Modeled ca. 1854, carved 1854
Marble
27¼ × 9 × 8⅞ in. (69.2 × 22.9 × 22.5 cm)
Inscribed on back of tree trunk: *E. S. Bartholomew / Rome / 1854*

Provenance [unidentified antique shop, New York]; James H. Ricau, Piermont, N.Y., by 1963

Exhibition History *The Ricau Collection*, The Chrysler Museum, Feb. 26–Apr. 23, 1989

Literature "Personal," *Home Journal*, Aug. 12, 1854, p. 3; "Edward S. Bartholomew," *Cosmopolitan Art Journal* 2 (Sept. 1858), 185; "Sketchings. Domestic Art Gossip. Bartholomew's Works," *Crayon* 6 (Jan. 1859), 27; Henry T. Tuckerman, "Two of Our Sculptors, Benjamin Paul Akers and Edward Sheffield Bartholomew," *Hours at Home* 2 (Apr. 1866), 552; Tuckerman 1867, p. 611; Clark 1878, p. 132; French 1879, p. 117; Waters and Hutton 1894, 1:36; Susan Underwood Crane, "Edward Sheffield Bartholomew," *Connecticut Quarterly* (July–Sept. 1896), 207, ill., 213; Taft 1924, p. 196; William H. Gerdts, "American Sculpture: The Collection of James H. Ricau," *Antiques* 86 (Sept. 1964), 294, ill., 298; Gerdts 1973, p. 82; Seidler 1985, 1:291;

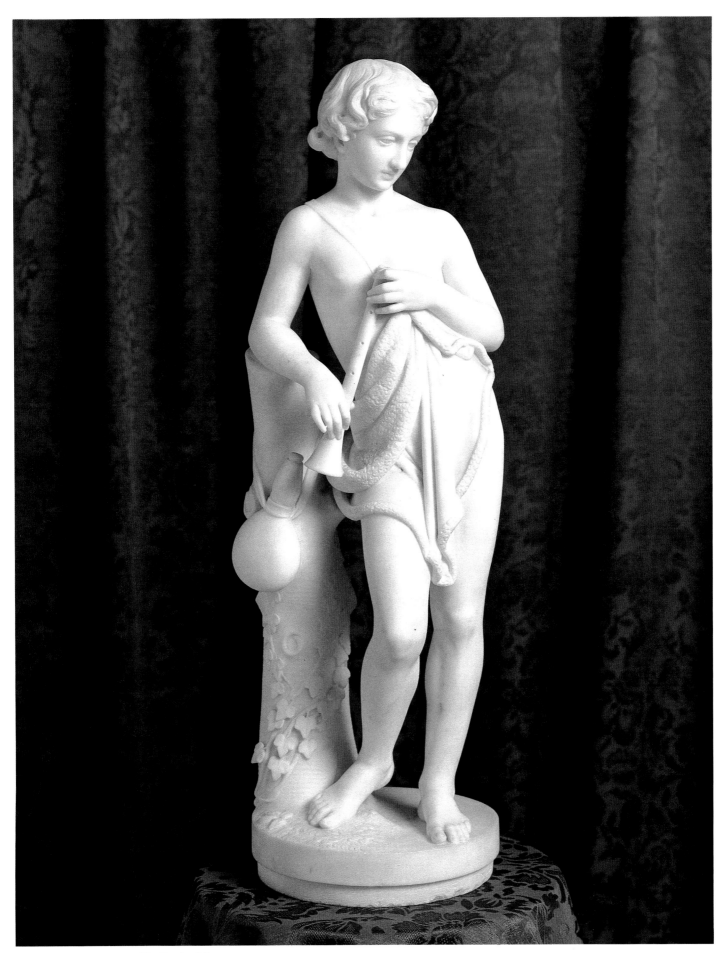

Cat. no. 45 Bartholomew, *The Shepherd Boy*

Headley 1988, pp. 318–319; Vance 1989, 1:320

Versions PLASTER (life-size) Wadsworth Atheneum, Hartford, Conn.; MARBLE (life-size) The Peabody Institute, Baltimore, Md.; The Charleston Museum, Charleston, S.C.; (three-quarter version) Malden Public Library, Malden, Mass.

Gift of James H. Ricau and Museum Purchase, 86.460

Edward Bartholomew's *Shepherd Boy* is a subject with origins in antiquity that sustained visual interest through the ages. The theme's universal appeal lay in its quest to evoke a Golden Age inextricably connected with the classical world. Even the youthful American Republic sought a state of innocence to combat growing urbanization and industrialization. For Americans living in Rome, such awareness was even more acute, as they moved from urban ugliness to an Arcadian charm of the outlying Campagna. This countryside, with its picturesque ruins and peasants, had been depicted by numerous American artists and had met with enthusiastic response.[1] Even the casual tourist could not escape its allure, as Grace Greenwood recounted:

I sometimes see in the streets a *contadina* from Albano, in a brilliant dress of red and white; or out on the Campagna a shepherd boy, clad in a regular John the Baptist kilt of sheepskin, who really look as though they had just stepped out of a picture.[2]

Sculptors, too, felt compelled to capture this paradigm of carefree innocence in the guise of the Arcadian shepherd.

Evocation of this pastoral idyll captivated several American sculptors at midcentury, and William Wetmore Story (q.v.) was among the earliest to address the theme.[3] In 1850 he commenced his subject, shown seated and playing pipes, but interruptions prevented him from completing the model until 1853. Translated into marble in 1855, it was purchased by subscription for the Boston Public Library, where it resides in the Art Reference Reading Room (fig. 79). Grace Greenwood commented on the model when she visited Story's studio and suggested the sculptor had been inspired by the works of the Elizabethan poet Edmund Spenser.[4] Unquestionably, Story's far-reaching knowledge of bucolic literature, in conjunction with his profound infatuation with Italy, accounted for the form of his first ideal subject.

Greenwood also saw a shepherd in Richard Greenough's (q.v.) studio, but this particular lad was fending off an

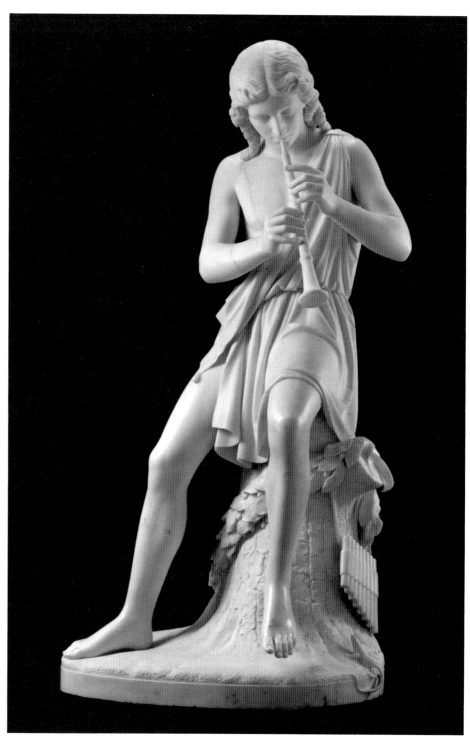

FIG. 79 William Wetmore Story, *The Arcadian Shepherd Boy*, ca. 1855. Marble, 58 in. (147.3 cm) high. Courtesy of the Trustees of the Public Library of the City of Boston. Photograph courtesy, Museum of Fine Arts, Boston

eagle who had caught him robbing his nest (BA). Shepherds abounded in other studios, although Greenwood made no mention of *The Shepherd Boy* when she stopped at Bartholomew's during her rounds. She alluded to a pair of ideal figures that were not far enough along to warrant comment, a monumental group of unspecified subject, a *Homer*, and his acclaimed bas-reliefs. Ostensibly,

Bartholomew's *Shepherd Boy* was in embryonic form at the time of Greenwood's visit, but it quickly took shape, since the *Home Journal* reported in August 1854 that the sculptor had finished a life-size copy in Carrara marble for Enoch Pratt, as well as a reduced version, which he intended to take to America.[5]

While Bartholomew did not have the range of education of a Story or a

Greenough, he experienced the lure of Italy and the classical world as keenly as they did. His study of collections in Rome and his travels through Greece and the Near East had a profound impact on his aesthetic vision, and he aspired to apply his formal vocabulary to the appropriate subject matter. Thus, like his kindred spirits Story and Greenough, Bartholomew recognized at the outset of his career the merit in selecting the shepherd for an ideal piece. Recent sources of inspiration blending the pastoral with the musical were available to any newcomer in Rome: Bertel Thorvaldsen's (q.v.) *Shepherd Boy* of 1817 (TMC) and Pietro Tenerani's (1798–1870) *Faun Playing a Flute* of 1823 (Museum of Rome at the Palazzo Braschi).

Whatever the impetus for *The Shepherd Boy*, Bartholomew captured the essence of his subject and received glowing praise for this early effort. The editor of the *Home Journal* reprinted a notice from a daily newspaper that offered a detailed description and evaluation of the work:

It represents a shepherd boy, draped in sheepskin, in the freshness and innocence of puerile and rustic simplicity, holding his pipe, with a downward look and thoughtful expression, apparently giving play to some pleasant bewitching fancy, which seems to have interrupted his playing. He leans against a trunk of a tree, entwined with ivy and on which hangs the kind of bottle used by the peasants of the Campagna, which is made of a gourd flattened by pressure while growing. The whole attitude, expression and lineaments are perfectly life-like and delightfully pleasing, and bear the imagination of the beholder to the mountainside, where the bleating of flocks mingles with the songs of birds, pastoral music and the babbling of streams beneath that sky which is without equal on earth.[6]

The author projected a sense of the contemplative restraint about the piece, and in the interpretation of capitulation to a "bewitching fancy" suggested a mood of melancholy or wistfulness. Thus, this elegiac quality spoke to the broader idea of the passing of happier times.

Although this review established a sylvan setting replete with sounds to give full sensory range to the contemplation of the sculpture, Bartholomew chose not to depict the shepherd performing. Thus, he skirted the issue of trying to convey a sense of sound in a silent medium, which was addressed by Tenerani and Story. Bartholomew opted for the contemplative rather than the active and through this caesura reinforced the silence that enhanced the poignant mood.

Formally, *The Shepherd Boy* identifies the central canon of Bartholomew's work with its reliance on Hellenistic sculpture. The attenuated hip-shot pose and miraculous translation of marble into unmuscled torso and limbs recall the work of Praxiteles, who had such a profound impact on Thorvaldsen and his followers. Although Praxiteles' *Hermes with the Infant Dionysos* was not excavated until 1877, it was known through Roman copies and engravings. Bartholomew also could have availed himself of the Roman copy after the early Hellenistic sculptor's *Apollo Sauroktonos* in the Vatican Museums.

Bartholomew placed a premium on smooth, delicate contours, flowing transitions, and consistency of surface, which culminated in a gentle and muted visual experience. This understatement, commingled with a nascent technical virtuosity, continued the prevailing neo-Hellenism adapted from Greco-Roman styles in American sculpture, which was soon to be supplanted by a more vigorous emphasis on naturalism.[7] Bartholomew felt strongly about this figure, since he created several copies in various sizes, as well as at least one bust of the shepherd boy (WAHC).[8] When the press noted the shipment of Enoch Pratt's version, they also mentioned the reduced version the sculptor intended to bring with him when he came to America. Soon after Bartholomew's death, the *Crayon* ran a notice of unsold works available in the sculptor's studio. Among these were a *Shepherd Boy* with revolving pedestal for $850 and a reduced version for $600.[9] Presumably, the large version, measuring 55 inches high (like the Pratt version), was the one acquired by Governor Aiken of South Carolina and is now in the Aiken-Rhett House in Charleston.[10] The reduced copy is most likely the 40-inch replica owned by the Malden Public Library in Massachusetts. It was originally purchased by Christopher R. Robert of New York and presented to the library by his daughter, Mrs. Ephraim L. Corning.[11] Whether the half-size version in the Ricau Collection is the one Bartholomew took with him on his first return visit to America is impossible to determine. Nothing is known of its history except that Ricau found it in an antique shop in New York City in the early 1960s.[12]

Notes

1. See John W. Coffey, *Twilight of Arcadia: American Landscape Painters in Rome, 1830–1880*, exh. cat., Bowdoin College Museum of Art (Brunswick, Maine, 1987), and, more recently, Stebbins et al. 1992.
2. Greenwood 1854, p. 174.
3. Seidler 1985, 1:286–294.
4. Greenwood 1854, p. 222. Seidler 1985, 1:287–288, develops this idea nicely.
5. "Personal," *Home Journal*, Aug. 12, 1854, p. 3.
6. Ibid.
7. Seidler 1985, 1:292–293.
8. Unless there is at least one more unlocated version, this may be the bust that was exhibited in Troy, N.Y., in 1862; *Catalogue of the Fifth Annual Art Exhibition of the Troy Young Men's Association at Their Gallery in the Atheneum, Troy, N.Y.* (Troy, N.Y., 1862), p. 8, no. 2.
9. "Sketchings. Domestic Art Gossip. Bartholomew's Works," *Crayon* 6 (Jan. 1859), 27.
10. Tuckerman 1867, p. 611, makes the first known published reference to Governor Aiken's ownership.
11. Letter to the author from Dina G. Malgeri, librarian, Malden Public Library, June 19, 1991. I am grateful to Ms. Malgeri for her assistance in this matter.
12. Letter to the author from James H. Ricau, June 12, 1990.

Peter Stephenson
American, 1823–1861

Although recognized during his lifetime as a prolific cameo cutter and carver of portrait busts and ideal pieces, Peter Stephenson is hardly known today. His sculptures are even more elusive, though his acclaimed masterpiece, *The Wounded Indian* (cat. no. 46), provides the most compelling insight into his craft. Stephenson died in the prime of his career at age thirty-seven after becoming deranged and confined to an insane asylum.[1] The author of the sculptor's obituary notice speculated that in his enthusiasm for his art, Stephenson may have applied himself too relentlessly. Stephenson made enough of an impression that Samuel G. W. Benjamin, an influential chronicler of American art in the latter part of the nineteenth century, wrote nearly twenty years after Stephenson's death that he was "an artist who died too early to achieve a national reputation, although not too soon to be esteemed by his fellow-artists for his abilities."[2]

According to his own account, Peter Stephenson was born in Yorkshire, England, on August 19, 1823, and moved with his family to Wayne County, New York, at age four.[3] He began drawing as a child on the large, flat stones surrounding the family's well. By age seven he was carving miniature ships with a jackknife, much to the delight of the local populace. In 1834 the Stephensons moved to Michigan, where social life was dominated by contact with local Indian tribes. Peter was very gregarious and recalled that the experience provided him with "the best opportunity for studying their characters, countenances, and peculiarities."[4]

Stephenson's father died in 1835, and Peter went to Buffalo, New York, the following year to apprentice in his brother's store as a watchmaker. He concentrated on this craft until his career plans shifted in 1839, when he began cutting cameos. Subsequently, he cut a bust in Vermont marble without any guidance from existing examples. Enjoying commercial success with his cameos, Stephenson decided to give up watchmaking and move to Boston in 1843. His overriding goal was to earn enough money to go to Rome and steep himself in the classical past.

In January 1844 Stephenson advertised himself as a cutter of cameos, claiming all likenesses were "warranted" or no charge would be made.[5] The critic for the *Boston Transcript* found Stephenson's work inferior in delicacy and finish to that of the established John Crookshank King (1806–1882) but predicted a bright future for the young man.[6] Stephenson applied himself assiduously and by November 1844 had saved enough money to apply for a passport and go abroad.[7] Stephenson arrived in Rome around March 1845 and spent about nineteen months there. He drew from nature and the antique, pursuing his studies until his funds were exhausted. He returned to Boston in the fall of 1846 and exhibited two works at the Boston Athenaeum taken from antique subjects.[8]

Nothing specific is known of Stephenson's activities until 1848, when he began work on *The Wounded Indian*. He is mentioned as instructing Harriet Hosmer (q.v.) from the fall of 1849 until the spring of 1850, when she went to St. Louis.[9] While the completion and exhibition of *The Wounded Indian* occupied him for much of 1850 and 1851, Stephenson addressed the practical side of his career and developed a clientele for portraits. The *Boston Transcript* carried notices of his completed portrait busts and referred to him as a "promising artist," whose work is "full of genius" and possesses "rare beauty and excellence."[10] Stephenson also participated in causes embraced by the artistic community and signed an open letter condemning funding for the proposed Washington Monument in the nation's capital, which the correspondents found highly objectionable.[11] The majority of signers were architects and painters. The sculptors consisted of Stephenson's older rivals John C. King and Richard S. Greenough (q.v.).

Stephenson's career gathered momentum, and the success of *The Wounded Indian* in Boston and London brought the sculptor substantial recognition. By late 1852 he had opened to a favorable reception his Gallery of Bronze and Marble Statuary in Boston's prestigious Amory Hall. He could savor spreading fame, for he received a commission for a large funerary monument to Captain Sheldon Thompson of Buffalo, New York.[12] But his crowning accomplishment may have come with the highly complimentary notice he received for his bust of Daniel Webster. Stephenson happened to share a railway carriage with the eminent statesman shortly before Webster's death. While talking with him, he carefully studied Webster's features. Unlike other interpreters, in sculpting Webster's likeness Stephenson avoided straining for effect—especially the exaggeration of Webster's prodigious forehead. One critic praised the result as "the most truthful and beautiful likeness ever presented to the world."[13]

In January 1853 Hannah Lee asked Stephenson to submit a memorandum of his career for her book on contemporary sculptors. He obliged and concluded by estimating he had cut between six and seven hundred cameo likenesses and about two thousand fancy designs, as well as several busts and statues. This constituted the only systematic account of Stephenson's life. The final eight years of his career reveal themselves only through sporadic references in the press and exhibition records.

Not surprisingly, Stephenson sent his most ambitious pieces to public exhibition. In April 1853 he exhibited a major ideal piece, *Una and the Lion*, a subject taken from Edmund Spenser's *Faerie Queen*, at the Massachusetts Academy of Fine Arts in Boston.[14] Nevertheless, *The Wounded Indian* was his signature piece and became a staple of the Boston Athenaeum from 1852 to 1856, when it was acquired by the Boston Mercantile Library. Stephenson also exhibited a cast of this work at the Washington, D.C., Art Association in 1857, thus broadening his exposure to the nation's capital.[15] Indian themes held a special appeal for Stephenson, who created reliefs entitled *Pocahontas, Indian Hunting Buffalo,* and *The Indian Bride,* which were exhibited at the Boston Athenaeum.[16] Undoubtedly, the sculptor's early years in Michigan had a profound impact on his choice of subject matter. While these grander conceits constituted his primary goal, Stephenson garnered considerable recognition with his portraiture and won medals in Massachusetts and Maryland.[17]

Newspaper notices occasionally identified some of Stephenson's sitters. In addition to Daniel Webster, Stephenson crafted a statuette of L. A. Jullien (1812–1860), the esteemed music director; a relief monument to John Howard Payne (1791–1852), author of *Home Sweet Home;* and busts of General Joseph Warren (1741–1775) and Rufus Choate (1799–1851).[18] Based on the few known examples of his portraiture, such as *Lucius Manilus Sargent* of 1853 (fig. 80), Stephenson embraced ancient Roman standards and recorded his sitters with a sensitive yet unflinching realism. No wrinkle or scar was too insignificant, and yet a quiet and enduring sense of dignity augmented the fidelity to appearance.[19] Stephenson proved himself an accomplished carver and struck a resonant balance between the immediate and the lofty.

Despite his evident talent, the sculptor was acutely aware of the obstacles confronting his profession. In his memorandum to Hannah Lee, he referred to a commission for an ideal piece at a fee that "would discourage a stonecutter." He did not complain but underscored his deter-

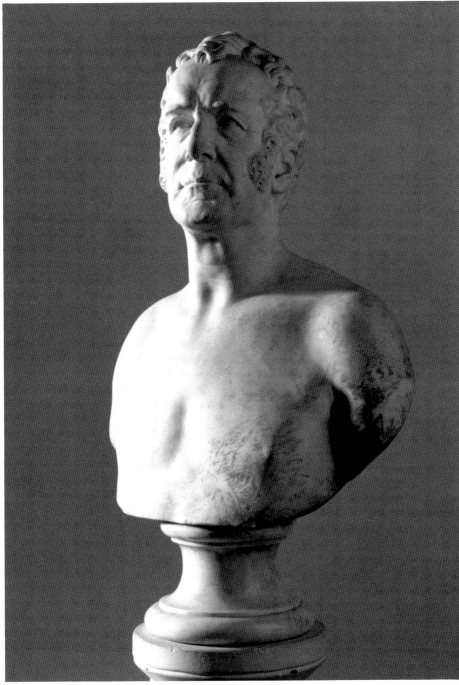

FIG. 80 Peter Stephenson, *Lucius Manlius Sargent*, 1853. Marble, 26⅜ in. (67 cm) high. Library of the Boston Athenaeum, Gift of the Sargent-Murray-Gilman House Association, Gloucester, before 1940, U.H. 118.1978

mination to succeed through hard work. It was hard work that contributed to his premature demise, since he was doing all the cutting and carving of marble himself. Little is known about Stephenson the man, although various eulogies referred to him as a caring and amiable individual.

After his death in Boston, Stephenson's widow moved to Buffalo, where she tried to keep her late husband's work before the public eye until at least 1875 by lending it to the annual exhibitions at the Buffalo

Fine Arts Academy.[20] These efforts were in vain, and Stephenson slipped into oblivion only to be partially resuscitated in the mid-1960s by the rediscovery of his masterpiece, *The Wounded Indian*.

Notes

1. This intelligence was reported in the *Boston Transcript*, Jan. 21, 1861, p. 2, two days after Stephenson died. This biography provides the first attempt at a sustained account of the sculptor.

2. Benjamin 1880, p. 156.

3. "Cameo-Cutting," *Boston Transcript*, Jan. 23, 1844, p. 2.

4. Lee 1854, 2:192.

5. *Boston Transcript*, Jan. 1, 1844, p. 3.

6. "Cameo-Cutting," *Boston Transcript*, Jan. 23, 1844, p. 2.

7. Passport number 2680 was issued to Stephenson on Nov. 28, 1844, at the request of W. A. Wellman of Boston. The passport provides a brief description of the sculptor at age twenty-one: he was five feet nine inches tall with brown hair, blue eyes, and a light complexion. He had a low forehead, long face and chin, short nose, and a large mouth. Passport applications, 1795–1905, *National Archives Microfilm Publication M 1372*, roll 15, General Records of the Department of State, records group 59; National Archives, Washington, D.C. I am grateful to Col. Merl Moore, Jr., for this information.

8. Perkins and Gavin 1980, p. 132.

9. Benjamin 1880, pp. 165–166.

10. *Boston Transcript*, July 25, 1850, p. 2, and Nov. 1, 1850, p. 2.

11. "The Washington Monument," *Boston Evening Transcript*, Feb. 26, 1850, p. 2.

12. *Boston Transcript*, Nov. 20, 1852, p. 2; "Thompson's Monument," *Gleason's Pictorial Drawing-Room Companion*, Sept. 4, 1852, p. 176.

13. L., "Busts of Webster," *Boston Evening Transcript*, Jan. 12, 1853, p. 1.

14. "Massachusetts Academy of Fine Arts," *Boston Evening Transcript*, Apr. 12, 1853, p. 2.

15. *Catalogue of the Works of Art Comprising the First Annual Exhibition of the Washington Art Association* (Washington, D.C., 1856 [*sic*]), p. 10. He also exhibited a relief, *The Descent of Pandora*, there in subsequent years.

16. Perkins and Gavin 1980, p. 132. *The Indian Bride* was shown posthumously in 1866 and 1867 and listed as owned by a Miss Bryant.

17. He was awarded a silver medal for portrait busts at the eighth exhibition of the Massachusetts Charitable Mechanics Association in 1856 and the same award for the same category at the Maryland Institute of Art in 1859; "Mass. Charitable Mechanics Association Eighth Exhibition—Premiums," *Boston Transcript*, Oct. 15, 1856, p. 1; "Awards to Boston Exhibitors," *Boston Transcript*, Nov. 17, 1859, p. 4.

18. "The Fine Arts," *Boston Evening Transcript*, June 30, 1854, p. 2; "Art Items," *Cosmopolitan Art Journal* 2 (Sept. 1855), 208; S., "Bust of General Warren," *Boston Transcript*, Oct. 14, 1858, p. 2; *Boston Transcript*, Aug. 6, 1859, p. 2.

19. For examples of Stephenson's portraiture, in addition to his bust of Lucius Manlius Sargent in the Boston Athenaeum, see the bust of an unidentified gentleman sold at Christie's East, New York, Nov. 14, 1991, lot 240.

20. Yarnall and Gerdts 1986, 5:3382–3384.

Bibliography

"Cameo-Cutting," *Boston Transcript*, Jan. 1, 1844, p. 3; "Cameo-Cutting," *Boston Transcript*, Jan. 23, 1844, p. 2; "The Washington Monument," *Boston Evening Transcript*, Feb. 26, 1850, p. 2; "Statuary," *Boston Transcript*, July 25, 1850, p. 2; "Old Paintings, Exhibition at the Athenaeum,"

Boston Transcript, Nov. 1, 1850, p. 2; "Thompson's Monument," *Gleason's Pictorial Drawing-Room Companion*, Sept. 4, 1852, p. 176; "Mr. Stephenson's Sculpture Gallery at Amory Hall," *Boston Transcript*, Nov. 20, 1852, p. 2; "Massachusetts Academy of Fine Arts," *Boston Daily Evening Transcript*, Apr. 12, 1853, p. 2; "The Mechanics' Exhibition," *Boston Daily Evening Transcript*, Sept. 15, 1853, p. 2; Lee 1854, 2:191–194; "The Fine Arts," *Boston Transcript*, June 30, 1854, p. 2; "Art Notes," *Cosmopolitan Art Journal* 2 (Sept. 1855), 208; "Sketchings. Domestic Art Gossip," *Crayon* 3 (July 1856), 221; "A Visit to the Mechanics' Fair," *Boston Transcript*, Sept. 19, 1856, p. 1; "Massachusetts Charitable Mechanic Association. Eighth Exhibition—Premiums," *Boston Transcript*, Oct. 15, 1856, p. 1; "Mere Mention. Artists in the East," *Home Journal*, Jan. 3, 1857, p. 3; "Fine Paintings," *Boston Transcript*, May 26, 1857, p. 2; "Art Intelligence," *Boston Evening Transcript*, Apr. 26, 1858, p. 2; "Sculpture," *Boston Transcript*, June 10, 1858, p. 2; S., "Bust of General Warren," *Boston Transcript*, Oct. 14, 1858, p. 2; "Awards to Boston Exhibitors," *Boston Transcript*, Nov. 17, 1859, p. 4; "Deaths," *Boston Transcript*, Jan. 21, 1861, p. 3; R., "Stephenson, the Sculptor," *Boston Transcript*, Feb. 25, 1861, p. 2; Gertrude S. Cole, "Some American Cameo Portraitists," *Antiques* 50 (Sept. 1946), 170–171; George C. Groce and David H. Wallace, *The New-York Historical Society's Dictionary of Artists in America, 1564–1860* (New Haven, Conn., 1957), p. 602; Yarnall and Gerdts 1986, 5:3382–3384; Harding 1984, pp. 57, 160; "Peter Stephenson," *National Cyclopaedia of American Biography*, 62 vols. (New York, 1898), 8:455

46
The Wounded Indian

Modeled ca. 1848–49, carved 1850
Marble
35½ × 59 × 30¼ in. (90.2 × 149.9 × 76.8 cm)
Inscribed at left of base: *P. Stephenson. Sculpt.* A.D. *1850*

Provenance Mercantile Library, Boston, by 1856; James H. Ricau, Piermont, N.Y., by 1967

Exhibition History Balch's, Boston, 1850; Fitchburg Depot, Fitchburg, Mass., Jan. 1851; Amory Hall, Boston, Jan. 29–Feb. 28, 1851; Crystal Palace Exhibition, London, 1851; Stuyvesant Institute, New York, ca. May 1852; Boston Athenaeum, Boston, 1852, no. 46, 1853, no. 46, 1854, no. 66, 1855, no. 66, 1856, no. 52; *The Ricau Collection*, The Chrysler Museum, Feb. 26–Apr. 23, 1989

Literature [Harriet G. Hosmer], *Boston and Boston People in 1850* (Boston, 1850), p. 20; "Statuary," *Boston Transcript*, Aug. 24, 1850, p. 2; "Fine Arts Gossip," *Literary World* 8 (Jan. 4, 1851), 11; "Statue of *The Wounded Indian*," *Boston Transcript*, Jan. 22, 1851, p. 2; "*Wounded Indian* on Display," *Boston Transcript*, Jan. 31, 1851, p. 3; "Literature, Science, Art, Personal Movements, Etc. United States," *Harper's New Monthly Magazine* 2 (Feb. 1851), 416–417; "Display of *Wounded Indian* Closing," *Boston Transcript*, Feb. 20, 1851, p. 2; *The Illustrated Exhibitor: A Tribute to the World's Industrial Jubilee; Comprising Sketches by Pen and Pencil, of the Principal Objects in the Great Exhibition of the Industry of All Nations, 1851* (London, 1851), pp. 133–134, ill.; John Tallis, *Tallis's History and Description of the Crystal Palace, and the Exhibition of the World's Industry in 1851, Illustrated*, 3 vols. (New York and London, 1851), vol. 1, pt. 1, p. 126, vol. 2, pt. 1, p. 38; "News from London," *Boston Transcript*, May 21, 1851, p. 2; "American Statuary," *Boston Transcript*, June 12, 1851, p. 2; "American Art Contributions to the World's Fair," *Bulletin of the American Art-Union*, June 1851, p. 49; "Wounded Indian," *Boston Transcript*, Nov. 28, 1851, p. 2; "Statue of *The Wounded Indian*," *Gleason's Pictorial Drawing-Room Companion*, Mar. 27, 1852, p. 200, ill.; "Fine Arts. Stephenson's *Wounded Indian*," *Home Journal*, May 22, 1852, p. 2; L., "Busts of Webster," *Boston Evening Transcript*, Jan. 12, 1853, p. 1; "Boston Athenaeum," *Ballou's Pictorial Drawing-Room Companion* 8 (Mar. 31, 1855), 201–202, ill.; "Sketchings. Domestic Art Gossip," *Crayon* 3 (July 1856), 221; T. A. R., "History of Art in Boston," *Home Journal*, Nov. 29, 1856, p. 1; R. L. Midgeley, *Boston Sights; or Hand-Book for Visitors* (Boston, 1859), p. 42; R., "Stephenson, the Sculptor," *Boston Transcript*, Feb. 25, 1861, p. 2; W., "Sketchings. Domestic Art Gossip," *Crayon* 8 (Mar. 1861), 70; Edwin M. Bacon, *King's Dictionary of Boston* (Cambridge, Mass., 1883), p. 292; *Mercantile Library Association, Constitution, By-Laws, Membership and Historical Sketch* (Boston, 1903), p. 27; Gerdts 1973, pp. 128–129, ill.; id., "The Marble Savage," *Art in America* 62 (July 1974), 66, ill.; id., "The *Medusa* of Harriet Hosmer," *Detroit Institute of Arts Bulletin* 56, no. 2 (1978), 97; Rosemary Booth, "A Taste for Sculpture," in *A Climate for Art: A History of the Boston Athenaeum Gallery, 1827–1873*, exh. cat., Boston Athenaeum (Boston, 1980), p. 33; Headley 1988, pp. 243–244

Version PLASTER presumed destroyed

Gift of James H. Ricau and Museum Purchase, 86.522

OF the four sculptures in the Ricau Collection that treat American Indian themes, Peter Stephenson's *Wounded Indian* is the most poignant. Each considers a contemplative aspect of its subject, but *The Wounded Indian* alludes to the Indian civilization's demise. The American Indian had long been the subject of artistic interest and gained substantial popularity in the wake of Jean-Jacques Rousseau's ruminations on the "noble savage" and Benjamin West's (1738–1820) famous likening of the *Apollo Belvedere* to a Mohawk warrior. Several earlier depictions of American Indians, such as John Vanderlyn's (1775–1852) *Death of Jane MacCrea* of 1804 (WAHC) or Horatio Greenough's (1805–1852) *Rescue*, 1837–51 (United States Capitol), chronicled a brutal rather than a noble savagery. But the preponderance of depictions reflected a loftier view. Such sentiments were also echoed in the literature of the day, especially the popular and influential writings of James Fenimore Cooper.

In the 1830s the efforts of Karl Bodmer (1809–1893), George Catlin (1796–1872), and Alfred Jacob Miller (1810–1874) brought the endangered existence of American Indians before the public's eye, and no less a figure than Judge Joseph Story, William Wetmore Story's (q.v.) father, acknowledged that the white man was at the root of this demise.[1] Undoubtedly, Stephenson's brief experience on the Michigan frontier engendered both respect and sympathy for the American Indians he befriended. He devoted at least four sculptures to the subject, and *The Wounded Indian* survives as eloquent testimony to his sensitivity.

Stephenson commenced his most ambitious work to date in 1848 or 1849 and completed the modeling and carving by 1850. It was soon exhibited at Balch's, an establishment in Boston partly devoted to the display of art.[2] Reaction, while complimentary to the sculptor's work, focused on the dearth of patronage in Boston, which Stephenson echoed in his autobiographical memorandum to Hannah Lee three years later. From the outset, critics lavishly praised the piece, admiring its grand conception, and anatomical and ethnographic accuracy. They took great pride in proclaiming it the first major piece cut from American marble—quarried in Rutland, Vermont.[3] One author even contended that *The Wounded Indian* was superior to Hiram Powers's (q.v.) highly esteemed *Greek Slave* (fig. 13) in all aspects of a genuine work of art, namely character, force, expression, truth to nature, and anatomical correctness.[4] When the sculpture was exhibited in New York in 1852, another observer found the attention to detail sufficiently adroit that he was able to identify the subject as a woodland Indian on the basis of the "refined lineaments" of the countenance

in contrast to the breadth and coarseness of the prairie tribes.[5] But the pinnacle of success was *The Wounded Indian*'s reception in London in the summer of 1851 at the Exhibition of the Works of Industry of All Nations, better known as the Crystal Palace Exhibition.

Although Powers's *Greek Slave* commanded the lion's share of attention and was considered the redeeming example of the American display at the exhibition, Stephenson received high praise for his effort.[6] He also benefited from association with Powers, and a critic for the *New-York Evening Post* linked the two men's works and credited them with offsetting the deficiencies of the American representation.[7] These encomiums were not merely chauvinistic opinion, since the critic for the *London Economist* observed, "The world may see, perhaps, with some astonishment, the sculptors of the United States bearing off the palm for beauty, and those of the continent conspicuous for rugged strength."[8]

The Wounded Indian also appeared as one of the principal objects in various souvenir handbooks of the exhibition. One volume illustrated it as a line drawing.[9] Another provided an extensive discussion and description.[10] The latter commentary connected *The Wounded Indian* with *The Dying Gaul* in Rome but commended Stephenson for his powers of invention. The author analyzed the sculptor's intent, namely to give a correct representation of the Indian races of North America, and observed, "The figure was represented wounded and fallen, thereby typifying the race." The article mentioned its proximity to Powers's *Greek Slave*, which was installed adjacent to a display of ethnographic materials pertaining to American Indian culture lent by the Smithsonian Institution and George Catlin. The metaphorical implication of both statues was not lost on the writer, who closed by asking, "Is it not suggestive that the Americans, proverbially a 'cute [*sic*] people, should have so publicly drawn attention to slavery and the extinction of the aborigines of the Far West?" While heralding American artistic ability, *The Wounded Indian* and *The Greek Slave* exposed the British and European public to symbols of the social ills confronting the American nation. The appeal of both works was confirmed by their reproduction in Parian ware, presumably by English manufacturers, to make them available on a mass basis in a convenient size.[11]

British enthusiasm for *The Wounded Indian* caused alarm that it would not return to America. This fear was unfounded, and the sculpture was exhibited in New York before returning to Boston in 1852. This exposure continued to provoke commentary, and the same critic who thought the detail was so explicit that he could ascertain the geographic origin of the subject also observed that the statue affirmed the warlike nature of these peoples. While Stephenson's experiences in Michigan instilled a sympathy for the American Indian, he shrank from the harsh realities of tribal conflict. By depicting his subject expiring from an enemy arrow, the sculptor avoided blaming the white man exclusively for the demise of native inhabitants.

After its success in New York, *The Wounded Indian* became a fixture in the statuary room of the Boston Athenaeum for the next four years (fig. 81). Some confusion exists as to exactly what was on view, since the exhibition records and at least one contemporary guidebook refer to the piece as "the original model of the statue."[12] The word *model* may be misleading, since the marble of *The Wounded Indian* was acquired by the Boston Mercantile Library Association in 1856, the last year it was on view at the Athenaeum.[13] Little is known about its subsequent history. It remained in the association's collection after the library was transferred to the Boston Public Library in 1881.[14] At this juncture, the institution became a social club with headquarters at the corner of Tremont and Newton streets. It disbanded in 1952.[15] There is no known record of the disposal of the piece; Ricau acquired it in Boston before 1967.[16]

FIG. 81 The sculpture gallery of the Boston Athenaeum. Wood engraving from *Ballou's Pictorial and Drawing-Room Companion* 8 (Mar. 31, 1855), 201. Photograph courtesy of the Library of the Boston Athenaeum

The protagonist is shown seated on the forest floor with his right leg folded under him and his left leg partially outstretched. His left hand, having pulled out the mortal arrow, rests on the ground. While he supports himself with his right arm, his left hand loosely rests on his bow and arrow. The head is deeply bowed as though the victim is about to pass into unconsciousness. The attention to detail is evident in the array of ferns, leaves, and flowers lying on the ground. The sculptor took great care with rendering such elements as the small shells piercing both ears, the texture of the girdle, and the crown and topknot.

The pyramidal form and complex pose signal an ambitious undertaking, especially for a first effort on such a large scale. Stephenson summoned the tradition of the classical past and used the famous *Dying Gaul* in the Capitoline Museum in

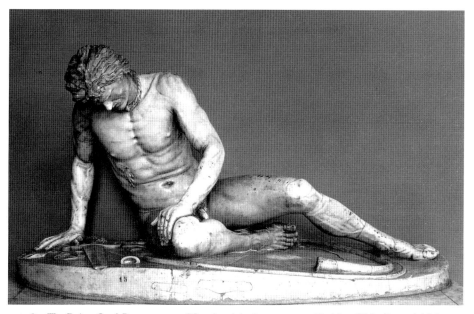

FIG. 82 *The Dying Gaul*, Roman copy of Greek original, ca. 220 B.C. Marble, 36⅝ in. (93 cm) high. Capitoline Museums, Rome. Photograph courtesy of Deutsches Archäologisches Institut

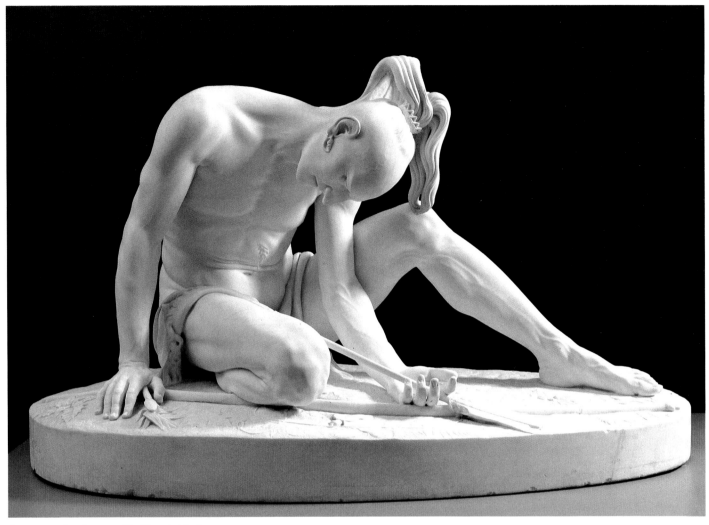

Cat. no. 46 Stephenson, *The Wounded Indian*

Rome as a point of departure (fig. 82). The pose, the weapons on the ground, and the attempt to maintain dignity even in death are common to both works. *The Dying Gaul* traditionally elicited praise for its verisimilitude and faithful reproduction of ethnic characteristics. *The Wounded Indian* attracted accolades for these traits, as well. Equally intriguing is that the Gaul, like the American Indian, was considered a barbarian. Both, however, were accorded nobility in death. Thus, social as well as formal parallels inform the works.

Stephenson appropriated the anatomical accuracy of *The Dying Gaul* and developed it as a tour-de-force display of his ability. The folds of abdominal skin are more pronounced than in the Hellenistic work, as are the bulging veins in the legs, arms, and head. There is less torsion and energy in the body of *The Wounded Indian* than in *The Dying Gaul*. The young sculptor may have intended to convey a mood of serenity and calm in contrast to the emotion and agitation of the prototype.

The treatment of the hair also underscores this difference, since the locks of the Indian are handled as smooth, flowing curves in comparison to the shaggy, energetic treatment of the Gaul's hair. The head of the Indian is even more deeply bowed, and the relaxation of the fingers that pulled out the fatal arrow conveys the impression that the Indian is much closer to death than the Gaul. Stephenson took the motif of blood pouring from the wound directly from his source, but he placed the gash under the heart rather than on the right side of the chest. It would be interesting to know if Stephenson consciously intended to deflect association with the lance wound of Christ to avoid any Christian overlay to the work.

The Wounded Indian is a remarkable first effort. The complex composition and myriad details signal the young sculptor's ambitions as he transcended mere technical accomplishment. In the image and message that he fashioned, Peter Stephenson demonstrated a sensitivity to

and respect for his subject as he articulated its dignity and plight in an even-handed yet forceful manner.

Notes

1. Mary E. Phillips, *Reminiscences of William Wetmore Story, the American Sculptor and Author* (Chicago, 1897), p. 43.

2. [Hosmer], *Boston and Boston People in 1850* (1850), p. 20. In the copy consulted, Hosmer's name is added by hand.

3. "Fine Arts Gossip," *Literary World* 8 (Jan. 4, 1851), 11.

4. "Statue of *The Wounded Indian*," *Boston Transcript*, Jan. 22, 1851, p. 2. The writer also feared that the piece would not return from its journey to the Crystal Palace Exhibition in London, so appealing would it be to foreign buyers.

5. "Fine Arts. Stephenson's *Wounded Indian*," *Home Journal*, May 22, 1852, p. 2.

6. See Wunder 1991, 1:244ff., for a discussion of Powers's work at the fair.

7. This commentary was carried in the *Boston Transcript*, May 21, 1851, p. 2.

8. "American Statuary," *Boston Transcript*, June 12, 1851, p. 2, reprinted observations of the critic for the *London Economist*.

9. *The Illustrated Exhibitor... of the Principal Objects in the Great Exhibition, 1851* (1851), p. 134.

10. *Tallis's History and Description of the Crystal Palace* (1851), vol. 1, pt. 1, p. 126.

11. For a discussion of manufacture of *The Greek Slave*, see Wunder 1991, 1:247ff.; the *Boston Transcript*, Nov. 28, 1851, p. 2, carried an advertisement for Parian statuettes of *The Wounded Indian*.

12. Perkins and Gavin 1980, p. 152, and Midgely, *Boston Sights; or Hand-Book for Visitors* (1859), p. 42.

13. "Sketchings. Domestic Art Gossip," *Crayon* 3 (July 1856), 221.

14. Bacon, *King's Dictionary of Boston* (1883), p. 292.

15. Walter Muir Whitehill, *The Boston Public Library: A Centennial History* (Cambridge, Mass., 1956), pp. 124ff.

16. In 1967 the Baltimore Museum of Art was contemplating an exhibition of American neoclassical sculpture to be organized by William H. Gerdts, who wrote to Mr. Ricau requesting the loan of *The Wounded Indian*, among other pieces. William H. Gerdts to James H. Ricau, Dec. 10, 1967, William H. Gerdts archive, New York.

William Henry Rinehart
American, 1825–1874

As Maryland's first sculptor of note, William Henry Rinehart exemplifies the success an artist can attain from a supportive local constituency. During his twenty-year vocation, Rinehart created an impressive number of portrait busts, funerary monuments, and ideal sculptures. His productive years bridged the transition in America from an admiration for classical grace and refinement to a growing predilection for naturalism. His premature death at age forty-nine left unanswered the question of whether his style would have been affected by this changing taste.

Born near Union Bridge, Maryland, about seventy miles west of Baltimore, Rinehart was the fifth of eight children of Israel and Mary Snader Rinehart. His father was of German descent, was strict, thrifty, and practical, and was determined that his sons, like himself, would prosper as farmers. Although Rinehart's mother was a Quaker who opposed the arts, she supported his renegade ways. While growing up, Rinehart showed little inclination for either farm- or schoolwork, although he later regretted neglecting the latter.[1] His rough-hewn nature was to stand him in good stead with his patrons, who were themselves primarily self-taught and self-made.

When various professions proved untenable for William, the elder Rinehart installed him in the shop of a new marble quarry on their property. Here he learned to saw, polish, and letter marble for tombstones, windows, doorsills, and mantelpieces. He flourished, having found his niche. Contrary to his father's expectations, work in the marble shop fueled Rinehart's desire to become an artist. When he was about twenty, William proved he had inherited his father's determination by persuading him that he needed to develop his newfound ability in Baltimore.

Aided by a letter of introduction, Rinehart was apprenticed to the most important stonecutting firm in Baltimore, Baughman & Bevan. The stonecutting trade was in its infancy, and the newcomer quickly demonstrated his talent and gained the respect of his employers. He soon had his own studio and undertook the firm's most demanding commissions. Repairing a mantelpiece allegedly brought Rinehart to the attention of William T. Walters, a leading Baltimore businessman, connoisseur, and philanthropist, who became one of the sculptor's major patrons and champions.[2] Such posi-

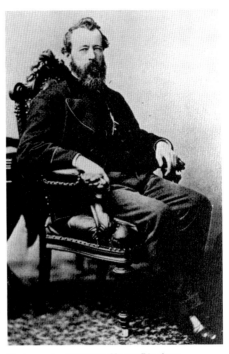

Photograph of William Henry Rinehart. Photograph courtesy of the Archives of American Art, Smithsonian Institution

tive developments redoubled Rinehart's determination.

Around 1850 he augmented his practical training by taking night classes in liberal arts, anatomy, architecture, and design at the Maryland Institute of the Mechanic Arts. He also began to exhibit his work with encouraging results. In 1851 the Art Committee of the institute awarded him a gold medal for a bas-relief, *The Smokers* (PIBM), which he based on a print after a painting by the seventeenth-century Flemish artist David Teniers the Younger. Although an unusual choice of subject, this work reflected the American taste for the low-key and familiar as opposed to the more elevating realms of antiquity.

Rinehart repeated his success two years later when the institute awarded him another medal at its annual exhibition for his statuary, which included portrait busts and an ideal figure of Faith. He also enjoyed practical recognition in 1855 when he sold his first statue, a marble representation of a backwoodsman, to S. G. Wyman, a Baltimore merchant. The author of a contemporary account of Rinehart's fledgling career noted that the piece was "full of life, spirit, and expression" and commended the sculptor for his choice of an American subject.[3] He urged Rinehart to honor the American Indian and "accomplish in marble what Longfellow has so triumphantly achieved in verse." This advice was timely, given

the efforts of Thomas Crawford (q.v.) and Peter Stephenson (cat. no. 46).

In spite of these auspicious beginnings, Rinehart became frustrated with the lack of suitable teachers in his profession and determined to go to Italy. Through the generosity of various businessmen, he realized his dream and departed for Florence in 1855. The journey left him sufficiently impoverished, and once there he had to work as a stonecutter. Through his initiative and perseverance, however, he improved his sculpting skills and began to create a respectable body of work. Rinehart came into contact with Florence's thriving community of American sculptors, although the presence of Hiram Powers (q.v.) and Thomas Ball (1819–1911) severely limited his access to portrait commissions. This competition forced him to concentrate on ideal pieces, and he executed four bas-reliefs, *Winter, Spring, Night,* and *Morning,* which followed in the tradition of such important models for American sculptors as Bertel Thorvaldsen (q.v.) and Antonio Canova (1757–1822). During this initial sojourn, Rinehart began two works with American themes, *The Indian Maiden* (Phoenix Art Museum) and *Pioneer and Family.* He may have undertaken these in response to the exhortations of the recent laudatory profile in the *Home Journal.* His account book also lists another early work, *Female Figure, Fully Draped,* which he modeled in 1856. This may be the statue in the Ricau Collection (cat. no. 51). Undoubtedly, his new environment began to affect his choice of subject matter.

His funds exhausted, Rinehart returned to Baltimore in 1857 and established a studio. He continued to receive encouragement and patronage from Walters and other wealthy and powerful businessmen. Rinehart was haunted by the lure of Italy, despite commissions that included a figure for the fountain in front of the old post office in Washington and caryatid figures for the clock in the House of Representatives. He returned to Italy in the fall of 1858, this time to Rome. With the untimely demise of Thomas Crawford in October 1857, Rinehart inherited the tradition of Thorvaldsen, Canova, and Crawford.

Rinehart's second trip proved more comfortable financially than his initial visit. He brought a number of portrait commissions with him, and he quickly appeared on the tour of studios considered obligatory by visitors to Rome.[4] This exposure resulted in more orders and enabled him to pursue his overriding interest in ideal pieces. In 1859 he modeled a religious figure, *The Woman of*

Samaria (WAG), giving her a neoclassical overlay. Walters ordered it cut in marble, thus generating the sculptor's first known life-size figure. The statue was praised for its "dignity, grace, simplicity, and refinement" and was appreciated for its "contrast to the sensualistic art which newspaper puffing through ignorance of refined standards has made so popular."[5] This assessment echoed Rinehart's sentiments of placing simplicity over decoration, which he expressed in a letter to fellow artist and Baltimore resident, Frank B. Mayer (1827–1899).[6]

At this time, Rinehart also embarked on conceptions of Hero and Leander, which further demonstrated his penchant for the neoclassical ideal (cat. nos. 47, 48). Remaining sensitive to the demands of the market, his portraits and funerary monuments carried a straightforward realism, reflecting the taste of Rinehart's middle-class clientele. During this period, the sculptor created his most popular work, *Sleeping Children,* initially commissioned by the Sisson family (Greenmount Cemetery, Baltimore) but generating at least seventeen subsequent orders.[7] This relatively small and accessible work revealed his pragmatic acknowledgment of a Victorian sentimentality, which responded to the melancholy connection of childhood and death.

By the early 1860s Rinehart had established himself as one of America's premier sculptors working in Rome. Further measure of his growing importance was his selection in 1861 to complete the House and Senate chamber doors in the Capitol in Washington, which Thomas Crawford had left unfinished at his death. When antiforeign sentiment dictated against Crawford's German assistant completing the work, Crawford's widow personally recommended Rinehart. The sculptor devoted much of the next four years to creating a balance between Crawford's original sketches and his own ideas. The Senate doors were fairly advanced, and Rinehart had little leeway with them, but he could use the preliminary drawings for the House doors as a point of departure and imbue the project with his own imprimatur.

Throughout the 1860s Rinehart was increasingly sought after. Among his major accomplishments were a funerary monument, *Love Reconciled with Death,* installed in 1867 for the grave of Mrs. William T. Walters in Greenmount Cemetery in Baltimore, and the translation into marble of *Hero* in 1866 (cat. no. 47). Demand for his portraits was so great that he ran two to three years behind schedule. No doubt these straightforward commis-

sions held less appeal for him than the more elevated aspects of his oeuvre.

Toward the end of the decade, the General Assembly of Maryland awarded Rinehart a commission for a monument to honor recently deceased Chief Justice Roger Brooke Taney, who led the state Supreme Court from 1836 to 1864. One of the crowning achievements of Rinehart's career, this work was placed in front of the state capitol in Annapolis. The sculptor was present at the unveiling on December 12, 1872, and basked in the encomiums of the keynote address delivered by Severn Teacle Wallis, who had recommended him. While appropriately bold, severe, and monumental, the well-received piece stood in marked contrast to the unfolding concerns for surface vitality, and technique espoused by the emerging French Beaux-Arts tradition.

The ideal compositions of the final phase of Rinehart's career evoked a serenity, harmony, and order consistent with the neoclassical mode. He was attracted to suitably subdued subject matter. Statues such as *Antigone,* 1870 (MMA), *Endymion,* 1874 (CGA), and *Clytie,* 1872 (cat. no. 50), reflect this meditative attitude. These works represent the apogee of neoclassicism in America. Rinehart's death in 1874 of consumption silenced a leading proponent of the tradition of sculpture so inextricably connected with classical antiquity.

Rinehart's will revealed his deep gratitude to the city that embraced him. He left his wealth in trust to establish a school for sculpture at the Maryland Institute as well as a scholarship fund to enable promising young sculptors to pursue their studies abroad. This largesse was an extension of his attentiveness to beginners in the profession, which Augustus Saint-Gaudens (q.v.) recalled with great appreciation. Through the diligent efforts of his trustees, Rinehart's legacy for travel was put into place by the mid-1890s. Significantly, one of the first recipients, Alexander Phimster Proctor (1862–1950), chose Paris while the other, Hermon MacNeil (1866–1947), selected Rinehart's beloved Rome. Appreciation of Rinehart's sculpture may ebb and flow with the shifting tides of taste, but his legacy to education and the nurture of sculpture is one that endures today.

Notes

1. This statement of his regret was originally carried in an article in the *Baltimore Evening Star,* ca. 1892–93, from undated clippings in the Peabody Library, Baltimore, and cited in Ross and Rutledge 1948, p. 7. The most recent treatment of Rinehart is to be found in Janet Headley, "English Literary and Aesthetic Influences on American Sculptors in Italy, 1825–1875" (Ph.D. diss., University of Maryland, 1988), pp. 254–529.

2. Rusk, *William Henry Rinehart, Sculptor* (1939), pp. 15–16.

3. Van Bebber, "Sketch of a Great Sculptor," *Home Journal*, May 10, 1856, p. 1. The work was exhibited at the Maryland Historical Society in 1856; see Ross and Rutledge 1948, p. 20.

4. Fuller 1859, p. 271.

5. "Sketchings. Domestic Art Gossip," *Crayon* 8 (Apr. 1861), 96.

6. Rinehart to Mayer, Nov. 6, 1860, quoted in Ross and Rutledge 1948, p. 59.

7. Ross and Rutledge 1948, p. 33.

Bibliography

Thomas H. van Bebber, "Sketch of a Great Sculptor," *Home Journal*, May 10, 1856, p. 1; "Sketchings. Domestic Art Gossip," *Crayon* 5 (Dec. 1858), 353; Fuller 1859, p. 271; "Return of a Baltimore Artist," *American Art Journal*, July 12, 1866, p. 187; Tuckerman 1867, pp. 592–593; "Visits to the Studios of Rome," *Art Journal* (London), n.s., 10, 33 (June 1871), 163; "Death of Rinehart, the Sculptor," *Baltimore Weekly Sun*, Oct. 31, 1874, n.p.; S., "In Memoriam," *Boston Daily Evening Transcript*, Nov. 3, 1874, p. 6; *Elenco della 1.a e 2.a vendita volontaria al pubblico incanto degli oggetti appartenuti alla chiara memoria W. H. Rinehart, scultore americano* (Rome, 1875); Esmerelda Boyle, *Biographical Sketches of Distinguished Marylanders* (Baltimore, 1877), pp. 329–331; Benjamin 1880, pp. 152–154; Clement and Hutton 1894, 2:213; "American Studio Talk," *Studio* 8 (Sept. 1899), x; Elihu Vedder, *Digressions of V* (Boston, 1910), pp. 157, 329–332; Post 1921, 2:256; Taft 1924, pp. 171–180; William Sener Rusk, "Notes on the Life of William Henry Rinehart, Sculptor," *Maryland Historical Magazine* 19 (Dec. 1924), 309–338; id., "Rinehart's Works," *Maryland Historical Magazine* 20 (Dec. 1924), pp. 580–585; id., "New Rinehart Letters," *Maryland Historical Magazine* 31 (Nov. 1936), 225–242; id., *William Henry Rinehart, Sculptor* (Baltimore, 1939); Gardner 1945, pp. 17, 22–23; Ross and Rutledge 1948; Marvin Chauncey Ross and Ann Wells Rutledge, "William H. Rinehart's Letters to Frank B. Mayer, 1856–1870," *Maryland Historical Magazine* 43 (June 1948), 127–138, and 44 (Mar. 1949), 52–57; Agard 1951, pp. 137–139; Gardner 1965, pp. 24–25; Craven 1984, pp. 288–295; Lillian M. C. Randall, "An American Abroad: Visits to Sculptors' Studios in the 1860s," *Journal of the Walters Art Gallery* 33–34 (1970–71), 42–51; Thomas B. Brumbaugh, "A Recently Discovered Letter of William Henry Rinehart," *Journal of the Walters Art Gallery* 33–34 (1970–71), 53–57; Gerdts 1973, pp. 37–39, 55–57, 72, 79, 86, 90–91, 116–118; id., *The Great American Nude* (New York, 1974), pp. 94–96; Tom Armstrong et al., *Two Hundred Years of American Sculpture*, exh. cat., The Whitney Museum of American Art (New York, 1976), pp. 43–44, 58; Wilmerding et al. 1981, pp. 60–61, 160–162; *The Taste of Maryland, 1800–1934*, exh. cat., Walters Art Gallery (Baltimore, 1984), pp. 50–56; Headley 1988, pp. 254–329; Vance 1989, 1:273–274 and passim; Stebbins et al. 1992, pp. 344–345 and passim

47
Hero

Modeled ca. 1858–59, carved 1874
Marble
34 × 27½ × 13⅞ in. (86.4 × 69.9 × 35.2 cm)
Inscribed on rock at rear: *Wm. H. Rinehart. Sculpt. / Rome. 1874*

Provenance Pauline Rose (?), Miami, Fla.; [Joseph Tudisco Antiques, Coral Gables, Fla., by 1979]; [Hirschl & Adler Galleries, New York, by 1982]; private collection, 1984; James H. Ricau, Piermont, N.Y., 1984

Exhibition History *Carved and Modeled: American Sculpture, 1810–1940*, Hirschl & Adler Galleries, New York, Apr. 20–June 4, 1982, no. 13; *The Ricau Collection*, The Chrysler Museum, Feb. 26–Apr. 23, 1989

Literature Fuller 1859, p. 271; Osgood 1870, p. 422; S., "In Memoriam," *Boston Daily Evening Transcript*, Nov. 3, 1874, p. 6; Huidekooper 1882, p. 184; Taft 1924, p. 175; Ross and Rutledge 1948, pp. 25–26, no. 17; Craven 1984, p. 293; Menconi 1982, pp. 32–33, ill.; advertisement for *Carved and Modeled* in *Antiques* 121 (May 1982), 982, ill.; Headley 1988, pp. 278–286, 436, ill.; Vance 1989, 1:218, 263–264, 328

Versions PLASTER National Museum of American Art, Washington, D.C.; MARBLE Pennsylvania Academy of the Fine Arts, Philadelphia; The Newark Museum, Newark, N.J.; Peabody Institute, The Johns Hopkins University, Baltimore; Collection of JoAnn and Julian Ganz, Jr., Los Angeles

Gift of James H. Ricau and Museum Purchase, 86.512

The subject of William Henry Rinehart's pendant marbles, *Hero* and *Leander* (cat. no. 48), had its classical source in the tragic love story recounted by Ovid in his *Heroides*. Hero, a beautiful priestess of Venus, met Leander at a festival of Venus and Adonis celebrated at Sestos on the Thracian coast. They immediately fell in love, but her position as a priestess and her parents' opposition dictated against their ardor. Geography also played a role since Hero lived on the west, or European, side of the Hellespont (now the Dardanelles), and Leander inhabited the eastern, or Asiatic, side in Abydos. None of these impediments deterred them, however, and each evening Leander would swim across the Hellespont to be with his beloved, guided by the light of the lamp she provided. One stormy winter night the wind blew out the light, and Leander lost his way and drowned. Overcome with grief, Hero threw herself into the sea to join her lover in death.

Perhaps because of Lord Byron's celebrated swim of the Hellespont in 1810 to emulate Leander and his subsequent poem *The Bride of Abydos* (1813), the story attracted great literary and artistic attention in the nineteenth century.[1] Poetry provided the earliest response, with other well-known poets such as John Keats and Alfred Lord Tennyson contributing to its popularity. The story had its artistic adherents. Joseph M. W. Turner (1775–1851) illustrated the myth in 1837, undoubtedly attracted to it by his own fascination with man's conflict with the elements. Appropriate to the romantic sentiment of the period, concern with death overshadowed the theme of love.

In America, Philadelphians saw one of the earliest plastic interpretations of the story when the German sculptor Charles Steinhauser (1813–1879) exhibited a marble group at the Pennsylvania Academy of the Fine Arts in 1848.[2] Encouraged by previous support from the noted Philadelphia publisher and arts patron Edward C. Carey, Jr., Steinhauser provided an extensive pamphlet whose opening sentence implied that the legend was well known.[3] In addition to a lengthy discourse on the work, the legend, and the artist, the pamphlet included excerpts of recent articles about Steinhauser's creation from *Godey's Lady's Book* and *Sartain's Union Magazine*. Thus, both the work and the subject received considerable attention in the American press.

An American did not address the subject until the mid-1850s, when William Wetmore Story (q.v.) embarked on an interpretation around 1856 (Post Road Gallery, Larchmont, N.Y.).[4] Although Story remained somewhat aloof from the American artistic community in Rome, his activities were noticed. Favorable reception of his *Hero in Search of Leander* by Nathaniel Hawthorne and others may have inspired Rinehart to undertake his version, whose popularity may have contributed to the eclipse of Story's effort.[5]

Hero was well enough along for a visitor to Rinehart's studio in late 1858 or early 1859 to mention seeing "a statue of *Hero waiting for Leander*." This tourist also singled out Story's *Hero* while visiting that studio, but offered no comparison of the two.[6] Rinehart received no request to translate the piece into marble until 1866.[7] After that the orders began in earnest: three more were ordered in 1867, an additional two in 1868, and one in 1869. An eighth replica, signed and dated 1871, was not mentioned in the sculptor's "Libra Maestro" (Rinehart's order book) but was owned by a Mrs. George Small, who gave it to the Peabody Institute in Baltimore.

This replica is now owned by the Newark Museum. The other version owned by the institute had been commissioned by Edward Clark of New York.[8] A ninth version was listed as number 12 in the catalogue of the sale of the artist's studio held in 1875.[9] Nothing is known of the history of this ninth replica, but since the Ricau version is signed and dated 1874, it is likely that it is the piece from the 1875 sale.

Hero is depicted sitting on a rock with her left leg folded under her right knee as she gazes intently into the distance. The gentle arc of her right leg creates a compelling outline and connects with the strong profile of her head. This establishes a specific viewpoint for the spectator and suggests the sculpture be seen as a very high relief. A cloak serves as a soft blanket to set on the hard rock and—blown by the wind—discreetly covers her genitals. She supports her upper torso with her left arm while she puts her right hand to her chest. Not only does this gesture heighten the sense of anxiety, but it also contributes to Hero's modesty by obscuring her breasts. The two narrative elements—the lamp, which is placed beside her with its flame burning, and the waves that lap at the base of the rock—explicitly convey the heightened drama of the episode.

Given his youth and recent arrival in Rome, Rinehart undoubtedly looked to a variety of sources for his composition. Recent scholarship has argued plausibly for a range of contemporary English sources, most notably John Gibson's (1790–1866) *Narcissus* of 1858 (Royal Academy of Arts, London) and Richard James Wyatt's (1795–1850) *Musidora* (Chatsworth House, Chatsworth, England),

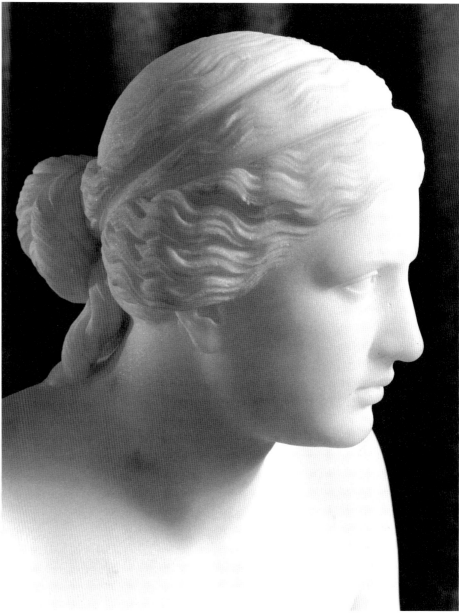

FIG. 84 Rinehart, *Hero*, detail of hair

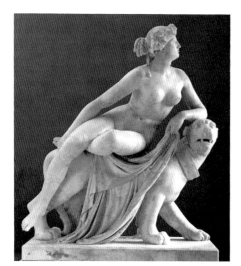

FIG. 85 Johann Heinrich Dannecker, *Ariadne on the Panther*, 1803–14. Marble, 57½ in. (146.1 cm) high. Städtische Skulpturensammlung im Liebieghaus, Museum alter Plastik, Frankfurt. Photograph Ursula Edelmann, Frankfurt

which appeared in the *Art Journal* of 1852.[10] Lorado Taft's initial association of it with Heinrich Dannecker's (1758–1841) *Ariadne on the Panther* of 1803–14 (fig. 85) remains equally compelling.[11] Dannecker's statue, housed in a private museum in Frankfurt at the time, became a required stop for nearly all Americans making the European tour. Most of them, including Harriet Beecher Stowe, accorded it rapturous praise.[12] This enthusiasm was not unanimous; Story objected to its lack of profound emotion. Nevertheless, *Ariadne* gained wide exposure through Parian-ware reproductions and stereoptic views.[13] However Rinehart knew the piece, he responded particularly to the planar relationship of the lower torso to the upper, which emphasized the profile.

In addition to myriad contemporary sources available to him, Rinehart displayed a strong sensitivity for Hellenistic sculpture in rendering *Hero*. Her head bears a strong resemblance to heads and hairstyles such as the *Aphrodite of Knidos* (ca. 350–330 B.C.) by Praxiteles, which was in the Vatican Museums. The wavy hairstyle covering the same amount of the ear, the ribbons in the hair, and the bun secured in the back are remarkably similar, although Rinehart made the waviness less pronounced (fig. 84). He also permitted a braid intended for the bun to fall loose along the nape of Hero's neck, which recalls the disengaged coiffure of works such as the *Venus de Milo*. The deep channeling of hair in the Praxitelean work generates a visual agitation that offsets the

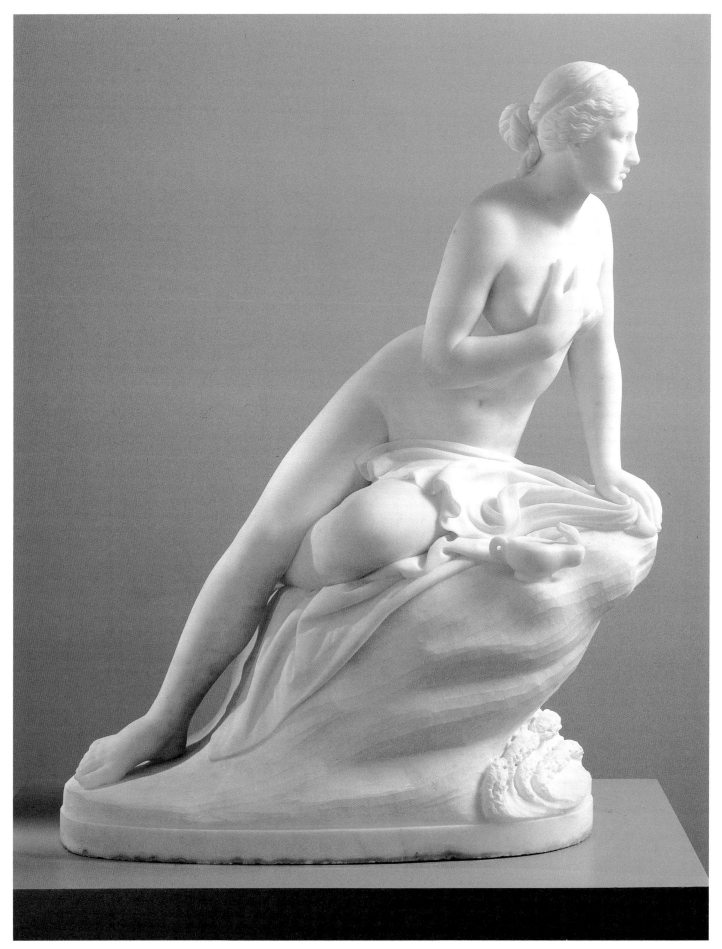

Cat. no. 47 Rinehart, *Hero*

smooth planes of the rest of the sculpture. At the same time, Rinehart's understated approach establishes a serene visual experience with only the fallen braid suggesting that something is amiss.

Rinehart replaced the gentle smile and tranquil expression of the Knidian *Aphrodite* with one of greater intensity that unmasked Hero's concern for her lover's treacherous task. The facial structure of both heads shares a grace and delicacy that bespeak Rinehart's further indebtedness. He altered the nose of the *Aphrodite*. Instead of an unbroken, subtly concave curve extending from the forehead to the tip of the nose, Rinehart substituted an indentation at the intersection of the nose and eye sockets. The resulting furrowed brow further underscores Hero's anxiety.

In dealing with the torso, Rinehart also looked to classical prototypes. He rendered the breasts according to an ideal that elevated the figure's nudity from a plane of sensuality to a more purified, cerebral plateau. The abdomen has definition and taut musculature that relate it to later Hellenistic works such as the *Venus de Milo*. Thus, Rinehart carefully studied ancient prototypes and combined them with his own nineteenth-century vision to achieve a lively balance between the contemporary and the antique. Undoubtedly, the chaste refinement and rich narrative content contributed to making *Hero* one of Rinehart's most popular works.

Notes

1. See Headley 1988, pp. 278ff., for a cogent treatment of the burgeoning literary interest in the subject.

2. Rutledge 1955, p. 214.

3. *Description of the Group of Statuary Representing* Hero and Leander, *by Charles Steinhauser, of Bremen* (Philadelphia, 1848), p. 3.

4. See Seidler 1985, 1:332–345, for a discussion of Story's interpretation.

5. Seidler 1985, 1:344.

6. Fuller 1859, p. 271.

7. Rinehart, "Libra Maestro," Jan. 3, 1866, p. 113, Rinehart papers, Peabody Institute archives, Baltimore.

8. Ross and Rutledge 1948, p. 25.

9. *Elenco della 1.a e 2.a vendita volontaria al pubblico incanto degli oggetti appartenuti alla chiara memoria W. H. Rinehart scultore americano* (Rome, 1875), p. 2.

10. Headley 1985, pp. 283–284.

11. Taft 1924, p. 175.

12. See William H. Gerdts, "Marble and Nudity," *Art in America* 54 (May–June 1971), 62–64.

13. Seidler 1985, 1:170.

48
Leander

Modeled ca. 1859, carved ca. 1870
Marble
42¾ × 16⅝ × 15¼ in. (108.6 × 42.2 × 38.7 cm)
No inscription

Provenance Lawrason Riggs, Baltimore; Mrs. Thomas H. Ballière, Baltimore; James H. Ricau, Piermont, N.Y., by 1962

Exhibition History *The Ricau Collection,* The Chrysler Museum, Feb. 26–Apr. 23, 1989

Literature "Sculptors and Sculpture," *Cosmopolitan Art Journal* 4 (Dec. 1860), 181; Tuckerman 1867, p. 593; S., "In Memoriam," *Boston Daily Evening Transcript,* Nov. 3, 1874, p. 6; Ross and Rutledge 1948, p. 28, no. 26; "Recent Acquisitions," *Museum* (The Newark Museum) 14 (Fall 1962), 11; William H. Gerdts, "American Sculpture: The Collection of James H. Ricau," *Antiques* 86 (Sept. 1964), 297–298, ill.; Craven 1984, pp. 290–291; William H. Gerdts, "Marble and Nudity," *Art in America* 54 (May–June 1971), 66–67, ill.; Gerdts 1973, pp. 56–57, ill.; John S. Crawford, "The Classical Tradition in American Sculpture: Structure and Surface," *American Art Journal* 11 (July 1979), 38–52; Headley 1988, pp. 278–286, p. 437, ill.; Vance 1989, 1:218, 328–331

Version MARBLE The Newark Museum, Newark, N.J.

Gift of James H. Ricau and Museum Purchase, 86.513

Depiction of the nude male form was far less common in nineteenth-century American sculpture than its female counterpart. Conditioned in part by the prevailing attitude that the female form constituted the preeminent canon for beauty, scarcity of the masculine form emanated from harsh criticism of early attempts. Horatio Greenough (1805–1852) was lambasted for several of his efforts, including his cherubs and most notably the seminude *Washington* intended for the Capitol.

Occasionally there was positive reaction to male nudes. Thomas Crawford (q.v.) achieved success with his *Orpheus and Cerberus* (BMFA), and Hiram Powers (q.v.) dispensed with any fig leaf or drapery in his *Fisher Boy* (VMFA) with admirable results. By midcentury there was less concern about undertaking such a subject, and William Henry Rinehart had little cause to worry about his interpretation.

References in his account book (which recorded his studio payments) indicate

that Rinehart turned the model over to a studio assistant to prepare for translation into marble in October 1860.[1] The following month the sculptor paid for a pedestal, although no order for *Leander* existed at this juncture.[2] Rinehart's intentions remain unclear, but *Leander* was sufficiently advanced to warrant attention in the press. In December 1860 the *Cosmopolitan Art Journal* published an account from a Baltimore paper that discussed Rinehart's budding career and included an extensive discussion of *Leander*. The author extolled the work, saying, "the figure is one of graceful and athletic young manhood, robust without grossness, and a marvel of beauty of conception and faultless execution."[3] The writer alluded to the near nudity of the figure but did not indicate that it was offensive.

Given this response, Rinehart had cause to be optimistic about *Leander*'s success. No purchase was forthcoming until 1865, however, when Edward Clark of New York requested a copy.[4] Nearly ten years after commencing the modeling of *Leander* and without the benefit of an order, Rinehart started another copy of the male figure, which was near completion in September 1870 when he paid one of his finishers for working on the statue.[5] Traditionally, Rinehart has been credited with completing only two copies. The late Ricau version presumably was the one auctioned at his studio sale in 1875.[6] Confusion does exist since Tuckerman in his *Book of the Artists* (1867) noted that a Mrs. Henry owned a statuette of *Leander*, while Rinehart's obituary referred to a *Leander* in the possession of "Mr. Riggs of Baltimore."[7] Tuckerman was not infallible, however, and early ownership is difficult to trace. Despite the possible proliferation of *Leander*s, Ricau acquired his copy directly from Mrs. Baillière of Baltimore. Ross and Rutledge connected this version back to Mr. Riggs.[8]

Leander is shown standing at the edge of the shore, signified by the ominously lapping waves at his feet, and gazing almost apprehensively over the water. While anxiety is mitigated by his relaxed pose as he appears to be disrobing for his nightly swim, one cannot escape the psychological drama that connects him with Hero. The drapery he holds in his left hand falls behind him and serves a twofold function: contrived modesty and structural support.

A rare instance of preliminary drawings (figs. 85, 86) that reveal an early conception of *Leander* provides further insights into the sculptor's working method.[9] Although schematic, they suggest a pas-

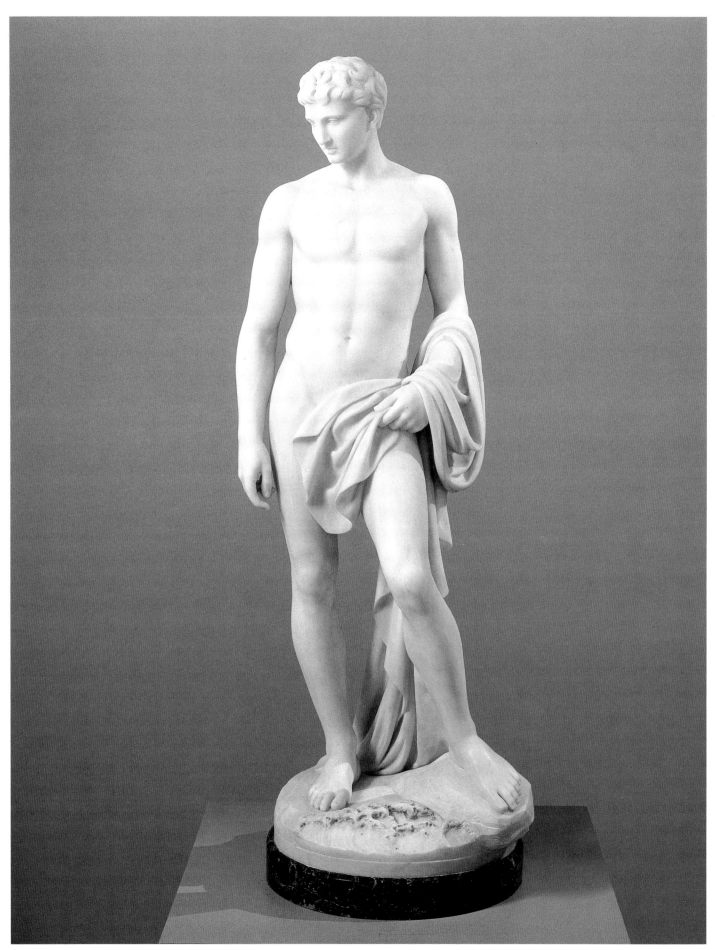

Cat. no. 48 Rinehart, *Leander*

FIG. 85 William Henry Rinehart, study for *Leander*, ca. 1855. Graphite on paper, 8¼ × 5¼ in. (21 × 13.3 cm). Archives of the Peabody Institute, Baltimore, Md.

FIG. 86 William Henry Rinehart, study for *Leander*, ca. 1855. Graphite on paper, 8¼ × 5¼ in. (21 × 13.3 cm). Archives of the Peabody Institute, Baltimore, Md.

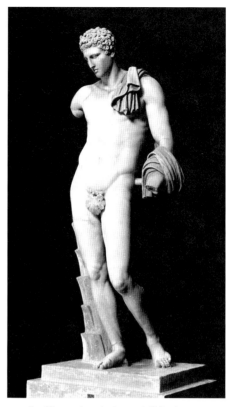

FIG. 87 *Hermes* (or *Antinuous*) *Belvedere*, Roman copy of Greek original, ca. 350 B.C. Marble, 76¾ in. (194.9 cm) high. Vatican Museums, Rome

tiche of working from both casts and life. The spare use of line connotes emphasis on contour and profile.

As his conception of *Leander*'s form evolved, Rinehart relied on a number of sources, ranging from the Hellenistic period to the Renaissance. The most precise comparison proffered relates *Leander* to a copy of the *Hermes* (or *Antinuous*) *Belvedere*, possibly by Praxiteles, in the Vatican Museums (fig. 87).[10] Modern analysis categorizes the work as an example of *surface classicism*, in which the sculptor appropriated from antique works the surface treatment, style of modeling, pose, anatomical proportions, and subject matter. Alterations have been made, such as subtle shifts in the location of each arm and the repositioning of the left leg. This more open stance connects the work to Michelangelo's *David* of 1501–4, which Rinehart knew from his stay in Florence. Despite this second debt, *Leander*'s smooth surfaces, gentle transitions, attenuated proportions, and graceful pose all reinforce an attitude close to Praxiteles' work.

With the hair, Rinehart permitted himself at least one more extrapolation from an antique source. The sculptor endowed *Leander* with triangular tufts of tousled hair that appear almost flamelike in

their agitation by the wind. This hairstyle, though less unruly, recalls *The Apoxyomenos* of ca. 325–300 B.C. by Lysippos (Vatican Museums, Rome). Interestingly, Lysippos's attenuation of the canon of proportion of the human body profoundly influenced the Hellenistic sculpture that Rinehart utilized for *Leander*. Thus, the American cast a wide net and delighted in fusing disparate elements into his own harmoniously pleasing creation.

Notes

1. Rinehart, Account Book, 1858–62, Oct. 16, 1860, p. 38; Rinehart papers, Peabody Institute archives, Baltimore. This account is in the name of Felice Passavanti, who is noted in the back of the book as being a pointer, the craftsman who translates the measurements of the plaster model to the marble block.

2. Account Book, 1858–62, Nov. 17, 1860, p. 14. Rinehart seems to have organized his account book by payment to specific craftsmen, in this case, Giovanni Giacomo, who is listed as preparing plinths and pedestals.

3. "Sculptors and Sculpture," *Cosmopolitan Art Journal* 4 (Dec. 1860), 181.

4. Rinehart, "Libra Maestro," May 9, 1865, p. 113, Rinehart papers, Peabody Institute archives, Baltimore. The following year Clark ordered the first copy of Rinehart's *Hero*.

5. Rinehart, "Libra Maestro," Sept. 10, 1870, p. 62. The account was under the name Clevice Leone, who was listed as a finisher.

6. *Elenco della 1.a e 2.a vendita volontaria al pubblico incanto degli oggetti appartenuti alla chiara memoria W. H. Rinehart, scultore americano* (Rome, 1875), p. 2, no. 13, in Rinehart papers, Peabody Institute archives.

7. Tuckerman 1867, p. 592. "Death of Rinehart, the Sculptor," *Baltimore Weekly Sun*, Oct. 31, 1874, n.p., Rinehart papers, Peabody Institute archives. Assuming Riggs acquired the version either Mrs. Henry or Edward Clark owned, this would indicate that there were at least three copies of *Leander* produced, and that one is still at large.

8. Ross and Rutledge 1948, p. 28. There does not appear to be any concrete evidence that the Riggs ownership and the Baillière ownership are connected, however. Mr. Ricau recalled tracking Mrs. Baillière down through the reference in Ross and Rutledge, probably in the late 1950s or early 1960s; interview with James H. Ricau, Piermont, N.Y., Oct. 4, 1990.

9. Rinehart, Sketchbook H, ca. 1858, Rinehart papers, Peabody Institute archives, AAA, roll 3116, frames 986, 1014.

10. Crawford, "The Classical Tradition in American Sculpture" (1979), pp. 39–40.

49
Portrait of Otis Angelo Mygatt
Modeled ca. 1868, carved 1874
Marble
41⅞ × 14¾ × 12¼ in. (106.4 × 37.5 × 31.1 cm)
Inscribed at left of base: *Wm. H. Rinehart.
Sculpt. Rome. 1874*

Provenance Sarah Matilda Robertson
Mygatt, New York; Otis Angelo Mygatt,
Paris, until ca. 1938–48; . . . ; [Christie's,
New York, May 31, 1985, lot 19]; [Kennedy
Galleries, New York]; James H. Ricau,
Piermont, N.Y., 1985

Exhibition History The Metropolitan
Museum of Art, New York, 1890s; *The
Ricau Collection*, The Chrysler Museum,
Feb. 26–Apr. 23, 1989

Literature "American Studio Talk,"
Studio 8 (Sept. 1899), x; Ross and Rutledge
1948, p. 60, no. 112

Versions PLASTER National Museum of
American Art, Washington, D.C.; MARBLE
VARIANT *Henry Elliot Johnston, Jr., as
"Cupid Stringing His Bow,"* National
Museum of American Art, Washington,
D.C.

Gift of James H. Ricau and Museum
Purchase, 86.515

WILLIAM HENRY RINEHART's personality
and down-to-earth temperament
endeared him to the wealthy self-made
Americans who embarked on the grand
tour after the Civil War. In return, they
provided him with financial security
through the portraits they commissioned.
Records show he received orders for more
than 110 likenesses, and his clientele
ranged far beyond the prominent citizens
of Baltimore.[1] He was in such demand
that the time between commission and
execution for these portraits was often
two or three years. The modeling, by
necessity, would be done in a timely fash-
ion, because of the sitter's limited time in
Rome. This was the case for the portrait
of Otis Angelo Mygatt, ordered in March
1868 but not completed until 1874, the year
of Rinehart's death.[2]

Sarah Mygatt, whose portrait Rinehart
made in 1860, requested full-length por-
traits of her two young boys, Robertson
and Otis, for 160 pounds each. Robertson
was to be depicted seated holding a bird's
nest, while Otis was to be portrayed as
Cupid stringing his bow. These were con-
ventional poses for children. The image
had ample precedent in sculpture ranging
from Bertel Thorvaldsen (q.v.) back to
antiquity. The statue *Cupid with Bow* in
the Capitoline Museum in Rome may
have offered the most convenient source.

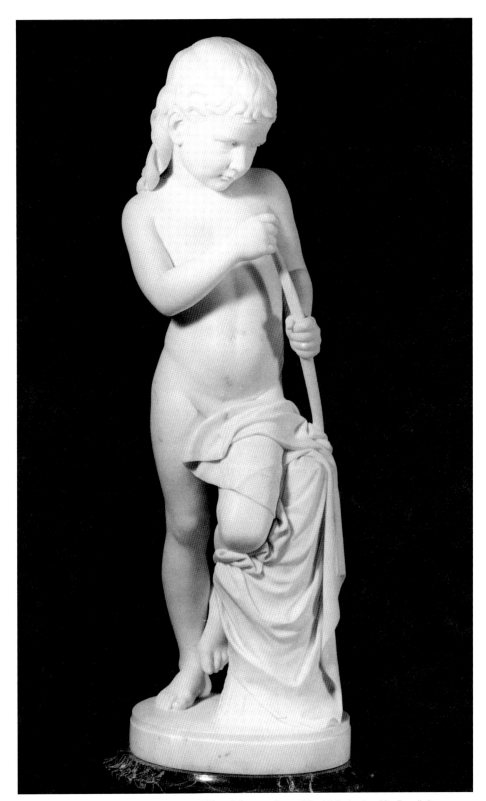

FIG. 88 William Henry Rinehart, *Henry Elliott Johnston, Jr., as "Cupid Stringing His Bow,"* 1874.
Marble, 42⅝ in. (108.3 cm) high. National Museum of American Art, Smithsonian Institution, Bequest
of Harriet Lane Johnston Collection, 1906.9.16

Rinehart avoided overt reference to the
mythological figure by eliminating the
wings, and his image conveys an unen-
cumbered innocence.

Given a child's restlessness, Rinehart
would have taken only a likeness of the
head and incorporated it into a generic
composition. This type of sculptural graft
is uncommon, although it is reiterated in
the commission Rinehart received from
Henry Elliot Johnston, Jr.'s, family during
the sculptor's last visit to Baltimore in
1872. Rinehart took a likeness of the young
boy's head in clay and then incorporated

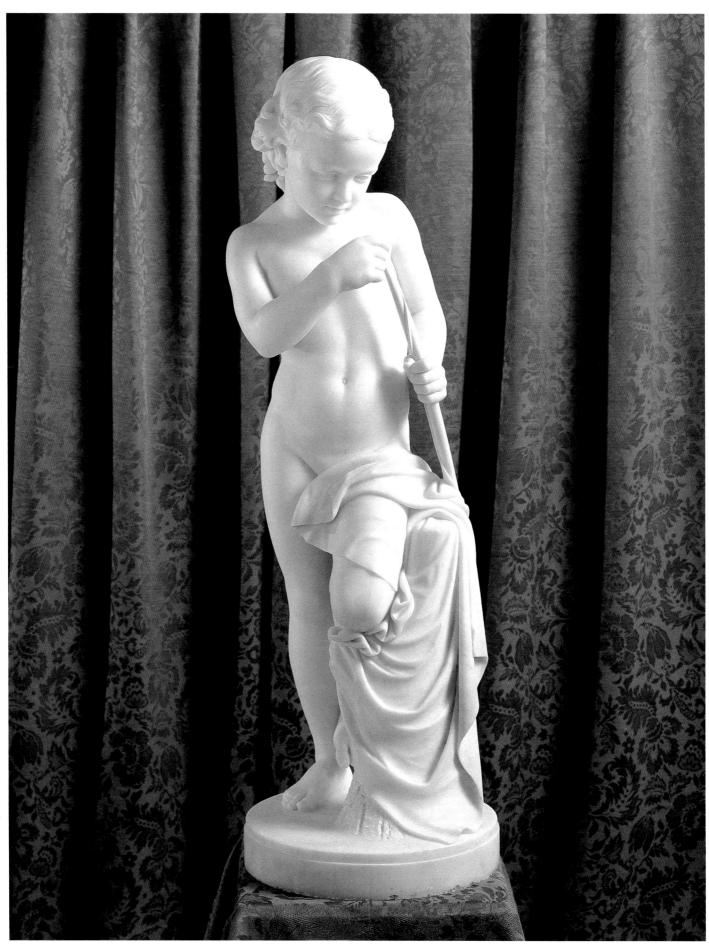

Cat. no. 49 Rinehart, *Portrait of Otis Angelo Mygatt*

it into the Cupid form he was using for Mygatt when he returned to his studio in Rome (fig. 88).

Rinehart infused the generic sculptural form with a convincing naturalism. The body has a soft, fleshy quality; the drapery is carefully rendered, and the pose transmits the feeling of a boy absorbed in his own private world. Rinehart captured the intense concentration a young child can bring to a task, which was remarkable given the sculptor's bachelorhood. The facial features and hair have a particularity that verifies its function as a portrait. This concern for individuality is corroborated by comparing the image of Mygatt with that of Johnston, whose hair falls down the back of his neck in distinctive ringlets. This engaging portrait provides a utilitarian balance to the sculptor's important ideal pieces.

Little is known about Otis Mygatt or his family. Both portraits of the Mygatt children were on loan to the Metropolitan Museum at the end of the century.[3] The critic for the *Studio* preferred the image of Otis, because the pose "was not a hackneyed one." After Mrs. Mygatt's death, the pieces passed to the children. Otis Mygatt married Elizabeth McClellan Greene in 1902 and moved to Paris. He and his wife had no children, and the sculpture was auctioned in the late 1930s or early 1940s.[4] It resurfaced at Christie's in 1985, and Ricau subsequently acquired it through private sale.[5]

Notes

1. Ross and Rutledge 1948, pp. 48–70.
2. Rinehart, "Libra Maestro," Mar. 16, 1868, p. 122, Rinehart papers, Peabody Institute archives, Baltimore.
3. "American Studio Talk," *Studio* 8 (Sept. 1899), x.
4. Ross and Rutledge 1948, p. 60.
5. Christie's, New York, May 31, 1985, lot 19, and interview with James H. Ricau, Piermont, N.Y., June 23, 1991.

50
Clytie

Modeled ca. 1869, carved ca. 1871–72
Marble
47⅜ × 13⅛ × 15¾ in. (120.3 × 33.3 × 40 cm)
Inscribed at left of base: *Wm. H. Rinehart. Sculpt. Roma*

Provenance E. H. Pember, Hertfordshire, England; . . . ; James H. Ricau, Piermont, N.Y., by 1961

Exhibition History *The Ricau Collection*, The Chrysler Museum, Feb. 26–Apr. 23, 1989

Literature Anne Brewster, "American Artists in Rome," *Philadelphia Bulletin*, June 15, 1869, p. 2; "Art Notes," *New York Albion*, Dec. 18, 1869, p. 767; Osgood 1870, p. 422; S., "In Memoriam," *Boston Daily Evening Transcript*, Nov. 3, 1874, p. 6; Harold N. Fowler, *A History of Sculpture* (New York, 1916), p. 391; Post 1921, 2:236; Adams 1923, p. 43; Taft 1924, pp. 175–176; Ross and Rutledge 1948, pp. 21–22, no. 8; William H. Gerdts, "American Sculpture", *American Artist* 26 (Sept. 1962), 45, 69; id., "American Sculpture: The Collection of James H. Ricau," *Antiques* 86 (Sept. 1964), 296, ill., 298; Gardner 1965, pp. 24–25; Craven 1984, p. 294; Russell Lynes, *The Art Makers of Nineteenth-Century America* (New York, 1970), p. 129; William H. Gerdts, "Marble and Nudity," *Art in America* 54 (May–June 1971), 62; Gerdts 1973, p. 55; Headley 1988, pp. 326–328, 340–341; Vance 1989, 1:260–261

Versions MARBLE (life-size) The Metropolitan Museum of Art, New York; Peabody Institute, The Johns Hopkins University, Baltimore; private collection, Scotland

Gift of James H. Ricau and Museum Purchase, 86.514

By the end of the 1860s William Henry Rinehart felt secure enough artistically and financially to embark on a nude female figure. Such a subject represented the epitome of ideal beauty and a natural goal for any sculptor. Earlier efforts by Hiram Powers (q.v.) and Erastus Dow Palmer (q.v.) had already established acceptance of the nude. Powers's *Greek Slave* (fig. 13) and Palmer's *White Captive* (MMA) met with enthusiastic response, and, in each case, the sculptor created an appropriate context of Christian justification for the work. These statues were said to possess a spiritual nudity. Rinehart, in selecting a pagan myth of unrequited love, did not adopt this tack but rather chose to celebrate physical beauty tempered by Platonic classicism.

FIG. 89 *"Clytie,"* Roman, ca. A.D. 40–50. Marble, 34 in. (86.4 cm) high. Copyright British Museum

Derived from Ovid's *Metamorphoses*, the myth of Clytie encountered modest artistic and literary attention through the years. Best known was the celebrated antique bust of Clytie, the prized possession of the English antiquarian Charles Townley, who bequeathed it to the British Museum (fig. 89).[1] Nineteenth-century English poets such as Thomas Moore and Thomas Hood made reference to Clytie, and William Wetmore Story (q.v.) published a poem about her in 1847.[2]

Clytie's story is unusual because it deals with a mortal who falls in love with a god instead of the more common, reverse situation. She was a water nymph who loved the sun god, Apollo. But he did not return her ardor, and for nine days Clytie sat on the ground, her eyes fixed on Apollo as he traveled across the sky. She did not eat and drank only her tears and the dew. Finally, Apollo turned her into a sunflower, and since Clytie was so enamored of the sun god, the sunflower always turns its head toward the sun. As a result, the sunflower has come to stand as a symbol of constancy.[3]

Rinehart depicted his subject standing in a relaxed pose with her head downturned in a moment of wistful contemplation. Her right leg is supported by a tree stump around which a number of sunflower plants grow, and the sculptor alluded to Clytie's imminent transformation as well as the constancy of her devotion through the sunflower she holds in her right hand. He imbued the work with an abstract, intellectual construction that

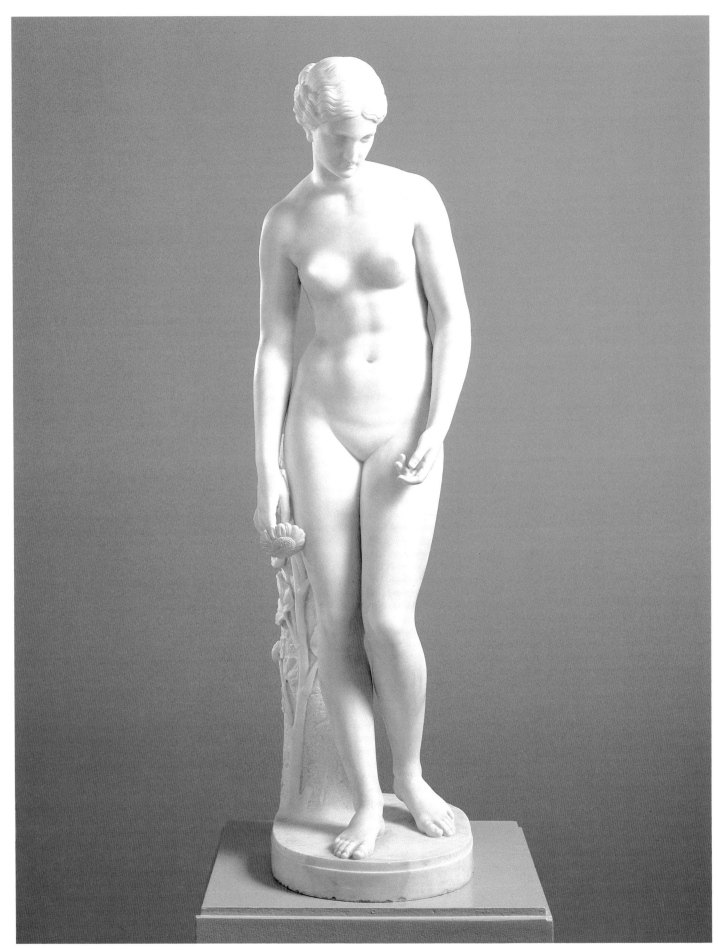

Cat. no. 50 Rinehart, *Clytie*

did not contain the emotional charge of a *Greek Slave* or *White Captive*. Rinehart began *Clytie* in early 1869, and by June it was far enough along for a correspondent of the *Philadelphia Bulletin* to acknowledge it as one of the sculptor's most graceful and beautiful works.[4] In January 1870 Rinehart wrote his major patron, William T. Walters, that *Clytie* was almost finished and that he would send him a photograph as soon as it was done.[5] The use of photography was not unique to Rinehart, and many sculptors found it useful in keeping patrons back in America apprised of their recent work.

Another aspect of Rinehart's working method surfaced in a commentary in the August 1870 issue of *Harper's New Monthly Magazine*. Samuel Osgood, reporting on his recent visit to artists' studios in Italy, recalled stopping to see Rinehart when he was working on *Clytie*. He was impressed that the sculptor was using a live model for the arms and that she was one of six models Rinehart employed to complete the figure.[6] This practice accounts for the sculptor's fusion of anatomical accuracy with his ongoing admiration for classical sculpture.

Clytie's pose echoes the *Aphrodite of Cyrene*, which was accessible to Rinehart in the Terme Museum in Rome. Given the antique statue's lack of head and arms, Rinehart had great latitude for interpretation. He altered the position of her left arm, letting it rest at the figure's side rather than extend away from the body. Rinehart further attenuated the Lysippic proportions of the figure so that she takes on an elongated elegance that nearly removes her from the realm of human anatomy.

Clytie quickly came to be recognized as Rinehart's masterpiece, and numerous important collectors were attracted to it. The original life-size copy was ordered in 1870 by Charles Gordon of Cleveland, Ohio. Two more were cut by March 1872 when Rinehart informed Walters that he had sent a copy to the Royal Academy. This one had sold so he was sending the other to Baltimore in hopes that Walters could dispose of it.[7] Presumably, this is the copy that the prominent Baltimore patron John McCoy bought and gave to the Peabody Institute. The one delivered to London was probably purchased by another Rinehart enthusiast, William Herriman, who later gave it to the Metropolitan Museum of Art. Herriman was responsible for disposing of Rinehart's studio and was concerned about a *Clytie* that remained unsold. Patrick Allen Fraser of Scotland bought it just before Herriman received an offer from Walters on behalf

of William W. Corcoran. Corcoran felt so strongly about the merit of the work that he requested a plaster cast, as did the British Academy in Rome. Rinehart's executors honored these requests.[8]

Of the five marble replicas recorded, all but one are listed as "large size."[9] Thus, it is likely that the Ricau version is the smaller replica ordered in 1871 by E. H. Pember of Hill House, Hertfordshire, England. Unfortunately, any subsequent history and how it passed into Ricau's collection remain a mystery, but *Clytie* endures as one of Rinehart's most beautiful works.

Notes

1. B. F. Crook, *Greek and Roman Art in the British Museum* (London, 1976), p. 181. The identity as Clytie has been questioned; it was based, in part, on the petal motif around the base that the figure emerges from, but Crook dismisses this and suggests that it may be a portrait of Antonia, the daughter of Marc Antony and mother of Claudius.

2. See *Bulfinch's Mythology*, comp. Bryan Holme (New York, 1979), p. 122; for Story, see Douglas Bush, *Mythology and the Romantic Tradition in Poetry* (New York, 1957), p. 578.

3. *Bulfinch's Mythology*, p. 122.

4. Anne Brewster, "American Artists in Rome," *Philadelphia Bulletin*, June 15, 1869, p. 2.

5. Rinehart to Walters, Jan. 2, 1870, Rinehart papers, Peabody Institute archives, Baltimore.

6. Osgood 1870, p. 422.

7. Rinehart to Walters, Mar. 18, 1872, Rinehart papers, Peabody Institute archives. *Clytie* was no. 1524 in the 1872 exhibition of the Royal Academy; see Algernon Graves, *The Royal Academy of Arts: A Complete Dictionary of Contributors and Their Work from Its Foundation in 1769 to 1904*, 8 vols. (London, 1906), 6:303.

8. Ross and Rutledge 1948, pp. 21–22.

9. Ibid., p. 22.

Woman in Mourning

Attributed to William Henry Rinehart
N.d.
Marble
48 × 18⅞ × 15⅝ in. (121.9 × 47.9 × 34.6 cm)
No inscription

Provenance [unidentified antique shop, University Place, New York]; James H. Ricau, Piermont, N.Y.

Exhibition History *The Ricau Collection*, The Chrysler Museum, Feb. 26–Apr. 23, 1989

Literature Ross and Rutledge 1948, p. 22, no. 9 (?)

Versions None known

Gift of James H. Ricau and Museum Purchase, 86.511

This sculpture of a three-quarter life-size female figure nearly enshrouded by her drapery and holding a rootlike branch in her left hand eludes unequivocal assignment to the hand of William Henry Rinehart. It is neither signed nor explicitly listed in the sculptor's "Libra Maestro," or order book, and the provenance offers no clues.[1] The closest reference in the literature is to *Female Figure, Fully Draped*. According to correspondence with Frank B. Mayer in September 1856, Rinehart mentioned sketches too preliminary to assess.[2] Despite the absence of documentation, the pose and sentiment of the figure bear an affinity to Rinehart's mature funerary works, such as the Walters Monument in Baltimore and the Paine Monument in Troy, New York.

The title, *Woman in Mourning*, is a modern assignation, since attempts to ascertain the work's precise iconography have proved futile. Central to decoding this puzzle is the identification of the rootlike branch, which has suggested to some the acanthus plant and to others the mandrake root (fig. 91).[3] Both have a strong connection to classical antiquity and would be consistent with the figure's appearance. There is no consensus, however, since several authorities deem these identifications unlikely.[4] Another possibility may be found in nineteenth-century funerary imagery such as the willow tree or young branches with shoots—signifying the death of a young child.[5] Whatever the source, there is a compelling association with death, and the demeanor of the figure, especially her shrouded head and downcast gaze, reinforces this hypothesis.

Several formal and stylistic clues place this piece in Rinehart's oeuvre. The stance and tilt of the head recall the figure in the

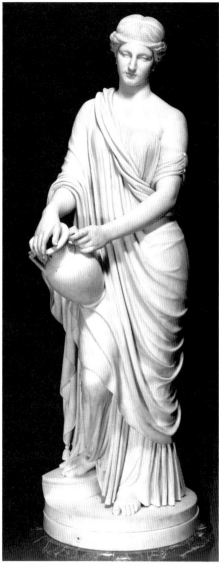

FIG. 90 William Henry Rinehart, *The Woman of Samaria*, 1861. Marble, 65 in. (165.1 cm) high. Walters Art Gallery, Baltimore

FIG. 91 Attributed to Rinehart, *Woman in Mourning*, detail of root

Paine Monument as well as *The Woman of Samaria* (fig. 90). The elements of grace, dignity, simplicity, and melancholy, which earned the latter piece high praise from the *Crayon* in April 1861, also emanate from the mysterious draped figure.[6] These statues share a similar objective of grandeur, which the sculptor sought to achieve with simplicity and severity.[7]

In his figures derived from antique subject matter, Rinehart relished the rendering of drapery, especially the folds. While not as complex or busy as the drapery in *The Woman of Samaria*, the garb of the draped figure possesses a similar columnar quality through the vertical folds and the diaphanous areas, where the material stretches across the body to reveal the anatomy underneath. Other elements are paralleled in Rinehart's *Antigone* (PIBM),

where corners of the dress contain similar oval pendants. Common to all three works is a crisp, sinuous elegance to the drapery folds.

Treatment of the anatomy also argues for Rinehart's authorship. Although the features are more delicate and a greater refinement is apparent in the signature pieces, a decided sympathy is evident. The heads all possess an elegance enhanced by the aquiline noses and graceful proportions. Other details betray a commonality, particularly the accomplished transition from the nose to the eye sockets and the sensitive rendering of the lips. The eyes of the draped figure are not as prominent, and the eyelids are less pronounced, especially the lower ones that lack the crisp articulation that recesses the eyes. Nevertheless, they convey a similar sense of mood, and the three statues share a poignant wistfulness. The hands and fingers have a delicacy and refinement consistent with Rinehart's work. The feet, however, have none of the detail or sophisticated articulation of those of *The Woman of Samaria* or *Antigone*. Whatever detail existed in the feet of the draped figure has been effaced by weathering. While the figure wears a sandal similar to the platform type of *Antigone*, it is devoid of credibility. All three pieces share an emphatic frontality that underscores the static effect. Despite its omission from Rinehart's documented output, *Woman in Mourning* conveys enough of his stylistic treatment to warrant inclusion in his oeuvre.

Notes

1. Mr. Ricau recalled that he acquired the piece from an antique shop, possibly Cherif on University Place in New York. But he did not remember when; interview with James H. Ricau, Piermont, N.Y., Oct. 4, 1990.

2. Listed as no. 9 in Ross and Rutledge 1948, p. 22.

3. The acanthus plant was suggested by Elizabeth Milleker, associate curator of Greek and Roman Art, The Metropolitan Museum of Art. She connected it with its use as an akroterion on top of grave monuments in the classical period in Greece. In Roman times, the acanthus plant, along with other vegetation, may have symbolized the wealth of the Golden Age; see Erika Simon, *Ara Pacis Augustae* (Tübingen, 1967), p. 13. I am grateful to Dr. Milleker and Thayer Tolles for their insights on this matter.

The mandrake root has been known since antiquity to possess narcotic powers. It was used as an anaesthetic with the caveat that overdosage could cause death. The root has traditionally been the emblem of the Greek Society of Anaesthetists; see Hellmut Baumann, *The Greek Plant World in Myth, Art, and Literature*, trans. and aug. William T. Stern and Eldwyth Ruth Stern (Portland, Oreg., 1993), p. 108. I am indebted to Elizabeth Lipsmeyer for first calling my attention to the mandrake root and to Dana Parker of the Norfolk Botanical Garden for the information about the Greek context.

4. Specialists from the Horticultural Library of the Smithsonian Institution questioned these identifications and could provide no definitive alternative; also any connection of the figure to an antique source remains elusive. I am indebted to Marca Woodhams of the Smithsonian, Bernard Jackson of the Graeco-Roman Department of the British Museum, and Marjorie Trusted of the sculpture department of the Victoria and Albert Museum for their efforts on my behalf.

5. The willow, as well as other plant forms, were common symbols in nineteenth-century funerary imagery; see Blanche Linden-Ward, *Silent City on a Hill: Landscapes of Memory and Boston's Mount Auburn Cemetery* (Columbus, Ohio, 1989). My thanks to Jonathan Fairbanks and Jeannine Falino, Department of American Decorative Arts, Museum of Fine Arts, Boston, for their assistance in this matter.

6. "Sketchings. Domestic Art Gossip," *Crayon* 8 (Apr. 1861), 96.

7. Rinehart to Frank B. Mayer, Nov. 6, 1860, cited in Ross and Rutledge 1948, p. 39.

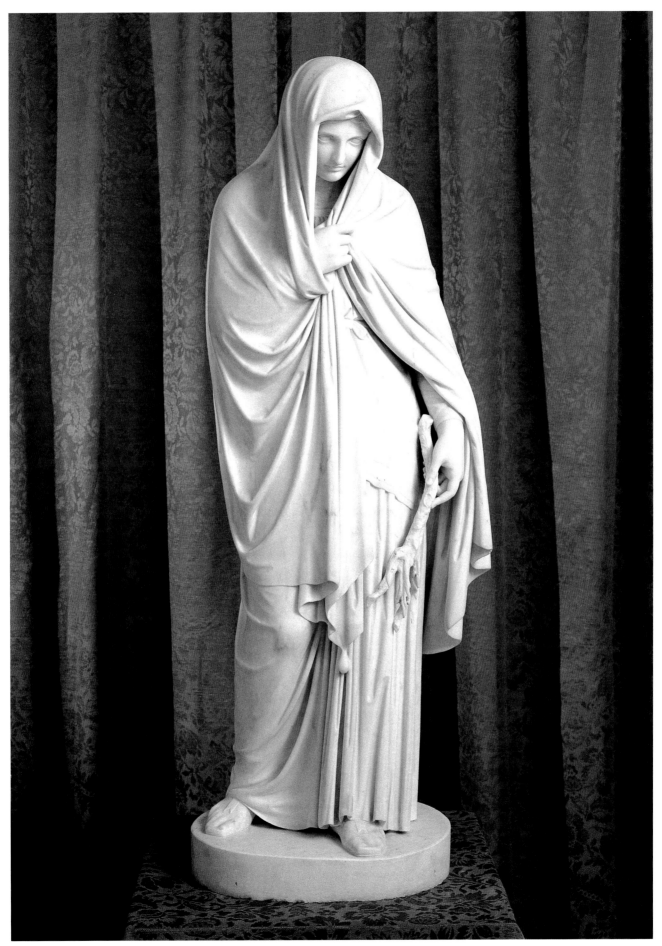

Cat. no. 51 Attributed to Rinehart, *Woman in Mourning*

Randolph Rogers

American, 1825–1892

When Randolph Rogers died in 1892, the president of the prestigious Academy of St. Luke in Rome honored its first American academician by eulogizing:

An American by birth, he had as his second mother-country this Rome, which gave him Life in the Art that made him famous; with the Art he pursued in masterly fashion, he honored both his countries; by attaining through the inspiration of one of the works of his genius, by enriching the other one by the works themselves, which will be a lasting monument of her glory.[1]

So complete was Rogers's embrace of Italy that he joined his wife, Rosa, under the tomb monument he designed in the Campo Verano, Rome's chief cemetery. America, however, was the principal beneficiary of his artistic talent, despite the close relationship he had with his adopted country.

Randolph Rogers was born in Waterloo, New York, in 1825.[2] His father was a mill-wright who moved west in successive stages, and by 1834 the Rogers family had settled in Ann Arbor, Michigan. Details of the sculptor's formative years are sketchy, but he was initially apprenticed to a baker. He abandoned this calling to become a clerk in a dry-goods store, supplementing his income with occasional freelance illustrations for Ann Arbor's newspaper. Motivated by his sideline, Rogers moved to New York around 1847 to train in an engraver's office. This ambition was not realized, and Rogers settled for employment in the dry-goods store of John Steward and Lycurgis Edgerton. Despite this setback, Rogers continued to pursue his artistic calling, drawing and modeling in his spare time. Impressed with their young employee's industry and talent, the two merchants sympathized with his desire to go to Italy to study sculpture. In 1848 they financed a trip to Florence for Rogers.

Why Rogers chose Florence remains unclear, although it has been suggested that Horatio Greenough's (1805–1852) presence may have been a determining factor.[3] However, Greenough's diminished activity and Hiram Powers's (q.v.) reluctance to take on pupils forced Rogers to seek Italian mentors and place himself under the tutelage of Lorenzo Bartolini (1777–1850). The elderly Bartolini's neoclassicism had been tempered by a blend of naturalism and romanticism, which set his teaching apart from the more severe doctrine to be found in Rome. Rogers's earliest recorded work was a bust of Lord Byron.

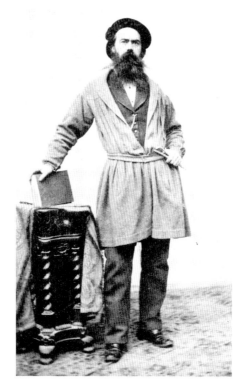

Photograph of Randolph Rogers. Photograph courtesy of Valentine Museum, Richmond, Va.

With Bartolini's death in 1850 and Greenough's departure for America in 1851, the sculptural profession in Florence was eviscerated. Feeling this lacuna and having achieved competency in modeling clay, Rogers moved to Rome. He gave no thought to returning to America, since he had never learned to carve in marble and adopted the customary procedure of leaving this task to a plentiful supply of Italian assistants.

In 1851 Rogers settled in Rome's English-speaking community, where he operated a studio for the next twenty years. He embarked on the standard practice of balancing portraiture with ideal works. In the latter category, *Ruth Gleaning* of 1853 (cat. no. 52) garnered him his first major recognition and financial security. The following year he continued to establish himself as a masterful interpreter of narrative through works such as *The Truant* (NMAA) and *Atala and Chactas* (Tulane University Art Collection, New Orleans). He assured his enduring fame and prosperity with the creation of *Nydia, the Blind Flower Girl of Pompeii* (BMFA) in 1855.[4]

This melodramatic work epitomized the sculptor's ability to capitalize on the prevailing penchant for sentimentality. Based on Sir Edward Bulwer-Lytton's popular novel, *Last Days of Pompeii*, which had been published in 1834, the sculpture depicted a young blind girl's valiant attempt to find her friends and lead them to safety in the wake of the eruption of Mount Vesuvius. Rogers deftly reinforced the theatrical drama of the scene by infusing his composition with an easily recognizable pose and expression taken from antique sources, especially Hellenistic ones. The sculptor marketed the work masterfully, offering a nearly life-size and a reduced two-thirds-scale version that were priced accordingly. So great was the demand that one visitor to Rogers's studio recounted seeing seven *Nydia*s being carved in a row.[5] This assembly-line approach brought Rogers criticism, but *Nydia*'s popularity required this technique, since he had so many orders.

Although work on *Nydia* dominated the latter part of 1855, Rogers returned to America in the spring to talk with the committee who awarded him his first public commission, a statue of John Adams for a chapel in Mount Auburn Cemetery in Cambridge, Massachusetts (transferred to Harvard University, Cambridge, Mass.). During his brief stay in America, the sculptor lived and worked at the National Academy of Design in New York. He visited his original sponsors and rewarded their faith with portrait busts. He also created a model of Adams that satisfied the committee and successfully negotiated his most important commission, the impressive bronze doors for the east entrance to the rotunda of the United States Capitol.[6] Rogers's presence in America possibly lulled the commission into thinking the work would be created on American soil, but this was not to be the case. Despite strong antiforeign sentiment, the sculptor argued persuasively for having the doors cast in Europe.

To avoid conflict with Thomas Crawford's (q.v.) designs for the doors to the House and Senate wings, which focused on the accomplishments of Washington, Rogers suggested honoring Christopher Columbus. In terms of design, however, both he and Crawford shared a debt to Lorenzo Ghiberti's renowned early-fifteenth-century doors for the Baptistery in Florence. Rogers completed his task by 1858, but the doors were not cast until 1861, and the installation did not take place until 1863. A rich conglomeration of tympanum, relief panels, portrait and allegorical sculpture, the doors satisfied the requirements for an impressive sculptural statement for an imposing architectural program. Despite myriad problems, Rogers's achievement set the standard for subsequent commissions in America.

Rogers's association with Crawford on commissions for the Capitol, his growing reputation, and his ties to Richmond

through marriage prompted Governor Wise of Virginia to ask the sculptor to complete the Washington Monument in Richmond. This had been left in limbo by Crawford's death in October 1857. This project, like William Henry Rinehart's (q.v.) assignment to complete the Capitol doors, required following through with extant plans as well as executing original ideas. Through modifications, Rogers enhanced Crawford's concern for immediacy and accuracy with an ennobling spirit of heroism and bravery. To some, Rogers's figures of Meriwether Lewis and Thomas Nelson for the monument in Richmond signal the highest achievement in portraiture.[7] Thus, within the first decade of settling in Rome, Rogers established himself as one of the major forces in American sculpture.

The pace of the 1860s was just as frantic for the sculptor. In addition to the inevitable demand for portrait busts, Rogers embarked on several ideal and allegorical pieces such as *The Somnambula* (NMAA), *Isaac* in two versions (cat. no. 53), *Children Playing with a Tortoise,* and the companion pieces *Indian Fisher Girl* and *Indian Hunter Boy* (Elvehjem Museum of Art, Madison, Wisc.). But he devoted the majority of his energy to public monuments. In 1865 Mrs. Samuel Colt commissioned Rogers to create a monument for her recently deceased husband, the inventor of the revolver. In *The Angel of the Resurrection* (Cedar Hill Cemetery, Hartford, Conn.), Rogers displayed his ongoing facility with biblical themes.

The Civil War generated substantial demand for civic monuments, and from 1865 until the early 1870s the sculptor was inundated with significant, often multifigured commissions commemorating combatants in cities ranging from Cincinnati and Detroit to Gettysburg and Providence. Personal as well as artistic appeal brought him success. As one visitor to Rome put it: "He is himself full of muscle and animal spirit, and there is a dash of vigorous life in all his statues that makes him an especial favorite with American committees."[8]

The final twelve years of Rogers's career saw little change in his activity, although he relocated his studio to more spacious quarters in a palazzo inhabited by Chauncey B. Ives (q.v.) and Rinehart. In 1870 he joined the legion of sculptors who created a monument to Abraham Lincoln, 1868–70 (Fairmount Park, Philadelphia). Demands on his time and creative energy were so great that he largely recycled the pose for his *William Seward* of 1875 (Madison Square, New York), and he was severely criticized for this unimaginative adaptation. His last important public commission came in 1877 for a winged Victory–type figure for the dome of the Connecticut State Capitol in Hartford. *The Genius of Connecticut,* as it was called, stood in place for nearly sixty years until a hurricane in 1938 caused enough damage to warrant its removal and destruction.

The other facets of Rogers's career did not go neglected, and he created several ideal pieces. *The Lost Pleiad* (The Art Institute of Chicago), created between 1874 and 1875, joined the list of his most popular efforts with more than one hundred replicas ordered. Taken from Ovid's *Fasti,* the subject was popular in nineteenth-century art and literature. Even for those to whom the subject was unfamiliar, the partially draped female striking a pose fraught with anxiety appealed to the sentimental sensibilities of the day. Rogers modeled his final work, *The Last Arrow* (MMA), in 1880. This equestrian group with two figures was among the most complex of his compositions, and the warrior on the ground, in evoking *The Dying Gaul,* reflected the sculptor's unyielding tribute to the classical past. Here Rogers focused on another aspect of American history and poignantly addressed the Indian's plight and inexorable decline.

In 1882 Randolph Rogers suffered a debilitating stroke that terminated his creative career. However, it did not prevent him from overseeing the ongoing production in his studio, which remained active until his death. He had ample time to reflect on a remarkably successful career. In 1873 he had been accorded one of the highest honors of the Academy of St. Luke, election as an academician of merit and professor in sculpture. Further recognition came in 1884 when the king of Italy knighted him and awarded him the order of Knight of the Crown of Italy. Despite his extraordinary assimilation into Italian culture and society, Rogers remained acutely mindful of his native heritage. He donated his plaster models to the University of Michigan Art Gallery. However, this important record suffered the fate of neglect and destruction that befell many collections, and only a small fraction survive today.

Rogers continued to live in splendor in his imposing town house on the Via Magenta. He maintained a wide circle of friends and provided a center of hospitality in Rome. This festivity ceased with the death of his wife, Rosa, in 1890, and Rogers's own declining health brought about his demise eighteen months later, in January 1892. Randolph Rogers's death marked the passing of an artist who had risen to extraordinary heights through initiative, discipline, and hard work. In addition to being a highly competent artist, he was an accomplished salesman. As a result, he never suffered financially and secured some of the most important public and private commissions in the third quarter of the nineteenth century. His legacy of straightforward naturalism was soon overshadowed by the artistic ferment erupting in Paris.

Notes

1. Soria 1982, p. 262. For the most recent account of Rogers, see Rogers 1971.

2. Rogers is usually listed as having been born in Waterloo, N.Y., although his passport application records Phelps, also in Wayne County. Passport number 10097, Oct. 16, 1848, Department of State, Washington, D.C., Passport applications, 1795–1905, *National Archives Microfilm Publication M 1372,* roll 23, General Records of the Department of State, records group 59, National Archives, Washington, D.C. I am grateful to Col. Merl Moore, Jr. for this information.

3. Rogers 1971, p. 13.

4. See Rogers 1971, pp. 32–40, and Jan Seidler Ramirez, *Nydia,* in BMFA 1986, pp. 155–158, for a thorough discussion of this work.

5. Armstrong, *Day before Yesterday* (1920), p. 194.

6. See Rogers 1971, pp. 41–68, for a complete account of this commission.

7. Craven 1984, p. 316.

8. Osgood 1870, p. 422.

Bibliography

Courtois, "Sculpture américaine. *Ruth,* statue en marbre," *Revue des Beaux-Arts* 4 (1853), 329–330; Greenwood 1854, p. 223; Florentia 1854, pp. 184–187; "Art in Florence," *Crayon* 2 (July 1855), 20–21; "Personal," *Home Journal,* June 11, 1859, p. 2; "Fine Arts Record—Foreign," *Fine Arts Quarterly Review* 2 (1864), 429; Walker 1866, pp. 101–105; Tuckerman 1867, pp. 591–592; "Randolph Rogers," *(Ann Arbor) Michigan Argus,* Dec. 6, 1867, n.p.: "Sculpture in the United States," *Atlantic Monthly* 22 (Nov. 1868), 559; Brewster 1869, pp. 196–199; "Fine Arts. Sculpture in America," *Albion,* Feb. 27, 1869, pp. 109–110; Osgood 1870, p. 422; "Fine Arts. Mr. Lincoln's Statue in Union Square," *Nation* 9 (Dec. 1, 1870), 373–374; James J. Jarves, "Visits to the Studios of Rome," *Art Journal* (London), n.s., 10, 22 (1871), 162–164; "Randolph Rogers in Rome," *Arcadian* 1 (Jan. 23, 1873), 11; "Honors to an American Artist," *San Francisco Daily Evening Bulletin,* Jan. 31, 1873, p. 2; "American Sculptors in Italy," *Aldine* 7 (Sept. 1874), 187; "Editor's Table," *Appleton's Journal,* n.s., 1 (Nov. 1876), 475–476; Clark 1878, pp. 75–80; S.P.Q.R., "American Studios in Rome. Randolph Rogers," *Boston Daily Evening Transcript,* Nov. 24, 1882, p. 6; Martin d'Ooge, *Catalogue of the Gallery of Art and Archaeology in the University of Michigan* (Ann Arbor, Mich., 1892), pp. 20–22; "Obituary," *New York Times,* Jan. 16, 1892, p. 5; "Randolph Rogers," *New York Herald* (Paris ed., Sunday supplement), Jan. 24, 1892, p. 3; "The Sculptor of the Doors of the Capitol," *Harper's*

Weekly 12 (Jan. 30, 1892), 116; "Randolph Rogers, the Sculptor," *Harper's Weekly* 12 (Feb. 6, 1892), 465; Waters and Hutton 1894, 2:218–219; Mary E. Phillips, *Reminiscences of William Wetmore Story, the American Sculptor and Author* (Chicago, 1897), p. 189; Henry S. Frieze, "Randolph Rogers," *Michigan Alumnus* 4 (Dec. 1897), 59–63; "American Studio Talk," *Studio* 8 (Sept. 1899), x; Taft 1924, pp. 159–170; Maitland Armstrong, *Day before Yesterday* (New York, 1920), pp. 194–197; William S. Rusk, "Randolph Rogers," *Dictionary of American Biography* (New York, 1935), 16:107–108; Donald C. Durman, *He Belongs to the Ages. The Statues of Abraham Lincoln* (Ann Arbor, Mich., 1951), pp. 38–40; Millard Rogers, "Randolph Rogers and the University of Michigan," *Michigan Alumnus Quarterly Review* 64 (Mar. 1, 1958), 169–175; Gardner 1965, pp. 25–27; Craven 1984, pp. 312–319; Rogers 1971; Jacqueline Simone Innes, "Belmont Statuary: Four Pieces," *Tennessee Historical Quarterly* 30 (Winter 1971), 369–378; Wilmerding et al. 1981, pp. 49, 60, 162–163; Penny Knowles, "Randolph Rogers," in *The Preston Morton Collection of American Art*, ed. Katherine H. Mead, exh. cat., Santa Barbara Museum of Art (Santa Barbara, Calif., 1981), pp. 128–132; Soria 1982, pp. 261–262; Hyland 1985, pp. 270–275; Vivien Green Fryd, "Randolph Rogers's *Indian Hunter Boy:* Allegory of Innocence," *Elvehjem Museum of Art Bulletin* (1986), 29–37; Fryd 1992, pp. 125–143; Stebbins et al. 1992, pp. 208–210 and passim; Rosa G. Rogers, "Biography of Randolph Rogers," unpublished manuscript, n.d., Michigan Historical Collections, Ann Arbor; "Diary of Henry S. Frieze: European Trip, 1855–1856," Michigan Historical Collections, Ann Arbor

52
Ruth Gleaning

Modeled ca. 1850, carved after 1853
Marble
35⅜ × 18⅞ × 18¼ in. (89.6 × 47.9 × 46.4 cm)
Inscribed at left rear of base: *Randolph Rogers, Rome*

Provenance Private collection, New York; James H. Ricau, Piermont, N.Y.

Exhibition History *The Ricau Collection*, The Chrysler Museum, Feb. 26–Apr. 23, 1989

Literature "American Artists in Florence," *Home Journal*, Aug. 31, 1850, p. 3; Andrew McFarland, *The Escape, or Loiterings amid the Scenes of Story and Song* (Boston, 1851), pp. 184–185; "Rogers," *Bulletin of the American Art-Union*, Apr. 1, 1851, p. 13; "Our Artists Abroad," *Home Journal*, Nov. 1, 1851, p. 2; "Movements of Artists," *Bulletin of the American Art-Union*, Nov. 1, 1851, p. 133; "Americans in Rome," *Boston Transcript*, Apr. 21, 1852, p. 2; "American Artists Abroad," *Home Journal*, June 26, 1852, p. 2; Courtois, "Sculpture américaine. Ruth, statue en

marbre," *Revue des Beaux-Arts* 4 (1853), 329–330; "Notice," *Charleston (S.C.) Courier*, Sept. 22, 1853, n.p.; Greenwood 1854, p. 223; Florentia 1854, p. 186; "Topics Astir. Randolph Rogers," *Home Journal*, Dec. 9, 1854, p. 2; "The Fine Arts," *Putnam's Monthly* 5 (Feb. 1855), 223–224; "Sketchings. Domestic Art Gossip," *Crayon* 4 (Apr. 1857), 123; Fuller 1859, pp. 270–271; J. Beavington Atkinson, "International Exhibition, 1862, No. VII: English and American Sculpture," *Art Journal* (London), n.s., 1, 24 (Dec. 1862), 231; "Randolph Rogers," (Ann Arbor) *Michigan Argus*, Dec. 6, 1867, n.p.; Huidekooper 1882, pp. 183–184; S.P.Q.R., "American Studios in Rome. Randolph Rogers," *Boston Daily Evening Transcript*, Nov. 24, 1882, p. 6; Martin d'Ooge, *Catalogue of the Gallery of Art and Archaeology in the University of Michigan* (Ann Arbor, Mich., 1892), p. 20; Waters and Hutton 1894, 2:219; Taft 1924, pp. 160–162; Gardner 1965, pp. 25–26; Rogers 1971, pp. 15–19, 83, 197–198; Gerdts 1973, pp. 68–69; Wilmerding et al. 1981, pp. 49, 60, 162–163; Penny Knowles, *"Ruth Gleaning,"* in *The Preston Morton Collection of American Art*, ed. Katherine H. Mead, exh. cat., Santa Barbara Museum of Art (Santa Barbara, Calif., 1981), pp. 128–132; Hyland 1985, pp. 272–273

Versions MARBLE (large version, ca. 46 in. high) The Detroit Institute of Arts; Hay House, Macon, Ga.; The Metropolitan Museum of Art, New York; The Newark Museum, Newark, N.J.; Virginia Museum of Fine Arts, Richmond; Woodmere Art Gallery, Philadelphia; [Sotheby's, New York, Feb. 1, 1990, lot 112]; [Spanierman Gallery, New York]; (smaller version, ca. 35 in. high) Albany Institute of History & Art, Albany, N.Y.; Belmont, Nashville, Tenn.; Santa Barbara Museum of Art, Santa Barbara, Calif.; The Museums at Stony Brook, Stony Brook, Long Island, N.Y.; The Toledo Museum of Art; JoAnn and Julian Ganz, Jr., Los Angeles; (undetermined size) Spencer Trask estate, Saratoga Springs, N.Y.

Gift of James H. Ricau and Museum Purchase, 86.519

Rᴜᴛʜ Gʟᴇᴀɴɪɴɢ is Randolph Rogers's first major ideal piece. Scholars generally credit him with modeling it in 1853 and exhibiting a marble copy at a private residence in Paris by September of that year.[1] Recently discovered references establish a considerably earlier date for its commencement and indicate that *Ruth* was Rogers's first religious subject. In August 1850 the *Home Journal* reported that Rogers was "engaged" on a statue of

Ruth.[2] In the fall of 1850 an American tourist in Florence visited Rogers's studio and reported seeing the model of *Ruth Gleaning* near completion.[3] The statue merited a substantial account in the April 1851 issue of the *Bulletin of the American Art-Union*, which gave an extensive description:

She is represented in an exceedingly graceful, half kneeling position, the drapery disposed with elegance, relieving the figure from all immodesty, and yet preserving the easy freedom of nature. The right hand, partially open, comes near the ground, while the left rests upon the thigh, holding a wheatsheaf. Emblems are scattered upon the earth. The head is turned slightly upward, (it is the moment Boaz appears before her,) with hair neatly arranged, in simple, natural tresses, and knotted behind.[4]

The work was described much as we know it today. In addition to an enthusiastic appraisal of the sculpture, the author mentioned that a patron of the arts in America had ordered a replica. An equally rapturous assessment appeared the following November that identified the purchaser as Dudley Selden, "from whose well-known taste and liberality the public will, no doubt, derive the opportunity of seeing the work on its arrival in the United States."[5]

Despite the patronage, the appearance of *Ruth Gleaning* in marble was not forthcoming, and its execution may have been delayed by Rogers's relocation from Florence to Rome at the end of 1851. A correspondent for the New York *Commercial Advertiser* reported in April 1852 that the statue was being cut in marble. He expressed hope it would be finished in time for the proposed Crystal Palace exhibition in New York.[6] Whether *Ruth Gleaning* came to America at this time is uncertain. It is known that Selden's copy was on view in Paris in September 1853.

A copy of *Ruth Gleaning* arrived in New York by December 1854, when she was shown in Rogers's studio at the National Academy of Design.[7] This replica was commissioned by John Steward, Rogers's early employer who had sent him to Italy to study sculpture, and it served as repayment of Rogers's debt to his benefactor. The initial exposure worked to the sculptor's advantage. *Ruth Gleaning* quickly gained favorable attention in Rogers's studios in both Rome and New York and became a cornerstone of his successful career.

Acclaim was not universal, however. Florentia, a correspondent for the *Art Journal*, enthused about her visit to Rogers's studio in 1854, but criticized *Ruth Gleaning*.[8] She accused the sculptor of succumbing to the epidemic of "Ruth

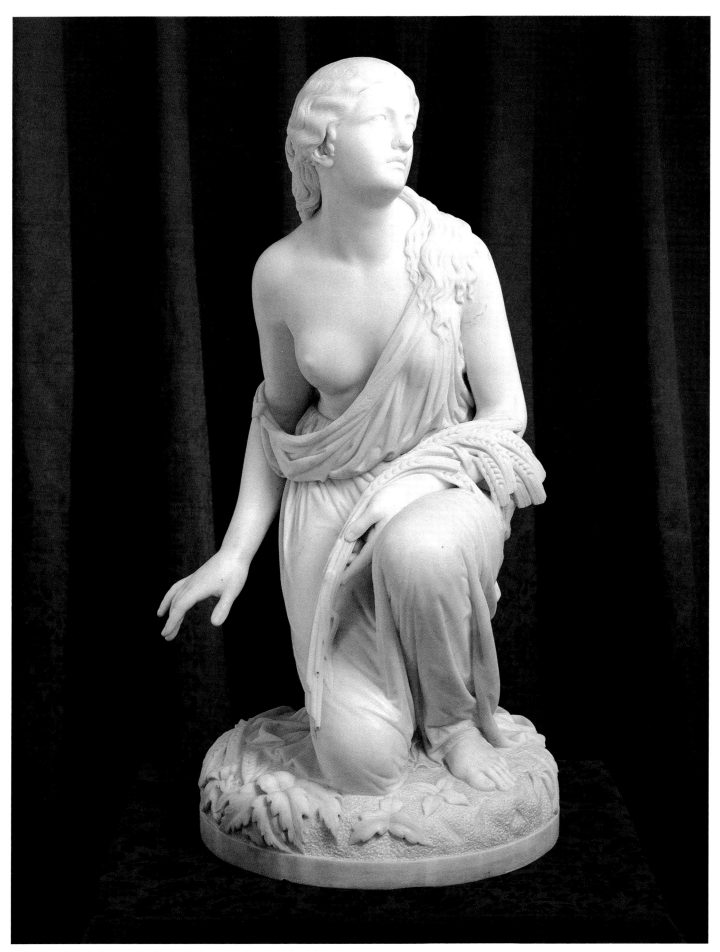

Cat. no. 52 Rogers, *Ruth Gleaning*

Fever" and creating a work indistinguishable from similar productions scattered among the studios in Rome. Her observation about the popularity of Ruth as subject matter was justified since she had been exhibited all over America in a variety of media.[9] This widespread exposure confirms Rogers's contention that taste was turning away from "heathen mythology" and that the Bible "will henceforth be the text-book of the artists."[10] By the mid-1850s, the Bible was in nearly every household, and the growing popularity of religious tracts may have contributed to an increased interest in visual representation of sacred themes.

Taken from the opening verses of Ruth, chapter II, *Ruth Gleaning* depicts the moment in the story of Ruth and Boaz when Ruth, working as a gleaner in the fields of the rich farmer Boaz, looks up and sees him for the first time. On the advice of her former mother-in-law, Naomi, who is related to Boaz, Ruth maintains a modest demeanor, showing her devotion to Boaz by lying at his feet one night as he sleeps in the field. Impressed by the qualities of her character, Boaz eventually takes Ruth as his bride.

In contrast to the earlier standing interpretation of Ruth created by Henry Kirke Brown (1814–1886) in 1845 (N-YHS), Rogers emphasized her humility by having her kneel at her task.[11] The sense of drama is tempered by elements of spontaneity. Ruth looks up with an expression of surprise that is reinforced by the gesture of her right hand. Not expecting to be interrupted, Ruth has allowed her loose garment to fall off her shoulder to reveal her right breast, but her association with chastity permits this without repercussion. The placement of Ruth's left hand holding several sheaves of wheat as it rests comfortably on her left thigh conveys a final note of informality. Consequently, Rogers struck a balance between the theatrical and the prosaic, which he reiterated in the sculptural treatment.

While *Ruth Gleaning* evokes a classicism reminiscent of the *Crouching Venus* (Vatican Museums, Rome) to which it is often compared, Rogers's Florentine beginnings suggest a more contemporary source in the guise of his mentor Lorenzo Bartolini (1777–1850). Modern scholarship has pointed to the significance of Bartolini's *Faith in God* (Poldi Pezzoli Museum, Milan) and *Thankfulness* from the Demidov Monument (Piazza Serristori, Florence) to Rogers's formative ideas for *Ruth Gleaning*. The later Demidov commission, with its increased emphasis on naturalism, would have been particularly meaningful.[12] Rogers revealed his own

preference for these ideas with his concentration on such anecdotal details as facial expression, hair, vegetation, and drapery. The conception is far more individualized than is typical of truly neoclassical works. In fact, Rogers's determination to capture persuasively a specific moment in Ruth's story challenged the neoclassic notion of timelessness. Thus, the sculptor took elements of the revered past—subject matter, motif, and lofty ideal—and fused them with attitudes of the present—sentiment, detail, and immediacy. The result was a work that captivated his audience.

Rogers recognized that *Ruth Gleaning* would be pivotal to his career. He offered it as an example of his work when he applied for the commission for the United States Capitol. He sent it to such important and prestigious events as the International Exhibition in London in 1862. At the Centennial Exposition of 1876 in Philadelphia, more than twenty years after its original appearance, *Ruth Gleaning* was deemed worthy of being reproduced in a souvenir handbook.[13] With his *Ruth Gleaning*, Rogers struck a resonant chord in contemporary taste by offering a noble sentiment interpreted in literal terms.

Notes

1. An article in the *Charleston (S.C.) Courier* of Sept. 22, 1853, recounted that Rogers had exhibited a statue in the house of Dudley Selden in Paris. This clipping is in the Anna Wells Rutledge papers, AAA, roll 116, no frame number.

2. "American Artists in Florence," *Home Journal*, Aug. 31, 1850, p. 3.

3. Andrew McFarland, *The Escape* (Boston, 1851), pp. 184–185.

4. S., "American Artists in Florence," *Bulletin of the American Art-Union*, Apr. 1, 1851, p. 13.

5. "Our Artists Abroad," *Home Journal*, Nov. 1, 1851, p. 2. The complete article was in the form of a letter from abroad and was published in a number of journals, including the *Bulletin of the American Art-Union*, thus ensuring reasonably wide exposure.

6. "Americans in Rome," *Boston Transcript*, Apr. 21, 1852, p. 2. The article originally appeared in the New York *Commercial Advertiser* under the date of Rome, Apr. 1.

7. "Topics Astir. Randolph Rogers," *Home Journal*, Dec. 9, 1854, p. 2.

8. Florentia 1854, p. 186.

9. Yarnall and Gerdts 1986 reveal no fewer than fifteen interpretations of the biblical Ruth in all the major cities on the eastern seaboard.

10. "Randolph Rogers," (Ann Arbor) *Michigan Argus*, Dec. 6, 1867, n.p.

11. A concise comparison of the *Ruth*s by Rogers and Brown with a discussion of the role of contemporary literary sources such as Keats and Thomas Hood may be found in Knowles, *Ruth Gleaning*, pp. 128–132.

12. Hyland 1985, pp. 272–273.

13. Edward Strahan, *Masterpieces of the Centennial International Exhibition*, 2 vols. (Philadelphia, 1876), 1:56, and Sandhurst 1876, p. 54.

53
Isaac
Second version
Modeled ca. 1864–65
Marble
42¼ × 25⅝ × 21¾ in. (107.3 × 62.6 × 55.2 cm)
Inscribed at left side of log: *Randolph Rogers. Rome;* on the pedestal: *Abraham lay not thy hand upon the lad.*

Provenance [Paul Gabel, Nyack, N.Y.]; James H. Ricau, Piermont, N.Y.

Exhibition History *The Ricau Collection*, The Chrysler Museum, Feb. 26–Apr. 23, 1989

Literature "Sketchings. Domestic Art Gossip," *Crayon* 5 (Nov. 1858), 329; "The Fine Arts," *Home Journal*, Apr. 2, 1859, p. 2; "Affairs in Rome. Art and Artists—New Sculptures," *New York Evening Post*, Jan. 5, 1865, p. 1; Walker 1866, p. 102; "Art Items. Sculpture," *New-York Evening Post*, Dec. 13, 1866, p. 1; "Randolph Rogers," (Ann Arbor) *Michigan Argus*, Dec. 6, 1867, n.p.; Osgood 1870, p. 422; "Sale of Bric-a-brac," *New-York Evening Post*, June 7, 1876, p. 4; Huidekooper 1882, pp. 183–184; S.P.Q.R., "American Studios in Rome. Randolph Rogers," *Boston Daily Evening Transcript*, Nov. 24, 1882, p. 6; Martin d'Ooge, *Catalogue of the Gallery of Art and Archaeology in the University of Michigan* (Ann Arbor, Mich., 1892), p. 20; "Randolph Rogers," *New York Herald* (Paris ed., Sunday supplement), Jan. 24, 1892, p. 3, ill.; Taft 1924, p. 160; Rutledge 1955, p. 185; Rogers 1971, pp. 93–96, 98, 207; Gerdts 1973, pp. 68–69, ill.; Janet A. Headley, "The (Non) Literary Sculpture of Hiram Powers," *Nineteenth-Century Studies* 4 (1990), 26

Versions MARBLE The Brooklyn Museum, Brooklyn, N.Y.; Wadsworth Atheneum, Hartford, Conn.; Oakland Museum of California; [Christie's, New York, Sept. 21, 1984, lot 110]; BRONZE Philip H. Likes, Yorktown Heights, N.Y.

Gift of James H. Ricau and Museum Purchase, 86.517

CONTRARY to the expectations of a country founded in part on Protestant principles, a substantial amount of religious art was made in America in the eighteenth and nineteenth centuries.[1] By the second quarter of the nineteenth century, sculpture had moved from adorning churches with crucifixes, organ screens, pulpits,

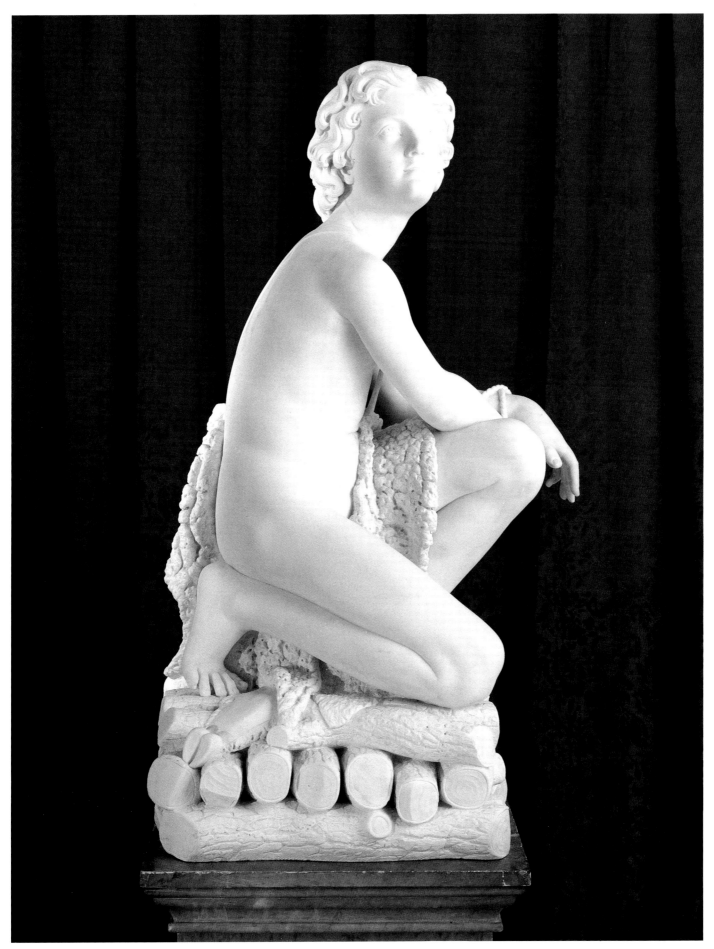

Cat. no. 53 Rogers, *Isaac*

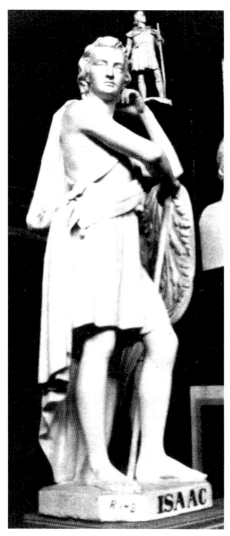

FIG. 92 Randolph Rogers, *Isaac* (first version). Plaster (destroyed). Photograph courtesy of Bentley Historical Library, The University of Michigan

and other ecclesiastical furniture to an independent interpretation of the Scriptures. The first generation of sculptors such as Horatio Greenough (1805–1852), Hiram Powers (q.v.), and Thomas Crawford (q.v.) all attempted works in this category. Consequently, Randolph Rogers was in the mainstream with his desire to depict biblical subject matter.

Rogers treated themes from the Scriptures from the outset of his career. His wife, Rosa, noted in her manuscript biography that he executed *Jacob and Rachel at the Well* shortly after his arrival in Rome in 1851.[2] Two years later he enjoyed a major critical and financial success with *Ruth Gleaning* (cat. no. 52). Attracted to the narrative richness of the Old Testament, the sculptor embarked on an *Isaac* about 1857–58. This version depicted Isaac standing (fig. 92), which Mrs. Rogers mentioned was the earlier of the two, although she dated it to about

1861–62.[3] The *Crayon,* however, reported in November 1858 the recent arrival of two statues by Rogers, *Isaac* and *Rebecca,* for the noted New York collector Robert L. Stuart.[4] The reporter presumably erred about Rogers's authorship of the *Rebecca,* which was subsequently credited to Joseph Mozier (q.v.).[5]

Rogers's account book offers little guidance in differentiating the orders between the first and second versions. The contemporary literature helps clarify the date that Mrs. Rogers assigned to the second version, as well as confirm its greater appeal. Mrs. Rogers indicated the second, kneeling version of *Isaac* was executed between 1863 and 1864, but various reports argue for a slightly later date. A correspondent for the *New-York Evening Post* sent a letter, dated November 10, 1864, but not published until January 1865, that mentioned Rogers was working on a kneeling Isaac that "promises to be one of his best, if not the best."[6] Frances W. Dunn, a traveler from Michigan, reiterated this assessment when she visited Rogers's studio in January 1866 and said she considered *Isaac* and *Nydia* the best things she saw there.[7] Dunn described *Isaac* as "a handsome boy, hands tied, kneeling upon a pile of faggots with face turned up just as the angel said, 'Lay not thine hand upon the lad.'" Commenting on Rogers's promotional abilities as well as his artistic merit, Dunn indicated the *Isaac* had been available for less than a year, yet Rogers already had fifteen orders.

Actual work on the model may have been protracted, since another visitor in early 1866 commented favorably on the piece, noting that "two copies in marble had already been bespoken, although the model was by no means complete."[8] Whatever the status of the completed model, a finished marble was in America by December 1866. The *New-York Evening Post* reported that several pieces of sculpture owned by T. C. Durant had recently arrived in the country. According to the *Post,* the most important work was by Rogers and represented the figure of Isaac about to be offered for sacrifice.[9] In addition to fully describing the piece, the author considered the pose "free and full of grace" and admired the careful modeling of the figure. The article commended the sculptor for infusing the figure with a transcendent sense of life and for the pose's ability to capture action in repose. The article promised that the public's curiosity would be accommodated since Durant intended to put his collection, which included works by Hiram Powers (q.v.) and Emma Stebbins (q.v.), on public view. This exposure soon extended

beyond New York to Philadelphia, where a second copy of Rogers's kneeling *Isaac* was exhibited at the Pennsylvania Academy of the Fine Arts in 1867.[10] In Rome *Isaac* continued to be singled out by visitors to the studio and praised for its "gentle sentiment and fine thought."[11] From the outset, Rogers's second version of *Isaac* enjoyed the critical acclaim and publicity that ensured its success and enhanced its creator's reputation.

The well-known story of Isaac's sacrifice is told in Genesis, chapter 22, in which God directs Abraham to take his beloved son Isaac to the land of Moriah and on one of the mountains there make a burnt offering of him. In the tradition of his Renaissance predecessors, Lorenzo Ghiberti and Filippo Brunelleschi, Rogers has depicted the moment when Abraham has bound his son and is about to slay him when the angel intervenes. This choice of moment is confirmed by the inscription of the text on the original pedestal, "Abraham lay not thy hand upon the lad."

Isaac kneels on a pyre of carefully sawn logs and gazes up to his right in puzzled resignation. His wrists, bound by rope, rest on his left knee. His hands, which dangle limply, give no evidence of the intense drama of the moment traditionally interpreted in painting and sculpture. Isaac's loins are covered by a lambskin that provides not only an iconographic reference to sacrifice but also a discreet means of covering the genitals. This interpretation differs markedly from the clothed Isaac in the earlier version who strikes a confident pose. Ostensibly, Rogers was chronicling a completely different episode of the boy's life.

The youth's wavy locks offer a visual counterpoint to the smooth handling of the unmuscled body befitting a boy his age. The spirited treatment of the hair provides the only intimation of tension in the entire work. With the exception of the rather perfunctory cutting of the pupils, details such as the animal skin, rope binding the wrist, and logs are lavished with such attention to detail that they detract from the impact of the central narrative. Yet, this component of literalism coupled with balanced sentiment made this work appeal to the sculptor's audience. Rogers's obituary in the Paris edition of the *New York Herald* selected it as the only illustration to accompany the article, confirming its central place in his oeuvre.[12]

Notes

1. Jane Dillenberger and Joshua C. Taylor, *The Hand and the Spirit: Religious Painting in America, 1700–1900,* exh. cat., University Art Museum, Berkeley (Berkeley, Calif., 1972).

2. Rogers 1971, p. 197. The manuscript biography by Mrs. Rogers is in the Michigan Historical Collections at the University of Michigan, Ann Arbor.

3. Ibid., p. 206.

4. "Sketchings. Domestic Art Gossip," *Crayon* 5 (Nov. 1858), 329.

5. "The Fine Arts. Mr. R. L. Stuart's House and Art Collection," *Home Journal*, Apr. 2, 1859, p. 2.

6. "Affairs in Rome," *New-York Evening Post*, Jan. 5, 1865, p. 1.

7. Frances W. Dunn, diary, Jan. 25, 1866, Michigan Historical Collections, University of Michigan, Ann Arbor. Cited in Rogers 1971, p. 96.

8. Walker 1866, p. 102.

9. "Art Items. Sculpture," *New-York Evening Post*, Dec. 15, 1866, p. 1.

10. Rutledge 1955, p. 185.

11. Osgood 1870, p. 422.

12. "Randolph Rogers," *New York Herald* (Paris ed., Sunday supplement), Jan. 24, 1892, p. 3.

54
Daughter Nora as the Infant Psyche

Modeled ca. 1871
Marble
21½ × 14⅛ × 8⅜ in. (54.6 × 35.9 × 21.3 cm)
Inscribed on back: *Randolph Rogers / Rome*

Provenance [Spanierman Gallery, New York]; James H. Ricau, Piermont, N.Y., by 1973

Exhibition History *The Ricau Collection*, The Chrysler Museum, Feb. 26–Apr. 23, 1989

Literature "Randolph Rogers in Rome," *Arcadian* 1 (Jan. 23, 1873), 11; advertisement for Spanierman Galleries, *Antiques* 94 (Dec. 1968), 820, ill.; Rogers 1971, pp. 130, 217; Gerdts 1973, pp. 92–93, ill.

Versions MARBLE Evansville Museum of Arts and Science, Evansville, Ind.; Cincinnati Art Museum

Gift of James H. Ricau and Museum Purchase, 86.518

The only portraits Randolph Rogers apparently made of his family were of his wife, Rosa (Grand Rapids Art Gallery, Grand Rapids, Mich.), and his sixth child, Eleanora, nicknamed Nora. The sculpture of his spouse was a conventional portrait, while Nora's likeness represented the mythological character Psyche. Some confusion arises in the records in differentiating between a *Portrait of Nora* and a bust of *Psyche*.[1] However, an article on the sculptor in an 1873 issue of the *Arcadian* confirmed that *Nora* and *Psyche* are the same.[2] The author singled out the bust of Rogers's daughter, "whose sweet intellectual face is faithfully delineated, her

blonde locks being caught up in a knot from which they escape naturally, the whole being embosomed in acanthus leaves." Although no reference is made to the butterfly that alights on the leaf adjacent to Nora's left shoulder, the description fits the sculpture in question, and the association with Psyche may have been an afterthought.

Rogers is presumed to have undertaken this portrait in 1871 as a release from the pressures inherent in overseeing various public monuments.[3] Its execution does not seem to have been for purely personal reasons, and the sculptor probably envisioned the bust in allegorical terms for wider distribution. Nora, who was about five years old at the time, provided a convenient model. In this manner, Rogers created an ideal figure with specific features and childish charm that would appeal to his more literal-minded clientele.

Psyche was a popular subject for neoclassical artists, with the story of Cupid and Psyche and the unfolding trials of their love story being the most prevalent. The works by J.-A.-D. Ingres (1780–1867) and Antonio Canova (1757–1822) brought the myth great renown. By the second quarter of the nineteenth century, Psyche had become standard fare as an ideal bust, and numerous American sculptors, including both Horatio Greenough (1805–1852) and Hiram Powers (q.v.), interpreted her.[4] The subject had special attraction since the classical source could be associated, through the butterfly, with the Christian idea of the transfiguration or immortality of the soul. This particular connection with death held exceptional poignance for Rogers, since three of his seven children had died in infancy, including Nora's younger brother Henry. Yet the sculptor did not consider it a private or personal memorial, and he accepted orders for at least ten replicas.

Rogers imbued this bust with a rich visual complexity. Nora emerges from a lush display of acanthus leaves and turns her head sharply to her left, creating a dynamic sense of torsion. The foliage offsets the truncated appearance evident in most portrait busts, and the sculpture emulates Hiram Powers's early versions of *Proserpine* (cat. no. 6). Unlike Powers, Rogers did not scale back the profusion of foliage to expedite output. By having the child turn to inspect the butterfly, Rogers created a feeling of spontaneity. He reinforced this casual moment through the large curl of hair that cascades down the front of Nora's left shoulder. This curl is out of place since the other six curls fall in a careful arrangement down the back of her neck.

The face possesses a specificity of features that confirms the sculptor's use of a particular model. The upturned nose, pursed lips, and full fleshy cheeks are convincing reminders of the individual. The intense expression enhances the girl's vitality, and her focused concentration is typical of a child this age. The one concession to idealization is the absence of pupils in the eyes, which normally heightens the sense of immediacy. With this minor exclusion, Rogers generalized the figure to broaden the appeal. Using his uncanny ability, the sculptor blended the right amount of the real with the ideal, layered with sufficient sentiment, to ensure the work's popularity.

Notes
1. Rogers 1971, pp. 216–217.
2. "Randolph Rogers in Rome," *Arcadian* 1 (Jan. 23, 1873), 11.
3. Rogers 1971, pp. 129–130.
4. Gerdts 1973, pp. 92–93.

55
Portrait of a Young Boy

Modeled ca. 1875–81
Marble
22⅜ × 14⅛ × 9⅛ in. (56.8 × 35.9 × 23.2 cm)
Inscribed at rear: *Randolph Rogers / Rome*

Provenance [The Pillars, New Woodstock, N.Y.]; James H. Ricau, Piermont, N.Y., 1968

Exhibition History *The Ricau Collection*, The Chrysler Museum, Feb. 26–Apr. 23, 1989

Literature Rogers 1971, pp. 118–120, 142, 222, 226, 229

Versions None known

Gift of James H. Ricau and Museum Purchase, 86.516

The unidentified portrait of a young boy by Rogers is one of three such youths in the Ricau Collection, which includes Chauncey B. Ives's *Sailor Boy* and Augustus Saint-Gaudens's early *Portrait of Frederick C. Torrey* of 1874 (cat. nos. 26, 65). Consistent with the realities of artistic survival in the nineteenth century, portrait busts comprise the largest number of works in Randolph Rogers's account book, and he normally charged one hundred pounds ($500) for a likeness. Unfortunately, the whereabouts or identity of few of the sculptor's portraits have come to light.

The account book indicates five possibilities for the work in question. The earliest is the portrait of Henry Steward, Jr., son of John Steward, the dry-goods mer-

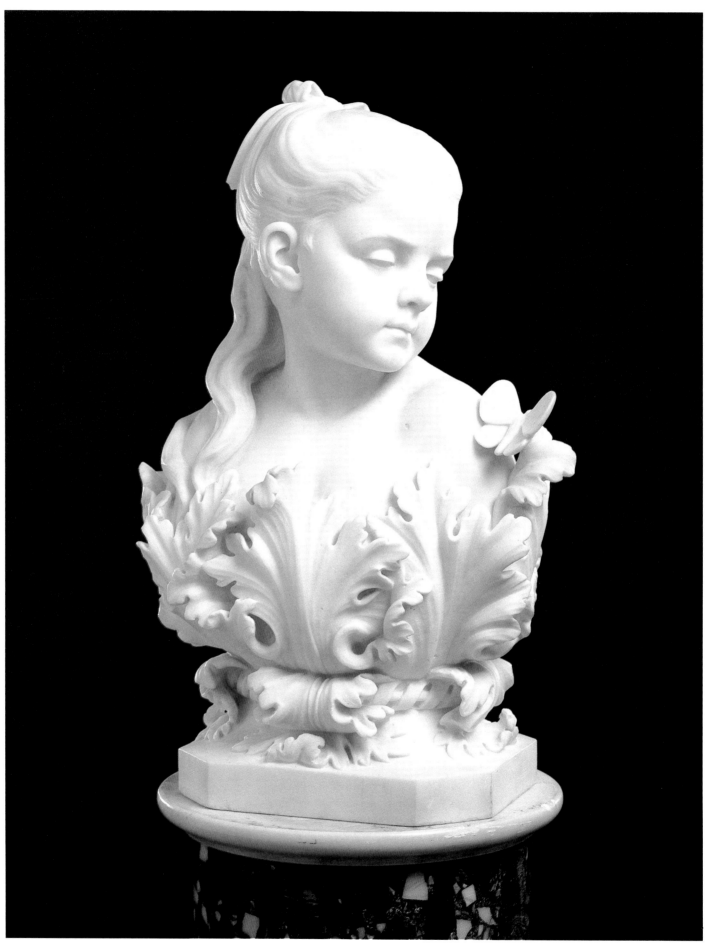

Cat. no. 54 Rogers, *Daughter Nora as the Infant Psyche*

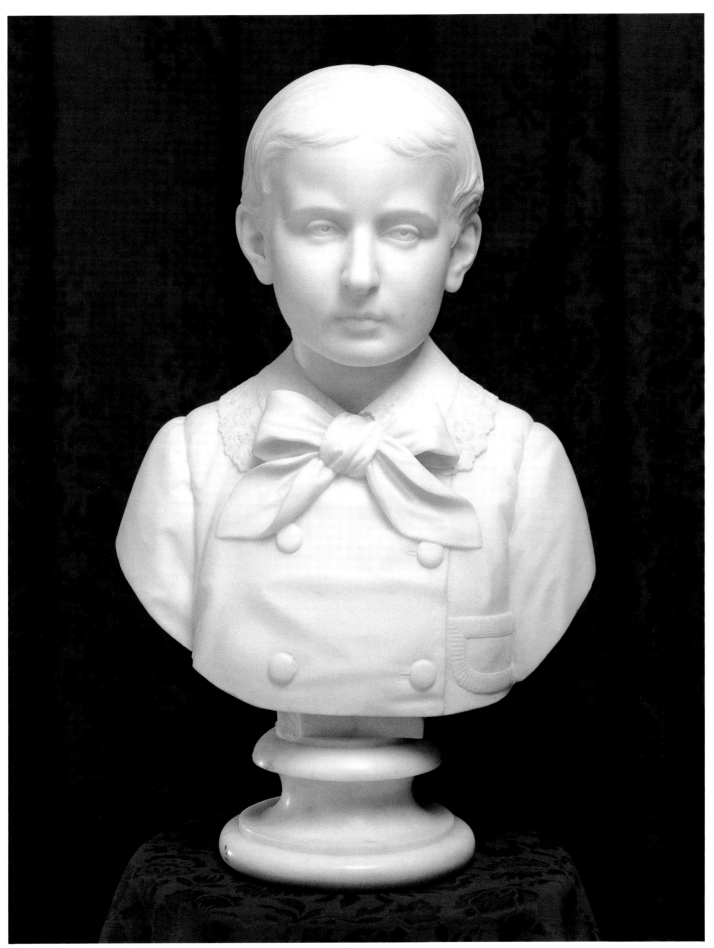

Cat. no. 55 Rogers, *Portrait of a Young Boy*

chant who helped finance Rogers's initial trip to Italy. The work would have been modeled in either Florence or Rome, presumably from memory, but cut in Rome since the Ricau bust is signed to that effect. Rogers also made likenesses of Mr. and Mrs. Steward and presented all three works to the family in token of his appreciation.

In 1875 or 1876 Mr. and Mrs. G. B. Carhart of Brooklyn, New York, ordered busts of themselves and their son, but nothing more is known. In 1881 Leland Stanford, the wealthy industrialist and former California governor, commissioned a portrait bust of his son, Leland, Jr., as well as busts of Henry Clay, William Henry Seward, and Washington. Again, little is known about the ultimate disposition of this order, but comparison with photographs of the young Stanford obviate his connection with the Ricau bust.[1] At about the same time he was negotiating with Stanford, Rogers was asked by Mrs. E. M. Storm of Bayside, Long Island, to create a bust of her son. Finally, there is a bust of an unknown youth (private collection, New York), which may be any of the commissioned busts. Ricau acquired his bust in the late 1960s, but nothing is known of its early history.[2]

Whatever the sitter's identity, the young boy clearly came from a family of means. He wears a tunic whose double row of buttons suggests a uniform, although the flamboyant cravat and lacy collar dispel this notion. Rogers's deft handling of these elements recalls the flair for costume he demonstrated in his statue of John Adams, whose exuberant lace ruffs enhance the wrists and neck. The boy's cravat and collar are remarkably successful in their simulation of pliant and translucent materials. In his preoccupation with detail, Rogers demonstrated the technical cleverness of his workmen. Attention to the particular is also manifested in the rendering of the features. The boy's facial structure is very convincing, and his sunken temples underscore the emphasis on individuality. The eyes, through their chiseled pupils, attempt to convey a fleeting moment of contemplation appropriate to youth, but the expression, though direct and straightforward, remains rather static. As with the textures of the costume, Rogers handled the flesh in a convincing fashion, imbuing the bust with a lifelike quality. The hair lends an added measure of authenticity in the way it is parted and combed back over the ears.

In this portrait Rogers demonstrated a tendency to create a very direct, almost clinical image that reveals a workmanlike approach. This is understandable given the role of portraiture as a necessary economic evil. Rogers's methodical attitude was, no doubt, applauded by his patrons who were more than satisfied with an objective if somewhat prosaic version of themselves.

Notes

1. I am grateful to Diana Strazdes, curator of American art at the Stanford University Museum of Art, for her assistance in this matter.

2. Interview with James H. Ricau, Piermont, N.Y., Oct. 4, 1990. Curiously, Millard Rogers did not know about this bust, although he knew of an unidentified female bust that Mr. Ricau owned that did not come to the Museum; Rogers 1971, p. 229. *Daughter Nora as the Infant Psyche* also eluded him, although it is not certain when Mr. Ricau purchased this piece.

Harriet Goodhue Hosmer
American, 1830–1908

Not long before her death in February 1908 at age seventy-seven, Harriet Hosmer was reported to have said, "I would rather have my fame rest upon the discovery of perpetual motion than upon my achievements in art."[1] Although she devoted the last thirty years of her life to this futile pursuit, Harriet Hosmer is best remembered as one of America's premier sculptors during the third quarter of the nineteenth century. She led a remarkable coterie of women sculptors working in Rome, whom Henry James patronizingly referred to as "the white, marmorean flock."[2] She doggedly considered herself an equal, if not superior, player in this male-dominated sphere. The chronicled story of her life reads like a picaresque novel, touching a full range of emotional peaks and valleys.[3]

Harriet Hosmer was born in Watertown, Massachusetts, into a family ravaged by tuberculosis. Her father, Dr. Hiram Hosmer, a distinguished physician, had seen his wife and three of his children succumb to the dreaded consumption. Determined not to lose his sole surviving child, Dr. Hosmer placed a premium on outdoor activity and maintained a laissez-faire attitude with regard to her academic curriculum. Consequently, the confines of the conventional classroom proved difficult for young Harriet to accept. Her free spirit and penchant for mischief prompted her indulgent but exasperated father to send her away to boarding school in Lenox, Massachusetts. The open-ended approach to education of Charles and Elizabeth Sedgewick suited Hosmer's independent spirit, and she established a productive academic regimen. She was captivated by a local circle of professionally accomplished women such as the author Catharine Maria Sedgewick and the author–political activist Lydia Maria Child. She also met the famous actress Fanny Kemble, who vacationed in Lenox because of its lively literary community. These role models instilled in Hosmer the notion that she could succeed at whatever vocation she chose and that she need not confine herself to the traditional role of homemaker.

During her initial outdoor curriculum at home, Hosmer delighted in modeling animals out of clay extracted from the banks of the nearby Charles River. Her father willingly indulged her and constructed a studio on the premises. In 1849 Hosmer sought professional instruction in drawing and modeling from Peter Stephenson (q.v.), which involved a

lengthy walk to Boston. Under his tutelage, she produced a portrait bust of a child and "a spirited head of Byron in wax."[4] Despite her father's position in the medical profession, Hosmer could not study anatomy at medical school, which was off-limits to women. Through Dr. Hosmer's connections, however, she received private instruction from Dr. Joseph McDowell at the McDowell Medical College in Saint Louis, and passed the exam that all students took.

This extreme geographical dislocation was mitigated by living with Cornelia Crow, a school friend whose family was from Saint Louis. Hosmer's engaging personality endeared her to one and all. Cornelia's father, Wayman Crow, became one of the sculptor's principal benefactors, while Cornelia loyally provided a sense of family and ultimately acted as her friend's literary executor.

After completing the medical course, Hosmer traveled alone up and down the Mississippi River and proved she was on a par with or better than her male counterparts in any physical undertaking or feat of marksmanship. In the summer of 1851 Hosmer returned to Watertown, where she resurrected her studio and began modeling portrait medallions, including one of Dr. McDowell and a bust of Napoleon for her father. In 1852 she completed her first independent ideal composition, a bust of Hesper (Watertown Free Public Library, Watertown, Mass.), which was inspired by Alfred Lord Tennyson's recently published elegy, "In Memoriam" (1850). Through the efforts of Lydia Child, *Hesper* and Hosmer gained notice in the *New York Tribune*. Despite favorable attention, Hosmer realized the limitations of America for an aspiring sculptor. At the recommendation of another recent acquaintance, the American actress Charlotte Cushman, Hosmer set her sights on Italy. Accompanied by Cushman and her ever-obliging father, Hosmer embarked for Rome in the fall of 1852.

Hosmer's ambition and determination knew no bounds, and she quickly infiltrated the fraternity of American artists working in Rome. She sought guidance from the English sculptor John Gibson (1790–1866), the dean of the neoclassical tradition who had inherited the mantle from Antonio Canova (1757–1822) and Bertel Thorvaldsen (q.v.). Apprised of Gibson's reluctance to take on students, Hosmer remained undaunted, sending the master daguerreotypes of her *Hesper* and impressing upon him the seriousness of her intent. Gibson capitulated and set up Hosmer in a special studio in his garden. From this apprenticeship evolved a deep

mutual respect and affection. Gibson instilled in Hosmer the quintessential principles of neoclassicism that centered on the discipline of drawing from the antique, especially Praxiteles and his Hellenistic disciples. Hosmer quickly assimilated the tenets of harmonious proportion and expression of feeling while absorbing the importance of technical considerations.

By 1854 Hosmer embarked on original compositions and completed busts of *Daphne* (WUAG) and *Medusa* (DIA). She also received her first major order from Wayman Crow for a full-length sculpture taken from a subject of her choosing.[5] She elected to depict Oenone, the shepherdess mate of Paris whom he abandoned for Helen of Troy (WUAG). Once again, a Tennyson poem, "The Death of Oenone" (1833 and revised in 1842), may have provided the inspiration. While working on this commission, Hosmer's confidence received an immeasurable boost when her mentor brought to her studio the venerable German sculptor Christian Rauch (1777–1857), acknowledged by Gibson to be "the greatest sculptor of the age." Rauch was pleased with what he saw and asserted that Hosmer "would become a clever sculptor."[6]

Although she completed *Oenone* by late 1855, Hosmer asked to keep it in her studio as a display piece, and Crow willingly obliged, ever sensitive to what was in his protégé's best interest. He did not receive the sculpture until 1856, which is the traditional date listed for its completion.[7] With its smooth surfaces, graceful curves, and elegant contours, *Oenone* admirably reflects Hosmer's training.

At this juncture, Hosmer could accuse herself of leading a charmed life. She was comfortably situated with such enviable amenities as a horse for her gallops in the Campagna. More important, her sculpture was earning respect from various quarters. The summer of 1855, however, brought the test of her true mettle. On the eve of leaving Rome to accompany Gibson to England, Hosmer received the distressing news that her father's financial affairs were in turmoil and he could no longer support her. Eschewing his directive to return to America, the sculptor jettisoned all unnecessary overhead expenses and made the risky decision to remain in malaria-ridden Rome for the summer to sculpt a marketable work. To this end, she created her *Puck* (cat. no. 56), which was her financial salvation. It was so successful that she created a companion piece, *Will-o-the-Wisp*, and at least two variants (cat. nos. 57, 58).

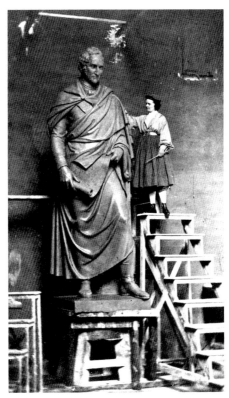

Photograph of Harriet Hosmer with statue of Thomas Hart Benton. Photograph courtesy of the Schlesinger Library, Radcliffe College

Although Hosmer exhibited remarkable initiative in stabilizing her monetary situation, Wayman Crow played a central role in providing financial security and nurturing her professional career. He persuaded the Mercantile Library in Saint Louis to commission a significant work, which resulted in the *Beatrice Cenci* of 1856. The literary association, in this instance Shelley's "Cenci," was appropriate for a library, while the subject matter acknowledged the sculptor's unfolding commitment to themes of tragically wronged women.

The sculpture was exhibited in 1857 at the Royal Academy in London, where George Ticknor, the Boston educator and author, reported its enthusiastic reception by such luminaries as Charles Eastlake, president of the Royal Academy and director of the National Gallery; the art historian Gustav van Waagen; public figures Lord and Lady Palmerston; and "other people, whose word in such a matter is law here."[8] Ticknor's journals reveal how easily the young sculptor moved among these aristocratic circles and how popular she was with this group both socially and professionally. A year later when he visited her studio, Nathaniel Hawthorne was captivated as much by her charm as her sculpture.[9]

Back in America, Crow engineered a public commission for Hosmer that was a departure in both subject matter and medium—the monumental image of Thomas Hart Benton, the recently deceased Missouri senator, which was destined for Lafayette Park in Saint Louis. The expectation of a literal interpretation as well as the choice of bronze, dictated by the outdoor setting, were unusual within the sculptor's oeuvre. The colossal likeness, which dwarfed the diminutive Hosmer, was cast into bronze at the Royal Foundry in Munich. The first public monument in Missouri, it was unveiled in 1868 to great acclaim before an enormous crowd with Hosmer in attendance.

A third major work, Zenobia of 1859, secured Hosmer's reputation as a serious sculptor. Known today only through a reduction (WAHC) and Parian-ware copies, this imposing effigy of the ancient queen of Palmyra depicted a moment of nobility in her captivity. Enthusiastically received at the International Exposition of 1862 in London, it found an eager market on both sides of the Atlantic. The department-store magnate Alexander T. Stewart acquired the original, and both the Prince of Wales and Mrs. Potter Palmer ordered replicas. Hosmer, demonstrating her business acumen, followed Hiram Powers's (q.v.) successful example with The Greek Slave and toured Zenobia around America in 1864 and 1865 to large and rhapsodic audiences, who filled the coffers with admission fees.

Hosmer's ascendant reputation attracted vitriolic and underhanded attacks by jealous rivals. As early as 1863 it had been insinuated that she was not doing her own work. Hosmer traced the unwarranted accusation to Joseph Mozier (q.v.), who had also maligned Hiram Powers.[10] Both Powers and Gibson came to her defense, but the incident prompted Hosmer to publish a detailed article on the sculptural process.[11] In this essay, Hosmer articulated the difference between the creative or inspirational aspect, which was the domain of the sculptor, and the straightforward mechanical execution, which fell to the assistants. Hosmer recognized that encroachment into the male-dominated field of sculpture by a growing sisterhood had generated enormous consternation. She addressed this issue in an entertaining piece of doggerel entitled "The Doleful Ditty of the Roman Caffe Greco."[12]

The issue of artistic integrity resurfaced in 1874. This time an entire group of sculptors was accused, and Hosmer could take satisfaction that she was linked with her male counterparts, including the dean of American sculptors in Rome, William Wetmore Story (q.v.). True to form, Hosmer took the initiative by publishing a spirited defense and proved, once again, that she was unflinching in the face of adversity.[13]

By this second attack, Hosmer had completed her last major works, The Sleeping Faun (BMFA) and its companion, The Waking Faun (private collection). These works, executed between 1864 and 1867, earned her unqualified praise from numerous influential corners.[14] The sculptor's inventiveness regarding The Sleeping Faun was deemed worthy of the antique, and her choice of subject matter responded visually to Hawthorne's recently published Marble Faun (1860), whose characterization of Hilda may have been modeled on Hosmer.

While her studio remained busy executing orders for replicas, Hosmer became less inclined to embark on new projects in the 1870s. Her expanding British, aristocratic circle of friends deflected her from sculptural pursuits. Having proved herself in this domain, she moved into another field of endeavor. By 1875 Hosmer had closed her studio and moved to England to live in Melchet Court with one of her greatest patrons, Lady Ashburton. Here she pursued her new passion, aspects of mechanical invention with particular emphasis on perpetual motion. These scientific pursuits absorbed her for the next quarter of a century, with only brief interludes in sculpture. Her most notable effort was a colossal portrait of Queen Isabella completed in plaster in 1892 and exhibited at the World's Columbian Exposition in 1893. The plaster modello is now lost, but Hosmer cast it in bronze, which she sold to the pope.[15]

In 1900 Hosmer returned to her native Watertown, where she lived out her final eight years in quiet though intellectually engaged seclusion before succumbing to pneumonia. Hosmer died insolvent, and it was a final testament of the loyalty of the Crow family that her childhood friend, Cornelia Crow Carr, settled her debts and assumed the role of literary executor.

Harriet Hosmer overcame formidable obstacles to secure an exalted position for herself in the panoply of American sculptors in the second half of the nineteenth century. Her conquests were myriad, both professionally and socially. She was the first American to receive a commission for a decoration in a Roman church, the funerary monument of 1857 for the young Judith Falconnet in the church of San Andrea delle Fratte. Her ideal works carried the neoclassical tradition well into the third quarter of the century, and her choice of subject forged a new realm of consciousness with regard to the role of women. In managing the complexities of a sculpture studio, Hosmer proved she was equal to both the creative and the administrative challenges of a male-oriented profession. She utilized her engaging personality to win the devotion of a wide circle of friends. This enviable combination of talent and charm enabled Hosmer to earn, with few exceptions, the respect of even her most confirmed detractors, and no one could deny her determined efforts to attain the respect that was her due.

Notes

1. "'Most Famous of American Women Sculptors.' Miss Harriet Hosmer of Watertown," *Boston Sunday Globe*, Mar. 1, 1908, p. 11. For the most recent account of Hosmer's life, see Sherwood 1991.

2. James 1903, 1:257.

3. Sherwood 1991.

4. Thurston, *Eminent Women of the Age* (1869), p. 571.

5. A letter from Hosmer to Wayman Crow, Apr. 10, 1853, acknowledges this commission; see Carr 1912, pp. 25–26.

6. Ibid., p. 24, in an undated communication from Gibson to Dr. Hosmer.

7. Sherwood 1991, p. 115.

8. Entry for July 29, 1857, George S. Hillard and Mrs. George Ticknor, eds., *Life, Letters, and Journals of George Ticknor*, 2 vols. (Boston, 1876), 2:383–384.

9. Hawthorne 1858, pp. 150–151, 217, 493–495.

10. For a full account of this episode, see Sherwood 1991, pp. 218ff.

11. Hosmer, "The Process of Sculpture" (1864), pp. 734–737.

12. [Harriet Hosmer], "The Doleful Ditty of the Roman Caffe Greco," *Boston Evening Transcript*, Nov. 17, 1864, p. 1. For Hosmer's role in a male profession, see Kasson 1990, pp. 142–146.

13. "A Letter from Harriet G. Hosmer," *New-York Evening Post*, July 23, 1874, p. 1.

14. See Jan Seidler Ramirez, *The Sleeping Faun*, in BMFA 1986, pp. 165–167.

15. See Judy Sund, "Columbus and Columbia in Chicago, 1893" (1993), 447.

Bibliography

Lee 1854, 2:221–226; Hawthorne 1858, pp. 140–143, 150–151, 202–205, 217, 493–495; Lydia M. Child, "Miss Harriet Hosmer," *Littell's Living Age* 61 (Mar. 1858), 697–698; M. H. H., "Harriet Hosmer," *Englishwoman's Journal* 1 (July 1858), 295–306; Mrs. Ellet, *Women Artists in All Ages and All Countries* (New York, 1859), pp. 349–369; "Miss Hosmer's Studio at Rome," *Harper's Weekly*, May 7, 1859, pp. 293–294; Lydia M. Child, "Harriet E. [*sic*] Hosmer: A Biographical Sketch," *Ladies' Repository* 21 (Jan. 1861), 1–7; [Harriet Hosmer], "The Doleful Ditty of the Roman Caffe Greco," *Boston Evening Transcript*, Nov. 17, 1864, p. 2; Harriet Hosmer, "The Process of Sculpture," *Atlantic Monthly* 14 (Dec. 1864), 734–737; Jarves 1864, p. 276; Rev. E. B. Thurston, *Eminent Women of the Age* (Hartford, Conn., 1869), pp. 566–598; Tuckerman 1867, pp. 601–602; H. W., "Lady-Artists in Rome," *Art Journal*

(London), n.s., 28 (June 5, 1866), 177–178; James Jackson Jarves, "Progress of American Sculpture in Europe," *Art Journal* (London), n.s., 10, 55 (Jan. 1871), 6–8; "Visits to the Studios of Rome," *Art Journal* (London), n.s., 10, 55 (June 1871), 162–164; W. H. Bidwell, "Harriet Hosmer," *Eclectic Magazine* 77 (Aug. 1871), 245–246; "Art in Continental States: Rome," *Art Journal* (London), n.s., 12, 55 (Jan. 1873), 12; Stephen W. Healy, "Alleged Art Frauds: Condition of American Sculpture in Italy," *New-York World*, Mar. 1, 1874, p. 3; id., "Alleged Art Frauds: Additional Charges against Our Sculptors," *New-York World*, Mar. 15, 1874, p. 2; Sculptor, "Friends in Correspondence as well as in Sculpture," *New-York Evening Post*, Mar. 26, 1874, p. 2; Harriet G. Hosmer, "A Letter from Harriet G. Hosmer: Her Defence of the American Sculptors in Rome," *New-York Evening Post*, July 25, 1874, p. 1; "Art: American Sculptors in Italy," *Aldine* 7 (Sept. 1874), 187; Clark 1878, pp. 134–139; Samuel G. W. Benjamin, "Sculpture in America," *Harper's New Monthly Magazine* 58 (Apr. 1879), 657–672; Benjamin 1880, pp. 152, 156; James 1903, 1:255–258; Clara Erskine Clement, *Women in the Fine Arts* (Boston, 1904), p. 165; "Most Famous of American Women Sculptors: Miss Harriet Hosmer of Watertown," *Boston Sunday Globe*, Mar. 1, 1908, p. 11; Ruth A. Bradford, "The Life and Works of Harriet G. Hosmer, the American Sculptor," *New England Magazine* 45 (Nov. 1911), 265–269; Carr 1912; "Life of Harriet Hosmer," *Nation*, Oct. 10, 1912, pp. 340–342; Taft 1924, pp. 203–211; Gardner 1945, pp. 49, 66–67; Margaret Farrand Thorp, "The White Marmorean Flock," *New England Quarterly* 32 (June 1959), 147–169; Susan Van Rensselaer, "Harriet Hosmer," *Antiques* 84 (Oct. 1963), 424–428; Thorp 1965, pp. 79–88; Margaret Wendell LaBarre, "Harriet Hosmer: Her Era and Art" (M.A. thesis, University of Illinois, 1966); Craven 1984, pp. 325–330; Lillian M. C. Randall, "An American Abroad: Visits to the Sculptors' Studios in the 1860s," *Journal of the Walters Art Gallery* 33–34 (1970–1971), 48–49; Cikovsky et al. 1972, no. 5; Gerdts 1973, pp. 62, 84, 123, 156; Joseph L. Curran, ed., *Hosmeriana: A Guide to Works by and about Harriet G. Hosmer* (Watertown, Mass., 1975); Joseph Leach, "Harriet Hosmer, Feminist in Bronze and Marble," *Feminist Art Journal* 5 (Summer 1976), 9–13; Joseph L. Curran, *Watertown's Victorian Legacy: A Bicentennial Art Exhibition*, exh. cat., Watertown Public Library (Watertown, Mass., 1976), pp. 1–8; Josephine Withers, "Artistic Women and Women Artists," *Art Journal* 35 (Summer 1976), 330–336; William H. Gerdts, "The *Medusa* of Harriet Hosmer," *Bulletin of the Detroit Institute of Arts* 56 (1978), 96–107; Barbara Groseclose, "Harriet Hosmer's Tomb to Judith Falconnet: Death and the Maiden," *American Art Journal* 12 (Spring 1980), 78–89; Alicia Faxon, "Images of Women in the Sculpture of Harriet Hosmer," *Woman's Art Journal* 2 (Spring–Summer 1981), 25–29; Dolly Sherwood, "My Dearest Mr. Crow," *Washington University Magazine* 51 (1981), 4–7; Wilmerding et al. 1981, pp. 49–51, 91–92, 144–145; Charlotte S. Rubenstein, *American Women Artists from Early Indian Times to the Present* (Boston,

1982), pp. 75–79; Susan Waller, "The Artist, the Writer, and the Queen: Hosmer, Jameson, and *Zenobia*," *Woman's Art Journal* 4 (Spring–Summer 1983), 21–28; Harding 1984, pp. 41–42; Jan Seidler Ramirez, "Harriet Goodhue Hosmer," in BMFA 1986, pp. 159–167; Sherwood 1991; Stebbins et al. 1992, pp. 226–228 and passim; Judy Sund, "Columbus and Columbia in Chicago, 1893: Man of Genius Meets Generic Woman," *Art Bulletin* 75 (Sept. 1993), 444, 447–448

56
Puck

Modeled ca. 1855–56
Marble
30⅞ × 15½ × 19¾ in. (78.4 × 39.4 × 50.2 cm)
Inscribed on back of base: HARRIET HOSMER FECIT–ROMÆ

Provenance [Louis Joseph, Boston]; James H. Ricau, Piermont, N.Y., by 1964

Exhibition History *19th-Century America: Paintings and Sculpture*, exh. cat., The Metropolitan Museum of Art, Apr. 16–Sept. 7, 1970; *The Ricau Collection*, The Chrysler Museum, Feb. 26–Apr. 23, 1989

Literature "Sculpture," *Watson's Weekly Art Journal*, ca. 1854–57, p. 69; T., "Art Matters," *Boston Transcript*, Jan. 14, 1857, p. 1; "Sketchings. Domestic Art Gossip," *Crayon* 2 (Mar. 1857), 90; Hawthorne 1858, 140–143, 151, 202–205; Mrs. Ellet, *Women Artists in All Ages and All Countries* (New York, 1859), pp. 368–369; "Personal Items," *Boston Transcript*, May 28, 1859, p. 2; "Personal," *Home Journal*, May 12, 1860, p. 2; "Sketchings. Domestic Art Gossip," *Crayon* 7 (May 1860), 142; "Miss Hosmer's Statue of *Zenobia*," *New Path* 2 (Apr. 1865), 53; "Art Matters," *Boston Evening Transcript*, May 24, 1866, p. 2; Walker 1866, p. 102; "American Artists in Europe," *New-York Evening Post*, June 21, 1866, p. 1; "American Female Sculptors," *Frank Leslie's Illustrated Newspaper* 22 (July 14, 1866), 259; Tuckerman 1867, p. 602; "The Women Artists of New York and Its Vicinity," *New-York Evening Post*, Feb. 24, 1868, p. 2; E. B. Thurston, *Eminent Women of the Age* (Hartford, Conn., 1869), pp. 578–579; Mrs. [Sophia Henrietta] Hawthorne, *Notes in England and Italy* (New York, 1872), pp. 265–266; "Puck. Engraved by G. Stodart from the Sculpture by Miss Hosmer," *Art Journal* (New York), n.s., 1 (Oct. 1875), 317; Clark 1878, p. 139; Samuel G. W. Benjamin, "Sculpture in America," *Harper's New Monthly Magazine* 58 (Apr. 1879), 668; Clement and Hutton 1894, 1:366; Ruth A. Bradford, "The Life and Works of Harriet G. Hosmer, the American Sculptor," *New England Magazine* 45

(Nov. 1911), 267; Carr 1912, pp. 40, 72, 76, 78–79, 94, 123, 135, 163, 184–185, 219, 278, 344, 346; Taft 1924, p. 205; Van Wyck Brooks, *Dream of Arcadia: American Writers and Artists in Italy, 1760–1915* (New York, 1958), p. 108; Margaret Farrand Thorp, "The White Marmorean Flock," *New England Quarterly* 32 (June 1959), 153, 155–156; William H. Gerdts, "American Sculpture: The Collection of James H. Ricau," *Antiques* 86 (Sept. 1964), 291, ill., 298; Margaret Wendell LaBarre, "Harriet Hosmer: Her Era and Her Art" (M.A. thesis, University of Illinois, 1966), pp. 200ff.; John K. Howat, John Wilmerding, et al., *19th-Century America: Paintings and Sculpture*, exh. cat., The Metropolitan Museum of Art (New York, 1970), no. 102, ill.; Lillian M. C. Randall, "An American Abroad: Visits to the Sculptors' Studios in the 1860s," *Journal of the Walters Art Gallery* 33–34 (1970–71), 48–49; Cikovsky et al. 1972, n.p., passim; Gerdts 1973, p. 156; Joseph L. Curran, *Watertown's Victorian Legacy: A Bicentennial Art Exhibition*, exh. cat., Watertown Public Library (Watertown, Mass., 1976), p. 6; William H. Gerdts, "The *Medusa* of Harriet Hosmer," *Bulletin of the Detroit Institute of Arts* 56 (1978), 99; Barbara Groseclose, "Harriet Hosmer's Tomb to Judith Falconnet: Death and the Maiden," *American Art Journal* 2 (Spring–Summer 1980), 79; Wilmerding et al. 1981, pp. 50, 144–145; Harding 1984, p. 41; Sherwood 1991, pp. 118–120

Versions MARBLE National Museum of American Art, Washington, D.C.; Wadsworth Atheneum, Hartford, Conn.; Art Gallery of New South Wales, Sydney, Australia; Senate Chamber of Barbados, Bridgetown, Barbados, B.W.I.; Lenox Library, Lenox, Mass.; Walker Art Center, Liverpool, England; Borough Museum, Kendal, England; [Richard York Gallery, New York]; [Christie's, New York, May 25, 1989, lot 51, and/or Nov. 30, 1990, lot 48]; [Estate Antiques, Charleston, S.C.]

Gift of James H. Ricau and Museum Purchase, 86.471

The realization of Harriet Hosmer's *Puck* was born of financial necessity, and the sculptor placed high priority on its marketability. Consequently, appeal, maneuverability, and affordability dictated the choice of subject and size of the sculpture. Because of its compact dimensions, *Puck* was ideally suited for a domestic setting, evident in the late-nineteenth-century view of the corner of a parlor of the Gardner Brewer House on Beacon Street in Boston (fig. 93). The work was an enormous monetary success, with

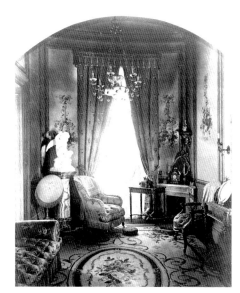

FIG. 93 Photograph of the parlor of the Gardner Brewer House, Boston (with Hosmer's *Puck*). Gift of Mrs. George Lyman, 1916. Courtesy of the Society for the Preservation of New England Antiquities

more than thirty replicas ordered at a price of one thousand dollars per copy. *Puck* found favor within the most exalted circles, which included the Prince of Wales, who purchased one for his rooms at Oxford.[1] This witty sculpture allowed Hosmer to continue her career and contributed immeasurably to reinstating her comfortable lifestyle.

The elfinlike subject constitutes a prime example of the "conceit" or "fancy piece." Unlike ideal sculptures, which were intended to instruct and ennoble the viewer, conceits were playfully imaginative works designed solely to amuse and delight. Appropriate to this less elevated moral or thematic ambition, childlike forms were used to obviate concern for monumentality.

Puck was originally a maleficent spirit, but in the sixteenth century this imp evolved into a playfully mischievous sprite. Most notably, the character of Puck, as he appears in Shakespeare's *Midsummer Night's Dream*, is described as

...that shrewd and knavish sprite
Call'd Robin Goodfellow: are you not he
That frights the maidens of the villagery;
Skim milk, and sometimes labour in the quern,
And bootless make the breathless housewife churn;
And sometimes make the drink to bear no barm;
Mislead night-wanderers laughing at their harm?
Those that Hobgoblin call you, and sweet Puck,
You do their work; and they shall have good luck:
Are not you he? (act 2, scene 1, ll. 33–42)

Puck's connection with "Robin Goodfellow" stems from English folklore, where he was known as the offspring of a young girl and a "hee-fairie." Thus, Puck possessed special powers, which he used to bring luck to the good and to punish the wicked with pranks.

In the nineteenth century Shakespeare's works played to receptive audiences on both sides of the Atlantic, and the bard's subjects enjoyed substantial popularity in English and American art. Themes from *A Midsummer Night's Dream* generated special appeal, and by midcentury there were ample depictions from which to cull inspiration. The Victorian sculptor John Graham Lough (1789–1876) contributed several Shakespearean subjects to the Crystal Palace Exposition of 1851, including a *Titania* and a *Puck* (both, Bethnal Green Museum, London).[2] These works were discussed at length in one of the exhibition's souvenir catalogues and connected to the *Puck* by Sir Joshua Reynolds (1723–1792).[3]

In the realm of painting, Sir Edwin Landseer's (1803–1873) atypical *Midsummer Night's Dream: Titania and Bottom*, 1848–51 (National Gallery of Victoria, Melbourne, Australia), formed part of a larger commission of Shakespearean subjects to decorate a dining room and attracted considerable attention.[4] In addition, works by the renowned painters of fairies Sir Joseph Noel Paton (1821–1901) and Richard Dadd (1817–1886) were admired. *The Quarrel of Oberon and Titania* of 1850 (National Gallery of Scotland, Edinburgh) by Paton and *Contradiction: Oberon and Titania*, 1854–58 (Tate Gallery, London) by Dadd fueled the fascination with this topic.

Even Reynolds's *Puck* of 1789 (Executors of the tenth earl of Fitzwilliam) and its subsequent engraving contributed to the widespread exposure of this irresistible character.[5] Not long after Hosmer completed her sculpture, Reynolds's painting was auctioned in London and garnered publicity in the American press when it realized a fourfold increase in price.[6] Hosmer's work was connected to Reynolds's in a less-than-flattering manner when the critic for the *New Path*, the Pre-Raphaelite organ in America, intimated that the sculptor lifted her figure directly from the English work. This accusation was subsequently refuted by the reviewer for *Watson's Weekly Art Journal*.[7] While each work shares the common motif of a pudgy child seated on an oversized mushroom, there is nothing beyond this to warrant any charge of plagiarism on Hosmer's part. In fact, another critic asserted that Hosmer "has accomplished for this fancy of Shakespeare what Sir Joshua Reynolds did in painting."[8] The sculptor, ever sensitive to the vagaries of popular taste, was simply responding to the prevailing climate. With *Puck*, she read the situation perfectly.

Hosmer depicted her mischievous forest elf sitting on a massive toadstool, cracking under the weight of the fairy, about to hurl a beetle to unnerve some unsuspecting victim (fig. 94). In addition to the devil's horns sprouting from his forehead, Puck wears a large scallop shell as a helmet, sports batlike wings, and holds a chameleon in his left hand, whose tail curls up the sprite's arm in a gesture of reptilian amicability (fig. 95). When *Puck* was exhibited at the Mercantile Library in Saint Louis in 1862, the catalogue carried

FIG. 94 Hosmer, *Puck*, detail of beetle

FIG. 95 Hosmer, *Puck*, detail of chameleon

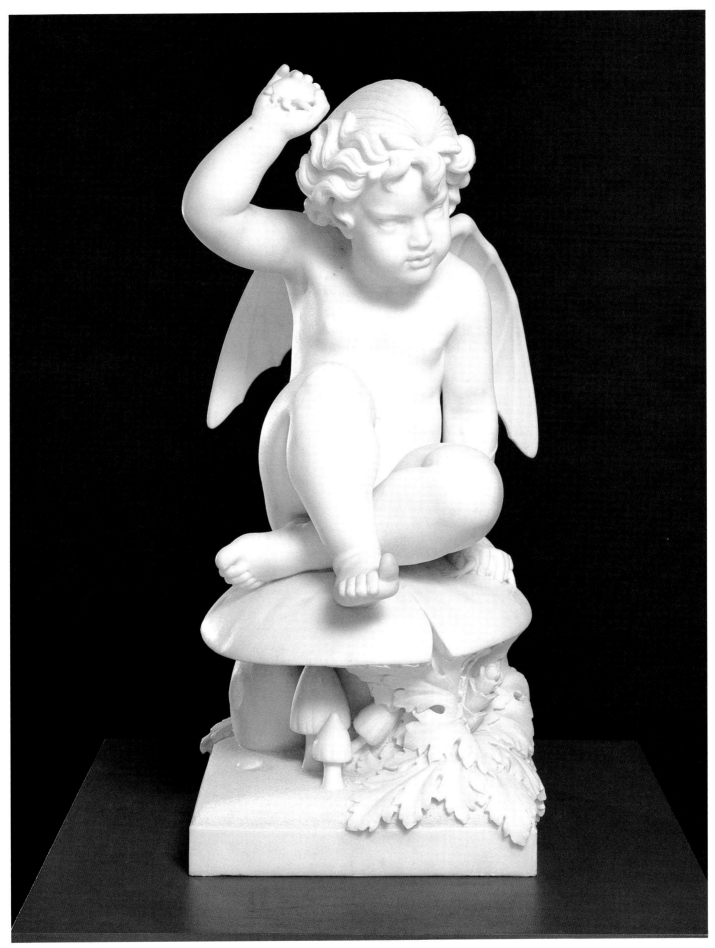

Cat. no. 56 Hosmer, *Puck*

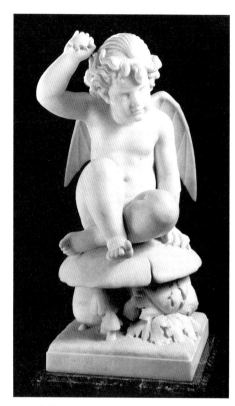

FIG. 96 Harriet Hosmer, *Puck*, 1856. Marble, 30½ in. (77.5 cm) high. National Museum of American Art, Smithsonian Institution, Gift of Mrs. George Merrill, 1918.5.5

a lengthy explanation about the theme of fairies and of Puck, in particular. This explained that the beetle Puck held indicated he was nocturnal and that the chameleon alluded to Puck's changeability, while the scallop shell signified his peripatetic nature.[9]

The vegetation beneath the large mushroom cap includes several more toadstools and a large acanthus plant, whose lush foliage spills over the plinth. Hosmer was not consistent with this aspect of the work, since the assumed earlier version at the National Museum of American Art, dated 1856, shows the adjacent mushrooms as less conical and the plant closed and not extending over the edge (fig. 96). The sculptor also replaced the cockle shell of the 1856 rendition with a scallop shell. This subtle visual variation did not alter the meaning, however. Curiously, the Ricau version, presumably a later variant, involved more carving, and perhaps Hosmer offered her clients varying degrees of complexity, undoubtedly at extra cost.

The child, with its appealing pudginess, recalls the cherubs of Renaissance fountain sculpture as well as Etienne-Maurice Falconet's (1716–1791) rococo conceit of 1757, *The Menacing Cupid* (Musée du Louvre, Paris). The figure conveys a real-

ism that reinforces the immediacy of the imminent action. The facial features possess a particularity that suggests portraiture. It has been said that there is a great deal of Hosmer in the image of *Puck*.[10] Although this observation eludes confirmation, it is well documented that the sculptor continually referred to her sculptures as her children, vicariously fulfilling a maternal desire.[11]

In addition to the sensitive modeling of the face, Hosmer revealed her anatomical training in the convincing rendering of the rest of the body. The surface is modulated in such a way as to convey the underlying skeletal structure of an otherwise chubby body. One distinguished visitor to her studio, the Crown Princess of Germany, commented on Hosmer's exceptional talent for toes.[12] Meticulous attention to the hair and subsidiary details, such as the insect, reptile, and foliage, separate this effort from the main thrust of Hosmer's oeuvre, which adhered to more elevated principles of neoclassicism. Her training centered on a nobility of purpose articulated in a restrained manner, but she realized that for a commercial proposition, the work demanded immediacy and charm.

Puck was in Boston by January 1857, where one critic deemed it "laughing, roguish and naive."[13] This copy, possibly the original, was owned by Samuel Hooper of Boston, who lent it to the annual exhibition at the Boston Athenaeum.[14] Nathaniel Hawthorne commented favorably upon it, calling it "full of fun" and "fanciful."[15] Mrs. Hawthorne also admired the piece and thought it "not so weird as Sir Joshua Reynolds' *Puck*, but very charming and jolly."[16] This preference over Reynolds was especially gratifying in light of the accusation by the *New Path*'s critic. *Puck* required little else to commend it, but the willingness of the Prince of Wales to send his copy to the London International Exhibition of 1862 only made it more desirable. As late as 1866 visitors to Hosmer's studio continued to be enchanted by the irresistible little elf. Indeed, a female viewer noted that "a mischievous morsel of humanity or fairyhood is native to a woman's fancy."[17]

The sculpture may have exerted its own influence. Twenty years after its conception, *Puck* was engraved for the *Art Journal* and accompanied by flattering words from the influential critic James Jackson Jarves.[18] Whether Richard Greenough (q.v.) was inspired by Jarves's praise of Hosmer's success to create his own statue of Puck in 1876 is not recorded, but he elected to illustrate *Puck*'s response to the command to fetch a special herb,

which required the sprite to "put a girdle around about the earth in forty minutes."[19]

Although *Puck* was one of Hosmer's least profound works, it was her most beloved. Responding to *Puck*'s extraordinary popularity, Hosmer created a companion piece, *Will-o-the-Wisp*, which did not fare as well (cat. nos. 57, 58). Yet this set of paired conceits probably influenced other sculptors such as Edmonia Lewis (1844?–ca. 1911) and Thomas Ridgeway Gould (1818–1881), to name but two who emulated this type of approach.[20] Thus, a piece that was spawned out of adversity evolved into the sculptor's signature work, and unquestionably she was most gratified, if not amused, by its phenomenal success.

Notes

1. This transaction was reported in the Boston papers; see "Personal Items," *Boston Transcript*, May 28, 1859, p. 2.

2. Benedict Read, *Victorian Sculpture* (New Haven and London, 1982), pp. 139–140.

3. John Tallis, *Tallis's History and Description of the Crystal Palace, and the Exhibition of the World's Industry in 1851*, 3 vols. (New York and London, 1851), vol. 3, pt. 1, pp. 9–10.

4. Richard Ormond et al., *Sir Edwin Landseer*, exh. cat., Philadelphia Museum of Art and Tate Gallery, London (New York and London, 1981), pp. 189–190. The work was exhibited in New York in the form of a watercolor copy at Williams & Stevens in 1855; see "Art Notes," *Cosmopolitan Art Journal* 2 (Sept. 1855), 208.

5. Nicholas Penny, ed., *Reynolds* (New York, 1986), pp. 322–323.

6. "Sketchings. Gleanings and Items," *Crayon* 3 (July 1856), 222.

7. "Sculpture," *Watson's Weekly Art Journal*, ca. 1854–57, 69.

8. "Art Gossip," *Cosmopolitan Art Journal* 2 (Dec. 1857), 58.

9. Saint Louis Mercantile Library Association, Saint Louis, 1862, pp. 5–6; cited in Yarnall and Gerdts 1986, 3:1795.

10. Sherwood 1991, p. 118.

11. Carr 1912, p. 76 and passim.

12. Sherwood 1991, p. 119.

13. T., "Art Matters," *Boston Transcript*, Jan. 14, 1857, p. 1.

14. "Sketchings. Domestic Art Gossip," *Crayon* 4 (Feb. 1857), 56, and Perkins and Gavin 1980, p. 81.

15. Hawthorne 1858, pp. 151, 495.

16. Hawthorne, *Notes in England and Italy* (1872), pp. 265–266.

17. Walker 1866, p. 102.

18. "Puck," *Art Journal* (New York), n.s., 1 (1875), 317 and engraving on following page.

19. "Art and Artists," *Boston Daily Evening Transcript*, Mar. 3, 1876, p. 6. This action is found in act 2, scene 1, ll. 175–176.

20. Gerdts 1973, pp. 156–157.

57
Will-o-the-Wisp

Modeled ca. 1858

Marble

35¾ × 16¾ × 18⅛ in. (85.7 × 42.6 × 46 cm)
Inscribed on front of base: WILL-O-THE-
WISP; on back of base: HARRIET HOSMER–
FECIT ROMÆ

Provenance Private collection, New
York; [Raymond's Antiques, Alexandria,
Va., by 1970]; Giacomo P. d'Avanzo, by 1971;
[Skinner's, Bolton, Mass., 1982]; [Hirschl &
Adler Galleries, New York, 1982]; private
collection, 1984; James H. Ricau, Piermont,
N.Y., 1984

Exhibition History *Lines of a Different
Character: American Art from 1727 to 1947*,
Hirschl & Adler Galleries, New York, Nov.
13, 1982–Jan. 8, 1983; *The Ricau Collection*,
The Chrysler Museum, Feb. 26–Apr. 23,
1989

Literature Hawthorne 1858, p. 494;
Mrs. Ellet, *Women Artists in All Ages and
All Countries* (New York, 1859), p. 369;
"Personal," *Home Journal*, May 12, 1860,
p. 2; Tuckerman 1867, p. 602; E. B.
Thurston, *Eminent Women of the Age*
(Hartford, Conn., 1869), pp. 578–579;
"Foreign Art Notes," *New-York Evening
Post*, May 24, 1872, p. 1; "Sale of Bric-a-
Brac," *New-York Evening Post*, June 7,
1876, p. 4; Clement and Hutton 1894, 1:366;
Carr 1912, pp. 123, 221–222; Taft 1924, p. 205;
Lillian M. C. Randall, "An American
Abroad: Visits to the Sculptors' Studios
in the 1860s," *Journal of the Walters
Art Gallery* 33–34 (1970–71), 48–49;
Cikovsky et al. 1972, n.p.; Joseph L.
Curran, *Watertown's Victorian Legacy:
A Bicentennial Art Exhibition*, exh. cat.,
Watertown Public Library (Watertown,
Mass., 1976), p. 6; *Antiques* 122 (Dec. 1982),
1154; *Lines of a Different Character,
American Art from 1727 to 1947*, exh. cat.,
Hirschl & Adler Galleries (New York,
1982), p. 36, ill.; Harding 1984, p. 41; Jan
Seidler Ramirez, "Harriet Goodhue
Hosmer," in BMFA 1986, p. 160; Sherwood
1991, pp. 173–175, ill.

Versions MARBLE National Museum
of American Art, Washington, D.C.;
[Christie's, New York, May 25, 1989, lot 31,
and/or Nov. 30. 1990, lot 48]; [Sotheby's,
New York, June 30, 1992, lot 89]

Gift of James H. Ricau and Museum
Purchase, 86.472

The popularity of *Puck* encouraged
Harriet Hosmer to create a companion
piece. The resulting *Will-o-the-Wisp* did
not follow until several years later, since
the sculptor struggled to visualize the
appropriate sequel. Finally, in March 1858,
she wrote to her patron, Wayman Crow:
"I have been rapping at my brains for the
last two years for a fitting subject as a pen-
dant [to *Puck*]. At last I have got it, and am
going to begin it immediately. I won't tell
you his Christian name, but will send you
a photograph from the plaster."[1]

Initial reaction was mixed. Elizabeth
Barrett Browning, whom Hosmer counted
among her closest allies, reported to their
mutual friend Isa Blagden that *Will-o-the-
Wisp* pleased her much less than *Puck*.[2]
Nathaniel Hawthorne was kinder, calling
both it and *Puck*, which he assessed from
photographs, "pretty and fanciful." The
object of his rapt attention, however, was
the unfinished *Zenobia*. He marveled at
the range of Hosmer's expressive abilities,
noting that the two conceits were "the
more natural offspring of her quick and
vivid character," while *Zenobia* was "a
high, heroic ode."[3]

By the spring of 1860 *Will-o-the-Wisp*
emerged as one of Hosmer's new cre-
ations, but it did not enjoy the enthusiastic
publicity or demand of *Puck*. Perhaps
clients found the prospect of pendant
sculptures too daunting and continued to
opt for the original, more roguish work.
Yet as a subject, *Will-o-the-Wisp* was not
without appeal, since Samuel Osgood
mentioned Thomas Buchanan Read's
(1822–1872) painted interpretation.[4]

Through *Will-o-the-Wisp*, Hosmer
alluded to the folkloric explanation of
marsh gas, an elusive light that tradition-
ally misled travelers and caused them to
lose their way. *Ignis fatuus*, or "foolish
fire," the alternate term, was connected to
the phosphorescent glow that occasionally
appeared over a marsh at night due to the
spontaneous combustion of decomposing
material. In its capacity to recede and dis-
appear, *ignis fatuus* assumed the identity
of a mischievous sprite who was the bane
of travelers. By extension, "will-o-the-
wisp" came to signify delusive hope.[5]

In chronicling *Will-o-the-Wisp*'s capacity
as a swamp dweller, the sculptor balanced
good and evil imagery. Hosmer depicted
him seated on a skunk cabbage, inter-
twined with cattails and flowers, while
a tortoise and snail (on the far side of
the composition) inhabit different parts
of the undergrowth (fig. 97). The child per-
sonifying the swamp dweller possesses
the same pudgy quality as his predecessor.
As with *Puck*, Hosmer gave this sprite
horns and ears that echo the suggested
malevolence of the former. *Will-o-the-Wisp*
works his mischief with a flaming torch
while pensively touching his cheek with
his left thumb and forefinger. His expres-
sion does not betray any contemplation
of mischief, however. His Phrygian cap is
surmounted by a diminutive owl, which
refers to the sprite's nocturnal existence.
Like *Puck*, *Will-o-the-Wisp* is equipped
with batlike wings that provide a darker
context for the little creature.

Stylistically, Hosmer attempted to rep-
licate *Puck*'s successful formula. She
achieved a similar sensitivity in the ren-
dering of the anatomy, flesh, and auxiliary
details. The facial features, however, are

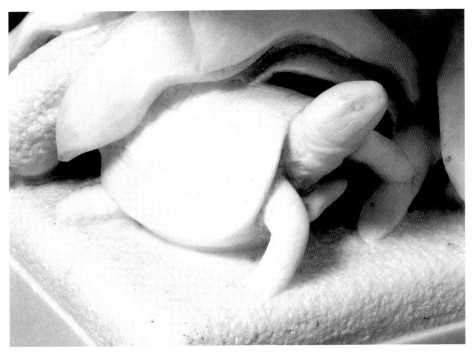

FIG. 97 Hosmer, *Will-o-the-Wisp*, detail of tortoise

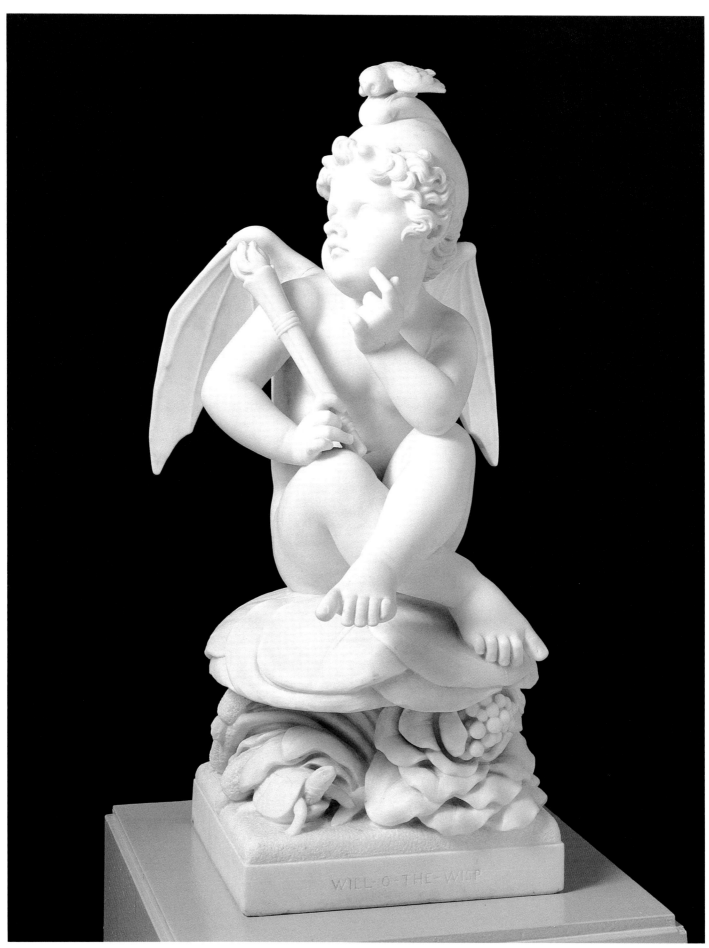

Cat. no. 57 Hosmer, *Will-o-the-Wisp*

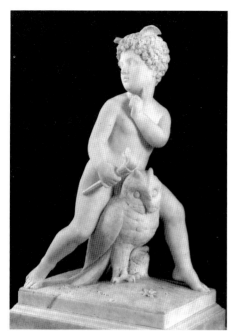

FIG. 98 Harriet Hosmer, *Puck and the Owl*, ca. 1856. Marble, 35½ in. (90.2 cm) high. Library of the Boston Athenaeum, Gift of Julia Bryant (Mrs. Charles J.) Paine, U.H. 22 (1876)

more refined and generalized than those of *Puck*, and the result is a sense of type rather than of individuality. Moreover, *Will-o-the-Wisp*'s expression is unconvincing. The cross-legged position looks uncomfortable and the left arm posed. Consequently, the figure appears artificial and is not as engaging as *Puck*. Hosmer's patrons may have recognized this shortcoming, which resulted in the lukewarm reaction. Its modest success may also explain why Hosmer attempted variations on the *Will-o-the-Wisp* as she searched for an image that would captivate the public the way *Puck* had.

At least two variants are known, one of which is in the Ricau Collection (cat. no. 58), and both are considerably more unsettling than the original conception. The Ricau example is closer compositionally to the initial conceit but is far more menacing. The second example constitutes such a radical departure that it has been mistakenly connected to *Puck*.

Puck and the Owl in the Boston Athenaeum (fig. 98) entered that collection in 1876 as a gift of Julia Bryant (Mrs. Charles J.) Paine.[6] She had lent it to the institution's annual exhibition ten years earlier, where it was titled *Will-o-the-Wisp*,[7] yet a recent publication on the Boston Athenaeum collection rejects this title.[8] However, contemporary evidence refutes this decision. Reference to this variant has surfaced in the myriad travel accounts published in the nineteenth century. Harriet Trowbridge Allen, who trav-

eled to Europe in 1858–59 and again in 1863–64, recounted visiting Hosmer's studio and seeing "a delicate little model called 'Will o' the Wisp,' a mischievous sprite astride of an owl with his torch by his side—a very splendid work."[9] Since Allen refers to Hosmer as busy modeling *Zenobia*—completed in 1859—at the time of her encounter, the variant with the owl was an early conception. Despite Allen's positive reaction and the work's quick placement with a buyer, this second variant did not command the commercial cachet Hosmer sought. One wonders whether this owl is capable of transporting his cargo. Nevertheless, the life-size owl possesses an expression that makes him far more beguiling than the youthful figure astride him. The boy, who rides the owl like a jockey, is still pudgy, but he reflects little of the sensitive handling of the previous two works. *Puck*'s facial features have become even more generalized, with the smooth planar surfaces offset by the stylized curls of hair. Hosmer augmented the figure's curiosity by having small bat wings sprout from the top of his head. The resultant mixture of impassive and bizarre carried Hosmer even farther from the engaging quality she sought. Since the Boston Athenaeum variant appears to be unique and this Ricau version is known in at least two replicas, it seems that Hosmer preferred this companion piece, even if it did not meet the standard of her *Puck*.

Notes

1. Letter from Hosmer to Wayman Crow, Mar. 11, 1858; quoted in Carr 1912, p. 123.
2. Browning to Blagden, Dec. 12, [1858]; Fitzwilliam Museum, Cambridge, England; quoted in Sherwood 1991, p. 173.
3. Hawthorne 1858, p. 494.
4. Osgood 1870, p. 424.
5. *The Oxford English Dictionary*, 2d ed., s.v. "will-o-the-wisp." For a contemporary treatment of the theme, see William Makepeace Thackeray, "The Devil's Wager," in *The Paris Sketch Book of Mr. M. A. Titmarsh and Easter Sketches* (New York, 1840), pp. 208–209.
6. Harding 1984, p. 41.
7. Perkins and Gavin 1980, p. 81.
8. Harding 1984, p. 41.
9. Harriet Trowbridge Allen, *Travels in Europe and the East: During the Years 1858–59 and 1863–64* (New Haven, Conn., 1879), p. 185.

58
Will-o-the-Wisp

Third version?
Modeled after 1864
Marble
31⅞ × 17⅜ × 23¼ in. (81 × 44.1 × 59.1 cm)
Inscribed on front of base: WILL-O-THE-WISP.

Provenance [Elmo Avet, New Orleans]; James H. Ricau, Piermont, N.Y., by 1973

Exhibition History *The Ricau Collection*, The Chrysler Museum, Feb. 26–Apr. 23, 1989

Literature Gerdts 1973, pp. 136–137, ill.; Sherwood 1991, pp. 173–175, ill.

Versions None known

Gift of James H. Ricau and Museum Purchase, 86.473

In hope of capitalizing on the success of her *Puck*, Harriet Hosmer sought to duplicate this achievement in the guise of *Will-o-the-Wisp* (cat. no. 57). As noted, her efforts fell short of her expectations, and she tried to modify her ideas on at least two occasions. Although a chronology of the various versions of *Will-o-the-Wisp* is difficult to establish, it seems plausible that the most benign one and the one most akin in spirit to *Puck* was the initial conception. Perhaps lack of differentiation worked against it and prompted the sculptor to embark on more radical tangents. The version in the Boston Athenaeum, referred to as early as 1859, is distinctive for its flirtation with the bizarre, which is articulated by the unsettling attributes.[1] Yet the alternate version in the Ricau Collection reflects a far more sinister approach.

Where the sequels fit within the chronology is problematic. There is reference to Hosmer's beginning a *Will-o-the-Wisp* in 1872, but information is so scant that it is impossible to be specific.[2] Since the Athenaeum variant is commented on as early as 1859, this suggests it was Hosmer's second attempt. The sculptor then returned to the general composition of her original conception, on the basis of the similar pose and flora and fauna of this variant.

Hosmer created a malevolent figure who sits in a carefree and natural pose on a bed of lush foliage that sprouts from a tree stump. This sense of ease is reinforced by his left leg, which extends forward and is supported by a pair of the thick-stemmed acanthus leaves that emerge from the base of the stump. An owl, reduced to a miniature size, peers out cautiously from the leaves (fig. 99). The elf's facial features have lost their chubbiness, making him

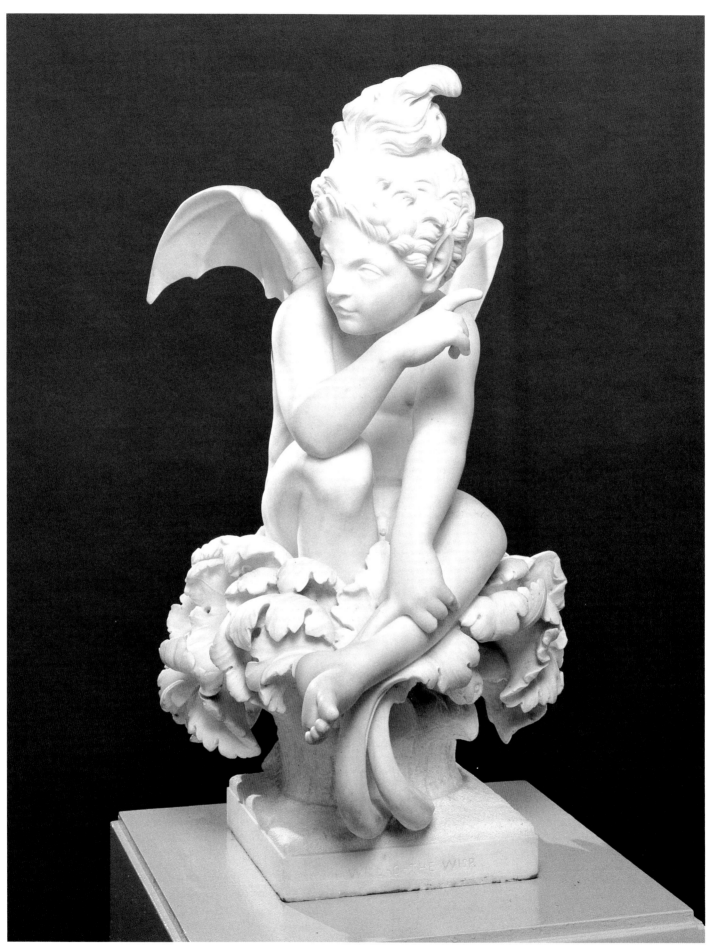

Cat. no. 58 Hosmer, *Will-o-the-Wisp* (third version?)

FIG. 99 Hosmer, *Will-o-the-Wisp* (third version?), detail of owl

seem older and more worldly. The pug nose of his predecessor has been replaced by one that is more aquiline. The hairdo, spiraling in a mass of locks on the top of the head, takes on a flamelike, infernal appearance. This coiffure, in conjunction with the pointed ears, curled lip, and daggerlike expression, countermands any notion of innocence or childish play. With this version, Hosmer let the pendulum swing to the other extreme.

These macabre elements aside, stylistically this *Will-o-the-Wisp* corresponds closely to the original conception. A sensitive refinement of smooth, planar surfaces is counterbalanced by a proliferation of meticulously rendered details—components central to Hosmer's initial effort. Although the sculptor did not achieve the commercial success she desired with this work, in her attempt to create a radical departure from her previous efforts, Hosmer nonetheless created one of the more unsettling sculptural images in the second half of the nineteenth century.

Notes

1. Harriet Trowbridge Allen, *Travels in Europe and the East: During the Years 1858–59 and 1863–64* (New Haven, Conn., 1879), p. 183.

2. "Foreign Art Notes," *New-York Evening Post*, May 24, 1872, p. 1.

Richard Henry Park

American, 1832–1902

Richard Henry Park's position as a lesser figure in the constellation of sculptors collected by Ricau is affirmed by the paucity of available biographical information. Until recently his date of death was unknown, and his middle name was listed variously, ranging from Hamilton to Howard.[1] Confusion even exists about where he was born, with both New York and Connecticut listed. One article has come to light that used the sculptor himself as a source, but this, too, is problematic, since the account contains inaccuracies.[2]

In his youth, Park was a dry-goods clerk who, by his own account, experienced a profound epiphany when he saw Hiram Powers's (q.v.) *Greek Slave* (fig. 13) when it began its national tour in Albany in April 1850.[3] Apprised that the statue was made of marble, Park determined to learn how to cut stone and entered a marble-cutter's establishment. Park persevered at this trade for five years until Erastus Dow Palmer (q.v.) noticed his work and took him on as a pupil. Park appears in Palmer's account books as an assistant from April 1855 to 1861. By 1859 he had been entrusted with pointing and finishing *The Little Peasant* (cat. no. 41).[4]

Confident of his skills in cutting marble, Park decided to test his mettle in New York City. He exhibited at the National Academy of Design from 1862 to 1865 and provided works to such benefit causes as the Artists' Fund Society in 1862 and the Metropolitan Sanitary Fair two years later.[5] Of the five works exhibited at the National Academy, three were portraits; all were lent by William Curtis Noyes, whose posthumous likeness Park created in 1865 (Litchfield Historical Society, Litchfield, Conn.). The same year Park submitted an ideal head, *Margaret.* Based on lines from Alfred Lord Tennyson, it had received favorable notice the previous fall.[6] The newspaper article predicted a bright future for the young sculptor and admired his resourcefulness and initiative in using photographs to apprise the critic of his work. Subsequent newspaper articles praised Park's ability to execute a strong likeness through fine modeling and sensitive carving, which reflected his training in Palmer's studio. Park withdrew from the public arena in the latter half of the decade and only exhibited *Little Nell* at the Goupil Gallery in October 1869.[7] This subject, taken from Charles Dickens, was a particular favorite of the sculptor, who donated a replica to the Metropolitan Sanitary Fair in 1864 and showed it again

in 1872.[8] Given his mentor's triumphs with ideal subjects based on small children, Park was attuned to this formula for success, and *Rosebud* is testament to this (cat. no. 59).

Around 1871 Park broadened his horizons by moving to Florence. He was among the last to choose Italy over France, and he stuck by his decision, maintaining his base in Florence until 1890. Little is known about his tenure there, with contemporary articles and notices composing but a fragmentary mosaic. In 1874 three of Park's ideal busts, *Sappho, Birdie,* and *Rosebud,* were advertised in a sale at the Clinton Hall Art Rooms in New York.[9] The consignor was not identified, but the sculptor did include replicas of these works in the group he sent to the Centennial Exposition in Philadelphia two years later. Thus, he may have favored certain pieces.

In the mid-1870s Park was among the artists attacked for using assistants to execute their work. If most attention was accorded to prominent figures such as William Wetmore Story (q.v.) and Harriet Hosmer (q.v.), Park's ascendant reputation emerges in this episode. In an article refuting this attack on sculptural integrity, the correspondent noted Park's well-known standing in the profession and concluded that he was a good artist and competent modeler with little pretense to greatness.[10]

Despite this modest assessment, Park's work attracted interest. A measure of his worth can be derived by comparing auction prices at a sale in February 1876. Nathaniel D. Morgan, a prominent New York collector, liquidated his paintings and statuary. Among the sculptures were ideal busts by Park and Hiram Powers. Powers's *Washington* realized $400, a *Proserpine* brought $500, and *Faith* made $720. In contrast, Park's *Purity* reached $755, while *Birdie* sold for $515.[11]

Park was not bereft of patrons. In 1875 he executed a full-figure sculpture titled *Mignon* for Mr. and Mrs. J. G. Schmidlapp of Cincinnati, Ohio, which has recently come to light (fig. 100). In Goethe's epic tale *Wilhelm Meister's Apprenticeship,* Mignon was a doomed elfin spirit of the theater world under Wilhelm's protection. Park captured Mignon's melancholy story as he depicted her resting her head forlornly on her cittern, which was the source of many plaintive songs. Stylistically, Park distanced himself from Palmer, since *Mignon* possessed greater fussiness and detail.

To enhance his reputation and generate greater exposure before an American audience, the ambitious Park sent twelve works to the Centennial Exposition at Philadelphia in 1876. While the final report

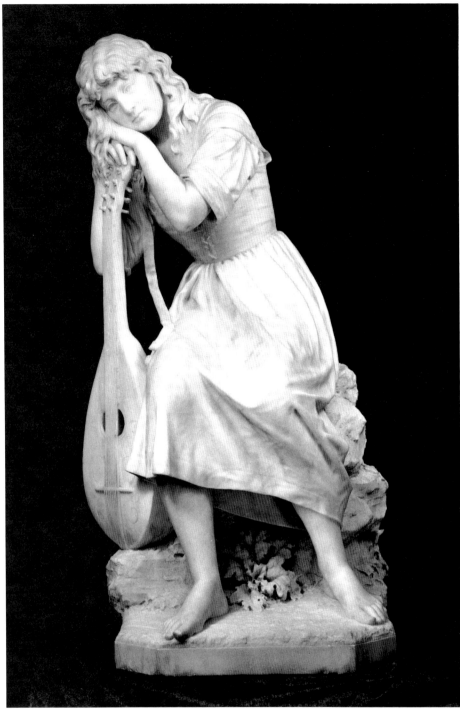

FIG. 100 Richard Henry Park, *Mignon*, before 1876. Marble, 47⅝ in. (121 cm) high. Courtesy of Spanierman Gallery, New York. Photograph by Helga Photo Studio, Upper Montclair, N.J.

the marble statues for the Stewart Memorial.[15] Despite the delays, his patron must have admired his work, since he acquired several other examples for his personal collection.[16]

In the 1880s Park was frequently awarded public commissions. The group Actors of New York requested he create a memorial to Edgar Allen Poe for the Metropolitan Museum of Art (now in the Edgar Allen Poe Museum, Richmond, Va.). In progress by February 1885, the memorial was unveiled May 4, 1885. It consists of a tabernacle of white marble, in the upper part of which is a life-size bronze bust of Poe in low relief. A classic female figure in marble stands to the left and holds a wreath of oak leaves and acorns to surround the relief. An extensive inscription, which eulogizes Poe and his connection to the dramatic profession, is placed in the lower half of the memorial. The combination of architecture, portrait bust, and allegorical figure recalls the monument to the painter Henri Regnault and to pupils of the Ecole des Beaux-Arts killed in 1870–71 (Ecole des Beaux-Arts, Paris).[17] The critic for the *Art Amateur* found this memorial and the previous statues for Stewart "commonplace."[18] Finding little to commend in the Poe Memorial, he considered the pose bereft of nobility and deemed the expression insignificant and simpering.

Other commissions came from farther afield, including two separate orders for monuments from Milwaukee citizens. A heroic-sized bronze statue of George Washington was unveiled in 1885. Two years later a second piece commemorated Solomon Juneau, Milwaukee's first white settler. Park recognized a less competitive niche and, tiring of the commute, decided to leave Florence and move to Chicago in 1890. Ironically, most sources lost track of him at this juncture.

The Midwest treated Park well, and the final decade of his career was accented by several major commissions in his adopted city. In conjunction with the Columbus celebration in 1893, Park executed a figure of the young explorer to adorn the elaborate drinking fountain commissioned as a gift to the city by the hotel owner John B. Drake.[19] The larger-than-life bronze statue depicted Columbus studying a globe. It attempted to combine historical accuracy with the prosaic naturalism that defined public sculpture of this era.

The sculptor's contribution to the Columbian Exposition was an eight-foot silver statue, *Justice of the State of Montana*, displayed in the Mines and Mining Building (fig. 101). Contemporary accounts paid considerable attention to the fact that Park used nearly a ton of sil-

to the commissioner expressed disappointment in the showing by American sculptors, Park was among those singled out for positive comments.[12] Encouraged by the favorable response in Philadelphia, Park showed most of this group in New York in January 1877.[13] In addition to noting the exhibition, a newspaper account indicated Park would model portraits until he returned to Florence in April.

Around this time, Park attracted the attention of Alexander T. Stewart, the

department-store magnate, who commissioned two life-size figures, *Hope* and *Religion,* for commemorative niches in Memorial Church in Garden City, New York.[14] Park shuttled between Florence and New York for this work, since the models were completed in America in 1879 and supposedly shipped to Florence for translation into marble. Completion of this task was not straightforward. In 1881 the *Art Journal* reported that Park was in America to supervise the cutting of

ver, which was valued at almost $250,000. The actual value was given some leeway since artistic merit had to be taken into account. Eventually melted down to resolve a legal dispute, the sculpture is known through a commemorative medal that was struck in 1893.[20] Justice stands on a globe that rests atop a spread-winged eagle. In her right hand she holds a sword; in her left are the obligatory scales. The model for the sculpture was the well-known actress Ada Rehan, who had recently performed in Montana. Once again, critics from the East excoriated the artist and his work:

The Montana statue cast in silver after a model of "Justice" by R. H. Park has had its day of advertisement for Miss Ada Rehan and other actresses, but it leaves the sculptor and the Montana commissioners laughing stocks. The last mentioned proclaim their crudeness; the sculptor has given everybody his measure as an artist. Between him and the ladies who clamor to model at the World's Fair in butter there is this difference, all in favor of the ladies: the latter are provincial amateurs; Mr. Park has had the advantage of travel and labor in his profession. The sooner Chicago sets Mr. Park to work which does not require artistic feeling the better, for monuments will last long after the people of that progressive city have discovered that in the higher sense he is no sculptor at all.[21]

This devastating diatribe, while hard on the ego, did not affect demand for Park's services. Orders for public works during these years included memorials to local philanthropists Michael Reese and Charles J. Hull (both 1893) as well as a monument to Benjamin Franklin erected in Lincoln Park in 1896, when homes and offices throughout the city were being electrified.

Franklin is Park's last-known work. In the twilight of his life, the sculptor could look back on a solid, though unspectacular, contribution to the field of American sculpture. His work sent mixed signals: some perceived an inability to transcend the pedestrian, while others admired him for competent handling. Discussion of the sculpture installation at the Metropolitan Museum in 1899 bears out this dichotomy. The critic for the *Studio* noted Park's *Sappho* in the entrance hall, surely a place of honor, and considered it "modern" in conception.[22] He admired the handling of details such as the olive leaves entwining the lyre, but found Sappho's face devoid of force or expression. In commenting on the Poe Memorial, he also relegated the allegorical figure's face to the realm of commonplace.

In retrospect, Park was unable to reconcile the message of his teacher, Erastus Dow Palmer, who advocated using nature as a point of departure to attain a higher

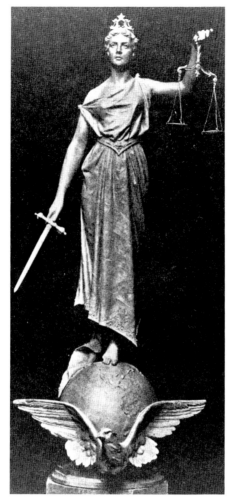

FIG. 101 Richard Henry Park, *Justice of the State of Montana,* ca. 1893. Silver (destroyed). Photograph taken from Hubert H. Bancroft, *Book of the Fair and Historical and Descriptive Presentation of the World's Science, Art and Industry, as Viewed through the Columbian Exposition at Chicago in 1893* (New York, 1895), p. 481

plane of meaning. Park's most enduring legacy may stem from his role as a teacher. He nurtured the young Lee Lawrie (1877–1963), who earned a significant reputation as an architectural sculptor.

Notes

1. Bach and Gray, *A Guide to Chicago's Public Sculpture* (1893), p. 126. This biography constitutes the first such sustained effort.
2. "Richard H. Parks [*sic*]," *Arts* 4 (July 1895), 4–5.
3. Ibid., p. 5.
4. Webster 1983, pp. 25, 157.
5. Maria Naylor, ed., *The National Academy of Design Exhibition Records, 1861–1900,* 2 vols. (New York, 1973), 2:716, and Yarnall and Gerdts 1986, 4:2668–2669.
6. "Fine Arts," *New-York Evening Post,* Oct. 24, 1864, p. 1.
7. "Fine Arts," *New-York Evening Post,* Oct. 25, 1869, p. 2.

8. "The Lanthier Art Rooms," *New-York Evening Post,* Dec. 19, 1872, p. 2. It is impossible to determine whether Park sent the bust from Italy or whether it was already in the possession of Mr. Lanthier, who was operating a commercial establishment.
9. "Sale of Paintings To-Night," *New-York Evening Post,* Feb. 27, 1874, p. 2.
10. Sculptor, "Frauds in Correspondence as well as in Sculpture," *New-York Evening Post,* Mar. 26, 1874, p. 2.
11. "Art and Artists," *Boston Daily Evening Transcript,* Feb. 1, 1876, p. 6. It should be pointed out that Powers's full-length figure, *Paradise Lost,* sold for $9,000.
12. Weir, "Group XXVII. Plastic and Graphic Art. Painting and Sculpture" (1876), 7:658.
13. "Art and Artists," *Boston Daily Evening Transcript,* Jan. 16, 1877, p. 6.
14. "Art Notes. Home," *Art Amateur* 1 (July 1879), 32.
15. "Art Notes," *Art Journal,* Feb. 1881, p. 64.
16. American Art Association, New York, *Catalogue of the A. T. Stewart Collections of Paintings, Sculpture, and Other Objects of Art,* Mar. 23–30, 1887, pp. 173–175, 179.
17. See Maurice Rheims, *Nineteenth-Century Sculpture,* trans. Robert E. Wolf (New York, 1977), p. 335 and fig. 45.
18. "My Note Book," *Art Amateur* 13 (June 1885), 2.
19. Bach and Gray, *Public Sculpture in Chicago,* pp. 290–291.
20. Hubert H. Bancroft, *Book of the Fair and Historical and Descriptive Presentation of the World's Science, Art and Industry, as Viewed through the Columbian Exposition at Chicago in 1893* (New York, 1893), p. 486.
21. "Monthly Record of Art. Items on Sculpture," *Magazine of Art* 16 (1892–93), xvi.
22. "American Studio Talk," *Studio* 8 (Sept. 1899), supplement, xi.

Bibliography

"Fine Arts," *New-York Evening Post,* Oct. 24, 1864, p. 1; "Art Notes," *New-York Evening Post,* Jan. 6, 1865, p. 2; "A Visit to the Studios. What the Artists Are Doing," *New-York Evening Post,* Feb. 16, 1865, p. 1; "Fine Arts," *New-York Evening Post,* Nov. 20, 1865, p. 1; "Fine Arts. Reopening of Goupil's Gallery," *New-York Evening Post,* Oct. 25, 1869, p. 2; "The Lanthier Art Rooms," *New-York Evening Post,* Dec. 19, 1872, p. 2; "Sale of Paintings To-Night," *New-York Evening Post,* Feb. 27, 1874, p. 2; Sculptor, "Frauds in Correspondence as well as in Sculpture," *New-York Evening Post,* Mar. 26, 1874, p. 2; John F. Weir, "Group XXVII. Plastic and Graphic Art. Painting and Sculpture," *U.S. Centennial Commission International Exhibition 1876. Reports and Awards, Groups XXI–XXVII* (Philadelphia, 1876), 7:608–639; Forney 1876, pp. 112–114; "Art and Artists," *Boston Daily Evening Transcript,* Dec. 12, 1876, p. 6; "Art and Artists," *Boston Daily Evening Transcript,* Feb. 1, 1876, p. 6; "Art and Artists," *Boston Daily Evening Transcript,* Jan. 16, 1877, p. 6; "Sale at Leavitt Art Rooms," *New York Herald,* Apr. 2, 1877, p. 3; "Art Notes. Home," *Art Amateur,* July 1, 1879, p. 32; "The Notebook," *Art Amateur* 2 (Feb. 1880), 47; "Sculpture. The Marble Group

'First Love,'" *Studio and Musical Review* 1 (Feb. 1881), 54; "Art Notes," *Art Journal*, Feb. 1881, p. 64; G. E. M., "New York Topics," *Boston Daily Evening Transcript*, Feb. 12, 1883, p. 6; [Clarence Cook], "The Poe Memorial," *Studio*, n.s., no. 20 (May 9, 1885), 233–235; "My Note Book," *Art Amateur* 13 (June 1885), 2; "Art and Artists," *Boston Daily Evening Transcript*, Feb. 5, 1884, p. 3; "Art and Artists," *Boston Daily Evening Transcript*, Oct. 21, 1885, p. 6; "Monthly Record of Art. Sculpture," *Magazine of Art* 13 (1889–90), xxxix; "American Notes," *Studio* 5 (May 31, 1890), 259; "The Hendricks Monument," *Harper's Weekly* 34 (June 28, 1890), 504; "American Notes," *Studio* 6 (Oct. 17, 1891), 370; "Monthly Record of Art. Items on Sculpture," *Magazine of Art* 16 (1892–93), xvi; Hubert H. Bancroft, *The Book of the Fair* (Chicago, 1894), pp. 484ff.; "Richard H. Parks [*sic*]," *Arts* 4 (July 1895), 4–5; Lydia Ely, "Art Exhibitions and Art Patrons," in *History of Milwaukee County*, ed. Howard L. Conard (Chicago, 1898), p. 93; "American Studio Talk," *Studio* 8 (Sept. 1899), xi; Frances Davis Whittemore, *George Washington in Sculpture* (Boston, 1933), pp. 110–113; Ira Bach and Mary L. Gray, *Guide to Chicago's Public Sculpture* (Chicago, 1983), pp. 126–128, 219–220, 290–291

59

Rosebud

Modeled ca. 1871–74
Marble
21⅜ × 13⅝ × 9¼ in. (54.3 × 34.6 × 23.5 cm)
Inscribed on rear: *R. H. Park. Sc.*

Provenance James H. Ricau, Piermont, N.Y.

Exhibition History *The Ricau Collection*, The Chrysler Museum, Feb. 26–Apr. 23, 1989

Literature "Sale of Paintings To-Night," *New-York Evening Post*, Feb. 27, 1874, p. 2; "Art and Artists," *Boston Daily Evening Transcript*, Jan. 16, 1877, p. 6

Versions None known

Gift of James H. Ricau and Museum Purchase, 86.496

THIS ALLEGORICAL WORK entitled *Rosebud* existed by 1874, when it was advertised as one of three busts by Richard Henry Park to be auctioned in New York City.[1] No information regarding consignor or buyer—if there was one—has come to light, but Park must have thought well of the work since he lent a *Rosebud* to the Centennial Exposition in Philadelphia in 1876.[2] A newspaper announcement of an 1877 exhibition of ten works in New York mentioned that all ten works had been created in Italy.[3] Therefore, it is likely that *Rosebud* was executed between 1871 and 1874.

The name "Rosebud" has enjoyed an association with children since at least the second decade of the nineteenth century, when the brothers Grimm published their *Kinder und Hausmärchen* (Children's and household tales). Translated into English in the 1820s, these fairy tales enjoyed great popularity in Europe and America. The story entitled "Dorn-Röschen"—also referred to as "Little Briar-Rose" or "Rosebud"—came to be best known as "Sleeping Beauty," yet it was published with the title "Rosebud" in an edition that appeared shortly before Park commenced work on his bust.[4] This particular publication may have attracted a different level of attention, since it included an introduction by John Ruskin, who was a major force in artistic and literary circles at the time. America, too, seemed smitten with the name early on. A periodical for children called *Rose Bud* was published for a brief time in the 1830s, and no doubt the name fostered an identity with childhood in subsequent decades.[5]

Children in the guise of allegorical figures were common themes for the sculptor's chisel in the third quarter of the

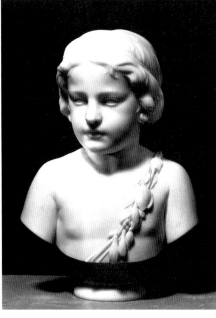

FIG. 102 Erastus Dow Palmer, *Infant Flora*, 1857. Marble, 17 in. (43.2 cm) high. Walters Art Gallery, Baltimore

nineteenth century. Randolph Rogers (q.v.) created his *Daughter Nora as the Infant Psyche* (cat. no. 54) around the time that Park commenced *Rosebud*. William Henry Rinehart (q.v.) portrayed children in mythological guises as exemplified by *Portrait of Otis Angelo Mygatt* (cat. no. 49), and Park's mentor, Erastus Dow Palmer (q.v.), used this convention regularly. In fact, Park had direct contact with one of his master's efforts since he was paid for blocking, or roughing out, the third replica of Palmer's *Infant Flora* in 1858 (fig. 102).[6] This experience must have had an impact since the young sculptor's earliest works included an ideal subject, *Summer*, described as "the head of a young and beautiful girl, with a wreath of roses and leaves twined around her brow."[7] The correspondent considered the countenance expressive of tenderness and sentiment and admired the carefully executed modeling. Such an assessment could just as easily have been applied to a bust by Palmer.

If Park's *Portrait of a Young Woman* in the Ricau Collection (cat. no. 60) is somewhat static and severe, *Rosebud* is lively and engaging by comparison. He infused a great sense of movement as the child looks up to her left and playfully tilts her head—a pose that borders on the coy. The sculptor reinforced this baroque feeling by allowing her gaze to move the viewers beyond the limits of the sculpture and involve them in a moment of surprise. The garment, with its decorated edge and tuniclike quality, has an affinity with the

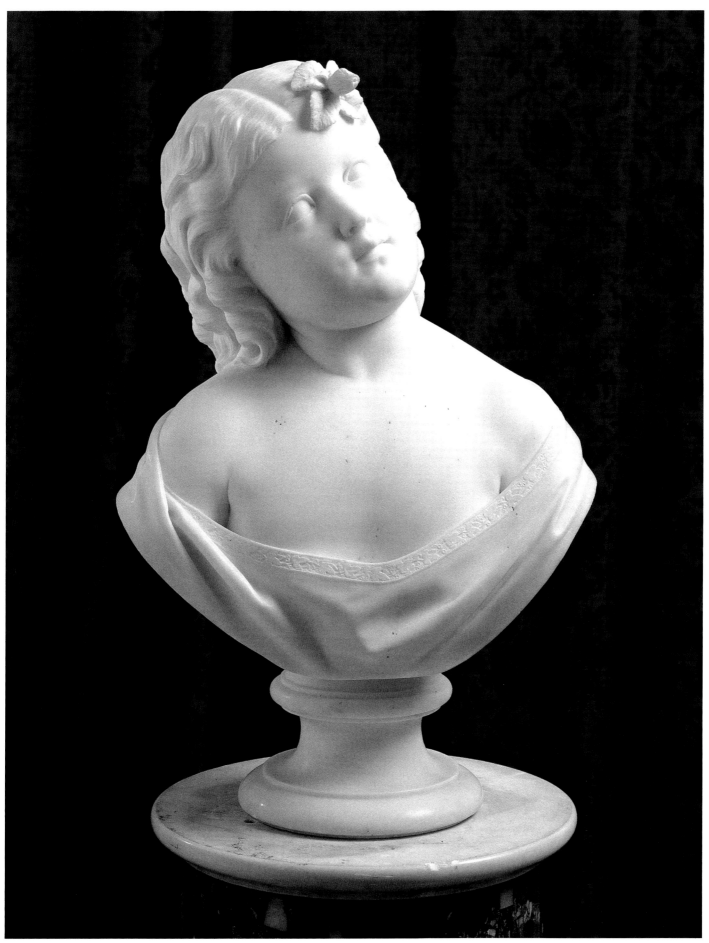

Cat. no. 59 Park, *Rosebud*

past, whether Renaissance or antiquity, and it enhances the visual dynamism through the interplay of vigorously rendered folds. The robe, with its dropped neckline, borders on the vampish and reinforces the message of playful energy. The top of the garment is edged with a trim decorated with ivy leaves, which endows a visual complexity to the lower part of the bust.

Park created a fleshiness in the face and body that is appropriate to the subject's youthful age—somewhere between five and eight—and he deftly handled the chin, lips, and nose. The hair, which is parted in the middle and falls in corkscrew curls to the child's shoulders, is carved with more attention to the individual strand than one would expect from a pupil of Palmer. As a result, the effect is more wiry and brittle than the softer textures of the more generalized treatment in the sculptor's *Portrait of a Young Woman* or Palmer's *Little Peasant* (cat. no. 41). The other major detail, the rosebud, is carved with great fidelity, and Park did not stint on his attention to it, since it gave the piece its name.

The rose has long been associated with the Virgin Mary; she is described as a rose without a thorn. By depicting the flower in its nascent bud stage, Park applied this association with purity and innocence to the realm of childhood. This concept attracted widespread interest from artists in the Victorian era, and such themes accommodated the predilection for sentimental subject matter. Because so little is known about Park's life, it is difficult to apprehend his motives. Was he, like Palmer, inspired by a close-knit family? Or was he simply capitalizing on the taste of the period? Whatever the reason, Park created a touching example of the universal reverence for the virtue and innocence of childhood in his *Rosebud*.

Notes

1. "Sale of Paintings To-Night," *New-York Evening Post*, Feb. 27, 1874, p. 2.

2. Yarnall and Gerdts 1986, 4:2669; no. 1185 in the original catalogue, *Rosebud*, along with the other eleven works by Park, was exhibited in the Art Annex Building.

3. "Art and Artists," *Boston Daily Evening Transcript*, Jan. 16, 1877, p. 6.

4. Jacob Grimm and Wilhelm Grimm, *German Popular Stories*, with illustrations after the original designs of George Cruikshank, ed. Edgar Taylor, intro. John Ruskin (London, ca. 1870).

5. Janie M. Smith, "'Rose Bud,' A Magazine for Children," *Horn Book* 19 (Jan. 1943), 15–20.

6. Palmer's account book entry for May 28, 1858, indicates that Park was owed $60 for this work; cited in Webster 1983, p. 153.

7. "Fine Arts," *New-York Evening Post*, Nov. 20, 1865, p. 1.

60
Portrait of a Young Woman

Ca. 1880
Marble
20⅛ × 12⅞ × 8¼ in. (51.1 × 32.7 × 21 cm)
Inscribed on center rear of bust: *R. H. Park. Sc.*

Provenance James H. Ricau, Piermont, N.Y.

Exhibition History *The Ricau Collection,* The Chrysler Museum, Feb. 26–Apr. 23, 1989

Literature None known

Version MARBLE [Sotheby's Arcade, New York, Sept. 12, 1994, lot 67 (not sold)]

Gift of James H. Ricau and Museum Purchase, 86.497

So little is known about Richard Henry Park and his oeuvre that it is often difficult to establish an identity or precise date of execution for this work. While the sitter remains anonymous, the hood covering the back of her head may have some iconographic significance and may even connect it to a literary source. A nearly identical example (the sculptor added a small crucifix just below the the collar) has come to light that is dated 1880 and provides some guidance for when the Ricau version was carved (see Version, above).

Park's debt to his mentor, Erastus Dow Palmer (q.v.), is obvious, especially in the generalized treatment of the hair. It is accented by prominent ridges that create an interplay of light and dark. The sensitive handling of surface also echoes that of Park's teacher. But unlike Palmer, whose busts possessed a warmth and feeling, Park endowed this young girl with a cold and hard countenance. Her lips are pursed, and there is no penetration of character. Although these traits may be attributable to a literary source, these elements nevertheless confirm the criticism often leveled at Park for creating faces with vacuous expressions.

An aura of reticence is reinforced by the choice of an extremely plain garment. The dress or blouse has a simple collar adorned with minimal trim and is invisibly fastened to eliminate distracting details. The pronounced simplicity of the drapery folds further underscores the bust's austerity.

Despite the feeling of remove inherent in this portrait, Park attempted to infuse life into it. The slight tilt and turn of the head to the girl's right intimate movement and a sense of the momentary. The subtle elongation of the features, accented by the delicate aquiline nose, signals a concern for the particular rather than the ideal. The youthful complexion is smooth and pure, yet the articulation of the temples and forehead suggest an individual physiognomy. The girl's flowing hair provides the single most convincing attempt at capturing a tangible characteristic. In the spirit of Palmer, this produces the one human element in the piece.

Despite his sensitive but methodical handling of surface, Park was unable to shed the hard coldness that defines marble. The bust's severity and standoffishness place it within the mainstream of prosaic portraiture produced in the second half of the nineteenth century.

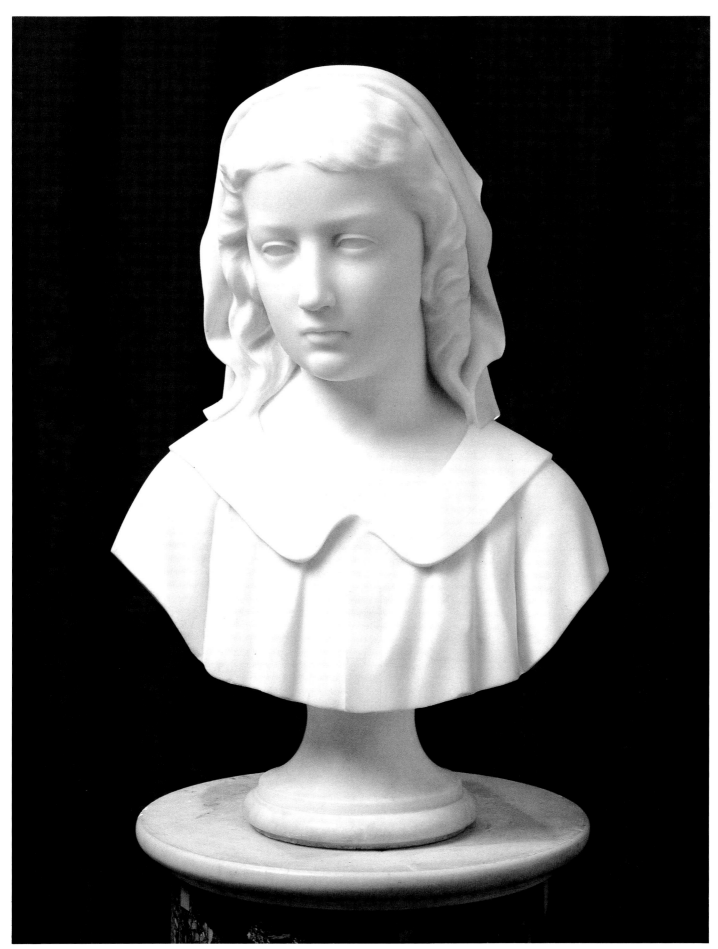

Cat. no. 60 Park, *Portrait of a Young Woman*

Launt Thompson
American, 1833–1894

The biography of Launt Thompson chronicles a successful career derailed by a weakness for alcohol. Thompson rose from humble beginnings to become a highly regarded artist who helped introduce animated naturalism into the realm of American portraiture in the last half of the nineteenth century. Despite a wit and charm that endeared him both professionally and socially, Thompson could not conquer his addiction to drink. The last decade of his life was unproductive, and his final years were spent in an institution, where the debilitating effects of his alcoholism and throat cancer brought Thompson's tragic existence to an end.

Launt Thompson was born in Abbeyleix, Queens County, Ireland, and was only three years old when his father died. His mother, for the same reasons that the Saint-Gaudens family and thousands of other Irish emigrated, brought her son to America, where she had family in Albany, New York. Young Launt initially appeared destined to join the medical profession. He went to work for Dr. James H. Armsby, an anatomy professor, and entered the local medical college, where he excelled in anatomy and dissection. Thompson spent his leisure hours drawing, and the quality of his efforts attracted the attention of Dr. Armsby, himself an amateur artist. Dr. Armsby introduced Thompson to the landscape painter William Hart (1823–1894), who in turn put him in touch with Erastus Dow Palmer (q.v.). While pursuing his medical studies, Thompson attended drawing classes and copied subjects Hart provided him. In spite of Thompson's success in the medical college, Dr. Armsby recognized that his protégé's true talent lay in the arts and arranged for him to enter Palmer's new studio.

Thompson spent nine productive, happy years as an apprentice assisting Palmer. In November 1858 he decided to strike out on his own in New York. Palmer felt the loss keenly and wrote to a friend that "a more faithful boy it would be difficult to find."[1] Thompson settled in the legendary Tenth Street Studio Building and immediately joined the lively artistic fraternity. Like Palmer and later Augustus Saint-Gaudens (q.v.), Thompson initially supported himself by cutting cameos and devoted his spare time to modeling ideal reliefs.

In the spring of 1859 Thompson submitted a marble medallion and a selection of cameos to the National Academy of Design. On the basis of these works, he was elected an associate academician.

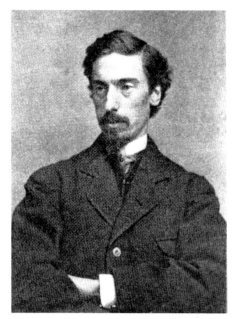

Photograph of Launt Thompson from *The Book Buyer* 23 (Jan. 1902), 537

But he expressed disappointment that his efforts attracted no attention in the press. Palmer took up his cause and wrote to John Durand, editor of the influential magazine the *Crayon*.[2] Out of respect for Palmer's opinion, Durand rectified this oversight in the June 1859 issue by commenting on the young sculptor's efforts: "For skill of finish, for modelling, for qualities of refinement and character, we know of no works . . . that are superior."[3] The early training with cameos provided dexterity and a sense of design that enhanced Thompson's mature works. The art of cameo cutting was but a stepping stone, and the following year Thompson signaled his more ambitious intentions by submitting to the 1860 academy exhibition two allegorical busts, *L'Allegra* and *La Penserosa*, as well as an unidentified portrait bust.[4] In 1862 he ascended another plateau with his election to full academician on the basis of *The Trapper–Grizzly Adams*, submitted to the annual exhibition that year. Thus, Thompson's position as a sculptor was secure.

The decade of the 1860s was extremely successful for Thompson both personally and professionally. He met William Waldorf Astor, heir of the wealthy fur merchant, and took him on as a pupil. Their ensuing friendship opened doors to New York's most elite society, a circle in which Thompson's wit and charm enabled him to circulate with great ease. He received a steady stream of portrait commissions from such influential patrons as James Gordon Bennett, publisher of the *New York Herald;* Edwin

Booth, the noted Shakespearean actor, and the influential businessmen Robert Minturn, Samuel Hallett, and Thomas Tileston. At this time, Thompson undertook the rather extraordinary commission of a full-length sculpture of Napoleon I (NMAA) for a Mr. Pinchot of Milford, Pennsylvania, who had served in the emperor's army before immigrating to America.[5] The sculptor exhibited the plaster of this statue, as well as *The Trapper,* at the Paris Universal Exposition in 1867.

Thompson won several public commissions during these years. He modeled the likeness of Daniel Huntington (1816–1906), president of the National Academy of Design, for the Century Association in 1863 (Century Association, New York). He also created a larger-than-life bust of William Cullen Bryant for Central Park. Completed in 1865 and cast in 1867, it was never installed outside and ended up in the Metropolitan Museum of Art. His full-length statue for West Point of the military hero General John Sedgewick was commissioned in 1869. Thompson was not always successful. His model for the Shakespeare statue in Central Park drew praise in 1866 for its "strength and intellectuality of expression,"[6] but the commission went to John Quincy Adams Ward (1830–1910).

On the basis of his activities, Thompson began to attract extended notice in the press. He was the subject of an article published in December 1865 that provided a detailed description of his studio as well as a thorough account of the procedure involved in sculpting a portrait.[7] A subsequent appraisal in 1867 commended the confident blend of vigor and ideality in his work.[8] The sculptor relished the critical attention that accompanied his commercial success.

Despite the enthusiastic response in America, by 1867 Thompson felt the lure of Europe, especially Italy. The positive reception of the *Napoleon* in Paris confirmed his resolve, and he spent the next two years in Rome competing with established sculptors for major commissions. Little is known about these years, except that Thompson returned to America in 1869 to marry Marie L. Potter, sister of Henry Codman Potter, rector of Grace Church and later Episcopal bishop of New York. This union further secured the sculptor's standing in the inner sanctum of New York's social elite, which remained a crucial source for commissions.

The following decade proved to be the culmination of Thompson's abbreviated career. Filled with intense activity, it also augured Thompson's demise. He executed numerous portraits, including a number

of his artist friends. His posthumous marble bust of Charles Loring Elliott (1812–1868) was finished in 1870, while a bust of Sanford R. Gifford (1823–1880) was cast in bronze the following year (both, MMA). The Gifford demonstrates Thompson's characteristic attention to facial structure and treatment of the flesh. His animated handling of the hair and beard imbued the likenesses with immediacy. Thompson also secured important public commissions. Among these were the full-length portrait of General Winfield Scott for the Old Soldiers' Home in Washington, D.C., which Scott founded; Admiral Samuel du Pont (dedicated 1884), originally erected in Dupont Circle in that city and removed to Wilmington, Delaware, in 1921; and Abraham Pierson, rector of Yale Collegiate School, commissioned in 1874. Thompson's election to the vice presidency of the National Academy of Design signaled further measure of his growing esteem.

With his career firmly established, Thompson returned to Italy via Paris, where he spent the fall of 1875. He moved on to Florence in the winter and stayed there until 1881. Little is known about his activities during this sojourn, but such paucity of information is significant. An artist of Thompson's stature would have attracted attention in the various accounts of artistic life abroad, which were a staple of American newspapers. Thompson did contribute to one article while in Paris.[9] Yet nothing has come to light detailing his activities. There is little evidence of productivity, and it is thought his behavior became erratic at this juncture.[10] Even after his return to America in 1881, he accomplished little and disappeared on lengthy binges. The only significant work he completed was the equestrian statue of General Ambrose E. Burnside, unveiled in Providence, Rhode Island, in 1887. An architect's involvement to design the pedestal ensured its completion. Otherwise Thompson's career was paralyzed by his intemperance. By 1890 his health deteriorated to such a degree that he was admitted to a private sanatorium, and two years later he was transferred to a state institution, where he passed the final two years of his fitful existence. Thus came to a sad conclusion the chronicle of an individual who exhibited great promise, who was accorded great respect, and yet who could not overcome his human frailty.

Notes

1. Erastus Dow Palmer, Albany, N.Y., to Edwin B. [sic] Morgan, Nov. 1, 1858, Wells College Library, Aurora, N.Y. This is in all likelihood the future governor of New York and patron of the arts, Edwin D. Morgan. For the most recent account of Thompson, see Craven 1984, pp. 237–240.

2. Erastus Dow Palmer, Albany, to John Durand, May 12, 1859, Durand papers, New York Public Library.

3. [John Durand], "Sketchings. National Academy of Design. Second Notice," Crayon 6 (June 1859), 192.

4. Cowdrey 1943, 2:159. The portrait bust was lent by Robert J. Dillon.

5. Tuckerman 1867, p. 595. It is extremely unlikely that Mr. Pinchot lived to see the ultimate realization of this project, since the Napoleon was not cast in bronze until 1889.

6. Paletta, "Art Matters," American Art Journal 6 (Dec. 29, 1866), 149.

7. T[homas] B[ailey] Aldrich, "Among the Studios," Our Young Folks 1 (Dec. 1865), 775–778.

8. Paletta, "Art Matters," Watson's Art Journal 7 (Aug. 31, 1867), 295.

9. Launt Thompson, "An American Sculptor in Paris," New-York Evening Post, Oct. 5, 1875, p. 1.

10. Craven 1984, p. 240.

Bibliography

"Artists' Reception," Home Journal, Jan. 29, 1859, p. 2; "National Academy of Design," Home Journal, Apr. 23, 1859, p. 2; "Sketchings. Domestic Art Gossip," Crayon 6 (Oct. 1859), 320; Z., "Fine Arts in New York," Boston Transcript, Nov. 7, 1859, p. 2; "Fine Arts," Home Journal, Dec. 1, 1860, p. 2; "Sculptors and Sculpture," Cosmopolitan Art Journal 4 (Dec. 1860), 182; "Artists' Studios," Round Table, Dec. 26, 1863, p. 28; "Art and Artists in New York," Boston Transcript, Nov. 17, 1864, p. 2; "Art Matters," New-York Evening Post, Feb. 16, 1865, p. 7; "Art. Art Notes," Round Table, Sept. 9, 1865, p. 7; T[homas] B[ailey] Aldrich, "Among the Studios," Our Young Folks 1 (Dec. 1865), 775–778; "Art Feuilleton," New-York Commercial Advertiser, Feb. 20, 1866, p. 2; "Our New York Painters," New-York Evening Post, Feb. 27, 1866, p. 1; Paletta, "Art Matters," American Art Journal 6 (Dec. 29, 1866), 149; Tuckerman 1867, pp. 594–595; Paletta, "Art Matters," Watson's Art Journal 7 (Aug. 31, 1867), 295; "Fine Arts," New-York Evening Post, Sept. 29, 1868, p. 1; "Art Notes," New-York Evening Post, Mar. 2, 1870, p. 1; "Art Notes," New-York Evening Post, Sept. 9, 1874, p. 2; "The Bust of Mr. Bryant," New-York Evening Post, Nov. 14, 1874, p. 4; Launt Thompson, "An American Sculptor in Paris," New-York Evening Post, Oct. 5, 1875, p. 1; "Monthly Record of Art. Sculpture," Magazine of Art 10 (1886–87), xxxvi; "American Artists in Florence," Boston Evening Transcript, July 12, 1890, p. 12; "Obituary Notes," Studio 9 (Oct. 1894); "American Studio Talk," Studio 8 (Sept. 1899), xi; Taft 1924, pp. 234–236; Gardner 1965, pp. 32–33; Craven 1984, pp. 237–240

61
Portrait of a Gentleman

Modeled ca. 1867, carved 1867
Marble
26¾ × 14 × 11 in. (67.9 × 35.6 × 27.9 cm)
Inscribed on lower right front of bust:
Launt Thompson Sc. 1867

Provenance James H. Ricau, Piermont, N.Y.

Exhibition History *The Ricau Collection,* The Chrysler Museum, Feb. 26–Apr. 23, 1989

Literature None known

Versions None known

Gift of James H. Ricau and Museum Purchase, 86.524

By 1867, when this bust of an unidentified gentleman was executed, Launt Thompson had acquired a formidable reputation as a modeler of portraits. He was admired for his ability to take a "strong and effective" likeness.[1] One critic reported:

Mr. Thompson's studio is a very interesting place. The heads of some of our strongest men are there absolutely fixed in marble, and character is seen in its most impressive form. Render a human face in marble, and it immediately becomes majestic, or at least sacred. Marble consecrates the most ignoble form.[2]

While this commentary dwelled on the transformative properties of marble, it also revealed the esteem enjoyed by the sculptor.

Contemporary literature provided insight into Thompson's working method. Thomas Bailey Aldrich, author and journalist, visited the Tenth Street Studio Building in September 1865 and found Thompson to be one of the few artists in residence. Aldrich was kindly disposed to the sculptor's work, since in 1860 Thompson had exhibited at the Düsseldorf Gallery a marble medallion entitled *Marguerite,* based on Aldrich's poem of that name.[3]

Thompson was starting to model a portrait bust on the day of Aldrich's visit, and the reporter took advantage of the moment to inform his readers of the sculptor's working method. He described the pivoting armature on which the clay was built up and explained the modeling process, with the myriad little wooden tools that were used for scraping, raking, and defining the likeness. Having witnessed the first sitting, Aldrich described the procedure:

Day after day the work goes on, the sitter getting more tired, the sculptor more interested, and the bust more lifelike, until, gazing on the

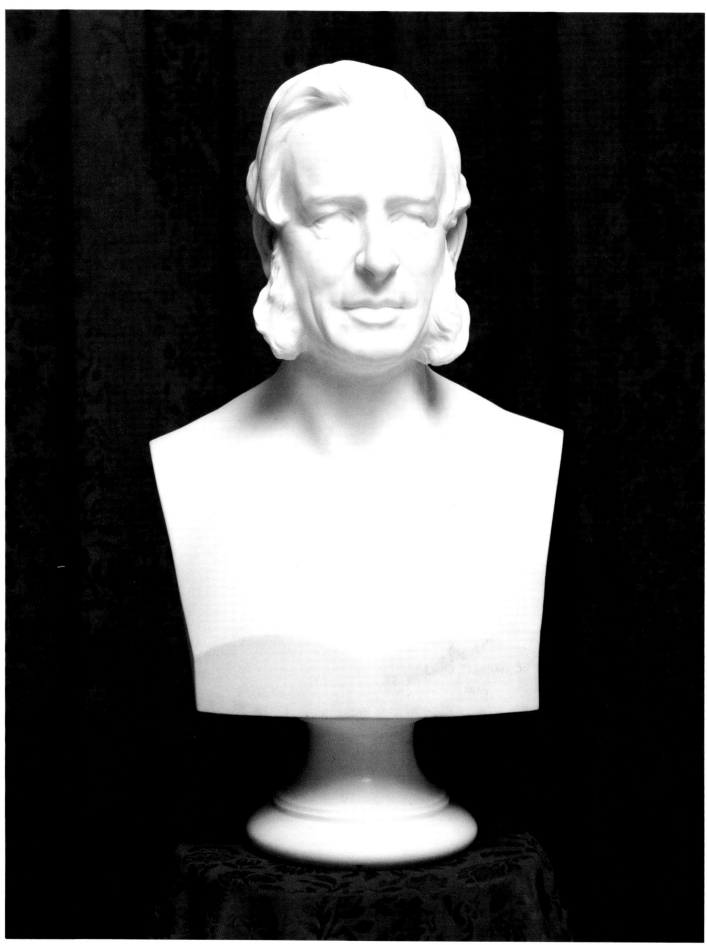

Cat. no. 61 Thompson, *Portrait of a Gentleman*

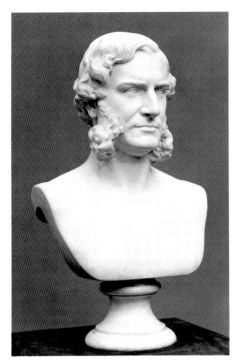

FIG. 103 John Quincy Adams Ward, *William Tilden Blodgett*, 1865. Marble, 26 in. (66 cm) high. The Metropolitan Museum of Art, Gift of J. Q. A. Ward, 1910 (10.200)

motionless face, the story of Pygmalion, who modeled a statue with such wonderful skill that it came to life one day, doesn't seem to be such a very big story as it is.[4]

Aldrich recognized that modeling in clay constituted the most interesting stage, since it embodied the direct touches of the sculptor. At this juncture, the model was turned over to assistants who cast it in plaster and translated it into marble. Aldrich emphasized Thompson's responsibility for the finishing touches, which ensured that the bust possessed "that exquisite texture for which his marbles are notable."

Few clues exist to identify this portrait. Thompson did not submit any work to the National Academy in 1867, and the following year the sole example was a portrait bust lent by John T. Daly, about whom nothing is known.[5] Added to this meager information is a brief article published in 1867 that mentioned ongoing work on the bust of William Cullen Bryant and the recent completion in marble of the "strongly marked and characteristic bust of J[ames]. G[ordon]. Bennett."[6] This must refer to a second replica of the noted newspaper publisher's portrait. It was reported in September 1865 that Thompson had just completed Bennett's bust and that the sitter was "in marble, much more dignified and handsome than he is on paper."[7] Presumably, the comparison alluded to the

editorial sensationalism that made Mr. Bennett's paper, the *New York Herald,* so popular.

Although the sitter for the Ricau bust defies identification, it is emblematic of Thompson's abilities in this genre, and the author of the 1867 notice affirmed this:

Mr. Thompson is always remarkably successful in catching the strong points of character and expression in his sitters; giving us portraits which rise above the mere commonplace of portraiture and possess an ideality and vigor both delightful and attractive.[8]

Indeed, these words could have described the bust in question.

Truncated in the manner of the antique, the bust achieves a balance between Greek idealism and Roman realism. Thompson avoided imbuing his subject with an overbearing severity. The lips almost break into a smile, yielding an expression of warmth that endows the portrait with a human and immediate quality. Compared to the bust of William Tilden Blodgett (fig. 103), sculpted two years earlier by Thompson's contemporary John Quincy Adams Ward (1830–1910), this anonymous person seems more approachable. The pronounced side whiskers and full, flowing hair are also evident in this portrait. These identify the tonsorial fashion of the day and lend a sense of vitality. The nose is an unavoidable feature of the physiognomy, and Thompson did not flinch from depicting its prominence. The high forehead is also distinctive. The composite effect is convincing as well as pleasing. The sculptor persuaded the viewer he was confronting real flesh and blood. Although the expression is benign, it possesses a calm dignity and quiet strength that justify the praise Thompson received for his interpretive abilities.

Notes

1. "Art Matters," *New-York Evening Post,* Feb. 16, 1865, p. 2.
2. "Art Feuilleton," *New-York Commercial Advertiser,* Feb. 20, 1866, p. 2.
3. Yarnall and Gerdts 1986, 5:3506.
4. T[homas] B[ailey] Aldrich, "Among the Studios," *Our Young Folks* 1 (Dec. 1865), 777.
5. Maria Naylor, ed., *The National Academy of Design Exhibition Records, 1861–1900,* 2 vols. (New York, 1973), 2:931. The bust is no. 553 in the catalogue.
6. Paletta, "Art Matters," *Watson's Art Journal* 7 (Aug. 31, 1867), 295.
7. "Art. Art Notes," *Round Table,* Sept. 9, 1865, p. 7.
8. Paletta, "Art Matters," p. 295.

Larkin Goldsmith Mead
American, 1835–1910

Lorado Taft, author of the earliest survey of American sculpture, characterized Larkin Mead as the last survivor of the "old-time brilliant exiles" in Florence. He suggested that Mead's contribution to the cause of American sculpture might have taken on a greater dimension had he chosen to remain in America.[1] Mead won his most important commission, the monument to Abraham Lincoln (Oak Ridge Cemetery, Springfield, Ill.), during a brief visit to the United States. However, like so many in his fraternity, Mead felt most creative in his adopted Italy. His sculpture embodied a subtle shift from pure classicism to a more realistic rendering, which, nevertheless, retained vestiges of classic reserve and idealization.

Larkin Mead, like his illustrious predecessor in Florence Horatio Greenough (1805–1852), came from prosperous colonial stock. His father was a successful lawyer; his mother was the sister of Humphrey Noyes, the founder of the Oneida community who believed sin could be eliminated through social reform. Born in Chesterfield, New Hampshire, but raised in Brattleboro, Vermont, young Larkin benefited from a household that engaged in lively intellectual and artistic activity. His sister Elinor was an artist who married William Dean Howells, the highly respected author and editor of the *Atlantic Monthly.* For years his brother William Rutherford Mead (1846–1928) was the central partner in the renowned architectural firm of McKim, Mead & White. Brattleboro, too, provided an exceptional location, since many prominent Americans traveled to Vermont to take the town's famous water cure.

Mead grew up in stimulating surroundings that did not look askance at his early dedication to drawing and sculpture. While working part-time in the local hardware store of Williston & Tyler, Larkin relaxed by drawing and carving. In the summer of 1853 Henry Kirke Brown (1814–1886) was said to have visited Brattleboro for his water cure and recognized Larkin's talent as a sculptor.[2] The older sculptor prevailed on Mead's family to allow him to develop Larkin's skills in a more systematic fashion. As a result, Mead went to New York to assist in Brown's studio, where he worked alongside John Quincy Adams Ward (1830–1910) for two years. Through this experience, Mead absorbed his mentor's preference for an artistic expression based on simple and direct naturalism.[3]

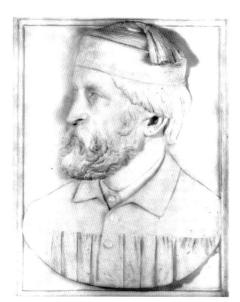

Larkin Mead, *Self-Portrait*, n.d. Marble, 17½ ×
14⅛ × 1⅜ in. (44.5 × 35.9 × 3.5 cm). Mead Art
Museum, Amherst College, Gift of Margaret P.
Mead, 1952.113

Mead returned to Brattleboro in
December 1855 to establish his career, and
he quickly demonstrated to the local pop-
ulace his talent and wit. In an episode that
quickly assumed legendary proportions,
Mead modeled an eight-foot sculpture of
an angel out of snow on New Year's Eve.
News of the *Recording Angel*, as it came
to be known, traveled far and wide, and
even gained immortality in James Russell
Lowell's poem, "A Good Word for Winter."
The work attracted as much notice for
its quality as a sculpture as it did for its
cleverness as a prank and caught the
attention of Nicholas Longworth of
Cincinnati. Longworth, an important arts
patron and sponsor of such sculptors from
the previous generation as Hiram Powers
(q.v.) and Shobal Vail Clevenger (1812–
1843), commissioned Mead to replicate
the angel in marble. Fame and admiration
brought other commissions, ranging from
portrait busts to public works. In 1857
Mead enjoyed favorite-son status with the
order for a nineteen-foot wooden figure
of Ceres to surmount the dome of the
Vermont Statehouse in Montpelier. The
following year, he was asked to provide
a colossal monument honoring the leg-
endary Ethan Allen. The *Crayon* covered
these two commissions and praised the
state government for giving the work to a
native son.[4] Mead responded with some
chauvinism of his own by selecting marble
from a quarry in Rutland, Vermont, when
the state finally authorized the translation
of Allen's likeness into marble in 1860.[5]
Unfortunately, due to the harsh climate,
neither work survives in its original form.[6]

While engaged in these major undertak-
ings, Mead created two other statuettes of
local interest, *Green Mountain Girl* and
Green Mountain Boy.[7]
Mead's burgeoning career was derailed
by the outbreak of the Civil War. He spent
part of 1862 traveling with the Army of the
Potomac and provided *Harper's Weekly*
with illustrations of camp life and battle
scenes. By November he was back in
Vermont and exhibited a bust of General
George McClellan, whose command had
recently been reduced from all the armies
of the Republic to only the Army of the
Potomac. The bust was pronounced an
excellent likeness that did credit to the
artist.[8]
Mead returned to Vermont to accom-
pany his sister Elinor to Paris for her
marriage to William Dean Howells, the
United States consul in Venice. The sculp-
tor undertook this journey to further his
study of sculpture in Florence. Even at
this late date, the emphasis on naturalism
associated with Florence held greater
attraction for Mead than the classicism
that dominated artistic thought in Rome.
Although he received a warm welcome
from Hiram Powers, with whom he
shared ties to both Vermont and Nicholas
Longworth, it was the Kentuckian Joel
Tanner Hart (1810–1877) who provided
Mead with space in his studio on the pop-
ular Piazza Independenza.
In December 1863 the New York press
reported on Mead's activities, noting that
he had completed works entitled *Sappho*
and *Joseph the Dreamer*, and had started
modeling *The Battle Story* (cat. no. 62).[9]
This account also praised a piece entitled
Echo (CGA) and indicated that several
copies had been ordered. *Echo* was
Mead's initial effort in Italy and grew out
of a study based on an antique torso. At
Hart's suggestion, Mead made it into a
full-fledged female figure he titled *Echo*,
in tribute to the mythological character.
According to legend, however, the statue
had its inspiration in the informal expres-
sion, "Ecco!" (Here it is!), which waiters
used in presenting dishes to their cus-
tomers.[10] The piece enjoyed an auspicious
beginning, since one of the initial replicas
was ordered in 1865 by William W.
Corcoran and ended up in the Corcoran
Gallery.
While pursuing his career in Florence,
Mead made extended forays to Venice to
visit his sister and brother-in-law and, on
occasion, served as consul in Howells's
absence. He was enchanted by Venice
and, despite the language barrier, fell in
love with one of the city's residents. In
February 1866 Mead married Marietta di
Benvenuti. The determination on both

sides was strong, since the marriage was
opposed by the pope because Marietta was
marrying outside the Catholic church.
This union may have inspired a marriage
portrait in the guise of *Venezia*, which was
completed around this time (cat. no. 63).
Soon after his marriage, Mead returned
to America with his bride and brought
several sculptures to exhibit in New York.
He rented space in the Tenth Street Studio
Building for a show that opened in May
1866. There were eight pieces in the exhi-
bition: two busts, four statues, one stat-
uette, and a large plaster model for a
monument to Lincoln.[11] All the finished
works were in Carrara marble. The four
statues listed were *Echo*, *The Mulatto Girl*,
The Battle Story, and *La Contadinella*. The
statuette was titled *Sappho Meditating the
Plunge*.
Major discussion of the exhibition was
devoted to *The Battle Story*, but the other
unlocated pieces were given descriptions
that may aid in their identification. *The
Mulatto Girl* was characterized as ideal in
form and features and described as danc-
ing through corn, playing "the bones,"
upon hearing she has been freed. Since
the Civil War was on Mead's mind, the
work was also referred to as *Thought of
Freedom*. *La Contadinella* was reported to
be a country girl feeding her chickens,
which reflected the sculptor's interest in
everyday subjects. One critic praised it for
its "exquisite refinement."[12] Mead's inclu-
sion of the plaster model for a Lincoln
monument revealed his shrewdness.
Public and political sentiment was ripe
for such an idea, and the critic for the
New York Times asserted that it was the
"most seasonable design he could possibly
exhibit."[13]
Mead's astuteness resulted in one of
the largest commissions received by any
sculptor to date, the Lincoln Monument
for Oak Ridge Cemetery in Springfield,
Illinois (fig. 104).[14] The monument
included a statue of the late president
with figural groups at the base represent-
ing the four branches of the military:
artillery, cavalry, infantry, and navy.
Mead modeled the figures in Florence,
but they were cast at the Ames foundry in
Chicopee, Massachusetts. Taft recounted
that the figures were modeled directly in
plaster, which suggests that Mead had
adopted Powers's innovative method.[15]
Work on the commission was protracted
by financial delays, and the memorial was
not unveiled until 1874, with the decora-
tive panels and auxiliary groups not com-
pleted for another decade. Although the
memorial brought Mead financial satis-
faction, it did not elicit critical favor.
Prevailing opinion held that the sculptor

FIG. 104 Larkin Mead, Lincoln Monument, Springfield, Ill., 1874. Photograph courtesy of the Illinois State Historical Library

had misplaced his emphasis on the slain president as military commander at the expense of the understated yet forceful internal strength of his oratory. A contemporary critic recognized a growing strength in Mead's work at this time and thought he had benefited by treating historical subjects rather than the more fanciful conceits of his earlier career.[16]

The late 1860s were also punctuated by another significant commission, *Columbus, Queen Isabella, and a Page* (Statehouse, Sacramento, Calif.), for the home of the Connecticut financier LeGrand Lockwood.[17] The group, which depicted Columbus receiving his commission to sail, was completed in 1870 but spent only a brief time in its original location since Lockwood was victimized by the financial panic of September 1869 and was forced to liquidate his possessions.

The group subsequently made its way to California.

Mead's native Vermont did not forget him and asked him to create another statue of Ethan Allen for the Statuary Hall in the United States Capitol. It was dedicated in 1876. If he used the same Revolutionary costume and episode of demanding the surrender of Fort Ticonderoga as he had earlier, the sculptor significantly altered the pose from the previous version. Mead's Italian experience allowed a certain vestige of Michelangelo's *David* to inform the stance and bearing, but the intense expression and contorted figure imparted a dynamism more akin to the baroque than to the Renaissance.

The balance of Mead's career proceeded at a leisurely pace as he assimilated himself into the Italian lifestyle. In 1882 he was appointed professor of sculpture at

the Academy of Fine Arts in Florence. Two of his most memorable subsequent accomplishments were a bas-relief of the distinguished art critic James Jackson Jarves (YUAG) and a reincarnation of the *Recording Angel* for All Souls' Church in Brattleboro. Among his last efforts were an allegorical figure of the Mississippi River, commissioned by Elliott F. Shepard of New York. *Mississippi* was in progress by 1883, but the work languished in Mead's studio until 1890, when the city of Minneapolis took over the commission for the front of its municipal building.[18] Mead also designed a pedimental program delineating the Triumph of Ceres (destroyed) for the Agricultural Building designed by McKim, Mead & White for the 1893 World's Columbian Exposition. The pediment of the Agricultural Building perpetuated the sweetness and grace of the outmoded neoclassicism and made no impact on the public in the way that Frederick MacMonnies's (q.v.) *Barge of State* did.

Although his approach to sculpture was *retardataire*, Mead attracted pupils. The aspiring sculptor Bessie Potter Vonnoh (1872–1955) elected to work in his studio for a brief period in 1897. William Dean Howells, who knew Vonnoh's work, assured the aging master that his protégée would put new life into the "old dry bones of an art."[19] Mead, whom Howells described as one of the wisest, most modest, and simple-natured men he knew, was content to let the new forces in sculptural expression pass him by and happily live out his life in Florence with his beloved Marietta. After his death in October 1910, she erected a tomb with the following inscription: "For forty-seven years a resident of Florence where he died, aged 75 years, this monument is erected in his memory by his loving wife." The harmony of his private life mirrored his career.

Notes

1. Taft 1924, p. 244. For the most recent accounts of Mead, see Craven 1984, pp. 521–523, and Jan Seidler Ramirez, "Larkin Goldsmith Mead," in BMFA 1986, pp. 177–178.

2. Burnham, *Brattleboro* (1880), p. 152.

3. Craven 1984, p. 146.

4. "Sketchings. Domestic Art Gossip," *Crayon* 5 (Sept. 1858), 267–268.

5. "Sketchings. Domestic Art Gossip," *Crayon* 7 (Apr. 1860), 114.

6. Charles T. Morrissey, "The Vermont Statehouse in Montpelier: Symbol of the Green Mountain State," *Antiques* 126 (Oct. 1985), 891, 893.

7. "Sketchings. Domestic Art Gossip," *Crayon* 8 (Feb. 1861), 45.

8. "Art Notes," *Boston Transcript*, Nov. 19, 1862, p. 4.

9. "Fine Arts," *New-York Evening Post*, Dec. 1, 1865, p. 1.

10. Sartain, *The Reminiscences of a Very Old Man* (1899), p. 258.

11. "Fine Arts," *New-York Evening Post*, May 1, 1866, p. 2.

12. Walker 1866, p. 104.

13. "American Art Feuilleton," *New York Times*, May 3, 1866, p. 4.

14. Durman, *He Belongs to the Ages: The Statues of Abraham Lincoln* (1951), pp. 41–44.

15. Taft 1924, p. 258.

16. Osgood 1870, p. 421.

17. Ibid.

18. "American Artists in Florence," *Boston Daily Evening Transcript*, July 12, 1890, p. 12.

19. Mildred Howells, ed., *Life in Letters of William Dean Howells*, 2 vols. (New York, 1928), 2:74–75; letter from Howells to Larkin Mead, Feb. 5, 1897.

Bibliography

"Sculptors and Sculpture," *Cosmopolitan Art Journal* 4 (Dec. 1860), 181; Tuckerman 1867, pp. 597–598; Osgood 1870, pp. 420–425; Benjamin 1880, pp. 152–153; Henry Burnham, *Brattleboro, Windham County, Vermont: Early History with Biographical Sketches of Some of Its Citizens* (Brattleboro, Vt., 1880), pp. 152–153; Oren Randall, *History of Chesterfield, Cheshire County, New Hampshire* (Brattleboro, Vt., 1882), pp. 589–590; John Sartain, *The Reminiscences of a Very Old Man, 1808–1897* (New York, 1899), pp. 237–239; Obituary, *American Art News*, Oct. 22, 1910, p. 2; Taft 1924, pp. 236–244; Mary Rogers Cabot, *Annals of Brattleboro* (Brattleboro, Vt., 1921–22), pp. 718–722; Charles E. Crane, "Larkin G. Mead," in *Vermonters: A Book of Biographies*, ed. Walter H. Crockett (Brattleboro, Vt., 1932), pp. 159–161; Donald C. Durman, *He Belongs to the Ages: The Statues of Abraham Lincoln* (Ann Arbor, Mich., 1951), pp. 41–44; Arthur W. Peach, "The Snow Angel," *New and Notes, Vermont Historical Society* 5 (Jan. 1954), 33–35; Thorp 1965, pp. 149–150; Craven 1984, pp. 321–325; Jan Seidler Ramirez, "Larkin Goldsmith Mead," in BMFA 1986, pp. 177–178; Lewis A. Shepard, *American Art at Amherst: A Summary of the Collection at Mead Art Gallery, Amherst College* (Amherst, Mass., 1978), p. 141

62
The Battle Story or *The Returned Soldier*

Modeled ca. 1863–65, carved ca. 1865–66
Marble
85⅜ × 51⅞ × 42⅜ in. (211.8 × 81 × 107.6 cm)
No inscription

Provenance Private collection, Croton, N.Y.; [The Den of Antiquity, Mamaroneck, N.Y., by ca. 1960]; James G. Gordon, Mamaroneck, N.Y., ca. 1960–64; [The Den of Antiquity, Mamaroneck, N.Y.]; [United Housewrecking, Stamford, Conn.]; [Paul Gabel, Nyack, N.Y., after 1975]; James H. Ricau, Piermont, N.Y.

Exhibition History Tenth Street Studio Building, New York, May 1866; *The Ricau Collection*, The Chrysler Museum, Feb. 26–Apr. 23, 1989

Literature "Fine Arts," *New-York Evening Post*, Dec. 3, 1865, p. 1; "Fine Arts," *New-York Evening Post*, May 1, 1866, p. 2; "An American Art Feuilleton," *New York Times*, May 3, 1866, p. 4; Walker 1866, p. 105; Tuckerman 1867, pp. 597–598; B. T., "American Sculptors in Florence," *New-York Daily Tribune*, Apr. 23, 1868, p. 4; "Brief Jottings. Personal," *Boston Daily Evening Transcript*, Aug. 22, 1868, p. 2; "Art in Connecticut," *New-York Evening Post*, Apr. 12, 1869, p. 4; Ambrose Brera, "American Artists in Florence," *Boston Daily Evening Transcript*, July 12, 1890, p. 12; Waters and Hutton 1894, 2:106; Taft 1924, pp. 237–258; Mary Rogers Cabot, *Annals of Brattleboro* (Brattleboro, Vt., 1921–22), p. 721; A. A., "Larkin Goldsmith Mead," *Dictionary of American Biography* (New York, 1933), 7:472; Jan Seidler Ramirez, "Larkin Goldsmith Mead," in BMFA 1986, p. 178

Version MARBLE (over-life-size) Veterans Home and Hospital, Rocky Hill, Conn.

Gift of James H. Ricau and Museum Purchase, 86.486

I N the closing decades of the nineteenth century, demand for public monuments accelerated across Europe and the United States. In the wake of the Civil War, the resilient young Republic claimed leadership in this endeavor.[1] The Northern states, especially, clamored for memorials to honor their dead. Tributes ranged from a simple monument of a single figure by Martin Milmore (1844–1881) to grace a village green or town square to triumphal statements such as the *Soldiers' and Sailors' Arch* in Brooklyn, primarily sculpted by Frederick MacMonnies (q.v.).

Testimonials of the Revolutionary War and the War of 1812 depicted gallant officers in military finery exhibiting a heroism consistent with the prevailing tenor of romanticism. Remembrances of the Civil War, however, took on a different cast, with Milmore's work setting the standard. The ordinary soldier and sailor were accorded significant honor and commemoration, and hero worship no longer centered exclusively on the stirring accomplishments of generals and admirals.[2] Although the soldier in Mead's *Battle Story* wears a sword, signifying his rank as an officer, the sculptor did not aggrandize the figure. Instead, there was a democratic leveling so the hero could be meaningful to everyone.

In addition to *Echo* (CGA), *The Battle Story*, or *The Returned Soldier* as it was often called in the press, was one of Larkin Mead's earliest and most ambitious undertakings after arriving in Florence. Contemporary accounts mention his modeling the over-life-size historical group as early as December 1863.[3] Undoubtedly, Mead's time with the Army of the Potomac made a profound impression on him, which he translated into a heartfelt and poignant rendering. Mead addressed the broad implications this devastating conflict had on families. While most critics interpreted the group as a father narrating episodes of the war to his daughter, at least one reviewer chose to heighten the pathos by indicating that the child was the orphan of one of the officer's fallen comrades.[4] This article focused on a visit in 1869 to the art gallery at the Home for Disabled Soldiers and Orphaned Children. The home had been founded five years earlier by Benjamin Fitch in Darien, Connecticut. A second replica of Mead's *Battle Story* was on display there at the time.

The sculptural group represents a Union officer, who sits on an outcropping of rock while holding a young girl on his knee as he recounts war adventures. His solemn, downcast expression with furrowed brow indicates the gravity of the story, and the girl's rapt attention and clinging pose attest to the gripping narrative. His posture, bent almost in resignation, alludes to the physical and emotional toll his recent activities have taken. His taut, outstretched hand reflects how intensely he relives the moment.

In addition to the cloak over his shoulders, the officer wears a coat, high-buttoned vest and shirt, and boots that extend to the knee. Details such as the intricately carved ring and braid on the sword, buckle on the left thigh, and beading of the leather strap reinforce the verisimilitude of the piece. The soldier appears bigger than life, and his massive hands and long fingers reinforce his monumentality. The young girl is equally compelling; her intense expression defines the drama of the moment. The folds of her dress and the deep undercutting of left sleeve and hem, in the correct light, create a convincing translucency. This fidelity to nature underscores the immediacy and plausibility of this work. And yet, despite the contemporary dress and realistic rendering of the faces, the soldier's pose harkens back to classical types of the Hellenistic and Roman periods. Ancient athletes and warriors were occasionally rendered in the same stoop-shouldered pose, and the soldier's declamatory ges-

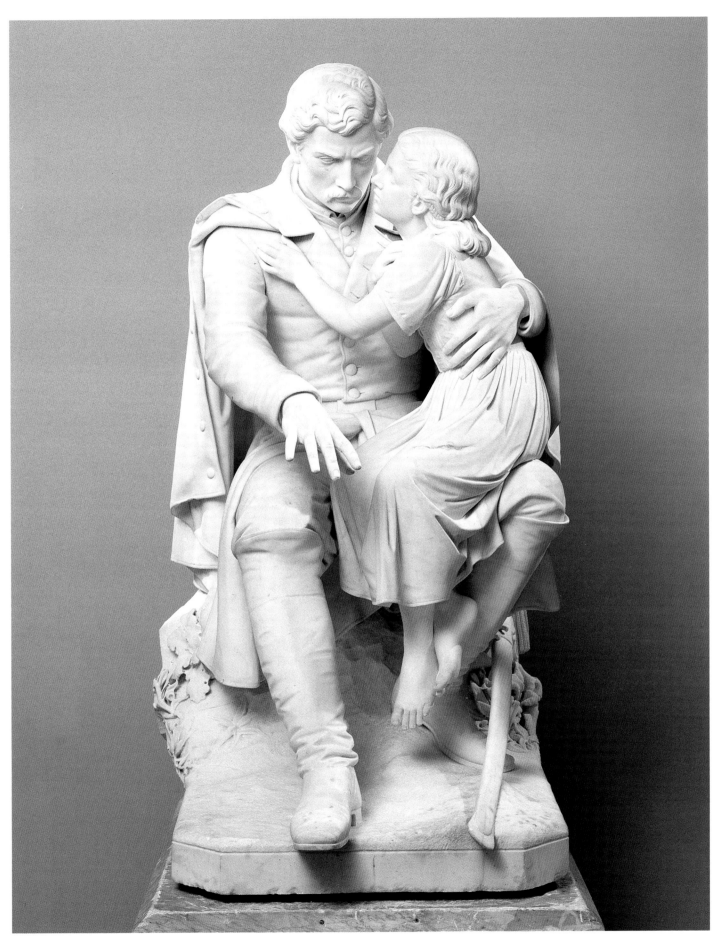

Cat. no. 62 Mead, *The Battle Story* or *The Returned Soldier*

ture recalls the depiction of Roman senators speaking in public. Thus, Mead successfully fused ancient and modern, blending classic forms with contemporary subject matter.

This composition, like Mead's model for the Lincoln Monument, struck a resonant chord when he exhibited it in New York in the spring of 1866, and critics agreed it was a forceful and significant work. The reviewer for the *New-York Evening Post* particularly lauded the soldier's attitude, gestures, and countenance, which he thought accurately reflected the figure's actions and narration.[5]

The original owner of this initial replica is not recorded. It was exhibited in marble in 1866 and antedated the second copy ordered by Fitch for his Soldiers' Home by at least a year. On a trip to Italy in 1865, Fitch searched for art for the gallery to be annexed to his institution. Upon seeing *The Battle Story*, he commissioned a replica and received it in 1867.[6] Initially, the statue was placed in the art gallery. It was later moved to the front of the chapel, where it remained until 1950, when the grounds were converted into a housing project. At this time, the sculpture was moved a short distance to the Spring Grove Cemetery maintained by the Veterans Home and Hospital Commission. It remained there until 1985, when it was transferred to the entrance of the Veterans Home and Hospital in Rocky Hill, Connecticut, near Hartford.

Except for varying patterns of weathering, the two versions are nearly identical. The one major difference between the two is the support from the right knee to the right forearm that the Fitch version requires. Possibly the sculptor did not want to jeopardize the most vulnerable point of this commissioned work.

Unfortunately, the history of the Ricau version is less complete than that of the Fitch replica. It came from a private estate in Croton, New York, in the late 1950s and spent much of its succeeding history in the possession of dealers until Ricau bought it in the late 1970s after many years of deliberation.

Notes

1. Janson 1985, p. 176.
2. Craven 1984, pp. 255–256.
3. "Fine Arts," *New-York Evening Post*, Dec. 3, 1865, p. 1.
4. J. A. E., "Art in Connecticut. A Visit to Fitch's Gallery at Darien," *New-York Evening Post*, Apr. 12, 1869, p. 4. He did, however, wrongly attribute the piece to Hiram Powers, who had donated a bust of Benjamin Franklin.
5. "Fine Arts," *New-York Evening Post*, May 1, 1866, p. 2.

6. A reference to the order appears in Walker 1866, p. 105. I am indebted to David B. McQuillan, Commandant, Veterans Home and Hospital, Rocky Hill, Conn., for supplying me with information about the history of the Fitch replica.

63
Venezia or *Venice, Bride of the Sea*

Modeled ca. 1865–66
Marble
28⅜ × 15⅝ × 10½ in. (72.1 × 39.7 × 26.7 cm)
Inscribed on a plaque on back at left:
L. G. MEAD / *Sculp.,*; on hair clasp at back: VENEZIA

Provenance [auction at 15th Street and University Place]; James H. Ricau, Piermont, N.Y.

Exhibition History *The Ricau Collection,* The Chrysler Museum, Feb. 26–Apr. 23, 1989

Literature A Boston Boy, "Random Glances at Things Abroad," *Boston Daily Evening Transcript,* Feb. 21, 1870, p. 1; Gerdts 1973, pp. 88–91; Jan Seidler Ramirez, *Venezia,* in BMFA 1986, pp. 178–180

Versions MARBLE Prof. and Mrs. William White Howells, Boston; Museum of Fine Arts, Boston; New Hampshire Historical Society, Concord; California Historical Society, San Francisco; private collection, New York; Dr. and Mrs. William H. Gerdts, New York; [Christie's, New York, Mar. 14, 1991, lot 141]; [Sotheby's, New York, Apr. 15, 1992, lot 4]; [Sotheby's, London, Nov. 21, 1995, lot 112]

Gift of James H. Ricau and Museum Purchase, 86.487

With at least ten known replicas, Larkin Mead's *Venezia* was his most popular work. It also ranked as his most personal since it likely was a marriage portrait of his wife.[1] Matrimony crystallized the young sculptor's decision to move to Italy in 1862 after he escorted his sister Elinor to her wedding with William Dean Howells, which they celebrated in Paris on Christmas Eve of that year. Howells was the American consul in Venice, and Mead enjoyed visiting them from his base in Florence. Occasionally, Howells prevailed on his brother-in-law to assume his consular duties when he anticipated an extended absence. Thus, when the Howells embarked on a two-months' tour of Italy in 1864 without their baby Winifred, the consular office and

child were entrusted to Mead and the Howellses' friend, Eugenio Brunetta.[2]

It may have been at this juncture that Mead began courting Marietta di Benevenuti, whose patrician but impoverished family lived above the Howellses in Casa Falier. Since neither spoke the other's language, Brunetta played an instrumental role as interpreter, and Howells entertainingly chronicled this romance in a sketch written more than fifty years later.[3] Despite the language barrier and strong opposition of the Benevenutis to their daughter marrying outside the Catholic church, Mead and Marietta were wed on February 26, 1866, and celebrated forty-four anniversaries before Mead's death separated them.

Besides succumbing to the charms of Marietta, Mead surrendered to the magic of Venice, and *Venezia* venerated both matrimony and metropolis.[4] Historically, Venice was inextricably tied to the sea and traditionally alluded to as the "Bride of the Sea." This sobriquet served as an alternate title for Mead's ideal bust, which conjured up various appellations. One studio visitor in early 1870 misidentified it as *Venice, Retiring from the Sea.*[5] The nuptial connection was well established and stemmed from an age-old ceremony in which the Venetian doge ritualistically wedded the Adriatic Sea on Ascension Day to commemorate Venice's former maritime supremacy. Thus, Mead deftly fused a private conceit with a public allegory.

The bust rises from a foundation of sea foam and clearly alludes to the birth of Aphrodite and her role as goddess of love. In employing this organic transition from bust to socle, Mead emulated Hiram Powers's *Proserpine* (cat. no. 6), where the sculptor obscured the abrupt termination of classical bust with a basket of flowers. Although Powers progressively edited the complexity of his floral motif in the interests of economy, Mead retained the intricate filigree effect that denied the material property of the stone. Treatment of such details as the hair, eyes, and tiara reflect the emphasis on accurately imitating the textures of the observed world, which was consistent with the approach in *The Battle Story* (cat. no. 62). The delicate, generalized handling of the hair gives it a soft, wispy quality, and the chignon, secured with an identifying clip inscribed VENEZIA, provides a rich visual focus for the back of the head (fig. 105).

Although *Venezia's* expression is contemplative, Mead incised the pupils and irises of the eyes to enhance the veristic handling of flesh and facial structure. The sculptor, shunning visions of opulence,

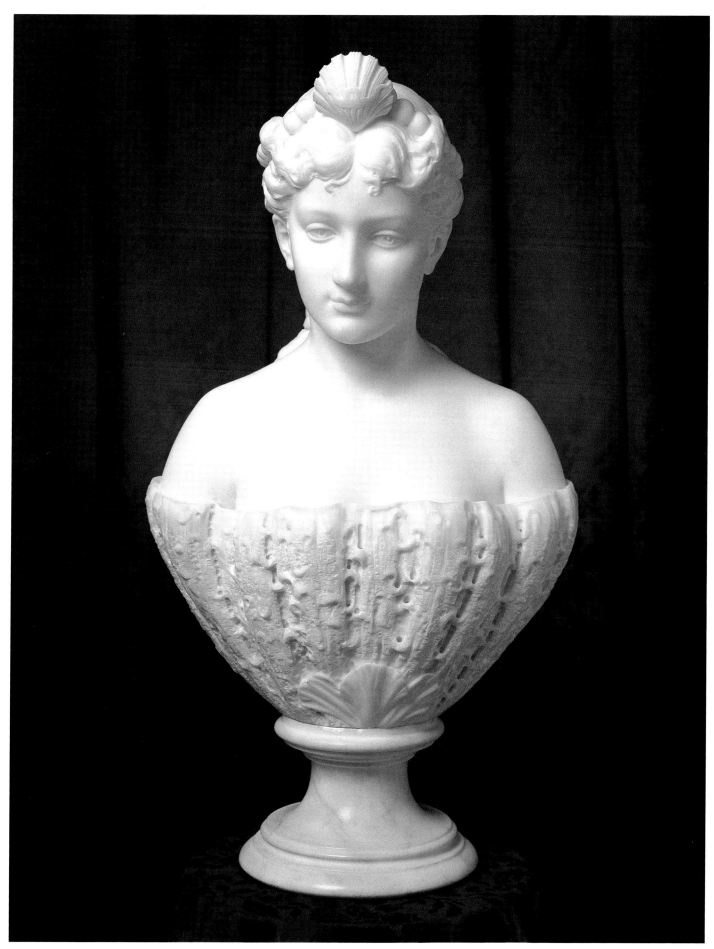

Cat. no. 63 Mead, *Venezia* or *Venice, Bride of the Sea*

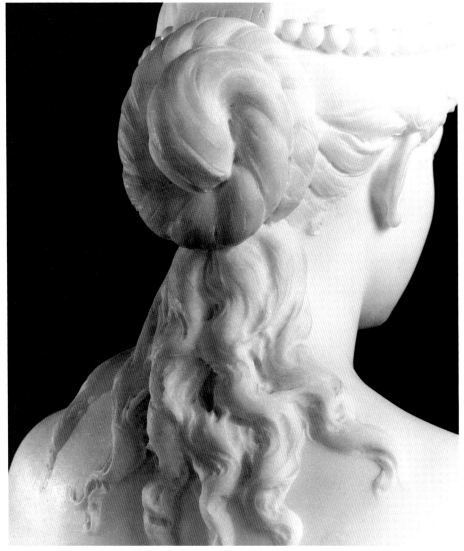

FIG. 105 Mead, *Venezia*, detail of "Venezia" clip on hair at back

FIG. 106 Mead, *Venezia*, detail of gondola on tiara

created an estimable tiara of beads and scallop shell emblazoned with a gondola, the universal symbol of Venice (fig. 106). So ingrained was the gondola in public consciousness that one American tourist observed it was as inseparable from the idea of Venice as flowers were from a garden.[6] Mead, through his penchant for detail, permitted viewers to bring a wealth of associations to their enjoyment of the work.

Water imagery was a popular motif in painting and sculpture during the mid-nineteenth century, and Mead was not immune to its allure. In 1866 he exhibited a statuette entitled *Sappho Meditating the Plunge* in New York, which referred to the poet's suicide by drowning because Phaon had spurned her. This work was in progress as early as 1863, and the happier theme of *Venezia* provided a pleasant antidote to the earlier subject of unrequited love.

Venezia is one of several works in the Ricau Collection that directly address the challenge of rendering aqueous imagery. Chauncey B. Ives's *Undine Rising from the Waters* (cat. no. 27) and William H. Rinehart's pair of ill-starred lovers, *Hero* and *Leander* (cat. nos. 47, 48), included physical manifestations of water, while Powers's bust *The Fisher Boy* referred to the sea in title only (cat. no. 7). Mead complemented these allegorical and literary works with an espousal of ideal beauty, but thematically, circumstances permitted him to infuse real context and personal meaning into his interpretation, which departed dramatically from the unhappy incidents chronicled by Ives and Rinehart.

Notes

1. See Ramirez, *Venezia*, in BMFA 1986, pp. 178–180. I am deeply indebted to her research in helping shape my own observations.

2. See James L. Woodress, Jr., *Howells and Italy* (Durham, N.C., 1952), pp. 17–20, for the friendship between Howells and Brunetta.

3. William Dean Howells, "A Young Venetian Friend," *Harper's Monthly* 138 (May 1919), 827–833.

4. Ramirez, *Venezia*, in BMFA 1986, p. 180.

5. A Boston Boy, "Random Glances at Things Abroad," *Boston Daily Evening Transcript*, Feb. 21, 1870, p. 1. In the context of this piece, the author did refer parenthetically to Mead's wife as "a beautiful Venetian woman."

6. Hillard 1854, 1:71.

George Edwin Bissell
American, 1839–1920

George Bissell's father was a quarryman and marble worker whose occupation undoubtedly influenced his son's vocation. Descended from Huguenot ancestors who came to America in the seventeenth century, George Bissell was born in New Preston, Connecticut, to Hiram and Isabella Jones Bissell. Around 1853, when George was fourteen, his family moved to Waterbury. His parents must have had some means since George attended private elementary and secondary schools, although he also worked as a store clerk. His aspirations to acquire a college degree were unhinged by the outbreak of the Civil War, and he enlisted as a private in the Twenty-third Regiment of the Connecticut Volunteers, in which he served from 1862 to 1863. After his company mustered out, Bissell continued to serve as a paymaster in the United States Navy and was attached to the South Atlantic squadron for the duration of the war. Four months after the cessation of hostilities, Bissell wed Mary Welton of Waterbury and settled in Poughkeepsie, New York, to join his father and brother in the marble business.

He soon augmented his usual duties by designing architectural ornaments and monuments, which included elaborate gravestones. He received his first formal commission in 1871 when the fire department of Poughkeepsie asked him to create a fireman to stand outside the station. This life-size figure marked Bissell's debut in carving marble and crystallized his determination to become a professional sculptor.

Little is known about the intervening years, but in December 1875 Bissell reinforced his artistic intentions by traveling to Europe to study.[1] In Paris he enrolled at the Académie Julian and Académie Colarossi and took classes at the Ecole des Arts Décoratifs with Aimé Millet (1819–1891) and at the Ecole des Beaux-Arts with Paul Dubois (1827–1905). He spent time in Florence, but his primary objective was Rome and the English Academy there.[2]

Bissell's traditional curriculum connected him to an earlier generation that espoused a straightforward naturalism rather than the vitalized approach being embraced by the likes of Augustus Saint-Gaudens (q.v.). These experiences abroad considerably enlarged Bissell's technical and visual vistas, and he returned to Poughkeepsie in 1876 to establish his own studio.

As the sole sculptor with advanced training in Poughkeepsie, Bissell enjoyed a monopoly on commissions for portrait sculpture and executed a large number of busts and reliefs. His first major commission was a gigantic granite figure for the John C. Booth family monument, but this was an exception, and it was not until the early 1880s that he began receiving larger orders on a regular basis. This new plateau in Bissell's career coincided with his decision to establish a Paris studio and divide his base between America and France.

Bissell's first civic commission was for the bronze Soldiers' Monument, ordered in 1883 by the town of Waterbury, Connecticut, where Bissell had spent his youth and enlisted in his Civil War regiment. Recognizing this association, Waterbury also honored him with the commission for a statue of Colonel John L. Chatfield, which was unveiled in 1887. Though both were created in Paris, neither monument reflected the impact of rich modeling and flickering surface treatment so prevalent in some contemporary Beaux-Arts sculpture.

Bissell was capable of more energized interpretation, however, and his next major undertaking, *Chancellor John Watts* (1886) for Trinity churchyard in New York City, demonstrated his willingness to accommodate the newer sculptural trends. Bissell delighted in the surface complexity of the fur trim and rich system of folds of the robe, the ruffles of the stock, and curls of the wig. He animated the physiognomy and enlivened the hands with prolific wrinkles. Curiously, Bissell modeled this work in Poughkeepsie instead of Paris and demonstrated he was not completely immune to the more experimental Beaux-Arts methods. The sculptor exhibited a replica of *Watts* at the Chicago Columbian Exposition of 1893 to critical acclaim.[3] The publicity and positive reaction brought him an increased flow of commissions.

The decade of the 1890s was a busy one. In addition to the constant stream of private orders, Bissell executed numerous Civil War statues, as well as a statue of General Horatio Gates for the Saratoga Battle Monument in Schuylerville, New York. He continued to shuttle between Paris and Poughkeepsie and chose Paris as the place to work on the statue of Lincoln to be erected in Edinburgh in memory of Scottish-American soldiers in the Civil War. By depicting Lincoln emancipating a kneeling slave at his feet, Bissell adopted a common Beaux-Arts device of utilizing subsidiary figures to enhance the subject's character.[4] His work on the Lincoln figure provided the foundation for a later, very popular portrait bust (cat. no. 64).

Photograph of George Edwin Bissell. Photograph courtesy of Boston University Archives, Mugar Memorial Library

In 1896 Bissell tired of traveling between Paris and Poughkeepsie and established a studio just outside Mount Vernon, New York. Soon after his permanent return to America, the de Peyster family commissioned him to create a statue of their seventeenth-century ancestor, Colonel Abraham de Peyster. It was originally placed on the Bowling Green in downtown New York near another family monument, that to Chancellor John Watts, and in 1972 it was moved to nearby Hanover Square. The necessity of employing greater imagination to capture the subject and the romantic fabrication of costume and details resulted in a bolder and more expressively handled work. For portraits less veiled by the shrouds of time, Bissell was far less imaginative. His statue of President Chester A. Arthur, unveiled in New York's Madison Square in 1899, was nothing more than pedestrian.

At the turn of the century Bissell contributed to several temporary displays, including allegorical groups of the Army and Navy for the Dewey Arch, which honored the admiral's visit to New York in 1899. He created *Hospitality* for the 1901 Pan-American Exposition in Buffalo and *Science* and *Music*, which formed part of the sculptural decoration of the Louisiana Purchase Centennial celebrated in Saint Louis in 1904. Among his durable achievements were the figure of Chancellor James Kent (1894) ordered for the Library of Congress and the statue of Lycurgus of 1900 for the Appellate Court Building in New York City. For *Lycurgus*, Bissell com-

bined elements of the Roman senator-philosopher type with components of Renaissance sculpture in the tradition of Ghiberti and Donatello. The statue of Chancellor Kent was considered by some to be Bissell's crowning achievement. Destined for the upper reaches of the library's new rotunda, the dictates of this remote location required a powerful facial expression and vigorous modeling in the costume that echoed but transcended those of Chancellor Watts.

Although his *Chancellor Kent* came close to approximating the spirited naturalism that defined sculpture in the last quarter of the nineteenth century, Bissell still did not sustain this more vibrant approach. He accommodated a willing market and occupied the balance of his active career with commonplace portraiture and monuments, such as the *Elton Memorial Vase* of 1905 (Riverside Cemetery, Waterbury, Conn.). Unwilling to endorse fully the new direction sculpture was taking at the outset of his career, Bissell could hardly be expected to embrace the radical departures unfolding in his twilight years. Indeed, his satisfaction with the status quo appeared in a comment he made about artistic approach:

From an artist's point of view, the result of the whole work as a suitable decoration for the site is the first to be considered. If a success in that direction, unsatisfactory execution of details may be overlooked.[5]

Although sensitive to the importance of a sculpture's placement, this statement betrayed a compromise of standards that relegated Bissell to the realm of the unexceptional. He had no pupils to whom he could pass his *retardataire* approach, yet he was well liked and respected by the younger generation of sculptors.

Notes

1. A subsequent passport application includes a memo that his previous passport was either applied for or issued on Dec. 10, 1875. Passport for George Edwin Bissell issued Feb. 14, 1883, number 5023; Passport Applications, 1795–1905, *National Archives Microfilm Publication M 1372*, roll 253, General Records of the Department of State, records group 59, National Archives, Washington, D.C. I am grateful to Col. Merl Moore, Jr., for this information. For the most recent account of Bissell, see Kathryn Greenthal, "George Edwin Bissell," in BMFA 1986, pp. 181–185.
 2. Taft 1924, p. 245.
 3. Craven 1984, p. 244.
 4. Greenthal, "Bissell," in BMFA 1986, p. 182.
 5. "Completion of a Remarkalbe [*sic*] Sculptured Vase," *International Studio* (?), Jan.–Mar. 1906 (?), p. 566. Unidentified clipping from vertical files at the Thomas J. Watson Library, Metropolitan Museum of Art.

Bibliography
Taft 1924, pp. 245–247; F. Lauriston Bullard, *Lincoln in Marble and Bronze* (New Brunswick, N.J., n.d.), pp. 94–99; Donald C. Durham, *He Belongs to the Ages: The Statues of Abraham Lincoln* (Ann Arbor, Mich., 1951), pp. 64–67; Craven 1984, pp. 243–245; Kathryn Greenthal, "George Edwin Bissell," in BMFA 1986, pp. 181–185

64
Bust of Abraham Lincoln
Modeled ca. 1892–93, cast ca. 1906–9
Bronze
26½ × 12⅜ × 11⅛ in. (66.7 × 31.4 × 28.3 cm)
Inscribed on back of bronze pedestal: Geo. E. Bissell / Sc. / Copyrighted / GORHAM Co.; inscribed on front of pedestal: *Honorable William D. Dickey / From the Attaches of the Supreme Court / State of New York King's County / 1909*

Provenance The Hon. William D. Dickey, 1909; . . . ; [unidentified antique shop, University Place, New York]; James Ricau, Piermont, N.Y.

Exhibition History *The Ricau Collection,* The Chrysler Museum, Feb. 26–Apr. 23, 1989

Literature "George E. Bissell," *Collector* 5 (Dec. 15, 1893), 88; Kathryn Greenthal, "George Edwin Bissell," in BMFA 1986, pp. 182–185

Versions See Greenthal, "Bissell," in BMFA 1986, pp. 184–185

Gift of James H. Ricau and Museum Purchase, 86.461

W HEN a modified replica of George Edwin Bissell's *Lincoln*, originally erected in Edinburgh, Scotland, was unveiled at Clermont, Iowa, in June 1903 as part of the reunion ceremonies of the Twelfth Iowa Veteran Volunteer Infantry, Senator J. P. Dolliver, a keynote speaker, said:

A statue of Lincoln, while it adds nothing to him, is in itself a worthy commentary upon the national character, for it brings us face to face with the grandest, simplest, purest life that was ever lived by a man among the children of men. It stands for an epoch in human affairs in which were blended all the pathetic sacrifices which have made the national life worth living.[1]

These sentiments help explain why Abraham Lincoln, sixteenth president of the United States, was such a compelling subject for so many artists. With the exception of the Southern states, images of Lincoln adorned schools and public buildings across the nation, and numerous foreign countries honored him, as well.[2]

While Dolliver spoke of Lincoln in heroic and absolute terms, the martyred president presented an enormous challenge to artists attempting to create his likeness. Lincoln's lanky figure and facial features defied conventional interpretations of dignity and beauty. A mutability of physiognomy elicited a wide-ranging response, even from the same source. Writing in 1865, one correspondent ventured:

[Lincoln] is, I think, the ugliest man I ever put my eyes on. There is also an expression of plebeian vulgarity in his face. . . . On the other hand, he has the look of sense and wonderful shrewdness, while the heavy eyelids give him a mark of almost genius.[3]

If there was any consensus about Lincoln's appeal, it was the magnetic power of his eyes and the remarkable facility and sense of conviction with which he changed expression.

Bissell's first commission to create an image of Lincoln came from abroad. Wallace Bruce, American consul to Edinburgh from 1889 to 1893, wanted for his adopted city a monument commemorating the Scottish-American soldiers who died in the Civil War. In 1892 Bruce was deeply moved by a widow's plea for the pension of her veteran husband whose life had been cut short by injuries sustained in the Civil War. She lamented that lack of funds forced her husband's unmarked burial in a potter's field reserved for the indigent.[4] Not only did Bruce secure the pension, but he decided to establish a suitable memorial to soldiers of Scottish descent who had fought in the war. He took his appeal to America and successfully solicited support. While residing in Paris in late 1892, Bissell secured the commission and completed the statue for unveiling in August 1893.

The sculptor recalled his reliance on a personal encounter to create the likeness:

I watched Lincoln carefully while he was delivering his Astor House speech on his way through New York to his inauguration. I can still recall the deep impression he made on me as he spoke. That impression I tried to reproduce in my statue for Edinburgh.[5]

Because more than two decades had passed since this event, Bissell must have used a photograph or Leonard Volk's (1828–1895) life mask of Lincoln, which became widely available in 1886.[6] Whatever his sources, Bissell produced an effective monument in a short period of time. Its successful reception encouraged the businessman in Bissell. When he returned to America in late 1893, the sculptor advertised that casts of Lincoln's head, taken from the monument, were

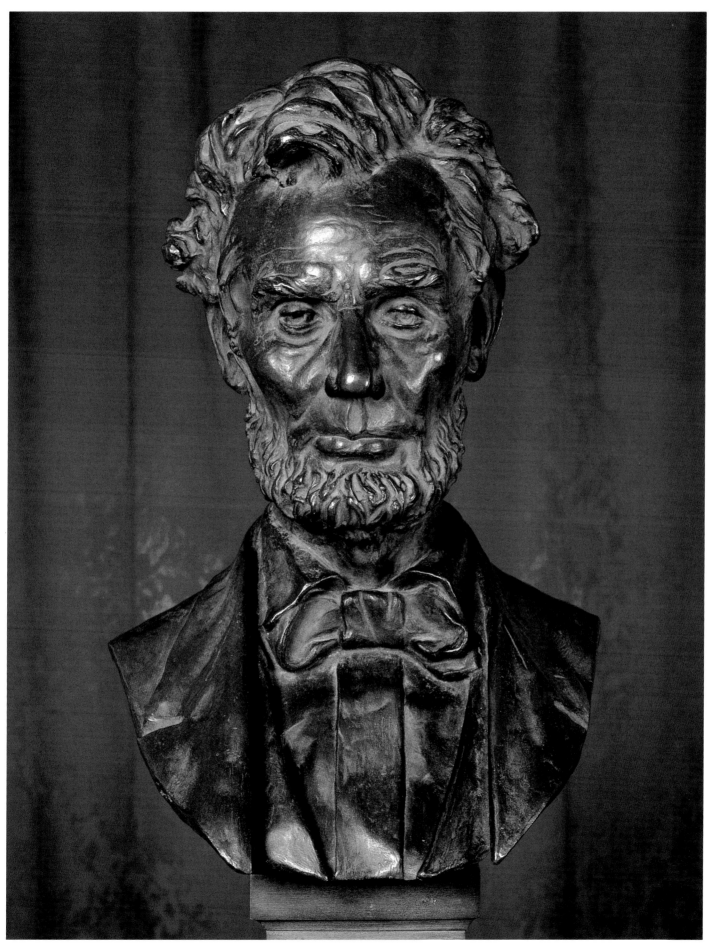

Cat. no. 64 Bissell, *Bust of Abraham Lincoln*

available for purchase in life-size, three-quarter-size, and half-size.[7]

Little is known about the success of these earliest advertised versions, and substantive information does not appear until Gorham & Co. began marketing replicas in 1906.[8] The Ricau version was produced by Gorham and corresponds in size to the largest bust the company produced, but it does not carry the identifying control marking, "Q48." Since the inscription on the pedestal of the Ricau bust indicates it was a presentation piece, it must have been cast to order and not taken from stock. This may also have been the case for a slightly larger variant in the Newark, New Jersey, city hall.[9]

In his handling of Lincoln's portrait, Bissell demonstrated his ability to rise to the occasion when the situation warranted. The sculptor succeeded in capturing his subject's dignity and solemnity. Lincoln defied prosaic interpretation, and Bissell extended himself well beyond his usual uninspired level of reading individual character. The sculptor paid sensitive attention to the handling of features and conveyed his understanding of anatomical structure and his ability to imbue vitality through animated surfaces. The wrinkles and crevices of Lincoln's face, as well as the boldly handled furrows of his hair, generate a literal and figurative field of personality. At the same time, his pensive, introspective gaze balances the dynamic aura and underscores the magnitude and profundity of the decisions that confronted Lincoln.

While Bissell's *Lincoln* may not possess the depth of feeling or monumentality of Augustus Saint-Gaudens's earlier effort destined for Lincoln Park in Chicago, comparison with the extrapolated bust provides Bissell a gratifying measure of accomplishment (fig. 107). In tilting the president's head forward, Saint-Gaudens augmented the notion of contemplation. At the same time, deep-set eyes contributed a more evocative dimension of gravity and anxiety. The costume, while admirable in Bissell's rendition, also revealed Saint-Gaudens's superiority in rendering a lively and credible sense of texture, especially in the treatment of the cravat. Nevertheless, Bissell's effort does him great credit and suggests he might have looked to Saint-Gaudens for inspiration, if only through photographs.

The Ricau version of Bissell's *Lincoln* was presented to the Honorable William D. Dickey, justice of the State Supreme Court of New York, in 1909 at the time of his retirement from the court. Consistent with abundant images of Lincoln in schools and public buildings, this gift rec-

FIG. 107 Augustus Saint-Gaudens, *Bust of Abraham Lincoln.* Bronze, 24¾ in. (62.9 cm) high. The Brooklyn Museum, Robert B. Woodward Memorial Fund, 23.257

ognized Dickey's long and distinguished service.[10] Little is known of the bust's subsequent ownership until it was relegated to an antique shop in New York City, where Ricau found it.[11]

Notes

1. Quoted in Donald C. Durman, *He Belongs to the Ages: The Statues of Abraham Lincoln* (Ann Arbor, Mich., 1951), p. 64.
2. F. Lauriston Bullard, *Lincoln in Marble and Bronze* (New Brunswick, N.J., n.d.), pp. 5–6.
3. Col. Theodore Lyman in a letter to his wife written in 1865, originally cited in Bullard, *Lincoln in Marble and Bronze,* p. 2.
4. "The Lincoln Statue in Edinburgh," *Boston Daily Evening Transcript,* Aug. 22, 1893, p. 4.
5. Gustave Kobbe, "While Controversy Rages over Barnard's Lincoln, for London, Another American's Lincoln Stands Calmly in Edinburgh," *New York Herald,* Feb. 10, 1918, p. 8.
6. Bullard, *Lincoln in Marble and Bronze,* p. 4.
7. "George E. Bissell," *Collector* 5 (Dec. 15, 1893), 88.
8. See Greenthal, "George Edwin Bissell," in BMFA 1986, p. 184, for a thorough discussion of the various replicas.
9. Ibid.
10. "Ex-Justice W. D. Dickey," *New York Times,* May 16, 1924, p. 19.
11. Letter to the author from James H. Ricau, June 12, 1990.

Augustus Saint-Gaudens
American, 1848–1907

Augustus Saint-Gaudens endures as one of the major forces in the history of American sculpture. He towers over his contemporaries and is distinguished from earlier generations in that his reputation suffered no eclipse after his death. He remained notable partly because of his prodigious output, which encompassed nearly twenty major monuments, eighty individual portrait medallions, numerous portrait busts, architectural sculptures, and smaller works that ranged from cameos to coins.

Saint-Gaudens also attracted a wide circle of friends and patrons with his flamboyant yet amiable personality. Not surprisingly, his roles of patron and friend were interchangeable. Although his youthful contribution to the hallmark Centennial Exposition of 1876 in Philadelphia was overshadowed by those of established sculptors such as Randolph Rogers (q.v.) and William Wetmore Story (q.v.), Saint-Gaudens dramatically altered the course of sculpture in the United States by embracing the new Beaux-Arts style unfolding in France.

Saint-Gaudens was born in Dublin, Ireland, in March 1848 to a French boot-maker, Bernard Saint-Gaudens, and an Irish mother, Mary McGuiness Saint-Gaudens. Soon after his birth, Augustus's family immigrated to America to escape the devastating economic conditions in Ireland. They settled in New York, where young Saint-Gaudens displayed artistic rather than academic tendencies. His father recognized his son's talents and apprenticed Augustus, then thirteen, to a French cameo cutter, Louis Avet. After three years, Saint-Gaudens found his master's fiery temperament overbearing and sought work with another French cameo cutter, Jules Le Brethon. He also formalized his artistic education by enrolling in drawing classes at Cooper Union and the National Academy of Design. Recent attention to Saint-Gaudens's years in the cameo shops demonstrated their importance for instilling manual dexterity, self-discipline, and sense of design.[1] These attributes, coupled with an intense commitment to succeed, kindled Saint-Gaudens's desire to study abroad.

With the financial assistance of his father and Le Brethon, the eighteen-year-old Saint-Gaudens departed for Paris in February 1867. While his French lineage may have influenced his selection of Paris over Rome, this choice had major ramifications. In addition to visiting the

Universal Exposition in Paris, where he saw the work of such eminent sculptors as François Jouffroy (1806–1882) and Paul Dubois (1829–1905), Saint-Gaudens enrolled in classes in sculptural composition and drawing from life, casts, and nature. He entered Jouffroy's studio and supported himself by working for a jeweler. His perseverance and ability impressed Jouffroy, who assisted Saint-Gaudens in gaining admission to the Ecole des Beaux-Arts in March 1868.

The outbreak of the Franco-Prussian War in 1870 disrupted this formative existence. Rather than acquiesce to his mother's desire that he return to America, Saint-Gaudens sought refuge in Rome. He eschewed formal training and let his independent spirit be his guide. The only American sculptor in Rome that Saint-Gaudens recalled with any degree of warmth was William Henry Rinehart (q.v.), whose sympathetic nature touched the young sculptor.[2] Saint-Gaudens supported himself by cutting cameos and copies of antique portrait busts, but the Roman atmosphere ignited his desire to undertake a monumental work. He soon embarked on his first full-length statue, *Hiawatha* (private collection), which emulated romantic literature more than ethnography. The work made a public impact and achieved its goal of attracting the attention of influential patrons. Consequently, Saint-Gaudens received portrait commissions, which encompassed an obligatory naturalism in classic form.

Between 1872 and 1875 Saint-Gaudens moved back and forth between Rome and New York, widening his circle of patrons. He lacked a major commission until the end of 1876, when he was awarded the Farragut Monument (Madison Square, New York). Completed in Paris and unveiled in 1881, this work was pivotal to his career. It forged a long-standing working relationship with the noted architect Stanford White (1853–1906), who designed the pedestal. It also heralded the truthful yet ennobling vitality and vigorous naturalism that became the basis of Saint-Gaudens's mature style. Critical acclaim for the Farragut Monument established his reputation and assured commissions for the rest of his life.

With his career on the ascendant, Saint-Gaudens and his wife, Augusta, and infant son, Homer, settled in New York in 1881, where he maintained his studio for the next seventeen years. He also purchased a summer residence in Cornish, New Hampshire, which became a vibrant artists' colony in the ensuing decades.[3] The 1880s saw the sculptor refine his bronze portrait reliefs as he codified his reverence for Italian Renaissance masters and several of his French contemporaries. These efforts culminated in an initial likeness of the Scottish author Robert Louis Stevenson, who sat for him in 1887 (Princeton University Library, Princeton, N.J.). The relief was remarkable for its manipulation of surface and texture as well as its exquisite incorporation of text into the composition. Above all, it possessed an uncanny ability to convey a hauntingly evocative sense of the sitter, even in profile.

In addition to many sensitive reliefs, Saint-Gaudens produced a number of major monuments between 1885 and 1897. *The Puritan* was completed in 1886 and installed in Springfield, Massachusetts, in 1887 to honor Deacon Samuel Chapin, one of the city's founders. The piece was the quintessential evocation of the seventeenth-century values of probity and moral rectitude. With his determined gait, *The Puritan* possesses a dynamism and vitality that recall the energy of the *Winged Victory* in the Louvre and underscore the indomitable will to realize one's goal. The over-life-size *Standing Lincoln* was unveiled in Chicago's Lincoln Park the same year. It was as reticent and self-contained as *The Puritan* was unyielding, yet conveyed an equal measure of dignity and honor. The range of Saint-Gaudens's output in these years knew no bounds. From architectural decoration for the Vanderbilt and Villard Houses in New York City to the weathervane *Diana*, surmounting the Madison Square Garden tower (PMA), to the tomb of the eminent New York statesman Hamilton Fish, the sculptor's genius was visible from the salon to the cemetery. Amid all this activity, he completed two enduring monuments that dealt with premature death: the Adams Memorial (Rock Creek Cemetery, Washington, D.C.), finished in 1891, and the Robert Gould Shaw Memorial (Boston), completed in 1897.

The Adams commission was fraught with complexity. The subject, Marian Hooper Adams, wife of the historian Henry Adams, committed suicide in 1885, which cast a pall over the project. The work became a collaboration of four exceptionally talented and sensitive people: Saint-Gaudens, Adams, White, and John La Farge (1835–1910), one of Adams's closest friends. They all aspired to a level of meaning that could encompass the mystifying notion of self-destruction. Its shrouded, oblique presence was a radical departure from the sculptor's direct approach, but in tackling a program steeped in the inscrutable and abstract, Saint-Gaudens, through his probing of

Photograph of Augustus Saint-Gaudens, 1874, by DeWitt Clinton Ward, New York City. Photograph courtesy of the Saint-Gaudens National Historic Site, Cornish, N.H.

intangibles, anticipated the conceptual concerns of twentieth-century sculpture.

The Shaw Memorial, thought to be his masterpiece, was exceedingly complex, and Saint-Gaudens took nearly fourteen years to complete it. The monument, which stands opposite the state capitol in Boston, is set in an architectural framework by Charles McKim (1847–1909). It honors Robert Gould Shaw and his African-American regiment, the Fifty-fourth Massachusetts Volunteer Infantry. Shaw and much of his regiment were killed in a catastrophic attack on Fort Wagner in Charleston Harbor, South Carolina, in July 1863. Initially, the patrician William Wetmore Story had been commissioned to create an equestrian statue of Shaw, which came to naught. Through the intercession of the noted Boston architect H. H. Richardson (1838–1886), Saint-Gaudens inherited the contract. It has been suggested that Saint-Gaudens's humble background resulted in a more empathetic interpretation of his subject, which chronicled the regiment as much as it did Shaw.[4] To the exasperation of the committee, Saint-Gaudens let the project consume him over an extended period, but in the end all agreed that it warranted the wait. A monument of profound power that eloquently ranged the gamut of emotions, it stood as a tribute not only to the valorous men of the Fifty-fourth but to soldiers of all time who gave their lives in conflict.

Finally released from the burden of this commission in 1897, Saint-Gaudens returned to Paris to complete his last

major public commission, the Sherman Monument. Destined for the Grand Army Plaza at Fifth Avenue and Fifty-ninth Street in New York, this gilded bronze equestrian statue honored one of the principal heroes of the Union Army, General William Tecumseh Sherman. Typical of Saint-Gaudens's ability to prolong matters, work on this project spanned eleven years, 1892–1903, and three locations—New York, Paris, and Cornish.

In 1900 Saint-Gaudens was diagnosed with cancer and decided to move to Cornish year-round. He continued to work, but not at the same intense pace or level of quality, and much of his output was executed by assistants. Undoubtedly, the disastrous studio fire of 1904 and the sensational murder of Stanford White in 1906 further weakened his resolve. His premature death in August 1907 at the age of fifty-nine constituted a major personal and artistic loss to the nation. That he was honored the following year with major retrospective exhibitions at the Metropolitan Museum in New York and the Corcoran Gallery in Washington, D.C., was fitting testimony to the enormous respect Augustus Saint-Gaudens was accorded by the artistic community.

Notes

1. Greenthal 1985, pp. 58–61. Also providing a good introduction to the sculptor and his life is Wilkinson, *Uncommon Clay* (1985).
2. Homer Saint-Gaudens, ed. *The Reminiscences of Augustus Saint-Gaudens* (1913), 1:139.
3. See Olney et al., *A Circle of Friends* (1985).
4. Greenthal, "Augustus Saint-Gaudens," in BMFA 1986, p. 217.

Bibliography

H. B. S., "American Artists at Rome," *Boston Daily Evening Transcript*, Jan. 28, 1874, p. 7; Charles H. Caffin, *American Masters of Sculpture* (New York, 1903), pp. 1–17; Royal Cortissoz, *Augustus Saint-Gaudens* (Boston, 1907); "Augustus Saint-Gaudens, Famous Sculptor, Dead," *Boston Sunday Globe*, Aug. 5, 1907, pp. 1, 6; "Augustus Saint-Gaudens, the Passing of Our Greatest Sculptor," *Boston Evening Transcript*, Aug. 5, 1907, p. 10; "Saint-Gaudens's Body to Be Cremated," *New York Times*, Aug. 5, 1907, p. 7; C. Lewis Hind, *Augustus Saint-Gaudens* (New York, 1908); Will H. Low, *A Chronicle of Friendships* (New York, 1908), pp. 215–230, 273–285, 387–395, 401–406, 496–507; Homer Saint-Gaudens, ed., *The Reminiscences of Augustus Saint-Gaudens*, 2 vols. (New York, 1913); David M. Armstrong, *Day before Yesterday: Reminiscences of a Varied Life* (New York, 1920); Joseph McSpadden, *Famous Sculptors of America* (New York, 1924), pp. 29–70; Taft 1924, pp. 279–309, 539, 542, 551–552, 556–557, 568, 576; Margaret Bouton, "The Early Works of Augustus Saint-Gaudens" (Ph.D. diss., Radcliffe College, 1946); Gardner 1965, pp. 45–56; Beatrice Proske, *Brookgreen Gardens Sculpture*, rev. ed.

(Brookgreen Gardens, S.C., 1968), pp. 7–11; John W. Bond, "Augustus Saint-Gaudens: The Man and His Art," Office of Archaeology and Historic Preservation (Washington, D.C., 1968); John H. Dryfhout and Beverly Cox, *Augustus Saint-Gaudens: The Portrait Reliefs* (Washington, D.C., 1969); Louise Hall Tharp, *Saint-Gaudens and the Gilded Age* (Boston, 1969); Lincoln Kirstein, *Lay This Laurel: An Album on the Saint-Gaudens Memorial on Boston Common, Honoring Black and White Men Together, Who Served the Union Cause with Robert Gould Shaw and Died with Him July 18, 1863* (New York, 1973); John H. Dryfhout, "Augustus Saint-Gaudens," "Robert Louis Stevenson," and "Diana," in *Metamorphoses in Nineteenth-Century Sculpture*, ed. Jeanne L. Wasserman (Cambridge, Mass., 1975); Tom Armstrong et al., *Two Hundred Years of American Sculpture*, exh. cat., The Whitney Museum of American Art (New York, 1976), pp. 47, 50–53, 62–66, 114–117, 120, 156–157, 506–507; Lois G. Marcus, "Studies in Nineteenth-Century American Sculpture: Augustus Saint-Gaudens (1848–1907)" (Ph.D. diss., The City University of New York, 1979); Dryfhout 1982; Craven 1984, pp. 373–392; Greenthal 1985; Janson 1985, pp. 252–259, 263; Susan Faxon Olney et al., *A Circle of Friends: Art Colonies of Cornish and Dublin*, exh. cat., University Art Galleries, traveled (Durham, N.H., 1985); Burke Wilkinson, *Uncommon Clay: The Life and Works of Augustus Saint-Gaudens* (New York, 1985); Russell Lynes, "Saint-Gaudens: His Time, His Place," *Archives of American Art Journal* 25 (1985), 2–9; Greenthal, "Augustus Saint-Gaudens," in BMFA 1986, pp. 214–217.

65
Portrait of Frederick C. Torrey (Freddie)

Modeled and carved 1874
Marble
21⅞ × 12⅞ × 9½ in. (55.6 × 32.7 × 24.1 cm)
Inscribed on upper left edge below shoulder: *Aug St. Gaudens / Roma 1874*; on lower front: FREDDIE

Provenance Mr. and Mrs. Franklin Torrey; Frederick C. Torrey, Washington, D.C.; Budlong family, Rye, N.Y., by 1958 until at least 1970; Ruth Ailey, New York; James H. Ricau, Piermont, N.Y.

Exhibition History The Landon School, Washington, D.C., Apr. 15, 1934; *The Ricau Collection*, The Chrysler Museum, Feb. 26–Apr. 23, 1989

Literature William McLenahan, "Lost Work of Saint-Gaudens Discovered," *Baltimore Sunday Sun*, Mar. 25, 1923, p. 8, ill.; "Saint-Gaudens Bust of Boy Worth $20,000," *Washington Post*, Mar. 6, 1923, p. 19; "Capital Educator Is Disclosed as First to Sit for Bust in Stone by Famous Saint-Gaudens," *Washington Post*, Mar. 29, 1934, p. 1, ill.; "F. C. Torrey, 80, Is Dead;

Expert in Genealogy," *New York Herald Tribune*, Apr. 5, 1948, p. 14; "Frederic [*sic*] C. Torrey, Ex-Head of School," *New York Times*, Apr. 5, 1948, p. 21; Dryfhout 1982, p. 73, ill.; Greenthal 1985, p. 75

Versions None known

Gift of James H. Ricau and Museum Purchase, 86.520

Unlike his reputation or his public monuments, some of Augustus Saint-Gaudens's works, primarily portraits of private individuals, slipped into oblivion. When the marble bust of Frederick C. Torrey surfaced in 1923, newspaper accounts erroneously hailed it as the first carving by the noted sculptor and ascribed it the sensational value of twenty or thirty thousand dollars.[1] This portrait was clearly not the sculptor's initial carved effort.[2] The assessment of its value, however, reinforced the continued high esteem Saint-Gaudens commanded.

Frederick Crosby Torrey (1868–1948) was born in Montclair, New Jersey, into a family that developed some of the earliest railroads in that state. When Freddie was a child, his father was appointed United States consul at Leghorn, Italy. It was during this Italian posting, when Freddie was six years old, that Saint-Gaudens modeled his portrait. How long the family remained in Italy is unknown, but Freddie completed Montclair High School and went to Princeton University, from which he was graduated in 1889.[3] He devoted his entire professional career to teaching, serving initially on the faculty of the Princeton School of Engineering, where he is said to have designed and installed the first dial telephone system in the United States. The end of his career, from 1929 to 1942, was spent at the Landon School in Washington, D.C., and at a tutoring school he founded in 1937. He was a dedicated genealogist, serving for two years as president of the National Genealogical Society. He wrote three books on the subject, including the two-volume *Torrey Families and Their Children in America.*[4]

In this portrait, Saint-Gaudens depicted Freddie wearing a soft bow tie and a coat whose collar is embellished with piping. In choosing appropriate costumes, Saint-Gaudens subscribed to an approach in which women and children wore contemporary dress, and men, in deference to the antique, were shown either bare-chested or clad in classical garb. Compared to the costumes of other boys, such as those by Chauncey B. Ives and Randolph Rogers in the Ricau Collection (cat. nos. 26, 55), Saint-Gaudens created a livelier sense of texture. This departure responded to the

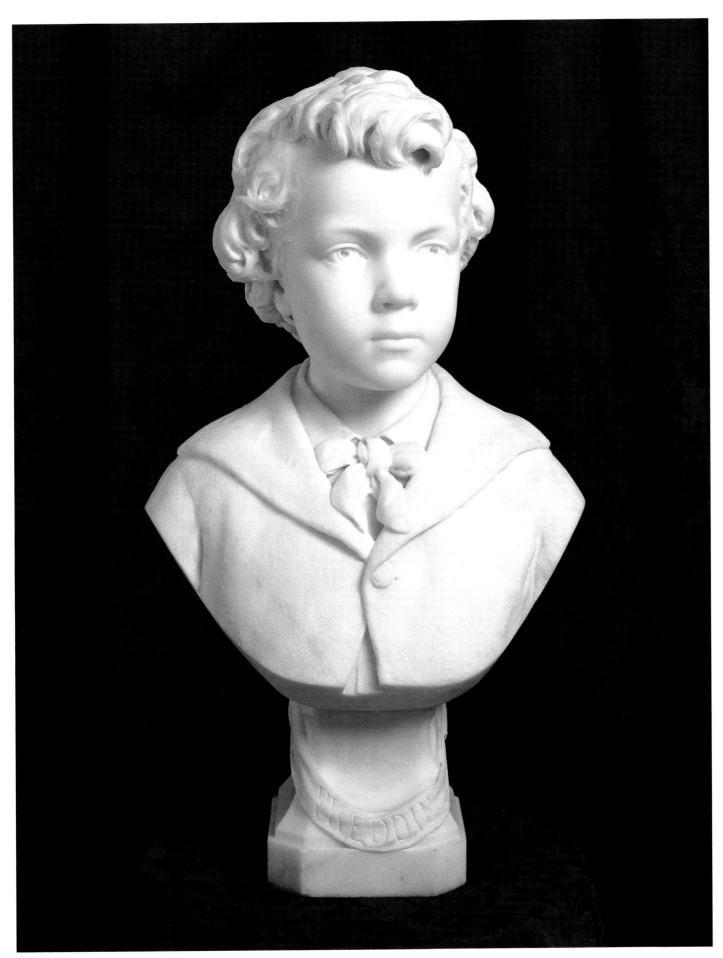

Cat. no. 65 Saint-Gaudens, *Portrait of Frederick C. Torrey (Freddie)*

greater consideration of surface effect that he encountered in French Beaux-Arts sculpture. In addition to the visual liveliness of the coat's surface, Saint-Gaudens augmented his concern for energy through the way the jacket parts below the button. The implied restlessness was appropriate for a sitter this age. Indeed, Saint-Gaudens probably used photographs to complete the work, a practice that was common even with portraits of adults.[5] The sculptor reinforced the sense of the momentary by turning the sitter's head slightly to his left, thus taking his cue from the nearly completed portrait of William M. Evarts (private collection).[6]

Freddie has long, flowing, unruly locks that are seemly for a child this age. As with the Evarts portrait, the hair is treated in a summary fashion, which connects it to the spontaneity of the clay model and underscores the emphatic freshness and vitality. The facial features conform to the pudginess of a six-year-old child, but subtle modulations of surface at the temples and the cheeks reveal a sensitivity to the underlying anatomy. The eyes are deeply chiseled and further create an air of spritely immediacy, while the gaze carries an expectancy that suggests the momentary. Saint-Gaudens's penetrating analysis of this unformed youth signals the sculptor's growing ability to interpret and capture the essence of his sitter. The portrait of Freddie, in the wake of Saint-Gaudens's work on the Evarts bust, reinforced the sculptor's continuing departure from the pedestrian naturalism that informed portraiture at this time and even defined his own earliest efforts. This portrait of a young boy, in its modest way, anticipated the significant achievements that Saint-Gaudens realized as a gifted renderer of the human likeness and an uncanny prober of the human psyche.

Why Freddie's father patronized the relatively unknown Saint-Gaudens is unclear. Perhaps he gravitated to the young sculptor on the recommendation of other clients, since prominent New Yorkers such as Montgomery Gibbs, William M. Evarts, and Edwin D. Morgan already graced this growing list. The bust of Freddie remained in the family until the middle of this century, when the history of its ownership becomes murky until Ricau acquired it in the early 1970s.

Notes

1. William McLenahan, "Lost Work of Saint-Gaudens Is Discovered," *Baltimore Sunday Sun*, Mar. 25, 1923, p. 8.

2. Dryfhout 1982, p. 57, cites the portrait of Eva Rohr, signed and dated 1872, as Saint-Gaudens's earliest known effort executed for a patron.

3. Much of the following information is culled from Torrey's obituary in the *New York Times*, Apr. 5, 1948, p. 21.

4. Frederick C. Torrey, *The Torrey Families and Their Children in America*, 2 vols. (Lakehurst, N.J., 1924 and 1929).

5. Dryfhout 1982, p. 73.

6. Greenthal 1985, pp. 72–74.

George Grey Barnard
American, 1863–1958

The art and life of George Grey Barnard were shaped by an epic vision that fueled the sculptor's internal and external struggles to express that vision. Contemporary assessments of his work spoke of its primal qualities, intensity of emotion, sense of suffering, and hauntingly compelling beauty. These judgments remain valid today.

The grandiose nature of Barnard's aspirations was conditioned by the ferocious determination and sense of purpose he instilled in himself. Not surprisingly, his culminating project, *The Rainbow Arch*, a colossal peace memorial commenced in the latter years of his career, was never completed. In the spirit of the Gothic age he revered, Barnard attempted to build the unbuildable and to fathom the unfathomable. Artistically, Barnard was part of the second wave of sculptors who gravitated to France and its Beaux-Arts training, yet his fierce independence and the profound impact on him of Michelangelo's sculpture prevented him from unequivocally embracing the constricting French academic dogma.

Barnard was born in rural Bellefonte, Pennsylvania, where his father had taken his first position as a Presbyterian minister. Barnard's youth was marked by a series of relocations as his father accepted successive pastorships in provincial towns in Wisconsin, Illinois, and Iowa. Although he was an avid reader, young George preferred exploring the countryside to pursuing his studies. His fascination with animals led to an interest in taxidermy, which developed skills in modeling and creating armatures that would be central to his eventual calling. During these formative years, Barnard visited the Philadelphia Centennial Exposition in 1876, where he would have seen a broad array of sculpture in the Arts Pavilion, ranging from the *retardataire* examples of committed neoclassicists such as William Wetmore Story (q.v.) and Randolph Rogers (q.v.) to the more progressive works by Daniel Chester French (1850–1931) and Augustus Saint-Gaudens (q.v.). The animal sculptures of Edward Kemeys (1843–1907) and the ascendant French tradition represented by Jules Dalou (1838–1905) and August Bartholdi (1834–1904) may have made their mark. Although what he saw remains speculation, Barnard's confirmed interest in drawing and modeling suggests that sculpture was a priority.

In 1879, at age sixteen, Barnard fashioned his first portrait bust, a likeness of his younger sister, and began working for

a local jeweler. He soon decided a more cosmopolitan environment was necessary, and in 1880 he moved to Chicago. While continuing to work as a jeweler's engraver, Barnard explored the possibilities of a career as a sculptor. He visited the studio of Leonard Volk (1828–1895), who was best known for his portrait of Abraham Lincoln taken from a life mask. Volk was not encouraging, but urged him to develop his skills as a draftsman and suggested enrolling in the recently reorganized Academy of Fine Arts (soon to become the Art Institute of Chicago).

Given the full-time demands of his employment, it is unclear what course of study Barnard pursued, but one thing is certain: he persisted in gaining access to the casts after sculptures by the renowned Renaissance artist Michelangelo, which had been put off-limits to students because of previous vandalism. Thus, he established an aesthetic and spiritual link with one of the supreme masters of the medium and mastered the disciplines of draftsmanship and foreshortening through intense study.[1] The only other instruction Barnard sought during his sojourn in Chicago was from the little-remembered David Richards (1829–1897), whose work Barnard may have encountered at the Philadelphia Centennial. At a time when most sculptors turned their models over to assistants for replication, Richards carved all of his own work, and Barnard acknowledged that Richards instilled in him the importance of this creative act, which further linked him to Michelangelo. At this time, Barnard received his first paid commission, a bust of a young girl, Laura Musser. The remuneration permitted him to realize his most fervent desire, study in Paris.

Barnard arrived in Paris in December 1883, where he quickly enrolled in the Ecole des Beaux-Arts and entered the studio of Jules-Pierre Cavelier (1814–1894), who is all but forgotten today. Cavelier, a disciple of David d'Angers (1788–1856), epitomized the conservative style and subject matter of the neoclassical tradition. Despite the difference in aesthetic outlook, Barnard benefited from developing his ideas through sketches and maquettes. The Ecole provided him a broad foundation and focused his training on the discipline of modeling. Through its collection of casts and its access to the museums and collections of Paris, the Ecole also enabled the young sculptor to reacquaint himself with the sculpture of Michelangelo, as well as other masters of antiquity and the Renaissance.

These early years in Paris were extremely stimulating. There was a growing

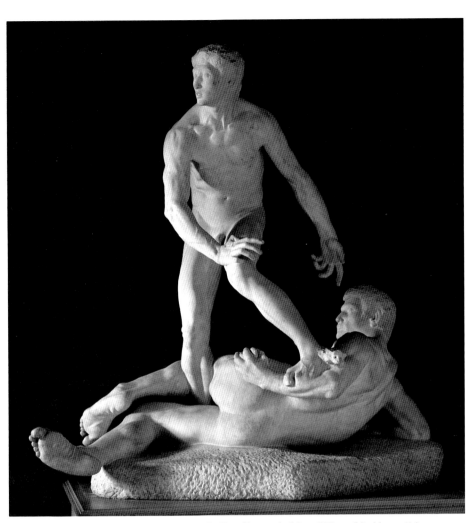

FIG. 108 George Grey Barnard, *Struggle of the Two Natures in Man*, 1888–94. Marble, 101½ in. (257.8 cm) high. The Metropolitan Museum of Art, Gift of Alfred Corning Clark, 1896 (96.11)

population of American sculptors, which included Paul Bartlett (1865–1925), Herbert Adams (1858–1945), Frederick MacMonnies (q.v.), and intermittently French and Saint-Gaudens. Apart from seeing MacMonnies, Barnard kept to himself. His abject poverty and relentless regimen for study necessitated this isolation. In the spring of 1886 this harsh phase of Barnard's sojourn took a dramatic turn.

While in the atelier of Cavelier, Barnard completed a crouching boy in clay that caught the attention of Alfred Corning Clark, wealthy heir of the founder of the Singer Manufacturing Company. Barnard was summoned to Clark's hotel and commissioned to translate the figure into marble. This meeting was momentous since it signaled Barnard's first major transaction and provided him financial security. Clark offered him a generous living allowance and ordered other significant monuments, such as the memorial to Clark's close friend, the Norwegian singer Lorentz Severin Skougaard, entitled *Brotherly Love*, of 1886–87 (cemetery, Langesund,

Norway).[2] While the composition of the two nude figures facing each other beside a stone slab recalls an ancient Greek stele, the figures, as they struggle to emerge from the stone, echo Michelangelo and signal the monumentality of Barnard's mature work.

In the ensuing years, Barnard worked almost exclusively for Clark and did not have to extend himself into the public domain. In the wake of *Brotherly Love*, he addressed numerous Norwegian themes, which introduced him to the riches of Norse mythology and fueled his own epic vision. By 1894, however, the sculptor felt compelled to extend his reputation and exhibited several works at the spring Salon of the Champs de Mars. Among the works on view was his heroic group entitled *Je sens deux hommes en moi*, which was inspired by Victor Hugo's poem. Commenced in 1888, the work came to be known as *Struggle of the Two Natures in Man* (fig. 108). Evolving from considerations of liberty and victory, it addressed the common suffering of victor and van-

Photograph of George Grey Barnard. Peter A. Juley & Son Collection, National Museum of American Art, Smithsonian Institution

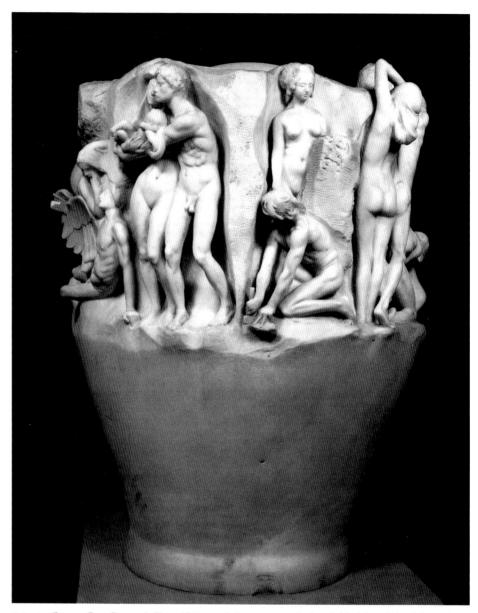

FIG. 109 George Grey Barnard, *Urn of Life*, ca. 1898–1900, reworked 1918. Marble, 37⅞ in. (96.2 cm) high. The Carnegie Museum of Art, Purchase, 19.7.1

quished. The composition, more than eight and a half feet tall, was as majestic in size as it was heroic in concept. Barnard did all the carving himself, which took more than two years. A tour de force, this sculpture single-handedly garnered Barnard universal recognition and fame, and Auguste Rodin (1840–1917) led the chorus of accolades. Barnard was elected an associate of the Société Nationale des Beaux-Arts on the strength of this work.

Even as he basked in the glory of this milestone, Barnard defied the concerted advice from Clark, Rodin, and others to remain in Paris, and he returned to New York. Personal matters shaped this decision, and he married Edna Monroe shortly after his arrival in America. He continued to work on various commissions from Clark, but the security of this arrangement came to an abrupt and unexpected end when his friend and patron died in April 1896. Despite the uncertainty, Barnard spent the ensuing four years working on projects originated for Clark. The major works were *The Hewer* (Estate of John D. Rockefeller, Jr., Pocantico Hills, N.Y.) and *Pan* (Columbia University, New York).

The Hewer was extrapolated from a larger figure group called *Primitive Man*, which Barnard had begun in 1895 but never completed. Originally envisioning Nordic imagery to tell the story of human labor, the sculptor infused the single figure with a more universal synthesis of humanity, labor, discipline, and dignity.[3] Barnard translated *The Hewer* into marble

in 1902 and exhibited it with critical success in a bronze cast at the Saint Louis World's Fair of 1904.

In addition to a growing number of private commissions, such as the cinerary urn in memory of Anton Seidl (fig. 109), that Barnard received after settling in New York, his ability to conceive on a colossal scale attracted widespread attention. The committee for the decoration of the Pennsylvania state capitol in Harrisburg awarded him the project in 1902. This was Barnard's most important commission to date, and the satisfaction of creating a major work for his native state was outstripped only by the enormity and complexity of the undertaking. By 1904 Barnard crystallized his ideas for the iconographic program and design and

determined that he must return to France to carry out this ambitious project. The grandeur of his original design, however, was severely compromised by political and financial controversy, none of which involved the sculptor.[4] The ultimate realization was two allegorical groups, *The Broken Law* and *The Unbroken Law*, which flank the main entrance of the capitol and symbolize man's fate in terms of right and wrong. Despite the tumultuous circumstances of their gestation, the two groups were unveiled in October 1911 amid great fanfare and praise for Barnard. The state even voted an additional appropriation to help Barnard defray his substantial personal expenditures. When the enterprise was in greatest jeopardy, Barnard began collecting and selling

medieval antiquities to finance the work. This sideline assumed substantial dimensions since he amassed an important collection that eventually comprised the Cloisters in New York as well as the core of medieval holdings at the Philadelphia Museum of Art.[5]

While working on the Pennsylvania capitol project, Barnard was invited to exhibit a selection of his works at the Museum of Fine Arts in Boston. The exhibition consisted of twenty-five works in various media and included the large marble figure *The Hewer*, which was placed in the triangle in front of Trinity Church in Copley Square.[6] Also on view was the *Urn of Life* and several individual details from it, including *Solitude* (cat. no. 66). Critical reaction confirmed the high level of esteem that Barnard was accorded at this time.[7]

Barnard remained in New York after his triumph in Pennsylvania. His connection to the international scene prompted him to participate in the Armory Show, which brought various facets of modernism before the American public in 1913. He lent five works, including several details from the *Urn of Life*, which were attuned to the more progressive examples in the exhibition.[8]

Around the middle of the decade, Barnard was awarded the commission to create a statue of Abraham Lincoln for the city of Cincinnati, which resulted in heated controversy. Through his research, the sculptor concluded that the only reliable image of Lincoln was Volk's life mask, which he had seen in Chicago at the outset of his career. When the bronze statue was unveiled in 1917, a storm of protest erupted regarding Barnard's interpretation of the great statesman, whom many thought the sculptor had portrayed as idiotic and disfigured. Although many defended it, including the influential critic Roger Fry, Barnard endured an overwhelmingly negative response. Despite the criticism, replicas were delivered to Manchester, England, and Louisville, Kentucky, and in 1919 Barnard created a marble head from the statue of Lincoln that was acquired by the Metropolitan Museum. Consistent with his penchant for the epic, Barnard began work on a colossal head of Lincoln, which was to measure sixteen feet high and overlook the Hudson River from the Palisades. This majestic statement was never fulfilled, just as the other major project of his late career was never resolved.

By the early 1920s, the most enduring aspects of Barnard's career had been accomplished. At this time he sold the bulk of his medieval art collection to John

D. Rockefeller, with other materials going to Philadelphia. The success of his career and the income from the sale of his collection provided financial security to embark on the most ambitious of undertakings, *The Rainbow Arch*, dedicated to Motherhood, Country, City, and State. Barnard envisioned a 100-foot-high arch spanning a tomb on which a marble figure of a dead soldier would lie. Additional sculptural groups would flank the arch with a 40-foot-high bronze Tree of Life adorning the 350-foot plaza. For the balance of his life, Barnard worked on the design and models, directing that the bulk of his sizable estate should underwrite the execution of the project. Even his substantial fortune was insufficient to accommodate these wishes, and this, the most imposing of his projects, remained uncompleted.

When Barnard died in 1938, the world was on the precipice of yet another cataclysm. In the world of art, a movement—Abstract Expressionism—was unfolding that would passionately probe man's inner recesses. In this regard, George Grey Barnard was a visionary; he had dedicated his entire career to exploring the full range of human emotions and to expressing them with a direct and personal intensity.

Notes

1. This experience was vividly recalled in a later recollection, published in Meltzer, "Petrified Emotion" (1910), 670–671. For the most recent information on Barnard, see Craven 1984, pp. 442–450, and Diana Strazdes, "George Grey Barnard," in *American Paintings and Sculpture to 1945 in the Carnegie Museum of Art* (1992), pp. 55–56.

2. See Dickson, "Barnard and Norway" (1962), 55–59.

3. Thaw, "George Grey Barnard, Sculptor" (1902), 2852.

4. Dickson, "Barnard's Sculptures for the Pennsylvania Capitol" (1959), 126–147.

5. Dickson, "The Origin of the Cloisters" (1965), 253–276.

6. *Exhibition of Sculpture by George Grey Barnard* (Boston, 1908), n.p.

7. For a sampling of these assessments, see Laurvik, "George Grey Barnard" (1908), 39–47, and Coburn, "The Sculptures of George Grey Barnard" (1909), 273–280.

8. Milton Brown, *The Story of the Armory Show* (New York, 1963), p. 221.

Bibliography

Regina A. Hilliard, "George Grey Barnard," *Munsey's Magazine* 20 (Dec. 1898), 456–459; Alexander Blair Thaw, "George Grey Barnard, Sculptor," *World's Work* 5 (Dec. 1902), 2857–2853; J. Nilsen Laurvik, "George Grey Barnard," *International Studio* 36 (Dec. 1908), 39–47; Frederick W. Coburn, "The Sculptures of George Grey Barnard," *World To-Day* 16

(Mar. 1909), 273–280; Charles Henry Meltzer, "Petrified Emotion," *Cosmopolitan* 49 (Nov. 1910), 670–671; Harold E. Dickson, "Barnard's Sculptures for the Pennsylvania Capitol," *Art Quarterly* 22 (Summer 1959), 126–147; id., "Barnard and Norway," *Art Bulletin* 44 (Mar. 1962), 55–59; id., "The Origin of the Cloisters," *Art Quarterly* 28 (Fall 1965), 253–276; Gardner 1965, pp. 85–88; Harold E. Dickson, "The Early Years of a Great Sculptor, George Grey Barnard," in *Pennsylvania's Contributions to Art*, ed. Homer T. Rosenberger (Waynesboro, Pa., 1967), pp. 25–36; Craven 1984, pp. 442–450; Diana Strazdes, *Urn of Life*, in *American Paintings and Sculpture to 1945 in the Carnegie Museum of Art* (New York, 1992), pp. 55–56

66
Solitude
Modeled ca. 1898–1900, carved 1906
Marble
26½ × 18 × 8¼ in. (67.3 × 45.7 × 21 cm)
Inscribed lower right: *Barnard / 1906.*

Provenance J. Randolph Coolidge Jr., Boston, by 1908;...; Martha R. Peters, Boston; [Vose Galleries, Boston, 1964]; James H. Ricau, Piermont, N.Y., 1964

Exhibition History Museum of Fine Arts, Boston, *Exhibition of Sculpture by George Grey Barnard*, Oct.–Nov./Dec. 1908, no. 8; *The Ricau Collection*, The Chrysler Museum, Feb. 26–Apr. 23, 1989

Literature "An American Sculptor," *Outlook* 90 (Nov. 28, 1908), 655–656; James Huneker, "The Boston Museum: George Grey Barnard," *New-York Sun*, Nov. 15, 1908, p. 8; Ernest Knaufft, "George Grey Barnard: A Virile American Sculptor," *American Review of Reviews* 58 (Dec. 1908), 691; Katharine Metcalf Roof, "George Grey Barnard: The Spirit of the New World in Sculpture," *Craftsman* 15 (Dec. 1908), 274, ill., 277–278; William Howe Downes, "Mr. Barnard's Exhibit in Boston, Which Appealed to the Connoisseurs and the Crowd Alike," *World's Work* 17 (Feb. 1909), 11,267; Harold E. Dickson, *George Grey Barnard, Centenary Exhibition, 1863–1963*, exh. cat., The Pennsylvania State University Library (University Park, Pa., 1965), pp. 24, 27, ill.

Versions MARBLE The Taft Museum, Cincinnati, Ohio; Vassar College Art Gallery, Poughkeepsie, N.Y.; [formerly James Graham & Sons, New York]

Gift of James H. Ricau and Museum Purchase, 86.459

Solitude articulates the conflicting forces of continuum and limbo in George Grey Barnard's career. The composition was extrapolated from an earlier project,

the *Urn of Life* (fig. 109), which languished after Barnard began it around 1898.[1] This ambitious undertaking, with its complex subject and design, epitomized the sculptor's commitment to exploring elusive themes and couching them in mysterious visual terms. The genesis of the *Urn of Life* was connected with a funerary monument to honor Anton Seidl, the great conductor of the Metropolitan Opera who died in 1898. The order was withdrawn, however, when the committee decided the monument was too ambitious and accepted a replica of one of the details instead.[2]

When the *Urn of Life* was exhibited in Boston in 1908, Barnard offered an explanation that did little to penetrate its meaning:

In the midst stands a veiled figure, neither male nor female, holding forth the mystery of life; a man from labor reaches up into space to touch the secret but cannot; and a woman demands its voice or word. To the right the mouth of the dead closed by an angel's hand. Above, an aged pair of lovers lean upon the angel's wing, their clasped hands kissed by the angel of life. To the left, Birth; a mother with the joy of the visitation, a father kissing her brow, an angel holding the new born. Above, a man carving the wing of an angel (the only way we beget our wings is by carving them). Beyond, a man laboring, his wife above, the unfinished space to be filled by the figures of two children. Family group. Dying poet.[3]

Certainly, Barnard's description is as enigmatic as the subject, and to place the figures in *Solitude* within this context is difficult.

In addition to presenting the *Urn of Life* in its entirety, the Boston exhibition included four independent details, including the Ricau version of *Solitude*.[4] Most critics fathomed Barnard's abstruse message and interpreted these sculptures in terms of such primal polarities as life and death, joy and sorrow, attachment and separation. *Solitude* was cast in less general terms as symbolizing the impenetrability of the human soul and its consequent isolation.[5] One critic saw the composition in more concrete terms: "Here the figures do not symbolize mankind in the abstract. They are man and woman, together yet alone, divided by the same barrier that even the closest of earthly love is powerless to break down entirely."[6] This conflict of the celestial and worldly is central to Barnard's creative outlook, and at least one reviewer equated the figures in *Solitude* to Adam and Eve.[7] These lofty ideals notwithstanding, one commentator commended Barnard's work, including *Solitude*, for the breadth of its appeal, noting that it attracted the

admiration of both the connoisseur and the general populace. Unquestionably, Barnard's sculpture elicited this response with its extraordinary technical virtuosity.

Solitude is a freestanding, deeply cut relief in which the figures emerge from the stone in a manner reminiscent of Michelangelo and Rodin (1840–1917). In fact, Barnard saw himself as inheriting the mantle of this impressive sculptural tradition. Although the French master did little of his own carving, he embraced an unfinished surface treatment to reinforce the emotional resonance of his subjects. The young American's admiration for Rodin was considerable, and their names were often linked. Despite his admiration for Michelangelo and their shared practice of carving, Barnard may have been closer in spirit to the work of his French mentor.

Technical matters also inform Barnard's relationship to his two paradigms. A crucial distinction with regard to Rodin and Michelangelo has been made recently about the different effects achieved from the direct carving process and pointing the work from the plaster model.[8] Michelangelo's ability to make the figure seem as though it were bursting from the stone was attributed to the function of the direct carving method, where the excess stone is chipped away to reveal the form hidden within. The sense of emergence stems from this subtractive process.

In contrast, Rodin created a model from clay that, after being cast in plaster, was turned over to a craftsman to translate into stone. The initial, creative step of modeling the clay was an additive process, and this accounted for the feeling of Rodin's figures being enveloped or absorbed by the stone. While the surface effects are remarkably similar, the visual message is different. Where Michelangelo strove to convey in an overt manner the titanic physical and spiritual aspect of his mission, Rodin sought to impart the haunting aspects of his vision through a more subdued and atmospheric veil. Unlike Michelangelo's surfaces, Rodin's are flowing and translucent, and dematerialize the form.

Barnard's approach constituted a synthesis of what he revered in these two masters. Although he personally executed the final phase of carving, he worked from a preliminary model. Consequently, there is not the edge of unfolding discovery and revelation that one experiences in looking at Michelangelo. Rather, it is more of a lyrical mystery associated with Rodin. The Frenchman's *Orpheus and Eurydice*, modeled in 1888 and carved in 1893 (fig. 110), exemplifies Rodin's approach and pro-

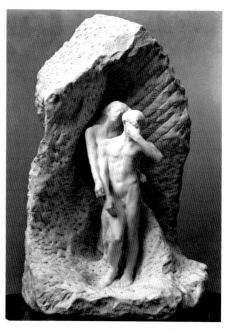

FIG. 110 Auguste Rodin, *Orpheus and Eurydice*, 1893. Marble, 50 in. (127 cm) high. The Metropolitan Museum of Art, Gift of Thomas F. Ryan, 1910. (10.63.2)

vides an interesting comparison with *Solitude*. Each work shares a similar attitude to the block of stone that functions as an integral part of the design and provides both base and setting for the composition.[9] The rough texture of the background wall in both works imparts a chthonic quality that reinforces the profound moment being conveyed.

Solitude depicts two figures, male and female, in the act of moving apart. The woman is standing still with her back to the viewer, while the man moves to the right at an oblique angle. Immediately, the sculptor set up a visual dichotomy of stasis and movement. The figures are connected by uncut stone at the calf, and the only point of physical contact is at the shoulder. Here again, Barnard suggests direct and indirect forces at work. The positioning of outside arms also implies polarity, as the bend at each elbow creates a centrifugal vector. The woman's left arm is raised over her head as her hand grasps the right side of her face. Her hand loses all sense of definition as it trails off into smooth yet uncut stone. The woman's hair conveys a swirling quality whose generalized treatment imparts a sense of envelopment. The man grabs the back of his head with his right hand, but it, too, possesses a similar sense of dissolution. Barnard's handling of anatomy is exemplary, and he simulates real flesh and bone. Curiously, the man's feet are too large in relation to the rest of his body, and this distortion of form for expressive

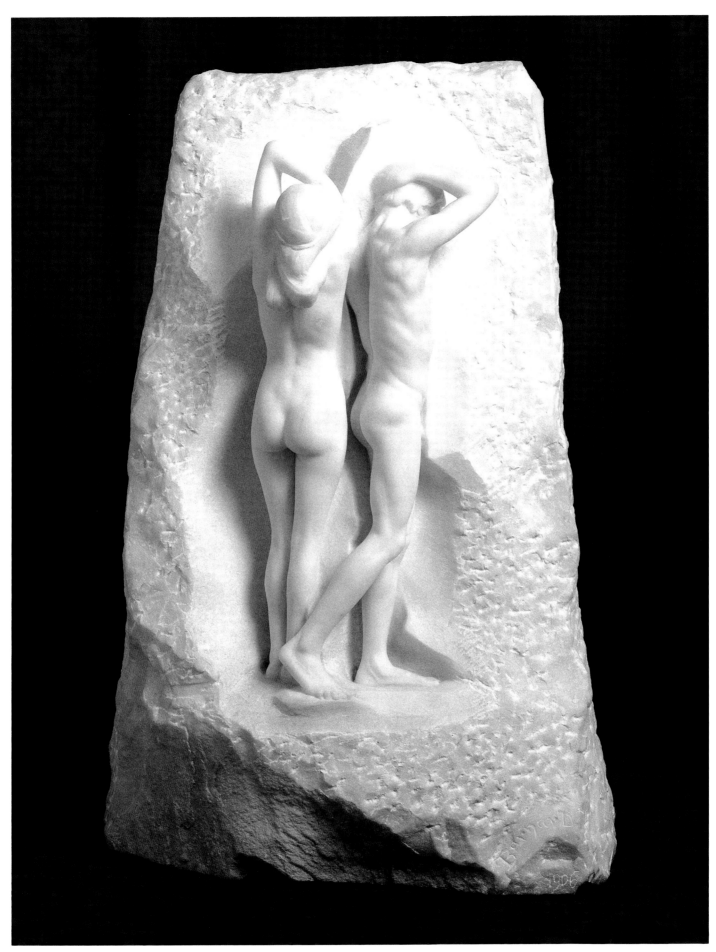

Cat. no. 66 Barnard, *Solitude*

effect suggests Barnard's admiration for Michelangelo.

In addition to the importance he accorded to the rendering of form, Barnard was concerned with the use of light. The high relief of the figures and rough textures permit a rich variety of shadows, while the smooth, translucent surfaces allow the work to cast an aura from within. Once again, multiple forces are at play as the sculptor attempts to establish tension between interior and exterior by manipulating light to theatrical and spiritual ends.

Solitude enjoyed some commercial success, and at least three other replicas exist. Photographs taken of the works in the Boston exhibition suggest that the Ricau version was in that show.[10] The identity of its original owner implies a larger context for the exhibit. Jefferson Randolph Coolidge, Jr., who initially owned the work, was an architect. More significant, he was interim director of the Museum of Fine Arts from 1905 to 1907.[11] He was enlisted in the wake of E. A. Robinson's resignation over a dispute regarding the fate of the museum's casts of antique and Renaissance sculpture. Robinson, who favored keeping the casts, was overruled and left to become assistant director of the Metropolitan Museum of Art in New York. Although Barnard's exhibit was on view after Coolidge stepped aside as director, it is more than coincidental that the sculptor was approached to provide an exhibition placing heavy emphasis on the finished marble. While a singular honor for the sculptor, it also may have served a larger purpose for the museum.

Barnard thought highly of *Solitude*, since he included it in the selection of works he sent to the Armory Show in 1913.[12] *Solitude* is paradigmatic of Barnard's creative genius. Without sacrificing monumentality, it established on an intimate scale the quintessence of his ideals and addressed themes that were both cosmic and personal. The force of his vision and the intensity of his artistic approach imbued his work with an elemental timelessness.

Notes

1. Diana Strazdes, *Urn of Life*, in Diana Strazdes, *American Paintings and Sculpture to 1945 in the Carnegie Museum of Art* (New York, 1992), pp. 56–57.

2. Ibid., p. 56.

3. Huneker, "The Boston Museum: George Grey Barnard," *New-York Sun*, Nov. 15, 1908, p. 8.

4. The other three sculptures were *The Visitation, Family Group*, and *The Dying Poet*; see *Sculpture by George Grey Barnard*, exh. cat., Museum of Fine Arts (Boston, 1908), nos. 8, 9,

and 10. None of their present locations is known.

5. "An American Sculptor" (1908), 655.

6. Roof, "Barnard" (1908), 278.

7. Knaufft, "Barnard" (1908), 691. In fact, when Vose Galleries acquired the work from the Peters's estate, it was listed as a subject of Adam and Eve.

8. Daniel Rosenfeld, "Rodin's Carved Sculpture," in *Rodin Rediscovered*, exh. cat., National Gallery of Art (Washington, D.C., 1981), pp. 96–98.

9. Rosenfeld, p. 96, initially made this observation.

10. Barnard papers, AAA, roll 1116, frame 712.

11. Walter M. Whitehill, *Museum of Fine Arts, Boston: A Centennial History* (Cambridge, Mass., 1970), p. 207.

12. Which replica was lent remains unanswered, except it was not the Ricau version, since Barnard lent one in his own possession.

Frederick William MacMonnies
American, 1863–1937

Frederick MacMonnies was a member of the generation of sculptors who used adherence to naturalism, animated modeling, and flickering surfaces to sustain the ascendancy of a new vision over the unraveling hegemony of neoclassical tenets. His career spanned the period that replaced this outmoded style. The same period was to be overshadowed in its turn by the modernist tendencies taking root in the early twentieth century.

MacMonnies was born in Brooklyn into comfortable means. His father was a successful importer of English goods, and his mother was related to one of the patriarchs of American painting, Benjamin West (1738–1820). From an early age, MacMonnies displayed a talent for modeling and manipulated whatever malleable material he could find. Around 1875 the young MacMonnies's life changed abruptly when his father's business failed and he was forced to leave school and find a job. Within four years his creative aspiration asserted itself, and MacMonnies entered the studio of Augustus Saint-Gaudens (q.v.). Once Saint-Gaudens recognized his abilities, MacMonnies escaped the drudgery of routine menial tasks necessary to the running of a successful studio. The master promoted him to assistant and engaged him in a variety of tasks, such as roughing out rudimentary forms or enlarging preliminary sketches, which refined his abilities as a modeler. In the evenings, when not working on his own creations, MacMonnies studied at the Cooper Union, the Art Students League, and the National Academy of Design.

During MacMonnies's tenure in Saint-Gaudens's studio he was introduced to many of New York's leading artists and architects. He helped decorate some of New York's grand houses, including the residence of Cornelius B. Vanderbilt II and the Villard House on Madison Avenue, designed by Stanford White (1853–1906). He also met White's partner, Charles F. McKim (1847–1909), who provided him with the financial assistance to go to Paris in September 1884.

Armed with glowing letters of introduction, MacMonnies gained quick entrée into Parisian artistic circles. His original intent was to study painting. Pecuniary restrictions prevented him from enrolling in the Académie Julian, and he settled for the more affordable Académie Colarossi. He also took advantage of the unrestricted morning classes at the Ecole des Beaux-Arts, where he benefited from Jean-Léon Gérôme's (1824–1904) critiques of his

drawing from the antique. As MacMonnies was preparing for the challenging entrance examination to the Ecole, cholera broke out in Paris and forced him to relocate to Munich, where he continued his studies at the Royal Academy. Following a brief interlude in New York to assist the over-extended Saint-Gaudens, MacMonnies returned to Paris in the summer of 1886 and embarked on a formal course of instruction at the Ecole. At the same time, he worked as an assistant in Jean-Alexandre Falguière's (1831–1900) studio and received private instruction from Antonin Mercié (1845–1916). Thus, his early grounding was firmly rooted in a new aesthetic.

In 1887 MacMonnies exhibited at the Salon for the first time and was honored with the Prix d'Atelier, the most significant award accorded a foreign student. He was similarly honored the following year, and tangible success quickly ensued. In 1888 the sculptor received one of his earliest commissions when he was asked to create three bronze angels for St. Paul's Church in New York. The year also marked his marriage to the painter Mary Fairchild (1858–1946), a union that ended in divorce in 1908.[1]

In 1889 MacMonnies established his own studio and submitted his life-size plaster *Diana* (bronze, PMA) to the Salon, where it received an honorable mention. The work reflected Falguière's influence in the infusion of a new vision into a classical subject, and only the crescent in the hair and the bow in her hand connected *Diana* to her antique antecedents. The contemporary face, svelte proportions, delicate modeling of flesh and hair, and fluid formal transitions all bespoke the modern aesthetic.

With increased recognition came a steady flow of commissions. In 1890 the banker Edward Dean Adams ordered a fountain sculpture, *Pan of Rohallion*, for his country estate in Seabright, New Jersey (private collection, New York), and Joseph H. Choate, lawyer and later ambassador to the Court of Saint James, commissioned *Young Faun and Heron* for his house in Stockbridge, Massachusetts. As was to become the sculptor's custom, each of the life-size works was available in reduced sizes, which were extremely popular.

MacMonnies's friendships proved useful to his career. Stanford White designed both the Adams and Choate houses and influenced sculptural decisions. Saint-Gaudens also acted in his interest, as he prevailed on the committee of the Sons of the Revolution of the State of New York to award his protégé the commission for a statue of Nathan Hale to be placed in City

Hall Park in New York City. In its capacity as MacMonnies's first competitive commission, *Nathan Hale* has been compared to his teacher's equivalent achievement, the Farragut Monument of a decade earlier. Apt analogies also have been made of the probing realism of Saint-Gaudens to that of Thomas Eakins (1844–1916) and the superficial bravura of MacMonnies to that of John Singer Sargent (1856–1925).[2] The scintillating surface of *Hale* intimated a disheveled appearance on the part of the Revolutionary War hero and spoke to the emotionally charged moment. Its summary, unfinished aspect disturbed many critics, and the controversy over the aesthetics of the sketch preoccupied arbiters of taste.

Despite the mixed reaction to *Nathan Hale*, MacMonnies embarked on his most ambitious undertaking to date, the immense Columbia Fountain (destroyed), commissioned for the World's Columbian Exposition held in Chicago in 1893. His ability to work quickly was an asset, since he had only twenty-two months to complete the project. He was equal to the task, however, and his caravelle-like barge, powered by eight allegorical figures redolent with motifs from the Renaissance and the baroque, was one of the highlights of the exposition.

Riding the crest of this critical triumph in Chicago, MacMonnies commenced *Bacchante and Infant Faun,* which stirred up an intense debate in its initial locale, the courtyard of the Boston Public Library. The work was castigated as much for its image of drunkenness as for its nudity, and in 1897 it was removed from Boston and presented to the Metropolitan Museum of Art in New York. The *Bacchante* did not disturb the French, and the government ordered a full-size replica for the Luxembourg Museum, making it the first American sculpture to enter the collection.

The decade of the 1890s was a frenzy of activity for MacMonnies, with numerous commissions for a wide variety of work. These included costume pieces, such as *Shakespeare* (Library of Congress, Washington, D.C.); sculpture to enhance architecture, such as the *Soldiers' and Sailors' Memorial Arch* and the *Horse Tamers* in Brooklyn, and a set of doors for the Library of Congress. MacMonnies's friend the painter Will Low (1853–1932) observed that while McMonnies's frantic pace of production might affect his conception, it rarely compromised his execution.[3] Indeed, the rapid working method conveyed a cursory approach that appealed visually but did not carry the staying power of Saint-Gaudens's or

Photograph of Frederick William MacMonnies. Peter A. Juley & Son Collection, National Museum of American Art, Smithsonian Institution

Daniel Chester French's (1850–1931) more methodical approaches. Nevertheless, MacMonnies's elaborate sculptures, with their complex poses and animated, shimmering surfaces, generated an enthusiastic response that enhanced the growing respect for American sculpture.

In 1898 MacMonnies and his wife purchased a residence in Giverny near Claude Monet (1840–1926), and the sculptor began to divide his time between the country house and Paris. He also started teaching, and among his more successful students were the portrait painter Ellen Emmet Rand (1876–1941) and the sculptor Janet Scudder (1873–1940). MacMonnies's good looks attracted a large following of female students, one of whom, Alice Jones (1875–1965), was the undoing of his marriage.

By the turn of the century, MacMonnies's energies began to lag with regard to sculpture, and he turned to painting. In 1898 he had traveled to Madrid to copy works by the Spanish baroque master Velázquez, which complemented his admiration of John Singer Sargent.[4] His efforts in this genre encompassed a direct execution and decorative style. The response to his painting was sufficiently mixed to prompt him to return to sculpture, which he did by 1905. He never recaptured the ebullience of his earlier work, and the ensuing output was pedestrian by comparison.

One of his first projects in this last phase of his career was the sculptural program for the Palace of Justice in The Hague, which was never executed (cat. no. 67). Others included equestrian monuments for Brooklyn and Washington,

D.C., the Pioneer Monument for Denver, Colorado, fountains for the New York Public Library, the Princeton Battle Monument, and a fountain personifying Civic Virtue for City Hall Park in New York City.

The onset of World War I forced MacMonnies and his new bride, Alice, to vacate Giverny and return to New York City, where he reestablished his studio. In addition to the works in progress, MacMonnies took on what was to be his last major undertaking, the Marne Battle Memorial to be built near Meaux, France, to commemorate the French soldiers who fought in the first battle of the Marne in September 1914.[5] This monument, for which MacMonnies agreed to donate his services in gratitude for his French education, was unveiled in 1932. Because of its enormous size and stone material it lacked the panache generally associated with the sculptor's work.

Civic Virtue for City Hall Park effectively brought a closure to MacMonnies's public career. In its evocation of the grotesque aspects of sixteenth-century Italian mannerist sculpture, the composition had little to commend it. The iconographic program, representing a male astride two female forms who signified graft and corruption, was even more problematic. Castigated by the press at its unveiling in 1922, *Civic Virtue* was also vehemently excoriated by women's groups for the sexual inequities of the imagery. MacMonnies had navigated into a formal and philosophical backwater, and he withdrew from the public arena. He spent the balance of his career creating portrait busts and reliefs. The stock market crash of 1929 brought his extravagant lifestyle to an abrupt end. When MacMonnies succumbed to pneumonia in 1937, he was impoverished, with a negligible reputation as an artist.

Notes

1. See Gordon, *Frederick William MacMonnies (1863–1937) and Mary Fairchild MacMonnies (1858–1946)* (1988), for a recent account of the relationship of these two artists.
2. Clark, "Frederick MacMonnies: An American Sculptor in Paris and New York," in *Frederick MacMonnies and the Princeton Battle Monument* (1984), pp. 10–11.
3. Craven 1984, p. 425. Originally published in Low, "MacMonnies" (1895), p. 617.
4. For a discussion of MacMonnies as a painter, see Doreen Bolger Burke, "Frederick MacMonnies," in *American Paintings in the Metropolitan Museum of Art, Volume III* (New York, 1980), pp. 447–450.
5. See Clark, "MacMonnies: An American Sculptor in Paris and New York" (1984), pp. 20–22, for a succinct discussion of this project.

Bibliography

Royal Cortissoz, "An American Sculptor, Frederick MacMonnies," *Studio* 6 (Oct. 1895), 17–26; Will H. Low, "Frederick MacMonnies," *Scribner's Magazine* 18 (Nov. 1895), 617–628; H. H. Greer, "Frederick MacMonnies, Sculptor," *Brush and Pencil* 10 (Apr. 1902), 1–15; French Strother, "Frederick MacMonnies, Sculptor," *World's Work* 11 (Dec. 1905), 6965–6981; Charles H. Meltzer, "Frederick MacMonnies, Sculptor," *Cosmopolitan Magazine* 53 (July 1912), 207–211; Post 1921, 2:257–258; Joseph W. McSpadden, *Famous Sculptors of America* (New York, 1924), pp. 73–112; Taft 1924, pp. 332–355; "MacMonnies Dies Here at 73 of Pneumonia," *New York Herald Tribune*, Mar. 23, 1937, p. 16; "F. W. MacMonnies, Sculptor, Is Dead," *New York Times*, Mar. 23, 1937, p. 23; W. Francklyn Paris, "Frederick MacMonnies 1863–1937," in *Hall of American Artists*, 10 vols. (New York, 1944), 3:113–122; Gardner 1965, p. 84; Beatrice Proske, *Brookgreen Gardens, Sculpture*, rev. ed. (Brookgreen Gardens, S.C., 1968), pp. xxi, 33–35; Edward J. Foote, "An Interview with Frederick W. MacMonnies, American Sculptor of the Beaux-Arts Era," *New-York Historical Society Quarterly* 61 (July–Oct. 1977), 102–123; Robert J. Clark, *Frederick MacMonnies and the Princeton Battle Monument, Record of the Art Museum Princeton University* 43, no. 2 (1984); Craven 1984, pp. 419–428; Paula M. Kozol, "Frederick William MacMonnies," in BMFA 1986, pp. 293–295; E. Adina Gordon, *Frederick William MacMonnies (1863–1937), Mary Fairchild MacMonnies (1858–1946): Two American Artists at Giverny*, exh. cat., Musée Municipal A.-G. Poulain-Vernon (Vernon, France, 1988); Mary Smart, *A Flight with Fame: The Life and Art of Frederick MacMonnies* (Madison, Conn., 1996); E. Adina Gordon, "The Sculpture of Frederick William MacMonnies: A Critical Catalogue," Ph.D. diss., Institute of Fine Arts, New York University, 1997

67
Pax Victrix

Modeled ca. 1906–7, cast in bronze by 1918
Bronze
37⅜ × 14¼ × 12⅛ in. (94.9 × 36.2 × 31.1 cm)
Inscribed on shield on front of pedestal: PAX VICTRIX; on pedestal at right rear below drapery hanging down: *F. MacMonnies;* foundry mark inscribed on plinth at right rear: JABOEUF ROUARD PARIS

Provenance [Neil Reisner, Scarsdale, N.Y.]; [Post Road Antiques, Larchmont, N.Y., 1977]; James H. Ricau, Piermont, N.Y., 1977

Exhibition History *An Exhibition of Small Bronzes by American Sculptors*, The Buffalo Fine Arts Academy, Albright Art Gallery, March 15–31, 1918; *The Ricau Collection*, The Chrysler Museum, Feb. 26–Apr. 23, 1989

Literature *Harper's Weekly* 51 (Aug. 31, 1907), cover, ill. of plaster; *An Exhibition of Small Bronzes by American Sculptors*, exh. cat., The Buffalo Fine Arts Academy, Albright Art Gallery (Buffalo, N.Y.), no. 38; "Exhibition of Small Bronzes," *Academy Notes* 13 (Apr.–June 1918), 58 and ill. 62; DeWitt M. Lockman, "Interviews with Frederick MacMonnies, N.A. (Jan. 29 and Feb. 16, 1927)," *DeWitt McClellan Lockman Collection of Interviews with American Artists, New-York Historical Society*, 2 vols. (New York, 1927), 2:7; Robert J. Clark, *Frederick MacMonnies and the Princeton Battle Monument, Record of the Art Museum Princeton University* 43, no. 2 (1984), 19–20, 30; E. Adina Gordon, *Frederick William MacMonnies (1863–1937), Mary Fairchild MacMonnies (1858–1946): Two American Artists at Giverny*, exh. cat., Musée Municipal A.-G. Poulain-Vernon (Vernon, France, 1988), pp. 59, 79 n. 104; Mary Smart, *A Flight with Fame: The Life and Art of Frederick MacMonnies* (Madison, Conn., 1996), pp. 215–216, 304; E. Adina Gordon, "The Sculpture of Frederick William MacMonnies: A Critical Catalogue," Ph.D. diss., Institute of Fine Arts, New York University, 1997, pp. 474–479

Version PLASTER unlocated

Gift of James H. Ricau and Museum Purchase, 86.485

FREDERICK MACMONNIES's maturation as a sculptor coincided with a growing concern on the part of society for large-scale monuments that embodied a civic ideal, a subject that has recently been accorded insightful treatment.[1] In the wake of the Civil War, his profession benefited from nationalist sentiment and the belief that sculpture could enrich the public's mind. Training in this demanding medium was significantly enhanced after 1865 by increased access for Americans at the Ecole des Beaux-Arts in Paris. MacMonnies's early education from Augustus Saint-Gaudens (q.v.) and the Ecole instilled in him a technical proficiency and sensitivity to the harmonious relationship of sculpture to architecture, as well as the intangible traits of cosmopolitanism and self-confidence. Moreover, his predilection for lively surfaces and textures disposed him to practice the prevalent aesthetic concerns of the Ecole.

Although his first public commission, *Nathan Hale* for City Hall Park in New York, was comparatively modest, MacMonnies quickly vaulted into the public eye with his *Triumph of Columbia*, the ephemeral barge that commanded one end of the lake at the Columbian Exposition in Chicago in 1893. This

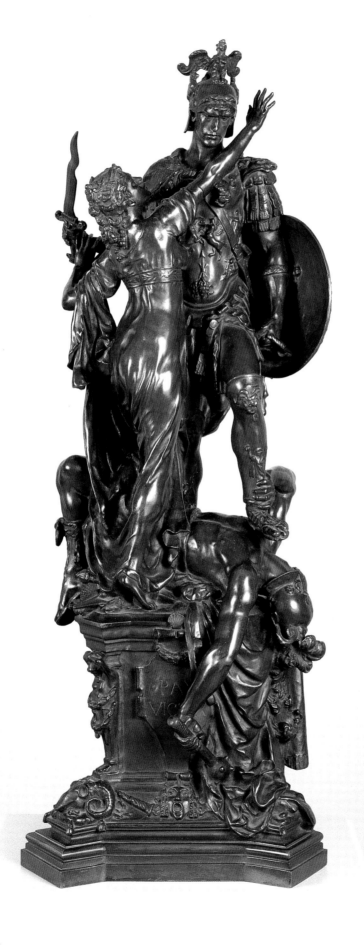

Cat. no. 67 MacMonnies, *Pax Victrix*

Beaux-Arts confection attracted a flood of orders, and the balance of the decade was occupied with fulfilling commissions. Many of these entailed adorning architectural monuments, such as the bronze decorations for John H. Duncan's (1855–1929) *Soldiers' and Sailors' Memorial Arch* and the *Horse Tamers*, whose bases were designed by Stanford White (1853–1906). Both were in MacMonnies's native borough of Brooklyn.

Despite his sabbatical from sculpture at the beginning of the century, MacMonnies was still sought after. In 1903 the United States government commissioned him to execute an equestrian statue of Major-General George B. McClellan for Washington, D.C. In the wake of the first international peace conference held in the Huis ten Bosch at The Hague in 1898, Andrew Carnegie, the industrialist turned philanthropist, made a gift of £500,000 to the Dutch government in 1903 to build a Palace of Peace in The Hague to house a permanent Court of Arbitration.[2] An international design competition drew 216 submissions. First prize was awarded to the Beaux-Arts–trained Louis-Marie Cordonnier, and the magnificence of his Renaissance-revival design was assured by the subsequent cooperation of the participating countries in contributing special building materials and decorative objects. With the announcment in 1905 that a second international peace conference would convene in 1907, MacMonnies conceived an allegorical monument to stand in front of the proposed Palace of Peace. The United States did not accept his design for its contribution, and he did not enter his model in the government-sponsored competition held in 1913. The artist recalled that the work's undoing was caused by "the channels of politics."[3] Despite the disappointment of not having the work enlarged, MacMonnies subsequently cast a version in bronze from the original model, on which Sherry Edmundson Fry (1879–1966) had worked as his assistant.[4]

Pax Victrix depicts a personification of Peace appealing to the victorious warrior to spare the life of an opponent who lies at his feet. The work reveals the sculptor at his most exuberant, and the composition has been connected to the overwrought, distended productions of the sixteenth-century Italian mannerists.[5] MacMonnies pays particular tribute to the famous statue of Perseus by Benvenuto Cellini, which was unveiled in the Loggia dei Lanzi in Florence in 1554, where it can still be found today. The similar pose of the victorious figure standing on his vanquished opponent suggests at least one point of inspiration, and the sword, with

its serpentine blade, is almost a direct borrowing. As an appropriately witty reference to this source, MacMonnies embellished the front of the warrior's shield with the head of Medusa, which the viewer only comprehends by moving around to the side of the sculpture (fig. 111). The sculptor displayed little concern for iconographic consistency but contented himself with the flourish of visual impact. The warrior's identity is further complicated by the lion's skin he wears as a cloak and the lion's face decorating his helmet. Although these associate him with Hercules, the leonine vestments were common for representations of military might. In the nineteenth century Paul Dubois (1829–1905) employed them in his figure *Military Courage*, which adorned the monument to General La Morcière installed in the cathedral at Nantes. This work enjoyed wide acclaim at the Paris Universal Exposition of 1878.[6] The winged creature surmounting the helmet of Dubois's figure also anticipated MacMonnies's more flamboyant effort. The armor of the latter's warrior evokes Roman antiquity, and the decoration on the breastplate, with its depiction of two centaurs locked in combat, is suitably adversarial. In addition to the grotesques covering the knees, the shin guards are adorned with female figures. One holds a wreath and bow, the other a wreath and eagle. MacMonnies literally sprayed the composition with pugilistic imagery and demonstrated that his primary concern was for visual impact rather than programmatic coherence.

Peace reaches for the warrior's sword with her left hand and extends her right arm in a gesture imploring him to desist. Her agitated state is in marked counterpoint to the workmanlike frame of mind with which the warrior goes about his task. Peace's role as interventionist was by no means unusual and brings to mind such episodes as Volumnia beseeching her son Coriolanus to spare Rome and, at the dawn of Roman history, Hersilia pleading with Romulus and her brother Tatius to cease what effectively had become internecine warfare. Jacques-Louis David (1748–1825) employed the latter episode in *The Intervention of the Sabine Women* (Musée du Louvre, Paris) in 1799 as an allegory of reconciliation at the conclusion of the French Revolution. MacMonnies's Peace is dressed in a high-waisted gown, which recalls Hersilia's garment in David's painting. While the simple folds of the delicate material are comparable, Hersilia's dress is cinched with a twist of ribbon just below the breasts, whereas Peace's is

enhanced with a decorative band of stylized leaves. The pedestal of *Pax Victrix* possesses a plethora of ornamentation consistent with the main body of the work. These details, too, refer to antique sources that were recast in a visually dynamic manner.

Stylistically, the work is more conventional than MacMonnies's efforts of the 1890s. The figures do not dissolve in the brio of his modeling, and there is a greater sense of structure. Yet the sculpture does not lack for animated surface; much of the detail is handled in a summary fashion that generates a sense of spontaneity. The many ridges and valleys created by the wealth of detail provide a lively arena for the reflection of light. MacMonnies positioned the figures in such a way that the spectator is compelled to walk around the work to appreciate it fully, and the continual unfolding of interlocking diagonals sustains the dynamic tension of the composition. *Pax Victrix* was originally intended to occupy a central space in front of the Palace of Peace, which accounts for its multiple views. MacMonnies, in turning to the virtuosity of mannerist sculpture and the eclecticism of the Beaux-Arts tradition, created a sculpture that, even in this modestly sized model, demands active physical and visual involvement that culminates in a sensory spectacle.

Notes

1. See Michele Bogart, *Public Sculpture and the Civic Ideal in New York City, 1890–1930* (Chicago and London, 1989), who offers an excellent introduction to this facet of sculpture for the period under consideration. Much of the context for this aspect of MacMonnies's career is based on her discussion.

2. *The Palace of Peace* (Rotterdam, 1920), p. 3.

3. Lockman, "Interviews with MacMonnies" (1927), 2:7.

4. I am deeply indebted to E. Adina Gordon for clarifying my thinking on the genesis of this sculpture. See "The Sculpture of Frederick William MacMonnies: A Critical Catalogue," Ph.D. diss., Institute of Fine Arts, New York University, 1997, pp. 474–479.

5. Clark, "MacMonnies: An American Sculptor in Paris and New York," in *MacMonnies and the Princeton Battle Monument* (1984), p. 20.

6. Janson 1985, p. 186. It is interesting to note that Dubois's *Military Courage* was reproduced in *The Appreciation of Sculpture*, a book by the well-regarded critic Russell Sturgis (New York, 1904).

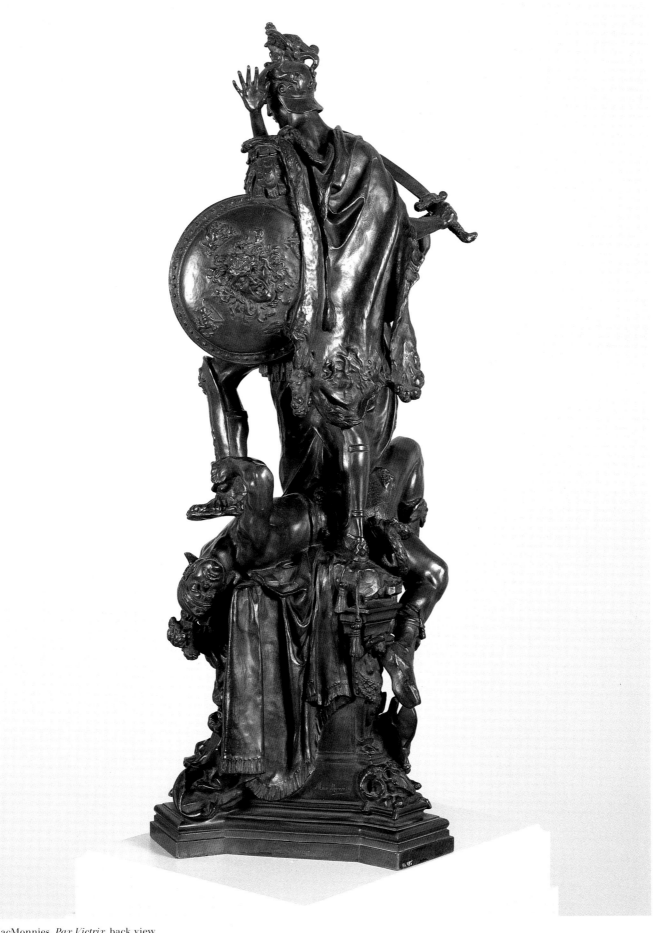

FIG. 111 MacMonnies, *Pax Victrix*, back view

68

Artist unknown (After Houdon)
Head of George Washington
Early 19th century
Marble
21¼ × 17⅞ × 12¼ in. (54 × 45.4 × 31.1 cm)
No inscription

Provenance James H. Ricau, Piermont, N.Y.

Exhibition History *The Ricau Collection,* The Chrysler Museum, Feb. 26–Apr. 23, 1989; USS *George Washington,* Norfolk, Va., July 3–5, 1992 (in conjunction with commissioning ceremonies)

Literature None known

Versions None known

Gift of James H. Ricau and Museum Purchase, 86.474

This anonymous bust of George Washington exemplifies the many representations that dignified residences and civic spaces of the young Republic. As early as 1815 substantial numbers of such likenesses in alabaster and marble began to pass through the office of Thomas Appleton, who exported art and marble furnishings while serving as American consul in Livorno, Italy, from 1802 to 1825.[1]

There were two primary sources for these images of America's great leader. The most influential was Jean-Antoine Houdon's (1741–1828) likeness based on the life mask.[2] The work of Giuseppe Ceracchi (1751–1801), who modeled Washington in Philadelphia in 1791–92, also had its admirers.[3] These two sculptors were the principal rivals for the initial government-sanctioned equestrian monument of Washington, a project that was not realized until the mid-nineteenth century.

Houdon's portrait of Washington derived from his visit to America in 1785, when the Frenchman traveled to Mount Vernon to take the distinguished military hero's likeness from life in preparation for the life-size statue for the Virginia state capitol. To augment the modest income generated from this complex commission, the sculptor made many busts of Washington in a variety of media that would be accessible to a wide market. Materials included terra cotta, plaster, marble, and possibly bronze. At a time when Washington was assigned iconic stature, his image was in great demand.[4] With the widespread dissemination of these works, it was easy for artists to gain access to an example for their own commercial opportunity. Busts of Washington in the spirit of Houdon's original flooded the market and were even sold door-to-door, as exemplified by Francis Edmonds's (1806–1863) *Image Pedlar* of 1844 (N-YHS). Exhibition records, too, indicate that a sizable number of busts "after Houdon" were on view in America during the nineteenth century.[5]

This bust of George Washington is one of three images of the statesman in the Ricau Collection and shares a common source in Houdon with Thomas Crawford's bust (cat. no. 38). Houdon, in planning the full-length statue, was forced to capitulate to his clients' demands that Washington wear his military uniform rather than a classicizing toga. For the bust, over which the sculptor exercised complete control, Houdon evoked the classical past through either a toga-clad or undraped rendering.[6]

The unidentified sculptor here honored his source and re-created the pose of the head, turned slightly to the left, and facial structure. He faithfully captured the sagging flesh, especially in the wattle under the chin and the creases where the chin and neck meet below the left ear. These defining elements, the generalized, planar forehead, and the boldly rendered folds of the togalike garment correspond closely to Crawford's Houdon-inspired effort.

There are several major differences between the two, however. In the work by this unidentified artist, the hair emulates the swept-back coiffure of the Houdon, but it is much more aggressively furrowed, with greater attention paid to creating patterns of curls. In this regard, Crawford was truer to Houdon, while the bust under discussion corresponds to the example by Raimondo Trentanove (cat. no. 3), even if the furrows are more delicate and the curls less massive in the anonymous version. The artist treated the eyes differently. Those of the unidentified version remain blank, in truer spirit of the antique, while the pupils and irises of the Crawford version are chiseled to convey a greater sense of immediacy. The furrowed hair and blank eyes also recall the bust of Washington by Antonio Capellano (act. in America, ca. 1815–27) in the Peale Museum in Baltimore and lend further credence to the likelihood of Italian craftsmanship at work in the Ricau example.

The truncation of the shoulders and chest in the unidentified version is close in form to the Houdon original, but the sculptor altered the garment, creating a toga, emboldened by massive yet simple folds, that is secured at the right shoulder by a round clasp ornamented with a rosette. Allusion to the lighter chemise of the original is evident in the small segment of the shirt enhanced with a delicate border of "gadrooning" and scallop decoration that barely appears beneath the drapery. This sculptor, sensitive to the appeal of Houdon, yet could not resist insinuating his own touches into the portrait. Although it is impossible to assign a specific hand to this replica, the fidelity to its source and workmanlike execution capture the dignity of the original sitter.

Notes

1. Philipp Fehl, "The Account Book of Thomas Appleton of Livorno: A Document in the History of American Art, 1802–1825," *Winterthur Portfolio* 9 (1974), 139ff.
2. See H. H. Arnason, *The Sculptures of Houdon* (New York, 1975), pp. 72–77, for a discussion of the original Washington commission.
3. See Ulysse Desportes, "Giuseppe Ceracchi in America and His Busts of George Washington," *Art Quarterly* 26 (Summer 1963), 140–179.
4. See Wendy C. Wick, *George Washington: An American Icon, the Eighteenth-Century Graphic Portraits,* exh. cat., National Portrait Gallery (Washington, D.C., 1982).
5. Perkins and Gavin 1980, p. 81, and Yarnall and Gerdts 1986, 3: 1797 and passim.
6. Arnason, *Houdon* (1975), p. 77.

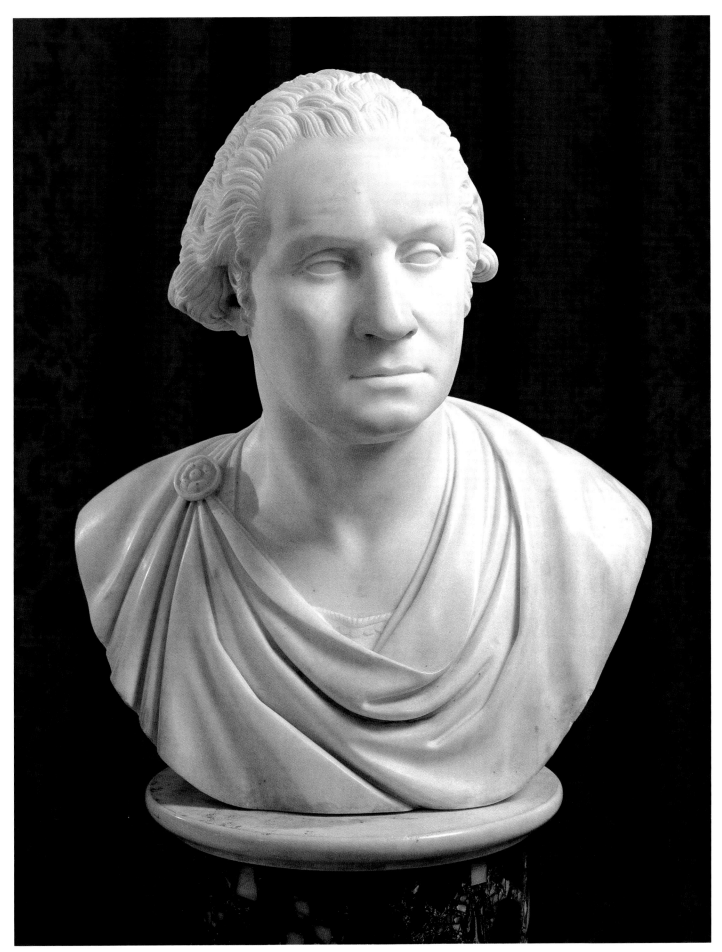

Cat. no. 68 Artist unknown (after Houdon), *George Washington*

69
Artist unknown
Abdiel
Mid-19th century
Marble
51¼ × 20¼ × 19¼ in. (130.2 × 51.4 × 48.9 cm)
Inscribed on front of base: ABDIEL

Provenance Joseph Storm Patterson, Philadelphia; The Union Club, Philadelphia, gift of Mrs. Joseph Storm Patterson, by 1902; James H. Ricau, Piermont, N.Y., by 1977

Exhibition History *The Ricau Collection*, The Chrysler Museum, Feb. 26–Apr. 23, 1989

Literature "Our Artists in Florence," *Literary World*, Feb. 16, 1850, p. 157 (as *David)*; Horatio Greenough, *Letters to Henry Greenough* (Boston, 1887), p. 201; *Catalogue of the Works of Art in the Union League of Philadelphia* (Philadelphia, 1908), p. 22; Thomas B. Brumbaugh, "Horatio and Richard Greenough: A Critical Study with a Catalogue of Their Sculpture" (Ph.D. diss., Ohio State University, 1955), pp. 135–136; Headley 1988, pp. 133–134; Janet A. Headley, "Horatio Greenough's Heroic Subjects: *Abdiel* and *David*," *Yale University Art Gallery Bulletin* (1991), 32–47, ill.

Versions None known

Gift of James H. Ricau and Museum Purchase, 86.467

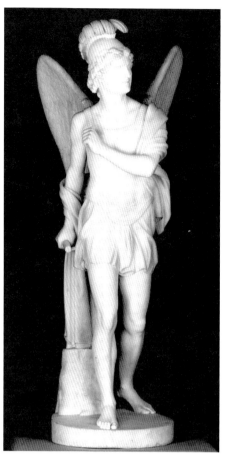

FIG. 112 Horatio Greenough, *The Angel Abdiel*, 1839. Marble, 40¾ in. (103.5 cm) high. Yale University Art Gallery, Bequest of Professor Edward E. Salisbury, B.A. 1832, M.A. 1835, LL.D. 1869, 1919.15. Photograph by Joseph Szaszfai

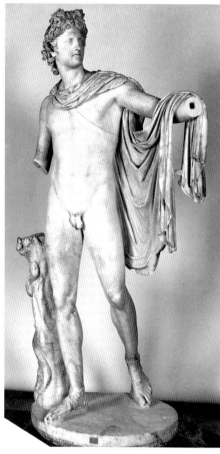

FIG. 113 *Apollo Belvedere*, Roman copy of Greek original, ca. 350 B.C. Marble, 88¼ in. (224.2 cm) high. Vatican Museums, Rome

AMONG the most beautiful sculptures in the Ricau Collection is *Abdiel*. It is also the most perplexing. When Ricau acquired it in 1977, he did not know its author, but he specifically ruled out Greenough.[1] Despite this rejection, an association with America's first professional sculptor was understandable, since Greenough had created an Abdiel in 1838–39 for his patron Edward E. Salisbury (fig. 112). The subject represents the angel from John Milton's epic poem, *Paradise Lost*, and interprets Abdiel's refusal to follow Satan's rebellion against God. The militant response of Abdiel is underscored by his costume of armor. Acting on the recommendation of his mentor, Washington Allston (1779–1843), that he satisfy the requirement for a lofty, uplifting subject, Greenough brought extensive education to this learned conceit.

The work in the Ricau Collection has been treated to a thorough argument that judiciously reidentifies it as the late *David* in the Greenough literature.[2] While many points are well taken, and the identification of the figure as the shepherd David is plausible, certain aspects of the argument

are debatable. Despite the formal affinities such as the mirror poses that connect the two works, it is difficult to unite the Ricau piece with Greenough on stylistic grounds.[3] While each sculpture could only be compared with its photographic counterpart, there were still enough differences to raise doubts. The overall delicacy and refinement of the Yale piece is not apparent in the Ricau work. The drapery in the Yale *Abdiel* is flowing and windblown, whereas that of the Ricau figure is stiff and columnar. The similar poses suggest there should be an equivalent sense of movement, which the Ricau work lacks. There is a greater feeling of fluidity and suppleness to the entire Yale figure. The original *Abdiel* has a facial expression of intensity and determination, whereas the so-called *Abdiel/David* wears an aloof and distant demeanor, which associates him with the classical rather than the naturalistic tradition. While both compositions derive from the *Apollo Belvedere* (fig. 113), the positioning of the arms may owe some debt to Bertel Thorvaldsen's (q.v.) well-known *Mercury as the Slayer of Argus* (National Museum,

Cracow, Poland). Here, too, the Yale piece asserts greater originality with its emphatic torsion and slender shoulders. In contrast, the Chrysler statue is less animated. Its right arm, crossing the body, is rigid and posed, conveying a stasis, whereas the corresponding arm in the Yale *Abdiel* generates a swinging motion. Finally, the facial features of the Ricau sculpture possess a crisp elegance and idealization that suggest a timeless remove rather than the illusion of flesh and momentary sense that inform Greenough's signature work.

In addition to these stylistic differences, there are points in the recent argument that are disturbingly circumstantial. It is correct to question the identity of the Ricau piece as Abdiel. Replacing the armor, helmet, and wings with classical garb and thin, ribboned headband implies a major change of identity. Yet it is equally hard to accept it as Greenough's *David* referred to in the literature. In general terms, the statue subscribes to the David type. In the 1840s Greenough apparently embarked on a conception that originally depicted the youthful hero victoriously astride the head

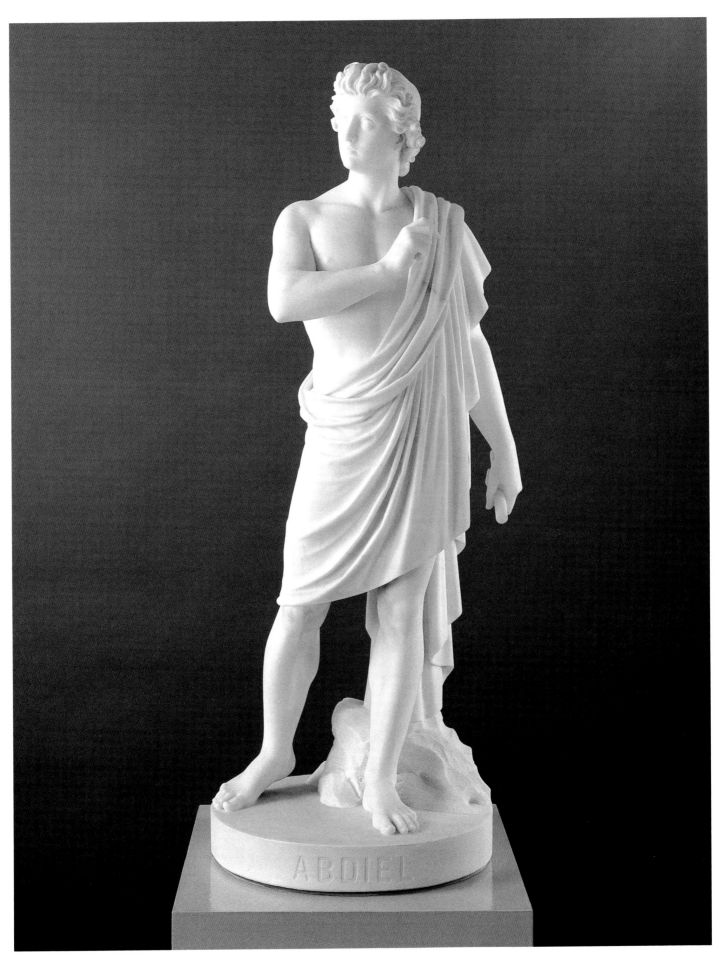

Cat. no. 69 Artist unknown, *Abdiel*

of Goliath while wielding his sword in the tradition of the Renaissance masters Donatello and Andrea del Verrocchio.[4] The sculptor changed his mind, and the revised work was described in 1847 as a "statue of David going to meet Goliath, with his staff and sling. The general idea is already developed. David may be supposed listening to the scornful reproach of the giant."[5] It is puzzling that the statue in question bears little affinity to this description. There is no clear evidence of a staff and sling; the truncated cylinder that the youth holds in his left hand is certainly not grasped in the way one would expect a staff to be held, and there is no indication of a sling. If the work were reported as "nearly finished" in 1850,[6] it seems unlikely that such crucial attributes of the piece would have been edited out.

Another point that compromises the recent argument is the contention that the piece was finished by studio assistants after Greenough departed for America in 1851.[7] While it is extremely difficult to ascertain what the correspondent in the *Literary World* meant by "nearly finished," this presumably referred to the clay or plaster model and not a marble translation. Greenough was not in a financial position at this juncture of his career to have a work translated into marble without the certainty of a commission. His creative energies and financial resources were tied up in the government commission, *The Rescue* (United States Capitol, Washington, D.C.).

Equally problematic is the assumption that Greenough's studio remained open after his departure from Florence in July 1851. It has been generally thought his return to America was permanent and that the studio was retained to store items he did not take with him. There is no compelling evidence to suggest that Greenough's work was continued.[8]

Once back in America, Greenough devoted the majority of his time to arranging for the shipment of *The Rescue*, which had preoccupied him prior to his departure. He spent the remainder of his time writing and lecturing. It was not an easy period for him since he was fighting a losing battle to a mental illness that finally claimed his life in November 1852.

Given all these circumstances, it is difficult to credit America's first professional sculptor with the elusive figure acquired by Ricau. Unfortunately, attempts to provide alternate authorship have proved equally frustrating, and the penumbra of its early history does not assist in clarifying matters. The earliest known reference to the sculpture was its presentation to the Union League of Philadelphia in 1902

by Mrs. Joseph Storm Patterson in memory of her husband, who had been active in the art affairs of that organization.[9] It remained catalogued there simply as *Abdiel* and was located in the reception room until the mid-1970s, when the club sold it to Ricau, who was moved by its beauty and undeterred by its anonymity. In spite of the flirtation with a Greenough attribution, this exquisite sculpture cannot be placed in his oeuvre until warranted by further research.

Notes

1. James H. Ricau to William H. Gerdts, Apr. 11, 1977, William H. Gerdts archive, New York.
2. Headley, "Greenough's Heroic Subjects: Abdiel and David" (1991), pp. 32–47.
3. William Gerdts has long resisted Mr. Ricau's change of opinion to assigning the work to Greenough's hand (letter to the author, Apr. 17, 1990), and other scholars familiar with Greenough's oeuvre who agree with Gerdts that it is not by Greenough are Nathalia Wright (letter to the author, July 22, 1990) and, somewhat more cautiously, Jan Seidler Ramirez (letter to the author, Jan. 23, 1993). I would like to express my appreciation to Janet Headley for her openness and assistance in discussing this vexing issue.
4. Headley, "Greenough's Heroic Subjects," p. 41.
5. "Greenough's New Works," *Boston Evening Transcript*, Mar. 19, 1847, p. 2.
6. *Literary World*, Feb. 16, 1850, p. 157.
7. Headley, "Greenough's Heroic Subjects," p. 43.
8. Nathalia Wright, *Horatio Greenough: The First American Sculptor* (Philadelphia, 1963), p. 263.
9. *Chronicle of the Union League of Philadelphia 1862 to 1902*, (Philadelphia, 1902), p. 343.

70
Artist unknown
Young Boy Praying or *St. John*
first half 19th century
Marble
27⅜ × 9½ × 9⅝ in. (69.5 × 24.1 × 24.5 cm)
No inscription

Provenance [Florentine Craftsmen, New York]; James H. Ricau, Piermont, N.Y., by 1963

Exhibition History *The Ricau Collection*, The Chrysler Museum, Feb. 26–Apr. 23, 1989

Literature None known

Versions None known

Gift of James H. Ricau and Museum Purchase, 86.468

THE number of subjects dealing with children in the Ricau Collection affirms the popularity of this theme in the nineteenth century. These images cover a broad spectrum, ranging from genre subjects such as Joseph Mozier's *Young America (Boy Mending a Pen)* (cat. no. 33) and Thomas Crawford's *Dancing Girl* and *The Broken Tambourine* (cat. nos. 36, 37) to allegorical motifs that include Heinrich Imhof's *Eros* (cat. no. 4), Randolph Rogers's *Isaac* (cat. no. 53), Chauncey B. Ives's classically inspired *Boy Holding a Dove* (cat. no. 19), and Emma Stebbins's *Samuel* (cat. no. 39).

Young Boy Praying, by an unidentified hand, resonates with the religious inspiration of Stebbins's statue. Religious imagery sustained its popularity among sculptors by midcentury. In general, New Testament themes were less prevalent than those from the Old Testament.[1] Unfortunately, lack of significant iconographic attributes confounds precise identification of this subject.

This diminutive statue, half-life-size, may be a more marketable reduction of a larger piece. It depicts a young boy of about eight clothed in classically derived garb who prays while looking fervently heavenward. The facial features, physique, hair, and garment are all rendered with a deftness of carving that imbues the hard marble with a persuasive softness. The convincing flesh and emotive expression impart a naturalism that distances it from a purely neoclassical aesthetic and connects it to the unfolding sentimentality of the Victorian era. While the work recalls images of youth by Horatio Greenough (1805–1852), such as *The Ascension of a Child Conducted by an Infant Angel* of 1833 (BMFA) or the portrait statue of Cornelia Grinnell of 1850–52 (private collection),

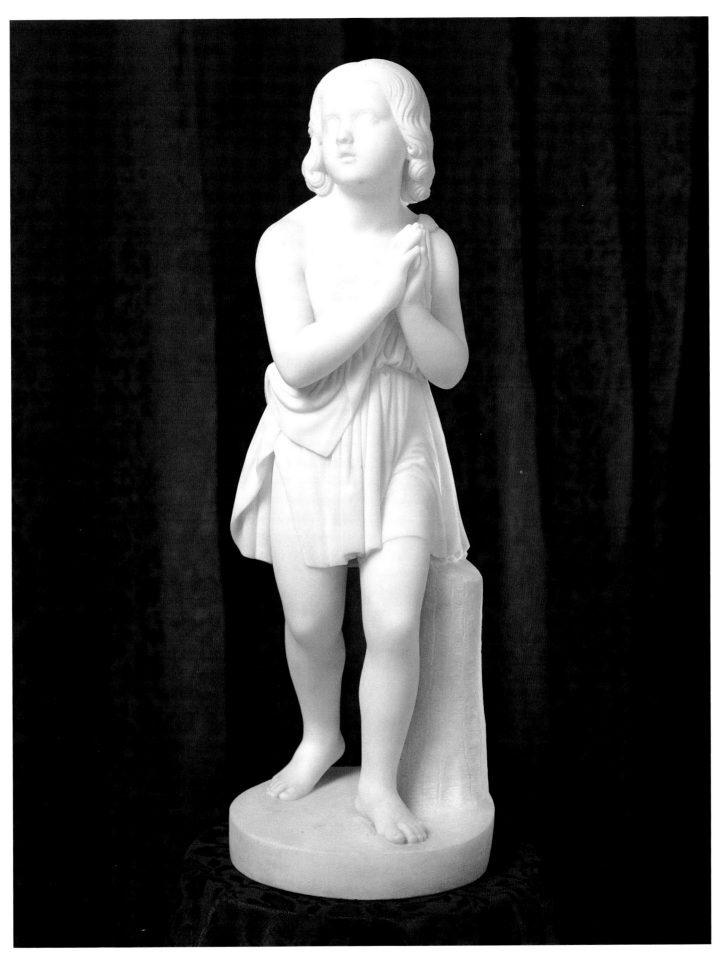

Cat. no. 70 Artist unknown, *Young Boy Praying*

Anno I. L'ape Italiana. Tav.VI.

LA CARITA' ~ MONUMENTO SEPOLCRALE.
Bassorilievo-Di Pietro Tenerani.

FIG. 114 After Pietro Tenerani, *La Carità—Monumento Sepulcro*. Engraving. From *L'ape italiana* 1 (1856), pl. 6

details such as the eyelids are too crisp and emphatic in the work of the Bostonian to warrant serious association with the softer, more languid effect of the Ricau statuette.[2]

The naturalistic elements that inform this anonymous work associate it with the trend away from neoclassical ideals unfolding in Florence under the leadership of Lorenzo Bartolini (1777–1850) in the first half of the nineteenth century. In its emphasis on soft flesh and saccharine emotion, *Young Boy Praying* echoes contemporary Italian sculpture such as the extremely popular *Orfano* by the Florentine Luigi Pampaloni (see cat. no. 2) and certain works by the more classically oriented Pietro Tenerani (1798–1870). The latter's sepulchral monument with the allegory of Charity included a youth in prayer, who corresponds to the Ricau work in both pose and expression. This design was published in an Italian journal, *L'ape italiana*, in 1855 and would have enjoyed substantial exposure (fig. 114). Common to these works is the emphasis on the innocence of childhood, which had special significance at a time when infant mortality remained an ominous threat. Resolution of the identity and attribution of this sculpture poses an intriguing problem that may only be solved through more vigorous study of the less-charted waters of nineteenth-century sculpture.

Notes

1. Gerdts 1973, pp. 72–73.

2. Mr. Ricau considered *Young Boy Praying* to come from the studio of Horatio Greenough, but this, too, is extremely difficult to verify; correspondence with James H. Ricau, June 12, 1990.

SHORT REFERENCES

AAA. Archives of American Art, Smithsonian Institution.

Adams 1923. Adams, Adeline. *The Spirit of American Sculpture.* New York, 1923.

Agard 1951. Agard, Walter R. *Classical Myths in Sculpture.* Madison, Wisc., 1951.

Atkinson 1863. Atkinson, J. Beavington. "Modern Sculpture of All Nations in the International Exhibition, 1862." *Art Journal* (London), n.s., 9 (1863), 313–324.

Ball 1891. Ball, Thomas. *My Threescore Years and Ten.* Boston, 1891.

Benjamin 1880. Benjamin, Samuel G. W. *Art in America: A Critical and Historical Sketch.* New York, 1880.

BMFA 1986. Greenthal, Kathryn, Jan Seidler Ramirez, et al. *American Figurative Sculpture in the Museum of Fine Arts, Boston.* Boston, 1986.

Brewster 1869. Brewster, Anne. "American Artists in Rome." *Lippincott's Monthly Magazine of Literature, Science, and Education* 3 (Feb. 1869), 196–199.

Calvert 1846. Calvert, George H. *Scenes and Thoughts in Europe.* New York, 1846.

Carr 1912. Carr, Cornelia, ed. *Harriet Hosmer: Letters and Memories.* New York, 1912.

Cikovsky et al. 1972. Cikovsky, Nicolai, Jr., William H. Gerdts, Marie H. Morrison, and Carol Ockman. *The White Marmorean Flock: Nineteenth-Century American Women Neoclassical Sculptors.* Exh. cat., Vassar College Art Gallery. Poughkeepsie, N.Y., 1972.

Clark 1878. Clark, William J. *Great American Sculptors.* Philadelphia, 1878.

Cowdrey 1943. Cowdrey, Mary Bartlett. *The National Academy of Design Exhibition Record, 1826–1860.* 2 vols. New York, 1943.

Crane 1972. Crane, Sylvania E. *White Silence: Greenough, Powers, and Crawford: American Sculptors in Nineteenth-Century Italy.* Coral Gables, Fla., 1972.

Craven 1984. Craven, Wayne. *Sculpture in America,* rev. ed. New York, 1984.

Dentler 1976. Dentler, Clara Louise. *Famous Americans in Florence.* Florence, 1976.

Dimmick 1986. Dimmick, Lauretta. "A Catalogue of the Portrait Busts and Ideal Works of Thomas Crawford (1813?–1857), American Sculptor in Rome." Ph.D. diss., University of Pittsburgh, 1986.

Dryfhout 1982. Dryfhout, John H. *The Work of Augustus Saint-Gaudens.* Hanover, N.H., 1982.

Florentia 1854. Florentia. "A Walk through the Studios of Rome." *Art Journal* (London), June 1, 1854, 184–187.

Forney 1876. Forney, John W. *A Centennial Commissioner in Europe, 1874–1876.* Philadelphia, 1876.

Freeman 1883. Freeman, James E. *Gatherings from an Artist's Portfolio in Rome.* Boston, 1883.

French 1879. French, Henry W. *Art and Artists in Connecticut.* New Haven, Conn., 1879.

Fryd 1992. Fryd, Vivien Green. *Art and Empire: The Politics of Ethnicity in the United States Capitol, 1815–1860.* New Haven, Conn., and London, 1992.

Fuller 1856. Fuller Ossoli, Margaret. *At Home and Abroad, or Things and Thoughts of America and Europe.* Boston, 1856.

Fuller 1859. Fuller, Hiram. *Sparks from a Locomotive.* New York, 1859.

Gale 1964. Gale, Robert L. *Thomas Crawford, American Sculptor.* Pittsburgh, 1964.

Gardner 1945. Gardner, Albert Ten Eyck. *Yankee Stonecutters.* New York, 1945.

Gardner 1965. Gardner, Albert Ten Eyck. *American Sculpture: A Catalogue of the Collection in the Metropolitan Museum of Art.* New York, 1965.

Gerdts 1973. Gerdts, William H. *American Neo-Classic Sculpture: The Marble Resurrection.* New York, 1973.

Greenthal 1985. Greenthal, Kathryn. *Augustus Saint-Gaudens: Master Sculptor.* New York, 1985.

Greenwood 1854. Greenwood, Grace [Sara J. Clark Lippincott]. *Haps and Mishaps of a Tour in Europe.* Boston, 1854.

Harding 1984. Harding, Jonathan. *The Boston Athenaeum Collection: Pre-Twentieth-Century American and European Painting and Sculpture.* Boston, 1984.

Hawthorne 1858. Hawthorne, Nathaniel. *The French and Italian Note-Books.* Boston and New York, 1858. References are to the 1883 edition.

Headley 1988. Headley, Janet A. "English Literary and Aesthetic Influences on American Sculptors in Italy, 1825–1875." Ph.D. diss., University of Maryland, College Park, 1988.

Hillard 1853. Hillard, George S. *Six Months in Italy.* 2 vols. Boston, 1853.

Huidekooper 1882. Huidekooper, Albert. *Glimpses of Europe in 1867–68.* Meadeville, Pa., 1882.

Hyland 1985. Hyland, Douglas. *Lorenzo Bartolini and Italian Influences on American Sculptors in Florence (1825–1850).* New York, 1985.

James 1903. James, Henry. *William Wetmore Story and His Friends.* 2 vols. Boston, 1903.

Janson 1985. Janson, Horst W. *Nineteenth-Century Sculpture.* New York, 1985.

Jarves 1864. Jarves, James J. *The Art-Idea.* New York. 1864.

Jarves 1869. Jarves, James J. *Art Thoughts: The Experiences of an American Amateur in Europe.* New York, 1869.

Kasson 1990. Kasson, Joy S. *Marble Queens and Captives: Women in Nineteenth-Century American Sculpture.* New Haven, Conn., and London, 1990.

Lee 1854. Lee, Hannah. *Familiar Sketches of Sculpture and Sculptors.* 2 vols. Boston, 1854.

Lester 1845. Lester, Charles E. *The Artist, the Merchant, and the Statesman of the Age of Medici and Our Own Time.* 2 vols. New York, 1845.

Lester 1846. Lester, Charles E. *The Artists of America.* New York, 1846.

Menconi 1982. Menconi, Susan. *Carved and Modeled: American Sculpture 1810–1940.* Exh. cat., Hirschl & Adler Galleries. New York, 1982.

Osgood 1870. Osgood, Samuel. "American Artists in Italy." *Harper's New Monthly Magazine* 41 (Aug. 1870), 420–425.

Perkins and Gavin 1980. Perkins, Robert F., Jr., and William J. Gavin III. *The Boston Athenaeum Art Exhibition Index, 1827–1874.* Boston, 1980.

Post 1921. Post, Chandler R. *A History of European and American Sculpture.* 2 vols. Cambridge, Mass., 1921.

Reynolds 1977. Reynolds, Donald. *Hiram Powers and His Ideal Sculpture.* New York, 1977.

Rogers 1971. Rogers, Millard F., Jr. *Randolph Rogers: American Sculptor in Rome.* Amherst, Mass., 1971.

Ross and Rutledge 1948. Ross, Marvin Chauncey, and Anna Wells Rutledge. *A Catalogue of the Work of William Henry Rinehart,*

Maryland Sculptor, 1825–1874. Exh. cat., Walters Art Gallery and The Peabody Institute. Baltimore, 1948.

Rutledge 1955. Rutledge, Anna Wells. *Cumulative Record of Exhibition Catalogues: The Pennsylvania Academy of the Fine Arts, 1807–1870.* Philadelphia, 1955.

Sandhurst 1876. Sandhurst, Phillip T., et al. *The Great Exhibition, 1876.* 2 vols. Philadelphia, 1876.

Seidler 1985. Seidler, Jan M. "A Critical Reappraisal of the Career of William Wetmore Story (1819–1895): American Sculptor and Man of Letters." 2 vols. Ph.D. diss., Boston University, 1985.

Sherwood 1991. Sherwood, Dolly. *Harriet Hosmer: American Sculptor, 1830–1908.* Columbia, Mo., 1991.

Soria 1982. Soria, Regina. *Dictionary of Nineteenth-Century American Artists in Italy, 1760–1914.* Madison, N.J., 1982.

Stebbins et al. 1992. Stebbins, Theodore E., Jr., William H. Gerdts, Erica E. Hirshler, Fred S. Licht, and William L. Vance. *The Lure of Italy: American Artists and the Italian Experience, 1760–1914.* Exh. cat., Museum of Fine Arts, Boston. Boston and New York, 1992.

Strahan 1879–82. Strahan, Edward, ed. *The Art Treasures of America.* 3 vols. Philadelphia, 1879–82.

Swan 1940. Swan, Mabel Munson. *The Athenaeum Gallery, 1827–1873: The Boston Athenaeum as an Early Patron of Art.* Boston, 1940.

Taft 1924. Taft, Lorado. *The History of American Sculpture.* Rev. ed. New York, 1924.

Taylor 1848. Taylor, J. Bayard. *Views A-Foot; or, Europe Seen with a Knapsack and Staff.* Philadelphia, 1848.

Thieme-Becker. Thieme, Ulrich, and Felix Becker. *Allgemeines Lexikon der bildenden Künste von der Antike bis zur Gegenwart.* 37 vols. Leipzig, 1907–50.

Thorp 1965. Thorp, Margaret F. *The Literary Sculptors.* Durham, N.C., 1965.

Tuckerman 1855. Tuckerman, Henry T. *Italian Sketch-book.* New York, 1855.

Tuckerman 1867. Tuckerman, Henry T. *Book of the Artists.* New York, 1867.

Vance 1989. Vance, William L. *America's Rome.* 2 vols. New York and London, 1989.

Walker 1866. Walker, Katherine C. "American Studios in Rome and Florence." *Harper's New Monthly Magazine* 33 (June 1866), 100–105.

Washington 1860. Washington, E. K. *Echoes of Europe; or, Word Pictures of Travel.* Philadelphia, 1860.

Waters and Hutton 1894. Waters, Clara Erskine Clement, and Laurence Hutton. *Artists of the Nineteenth Century and Their Works.* Rev. ed. 2 vols. New York and Boston, 1894.

Webster 1983. Webster, J. Carson. *Erastus D. Palmer.* Newark, Del., 1983.

Weed 1866. Weed, Thurlow. *Letters from Europe and the West Indies, 1843–1852.* Albany, N.Y., 1866.

Whiting 1910. Whiting, Lilian. *Italy, The Magic Land.* Boston, 1907.

Wilmerding et al. 1981. Wilmerding, John, Linda Ayres, and Earl A. Powell. *An American Perspective: Nineteenth-Century Art from the Collection of Jo Ann and Julian Ganz, Jr.* Exh. cat., National Gallery of Art. Washington, D.C., 1981.

Wunder 1991. Wunder, Richard P. *Hiram Powers: Vermont Sculptor, 1805–1873.* 2 vols. Newark, Del., 1991.

Yarnall and Gerdts 1986. Yarnall, James L., and William H. Gerdts. *The National Museum of American Art's Index to American Art Exhibition Catalogues from the Beginning through the 1876 Centennial Year.* 6 vols. Boston, 1986.

INDEX